Nicholas Roerich

RUSSIAN AND EAST EUROPEAN STUDIES

JONATHAN HARRIS, EDITOR

Nicholas Roerich

The Artist Who Would Be King

JOHN McCANNON

University *of* Pittsburgh Press

PUBLISHED BY THE UNIVERSITY OF PITTSBURGH PRESS, PITTSBURGH, PA., 15260

Manufactured in the United States of America

Printed on acid-free paper

10 9 8 7 6 5 4 3 2 1

Cataloging-in-Publication data is available from the Library of Congress

ISBN 13: 978-0-8229-4741-7
ISBN 10: 0-8229-4741-2

Cover art: S. N. Roerich, *Portrait of N. K. Roerich with Mountains* (1934). Oil on canvas, 133 x 118 cm. National Gallery of Foreign Art, Sofia, Bulgaria.

Cover design: Alex Wolfe

With love to Pam and Miranda

Contents

Acknowledgments

It took a long time to write this book, and I accumulated many debts along the way. (So many, in fact, that I apologize in advance for the inevitable but, I hope, not too numerous omissions.) My graduate-school days are far behind me, but I nonetheless owe thanks to my advisers at the University of Chicago, Richard Hellie and Sheila Fitzpatrick, who supported early stages of this research despite its sharp departure from my dissertation work. Mark Bassin has acted as a mentor and friend throughout my career. As always, I am perpetually grateful to my Chicago classmates for years of camaraderie and encouragement.

When I began this project, I fretted about trespassing on the domain of art historians, only to find myself welcomed to the field by a hospitable group that includes Karen Kettering, Rosalind Blakesley, Susan Reid, Jane Sharp, and Andrea Rusnock. The Society of Historians of Eastern European, Eurasian and Russian Art community, both online and in person, continues this standard of good will. Beyond that, many scholars from various disciplines have answered queries, read draft versions of my work, or included me in conference panels and essay collections. Though this list could be much longer, I wish to thank Jim Andrews, Christopher Ely, Willard Sunderland, Maria Carlson, Bernice Glatzer Rosenthal, Birgit Menzel, Manju Kak, Ludmilla Voitkovska, and Lisa Smith. Special notice goes to a cohort of Roerich specialists who proved particularly generous about collaborating and exchanging ideas and insights: I owe a great deal to Alexandre Andreyev, Dany Savelli, Andrei Znamenski, and Ian Heron, and I likewise appreciate the advice and materials I received from Vladimir Rosov, Darya Kucherova, Markus Osterrieder, Anita Stasulane, and Shareen Blair Brysac.

Over the course of writing this book, I benefited from the help of staff and specialists at almost four dozen archives, libraries, and museums. I especially thank Fernanda Perrone, Tanya Chebotareva, and Stanley Rabinowitz at the Rutgers Special Collections, the Bakhmeteff Archive at Columbia University, and the Amherst Center for Russian Culture, respectively, and also Linda Briscoe Myers of the Harry Ransom Center at the University of Texas. I am grateful to Oriole Farb Feshbach, not only for granting access to privately held papers, but also for graciously answering endless questions about her family's involvement with the Roerich saga. Most of all, I had the pleasure during the late 1990s of visiting the Nicholas Roerich Museum regularly, making use of its archives and interviewing

its staff. I cannot speak highly enough of the kindheartedness of Daniel Entin, the museum's director at the time, and its archivist, Aida Tulskaya, a lively interlocutor whose conversations I still remember fondly. I owe added thanks to the museum's current director, Gvido Trepsa, for continuing this collaborative relationship.

Funding for this project came from various sources, including the National Endowment for the Humanities (United States), the Social Sciences and Humanities Research Council (Canada), the American Historical Association, and the Kennan Institute for Advanced Russian Studies at the Woodrow Wilson International Center for Scholars. I also acknowledge the research stipends I received from the University of Saskatchewan and Southern New Hampshire University while completing this work.

This book would not exist without the efforts of those who brought it into being at the University of Pittsburgh Press. Many thanks go to Peter Kracht, Jonathan Harris, and Amy Sherman as editors; Alex Wolfe for his technical expertise; Therese Malhame for meticulous copyediting; and the press's anonymous reviewers for helpful feedback. I was aided in my research by a University of Saskatchewan doctoral student, Rob Morley. To test this manuscript's readability, some of my oldest friends, including Trek Doyle, Patrick Myers, Michael Templeton, and others in our Texas-Ohio gaming crew, volunteered their time and patience. Finally, nothing worthwhile in my life gets done without my partner in all things, Pamela Jordan, who has shared countless adventures with me and supported the writing of this book in many ways (not least with her incisive editorial skills). Our daughter Miranda has had to live with this project her entire life—much like growing up with a demanding and not always well-behaved sibling—and I am grateful to her for putting up with it (and even helping to finish it by assisting with image selection and reproduction). As meager a reward as it may be for so much encouragement and affection, I dedicate this book to Pam and Miranda.

Note on Languages, Names, and Dates

For Slavists, transliterating Cyrillic letters into English is always a fraught exercise—"Chaikovskii" or "Tchaikovsky"? "El'tsin" or "Yeltsin"?—compounded by the question of whether to use Russian first names or their anglicized equivalents ("Pavel" vs. "Paul," or "Alexei" vs. "Alexis"). If anyone has hit upon a way of doing either that is both academically precise and reliably reader-friendly, I have yet to hear about it.

Therefore, while I follow scholarly convention in the notes and bibliography by citing Russian-language sources according to the Library of Congress system, I have focused in the main text chiefly on the needs of nonspecialist readers. This means privileging phonetic simplicity and familiar usages over linguistic consistency ("Gorky" rather than "Gor'kii," for example, or "Fyodorov" instead of "Fedorov"). First names are given in their Russian form—such as "Sergei" in favor of "Serge"—except where common usage in English dictates otherwise, as in Nicholas II or Leon Trotsky, rather than Nikolai II or Lev Trotskii. As for the Roerichs themselves, I have Westernized their names because it was in that fashion that they published books and earned fame in Europe and America. Hence, "Nicholas" and "Helena," not "Nikolai" and "Elena." (And, of course,

"Roerich" instead of "Rerikh.") By the same token, George is not "Yuri," except when I write about him in his youth. I deviate from this rule in referring to Sviatoslav only by that name and discarding the unorthodox "Svetoslav" that was often used in the West. (I retain the nickname "Svetik," owing to his parents' fondness for it.)

Translations from Russian and other European languages are my own unless otherwise indicated. In cases where my own rendering of a Russian source closely matches or has been influenced by an earlier researcher's translation, I have chosen to acknowledge the overlap in my notes rather than resorting to suboptimal wording simply for the sake of staking out a version of my own.

Names and terms taken from Tibetan, Mongolian, and other Asian languages are transliterated with an eye toward familiarity and reader-friendliness. With respect to Chinese, I have favored the Wade-Giles system of romanization, both for period flavor and because Roerich himself used it in his English-language publications, but I have included pinyin versions for the sake of clarity.

Place names in Europe and Asia have changed frequently since Roerich's birth, or are rendered differently by neighboring languages. Throughout the text, I have attempted to make it clear how, when Roerich

was in what he considered to be Peking, Urga, or Bombay, he was in Beijing, Ulaanbaatar, and Mumbai—and so forth—and anyone familiar with Russian history knows how Roerich's hometown of Saint Petersburg became Petrograd during World War I, Leningrad from the 1920s through the 1980s, and Saint Petersburg again after the collapse of the USSR. Regarding dates, Russia before 1918 continued to measure time with the Julian calendar, which ran thirteen days behind the Gregorian calendar used commonly in the West. When necessary, this book distinguishes between the two systems by using the abbreviations "OS" (old style) and "NS" (new style), respectively.

Abbreviations and Foreign Terms

Amtorg	American Trading Corporation (joint-stock enterprise facilitating Soviet trade in the United States)
ARCA	American-Russian Cultural Association
GKK	Main Concessions Committee (aka Glavkontsesskom)
GOI	Government of India
Gosizdat	State Publishing House of the USSR
HRI	Himalayan Research Institute (aka Urusvati)
IAK	Imperial Archaeological Commission
INO	Foreign Department (of the OGPU)
IOPKh	Imperial Society for the Encouragement of the Arts
IRAO	Imperial Russian Archaeological Society
IRCA	Indo-Russian Cultural Association
Kadet	Member of Constitutional Democratic Party
KMT	Chinese Nationalist Party (Kuomintang)
miriskusnik	Member of World of Art Society
Mir iskusstva	World of Art (exhibition society and art journal)
MKhT	Moscow Art Theatre
MTsR	International Center of the Roerichs (Moscow)
NEP	New Economic Policy
NKID	People's Commissariat of Foreign Affairs (aka Narkomindel)
NKVD	People's Commissariat for Internal Affairs (Soviet secret police, 1934–1946; see also OGPU)
NOLD	Novgorod Society of Antiquarian Enthusiasts
NRM	Nicholas Roerich Museum (New York)
OGPU	Unified State Political Administration (Soviet secret police, 1923–1934; also see NKVD)
peredvizhniki	Wanderers or Itinerants (exhibition society)
PPC	Pre-Petrine Commission
RAO	Russian Anthroposophical Society
ROVS	Russian All-Military Union

RPS	Religious-Philosophical Society
RTO	Russian Theosophical Society
SDI	Union of Practitioners of Art (aka Arts Union)
Smena vekh	Change of Landmarks (émigré publication)
SR	Member of Socialist Revolutionary Party
SRKh	Union of Russian Artists
TASS	Telegraph Agency of the Soviet Union
TS	Theosophical Society
Vesy	*The Scales* (art journal)
VOKS	All-Union Society for Cultural Relations with Foreign Countries
VSNKh	Supreme Council of the National Economy
Zolotoe runo	*Golden Fleece* (art journal)

Code Words and Spiritual Names Used by Roerich's "Inner Circle"

Albina	Maria Germanova
Amrida	Katherine Campbell
Avirakh	Maurice Lichtmann
Chakhembula	Nikolai Kordashevsky
the "Flaming One"	Franklin Delano Roosevelt (also the "Wavering One" and "Stephen")
Fuyama	Nicholas Roerich
Galahad	Henry Wallace
Kai	Stepan Mitusov
Kansas	Mongolia
Liumou	Sviatoslav Roerich
Logvan	Louis Horch
Modra	Frances Grant
"Monkeys"	the British
Naru	Tatyana Grebenshchikova
Ojana	Esther Lichtmann
Poruma	Nettie Horch
Radna	Sina Lichtmann
"Rulers"	the Japanese (also "Our Friends")
the "Sour One"	Cordell Hull
Tarukhan	Georgii Grebenshchikov
"Tigers"	the Soviets
Udraya	George Roerich
Urusvati	Helena Roerich
Yaruya	Vladimir Shibaev

Nicholas Roerich

INTRODUCTION

The Artist Who Would Be King?

It may be that you do not like his art, but at all events you can hardly refuse it the tribute of your interest. . . . The adulation of his admirers is perhaps no less capricious than the disparagement of his detractors; but one thing can never be doubtful, and that is that he had genius.

—W. Somerset Maugham, *The Moon and Sixpence*

On **September 20, 1927,** one of the most unusual expeditions in modern history approached the Dumbur Pass, the gateway leading from southwest China into northern Tibet. To the rear lay the salt flats of the Tsaidam Basin and the sunbaked wasteland of the Gobi Desert. Ahead was the road to Lhasa, the seat of His Holiness the Thirteenth Dalai Lama, and the least accessible city on earth. This curious caravan flew the United States flag, but not one of its members was American, and it had traveled part of its way in vehicles provided by the Soviet Union. The party included Buryat and Mongol porters, Tibetan lamas, and nine Russians—among them a Leningrad physician, a former tsarist colonel, a future priest, a Harvard-educated scholar of Asian languages, and two teenaged girls. Leading them were a middle-aged woman of aristocratic bearing and her husband, a bald, bearded painter of small frame and medium height. His name was Nicholas Roerich.

Before setting out, Roerich had told the world that his journey's aims were artistic and academic. He wished to paint the Himalayas and other remote parts of Asia. An amateur archaeologist and ethnographer, he hoped to study the myths and folklore of this poorly understood corner of the earth. He completed his canvases and conducted his research, but kept his primary goal a secret from the press and the public: Roerich went to the east desiring to locate the legendary kingdom of Shambhala and, using it as a foundation, establish a pan-Buddhist state of his own, encompassing Mongolia, Central Asia, the Himalayas, and parts of Siberia. Fulfilling this "Great Plan," he believed, would give a final turn to the cosmic

wheel. Maitreya, the Buddha of the Future, would manifest himself and shepherd the world through apocalypse to an age of peace and beauty.

Roerich's expedition, of course, ushered in no such epoch. He failed even to reach Lhasa, and his party was expelled from Tibet after a brutal—and, for some, fatal—winter in the highlands. This did not stop him from claiming fame on the order of explorers like Sven Hedin, Aurel Stein, and Roy Chapman Andrews. Seven years later, he received another chance to bring his Great Plan to fruition, during a trip sponsored by one of Franklin Roosevelt's cabinet members and paid for by the US government. This second venture faltered as badly as the first, precipitating scandals that influenced the outcome of no fewer than three presidential elections.

In his seventy-three-year lifetime, Roerich came to know the world's most famous artists, celebrities, and political leaders. He baffled foreign-affairs and intelligence services in half a dozen countries. Thousands saw in him a profound, if not divinely inspired, humanitarian, while others thought him a fraud or a madman. One of his colleagues, the art historian Igor Grabar, remarked with bemusement that "about Roerich, one could write a most fascinating novel."[1] Indeed, his tale is worthy of the pen of a Jules Verne or a Rudyard Kipling, whose Himalayan-adventuring antiheroes in *The Man Who Would Be King* are matched by the artist for sheer audacity. It is all the more remarkable for being true.

Roerich is a household name in his native Russia, and he has a reputation in India, where he lived for more than twenty years. Those who have heard of him in Europe and North America tend to know one or two aspects of what was an extraordinarily complicated life. He is familiar to specialists in Russian art and to aficionados of ballet and opera, and scholars of American history still study his impact on FDR-era politics. Fans of his visually distinctive art continue to grow in number, in the West as well as in Russia, and his following among "new age" devotees is correspondingly large. His fame is not meager, but better thought of as oddly compartmentalized.

Even a partial list of Roerich's accomplishments should make all but the most incurious wish to hear more about him. He designed for Diaghilev's Ballets Russes and, with Igor Stravinsky, cowrote the libretto for *The Rite of Spring*; his sets and costumes were onstage when the ballet made its immortal premiere in 1913. Before the communist takeover of 1917, Roerich became Russia's most renowned painter of scenes from Slavic antiquity, and he rose to direct one of the country's largest art schools; among those studying under him was a young Marc Chagall. After the revolution, Roerich and his family emigrated to England, where he befriended H. G. Wells and modern India's greatest poet, Rabindranath Tagore. He then went to America, making his mark as an artist, explorer, and peace activist. To

house his art and his many enterprises, his supporters erected a landmark skyscraper that still towers over Manhattan's Riverside Drive. The 1925–1928 expedition added not just to his own stature, but to the larger Tibetomania that inspired James Hilton to create the Himalayan dreamland of Shangri-La in his 1933 bestseller, *Lost Horizon*. Roerich's efforts on behalf of a treaty to protect art and architecture in times of war—the so-called Roerich Pact, signed into law by the United States and twenty-one other nations in 1935—earned him praise from George Bernard Shaw, Albert Einstein, and Eleanor Roosevelt, and multiple nominations for the Nobel Peace Prize. In the 1930s, Roerich and his circle entered into a relationship with the US secretary of agriculture and future vice president, Henry A. Wallace, and, for a time, had the ear of President Roosevelt himself. In his old age, residing in the Punjab, the artist became a favorite of Jawaharlal Nehru, India's first prime minister, and it was Nehru who delivered the eulogy when Roerich died in 1947.

In various and sometimes curious ways, Roerich's influence has persisted and grown. Every American encounters him on a daily basis without knowing it: the inclusion of the Great Seal's Eye of Providence on the one-dollar bill, part of the currency redesign carried out in 1935 by treasury secretary Henry Morgenthau, was suggested by Henry Wallace, with approval and encouragement from Roerich. The cosmonaut Yuri Gagarin, the first human being to gaze upon the earth from space, likened this unprecedented experience to his first encounter with Roerich's paintings.[2] In 1974, on the centenary of Roerich's birth, India's prime minister Indira Gandhi dubbed him a "combination of modern savant and ancient *rishi*."[3] Between 1987 and 1991, the Soviet leader Mikhail Gorbachev established the grand museum complex in downtown Moscow that, until 2017, was administered by the International Center of the Roerichs. The Hague convention governing the treatment of cultural property during times of armed conflict is modeled in large part on Roerich's 1935 pact.[4] In recent years, his paintings have fetched steadily higher prices at auction houses like Sotheby's and Christie's, and they form part of many key collections of Russian art.[5]

But to all this, there is a shadowy underside. Stravinsky once said of Roerich that "he looked as though he ought to have been a mystic or a spy."[6] And while the composer had his own reasons for casting his onetime friend in such suspicious light, Roerich was self-avowedly the former and, if not literally the latter, close enough to make the distinction semantic.

No later than 1905, Roerich and his wife Helena took up a variety of esoteric doctrines and practices, among them Theosophy. By itself, this was nothing strange: the Victorian-era crisis of faith caused Europeans in huge numbers to embrace alternative spiritualities as a way of "searching for

a soul," to borrow Carl Jung's phrase, in an increasingly secular world.[7] Public figures drawn to such beliefs, whether temporarily or permanently, include Arthur Conan Doyle, the French actress Sarah Bernhardt, the inventors Thomas Edison and Nikola Tesla, the Dutch painter Piet Mondrian, and Frank Lloyd Wright. Russia was part of this trend, and so much in its forefront that, as the historian Maria Carlson has observed, studying late tsarist Russia without reference to the occult is like studying medieval Europe without reference to Roman Catholicism.[8] In such an environment, it would have seemed almost more odd *not* to experiment with mysticism. Even so, by the early 1910s, the Roerichs stood out as unusually intense believers, and the experience of world war, communist revolution, and emigration raised them to a higher pitch of apocalyptic literal-mindedness. In 1920, they founded Agni Yoga, the "system of living ethics," purporting to receive sacred instruction from the same supernatural masters said to have initiated Madame Blavatsky into the mysteries of Theosophy half a century earlier.

Whatever their source, such revelations led the family to play at spiritual geopolitics on a globe-girdling scale. Believing himself to be the reincarnation of the Fifth Dalai Lama, Roerich dreamed of enthroning himself as the ruler of a theocratic New Country that would unite the political and religious destinies of the West with those of the East. More astounding than the aspiration itself was how much progress

he made in his attempts to realize it, and how far it drew him into the murky underworld of intelligence peddling. In his own time, Roerich was suspected of political scheming, and many have tried for decades to discern the nature and extent of his clandestine activities. Gaps in the record remain, but the materials we have indicate that Roerich was no spy in the conventional sense of being employed by a particular intelligence bureau. Instead, he operated as an independent adventurer, striking deals with various parties to advance his own agenda. Complicating matters further, he shifted allegiance more than once and did not hesitate to cooperate with different, even competing, partners if he thought doing so would serve his interests.

In 1918, fearing the consequences of Red victory, Roerich fled Russia, declaring himself a foe of the Leninist regime. Then, no later than 1923 or 1924, he not only put aside his anti-Bolshevik passions, he sought ways to reconcile Buddhist and Agni Yogist dictates with Soviet communism. It was not rare in the 1920s for formerly White émigrés to come to terms with the permanency of Red rule in Russia, but Roerich's actions placed him well outside this trend's normal bounds. Between 1924 and 1928—while he traveled publicly with American backing (and, en route, repeatedly requested aid from British and American diplomats)—he entered into a covert, two-pronged set of negotiations with the Kremlin. On one front, he tried to secure economic concessions that would allow him and his US associates

to develop the industrial potential of the Altai Mountains, which he hoped would serve as the capital of his New Country. On the other, he strove to convince the Soviet People's Commissariat of Foreign Affairs and the foreign intelligence directorate of the secret police that, by fusing Buddhism, communism, and anti-colonial ideology as he suggested, the USSR could win the loyalty of millions of Indians, Tibetans, Mongols, and Chinese. Outlandish as such a proposal may sound, Soviet officials at the highest level, including the foreign affairs commissar, Georgii Chicherin, were sufficiently intrigued to hear Roerich out in person, during a surprise detour from Chinese Turkestan to Moscow in 1926, and to lend him logistical assistance on the road to Mongolia and Tibet in 1926–1927.

Mutual suspicion, however, and the wreck of his plans in Tibet ended Roerich's first rapprochement with the USSR; by late 1927, he had drifted back into the anti-Soviet orbit. Over the next half decade, Roerich relied on his US followers to build his skyscraper-museum in New York, to acquire property for him in India, and to gain access to as many American tycoons, celebrities, and politicians as possible. Roerich did not fare well with the Hoover administration, but the election of Franklin Roosevelt as president in 1932 brought him a windfall in the person of Henry Wallace, a mystically minded agronomist who had already spent several years under Agni Yoga's spell, and was now raised up to a post in FDR's first cabinet. Wallace persuaded Roosevelt to sponsor Roerich's treaty effort (against the advice of the State Department) and, under the pretext of hiring him as a Department of Agriculture expert to search for drought-resistant grasses in Asia, arranged Roerich's expedition to Manchuria and China in 1934–1935. In the process, Wallace left behind one of the most bizarre bodies of correspondence in US history: the "Dear Guru" letters, which played a role in the presidential elections of 1940, 1944, and, most sensationally, 1948. Simultaneously, Helena Roerich, writing from India, entered into a strange nine-letter exchange with FDR himself, an interaction that has perplexed historians for years.

What Roosevelt did not know in 1934 and 1935 was that the Roerichs were hedging their geopolitical bets with a pro-Japanese hole card. The United States granted diplomatic recognition to the USSR in the fall of 1933, and Roerich now doubted whether he could depend on America to stand firmly against communism. So, once in China, the artist—technically an employee of the US government—broke free and launched a renegade campaign to exhort Japanese forces and White Russian émigrés in Asia to band together against the Stalinist menace. Here, Roerich overreached himself. Years of zigzagging had made it impossible for anyone to trust him, and far from answering his call, both the Whites and the Japanese accused him of espionage, as did the Chinese and Soviets. Worse, Roerich's gamble forfeited the political and material capital he had accumulated in the United States.

In the summer of 1935, Wallace, desperate to stave off political ruin, severed all connection with the Roerichs. The New York circle split, and the faction led by Roerich's chief financial supporter renounced him. This group, with help from Wallace, turned the New York courts and the Internal Revenue Service against the Roerichs. The family fled and never again set foot on US soil.

Roerich lived the rest of his days in northwestern India, nursing grievances against America (a land of "thieves" and "gangsters") and Britain ("tyrannical oppressor" of his newly adopted home).[9] His political sympathies lay with the Indian Congress and its quest for independence, and he inclined once more toward the Soviet Union, even though he was regarded there as a "religio-mystical reactionary," an American or Japanese agent, and a "Buddhist-Masonic conspirator."[10] Admiration for the USSR's struggle against Nazi aggression confirmed Roerich as a Soviet patriot, and he spent the wartime years painting heroic images from Russian myth and folklore. Afterward, he tried to hammer out a repatriation agreement with Moscow, but to no avail. He lived to see India freed from British rule, but never returned to his beloved motherland—which did not love him back until the late 1950s, when the Khrushchev regime restored him to his place in Russia's artistic canon.

A prodigious amount of material has been written about (and by) the Roerichs. So what need is there for another book about them? The fact is that little of the work on Roerich, despite its volume, manages to portray him both convincingly and thoroughly. There is an excellent literature dealing with his art, and research into his expeditions and political activities has improved over time.[11] By contrast, comprehensive studies are mostly unreliable or incomplete. In many cases, they willfully sidestep any issue that might cast their subject in a less than favorable light.[12]

Why such a state? Several difficulties have skewed biographers' attempts to perceive Roerich in his totality. The most straightforward has to do with time: before the 1990s, important collections of Roerich-related documents remained hidden or unavailable, and anything written before their reemergence is sorely lacking.[13] The wide dispersal of Roerich's papers poses a second problem. The biggest archival holdings are located not just in Russia, but in Washington, DC, New York, London, and Naggar, India, with smaller repositories strewn throughout the United States, Europe, and Asia. Late in his life, Roerich, wondering "where and in what condition are my archives?" bemoaned the scattering of his records and effects to the far ends of the earth—a personal tragedy for the artist and a hardship for any would-be chronicler of his career.[14]

National perspectives have also distorted work on Roerich. The bulk of Russian writing about him has been shaped by Soviet-era ideological constraints and

post-Soviet patriotism. During the Cold War, researchers were forbidden to touch on political controversies or speak frankly about Roerich's mysticism. Instead, they built him up as a painter of brilliance, a philosopher of "cosmic" and "universal" insight, and an explorer who contributed invaluably to the field of Asian studies. (This last assertion was so successfully propagated that even in the West, more than a few reference works, including the *Times Atlas of World Exploration*, refer—more confidently than they should—to Roerich as providing the "bedrock" for anthropological understanding of Central Asia.[15]) In the post-Soviet era, Russians have been free to think of Roerich what they will, and some have put aside the old, blandly idealized image. However, nationalistic pride has kept that image largely intact, and the growing appeal of new age movements has added to it. In the West, popular writing about Roerich is dominated by admirers of his art or his spirituality, but scholarship has been far more critical than in Russia. He receives due credit as an artist of importance, but many art historians find his style not to their taste, and his mysticism and political skulduggery have called forth skepticism and scorn.

Polarization of opinion has similarly confused the biographical record. Both in Russia and abroad, Roerich is commonly viewed in two dimensions rather than three, as a saint limned on an icon or as a cartoon villain. His admirers, whether they venerate him as a guru or merely enjoy his art, typically cling to hagiographic understandings of him as a benign sage: politically blameless, esoteric in a philosophical rather than a cultish sense, and imbued with the compassion and social conscience of an Albert Schweitzer or a Gandhi. Some see Roerich this way because they know no better; others more consciously refuse to face unflattering facts about him. For example, one scholar at a major US university angrily dismissed as "fantasy" the research of a peer for daring to suggest that Roerich conducted himself less than spotlessly.[16] Moscow's International Center of the Roerichs, which touted itself from the 1990s through the 2010s as the "defender" of the family's spiritual and cultural legacy, declared it a "sin" and "abomination" to speak of the Roerichs as one would "mere historical figures."[17]

On the other side of the coin, criticism has been fierce, sometimes unfairly so. The art historian Kenneth Archer notes how the "saint-making rhetoric" of Roerich's followers has provoked an unfortunate but predictable backlash, in which many of those engaged in the much-needed stripping away of Roerich's façade go too far, damaging the underlying structure.[18] Robert Craft, Stravinsky's longtime secretary, is guilty of this when he brands Roerich "a monumental con artist," as are those who marginalize him as a spy, a huckster, or a lunatic.[19] Such rhetorical excess has gone farthest in post-Soviet Russia, where journalists have spun lurid speculations about Roerich as a "terrorist" or a Comintern mastermind, and where the Orthodox Church has denounced him as a "satanist."[20] Not everyone writing about

Roerich has been a partisan or a detractor, but much room remains for studies that combine dispassionate judgment with close attention to sources.

Apart from the Roerichs' furtiveness and the mutability of their motives, the thorniest issue confronting anyone studying their lives is how to construe their mysticism. Simply understanding the basics of what the Roerichs did and believed can be a challenge, thanks to the esoteric tone that pervades nearly everything they wrote. Even to comment on mundane topics, the family used the rarefied vocabulary of transcendence, and when they spoke of their experiences in Asia or the rapturous future they believed was fast approaching, their language became more oracular yet. Excerpts like this, from Helena's *On Eastern Crossroads*, are routine fare: "Through the desert I come—I bring the Chalice covered with the Shield. Within it is a treasure—the Gift of Orion. By the sign of the seven stars shall the Gates be opened. Let us retire into the city on the White Mountain and hearken to the Great Book."[21] These sentences were not meant merely as rhetoric, but as a guide to practical action, although knowing this makes it no easier to fix a specific meaning to prose so impenetrably gnomic. The Indian critic B. N. Goswamy has noted, "While the flow of [the Roerichs'] words is quite remarkable, the sequence of thoughts [is] as hard to follow as the jagged peaks of the mountains."[22]

Poring over such passages, one is left wondering how best to answer the most fundamental questions about sincerity, hypocrisy, and the family's actual intentions.[23]

But the problem runs deeper. Ultimately, any researcher dealing with Roerich's life has to render a judgment about his belief system: If one does not share it, does one consider it the product of a cold-blooded spiritual con? Or of sheer mental folly? Or does Agni Yoga deserve to be studied the way any other religion would be? This last option—critical but nonprejudicial skepticism—follows the pattern set by a growing number of scholars and journalists who find themselves examining the modern era's profusion of synthetic doctrines. Regardless of how one feels about Scientology or the Reverend Moon, for instance, how does one objectively distinguish them from more mainstream belief systems as objects of academic inquiry? An arresting passage from *The Quiet American*, Graham Greene's classic novel of the Indochina wars, addresses this conundrum. The scene in question places the main character, a British reporter, at a temple in the town of Tây Ninh, where he observes a Caodai ritual. A young and consciously syncretic doctrine, Caodai blends Catholicism with elements of Confucianism and Vietnamese Buddhism, and the sight of such reverence being paid to this "Walt Disney fantasia of the East" moves the narrator to reflect that only durability and good luck distinguish cults from accepted religions. "If this cathedral had existed for five centuries instead of two decades,"

he muses, "would it have gathered a kind of convincingness with the scratches of feet and the erosion of weather?"[24]

Despite the oceans of ink spilled over this question by theologians, anthropologists, and philosophers, there is, beyond a point, no logically consistent way to differentiate "authentic" faiths from those on the so-called fringe. I am not an Agni Yogist or a Theosophist, nor am I convinced that the Roerichs possessed supernatural gifts. Yet I believe that nonmainstream creeds can be studied in terms similar to longer-established ones as genuine expressions of spiritual conviction, and my aim has been to discuss the Roerichs' beliefs as open-mindedly as academic responsibility will permit.

I have felt aided here by the Roerichs' apparent earnestness with respect to their teachings and actions. This is not to deny the couple's frequent duplicity or their emotionally manipulative handling of supporters, or even the chance that their talk of Shambhala was rank charlatanism. As the Vedantist monk Vivekananda—a teacher highly regarded by the Roerichs themselves—once remarked, when people attempt religious leadership, "eighty percent of them turn into cheats, and about fifteen percent go mad. So beware!"[25] Still, protracted examination has led me to conclude that the Roerichs believed in what they prophesied. Readers will cherish or deride those prophecies as they will, but I do not consider them fraudulent in the sense of having been manufactured solely to deceive.

In this, I am not alone among Roerich scholars: I share Alexandre Andreyev's opinion that the family's predictions and pronouncements were "mental constructs or dreams," and Markus Osterrieder's that they "understood themselves and their 'mission' as part of some larger spiritual plan [and] did not consciously act as imposters."[26] Although it is risky without clinical records to attempt the diagnosis of long-dead historical figures, physiological and psychological factors appear to have affected the Roerichs. Migraines plagued Helena from an early age, and in her later years, her family physician believed her to be prone to some form of long-term epileptic distress; either or both could account for the visions and psychic communications she claimed to have.[27] Andreyev confidently labels Roerich himself "a typical neurotic," and one or both of the Roerichs may have suffered narcissistic personality disorder, which many scholars associate with the founders of new spiritual movements. "Whether gurus have suffered from manic-depressive illness, schizophrenia, or any other form of recognized, diagnosable mental illness is interesting but ultimately unimportant," notes the Oxford psychiatrist Anthony Storr. "What distinguishes gurus from more orthodox teachers is not their manic-depressive mood swings, not their thought disorders, not their delusional beliefs, not their hallucinatory visions, not their mystical state of ecstasy: it is their narcissism."[28] Narcissism's chief symptoms—a "pervasive pattern of grandiosity" and a yearning for "excessive admiration"—seem to go a long way toward explaining much of the Roerichs' conduct. Either way, the

family's stated beliefs, even at their most unconventional, strike me as having been sincerely held.

Consequently, I have not engaged in a line-by-line debunking of the Roerichs' precepts. I provide context as needed; where I appear to be speaking of revelations as "true," or of spirit entities as engaged in discourse with the Roerichs, readers should understand me to be writing from the family's perspective, not my own. I have endeavored to show good judgment about Roerich without being judgmental. How far I have succeeded will be for each reader to decide.

Does this book close the case on Roerich? Nothing would make me happier than to say "yes," but uncertainties remain. Where his early life is concerned, we are forced to rely heavily on Roerich's own word for details, and not all the details add up. As for the Roerichs' claims to have commanded arcane powers, my working assumption—that the Roerichs *believed* those claims to be true— can never be decisively proven.

Also, certain aspects of Roerich's religio-political venture continue to defy analysis. Attempting to solve the Great Plan's riddles has been like assembling a jigsaw puzzle that not only lacks pieces, but has had extra ones thrown in to confound things all the more. Parts of the précis I have given above of Roerich's political maneuvering remain open to question. Exactly when did Roerich turn toward, away from,

and back to Soviet communism? How seriously did the USSR take him and his ideas in the 1920s, and was there any realistic chance he could have returned there, without risking imprisonment or execution, in the late 1930s or 1940s? To what extent did pre-1917 occultist or secret-society ties create bonds between Roerich and certain Soviet officials, and how far can scholars pursue this question without following it into the intellectual wormhole of conspiracy-theory history? Even presuming that we understand the spiritual and political *results* the Roerichs wanted to achieve, we are left trying to fathom *how*, at the nuts-and-bolts level, they intended to bring them about, or what their New Country would have looked like had it come into being. Researchers still lack complete access to Roerich's secret police files in Russia, and uncertainty remains as to what relevant archival materials might exist in China, Mongolia, and Japan.

On the other hand, more information does not invariably mean more clarity. Official papers from several countries make it obvious that no government had a good handle on Roerich himself or what he was about, and no "magic bullet" materials are likely to clear up all of Roerich's affairs. Too many of life's moments pass without being committed to the written record, and there are limits to what we will ever learn about what transpired in the Himalayas, on the windy plains of Manchuria, in the back rooms of Roerich's New York museum (or in the Oval Office and the Kremlin), and in Roerich's own mind.

In short, anyone who purports to have all the answers about Roerich possesses more self-assurance than I do. I believe this book to be a sound valuation that synthesizes older research with recent revelations and fresh views of Roerich's mysticism, politics, and overall significance. Does it penetrate more deeply than that? Perhaps, but too many of those who befriended Roerich and worked with him turned out not to have perceived him well at all. On what may be the ultimate impossibility of grasping Roerich's essence, we can do no better than to turn again to Igor Grabar: "Even now I do not know, and in fact have never known, where Roerich's sincerity—his true credo—ends, and where his pose, his masquerade, and his shameless dissimulation begin. Or how much his sage-like image is calculated to fool viewers, readers, and buyers. But there is no doubt that these two elements—truthfulness and dishonesty, sincerity and falsehood—are inextricably joined in Roerich's life and art."[29] Surely an enigma if ever there was one. In portraits and photographs, Roerich gazes out at us with an unchanging, sphinxlike stare. In the chapters that follow, we will attempt to gaze back and within.

CHAPTER I

Childhood and Youth, 1874–1893

The integrity of an artist lifts a man above the level of the world without delivering him from it.

—Thomas Merton, *The Seven Storey Mountain*

In the fall of 1874, Alexander II, the emancipator of Russia's serfs thirteen years before, had been nearly two decades on his country's throne. His campaign of Great Reforms was nearing its end. The Russian countryside had undergone the so-called mad summer, as thousands of radical students attempted to preach socialism to the peasant masses, in an idealistic but futile campaign known as "going to the people." The army was hard at work incorporating the khanates of Central Asia into the empire's recently conquered territories in Turkestan, and the anti-Ottoman uprisings in Herzegovina and Bosnia that would draw Russia into the Balkan Crisis of 1875–1876 were only months away. Farther afield, gold had been unearthed in the Dakota Territory's Black Hills, and the journalist-adventurer Henry Morton Stanley was en route from England to Zanzibar, the starting point for his monumental trans-Africa expedition. Karl Weyprecht and Julius Payer were nearing the completion of their Austro-Hungarian North Pole Expedition, which resulted in the discovery of the Franz Josef archipelago.

In the cultural sphere, Leo Tolstoy was at work on *Anna Karenina*, while Modest Mussorgsky completed *Pictures at an Exhibition* and *Boris Godunov*, the crown jewel of Russian operas. Earlier that year, the first Impressionist exhibition had set off a seismic shock in the Paris art world. Wagner finished the score of *Twilight of the Gods*, the fourth and final opera in his mammoth Ring cycle. Thomas Hardy published *Far from the Madding Crowd*, while Verdi composed his *Requiem*.

In the midst of all this, on September 27 (October 9, by the Gregorian calendar used in the West), a boy named Nicholas

was born to the Saint Petersburg family of Konstantin Fyodorovich Roerich and his wife, Maria Vasilievna. Other notable figures sharing the same year of birth include the authors Gertrude Stein and Robert Frost; the composers Arnold Schoenberg and Gustav Holst; and the politicians Herbert Hoover, William Mackenzie King, and Winston Churchill. The two men who would rule Russia as it entered the twentieth century—Nicholas II and Vladimir Ulyanov, better known as Lenin—were, respectively, six and four years old.

The Roerich family was respectably white-collar and comfortably well-off. Maria, née Korkunova-Kalashnikova, born in 1844, came from Ostrov, in the Pskov region, where her ancestors had settled in the tenth century. The Roerich clan originated on the Danish island of Sjælland (Zealand); a branch of the family migrated to the Baltic coast, abandoning its Lutheran faith for Eastern Orthodoxy and taking up citizenship in the Russian Empire. Over time, the surname, rendered variously as "Röhrig" or "Rörich" in the Latin script, came to be Cyrillicized as Рерих (Re-rikh) and pronounced "REHR-ik" by most Russians.[1] As he grew up, Nicholas came to prize this Slavic-Scandinavian heritage.

The household patriarch, Konstantin Fyodorovich, was born in 1837, in Gazenpot (Aizpute, in present-day Latvia), on the coast of what was then the Russian province of Courland. Recent research suggests that he may have been the illegitimate son of a local nobleman, Eduard von der Ropp, and a servant girl working on the family's country estate. In this scenario, the infant Konstantin was handed over to Fyodor Ivanovich Roerich, a tailor's son and future civil servant.[2] Whatever the truth, Konstantin relocated to Saint Petersburg, the imperial capital, to work as a notary public. A specialist in inheritance law, he built up a lucrative private practice and was appointed in 1872 to the Saint Petersburg Circuit Court. By the time of Nicholas's birth, the elder Roerich was a man of means, easily able to support the family he had started with his marriage to Maria in 1860.

Home life in Petersburg provided Nicholas—Kolya to his family and friends—with a rich childhood environment.[3] The family residence on Vasilievsky Island was a lively place. Konstantin ran his business from an office on the bel étage. Servants, siblings, and relatives filled the rooms with activity. Nicholas, the eldest son, had an older sister, Lydia, born in 1867, and two brothers, Vladimir and Boris, followed in 1882 and 1885. (Another brother, Leonid, had died as an infant, shortly after his birth in 1863.) Fyodor, Konstantin's father, sometimes boarded with the family, surviving to his hundred and fifth year despite a smoking habit so strong that his grandchildren joked that he could serve as a "living advertisement for a tobacco factory."[4] Maria Vasilievna prided herself on her homemaking skills. The furniture's dark wood gleamed with polish, and the crystal and silver, all of good quality, sparkled. The

Roerichs lived on the Nikolaevsky (now University) Embankment, on the northern bank of the Neva River, at the foot of the Blagoveshchensky Bridge. Across the waterway, a grand tableau presented itself: the Winter Palace, the Admiralty, the dome of Saint Isaac's Cathedral. At the eastern tip of the island was the city's financial hub, the Bourse. Of greater interest to young Nicholas were the buildings of Saint Petersburg University and the Imperial Academy of Fine Arts.

One benefit of Konstantin's success was an impressive set of connections with the city's intellectual community. Liberal in his politics, Roerich senior belonged to the Free Economic Society, which supported the 1861 emancipation of Russian serfs, and he was likely a Freemason, a common affiliation among reformers and progressives in nineteenth-century Europe.[5] He counted among his acquaintants Dmitri Mendeleev, the renowned chemist who devised the periodic table of elements, as well as historians, legal experts, literary critics, and poets. Most exciting to Nicholas, who listened attentively as his father's guests conversed, were the orientalists and artists. He was enraptured by Konstantin Golstunsky and Alexei Pozdneyev, who conducted linguistic and ethnographic research in Central Asia and Mongolia. Even more important was the painter and sculptor Mikhail Mikeshin, a family friend for many years and a key influence as Kolya grew up.

The best-known photograph of the Roerichs shows the subjects stiff and unsmiling: a content, if slightly stuffy, bourgeois family (see Illustration 1). Portly and bewhiskered, Konstantin sits in front, while a plump Maria cradles baby Vladimir in her lap. Lydia, tall and lithe, stands in the center, while Nicholas—bespectacled, blond, and wearing the same serious expression he would wear in every picture taken throughout his life—looks out from behind his father's left shoulder.

For a boy of Nicholas's standing, Saint Petersburg was a delightful place to grow up, but the countryside shaped him just as much. The family occasionally visited Maria's mother Tatyana, who lived near Pskov. There, Kolya gathered raspberries and, donning cardboard armor and a wooden sword, pretended to slay dragons and battle savage foes. There were trips to Gazenpot and Riga to see Grandpa Fyodor, whose home was full of dragon-carved chairs and other curiosities. On its way to the Baltic shore, the train passed through the fortress town of Narva and the Estonian city of Reval (now Tallinn). Peaceful and prosperous during Roerich's childhood, these regions had been fought over for centuries by Russians, Poles, Swedes, Balts, Finns, and Teutonic Knights, first with broadsword and axe, later with musket and cannon. With these combats raging in his imagination, a fascinated Kolya peered through his railcar window at the towers and castles that studded the landscape.[6]

The wellspring of Roerich's childhood happiness was the family estate of Isvara, some fifty miles southwest of Petersburg. In

later years, Roerich remembered that "everything special, everything pleasant and memorable about my early life, is connected with my summer months at Isvara."[7] Country air gave him relief from the bronchitis he was prone to in river-soaked Petersburg, and Isvara was a wonderland in its own right. Owned originally by Count Semyon Vorontsov, a courtier during the reign of Catherine the Great, the estate, encompassing nearly four thousand acres, was acquired by the Roerichs in 1872. At the center stood a two-story manor house, flanked by slender spires. The grounds contained a thirty-horse stable, a barn with seventy-two head of cattle, a smithy, a watermill, a trout hatchery, and a distillery. For the elder Roerich, Isvara was both hobby and business venture. An amateur agriculturalist, Konstantin enjoyed overseeing the estate's workings, and succeeded until near the end of his life in keeping it profitable. In 1890, the Northern Insurance Company valued the property at the sum of 70,000 rubles.[8]

Every summer and during the winter holidays, the family vacationed at the estate, and Roerich fondly recalled the journey from city to countryside. First, a train to Volosovo, with a transfer at Gatchina. Waiting patiently at the station with a four-horse carriage would be the family coachman, Selifan, who jokingly referred to Konstantin as "Baron Roerich." The "younger baron," as the old servitor called Kolya, could scarcely contain himself as servants loaded the luggage, the family clambered into the coach, and the final miles melted away under the horses' trotting hooves.

To the children, the manor house seemed a fairy-tale castle. Bookish at an early age, Nicholas was drawn to the library, where he devoured a large collection of historical volumes—full of princes, warriors, and long-suffering monks and saints—written and illustrated for young readers. One of these, Gaston Tissandier's *Martyrs of Science*, made a lifelong impression. (In his old age, Roerich repeatedly identified himself with the persecuted figures described in this book.[9]) Nicholas also admired the house's collection of paintings. Dutch landscapes, a genre he collected avidly as an adult, were displayed on the walls, but most intriguing was an untitled canvas, hanging in the living room and depicting a snow-covered peak under the rays of the setting sun. Kolya learned that this was Kanchenjunga—a Himalayan giant, rising up from the Nepal-Sikkim borderland—but had no way of knowing that he would one day paint it himself. The estate's very name foreshadowed his later career: *isvara* means "lord" or "supreme being" in Sanskrit, an appellation Count Vorontsov decided on after a visit to India. As his own interest in the East deepened, Roerich attached much significance to this coincidence.

If Isvara the manor was enticing, Isvara the country preserve provided a magnificent bucolic escape. Cornflower and rye grew in the pastures, and cold springs bubbled in the nearby lake. Best of all was the outlying woodland, which lay adjacent to an imperial hunting ground and teemed with fox, sable, and elk, and even lynx and the

occasional bear. Kolya and his brothers rambled through this sylvan domain of fir and birch, enjoying all the outdoor adventures youngsters can invent for themselves. From this, he gained happy memories, a deep love of the environment, and an instinctual feel for the Russian landscape. As the painter David Burliuk later wrote, "it was here that he taught himself to see and understand nature: the gloomy sighing of the pensive northern woods and the icy tranquility of winter."[10]

As much as he treasured his Isvara idylls, Nicholas, an excellent student, also valued the education he received in Petersburg. Until he was almost nine, he had private tutors, like most children of his class. Then, in 1883, Konstantin sent him to the May Gymnasium, which offered a general education for boys with gentlemanly aspirations and plans to attend university. During the 1880s and 1890s, the gymnasium, named after its headmaster, Karl von May, a Russianized German, was among Petersburg's most prestigious. A long-standing biographical anecdote has it that Nicholas scored high enough on the school's entrance exams that von May identified him as "a future professor."[11]

Many noteworthy Russians testify to having been happy at von May's school. An irrepressible popinjay, von May wore gold-rimmed eyeglasses, took snuff, and sported red and yellow handkerchiefs in the breast pocket of his frock coat. Madame von May, who liked to be called "Aunt Agnes," distributed chocolate and other treats to the boys. The headmaster's motto was "First love, then teach," and he acted on it, the first thing every morning, by greeting each of his students with a handshake.

Nicholas was a "May Bug," as the students named themselves, for almost a full decade. Each morning, he walked to school. The day began with a dual prayer service, led by a Lutheran pastor and an Orthodox deacon. Then, off to the classroom. Roerich did well in all subjects, but was most enthusiastic about literature, history, and geography. He enjoyed foreign languages, learning Latin and rudimentary Greek. His German became fluent; much of the school's instruction was in that tongue. He also picked up French and some English, though real aptitude in those came later, during his European travels.

Kolya's artistic and literary tastes showed early.[12] Until age eight or nine, his favorite toy was a miniature theater; as a teenager, he accompanied his parents to the opera. He dog-eared the family copy of Scott's *Ivanhoe* with repeated readings and moved on at school to Ruskin, Blake, and Carlyle. The German Romantics "occupied honored places on my desk," and he wrote term papers on Schiller's "Undine" and Goethe's "Elf-King." Shakespeare interested him, as did Poe and Twain. He spent his teenage years infatuated with Gogol's tales and, at seventeen, made his first foray into student theatricals by appearing as the sailor Zhevankin in Gogol's *The Wedding*. As for music, Roerich gravitated to Russian composers: for him,

Glinka, Mussorgsky, and Rimsky-Korsakov trumped most Westerners, although he appreciated the "oriental" splendor of Verdi's *Aida* and Meyerbeer's *L'Africaine*. The one exception was Richard Wagner, for whose works Roerich conceived a lifelong passion. In 1889, Nicholas had the good luck to attend Saint Petersburg's first staging of the Ring cycle, by Angelo Neumann, director of the German opera in Prague, an event that profoundly affected many Russian artists and composers, including Rimsky-Korsakov and Alexander Glazunov.[13]

That Nicholas blossomed at the May Gymnasium is not surprising. University life in Russia was stultified by the reactionary politics of the 1880s and 1890s—the reign of the bullheaded Alexander III—but secondary schools proved safer havens for young minds wishing to push beyond the confines set by state censors. In 1889, for exactly this reason, a number of von May's students, led by the artist Alexandre Benois and including Konstantin Somov, Dmitri Filosofov, and Walter Nouvel, formed the Society for Self-Education, known in lighter moments as the "Nevsky Pickwickians." The Pickwickians read journals from Western Europe, debated the merits of foreign composers, and smuggled banned literary works to each other, reveling in the poetic decadence offered by Verlaine and Baudelaire. Benois graduated in 1890, and his friends soon after, but before the decade was out, this same group, joined by Léon Bakst and the enterprising Sergei Diaghilev, reconstituted itself as the famed World of Art Society.

This circle left an indelible mark on Russian culture, and because Roerich involved himself with its activities during the 1900s, the question of whether he did so earlier naturally arises. He did not.[14] He knew the Pickwickians and shared many of their views. But while Benois later remembered him as a "handsome" and "affectionate" classmate, he also described him as "bashful before his elders."[15] The Pickwickians were on average four to five years older than Nicholas, and he had few boyhood ties with them. To the extent the May Gymnasium shaped his teenage views on art, it was the school's general ethos that mattered.

Nicholas was drawn like iron to a magnet by geography, history, and archaeology. Von May taught the first two subjects with skill, as did one of the school's youngest instructors, Alexander Lipovsky, who remained friends with Roerich after his graduation. With spellbinding stories of far-off realms echoing in his ears, Kolya drafted maps and molded mountain ranges out of clay, daydreaming about future travels. Nor was he immune to the sense of excitement stirred up by the explorers of the day, who spent the century's waning decades racing to the North and South Poles, plunging into the jungles of the Amazon, or braving the depths of Africa. Among the spaces remaining blank on the world map were the steppes and deserts of Central Asia, and the Himalayan peaks that lay beyond.

The Russians, living in proximity to these regions, were instrumental in exploring them. The Russian Geographical Society was founded in 1845. Three decades later, by the time of Roerich's infancy, it had sponsored or assisted expeditions to Turkestan; the Ussuri and Amur basins; the Pamir, Tien Shan, and Karakoram ranges; and Mongolia and the Gobi Desert. Most alluring of all to Roerich's mind were the hidden mysteries of Tibet and the Himalayas. Like others of his generation, Kolya read about his compatriots' exploits in magazines such as the *Illustrated World*, the *Global Traveler*, and *Nature and People*, across whose pages the names of Nikolai Muraviev-Amursky, Pyotr Semyonov-Tien-Shansky, and Grigori Potanin marched as intrepidly as their real-life owners did across the mountains and expanses of Asia. The visual appeal of Vasily Vereshchagin's celebrated paintings of Turkestan, Sikkim, and Kashmir added to the public's (and Nicholas's) enthusiasm. Most heroic was the officer-geographer Nikolai Przhevalsky, who logged tens of thousands of miles in Mongolia, Turkestan, and Tibet during the 1870s and 1880s, and brought into Western scientific classification the wild steppe horse that bears his name. Przhevalsky's celebrity status was at its height when Kolya was at his most impressionable. Forty years later, an older Roerich, walking paths that Przhevalsky had walked, had a sense of following in an idol's footsteps.

For now, Nicholas contented himself with adventures closer to home. When not at the gymnasium, he spent as much time as possible at Isvara. Puberty did nothing to cure his bronchial ailments, and Petersburg's autumn dampness caused him distress every year. As with Teddy Roosevelt half a world away, Nicholas's doctors suggested that he toughen his lungs by spending time outdoors and away from the city, especially during the winter. He took up horseback riding and hunting, as well as natural history. He compiled collections of plants and minerals, classified butterflies and beetles, and completed ornithological studies competent enough that, in 1892, the Forestry Department granted him a license to collect eggs from nests in state-owned woods for scholarly purposes. As he neared graduation, he wrote magazine articles on outdoorsmanship.

Roerich's fascination with archaeology began around the time he entered the May Gymnasium and grew into a cherished avocation.[16] When he was nine, one of his father's acquaintances, the archaeologist Lev Ivanovsky, excavating nearby burial mounds, or kurgans, paid a visit to Isvara. Noting Kolya's inquisitive nature, he invited the boy to see what had been unearthed. The sight of the age-old weapons, broken pottery, and jewelry transported him to the Stone Age, where, it can safely be said, his soul remained for decades to come. He filled his library with every book about archaeology and prehistory he could lay his hands on. He read about the Altamira cave paintings, the carvings of winged bulls in the palaces of Nineveh, and Heinrich Schliemann's triumphant uncovering of the ruins of Troy.[17]

To gain his own field experience, Nicholas, at about age fourteen, explored

tumulus tombs in the Isvara area, helped by the village deacon's sons, who kept their role secret because their father considered it impious to show such curiosity about pagan sites. His first finds included gold and silver coins from the tenth and eleventh centuries. The thrill of success spurred him to read Count Alexei Uvarov's standard text, *The Archaeology of Russia*, and essays by Alexander Spitsyn and Prince Pavel Putiatin, whose niece he would later marry. In 1892, Nicholas took his pastime to a more scholarly level by establishing contact with the Imperial Archaeological Commission (IAK).

That year, Roerich received permission from the IAK to conduct surveys around Isvara and Volosovo, where Ivanovsky had worked. He entered into correspondence with Spitsyn, who eventually involved him in various research ventures and supported his application for membership in the Imperial Russian Archaeological Society (IRAO). Given different circumstances, Roerich might easily have made archaeology, rather than painting, his career.

Roerich's artistic gifts became apparent when he was a teenager. For school assignments and for himself, he wrote poetry, principally historical ballads like "The Battle of Roncesvalles" and "The Sea Pirate." From 1890 to 1892, he penned "Winter Sketches," a series of prose tales about life outdoors. These were capable narratives, and some were published in periodicals like *Russian Hunter*, *The World's Echoes*, and *Nature and Hunting*. Roerich concealed his identity, using the pseudonyms Molodoi ("the young one") and, more frequently, Izgoi, meaning "the outcast" or "the exile."

To illustrate his stories and record his archaeological activities, and to remind himself of Isvara during his months in the city, Nicholas sketched animals, views of the estate, and cross-sections of burial mounds. At the gymnasium, he drew portraits of teachers and friends, and designed sets for the student theater club. How far this budding talent would have taken him had it not been nurtured is impossible to say. At this juncture, though, one of his father's friends stepped in: Mikhail Mikeshin, a painter and sculptor whose best-known works, the *Russian Millennium* memorial in Novgorod and Kiev's statue of the Ukrainian hero Bogdan Khmelnitsky, attract sightseers today. Ilya Repin's 1888 portrait of Mikeshin shows a confident man with dandyish mustaches, waxed and pointed.

In 1891, when Nicholas was seventeen, Mikeshin saw some of the young man's drawings and perceived in them a genuine charm and a keen power of observation. Knowing Konstantin to be indifferent to his son's artistic efforts, Mikeshin taught the eager youth the fundamentals of method, composition, and technique. He arranged for supplemental instruction from Ivan Kudrin, a well-known mosaicist. He wrote Nicholas often, referring to him fondly as "the son granted me by Apollo."[18]

These were not idle words, as evidenced by Mikeshin's role in determining the

direction of Roerich's postsecondary education. In 1893, Nicholas was eighteen and a half. In June, he would leave the May Gymnasium, and a long-suppressed conflict now rose to the surface. The family had always assumed that Nicholas, as the eldest son, would attend Saint Petersburg University, take a law degree, and follow his father's trade or pursue a career in civil service.

Konstantin and Maria were shocked, then, to hear that Nicholas, prompted by Mikeshin, had decided to enter the Imperial Academy of Fine Arts. Roerich's parents were highly cultured, but also practical folk for whom art, music, and literature took second place to prosperity and comfort. They had not forbidden him to draw or write, but neither had they encouraged him. For their son to dedicate himself to the Muses instead of taking up gainful employment was not to be contemplated.

A difference in temperament added to these troubles. Konstantin, an unsentimental man, enjoyed his friendships and the finer things in life, but put work first; he has been aptly described as "a Petersburg bourgeois, all business and utterly unromantic."[19] Nicholas, nurtured more by his mother, had a polite relationship with his father, but not an affectionate one, and adolescence widened this emotional distance. As he grew more sensitive and introspective, Nicholas shut a vital part of himself away from his self-assured parent. Consciously or not, he sought in his art teachers—first Mikeshin, then, at the academy, Arkhip Kuinji—figures who could act as surrogate fathers.

As for the senior Roerich, he had viewed his son's artistic pretensions with a mixture of amusement and disdain. He could afford to be indulgent while Kolya was a boy, but now his patience ran out, and he unshakably opposed the notion that his eldest son might daub his life away with paints and pastels. Something besides pragmatism may have sharpened his feelings. During his own student days, Konstantin had tried his hand at playwriting. These attempts led nowhere, and he lost or destroyed whatever literary fragments he created.[20] Later, a successful professional, he entertained his friends by mocking the ambitions of his youth. But did the laughter hide regret? Did Konstantin seek to dissuade Nicholas from becoming an artist because he was jealous of his son's talent? Or did he wish, in his gruff way, to spare Nicholas the painful lesson that art is a fickle master, and that one's gifts are rarely adequate to the task of serving it?

However this debate played itself out—angry shouting, icy silence, or reasoned discussion—the Roerichs, with Mikeshin serving as referee, reached a compromise. As the family wished, Nicholas would study law at Saint Petersburg University. As long as he performed well there, he would also be permitted to take courses at the Academy of Fine Arts. At first, Konstantin consented only to let Nicholas attend the academy as an auditor. By June, he broke down and allowed him to enroll as a regular student.[21] It was an imposing challenge, but Nicholas gladly took up the burden.

CHAPTER 2

Academy Days, 1893–1897

To send light into the depths of the human heart—that is the artist's calling!

—Robert Schumann

Growing up on the banks of the Neva, Roerich had often played with his siblings on the pedestals of the stone sphinxes that stand watch near the entrance of the Imperial Academy of Fine Arts. In 1893, an older Roerich, eighteen going on nineteen, passed under the gaze of those familiar statues, not to frolic as he had years before, but to study. Behind the Tuscan columns of the academy's façade, he would grow into adulthood.

The academy's motto—"Dedicated to the Free Arts"—speaks of the devotion the institution sought to inculcate. To many, these were simply words, but Roerich, a lifelong idealist, strained harder than most to meet this lofty standard. A photograph from 1893 hints at his determination: a clean-shaven youth, his tufted hair razor-cut on the sides, wears steel-rimmed glasses and an impeccably proper cravat and collar (see Illustration 2). His face is unsmiling and stern.

Such severity was partly an adolescent's attempt to put on airs of gravity. But it was not all pose. As an adult, Roerich would view art as the most exalted of human endeavors—indeed, the only means by which humanity could reach its highest state of development. Such high-flown musings were not yet on his mind, but he was already coming to think of art as a vocation in the full sense: not just as an occupation, but as the most elevated of callings.

After June, when Nicholas left the May Gymnasium, his summer flew by. He celebrated his graduation and went with his family to Isvara, but also readied himself for the academy's entrance exams. Coached

by Mikhail Mikeshin and Ivan Kudrin, he vaulted over this hurdle and, in the fall of 1893, matriculated there and at Saint Petersburg University.

In Russia, many artists of Roerich's generation took degrees in law. It was less common to do so while studying art formally, and Roerich found it no easy thing to shoulder two educations at once. Sheer hard work saw him through, as did a rigid scheme of time management. After breakfasting, Nicholas began his workday by leaving the house at 9:00 a.m. From ten in the morning to one in the afternoon, there were lessons at the academy. After a quick lunch (if he had time), he dashed to the university to hear lectures, generally from 1:00 to 3:00 p.m. Until about five, he worked on his sketches, then returned to the academy for evening classes, which ran from 5:00 to 9:00 p.m. This was followed by reading, study time, and whatever extracurriculars he could cram into these later hours. If he made it to bed by midnight, it had been a light day.[1]

At both schools, Roerich gained the reputation of a workhorse. An academy friend, Leon Antokolsky, remarked to him, "You're not like the rest of us. Before classes, we sit around, drinking tea and chatting, while you're constantly working or thinking."[2] Roerich took pride in being thought more industrious than his peers, but his diaries reveal how exhausting he found this "double life," and how "terrified" he was of being expelled.[3] "After working on sketches today," he noted, "I went back to the University for lectures, but was so run-down and

tired that I couldn't take in a single thing."[4] Elsewhere, he moaned, "I suppose I'm fated to hurry all my life. I wonder if I'll even find time to die."[5]

When Roerich cut corners in his schedule, it was at the university. Certain classes interested him, but law he found tedious.[6] He hated his course on Russian legal history and feared that the professor, Vasily Latkin, whom he referred to as an "ugly evil spirit" in his diaries, would fail him.[7] Nikolai Korkunov, a relative on Nicholas's mother's side of the family, taught legal philosophy, but while he was "occasionally amusing," his instruction proved little better than Latkin's. Roerich fared better in Sergei Bershadsky's survey of legal theory, and he enjoyed Roman jurisprudence with Vasily Yefimov. Even here, though, this had more to do with the fact that Yefimov appreciated Roerich's interest in art and recognized how unlikely it was that he would pursue a career in the law. These exceptions aside, Nicholas regarded his law professors with indifference.

Instead, he audited lectures in history and archaeology.[8] Alexander Spitsyn and Nikolai Veselovsky encouraged him to report to the Imperial Archaeological Commission about his Isvara digs, and both used his drawings to illustrate their own publications. Roerich corresponded with Ivan Zabelin, head of the Russian Historical Museum in Moscow, and he admired the Romano-Germanic philologist Fyodor Braun and the acclaimed historian Sergei Platonov, whose study of Boris Godunov

remains a standard text. Roerich found things and people at the university to engage him, but only at the academy did he feel truly enlivened.

Roerich entered the academy as it underwent major curricular changes.[9] This proved crucial in shaping his generation of painters, many of whom went on to lead Russia's transition from nineteenth-century academic realism to radical avant-gardism. Roerich and his cohort—born in the 1870s, educated during the 1880s and early 1890s, springing mainly from the white-collar intelligentsia—did not cause the decisive break that later groups would, but they put visible cracks in the foundation of traditional Russian culture.[10] In the autumn of 1893, as Roerich began his studies, little of this could have been guessed at.

The reforms of 1893–1894 did not immediately affect Roerich and his classmates. As first- and second-year students, they were still required to take introductory courses in figure and life drawing. Working from plaster casts and live models, Nicholas and his fellows underwent a battery of assignments intended to teach the graceful and accurate rendering of the human body. While this was useful, it was basic drill, and everyone, certainly Nicholas, was eager to get through it quickly.

Roerich's most memorable teacher during his first two years was the curmudgeonly Pavel Chistyakov, a taskmaster with a blistering sense of humor.[11] Chistyakov spared no criticism when reining in starry-eyed youths whose aspirations ran ahead of their skills. He hammered away at Roerich's ego, scolding him the first time he examined his drawings. "You want very badly to be original," he observed. "But right now, it would be better to complete this subject more routinely."[12] Chistyakov dogged him to the last. During his final examination, Roerich was asked to draw a figure of Apollo, and midway through the exercise, Chistyakov exploded. "That's not Apollo!" he shouted. "That's some kind of French fop! Look at those skinny legs!"[13] A petrified Nicholas thought he would fail the course, but while Chistyakov was barb-tongued, he was not mean-spirited, and Roerich received extra time to give his effete deity a more manly pair of legs. Later, Roerich labeled Chistyakov "unfair" and "unfeeling," but he probably benefited more from a firm hand than he cared to admit.[14]

Regimented as the drawing classes were, they allowed some individual expression, especially in the second year. When he had a choice, Nicholas picked themes from the past. *Sviatopolk the Damned*, *The Sea Pirate*, and *Warrior of Pskov* reached back to Slavic antiquity, as did his studies of kurgan tombs. Russian and Baltic legend informed *Vaidelotka at Prayer* and *The Horse of Svetovit*. Nicholas's first triumph at the academy was *Yaroslavna's Lament* (1893), an episode taken from *Prince Igor*. It won a student prize and prefigured the opera's central importance to his career.

In 1894, Nicholas started drawing and writing for profit. Earning money was a form of mild rebellion. He lived at home and, for tuition and most expenses, had no choice but to accept support from his parents. His art supplies, however, he resolved to pay for on his own—a token gesture, but symbolically important, with his father steadily more resentful about his son's career choice. Buying paint and brushes with money he had made himself allowed Nicholas to keep his art, the one pure thing in his life, free from the taint of his father's cynicism.

Whatever his reasons, he successfully submitted *The Young Fox*, *Ivan the Woodsman*, and similar drawings to periodicals like the *Star* and the *Illustrated World*, and he brought in more money by illustrating a Bosnian novel and touching up old icons for churches. He put his prose skills to work as well, reviewing local art shows for newspapers, while Alexander Lipovsky, one of his favorite teachers from the May Gymnasium, arranged for him to write a few pieces for the Serbian journal *Nada*.

Initially, Roerich strove to emulate history painting as practiced by the dominant artistic school in Russia: the Wanderers, who had defined themselves in opposition to the establishment, only to become the establishment over time. In 1863, fourteen academy students, weary of the neoclassical conventions that governed Russian painting, dropped out to form a loose cooperative. Calling themselves *peredvizhniki*, or "wanderers" (sometimes translated as "itinerants"), they held their first show in 1871.

The Wanderers survived the 1870s, then flourished during the 1880s and 1890s. At first, they were civic activists, taking as their credo Nikolai Chernyshevsky's declaration that "art's aim is to understand and explain reality, then use this explanation for man's benefit."[15] Under Alexander II, the tsar-reformer, artists could, within limits, comment on poverty and other social ills. One of the best-known works in this vein, Ilya Repin's *Volga Boatmen* (1870–1873), depicts a cluster of barge haulers, ropes around their waists and shoulders, dragging a flatboat against the river's current. Things changed after 1881: terrorists assassinated Alexander II, and his archconservative son, Alexander III, lashed back hard, making criticism of the regime riskier. Also, with age and fame came a touch of complacency. Some Wanderers were caught up in the patriotic surge that followed the Russo-Turkish War, and the group as a whole evolved from a band of nonconformists into a national school, occupying positions of power and matching their viewpoint more closely to that of the official order.

Their style remained realist, with touches of Impressionism and Art Nouveau, but their subject matter changed. Sociopolitical content fell by the wayside; landscape and portraiture became more common, as did historical painting, exemplified by the work of Repin, Vasily Surikov, and Viktor

Vasnetsov. Before, the Wanderers had used past scenes to comment obliquely on present conditions. Now they glorified Russia and its history.

The young Roerich was enamored of this neo-nationalism, and he fully intended to follow in the Wanderers' footsteps—especially those of Repin, who joined the academy's faculty in 1894. Of equal interest was Vasnetsov, a specialist in the earlier periods Roerich loved, and a popularizer of Art Nouveau. Roerich admired Vasnetsov's ability to infuse genre painting with the wonder of fairy tales, and he worked to develop this skill as well.

By the spring of 1895, Nicholas had earned a name for himself, not just for single-minded devotion to work but also for aloofness.

This is not to say he had no friends, or that he was overly withdrawn. But he let few get close to him. Contemporaries agree that he presented a well-tailored but standoffish exterior. Mstislav Dobuzhinsky knew of him at Saint Petersburg University, but "was not introduced to him. He always looked the same, with his rosy face, his tidy beard, and his shirt buttoned all the way to the top."[16] Igor Grabar studied at the academy with Roerich and knew him for years, yet wrote in the 1930s that "to all of us, [he] was a complete riddle."[17] Others saw him as courteous but enigmatic—a quality that the painter Stepan Yaremich saw not as arrogance or shyness, but as delicacy:

Yes, he is too reserved by nature. But not in the sense of being secretive. Roerich's reserve is more like solitude and expressed in his unusual tactfulness and sensitivity. Once I heard Roerich compare himself to a flower that cannot tolerate being touched. The slightest contact, and it closes. . . . Though he is as trusting and tolerant of people as a child, he will hide in his shell if approached by anyone in the least indelicate way. What remains is an ordinary relationship, simple and polite, but at the same time cold and profoundly indifferent. This type of alienation stems in part from an instinctive sense of self-preservation and a fear of losing one's emotional balance, but mainly from mature judgment and an unwillingness to profane one's holy of holies.[18]

Such guardedness caused others to think Roerich haughty, as shown in an unhappy episode from his second and third years at the academy. In 1894, he helped to organize a "Circle of Young Artists for Mutual Education," but within a year, this group fell apart, due to accusations of "elitism" and "aristocratism" made against Roerich by some of its members—"those pigs," as he calls them in his diaries.[19]

If Roerich took himself too seriously, he was mindful of it. In his diaries, he confesses his "self-love" and "self-conceit."[20] Sadly, awareness of this failing did not save him from its corrosive effects, and the same distressing pattern recurred throughout

his life: he would desire to work toward a greater good, his stiff demeanor would cause his fellows to misinterpret his motivations, and he would succumb to his habit of taking offense too easily. Mutual recrimination was the typical result.

Regardless, Roerich made useful and pleasant connections at both schools.[21] His social pursuits tended more toward the cerebral than the festive. During his time at the university, he attended only one law school party, and he loathed the experience: "It dragged on till midnight—and I was even forced to dance. What absurdity!"[22] At the university, Roerich socialized with Nikolai Lossky, later one of Russia's most distinguished philosophers, and Sergei Metalnikov, a future scientist at Paris's Pasteur Institute. Other companions included the poet Leonid Semyonov-Tien-Shansky, grandson of the eminent explorer, and the mosaicist Vladimir Frolov. His closest friends were Leon Antokolsky, nephew of the sculptor Mark Antokolsky, and a pair of art students named Gleb Voropanov and Alexander Skalon. Academy wags dubbed Skalon "Roerich's twin," not only because the two were inseparable, but out of a sense of irony: where Nicholas was blond, of medium height, and immaculately groomed, Skalon was dark, tall, and sloppy.[23] Roerich maintained ties with Skalon until halfway through their time at the academy, after which the pair grew apart.

Paradoxically, another classmate merits attention for most likely *not* having known Roerich. This was Georgii Chicherin,

people's commissar of foreign affairs for the Bolshevik regime some thirty years in the future—and, in his youth, a law student whose time at Petersburg University overlapped with Roerich's. As discussed in chapters 10 and 11, Roerich and Chicherin had important dealings in the mid-1920s, a fact that has caused much speculation about whether the two interacted as students. Many have assumed that they must have, and those who see Roerich's interwar travels as part of a secret plan, coordinated over decades, take it as an article of faith that they were close. This rests, however, on the shaky premise that all students attending a given school are meaningfully acquainted. It cannot be proved that Roerich and Chicherin did *not* know each other at university, but nothing in the record speaks to any relationship of consequence between them, and their correspondence from the 1920s contains no hint of prior recognition, much less warmth. Talk of a university friendship is best regarded as supposition. (Similarly, though less often, theories have been spun out of the fact that Vyacheslav Menzhinsky, head of the secret police in the late 1920s, received his law degree from Petersburg University at the same time Roerich did. Here, too, one should not presume too much.)

As a student, Roerich remained politically inactive; he based his relationships on artistic interests or personal affinities. He noted with disapproval how Skalon attended "student meetings of all sorts," and he dismissed as "cattle" those students who brawled with police in 1895, on February 8,

the anniversary of the university's founding, and a day traditionally given over to drunken carousing in the street.[24] Except during one academy controversy in 1897, described below, Roerich made no trouble, and his student record remained unblemished by protest, agitation, or party membership. Patriotic in a youthfully idealistic way, he admired Nicholas II as a "good and warm man," whatever he thought about tsarism overall.[25] For now, he kept to his friends and his art—and let the outside world keep to itself.

Roerich's upperclassman years were increasingly eventful, thanks to the academy reforms begun when he first entered. Several senior instructors were sacked, and new ones, many of them Wanderers, were brought on. Fresh subject material was added to introductory courses. The greatest change, however, and the one that most affected Roerich, involved instruction at the advanced level.

After two years of basic courses, academy students moved on to the studio, where, under the supervision of a single instructor, they completed major projects and prepared the graduation pieces that would earn them the official title of "artist." Before the reform, the academy had assigned a single theme each year and required all students to base their graduation pieces on it. It had also determined studio placements. After 1893–1894, students selected the professors

in whose studios they wished to work, although first choices were not guaranteed. They were likewise permitted to pick their own graduation subjects.

So, in the fall of 1895, Nicholas, as a third-year student, faced the biggest decision of his academic career. In whose studio would he put the capstone on his painterly education? His interest in history made it natural to turn to Ilya Repin. The older artist had praised Roerich for working "artfully and with talent," although, like Chistyakov, he advised against straying from assigned themes.[26] On October 2, 1895, Nicholas went to Repin, presented his portfolio, and requested a spot in the artist's studio. However, Repin's reputation had drawn too many students, and there was no more room. He "said many kind things" about Nicholas's work and assured him that, "honestly, without flattery, I can say that I would be honored to have you in my studio. But there is simply no place for you."[27] Repin put him on a standby list and offered, if need be, to write him a recommendation.

Whether Repin spoke sincerely or out of politeness, Nicholas had no wish to wait for a possibility that might never materialize. His next choice was Arkhip Kuinji, one of the Wanderers' leading landscapists, and a recent addition to the academy faculty. Roerich applied and this time succeeded. On October 30, he exclaimed in his diary, "A great happening—I have been accepted by Kuinji!"[28]

At first glance, student and master seemed mismatched. The well-bred

metropolitan who wished to paint scenes of the past was paired with a specialist in a different genre who came from a background completely opposite to his. The child of a Greek-descended cobbler from Mariupol, Kuinji was orphaned at an early age and grew up an unlettered shepherd boy. He taught himself to draw and paint, and a "wild barbarity," as Repin called it, lent power to his work.[29] Three times, he failed the Academy of Arts' entrance examination, so he turned in 1874 to the Wanderers, gaining fame with canvases like the serene *Birch Grove* (1879–1882) and *Night on the Dnieper* (1880–1882), with its breathtaking depiction of moonlight over water.

How well would such a teacher suit Roerich? Roerich had first noticed Kuinji eight months before, in February 1895, and remarked then that the slovenly Crimean looked like "a pig dressed up in a folk shirt."[30] But he came to love the informal atmosphere of Kuinji's studio (see Illustration 3), as did his fellow "Kuinjists," who included Arkady Rylov, Nikolai Khimon, Konstantin Bogaevsky, Konstantin Vroblevsky, Viktor Zarubin (with whom Nicholas was closest), the Polish landscapist Ferdynand Ruszczyc, and Vilhelms Purvītis of Latvia. Kuinji was tough but flexible: "If you are so delicate that you have to be put in a glass case," he told his students, "then better perish as soon as possible, because our life does not need such an exotic plant."[31] But concerning style and content, "everyone is entitled to his own opinion, otherwise there would be no growth in art."[32]

The shaggy, broad-chested Kuinji had a tender side that caused Roerich to idolize him as a "benevolent Zeus."[33] He lent money to struggling students, fed an astounding number of stray cats, cared for the birds living on his rooftop, and once attempted to repair the broken wing of a butterfly.[34] In Roerich's view, Kuinji was a reborn Saint Francis who despised hypocrisy in all forms, and in him Roerich found the paternal figure his own sire had failed to be.[35] Rylov felt the same way, describing Kuinji in his studio as "a father with his children."[36] As his interest in Eastern spirituality strengthened, Roerich wrote of Kuinji as "a real guru in the high Hindu conception," and attested that "Arkhip Ivanovich became my teacher not only of painting, but of life."[37]

Being taught by a landscapist proved no detriment. Roerich could teach himself history or learn about it from others. From Kuinji, he learned that painting nature properly did not mean attempting to render it with photographic accuracy. Kuinji maintained that inner meaning was more important than outward form: the artist should *interpret* landscape, not mimic it. Over time, Roerich parted ways with Kuinji's style and subject, but his philosophy of painting stayed with him for good.

For scholarly development, Roerich was indebted to another mentor, also cultivated in 1895. This was Vladimir Stasov, head of the Imperial Public Library's art department

and Russia's most outspoken arts journalist of the late nineteenth century. Stasov befriended and championed the Wanderers, the author Leo Tolstoy, and musicians like Rimsky-Korsakov and Mussorgsky. A rare bird, Stasov is thus described by the musicologist Richard Taruskin: "His tone was ear-splitting, his style at once hectoring and prolix, gratuitously redundant, supererogatory. His arguments gave new meaning to the word tendentious. Though his works are an inexhaustible mine—of gold, pyrites, and sheer dirt—and exert the inevitable fascination of eyewitness reportage, he is about the most annoying writer in the Russian language. Yet he must be given his due: with apologies to Gogol, he had a nose."[38] Stasov wrote extensively about early Russian culture and its origins, and background research for historical paintings led Roerich to some of his articles. In September 1895, he approached the elderly critic at the library, seeking feedback on an essay he had drafted about the role of art in modern society. Stasov thumbed through it, said at first that "nothing good" would come from it, then changed his mind. He asked if he could keep the paper and invited Nicholas to call on him again. That evening, Roerich jotted a note in his diary, calling Stasov "a particularly strange fellow."[39]

He went back, however, and began meeting Stasov regularly. One photograph shows them at the library, surrounded by the piles of books and papers that threatened to engulf Stasov's office (see Illustration 4). The two wrote frequently, and Nicholas sent small sketches as gifts. Stasov's eccentricities came to the fore. His letters were shrill, rife with exclamation points and words underlined two or three times, ink spots splattered with the force of the pen marks. On occasion, Stasov forgot Roerich's patronymic, addressing him as "Nikolai Fyodorovich," instead of the correct "Nikolai Konstantinovich."

Still, if Kuinji taught Roerich how to paint, Stasov taught him *what* to paint. Now and for the next decade, Roerich anchored his work as firmly as he could in historical reality. To augment his understanding of the past, he put questions to his history professors and his archaeologist friends. He read the renowned folklorist Alexander Afanasev, the lives of the saints, and key medieval texts like the *Primary Chronicle*. But most of all, he turned to Stasov.

Stasov influenced Roerich most profoundly by focusing his attention eastward. Borrowing from the research of pathbreaking Indologists, such as Theodor Benfey and Max Müller, Stasov believed that early Russian art and lore had been shaped above all by interchange with ancient cultures in Asia: Persia, Turco-Mongol Tartary, and India. Stasov outlined this reasoning in an 1868 essay, "The Origin of Russian Epics," published by the journal *Herald of Europe*.[40] Here, he contended that Russia's *byliny*, or epic poems—Slavic equivalents to the *Iliad* and *Nibelungenlied*—bore an unmistakable resemblance in structure, symbology, and subject to India's *Mahabharata*, Persia's *Shahnameh*, and similar sagas. The Russian

folk hero Ruslan was Persia's Rustem in different guise, while the warrior Dobrynia Nikitich and the shepherd Lel recalled incarnations of the Hindu demigod Krishna. The *vodyanoi* water spirit was a variant of the Indian *naga*, or snake-king, and the Russian word *bogatyr* ("hero-warrior") descended from the Mongolian *bagadyr*. Stasov voiced this theory in other works, including *Russian Folk Ornament* (1872) and *Slavic and Oriental Ornament* (1884–1887).

Stasov's logic appalled the Slavophile folklorists of the older "mythological" school, which followed Alexander Afanasev in holding that Russian legends had emerged primarily from the Slavic-Scandinavian milieu. But Stasov considered his own view equally patriotic, if not more so. In his understanding, Russian poetry was no mere offshoot of Romano-Gothic culture, as supposed by many, but something altogether its own. In fact, it was more attuned to the original Asian source material, thanks to Russia's geographical location, and therefore more authentic than the products of the West. Whatever the case, while Afanasev remained one of Roerich's favorite scholars, the young painter adopted Stasov's vision of Eurasia as a great-bellied cauldron of cultures, in which dozens of ethnicities traded, preached to each other, and exchanged songs and stories. He also accepted Stasov's solution to the dilemma facing those who studied prehistoric Russia. Archaeological traces of the ancient Slavs' material culture were scanty and, in many cases, indistinguishable from those left behind by earlier inhabitants. If one wished to know what the Slavs' artifacts, dwellings, and clothing might have looked like, one had to resort to well-informed extrapolation. And the best way to do so, Stasov told Roerich, was to examine the cultures of the east.

Thus, under Stasov's guidance, the young artist took the first steps on his long road to Asia. He devoured all the readings Stasov suggested to him, including as much Indian literature as he could find in translation. He concentrated more intently on the orientalists he had admired during his May Gymnasium days. From the writings of Nikolai Przhevalsky and Grigori Potanin, ethnographer of the Amur region and author of the 1899 tome *Eastern Motifs in the West European Epic*, he gleaned everything he could about the intermingling of Russian and Asiatic folklore. Potanin in particular, who proposed that Siberia and Mongolia were "steeped in rich culture more ancient than that of European Russia," reinforced everything Roerich was so assiduously learning from Stasov.[41]

Also thanks to Stasov, Roerich was privileged to meet the philosopher Vladimir Solovyov, the intellectual titan of fin-de-siècle Russia and a forceful advocate of transcendent Christian idealism. At the library, Stasov and Solovyov ruminated about Asia, and Roerich remembered how the latter would lean back, stroke his iron-gray beard, and murmur that "in the end, it all comes from the East, the great East." Stasov would stroke his even grayer beard and ask Solovyov about Sanskrit's influence on

Baltic languages or the connections between Indian philosophy and Russian thought.[42] Roerich admired the philosopher's stand against modern materialism, and much of his work to come was informed by Solovyov's theories regarding Sophia, the biblical embodiment of Holy Wisdom, as a symbol of the Eternal Feminine.

It was under Stasov's tutelage that Roerich encountered many of the myths and legends that later shaped his occultist worldview. Potanin's and Przhevalsky's books were full of tales about Shambhala, the mountain paradise, Maitreya, the Buddha of the Future, and the Chud, subterranean dwellers of Altaic legend. Roerich was still at the academy when he first heard of Helena Blavatsky, cofounder of the modern Theosophical movement and the most famous occultist of her day. He took notes on *From the Caves and Jungles of Hindostan*, Blavatsky's account of the travels she claimed to have made through South Asia, and thought about painting a scene or two from it.[43] Soon enough, he would acquaint himself more intimately with Blavatsky's body of work.

How Roerich interpreted what he was reading is difficult to say. Now and for a while yet, his stance seems to have been the academic one taken by most scholars of folklore since the unveiling of the philosopher Vico's "new science" in the 1700s: myths were cultural artifacts that preserved kernels of historical reality and collective memory. Was he already convinced of these legends' literal truth, as he later would be?

Probably not. But Stasov's promptings had started a process that went beyond anything he could have predicted. Roerich was acquiring the vocabulary with which he and his future wife would later articulate their own spiritual language.

Ensconced in Kuinji's studio, Nicholas finished various projects, and the summer and fall of 1895 saw him working on *The Varangian in Tsargrad*, a portrait of a Viking mercenary in Byzantine service. *Varangian* was well spoken of in the press and earned Roerich his first major sale: at an academy exhibit of student work, the collector V. S. Krivenko asked the curator, Alexander Sokolov, to negotiate a price for it. Nicholas, a neophyte in the art of haggling, blurted out "eighty rubles," the first figure that popped into his head. He worried that even this low sum might scare off his buyer, but Sokolov, knowing better than the painter what a bargain Krivenko was getting, merely smiled and said, "consider it sold." Later that evening, Nicholas's classmate Ferdynand Ruszczyc congratulated him, then dressed him down for having sold himself cheap.[44]

During his third and fourth years, Nicholas devoted more of his time and sociability to Kuinji's studio, and some of his earlier friendships, notably those with Skalon and Antokolsky, cooled. When he was not painting or engaged in historical research, he took his ease at Isvara or traveled. Any chance to leave the capital

was welcome; many entries in Nicholas's diaries speak to his dislike of the city and its "nervous, sickly joys and pleasures."[45] In the summer of 1896, he went on a long vacation down the Volga, continuing to Kiev and the Crimean peninsula. Under Nikolai Veselovsky's supervision, he worked on archaeological digs in the Petersburg suburbs of Tsarskoe Selo and Peterhof. In 1897, he joined the Imperial Russian Archaeological Society.

Around this time, Roerich dedicated much thought to the question of what it meant to be an artist. His diaries show him still to be a Romantic, wandering freely, like many of his countrymen, in the "enchanted forest of German metaphysics."[46] As before, he considered Wagner godlike, but no longer just for his music. Of equal import was Wagner's heroic conception of the artist, whose genius sets him apart from society and elevates him to sublime, even noble status. An 1897 photo shows Nicholas painting on the veranda of the Isvara manor house. Looking at his proud carriage, one imagines that he had in mind, at least subconsciously, Wagner's rhetoric about "princes of art."

Roerich also treasured Wagner's theory of the "united art work" (*Gesamtkunstwerk*) and later put it into practice, both as stage designer and teacher of art. He felt a growing attraction to the Arts and Crafts ideals of John Ruskin and William Morris, with their assertions that true worth was to be found in preindustrial handiwork. Roerich took to heart Ruskin's proposition that art acts in the world as a revitalizing force—a

thought that harmonized well with Solovyov's teachings and Dostoevsky's dictum that "beauty will save the world."

Growing out of these impulses was a taste for teleological thinking: a lifelong conviction that humankind was progressing toward some grand destiny. Taken together, such ideas formed an effervescent, if rawly blended, mix. Most of the ingredients for a larger intellectual and philosophical unity were present, and it required only time and experience for them to steep and cohere.

In 1897, Roerich set his sights on graduating from the academy. That March, he completed his coursework at Petersburg University, but took a slower pace with the rest of his degree requirements, which included a thesis, written under Vasily Sergeyevich, a historian of law, and his final exams. These he would finish in the spring of 1898. In the meantime, he applied himself to his last studio works. Among these were *The Evening of the Knighthood of Kiev* (1895–1896) and *The Morning of the Knighthood of Kiev* (1896–1897), which hearkened to the mythic days of Russia's *bogatyri*. Their fairy-tale manner reminded viewers of Vasnetsov's work.[47]

Roerich's graduation piece was planned as part of a grandiose series: the "Slavic" suite, each painting meant to illustrate a scene from the twelfth-century *Primary Chronicle*, the standard account of Russia's earliest years. The suite would cover the

pivotal years between 860 and 862, when war broke out among the Slavic tribes, who then, according to the *Chronicle*, invited the Rus, a Viking subgroup, to rule them. The Rus prince Rurik is said to have established seats of government in the north, at Novgorod and Staraya Ladoga, founding the dynasty that held Russia's throne until the late 1500s. His successors extended their reach southward to Kiev.

In fact, the *Primary Chronicle* contains much fabulation in the same vein as tales of King Arthur or Romulus and Remus. Rurik himself may never have existed, and the story is seen by many scholars as a fanciful encapsulation of the more prosaic process by which Viking merchants, seeking to trade with Byzantium, sailed down Russian and Ukrainian rivers, building outposts and gradually assimilating into local Slavic populations.[48] Whether Roerich read the tale as fact or metaphor, what mattered to him most was the opportunity to express in pictorial form the Slavic-Scandinavian interaction that gave birth to Russia, and which he felt himself, with his ancestry, to embody in the flesh.

In February 1897, Nicholas outlined to Stasov the scenes he wished to paint.[49] Peace would be shattered in *The Slavs*, while in *The Messenger*, an envoy would bear the news of war. Five canvases—*A Meeting in Haste*, *Fortunetelling*, *The Raid*, *The Battle*, and *After the Battle*—would convey the horrors of intertribal bloodshed. The Rus would be introduced in *The Varangians at Sea* and *Midnight Guests*; in *The Victorious Ones*, they

would reach the city of Constantinople. *The Prince* would depict a Viking noble collecting tribute from the Slavs, whose leaders, in *The Assembly*, would decide beneath a sacred oak to accept Rus overlordship. *The Apotheosis*, featuring a row of burial mounds, would remind viewers that the yawning gulf of eternity awaited all. An enthusiastic Stasov offered ethnographic advice and sent sketches of his own. "This will be a first-class work," he wrote, but he warned against impatience: "To hurry will be harmful."[50] It was decided that Nicholas should start with *The Messenger*.

That spring, as Roerich painted his harbinger of strife, controversy tore the academy apart. The rector, Antony Tomishko, insulted a student and then, despite mounting anger, refused to apologize. Out of institutional reflex, the faculty backed Tomishko, while many students expressed their displeasure by boycotting their classes. All the Kuinjists, Roerich included, joined this "strike."[51] Kuinji, less a stickler for formality than his colleagues, met with the students and discussed their grievances. No supporter of the strike, he hoped to persuade the students to swallow their pride and return to class. The consultation settled nothing, but at least engaged the students on their own terms.

It also resulted in Kuinji's firing. Academy administrators accused him of inciting the students to further rebelliousness, then forced his resignation. In solidarity, Kuinji's students withdrew from the academy, leaving them trapped on the outside when the

original "strike" ended and other students went back to their classes. Various instructors tried to lure the Kuinjists into their own studios; Vasily Maté courted Roerich, promising a postgraduation study trip to Paris, complete with stipend. When Maté persisted, Roerich threw up his hands, crying, "Professor, have mercy and do not make a Judas of me!"[52] (Kuinji felt amused pride upon hearing how this figurative thirty pieces of silver had been rejected, remarking with a laugh, "At least my students know my worth!")

As the year wore on, Kuinji's renegades got on with their work and hoped for resolution. Kuinji took some of them on an art tour of France, Germany, and Austria, but Roerich, constrained by university obligations and tight finances, remained in Petersburg. He completed *The Messenger* in the summer, giving it the subtitle "Tribe Has Risen Against Tribe," from the text of the *Primary Chronicle*. In this nighttime scene, an aged emissary arrives by boat to deliver the tidings of war to an allied village (see Illustration 5). A hilltop citadel is visible in the moonlight, and a sense of danger radiates from the canvas. Any Wanderer would have been proud of its gritty realism.

In the fall, the academy forgave the Kuinjist defectors. Kuinji himself did not return to the faculty, but his pupils were allowed to graduate and take part in the academy's annual student exhibition in November. At the exhibition, Kuinji's students were judged to have submitted the best pieces, and opinion especially favored

The Messenger. A young Sergei Diaghilev, reviewing the show for *Novosti*, approved of the painting, as did Repin, Vasily Vereshchagin, and Sergei Ernst of the Hermitage, who said of it that "the naked and unembellished face of antiquity, strong and wholesome, has disclosed itself to the artist."[53] Prompted by Vereshchagin, the collector Pavel Tretyakov purchased *The Messenger* and spoke with Roerich about acquiring the entire Slavic suite, should it be completed.[54]

No one could have asked for a better finish to such a tension-filled year, yet there was more. Stasov decided to reward his young friend by taking him to visit Leo Tolstoy, the elder statesman of Russian letters, now in retirement.[55] "You must come with me," he insisted. "Who cares about your diplomas and awards? Let the greatest writer of Russia recognize you as an artist. That will be a real distinction. And no one will appreciate your *Messenger* more than Tolstoy. . . . Don't delay! In two days I am going." So, as the year neared its end, Nicholas found himself on the overnight train from Saint Petersburg to Moscow. He shared a compartment with Stasov, the sculptor Ilya Gintsburg, and Rimsky-Korsakov, Roerich's favorite living composer.

With Stasov grumbling that he could not sleep and peevishly arguing about music with Rimsky-Korsakov, it was a lively trip. But also peculiar, in that Roerich came away with two different stories to tell about it. The disparity is interesting in its own right and sounds an early alarm about depending

too heavily on Roerich's autobiographical reminiscences. According to the version Roerich told publicly, Stasov led the way to the Tolstoy house in Moscow's Khamovniki district. Roerich recalled the "quiet side streets, the historical dwellings, and the fragrance of apples in the air." The visitors were greeted by Countess Sophia, Tolstoy's wife, then by the writer himself, dressed in a peasant blouse. For Nicholas, the moment was akin to entering a demigod's presence. Over tea, Tolstoy passed judgment on everyone's work: Rimsky-Korsakov's latest libretto, Gintsburg's plans for a new sculpture, and a photograph Roerich had brought of *The Messenger*. Of the latter, Tolstoy is said to have pronounced, "Have you ever crossed a swiftly flowing river? You must always steer for a spot upstream from where you want to end up, or the current will carry you downward. So also in the moral sphere one must steer higher—for life carries everything downstream. Let your messenger hold firm to the helm, and he will reach his goal." On the way back to Petersburg, Stasov told Nicholas, "Now you can consider yourself to have received the title of 'artist.'"

A charming vignette, and a standard part of Roerich's biography for decades. All the more startling, then, to see how he described this moment in private. In 1922, he related this episode to friends in America, but spoke of himself as having been so shocked by the "foolish things" Tolstoy said about art that he burst out of the house, wandered Moscow on his own, and rejoined the others at the station when it was time to return to the capital. An amused Stasov supposedly told Roerich later that, had he stuck around for dinner, he would have heard Tolstoy make even more an ass of himself, pontificating about music.[56]

Neither retelling is completely convincing. The first is easier to believe, but like so many favorite anecdotes, it has an overly pat feel to it. As for the second, it strains credulity to imagine the prim and proper Roerich acting with such astonishing discourtesy, or Stasov viewing such behavior so matter-of-factly. Here, one suspects Roerich of exaggerating his independence of mind to impress new friends and avoid coming across as a starstruck adolescent. In the end, there is no way to determine the truth of either narration; it may simply be that Tolstoy praised *The Messenger* politely, while Roerich received that praise with equal politeness.

Leaving the Tolstoy interlude aside, it was as an officially designated artist that Roerich greeted the new year. In 1898, he would put his training to the test and pursue the making of art not just as a personal passion, but as a livelihood. The next few years would show whether he was equal to the job.

CHAPTER 3

Journeyman Years, 1897–1902

Art exists to help us recover the sensation of life.

—Viktor Shklovsky, "Art as Technique"

Roerich's journeyman years proved anything but tranquil.

During this half decade, Roerich made his living not just as a painter, but as a writer, editor, and administrator. His style evolved, as did his philosophy of art, and he expanded his network of allies. Moreover, he learned his trade at a time of knuckleduster debates about art, and he bloodied himself, sometimes badly, as he joined in these struggles. More than once, his mentor Stasov tried to lift his spirits by pressing on him the maxim that "only in battle will the truth be found."[1]

Roerich's personal affairs were just as much in a state of flux. He widened his spiritual horizons, heeding for the first time the siren call of the occult. Most dramatically, he fell in love, wooing a spouse and gaining, in more than the usual sense of the word, a soulmate. He lost his father but became a

father himself. The one constant in his life was soaring ambition—fueled in equal proportion by a strong ego and an increasingly ardent utopianism.

In spring 1898, with his academy graduation behind him, Roerich turned to unfinished business at the university. Although his law degree ultimately proved of little consequence, he owed it to his parents to finish it. Doing so induced more stress than is generally thought. His coursework completed in 1897, Roerich now submitted his thesis, on the appropriately chosen topic of "The Legal Position of Artists in Old Russia." All that remained were his final exams, but anxiety about these nearly laid him prostrate. The examiner assigned to Nicholas was reputed to be "a terrible beast," and in early April,

before his first test, he sent a frenzied letter to the historian Sergei Platonov, describing himself as on the verge of tears and asking whether he could transfer to the program in history if he failed to gain his law degree.[2] To Roerich's relief, this last hurdle proved easier to clear than expected, though he froze up at first and had to be coached through his initial panic by the examiner (a less astringent character than advertised). By the end of April, Roerich's formal schooling was over.

Young and relatively unknown, Roerich would have been hard-pressed at this point to earn his keep by painting alone. To save money, he lived with his parents, although as soon as he could afford it, he rented a sixth-floor studio in the city center. In his search for paying jobs, he was assisted by Vladimir Stasov, who secured two posts for him in 1898: one with a new journal, the other with an artistic institution of almost eighty years' standing.

The journal, *Art and Artistic Industry*, was published by the art historian Nikolai Sobko, debuting in the fall of 1898.[3] Editorially, it sympathized with the Arts and Crafts ideals championed by John Ruskin and William Morris, but its main purpose was to serve as artillery in Stasov's war against Diaghilev's recently founded World of Art Society, of which more later. Sobko headed the journal, but Roerich did much of the practical work, also contributing articles and reviews under his nom de plume Izgoi, or "Outcast." He wrote for other papers, including *New Times*, *Bourse Gazette*, and

Niva, gaining friends among the city's journalists. This permitted him to boost Stasov's confederates and artists he himself liked, including the Kuinjists. Soon, though, he would tire of the combat into which Stasov had forced him.

Roerich's second employer proved more crucial. In 1898, he began a two-decade association with the Imperial Society for the Encouragement of the Arts (IOPKh). Founded in 1820, the society operated out of facilities in central Saint Petersburg, at 38 Bolshaya Morskaya, just east of Saint Isaac's Square, with a southern exposure facing the Moika Canal. It housed a museum, a printing press, a school of industrial arts, and a school of painting, one of Russia's largest. Roerich started as the museum's assistant curator, quickly rising to become the society's assistant secretary. At first, he was fortunate in his bosses. The IOPKh's curator, Dmitri Grigorovich, was a friend of Stasov's, and it was Sobko, from *Art and Artistic Industry*, who served as secretary. But Roerich enjoyed neither man's protection for long: Grigorovich died in 1899, Sobko soon after. Foes now surrounded him, the worst being the new curator, Mikhail Botkin, an artistic conservative whose work as a restorer of church art Roerich had condemned in the pages of *Art and Artistic Industry*. This "evil reactionary," as Roerich thought of him, opposed his younger subordinate for years.[4] Nonetheless, Roerich persevered, arranging exhibits, organizing files, and slogging through piles of correspondence, unaware of how important an institutional

home the IOPKh would be for him as he matured.

History and archaeology remained central to Roerich's efforts in 1898 and 1899. He never finished the "Slavic" suite that *The Messenger* was to have begun, but he turned out enough scenes of Russia's past to make up for it. Among the first were *Gathering of the Elders* (1898), a nighttime convocation of tribal leaders, and *The Campaign* (1899), in which dispirited soldiers plod through a snowy landscape. Even architectural pieces, such as *Church of the Savior at Nereditsk* (1898–1899), sang the virtues of a bygone age.

Roerich chose his subject matter easily, but was less sure of himself concerning style. Should he continue imitating the Wanderers' clear-cut realism or experiment with something fresher? The contrast between *Gathering of the Elders* and *Church of the Savior at Nereditsk* shows how Roerich wrestled with this question: the former is cut from the same cloth as *The Messenger*, whereas the latter takes perceptible steps away from straightforward representation. In *Nereditsk*, a small jewel of a canvas and one of Roerich's personal favorites, plaster walls and green domes are drawn with a wavy line, and the broad patches of white snow and slate-blue sky are full of twists and swirls.[5] *Nereditsk* is hardly a van Gogh, but in it (and to an extent in *The Campaign*), Roerich reaches out for a new mode of self-expression. Decisions

about style, of course, could not be made purely on aesthetic grounds. Roerich had the market to think about, not to mention his standing in a community already splintering into feuding factions. Unhappily, he would stumble clumsily into these artistic struggles, increasingly estranged from older mentors, but not yet accepted by his peers.

Archaeological and folkloric research aided Roerich in painting the past. Between 1899 and 1905, he carried out fieldwork, sanctioned by the Imperial Archaeological Commission, at no fewer than 240 sites in northern and western Russia.[6] Such undertakings caused him to see the country as Eurasia's geographic and cultural heart: to his earlier understanding of Russia as a "northern" homeland of Slavs, Vikings, Balts, and Finns, he added Stasov's conception of Russia as a larger realm, spanning west and east, linked to Asia's myriad cultures. Like many leading orientalists, Roerich believed that Russia's presence at the epicenter of such grand ethnocultural interplay conferred upon it a position unique among nations—that of "mediator between European civilization and Asiatic wisdom."[7]

So Roerich interpreted the academic theories of the day. In summer 1899, he traveled by boat from Petersburg to Novgorod to dig at a series of burial grounds along the Shelon River. The cruise took him along the same waterways the Vikings had plied as they sailed to the Black Sea, and it inspired one of his most famous essays, "On the Route from the Varangians to the Greeks," published that July by *Art and Artistic*

Industry.[8] Roerich called for the preservation of medieval architecture, a cause dear to him, but also contemplated Russia as a crossroads between Scandinavia, the Mediterranean, and points farther east. The Slavic-Scandinavian north still interested him; his 1899 story "Grimr the Viking," for example, grew out of his reading of Norse sagas.[9] But the larger Eurasian landscape mattered more now.

Roerich's approach to archaeology blended the artistic and the academic. This is not to deny his scholarly accomplishments. Amateur he may have been, but his work earned the respect of the profession's most skilled practitioners, and he took part in meetings of the Imperial Russian Archaeological Society (IRAO) and the Saint Petersburg Archaeological Institute. His closest colleagues were Alexander Spitsyn, Nikolai Veselovsky (until a quarrel in 1902–1903), Nikolai Makarenko, and Anatoly Polovtsov, and he was thought of highly by such stars in the profession as Mikhail Rostovtsev, Nikodim Kondakov, Boris Farmakovsky, and Countess Praskovya Uvarova.[10] Each summer, Roerich spent weeks in the Novgorod, Pskov, and Tver Provinces, surveying kurgans near Lake Chud with Spitsyn, digging along the banks of the Shelon and the shores of Lake Piros, and exploring the Valdai Hills.[11]

Roerich could catalog like a scientist and sketch with a draftsman's precision. In 1897, Veselovsky, having neglected to photograph a newly opened kurgan near Maikop before starting to dig, described the untouched tomb by memory to his young colleague when he returned to Petersburg, and Roerich reproduced the scene so accurately that the drawing was used to illustrate Farmakovsky's 1914 classic, *The Archaic Period in Russia*.[12] Still, archaeology for him was as much an aesthetic exercise as an empirical one. Many of his writings on the subject are in the mode of Keats pondering his Grecian urn. In "At a Tumulus," from 1898, Roerich meditates on the delight of discovery: "With each swing of the shovel, each stroke of the spade, an alluring kingdom emerges. How mysterious! How wonderful!"[13] Archaeology for him was no mere tool for the accumulation of facts, but a way to recapture lost beauty and grace.

In 1898, Roerich delivered a talk on this theme to the IRAO, publishing it that December in *Art and Artistic Industry*.[14] A hymn in praise of forgotten epochs, "Art and Archaeology" is replete with references to Tolstoy, Ruskin, and William Morris, but most telling is Roerich's comment about methodology. "Many aspects of archaeology are poetical in nature," he wrote. "Every archaeologist must be an artist, at least in spirit." Ruskin had said of architecture that "it ought to be a science of feeling more than of rule," and that "no man can be an architect who is not a metaphysician."[15] Roerich had this passage in mind as he maintained that archaeology, however scientific, must transcend the cold sphere of logic if it wished to grasp antiquity's true essence. Already at this early stage, imaginative license governed his practice of the discipline as much

as scholarly convention. Eventually, spiritual conviction would overmaster both.

Through a random turn in 1899, archaeology changed the course of Roerich's life, leading to his first and only great romance.[16]

Upon finishing his excavations near Novgorod that summer, Roerich went east to the Tver region to dig around Bezhetsk. On the way, he detoured to the country estate of Bologoe, home to Prince Pavel Putiatin, an archaeologist whose work he had read for years, but whom he had never met. He arrived at dusk on a Saturday evening, his boots dusty from the road. As his room was prepared and his luggage taken up by the servants, the prince gave him a tour of the house, and it was then that the painter met his future wife, Helena Shaposhnikova, the prince's twenty-year-old niece. It was a brief encounter, with Helena returning from the bathhouse, her hair damp and her features flushed. She saw a blond-bearded man conversing with her uncle, but, in a rush to get back to her room, did not linger. She left with the impression that the young guest was an architect or surveyor, and not till the next morning, properly introduced over breakfast, did she realize he was an artist. She remembered having seen and liked his *Gathering of the Elders* at an exhibition earlier that year.

Roerich spent three days at Bologoe before proceeding to Bezhetsk, and he left with more than archaeology on his mind.

To that date, he appears to have had little if any experience with women. Whether out of prudishness or to cultivate willpower—he had just begun to read Nietzsche—Roerich professed an admiration for the Tolstoyan ideal of chastity and had noted in his diary that only the perfect female (who he was not sure even existed) could move his heart to tenderness.[17] He now succumbed to an irresistible attraction and started writing Helena. Fortunately, the Shaposhnikovs resided in Saint Petersburg. Not so fortunately, Helena's mother, Yekaterina, judged Roerich unworthy as husband material and refused to let Helena receive him at home. It was not the last obstacle she would place between the two lovers.

Helena gladly defied her mother for the sake of her "bright-eyed" young man (see Illustration 10).[18] She met her aspiring beau at concerts and even his studio, though she risked scandal in going there alone. When he finally gained access to the Shaposhnikov home, Nicholas found that his troubles had only begun. Highborn and beautiful, Helena did not lack for suitors, and her relatives preferred every one of them to him. Her father was descended from Tatar princes who, converting to Orthodoxy, had served the tsars of Muscovy. On her mother's side, Helena was a Golenishchev-Kutuzov: a great-granddaughter of Field Marshal Mikhail Kutuzov, the "fox of the North" who foiled Napoleon's 1812 invasion of Russia, and a cousin once removed to the composer Mussorgsky. By comparison, the Roerichs were, as a Victorian novelist might

have put it, "in trade." Yekaterina more than once disparaged them as "mercantile."

Class difference, however, meant nothing to Nicholas, who could not tolerate the thought of his courtship failing. By the fall, his feelings for Helena were so strong that he noted in his diary, "I fear for myself. I wish to see her as often as I can and to be always where she is."[19] He hid none of these emotions. "May I come to see you tonight, straight from the studio?" he asked in one letter. "It feels that this blasted evening will never arrive. All my thoughts are of you."[20] In January 1900, he asked Helena to marry him.

Equally enamored, she said "yes," but, foreseeing problems with her family, asked him to keep the engagement secret for two years. Nicholas agreed, but did not hold to his promise for long. In February, on Helena's birthday, he dropped by the Shaposhnikov house to give her a gift and wish her the best of the occasion—entering just in time to observe a handsome cavalry officer flirting with her. With gallant impetuosity, he marched up to Yekaterina and announced his intention to wed her daughter, setting off exactly the kind of crisis Helena had hoped to avoid. Yekaterina and the aunts demanded that Nicholas return the letters Helena had sent him; all his letters to her were opened and, to her mortification, read out loud. After some weeks, the worst of the anger died down, and the two resumed their relationship. Still, a year and a half would elapse before the couple exchanged vows. Nicholas had his own family tragedy

to cope with: his father was ailing and not expected to live out the year. Also, before marrying, he wished to improve his standing as an artist, perhaps studying in Europe for a few months, and get a better-paying job with the Society for the Encouragement of the Arts. The Shaposhnikovs, hoping to change Helena's mind about Nicholas, were more than willing to postpone the nuptials. Nicholas's mother had her own misgivings, worrying that her boy, in falling for such a beauty, and one used to such luxury, might have gotten in over his head.

Helena Ivanovna Shaposhnikova was born on January 31, 1879 (February 12 by the Western calendar), making her five years younger than her husband-to-be. By her own admission she was "terribly proud and not especially obedient," a willful girl prone to daydreams and fonder of reading than of fashion.[21] She adored her father Ivan, a successful architect, but got along less easily with Yekaterina, her status-conscious and stuffily pious mother. Yekaterina perpetually mocked Helena for spending all day with her nose buried in books, and when arguments grew heated, berated her for "offending God" with her behavior. (Helena later claimed that Yekaterina had tried to abort her before birth; if true, this doubtless added to the resentments between them.[22]) Helena suffered headaches, fatigue, and melancholy, the last made worse by the loss of both her siblings, Anna and Ilarion, in childhood. Educated by private tutors and at the Mariinsky Lyceum, she became an excellent pianist. She wished to attend

university, but her parents, fearing revolutionary influences there, would have none of it. As a compromise, they allowed her to continue piano studies at the Saint Petersburg Conservatory.

A common trope in the life stories of female occultists is the claim to have gained second sight in childhood, and to have received mysterious visitations from ascended masters and spiritual adepts. So it was with Helena, who spoke of having predicted a fire at the age of nine, as well as the deaths of several relatives, including her father.[23] Most important, two spectral beings appeared to her regularly after she turned six: Asiatic in guise, they emanated shafts of light from their eyes and right hands, and silver threads snaked out of their torsos. At the age of thirteen, during the feast of Ivan Kupala, when Russian girls hope to dream of their future husbands, she saw a vision of herself dressed in a wedding gown, kneeling before an icon of the Virgin Mary, with one of these dark-haired men standing behind her. These, she later said, were astral projections of Morya and Koot Hoomi, the mystic guides who revealed the secrets of Theosophy to Madame Blavatsky; the former had chosen Helena as his spiritual bride.[24]

Such tales are accepted by the faithful as literal truth and scorned by skeptics as self-serving lies. One can also grant that they are *psychologically* real—the product of wishful thinking, an overactive imagination, or physiological stimuli—without regarding them as *actually* true. As a girl, Helena was thrilled by books with gothic imagery, and migraines of the type she endured are known to cause hallucinations.[25] In later years, Helena spoke of having taken a concussive blow to the head as a child, and the Roerichs' family doctor believed that her visions derived from a lifelong nervous disorder related to epilepsy.[26] It is impossible to know whether Helena believed herself to have had the experiences she describes or fabricated them to elevate her status as a spiritual leader. What is certain is that she became interested in eastern philosophy and esoteric literature during her teens and early twenties, and this interest never faded. Known influences include the Russian orientalist Zinaida Ragozina and the French Theosophist Camille Flammarion, whose novel *Urania* she read as an adolescent.[27]

Helena and Nicholas were well matched. Years before, Roerich had written a story called "A Child's Tale," in which a young bard vies against a warrior, a merchant, and a prince for the hand of a princess, winning her over with his desire for a bold wife who will sing with him and travel with him to far-off lands.[28] The tale describes Nicholas's ideal woman, and Helena more than fit his criteria. Her influence on his art and career was total: she advised him what to paint and how to paint it, and she transmuted his interest in Asian cultures into a full-fledged affinity for the occult. She accompanied him on his archaeological excavations and his long wanderings through Europe, America, and Asia. In this beautiful, ethereally minded woman, Roerich found a life partner beyond compare.

Choppy crosscurrents troubled the Russian art world at the century's turn, and Roerich navigated them less than adroitly. He welcomed certain changes but, to his grief, spent several years opposing the group most responsible for them.

Artistic transformation in Russia proved neither sudden nor simple. During the late 1880s and 1890s, a few senior Wanderers, including Kuinji, Vasnetsov, and Repin, were sympathetic to limited experimentation. Younger *peredvizhniki* like Mikhail Nesterov and Valentin Serov—the group's "stepchildren"—departed further from the status quo, and an even more daring agent of change was Mikhail Vrubel, whose uniquely decorativist style paved the way for Russia's Symbolist painters.[29] These transitional figures enjoyed support from private patrons: the Shchukins, the Tretyakovs, and the railway magnate Savva Mamontov, whose country estate of Abramtsevo provided a haven for the abovementioned painters, along with musicians and performers like the acclaimed basso Fyodor Chaliapin.[30] Bankruptcy in 1899–1900 ruined Mamontov, but the patroness Maria Tenisheva attempted to duplicate his efforts at her own art colony, Talashkino. (Roerich never worked at Abramtsevo but, starting in 1903, spent many summers as Tenisheva's guest.[31]) To a modern eye accustomed to Picasso and Malevich, much of this work appears conventional, yet it stirred up controversy. When Pavel Tretyakov purchased Serov's mildly Impressionist *Girl in the Sunlight*, the tradition-minded Vladimir Makovsky railed at him for allowing such "syphilis" to infect his gallery.[32]

Even so, the real shocks were touched off by newer associations emerging at the end of the decade. Most influential was the World of Art Society (in Russian, *Mir iskusstva*), established in 1898.[33] The earliest of these *miriskusniki* were former members of the May Gymnasium's "Nevsky Pickwickians." Alexandre Benois, Dmitri Filosofov, Walter Nouvel, and Konstantin Somov continued to meet after graduation, attracting newcomers like Alfred Nourok, Léon Bakst, and Filosofov's cousin, Sergei Diaghilev. The group's adolescent enthusiasms matured into a sophisticated appreciation of newer trends from Western and Central Europe.

Brilliance and bohemian cockiness defined the cohort's collective personality. Intellectual leadership came from Benois. Of French and Italian descent, he boasted that his blood was Mediterranean, his artistic sensibilities Latin and Western.[34] He is remembered not just as a painter, but as a critic and art historian of unmatched erudition. Touchy and easily offended, he was nonetheless an invaluable teacher to the rest of the group (see Illustration 11). Equally dominant was the flamboyant Diaghilev, without whom the group would have remained an obscure salon. No artist himself, Diaghilev studied law at Saint Petersburg University, then emerged as one of the century's most talented impresarios.

The World of Art grew out of Diaghilev's early efforts to develop that talent. In March 1897, he arranged his first major event, an exhibition of foreign watercolors at the Stieglitz Art Institute. That fall, he put together a collection of Scandinavian paintings at the IOPKh Museum. In January 1898, he returned to the Stieglitz, featuring Finland's star painter, Akseli Gallen-Kallela. His next venture, his most ambitious yet, was to create an exhibition society that, in addition to organizing shows, would publish its own journal—something to match the groundbreaking, sumptuous almanacs of Europe, such as *Jugend* and *The Yellow Book*. Benois, Diaghilev, and the rest were soon joined by Konstantin Korovin and Valentin Serov, who brought prestige and excellent connections. Diaghilev convinced Savva Mamontov and Maria Tenisheva to bankroll the group. Each provided half its funding, although this arrangement lasted only until 1900, when Mamontov lost his fortune and Tenisheva broke with Diaghilev over philosophical differences.

World of Art's first issue came out in November 1898, and the group's first exhibit—which included works by Monet, Whistler, and Beardsley, as well as glass and jewelry by Lalique and Tiffany—opened to acclaim in January 1899 at the Stieglitz. Tsar Nicholas II attended the show, and Diaghilev, caught off guard, had to squeeze into a tuxedo jacket borrowed from the better-prepared but slimmer Korovin. Others attached themselves to the group, including Benois's nephew Yevgeny Lanseré, Anna Ostroumova-Lebedeva, Mstislav Dobuzhinsky, Alexander Golovin, the scholar-painter Igor Grabar (see Illustration 11), and the Symbolist authors Dmitrii Merezhkovsky and Vasily Rozanov.

The *miriskusniki* had no formal program, and individual tastes varied, but as a whole they favored Symbolism, Secessionism, and Art Nouveau. They admired the Wagnerian *Gesamtkunstwerk*. They did not abandon pictorial representation, but rejected the Realist credo that art should serve social and political purposes. Benois decried such utilitarianism as "a slap in the face of Apollo," and the group took up the "art for art's sake" cry then rallying artists and authors across Europe.[35]

Was conflict between the *miriskusniki* and the artistic establishment inevitable? At first, it seemed not to be. Older Wanderers like Vasnetsov and Kuinji turned a friendly face to the World of Art, and Repin went so far as to call Diaghilev "a damn fine fellow, just what this country needs!"[36] One of the journal's early numbers devoted a section to Vasnetsov, and Repin's paintings appeared in the group's January 1899 exhibition. Such goodwill, however, soon evaporated. One reason was philosophical incompatibility; as Grabar noted, "even the best of the Wanderers were fundamentally alien to us."[37] Also, extremism won out on both sides. In the editoral "Complex Questions," Diaghilev derided the "pitiful remnants of a false classicism"; elsewhere, he printed a long list of nineteenth-century paintings, many of them by Wanderers, he thought should be removed

from Russia's museums. An enraged Repin severed all ties with the World of Art in an open letter to the newspaper *Niva*.[38]

Other critics accused the *miriskusniki* of "decadence." They referred not just to theme or style, but to dandyism and deviance *à la* Oscar Wilde or France's poètes maudits, and the known homosexuality of Somov, Filosofov, and Diaghilev lent greater force to such charges. The most vocal foe was Stasov, who had made a long career out of pro-Wanderer partisanship. He rearranged Diaghilev's name to spell it "Gadilev," punning on the Russian word for "poison" or "filth." He called the Russo-Finnish exhibition of 1898 "an orgy of depravity and madness," and in a review of the first World of Art show—an 1899 piece titled "The House of Lepers"—he warned that if the World of Art style caught on, "humanity [would] have to be locked up in insane asylums."[39]

All this placed Roerich in an unenviable position. He shared many of the World of Art's likes and dislikes, and was roughly of an age with its members. Personal and professional loyalties, though, obliged him to take up arms against it. In July 1898, Stasov wrote to prepare Roerich for the impending conflict: "This fall and winter, we shall hear nothing but news of great battles. No doubt *you* will be at our side in these engagements? Write me at once."[40] Hardly a Saint Crispin's Day speech, but the letter reminded Roerich where his duty lay.

Stasov expected his protégé to assault the World of Art on all fronts: to blast it in the pages of *Art and Artistic Industry*, to sway opinion against it in conversation with other artists, to ensure that the IOPKh Museum's doors remained closed to it. Others were not so bloody-minded, but as positions hardened, Roerich realized that any sign of amicability toward the World of Art could only harm him in his relations with artists and critics of the older generation. So he answered Stasov's call and entered the fray.

Roerich made a reluctant soldier at first, but grew more combative. He packed little powder into his opening salvos, preferring to trivialize the World of Art or keep silent about it.[41] As 1899 progressed, his blows fell more heavily and were aimed more frequently on an ad hominem basis. Roerich respected Serov and later grew close to Grabar and Golovin, but most of the *miriskusniki* he disliked personally—especially Benois. This was a case of two men being too alike *and* too different to get along. Both were learned, but both had prickly egos, and, as Benois observed many times, they looked at the world in diametrically opposed ways. One valued rationality and baroque refinement, the other mysticism and primevalism. They despised each other for half a century.

Roerich sharpened the tone of his reviews and used his clout to bar *miriskusniki* from exhibiting or selling their work. In early 1899, when the World of Art made an overture to him, he turned it down. Sadly, he allowed this struggle to coarsen his views

in a particularly deplorable way: several times in his journals, he marks out Benois and other rivals as "the Jews," resorting to the vulgar term "yids" (*zhida*). For example, having won the final word on selecting works for an upcoming show, he rejoices that "the yid Benois is in deep trouble. I have put together the jury, and I will toss out the Jews Benois, Braz, and Gintsburg. It'd be such a happy day if they'd all go to hell." Elsewhere, he relates his efforts to persuade Kuinji to cut ties with this group: "I have tried to warn Arkhip to stay away from the yids."[42]

Do such passages reveal Roerich to be an antisemite? Not in the conventional sense of harboring a sustained or special animus toward Jews, and no more so than multitudes of other Russians in an age and place where anti-Jewish discrimination was tightly woven into everyday life and the laws of the land. Later, as a public figure, Roerich spoke out forcefully against antisemitism, and at all stages of his life, from youth to old age, he formed close social and professional ties, including his and Helena's most important friendships outside Russia, with Jews. Even Gintsburg, "tossed out" by Roerich with such heat in 1899, would be employed by him as an art teacher in a few short years.

However, context and the timeworn "some of my best friends . . ." plea can only excuse so much. Widespread and unshocking as the epithet *zhid* was in fin-de-siècle Russia, no one mistook it as anything but pejorative. Even if one grants that Roerich

did not resent Benois and the others *because* they were Jewish, but permitted himself this insult because they were already his adversaries, it shows him at a minimum to have been unbothered by the structural prejudices of his day.[43] Nor was his use of the slur isolated; it appears in his private papers over a number of years, as in a 1911 letter to Helena from the German resort of Bad Neuenahr, where he complained about the philistinism of the "little yids" (*zhidki*) visiting there from Russia.[44] It is entirely possible to exhibit casual insensitivity concerning race without being programatically or consciously racist, and this seems to have been the case with Roerich's lapses, reprehensible as they are. Either way, these and similarly mean-spirited outbursts remind us of Alexandre Andreyev's observation that "another Roerich" exists, caustic and unpleasant, very much at odds with the "spiritual and idealistic" image he wished to project.[45]

This thorny digression aside, Roerich's dilemma in 1899 and 1900 was that he fought hard enough to antagonize the World of Art, but not hard enough to satisfy the old guard. His own art reflected this middle-ground posture, and its reception demonstrated its perils. Compare the fates of *Gathering of the Elders* and *The Campaign*. *Elders* showed at the Academy of Art's spring exhibition in 1899 and was selected to represent Russia at the 1900 Paris Universal Exposition. *Art and Artistic Industry* named it the exhibition's "most significant" piece (no surprise, given Roerich's affiliation with the journal), and it earned congratulations from older painters

like Surikov, Vasnetsov, and Vereshchagin. The World of Art dismissed it as boring.[46]

Conversely, *The Campaign*, with its slightly modernist feel, received only token praise from *Art and Artistic Industry*, and upset Kuinji enough that he visited his former student to voice his displeasure. Kuinji repented within half an hour, running back to the studio and up six flights of stairs to deliver a red-faced, out-of-breath apology—but only about the harsh tone he had taken, not his actual comments.[47] Stasov ranted about *The Campaign*'s "shameful" lack of patriotism, complaining, "Not one of your soldiers shows the least bit of bravery!"[48] In May 1899, he informed Roerich how unhappy others were with the piece: "In conversation with me [about *The Campaign*], Repin happened to say that 'Roerich is capable and talented . . . everyone knows there is a certain poetry to his art. But the fact that his technique is only *half-formed* hinders, even threatens, his work.'"[49] It was, unexpectedly, from the *miriskusniki* that Roerich won approval. Diaghilev published an image of *The Campaign* in his journal and, in February 1899, asked Roerich to include it in the World of Art's second exhibition, scheduled for early 1900.[50] Roerich wavered, then declined, citing an earlier promise to display *The Campaign* at the academy's 1900 spring exhibition. He did not precisely lie, but it was partisanship that caused him to turn down the offer. "I can imagine what a scandal it would cause," he noted in his journal. "Stasov, for one, would howl, and many people would not know what to think."[51]

Had Roerich known what was coming, he might have acted differently. For his steadfastness, he received not praise from Stasov, but the tongue-lashing quoted above. (If Stasov's tirade had come earlier, would it have induced Roerich to cast his lot with Diaghilev?) And by rejecting the World of Art's olive branch, Roerich invited a series of reprisals that spoiled what should have been a happy occasion: his international debut at the 1900 Universal Exposition in Paris.

One of the belle époque's defining moments, the Paris Expo ran from April to November and ushered the new century in with gaiety and panache.[52] More than forty nations took part, and millions marveled at the recently constructed Grand Palais, Hector Guimard's Art Nouveau designs for the Paris Métro, and more than two hundred pavilions. The exposition brought together the largest international display of painting, sculpture, and design ever assembled to that date. Only "contemporary" submissions, completed in 1890 or afterward, were eligible.

Gathering of the Elders and other Roerich pieces hung in the Russian pavilion, alongside works by Repin, Vrubel, Nesterov, Vasnetsov, and Serov. Simply to have a spot was an honor, and the exposition—which Roerich witnessed in person in October—should have been a delight. Instead, it was misery from start to finish. Roerich's paintings were displayed poorly, tucked in an out-of-the-way corner. Worse, he received not a single award. The jury considered *Elders* for

a bronze medal, but ten votes were needed to win, and only three hands went up in its favor.[53]

Failure smarted all the more because the Russians as a whole did well in Paris. Due to faulty intelligence, Roerich did not know this at first, and for a few weeks comforted himself with the thought that his countrymen had also been passed over. "Thank God," he wrote Helena in July, "none of this reflects badly on me, for Vasnetsov, [Isaak] Levitan, and Surikov got nothing."[54] It was doubly bitter, then, to hear that Serov had come away with a special gold medal, and that honors had gone to Vasnetsov, Vrubel, Golovin, and others.

With undisguised glee, the World of Art rubbed Roerich's face in this mediocre showing. When the *New Times* correspondent Alexander Kosorotov complained that Roerich had been shortchanged by the exposition judges, Nourok, writing in *World of Art* as "Silenus," challenged him, asking, "Can it be helped if Mr. Roerich does not possess the same talent as Mr. Maliavin [and other prizewinning Russians]?" He followed with a condescending backhand: "Had the bronze medal depended on our vote," he wrote, "we would have bestirred ourselves to cast a fourth one on his behalf." He then implied insultingly that Roerich was so mercenary that he would align himself with any patron or style if it advanced his career. "This Roerich," Nourok jeered, "is a most affectionate calf, eager to suck from the teats of not just one mother, but two or even three."[55]

In a different key, Benois added his voice to the chorus. "Mr. Roerich has put himself forward as a painter of history," he noted. "But I do not believe in his Slavs or in his elders. It seems that he has invented these scenes in his own imagination, and therefore his paintings impress me only by how boring and affected they are."[56] This review stung Roerich so badly that he clipped it out and mailed it to Helena, attached to an angry note: "Read here the verdict *World of Art* has just passed on me. In its naïvete, the rest of the world has come to think of historical painting as my forte. But here is Mr. Benois, who knows better and advises me to find a different sphere altogether!"[57]

The squabble took a new turn in the fall, when Kosorotov of the *New Times* reported that the World of Art's savaging of Roerich had less to do with artistic merit than with a petty desire to punish him for refusing to take part in the group's 1900 exhibition. Kosorotov meant to defend Roerich, but left him vulnerable to Diaghilev's riposte. Starting in October and continuing into December, Diaghilev and Roerich traded letters in the newspaper *Russia*, the former insisting on the technical distinctions between his own person, the World of Art's executive committee, and the *World of Art* as a journal. He himself had never invited Roerich to do anything, and frankly did not care whether any given artist opted to exhibit with the World of Art. Roerich, now in Paris, tried to put aside the bickering to concentrate on his studies. As he told Stasov in November, "Diaghilev and *tutti*

quanti can waste time cursing each other."[58] He had his own work to do.

However, he could not hold his tongue for long. In December, he wrote the editor of *Russia*, referring to Nourok's "affectionate calf" joke—"an amusement at my expense that verges on slander"—from earlier that year: "Mr. Diaghilev permitted such an insinuation to be printed in *World of Art*, his own journal. At the same time, he was sending me, as if I were a participant in his 'World of Art' exhibition, notices about the acceptance of my paintings and the dates of the exhibition. Imagining such a comic picture to myself—that of this 'affectionate calf' taking the trouble to haul its paintings to such an exhibition as Mr. Diaghilev's—I cannot help but laugh."[59] If Roerich hoped to match Diaghilev's archness, he did so in vain. Diaghilev refuted his accusations, splitting hairs as before. He had never offered anything to Roerich, and "Silenus," not Diaghilev, had jested about calves and their affections. As editor, Diaghilev prided himself on giving a free hand to the *World of Art*'s writers; who was he to censor their opinions? Perhaps Roerich needed a better sense of humor.

With Roerich thus stymied, the war of words cooled, but not so the hard feelings. In time, Roerich crossed over to the World of Art and, after that, to Diaghilev's Ballets Russes. Still, he never fully belonged to Diaghilev's camp, and mutual ill will prevailed during his association with it. It was a galling irony that Roerich, who cherished above all the ideal of artists in pure fellowship, should gain his greatest fame with the colleagues he most disliked.

Roerich contended with more than artistic politics during this interlude. Family matters came to the fore as well.

His engagement to Helena continued, but no wedding date was set. Indeed, it was not yet safe to assume that there would be a wedding. Helena's father, having died in 1898, had no say in the matter, but her mother and aunts, Dunya (the nickname of Prince Putiatin's wife Yevdokia) and Lyudmila Ryzhova, were determined to keep the upstart painter from elbowing his way into their beau monde clan. They lay in wait, looking for any chance to derail the pair's plans.

More serious was the condition of Roerich's father, who spent the first half of 1900 dying. As Roerich recalls, Konstantin Fyodorovich had not taken care of himself in middle age: "My father didn't like to undergo medical treatment. For a long time, his doctors demanded that he rest. But he didn't know life without work. They asked him to stop smoking—or at least cut down—because he was in danger of nicotine poisoning. But he responded, 'If you smoke, you die. And if you don't smoke, you also die.'"[60] With poor health perhaps affecting his judgment, Konstantin made a string of unwise investments in 1899, saddling the family with debt. Late in the year, he was diagnosed with heart disease and had to

stop working. The Roerichs gave up their beloved apartment on the Embankment and moved to less capacious quarters on Line No. 16, farther to the west and well away from the river.

With the new year came a trying time for the whole family. There was no stopping Konstantin's deterioration, and as his heart weakened, so did his memory. He suffered from delusions and imagined himself surrounded by enemies. Watching as the illness consumed its victim pained Nicholas and his siblings, but affected their mother most of all. "Mamasha faded to the point of transparency," Roerich remembered, "and she wept constantly."[61] In June, the family moved Konstantin to the Peski Sanatorium, southwest of Saint Petersburg.

The sense of impending loss tormented Nicholas. The past two years had further soured relations with his father, as his determination to avoid the legal profession hardened into irreversibility. Less shrewd in his emotional dealings than in business, Konstantin had allowed himself to hope that his son might come to his senses and give up brush and easel for the bar. Nicholas's success at the academy shattered this hope, and Konstantin never forgave him. Nicholas still loved his father, but tension between them made it hard to bear the strain of the deathwatch. In July, Nicholas frequently absented himself, carrying out archaeological research near Okulovka, in the Valdai Hills.[62] To distract himself from despair, he turned to Nietzsche—a copy of *Thus Spake Zarathustra* remained by his side all

summer—and he took solace in letters from Helena.[63] The two spun escapist fantasies of running away to Europe, where they would study music, art, and philosophy. Dreams, however, were no proof against reality: near the end of July, after a brief rally, the elder Roerich passed away in his sleep.

For the rest of his life, Nicholas found it hard to come to grips with his father's death. He felt sorrow, but also resentment, tinged with guilt at having failed to overcome his and Konstantin's differences. "What do we know about my father?" he asked. "There is not much to know. Many things went unsaid. There were disappointments. His friends died before him, and he did not make new ones. Plans fell into ruin. His aspirations went unfulfilled. Few people, maybe no one, knew what troubled his heart."[64]

In keeping with this morose picture, Konstantin's funeral was a subdued event. His legal business had fallen off, and his circle of acquaintance, once so wide, had shrunk. A respectable service was held in his memory. But it was not well attended.

A month and a half after his father's death, Roerich left Saint Petersburg to study in Paris. It was almost not so: that summer, he considered working in Munich, a cradle of the Secessionist movement.[65] He was more fluent in German than in French, and for a while, his newfound infatuation with Nietzsche tilted his thoughts in a Teutonic

direction. But especially with the Universal Expo in progress, Paris in 1900 remained the world capital of painting, and it was there he went in the end.

Either way, he had long ached to be in Europe, both for its own sake and to erase the embarrassment of never having traveled there. As Rylov told him one day over lunch, his classmates found it peculiar that almost three years after graduation, he had not yet gone abroad.[66] The journey came at a steep price, for only the financial settlement that followed Konstantin's death made it possible. Maria's sole recourse, if she wished to hold onto the family's Petersburg apartment, was to sell the Isvara estate. A portion of the proceeds went toward Nicholas's trip to France. He set out in September, after arranging a leave of absence from the Society for the Encouragement of the Arts, planning to return in the summer of 1901.

The transition jolted Roerich in several ways. He parted from his family while it was still in mourning, and he opened himself to a flood of new impressions and experiences. Also, he loosened the tether binding him to Stasov, who strenuously opposed his leaving. "Why on earth should you go abroad?" Stasov asked, "when what you really need is not to look at foreign paintings (you have done enough of that), but to sit yourself down in a figure-drawing class (human figures) and work persistently and ceaselessly! I have always thought this and said it, and I say it again now. Studying abroad will not bring forth anything more from you!!! Heed my reasoning, and do not be angry with

me."[67] Roerich, of course, *was* angry. Not enough to sever ties, but enough to fill him with defiant satisfaction as his train rolled westward.

He went slowly, taking time in September and October to tour Berlin, Dresden, and Munich. He wrote his brother Boris from Berlin, describing his visit to the Zoological Garden, where he was struck by how contentedly the crowds promenaded through the zoo's arcades and winding pathways. "The entire city seemed to be gathered there," he wrote, concluding enviously that, "outside Russia, people live happier and fuller lives than we do."[68] For such a staunch Russophile, it was a rare moment of yearning for Western ways.

The artist spent late October and early November settling into Paris. He lodged first at the Hôtel de Burgundy, then relocated to the Rue du Faubourg Montmartre, a thoroughfare winding southward through the ninth arrondissement, from the outskirts of Montmartre to the Paris Stock Exchange. Inexpensive and simply furnished, his quarters contained a bed and table, a washstand, a wood stove, and a single lamp. The room was sizable and well lit, with a large window overlooking the street. The Paris Opéra lay within walking distance.

Roerich's early weeks passed in solitude. In mid-November, he noted to one friend, the archaeologist Anatoly Polovtsov: "I am sure you will be amazed to receive from me this letter from Paris, not to mention the news that I will be here for a while, in order to work—outwardly, in the midst of much

hustle and bustle, but inwardly in silence. The swampy muck of Saint Petersburg was choking me, and I wanted to bathe in fresh waters, not stew in old juices. I want to gather into myself something of the eternal culture of the West, against whose background our own original creations stand out in relief, and elaborate further upon it."[69] Never one to admire the frenetic energy of urban life, the artist sampled few of Paris's bohemian delights. Not for him the showgirls of the Moulin Rouge or the dusky oblivion of absinthe; there were no late-night, wine-soaked debates in dimly lit taverns. Gazing upon Paris's metropolitan liveliness, Roerich denounced the city as a "new Babylon" and shied away from its "glittering façade." "I lead a monkish form of existence," he told Polovtsov. "I see few people, and, aside from museums, go almost nowhere."[70]

Although he spent more time with others as the months wore on, Roerich structured his hours the same way he had at the academy. From nine in the morning to five in the evening he painted. Spare time went to museum visits or the study of French and English. Only on occasion did he deviate from this regimen. As he wrote Helena, "I am working very hard, so much so that I recently had to take three days off and see some of the city. I was suffering headaches otherwise. I am drawing, painting, and composing many pieces, both large and small."[71]

In Paris, Roerich studied with the historical painter Fernand Cormon, who had instructed van Gogh, Toulouse-Lautrec, and the Russian Symbolist Viktor Borisov-Musatov. Cormon did not hesitate to point out Roerich's weaknesses, especially his rendering of human figures. But he found much to praise, and he encouraged Roerich to delve further into the Slavic past. "Cormon approves of my Russian studies," he informed Polovtsov. "I am sure you too will be happy with some of the themes I am working on."[72] Cormon advised the young Russian not to become too Europeanized. "*Nous sommes trop raffinés* [We are too refined]," Roerich remembers him saying. "You should go your own way. We will learn from you. You have so much that is beautiful."[73]

Three things disturbed Roerich's hermit-like routine. One was the unpleasantness with Diaghilev and the World of Art over his reception at the Universal Exposition, although that ran its course by the end of the year. Second was a startling moment whose ramifications lasted a lifetime. One night, at a gathering hosted by E. K. Losskaya-Galstunskaya, a former schoolmate of Helena's, Roerich took part in a séance. Spiritualism was such a fad that he could not help knowing of it, though to this date he had never given it serious thought. He went along for amusement's sake, but suddenly, as he said in his next letter to Helena, "something extremely curious took place." Earlier that day, he had been working on a sketch of a Scythian funeral procession, and when his turn came to question the spirit supposedly present, he asked idly which of his current projects was the best. The answer—"Scythians burying a dead

man"—made him sit upright in ice-cold shock. "Imagine my amazement," he told Helena. "You know I have never trusted table-rapping. But nobody present could have known about this subject, because I had just come up with it that day and hadn't told anybody about it. Isn't it a wonder?" He claimed not to be fully convinced yet, but said excitedly that "I must give it another try."[74] At a subsequent sitting, the presiding clairvoyant claimed to see a beautiful young woman practicing the piano back in Saint Petersburg, and Nicholas, taking this to be a vision of his betrothed, suggested to Helena that they try communicating via hypnosis.[75]

Nothing came of that particular idea, but Helena herself remained Nicholas's third and most time-consuming distraction. Their long separation hurt badly enough. Knowing that Helena's relatives were doing their best to make it permanent heightened Roerich's anxiety. Yekaterina and Aunt Dunya swept Helena into the capital's circuit of banquets and balls, steering her in the path of as many eligible bachelors as possible. And when they took her on vacation to Nice, Milan, and the Lido, it was not just to escape the Petersburg winter, but to distract her from her unsuitable fiancé.

Consequently, if there was one thing Roerich did not begrudge, even at the expense of his painting, it was composing letters to "Lada," the nickname he gave Helena. Volumes of mail went back and forth between them, and Roerich poured out a torrent of passion that would have surprised anyone accustomed to his imperturbable exterior. Hearing that Helena was in Nice, he grew fevered at the thought that only a short train ride kept them apart. "My dear, my little dove," he pleaded, "please come visit me. I must see you. You are so much in my mind that I cannot concentrate on my work."[76]

Such emotional flights were the product of fear as well as ardor. All along, Roerich had competed with others seeking Helena's hand, starting with the interfering hussar from February and continuing with the son of a shipping mogul and a classmate from the May Gymnasium. He could not help thinking that the Shaposhnikovs' scheming, aided by the months and miles dividing him from Helena, might undo their engagement. So when Helena reminded him that her mother and aunt would never permit an unmarried woman of breeding to travel alone to visit an unmarried man, it is no surprise that he replied like this: "Perhaps it is not they who prevent you from leaving? Are you certain this is not something you yourself desire? After all, you have written how much you enjoy yourself at these dances."[77] Outwardly, this was meant to tease, and Roerich ended the letter in a gush, signing "I love you" five times. But beneath this attempt at humor ran an undercurrent of worry: Was he, in jest, touching on an uncongenial truth?

If Helena could not come to him, Nicholas would go to her. He called on the Shaposhnikovs in Nice, and in Italy as well. He did not delight Yekaterina or Aunt Dunya by doing so, but Helena was overjoyed

to see him. Around Easter week, Helena's family went back to Petersburg, but she remained true and resisted all further efforts to divert her affections. She and Nicholas would marry in the fall of 1901. During his time in Paris, though, the agony of uncertainty exhausted his emotions.

With so much happening in his life, it seems almost anticlimactic to ask what impact Roerich's stay in Europe had on his art. He improved his technique in Cormon's studio, but learned just as much from months of exposure to Paris's vibrant art scene. He had studied foreign art in Russia, but there was no substitute for strolling the corridors of the Louvre, or visiting studios and attending exhibitions in person. Observation and immersion did more than anything to change the way Roerich painted.

From whom did Roerich learn? With the exception of Degas, the Impressionists left him indifferent.[78] His tastes ran more toward Symbolists and certain post-Impressionists. He admired the Italian landscapist Giovanni Segantini, along with Émile Bernard, who helped birth the Cubist movement with his suggestion to Cézanne that he reduce all forms to the cone, cylinder, and sphere. He was intrigued by Gustave Moreau (in whose studio he had considered studying), Odilon Redon, Germany's Hans von Marées, and the Swiss Symbolist Arnold Böcklin.[79] Although sculpture was not a medium he knew well, he enjoyed the robustness of Auguste Rodin's work. With a group of Cormon's students, he got the chance to meet the sculptor in person, during a Sunday-morning trip to Meudon. Several years later, he had his own work praised by Rodin. A mutual friend, the orientalist Viktor Golubev, accompanied Rodin to the Paris Salon d'Autômne, where some of Roerich's paintings were on display. Afterward, Golubev reported to Roerich: "This Sunday I showed Rodin your canvases at the Salon. He was very interested in them and asked many questions about our ancient legends, the links between Russian faith and Russian art, and about monasteries, pine groves, and much more."[80]

At this time, two artists influenced Roerich above all: the French muralist Pierre Puvis de Chavannes, a precursor of the Symbolist movement, and Paul Gauguin. Puvis, whose works grace the Sorbonne and the Boston Public Library, combined monumentalism with ethereal purity. Many Russians—among them Diaghilev, Borisov-Musatov, and Kuzma Petrov-Vodkin—valued him highly, and, after viewing Puvis's scenes from the life of Sainte Geneviève in the Panthéon, Roerich joined their ranks. "The more I examine Puvis's art," he told Helena, "the more I learn about his method of working, his life, and his habits, the more amazed I am by the great similarities with what I find in myself."[81] As for Gauguin, while Roerich hardly emulated his hedonism, he took after his style and technique. The vivid splashes of bright color, the deliberate flatness of composition, the penchant for exotic, "primitive" subject matter: all these made their way into Roerich's work, which bore the Frenchman's imprint into the early 1920s.

Time in Paris shaped Roerich's art in one last respect. He kept painting scenes from history, but now began a long shift from literal narrative to symbolic universality. As Vsevolod Ivanov, one of his first biographers, notes, "had Roerich continued on the same course, he would have fallen into sterile historicism. He would have kept painting renditions of the past that, while superb, would have been suited only for the classroom, perfect for elucidating the history of culture or ethnography. But his art was meant for more than this."[82] Roerich had captured the *image* of history, but unless he wished to remain a soon-to-be-forgotten illustrator, he had to capture history's *meaning*. Paris moved him toward more creative interpretations of the past.

Roerich returned to Petersburg in the summer of 1901, with a busy half year in front of him. On October 28, he and Helena were married, with a celebration afterward at the Academy of Arts. The newlyweds lodged with Roerich's mother, although they hoped to move soon to less crowded quarters. Roerich resumed work at the Society for the Encouragement of the Arts and earned a promotion right away. Nikolai Sobko, the IOPKh secretary, had recently died, and Roerich applied for the post, which brought with it better pay and more interesting work—but also more stress.

Brimming with ideas from his time in Paris, Roerich turned out a quantity of northern works, filled with a vigor to match their rugged setting. Among them are *Ominous Ones* (1900–1901), featuring ten ravens, birds of portent in Norse and Slavic myth, on a pile of mossy rocks, plus *Sorcerers* (1901) and *Battle with the Serpent* (1902). Two other pieces exemplify his newer style. *Idols*, from 1901, exudes a "virile pagan mood," in Roerich's own words, and had Gauguin ventured not to the South Seas but backward in time and to the north, he might have produced such an image.[83] A sacred circle of wooden pillars, carved in the form of old gods and patterned with red glyphs, stands within a wall of stakes, on which hang the bleached skulls of horses. A Fauvist riot of color spills out over the canvas.

The same is true of *Overseas Visitors*, also known as *Overseas Guests* (two versions, 1901 and 1902), with its burst of vermilions, viridians, and sapphire blues.[84] A pictorial accompaniment to Roerich's 1899 essay, "On the Route from the Varangians to the Greeks," this eye-catching scene of dragon-prowed Viking boats surging toward Byzantium along Slavic riverways remains one of his most enduring works (see Illustration 6). Routinely used to illustrate history texts at all levels from kindergarten through university, *Overseas Visitors* possesses in Russia an iconic quality like that of *George Washington Crossing the Delaware* in the United States or Holbein's portraits of Henry VIII in England. It has appeared on postage stamps, postcards, and posters, and in countless albums. Though Roerich himself might have looked askance at such

commodification, museum gift stores cheerfully provide *Overseas Visitors* keychains, puzzles, and other knickknacks to souvenir hunters in Moscow and Saint Petersburg.

Not that Roerich opposed the success such works brought him in 1901 and 1902. *Overseas Visitors* sold for 1,000 rubles, a sum that would have done credit to a more established painter, and even *Red Sails*, an early study for *Visitors*, went for 500 rubles.[85] Sergei Shcherbatov, a board member of the Tretyakov Gallery, acquired his *Siberian Frieze* (1902) and followed his career closely (though he came to dislike him personally). Roerich received one of his first architectural commissions in 1901, when the Grand Princess Olga Alexandrovna asked him to design two panels—*Princely Hunt: Morning* and *Princely Hunt: Evening*—for the dining hall of her Voronezh estate. Also in 1901, Roerich used his IOPKh position to organize his own one-man exhibit at the society's museum. This sparked an unanticipated scandal: in the interest of "safeguarding" public morality, government approval was needed for shows and performances sponsored by state institutions, and the official who handled Roerich's case, General Nikolai Kleigels, turned out to be more than normally prudish. Objecting to a set of nude studies, he cried out, "These are impossible! Just imagine—there will be ladies in attendance, and their daughters!" Roerich pointed out that nudity was not unheard of in the world of high art and that the avenues of Petersburg's Summer Garden, as public a space as could be, were lined with statues of unclothed and partly clothed figures. The general snapped back, "The Summer Garden does not fall within my purview. Your exhibition does."[86] In the end, Kleigels forced Roerich to withdraw only one of his sketches.

Things went more smoothly at the Academy of Art's 1902 spring exhibition. Tsar Nicholas II, struck by the liveliness of *Overseas Visitors*, purchased it for his own collection.[87] Another surprise came from the World of Art, which expressed admiration for Roerich's stylistic adjustments. Nourok, who had needled him so mercilessly in 1900, now wrote that his paintings were "exceptionally interesting, attractively colored, and well-drawn, showing how much he has changed for the better."[88] Diaghilev took an interest in Roerich's latest project, *They Are Building a Town*, and in summer 1902, *World of Art* printed black-and-white copies of ten of the artist's paintings, with *Overseas Visitors* as the centerpiece.[89] None of this meant that Roerich and the Diaghilev group were at peace; numerous conflicts awaited. Still, *miriskusnik* acknowledgment of Roerich's worth brought the two parties nearer to a working truce—and to several fruitful collaborations.

Roerich was nearly twenty-eight as the end of 1902 approached. He had successfully launched his artistic career, and he now enjoyed a rich family life. He remained a devoted son and affectionate brother, gently

chiding his sister Lydia for writing dull letters, and dispensing advice to his younger brothers, especially Boris, an aspiring architect who shared Nicholas's love for art and literature. (Vladimir, training as an agronomist, was often away from Petersburg and, as his mother and brothers complained, lazy about keeping in touch.[90]) Nicholas won a measure of acceptance from his mother-in-law and Helena's aunts, while archaeology gave him a common bond with Prince Putiatin, and also with Helena's cousins Mikhail Putiatin and Boris Ryzhov. Of Helena's relatives, Nicholas was friendliest with the composer Stepan Mitusov, Yevdokia Putiatina's son from an earlier marriage, and Helena's dearest companion from childhood. Most exciting, Nicholas and Helena became parents in August 1902. Appropriately enough for a future explorer, Yuri—George in English—was born in the field. Roerich worked that summer with Ryzhov and the archaeologist Sergei Tsyganov in the Valdai Hills, and the pregnant Helena, her mother in tow, made a vacation of it by taking a dacha in Okulovka, the biggest village in the area, and having her baby there.

As much as he had matured, Roerich was still in his twenties, with a personality far from fixed. An interesting document from May 1900 lends insight into his psychology at the time. Among the people Roerich came to know through Stasov were the Schneider sisters, Alexandra and Varvara—nieces of the orientalist Ivan Minaev—who kept in their parlor an English guestbook titled *Confessions*. Eighty or so people,

Roerich one of them, answered the twenty-three questions printed on each page. Roerich's responses are recorded in full:

Your favorite virtue: *indefatigability.*

Your favorite qualities in a man: *talent, a defined goal.*

Your favorite qualities in a woman: *femininity.*

Your favorite occupation: *[my] work.*

Your chief characteristic: *wanderer.*

Your idea of happiness: *to find one's path.*

Your idea of misery: *to be misunderstood.*

Your favorite color and flower: *violet (ultramarine, Krapplack), Indian yellow.*

If not yourself, who would you be? *traveler-writer.*

Where would you like to live? *in my native land.*

Your favorite poets: *A[lexei] Tolstoy.*

Your favorite prose authors: *L[eo] Tolstoy, Gogol, Ruskin.*

Your favorite painters and composers: *Beethoven, Wagner, Glinka, Borodin, Rimsky-Korsakov, V[iktor] Vasnetsov.*

Your favorite heroes in real life: *Leonardo da Vinci, the* skhimnik [an ascetic monk under the strictest of vows].

Your favorite heroines in real life: [left blank].

Your favorite heroes in fiction: *Don Quixote.*

Your favorite heroines in fiction: [left blank].

Your favorite food and drink: *kvass, very rare (alas) roast beef.*

Your favorite names: *Yelena* [the Russian spelling of "Helena"], *Tatyana, Nina, Ingegerda, Roman, Rostislav, Arseny.*

Your pet aversion: *vulgarity and s mugness.*

What characters in history do you most dislike? *Peter the Great* [the Westernizing modernizer of eighteenth-century Russia].

For what fault have you most toleration? *passion.*

Your favorite motto: *"Forward, without looking back!"*[91]

Most of this speaks for itself, and it confirms our impression thus far of Roerich as a dedicated Russophile and a fervent lover of all things premodern. It shows as well how closely coupled were his neo-Romantic idealism and his melodramatic sense of self-importance.

Certain changes were yet to come. Roerich's future mysticism is barely hinted at here, except possibly in his *skhimnik* reference, and even that was more about strength of spirit. His condescending view of women, all too common among Victorian-era men, would give way to greater respect, a development for which Helena deserves credit. In 1900, he had not yet gotten much Nietzsche under his belt; a season later, the philosopher would likely have earned a place among "favorite prose authors." (How much Nietzsche's thinking stayed with him in the long run is less certain.)

These items aside, Roerich's "confessions" reveal attitudes that remained characteristic for the rest of his life. Whether twenty-five or sixty-five, he perceived himself as a lone crusader, struggling on behalf of integrity and beauty against modern amorality and degeneracy. Over the passing years, the fires of this conviction, far from dampening, burned with ever-greater heat.

CHAPTER 4

The Architecture of Heaven, 1903–1906

I believe in a Last Judgment at which all those who have in this world dared to traffic in sublime and chaste art, all those who have polluted and degraded it by the baseness of their sentiments, by their vile greed for material pleasures, will be condemned to terrible punishment. On the other hand, I believe that the faithful disciples of great art will be glorified and, surrounded by a heavenly amalgam of rays, perfumes, and melodious sounds, will return to lose themselves for all eternity in the bosom of the divine source of harmony.

—Richard Wagner, "An End in Paris"

Roerich turned thirty in the fall of 1904, and a portrait done three years later, by the *miriskusnik* Alexander Golovin, gives a good impression of him at this age. By now he had gone mostly bald. Losing his hair accentuated the slant of his eyes, giving what he felt was an Asiatic cast to his features. His mustache and goatee were close-trimmed and blond; he had not yet started growing long whiskers to cultivate the image of sage and guru.

Already, though, he was undergoing the spiritual adjustment that led him to do so. Around 1905, with Russia convulsed by a ruinous war and social upheaval, Roerich lifted his eyes to a loftier plane and began tracing the lineaments of what he called the "architecture of heaven."[1] Religious themes—Christian, pagan, and Asian—appeared

in his work, and the mental space he most frequently inhabited was a dreamworld of the past, where historical and archaeological fact commingled with myth, primeval beauty, and pantheistic mystery. To a degree, this grew out of a wider antimodern trepidation that caused many to warn, as the Austrian writer Hugo von Hofmannsthal did, that "we shall endure only if we create a new antiquity for ourselves."[2] Even more, it was a question of purifying one's soul. Guided by Helena, Roerich began hewing to creeds like Vedanta and Theosophy, and such esoterica colored his art and his perception of the ancient world.

Empyrean fascinations did not disentangle Roerich from mundane concerns. The Russo-Japanese War and 1905 Revolution touched him personally and professionally. At the Imperial Society for the

Encouragement of the Arts (IOPKh), his bureaucratic duties multiplied, and he took on added responsibilities elsewhere. He came into his own as an artist, exhibiting his work and building up an enviable reputation. He remained as thin-skinned as ever, and this trait, combined with the increasingly rancorous fracturing of Russia's artistic community, embroiled him in numerous debates and quarrels. Roerich associated with many coalitions and movements—but rarely did he belong to them fully.

In 1903 and 1904, Roerich continued his search for stability in an ever-changing art scene. At the end of 1902, he had taken a decisive step by agreeing to exhibit with Diaghilev's World of Art. *They Are Building a Town* (1902) and other works were included in the fifth and sixth World of Art shows, held in Moscow and Petersburg between December 1902 and March 1903. Diaghilev considered *Building a Town* to be near perfect. Asked by the artist whether it needed further embellishment, he exclaimed, "Not one brushstroke more!"[3]

Others shared his opinion. The Symbolist writer Vasily Rozanov said of *Building a Town* that its "naturalness and animation cause one to sniff the air, so as to catch the lovely scent of newly-cut pine," and Vasily Surikov spoke so highly of it that he moved Roerich "almost to tears."[4] (Seven decades later, the beloved children's poet Kornei Chukovsky, during a long hospital stay,

considered it "horse-like" ignorance when his "idiot-professor" ward-mate confessed to never having heard of *Building a Town*.[5]) On Surikov's and Valentin Serov's advice, Ilya Ostroukhov arranged for the Tretyakov Gallery to acquire the canvas for the generous sum of 2,500 rubles. Anna Botkina, Pavel Tretyakov's daughter and the wife of Mikhail Botkin, Roerich's enemy at the IOPKh, opposed the purchase. In rebuttal, Ostroukhov remarked that "Roerich's painting, *like almost everything that is new, bold, and full of talent*, has not enjoyed immediate *public* success," but deserved support from those of true discernment.[6] Other *miriskusniki*, like Dobuzhinsky and Grabar, had come to admire Roerich's "brilliant gifts," and even Benois admitted that his rival's style had grown "more powerful and enduring."[7]

This was détente, however, not amity. Roerich would never forget the insults dealt him by Nourok, Benois, and Diaghilev in 1900–1901. And whatever they thought of his art, most *miriskusniki* viewed Roerich as eccentric or antisocial. Serov considered him a "typical Petersburg careerist," and Grabar's characterization of him as "a complete riddle" has already been noted.[8] Dobuzhinsky recalled that "Roerich regularly took part in the World of Art exhibitions, but kept everybody at a distance. Even later on, when we began addressing each other familiarly, we were never really close. Roerich was a mystery to all of us, and his personal life was hidden from everyone. He never 'came out of his shell,'

and, apparently, he was busy with his own quite stellar career."[9] Even had Roerich gotten along with it better, the World of Art would soon have ceased to provide safe haven. Differences of opinion and divergent interests were pulling the group apart, and money was drying up. Since 1900, the World of Art had been funded by a stipend from Nicholas II. In 1904, however, the Russo-Japanese War diverted the tsar's attention, and his support vanished. Not long after, the World of Art, both journal and group, did the same.

With whom, then, could Roerich align himself? Not his old mentors. Stasov, who saw in *Building a Town* a "slovenly, disorderly Babel," lambasted him for forsaking his earlier work, "in which your depiction of Russian antiquity struck a true note."[10] Worse, he aired his opinion openly in reviews like "Two Decadent Exhibitions," which spoke of Roerich as "having worsened all around."[11] Stasov seems to have believed that hurling invective was the best way to shame his protégé back into obedience, but Roerich exploded, accusing Stasov of defaming him. The critic retreated, protesting, "I *am not abusing your name*, I *have not abused your name*, and I *have no intention of abusing your name*. Whoever has told you this nonsense, this calumny, is lying through his teeth!!!"[12] This was as close to an apology as Stasov could come, and Roerich's correspondence with him tapered off considerably in the months before Stasov's death in 1906.

Neither did Roerich see eye to eye with Kuinji. Student and teacher had drifted apart on questions of style and now clashed over politics and pedagogy. Serving together on an Academy of Art commission to evaluate reform proposals, the two took opposite sides, with Kuinji resisting change. Kuinji consorted with people Roerich disliked and condemned his art in public. Once, he offended on both counts by arriving at an exhibition in the company of Savely Zeidenberg and the sculptor Ilya Gintsburg—two members of the clique that the younger Roerich had denigrated as "yids" in his diaries—and commenting loudly that Roerich's contributions to the show were not as innovative as their creator imagined. "I am terribly angry at Kuinji," Roerich wrote that evening. "He found himself a bully pulpit, and didn't he just preach!"[13] Roerich retained more affection for Kuinji than he did for Stasov, but was no longer his ally in art.

One group Roerich drew closer to was the Union of Russian Artists (SRKh). Founded in 1903, the union first took shape in 1901–1902 as the Thirty-Six, a loose association of painters dissatisfied with Diaghilev's imperious ways and with what they saw as his disproportionate emphasis on Western art. In 1902, Mikhail Nesterov and Apollonius Vasnetsov, leading members of the Thirty-Six, tried to recruit Roerich, but, still hoping to come to terms with the World of Art and not wanting to be accused of dividing his loyalties, he fended off these early advances.[14] Only in 1903, when the World of Art and the SRKh began negotiating a merger, did Roerich consider it safe

to accept the latter's offer. In November 1903, he agreed to enter his work in the next SRKh exhibition. In 1904, the SRKh and the World of Art formed a partnership that lasted until 1910.

Also in 1903, two important supporters came Roerich's way. One was Sergei Makovsky, a gifted critic and a key promoter of Symbolist painting in Russia.[15] The other was Maria Tenisheva, who met Roerich that summer and discovered how attuned their views were. With Tenisheva's backing, Roerich waged artistic war against Diaghilev and Benois, while technically remaining a member of their cohort. These firefights flared until the end of the decade, continually complicating Roerich's career.

As Roerich established himself more solidly, he exhibited more widely. When the World of Art show closed in March 1903, he followed up with appearances at the "Old Petersburg" exhibit and the Contemporary Art Exhibition, an Art Nouveau extravaganza organized by Grabar and modeled on the Maison Bing in Paris.[16] In 1904, he took part in the first SRKh exhibition, as promised. Most important was his one-man "Ancient Russia" exhibit, hosted in December 1903 and January 1904 by the Society for the Encouragement of the Arts. Among the highlights were *They Are Building Boats*, a companion piece to *They Are Building a Town*, and an assortment of the Architectural Studies Roerich had begun in 1903

and would continue in 1904. On January 28, Nicholas II attended the show, voicing admiration for everything he saw and proposing to have the Museum of Alexander III (the present-day State Russian Museum) buy the Architectural Studies once they were done. Great things appeared to be in store—although this chain of events would end less than happily.

The Architectural Studies project arose from the shock Roerich experienced in 1899, seeing firsthand the wretched condition into which so many medieval buildings had fallen. The preservation of old architecture became one of his chief passions, and he defended the cause with the most forceful prose of his career. In *The Seven Lamps of Architecture*, John Ruskin had written that "the moral integrity of a people can be read in their artifacts," and Roerich framed his arguments in identical terms. In "Ancient Times," serialized by the journal *Architect* in 1904, he equated neglect of architecture with "sinfulness."[17]

Roerich saved such polemics for pen and paper. When he took up his brush, he paid tribute to the architecture itself. Over two summers, often accompanied by Helena and their infant son, he visited almost thirty towns and cities, capturing on canvas the heritage he feared was fast disappearing.[18] Helena did the same with her camera, assembling a portfolio of well-regarded photographs. The family did most of its traveling in 1903. Its route began with Russian Poland and the Baltic provinces, then took a southward turn to Chernigov, Kiev, and Crimea.

Next came Pskov, Moscow, and the "golden ring" towns encircling Moscow, including Vladimir and Suzdal. Then Kazan, on the threshold of Asiatic Russia. Among the stops were Smolensk and Talashkino, where Roerich stayed as the guest of Maria Tenisheva. Helena and Yuri spent much of the season with the Putiatins at Bologoe, where Helena's mother and relatives could dote on the youngest Roerich. After mid-July, Nicholas joined them for the rest of the summer.

In 1904, financial constraints limited the Roerichs' itinerary, as did Helena's second pregnancy. Nicholas did not travel far, concentrating on Tver and Uglich, the Valdai Hills, and Zvenigorod. Again, he visited Tenisheva at Talashkino. Afterward, he took his ease with the Shaposhnikov-Putiatin clan, this time at Beryozka, a rustic setting on the shores of Lake Imolozhe, and one of the family's favorite haunts over the next few years. With his cousin-in-law, Mikhail Putiatin, he did some archaeological spadework near Lake Piros.

Building a collection of more than seventy studies and canvases, Roerich painted castles, cathedrals, and monasteries, some standing proudly, others crumbling into ruins. On his list were recognized treasures, such as the Saint Dmitri Cathedral in Vladimir, the Church of the Intercession on the River Nerl, the Pskovo-Pechersky Monastery, the Rostov Kremlin, and Yaroslavl's Church of the Nativity (see Illustration 7). But he also found time for the overlooked and the nameless: a candlelit chapel in a country convent, a stone cross by the roadside, a solitary watchtower draped with ivy and worn by wind and rain. A mildly impressionistic touch gave these dusty-hued works more life than any attempt at snapshot accuracy would have. As Sergei Makovsky noted, "All those cathedrals, their white walls firmly rooted in the earth, the kremlins with their tent roofs, the quiet churchyards, and the frowning fortress towers are not depicted the way they appear to the indifferent eye of a casual passerby. The artist has painted their poetry, their ancient soul. He closely scrutinized the stone face of ancient times and grasped its expression."[19] Helena's creativity received credit as well. Selections from her photo collection were exhibited alongside Nicholas's paintings, and later used by Igor Grabar to illustrate the architecture volumes of his "History of Russian Art" series.

Too many times to count, the loss or destruction of his art caused Roerich grief. But nothing doomed him to greater disappointment than the fate of his Architectural Studies. Nicholas II's praise, plus the possibility that he might purchase the entire series, raised Roerich's hopes to euphoric heights. Sadly, Japan had just launched a surprise attack on Russia's Pacific naval base at Port Arthur, and war between the two countries was formally declared on the very afternoon Nicholas dropped by Roerich's show. The tsar had matters more urgent

than the acquisition of art on his mind, and all talk of buying Roerich's new pieces was forgotten.

A seemingly excellent alternative cropped up right away, as Russia prepared to take part in the Louisiana Purchase Exposition, held the summer of 1904 in St. Louis, Missouri. More than six hundred artworks were assembled for display, the largest collection of Russian art to leave the country to that date. Roughly one in eight belonged to Roerich, who lent seventy-five paintings, including *They Are Building Boats*, *Meeting of the Elders*, and most of the Architectural Studies he had completed in 1903.[20] Then, at the point of departure, the Japanese conflict interfered once again. Russia's exhibition space in St. Louis neighbored Japan's, and the tsar's emissaries demanded that the Japanese be asked to move. When the exposition organizers dismissed their request, the Russians dismantled their half-built pavilion and boycotted the event. Twice in a row, the war had deprived Roerich of a sponsor, and he and his fellows were left with no way to get their art to America.

Or so they thought. Entering from the wings was Eduard Grunwaldt, a Petersburg fur merchant who offered to display the collection in St. Louis as a private contractor. In exchange for a 30 percent commission, he would ship the art at his own expense, guarantee it against damage and loss, and sell it under conditions set by each artist. Roerich signed on, as did three dozen others. They did not foresee the eight years of foolishness and fraud that would follow.

The Russian collection went by train to Copenhagen, then by boat to New York, where it arrived in June 1904. Grunwaldt bonded seventy cases of art with the New York Collector of Customs but did not at this juncture pay the 20 percent tariff levied by the Treasury Department on foreign artworks imported for sale in the United States. Wrongly, Customs anticipated that Grunwaldt would settle up after auction. Grunwaldt showed the collection at the St. Louis Exposition, but without success. The new exhibition space, hastily thrown together, was too small to house so much art. As the Russo-Japanese War escalated, public opinion in America favored the Japanese, whose graceful pavilion, just next door, attracted more visitors and won more prizes. Not a single Russian painting or sculpture sold.

The exposition closed in December 1904. The following June, Grunwaldt took the collection back to New York, securing permission from the Treasury Department to stage a Russian Fine Arts Exhibition in Manhattan between September 1905 and early 1906. He chose not to inform the department about the second part of his plan, which was to end the show with a public auction, starting on March 7, 1906, and continuing till everything was sold, regardless of price. Even supposing that Grunwaldt had been guilty so far of nothing but incompetence, he now graduated to dishonesty. Not only was he squirming out of the 20 percent tariff, he was knowingly violating his contracts, for not all the art had been slated for

auction. Many clients had asked that their work be brought back to Russia, and those who wanted Grunwaldt to sell their art had set reserves, or minimum prices, for their contributions. Grunwaldt planned to unload everything, at whatever cost.

The March auction proved a bust in every sense of the word. In two nights, Grunwaldt let 130 lots go for bargain-basement prices. On March 9, the secretary of the Treasury put an end to the event, ordering the New York collector of customs to recover all items that had been sold, and to impound everything. With the exception of eight canvases that the Toledo Art Museum took away legally, the Russian collection was designated "unclaimed merchandise" and locked away in a New York warehouse. Technically, Grunwaldt owned the collection, but the only way to redeem it was to pay a fee he could not afford. As for the artists in Russia, they lost title to their work, without a kopeck in return.

The Russian government made token attempts to restore ownership to the artists, but bowed out of the dispute in 1908—a decision Roerich regarded as betrayal and held against Nicholas II for years.[21] Grunwaldt allowed title to slip into the hands of his attorney, Colonel Henry Kowalsky, a flamboyant rogue notorious for once facing down a pistol-packing Wyatt Earp and for helping Leopold II of Belgium obtain US diplomatic recognition for the Congo Free State, one of history's most odious colonial regimes.[22] Kowalsky engineered the collection's transfer to Canada in 1908; two years later, short

of cash, he schemed with the California tycoon Frank Havens to display the collection at Oakland's Piedmont Gallery, sell it off, and split the profits. However, in April 1910, when the forty-six crates of artwork crossed into Michigan, the Bureau of Customs, noticing that Kowalsky and Havens had understated the collection's value to avoid high tariffs, seized the shipment. The art was taken to San Francisco, where, by early 1911, the collector of customs properly assessed its worth. He then held the collection for one year, during which time anyone with a clear title (which Kowalsky had, although Grunwaldt was still contesting the point) *and* a valid bill of lading (in Havens's possession) could claim it after first paying the tariff. No one came forward, and in February 1912, Havens snapped up the collection at public auction for $39,999.

Many of Roerich's paintings made their way back to Russia, but not until long after his death. Desperately in debt by 1916, Havens liquidated the collection, and William Porter, personal physician to the writer Jack London, picked up all of Roerich's canvases for the paltry sum of $138. Some ended up with private owners, but forty went to the Oakland Museum of Art, which in 1957 sold them to the Nicholas Roerich Museum in New York. As a goodwill gesture in 1974, the one-hundredth anniversary of Roerich's birth, the museum's vice president, Katherine Campbell, returned the Porter bequest, which included the largest single set of Architectural Studies in existence, to Russia. Since 1976, these works have hung

in Moscow's Museum of Oriental Art. None of this, of course, came soon enough to console Roerich, who forever mourned his lost art and, permanently embittered by the St. Louis experience, denounced more than once the moneygrubbing "cult of the exhibition."[23]

During both of his Architectural Studies trips, Roerich spent several weeks outside the city of Smolensk, at the Talashkino estate of Princess Maria Tenisheva (see Illustration 11). So began a close friendship that lasted more than a decade.[24]

Tenisheva ranked high among Russia's cultural patrons. A dark-haired woman of Junoesque stature—Vrubel painted her in the guise of a Valkyrie, a look that fit her well—she possessed a beautiful singing voice and a collector's discerning eye. Idealistic and ambitious, she strove to surpass Savva Mamontov as a sponsor of the neo-Romantic *style Russe*. Whether or not she bested him, she outlasted him, thanks to his financial ruin in 1900, and gathered to herself many of the same artists and literati he had.

Not that she got along with them as well. The princess handled disagreements badly and dealt naïvely with artistic politics, as demonstrated by her interactions with Diaghilev and the World of Art. From 1898 to 1900, she had provided Diaghilev's journal with half its funding, partly to keep up with Mamontov, who saw to the other half, but even more in hopes of converting Diaghilev to her cause of creating a uniquely Russian culture, accessible to all citizens. Diaghilev saw in Tenisheva nothing more than a source of cash; as her husband warned her, "he finds you as interesting as last year's snow—he just wants your money."[25] Allegiance with the *miriskusniki* cost Tenisheva more than legal tender. It frayed her ties with elders like Repin and Stasov, and humiliation on a national scale came in late 1900, when the gazette *Buffoon* ran a vicious caricature featuring a woman-headed cow, her flank bearing the caption "Mother of Decadence." The cow's face is Tenisheva's, and sitting on a stool, milking as hard as he can, is Diaghilev. (At the time, Roerich was studying in Paris, but Stasov told him about the cartoon, cackling about how "wonderful" it was.[26]) Had Diaghilev proved more biddable, Tenisheva might have withstood such jibes, but he paid her insufficient respect. Besides, the World of Art's outlook was too Western to suit her taste. She withdrew her support and became an implacable enemy to Diaghilev.

In July 1903, with Roerich about to visit Talashkino for the first time, the princess anticipated that she and he would find each other good company and useful allies, and was anxious to make him feel welcome. "I wanted to receive Nikolai Konstantinovich," she later recounted, "in such a way that he would enjoy the place, come to love it, and return often."[27] She need not have worried. Roerich took delight in the estate's gorgeous vista—high on the oak-lined banks

of the Dnieper, overlooking green meadows as they undulated outward—and was fascinated by Talashkino's museums and workshops, which manufactured ceramics, embroideries, and other handicrafts. He regretted only the heavy rains, which kept him from painting as much as he would have liked.[28]

As Tenisheva guessed, she and Roerich had much in common. Passionate Russophiles, each viewed culture as an expression of the national spirit, with the power to raise social and moral consciousness. Both were easily frustrated and emotionally brittle utopians. Each detested Diaghilev. Tenisheva's memoirs go on at length about their bond: "I knew Roerich for a long time, and our relationship was unusually friendly. Of all the Russian artists I met in my life, he was the only one—with the exception of Vrubel—with whom one could converse: we understood each other with half a word. He was cultured, erudite, a true European, neither narrow-minded nor one-sided. He was well-bred and pleasant to deal with, and his company was indispensable. We were kindred spirits. . . . Whenever he left, all charm seemed to vanish from life, like dissipating smoke."[29] Much of Tenisheva's liking for Roerich stemmed from his skill at flattering her. "I had only to speak one word," she remembered, "and he would respond."[30] (To lovers of English literature, contemporary accounts of how the artist behaved around Tenisheva may call to mind the unctuous clergyman Mr. Collins from *Pride and Prejudice*, fawning over Lady Catherine de Bourgh.) That said, Roerich's affection for the princess appears to have been genuine.

Longer visits followed in 1904 and 1905, and again from 1908 to 1914. The second period went toward designing art for the Church of the Holy Spirit built by Tenisheva on the adjacent Flenovo estate. During the first, Roerich learned about folk art. Although Talashkino was not quite a Kelmscott on the grasslands, Tenisheva borrowed copiously from England's Arts and Crafts ideology. Folk and *kustar* (cottage industry) creations, she felt, were just as much "art" as the most refined sculptures and paintings. Like Morris and Ruskin, she wished to shield traditional artisanry from the threat of obsolescence in an age of mass production. Also like them, she feared that industrial modernization would leave the lower classes economically debased and spiritually hollowed out. With all the fervor of missionaries, she and her lifelong friend, Princess Yekaterina Sviatopolk-Chetvertinskaya, poured money and effort into popular education.

Roerich, long an admirer of Ruskin, fell readily into step with Tenisheva's thinking, and he himself experimented with the folk idiom. Tenisheva commissioned him to design furniture for her library and a frieze for the Talashkino theater, and he told her excitedly that "this will be the first time I have essayed the Arts and Crafts route."[31] When he returned in 1904, the furniture was built to his specification: a bookshelf, table, chair, and divan, all covered with interlocking

animal motifs. The northern-themed frieze, installed during his 1905 visit, consisted of three majolica panels, depicting a walrus hunt, a ceremonial dance, and a reindeer herd. Tenisheva loved these pieces and praised their creator as "my Bayan," an allusion to the great bard of Slavic myth.[32]

Roerich's views accorded so well with Tenisheva's that the critic Alexander Rostislavov dubbed him the "theoretician of Talashkino."[33] For years, the pair skirmished with Diaghilev and Benois. They wrote each other constantly. However, the dread-filled year of 1905 temporarily halted their happy summer visits: by the end of Roerich's third Talashkino sojourn, Russia was ablaze with riot and rebellion.

Tsar Nicholas blundered into the Russo-Japanese War, annexing in 1903 a swath of Manchurian territory that included the naval base of Port Arthur. Doing so violated earlier agreements, but he pressed on, motivated by xenophobic dislike of the Japanese and the assertion of Interior Minister Vyacheslav Plehve that "a small, victorious war" was just what the country needed, to distract from economic difficulties and internal discontent.

On February 8, 1904—January 26 in the old style—Japan stunned the Russians with a torpedo-boat assault on Port Arthur, a devastating blow from which Russia never recovered. Dominating the local waterways, Japan lost no time landing troops in Korea:

one force surrounded Port Arthur, the other moved northwest to prevent Alexei Kuropatkin's Manchurian Army from raising the siege. Outnumbered on the spot, the Russians realized to their dismay that they were facing not the racial inferiors they had expected, but an efficient military machine, and that their only supply line was the Trans-Siberian Railway, a slender thread stretching over thousands of miles and not yet fully tracked. At summer's end, Kuropatkin lost 20,000 killed and wounded in the battle of Liaoyang, followed by another 41,000 that autumn. In January 1905, the Russians in Port Arthur, after months of merciless bombardment, surrendered. Kuropatkin, hoping to retreat into the interior and overextend the Japanese while waiting for reinforcements, was ordered by Nicholas II to stand and fight for the sake of Russian honor.

Effects on the homefront were disastrous. The war had begun wth an outpouring of patriotic zeal, but setbacks soured the public's mood. Russia's economy was strained to the limit, and stepped-up conscription proved unpopular. Strikes and disturbances erupted throughout 1904. That summer, Plehve, the much-hated interior minister, was assassinated. Andrei Bely's dark novel *Petersburg*, set during the war, describes a Russia apoplectic with fear that "a yellow horde of Asiatics, stirring from their age-long retreats, [would] redden the fields of Europe with an ocean of blood."[34]

Defeats like Liaoyang and Port Arthur pained Roerich as they pained all Russians,

but his thoughts in 1904 were fixed more on his own affairs: the Architectural Studies, his time at Talashkino, and the October birth of his and Helena's second child, Sviatoslav. Nor did he refrain from artistic politicking, which connected him at the end of the year with the demise of the *World of Art*.[35] The journal owed its continued publication to an annual subsidy from Nicholas II, but the war drew those purse strings shut. In late 1904, Diaghilev turned to Tenisheva for support, despite the ugliness of their break in 1900. Playing the magnanimous but firm-handed grande dame, Tenisheva agreed to help, but on two conditions. First, the journal was to stop "eulogizing" Western art. Second, Benois was to be replaced on the editorial board by Roerich. Benois complained sarcastically to Serov about Tenisheva's plans to give his spot to "this most Russian of all artists," but would rather have swallowed broken glass than yield the least bit of ground to Roerich.[36]

Diaghilev seems to have contemplated making the switch, but did not do so. Some of this was loyalty to Benois, but he also saw that no amount of cash would rescue the World of Art. The circle's success had spawned a host of competitors, and many *miriskusniki* were hiving off to pursue other interests. Some were lured away by the new literary-artistic almanac *The Scales*. Others, like Dmitri Filosofov and Dmitri Merezhkovsky, with his wife, the poet Zinaida Gippius, preoccupied themselves with the mystically oriented Religious-Philosophical Society and its journal, *New Path*. Benois

was busy with scholarship and trips to Europe. Diaghilev published the *World of Art*'s final issue in December 1904 and staged the society's seventh and—for the time being—last show in 1906. In a broader sense, the association survived, held together by personal and professional ties, not to mention participation in Diaghilev's next venture, the Ballets Russes. Starting in 1910, it would enjoy a second life as an exhibition society. In 1904, however, its dissolution looked permanent enough: one of the many wounds inflicted by the war on Russia's cultural community.

Worse came in 1905, which opened with an explosion that reverberated for months and nearly toppled the Romanov dynasty. The fuse was lit on January 22 (January 9, OS), when 150,000 petitioners marched on Saint Petersburg's Winter Palace, hoping to move the tsar to end the war. Unbeknownst to them, their ruler was in the suburb of Tsarskoe Selo, and the only authority awaiting them was a contingent of Cossacks and police troops. Without provocation, the police fired into the hymn-chanting, icon-carrying crowd, wounding 3,000 and killing over 500. This "Bloody Sunday" fiasco catalyzed an interminable wave of strikes, mutinies, and peasant revolts, collectively termed the 1905 Revolution.

A deadly synergy crippled the regime. Every military misstep, like the fall of Port Arthur or Kuropatkin's shattering February loss at Mukden, brought new domestic disturbances. Each of these weakened Russia's ability to fight, causing more failures. Finally, on May 28, in the straits of Tsushima,

Japan scored a naval triumph to rank with Salamis and Trafalgar by destroying Russia's Baltic Fleet, which had steamed halfway around the world to meet with utter ignominy. Combat ceased soon after, and peace talks, brokered by Theodore Roosevelt, began in New Hampshire. The diplomatic defeat proved less crushing than the military one, due to shrewd bargaining on the part of the former finance minister Sergei Witte, an opponent of the tsar's earlier recklessness in Manchuria. Witte signed the Treaty of Portsmouth for Russia in September.

But the revolution was no longer about the war. It was now about unfair working conditions, rural impoverishment, discrimination against ethnic minorities, and general dissatisfaction with the regime. By May, the Union of Unions, led by the liberal historian Pavel Miliukov, was organizing opposition to the government; in the fall, it was joined by radical soviets, or workers' councils, in cities like Moscow and Saint Petersburg, where a young Leon Trotsky rose to prominence as an agitator. In the countryside, peasants burned and looted their landlords' estates, and even the armed forces could not be counted on. The best known of 1905's military risings occurred in June, as the crew of the battleship *Potemkin* led an abortive takeover of the port of Odessa, then escaped by sailing to Romania.

Artistic reactions to 1905 varied. Some of Roerich's peers turned leftward. Yevgeny Lanseré and Ivan Bilibin illustrated satirical journals, and Dobuzhinsky circulated a manifesto calling on artists to "educate the masses in a spirit of beauty." Serov painted a scene of police cavalry riding down an unarmed crowd and mockingly titled it *Soldiers, Soldiers, Every One a Hero*. The poet Konstantin Balmont joined the Bolshevik Party and damned Nicholas II as a "bloody hangman."[37] As they would in 1917, Andrei Bely and Alexander Blok attached near-supernatural significance to the year's events, and Valery Briusov saw in 1905 "the face of Medusa," an "interlacing of snakes [and] black chaos . . . draw[ing] us as to ruin."[38] Many simply departed. Among these was Princess Tenisheva, who, fearing peasant violence around Smolensk, relocated to Paris until 1908.

If Roerich belonged to a camp in 1905, it was one of conflicted moderation.[39] No longer youthfully enamored of Nicholas II, he disapproved of tsardom's inefficiencies and abuses. Like many in his circle, he felt reformist sympathy for the lower orders. On the other hand, his career interests were best served by the smooth functioning of society, to say nothing of aristocratic and royal patronage. Also, his personal fastidiousness extended to the public sphere: he deplored disorder of any kind, violence most of all. Bloody Sunday threw him into a state of vacillation. In letters to Tenisheva, he described the demonstrators filing past his home that morning, on their way to the Winter Palace. An hour later, he looked on in horror as "the same crowd ran back, chaotic, howling, throwing their arms in the air. Lancers with sabers were trampling them down." Then, in a passage key to

understanding his politics, he told the princess that, "had the mob started beating up a lancer, I would have been tempted to shoot at them in defense of the weaker party. But now, as the horses jumped and trampled defenseless people, deep in my heart I wanted the opposite."[40]

Roerich continued in a similar vein for weeks, relating to Tenisheva and others the sight of teeming protestors, soldiers and police patrolling the public squares, and the barricades, festooned with red flags that sprang up like mushrooms in the rain. Policies and party platforms mattered less to him than the frightful prospect of lawlessness and fratricide. At first, Roerich blamed both sides for Russia's plight. Which was preferable, he asked: the whip of the Cossack or the crude tyranny of mob rule? "Misfortune," he cried, "great misfortune! These days, terror surrounds you from both sides, and one is afraid to leave one's own home!"[41]

In time, Roerich inched toward the sheltering power of the state. While the upsurge of long-oppressed masses exhilarated many of his colleagues, such uncontrolled fury unnerved him. He acknowledged that the downtrodden had legitimate grievances, but viewed with trepidation the radicals and demagogues leading them, distinguishing between unscrupulous "revolutionaries" and the more relatable "working-class movement."[42] One would have searched for him in vain at rallies or on the street.

Roerich sounded warnings about the need to protect art in this time of danger,

twice in *The Scales* and in several public lectures.[43] He finished a number of paintings that year, including an antiwar allegory, *The Patrol*, in which mail-clad troops return from a failed reconnoiter, and two exceptional pieces: *Slavs on the Dnieper* and *Treasure of the Angels*. As much as possible, he distanced himself and his family from the "twin terrors"—state repression and popular rampages—tormenting the capital. He spent part of the spring in Prague, and the family returned to Beryozka for the summer, with side trips to Vyazma and Valdai. At Talashkino, Roerich helped Tenisheva prepare for her move to Paris, while archaeology took him to Voronezh with his brother Boris, and to Lake Piros with Mikhail Putiatin.[44] He prayed for the tempest to blow over, and for Russia to pass through it intact.

It very nearly did not. In October, a two-million-strong work stoppage brought the nation to a standstill and compelled Nicholas II to choose between making concessions or losing his throne. Sergei Witte, just back from the Portsmouth peace talks, countered with the October Manifesto, a pivotal document that abolished censorship, legalized political parties, and established a parliamentary body, the Duma, to share power with the tsar. It did not end the tumult right away, but was generous enough to split centrist and liberal elements of the opposition away from the more rebellious radicals. Violence continued through November and December into early 1906, but with so much of its force leached away, the

revolution flickered out, and Nicholas II kept his crown.

Roerich took several lasting lessons from 1905.[45] First, he believed the revolution had resulted more from moral and cultural flaws than governmental ones. This view aligned him partly with the "god-seeking" tendency among Russian thinkers, which held that no social or political program could succeed unless grounded in religious values. ("God-seeking" drew from the left as well as the right, attracting liberals, lapsed Marxists, and nonconformist Christians.) Second, Roerich persuaded himself that salvation lay in the communitarian wisdom of the past. Finally, and distinguishing his brand of communalism from radical and socialist ones, he concluded that political change could not be entrusted to the hoi polloi, even if the changes were for their sake. The terrifying spectacle of desperation-crazed mobs convinced him that societal transformation had to be steered from above. Given culture's central importance to public life, it followed that artists should guide the hand of government. Later, he came to believe that they should take the reins themselves. Here, he would reprise the Wagnerian "princes of art" theme, adding notes from Plato's rhetoric of the philosopher-king, with himself in the title role.

In October 1905, the avant-garde author Alexei Remizov (see Illustration 11) visited the offices of Georgii Chulkov, poet and editor of the journal *Questions of Life*. Roerich was paying a call as well, and Chulkov introduced the two. That evening, Remizov recorded his impression of the encounter: "A new acquaintance in N. K. Roerich. He knows everything about Russian history. Two hundred thousand years gaze out through his stony eyes."[46]

Many perceived Roerich as socially withdrawn, even awkward, but he possessed a sort of charisma that functions well in quiet settings and among small groups. Remizov was not the only one to find him captivating, and, over certain personality types, he exerted a pull nothing short of magnetic. The British Buddhist and jurist Christmas Humphreys—a member of the Allied prosecutorial team at the 1946 Tokyo Trials, and by no means a flighty individual—later spoke of Roerich's "immense power to enfold one's mind in his."[47] Also, those who knew him well described his ready wit, an attribute not obvious to casual observers (or from his photographs, where he never smiles).

Based on negative comments about him from the best-known *miriskusniki*, Western scholars have tended to underestimate Roerich's standing among the Silver Age intelligentsia. But while he faced the difficult balancing act of remaining loyal to Tenisheva without alienating Diaghilev, the truce between the SRKh and the *miriskusniki* allowed him to maneuver freely among different cliques and coalitions. He led the Tenisheva coterie, both at Talashkino and in Petersburg. On Wednesday evenings, he

attended the "Tower" salon hosted by the Symbolists Vyacheslav Ivanov and Lydia Zinovieva-Annibal in their Zubovsky Boulevard apartments, and he often went to gatherings of Merezhkovsky's Religious-Philosophical Society. Archaeology and preservationist efforts forged additional ties, not only among the scholars mentioned thus far but with antiquarians like Nikolai Wrangel and the Grand Princess Maria Pavlovna. Certain papers, such as the *New Times* and *Niva*—whose editor, Arkady Rumanov, became a good friend—could be counted on for positive coverage. So could *The Scales*, *Golden Fleece*, Nikolai Tarovaty's short-lived *Art*, Wrangel's and Stepan Yaremich's *Bygone Years*, and, before long, Sergei Makovsky's *Apollo*.

All of the above published Roerich's reviews and essays, even his fiction. His articles, bearing hard-hitting titles like "Quiet Pogroms" and "Golgotha of Art," sermonized about artistic integrity and railed against the philistinism of collectors and curators. "We have become impoverished," he mourned in one of these jeremiads. "We cannot expect to find the beauty of past eras in the rush of the metropolis, or in poor museums and commercialized art. . . . Dead, dead is the great god Pan!"[48] Poems and stories like "Leader," a 1904 verse about Genghis Khan; "Devassari Abuntu," a tale of enlightenment set in India; and "Italian Legend," which explains fireflies as the disembodied souls of repentant sinners, given tiny lights by a merciful Saint Peter, reflect growing interests in Asia and spiritual growth.[49]

Roerich mixed more with Russia's Symbolist writers than is typically acknowledged, and with Symbolist painters as well, as members of the Moscow-based Blue Rose group migrated to the World of Art when it re-formed in 1910. Like most Symbolists, Roerich followed the philosopher Solovyov in thinking of art as "theurgy," as a divine rite capable—literally or metaphorically, depending on one's commitment to the idea—of transforming terrestrial reality.[50] Based on visual comparison, Sergei Makovsky believed that, in his friend's work, there was more of the Blue Rose's "prayer-like" purity than the Diaghilev group's "boudoir elegance."[51] But Roerich never joined an exclusively Symbolist group, nor did he apply the label to himself.

New friendships worth noting include the ones begun with Tenisheva, Makovsky, and Remizov. Ivan Bilibin, beloved for his illustrations of Russian fairy tales, became a valued companion. Also entering his life was the spruce and affable Igor Grabar, a World of Art painter and, with help from Benois, editor of the multivolume *History of Russian Art*, published between 1910 and 1915. In his 1937 autobiography, Grabar, then living and working under Soviet rule, distanced himself from Roerich, whom the Stalinist authorities suspected of being a spy. In reality, the two enjoyed a cheerful friendship before 1917, addressing each other with the familiar "thou" (*ty*) and cooperating on SRKh and World of Art projects. Grabar invited Roerich onto the *History of Russian Art* board, often smoothing things over between him

and Benois when they threatened to get out of hand.[52]

Roerich had an excellent entrée into Russia's music world in the person of Stepan Mitusov, Helena's cousin, and it was thanks to Mitusov that, in 1904, he first encountered Igor Stravinsky (see Illustration 11). Six years later, Roerich and Stravinsky would join forces to create one of the most innovative artworks in modern history, but there was no hint of this in their introduction. "I met him," Stravinsky recalls, "a blond-bearded, Kalmuck-eyed, pug-nosed man, in 1904. His wife was a relative of Mitusov's, my friend and co-librettist of *The Nightingale*, and I often saw them at Mitusov's Saint Petersburg house. I became quite fond of him in those early years, though not of his painting."[53] Stravinsky's last comment is disingenuous. By the time he voiced it, controversy had emerged over who deserved credit for the concept behind *The Rite of Spring*, and the composer's airy dismissal of Roerich's art, which jars even with his own version of their collaboration, is a way of staking his claim to ownership. The two men had a long way to go before such friction troubled them, and they liked each other well enough in the meantime. Roerich was on cordial terms with Rimsky-Korsakov, whose family befriended him for years, and also with Rimsky-Korsakov's student, the reclusive Alexander Lyadov. He never failed to speak highly of Scriabin, and may have known him personally, though it seems likelier that he did not.[54]

Two partings brought sorrow to Roerich. In 1905, he had his final meeting with Mikhail Vrubel, whom he idolized. Roerich knew the painter only a short while, visiting him in Moscow in 1904 and growing closer to him that fall, when Vrubel relocated to Petersburg. But this was not long before Vrubel's tragic mental decline, and the last moment Roerich passed in the artist's company was at an evening party he and Helena hosted. Vrubel arrived late, interrupting the after-dinner conversation, and sat down without a word. Suddenly,

> Vrubel pricked up his ears. We asked him what the matter was. He whispered, "He is singing."
>
> We asked, "Who is singing?"
>
> "He is singing so wonderfully."
>
> We grew alarmed, for there was complete silence. "Mikhail Alexandrovich, who do you hear singing?"
>
> Vrubel's eyes glazed over. "Yes, of course. It is the demon singing." He waved his hand, as if to ask us not to bother him.
>
> We fell quiet. Helena Ivanovna, who felt a great affection for Vrubel, gave me a worried look, and there was a pregnant pause. Finally, Vrubel let out an especially deep sigh. His watchfulness melted away. Then he rose quickly from the table and quite prosaically took his leave, apologizing for the late hour.[55]

Vrubel lived till 1910, but Roerich never saw him again. Less eerie, but also affecting, was Stasov's death in 1906. Although communications between the two had all but

ceased, their recent disagreements did not blind Roerich to the intellectual and professional debts he owed his onetime mentor. Past anger made the loss no easier to bear.

Ever since the 1900 Paris Exposition, where he had earned mockery from his foes for failing to win prizes, Roerich had felt jaundiced about exhibitions; the St. Louis debacle of 1905 did nothing to improve his attitude. He accepted shows and auctions as the means by which artists sold their work and defined their standing, but viewed them as a necessary evil. In "The Exhibition," from 1904, he complained that too many who attended art shows did so for amusement, as if they were going to a circus, or to socialize and flirt. It angered him to subject art to the ignorant attentions of any light-minded gawker who could afford the ticket price of thirty kopecks—a reference not to actual admission costs, but to Judas Iscariot's pieces of silver.[56] Buying and selling gave exhibitions the character of a bazaar, and competing for prestige brought out the worst in the artists themselves.

Still, one had no choice unless one sought obscurity. As described above, Roerich showed in the second SRKh and seventh World of Art exhibitions in 1905 and early 1906, but most of his efforts went toward a grand venture that spotlighted his art for months, taking it from Prague to Paris. In the fall of 1904, the Mánes Society, an influential art association in Prague, invited

Roerich to put on a one-artist show.[57] He agreed, then arranged for the collection to travel west, reaching the French capital in time for sixteen of his pieces to be included in the Russian section of the 1906 Salon d'Autômne.

The Mánes exhibition opened in the spring of 1905 and was enthusiastically reviewed by *Modern Revue* as "A Dream of the Past." The philosopher Tómaš Masaryk, the future founder-president of modern Czechoslovakia, came to greet Roerich, and Masaryk's family remained well disposed toward him through the 1930s. From Prague, the show moved on to Vienna, Venice, Munich, Berlin, Düsseldorf, the Milan Exhibition of 1906, and Paris. Rome's National Museum purchased some of Roerich's paintings, and the Milan Exhibition awarded him a special diploma.

At the Paris Salon, Roerich was no longer a solo act; two dozen artists had been tapped to represent Russia at the event. Power of selection belonged to Diaghilev, in consultation with Benois and Bakst. Most of the *miriskusniki* were present, as were a few of the Blue Rose Symbolists and, in a nod to the future, the avant-gardist Mikhail Larionov. From the Wanderers' generation, Diaghilev included only Repin and others of too great a stature to ignore. Vrubel made the cut, though Vasnetsov and Nesterov did not.[58]

Roerich was pleased to have been picked, but unhappy with the exhibit's outcome. He disagreed with Diaghilev about which of his paintings should be displayed.

"Why did he not exhibit my best work, as I requested?" he asked Grabar. "When I suggested newer and better pieces, why did he ignore them?"[59] Just as irksome was Diaghilev's decision to have Benois edit the exhibition catalog; the last word on who and what mattered in Paris would go to the person Roerich least wanted to have it. Also, Roerich found himself caught up in the contest for trendsetting preeminence still playing out between Diaghilev and Princess Tenisheva. Success at the 1906 Salon would add to Diaghilev's stature, and while Tenisheva could not supplant him as a Salon organizer, she would try to outdo him in the arena of public opinion.

Roerich stood with Tenisheva. For months, he assembled a cohort of *nashi*, or "our people," whose loyalty could be relied on. Among these were Makovsky, Grabar, and the architect Alexei Shchusev; painters included Viktor Zamirailo, Dmitri Stelletsky, and Ivan Bilibin, the last two having graduated from the Tenisheva Studio in Saint Petersburg.[60] Roerich himself could not be in Paris that fall, due to new obligations with the Society for the Encouragement of the Arts. For intelligence, he depended on Tenisheva, Makovsky, and other allies, like the reporter Alexander Kosorotov and Prince Sergei Shcherbatov.

As a whole, the Russian exhibition, housed in the Petit Palais, met with approval, from both European and Russian correspondents.[61] Roerich's paintings earned special notice from French reviewers as well as from friendly parties like Makovsky and Kosorotov, and the Louvre and Luxembourg Museum each made purchases. Shcherbatov told Roerich that his canvases, "displayed very nicely against a pleasant, dark-green background," were attracting favorable attention. He regretted only that none of Roerich's recent work was on view.[62]

Behind the scenes, spite reigned, much of it stirred up by Tenisheva. In October, she complained that Benois's catalog radiated malice and contained many errors. She worried about her ability to sway journalistic opinion toward "her" artists, and it seems that, if persuasion did not suffice, she was not above providing financial incentive: "As far as the reviews are concerned, Clement Jeannin has told me that there is little use in trying to influence the minor papers, such as the one he writes for. There are three or four critics whose opinions truly matter. Diaghilev, Benois, and Bakst know this all too well, and they, of course, have these critics under their thumb. I attempted to find out whether it might be possible to pay them. But here my efforts foundered, as if I had run up against an underwater mine."[63] She wrote again, her mood even more oppressed: "Diaghilev is moving in the best circles here. He has been received with honor at the embassy. Everywhere, he and his satellites, Bakst and Benois, are promoting themselves. Yes, Diaghilev and Co. have gathered a terrible strength, and I do not know how to fight them."[64] In November, better news offset some of Tenisheva's gloom. Kosorotov savaged Benois in the *New Gazette*, prompting an angry Bakst to tell his wife Lyubov that

the reporter had dumped "buckets of filth on [Benois's] head. Roerich, S. Makovsky, and Kosorotov have united for the purpose of slandering [Benois], Diaghilev, and me. These scoundrels operate subtly, and they shrink from nothing."[65] Just as cheering was a review by Roger Marx in the *Gazette des Beaux-Arts*. Marx disapproved of Somov, Bakst, and Benois, who seemed to have done nothing but imitate the kind of work Europeans had mastered years ago. What he wanted from Russians was art that captured *Russia's* essence, and he extolled those he thought had succeeded, notably Korovin and Roerich. Marx urged Tenisheva to stage her own exhibition in Paris, featuring artists who exemplified Russia's national spirit. Buoyed by the meeting, she took Marx's suggestion to heart and followed up on it in 1907, setting the stage for yet another Tenisheva–Diaghilev struggle.

From Saint Petersburg, Roerich looked with mixed feelings at what happened in Paris. He sold paintings to prestigious museums, and the press dealt with him kindly. But Europe had not seen his newest work, and the permanent record of the Salon—Benois's catalog—misrepresented him. Most galling was an error in the text describing Roerich and Nesterov as "principal followers" of Vasnetsov. This was false in Nesterov's case and did no justice to Roerich, who rated Vasnetsov highly, but did not model himself on him as Benois implied. In a *Golden Fleece* article the following spring, Makovsky criticized Benois, wondering whether his inaccuracy was a

product of "shortsightedness or malicious flippancy." But Makovsky could not unwrite what Benois had written, and the mistake stood.[66]

The backbiting wore on Roerich's nerves. He was not blameless when it came to the cut and thrust of artistic blood feuds, but as self-righteous as his idealism could be, it was rarely insincere, and his frustration in this letter to Grabar was genuine: "I have always maintained that it would serve us best to work together and not let internal dissension weaken our little group. But Benois is always ready to do me harm, and Diaghilev does not always conduct himself forthrightly with me. Even so, it does not follow that we must quarrel so. It would be to our mutual benefit to cooperate. It is easier to achieve a goal if we strive toward it together."[67] All the more unfortunate, then, that the same battles continued in 1907.

In fact, Roerich had little time that autumn to vex himself about cross-continental connivance. He was busy with a new post at the Society for the Encouragement of the Arts, having vaulted upward from the IOPKh secretaryship. The old job had given him many duties but little authority, and had left him vulnerable before the society's disputatious board of directors, on which sat several of Roerich's enemies. A photo from this time gives a good impression of Roerich's IOPKh workload: wearing his customary three-piece suit, he sits at a desk that seems

to groan with the weight of stacks of documents and files. Roerich favored the catchphrase "work is the best holiday," and never lost his ability to pursue multiple tasks simultaneously. But even he felt ground down by the paper-pushing humdrum.

Then, in the spring of 1906, the directorship of the society's art school came open. The IOPKh School, one of Russia's largest institutions of artistic education, prided itself on its accessibility to students of both sexes and from all walks of life, but its quality had recently slipped, due to the lethargy of the outgoing director, Yevgeny Sabaneyev. Roerich saw a chance to better his circumstances and mold a rising generation of artists, so he applied for the post. Straightaway, he met resistance from conservative foes. Count Ilya Tolstoy, the society's vice president, disliked him, and others thought him too inexperienced and too likely to encourage newfangled thinking. Worst of all was Mikhail Botkin, curator of the IOPKh Museum, with whom Roerich had innumerable unfriendly exchanges. Once, running into Roerich as he left an exhibition of new paintings, Botkin, fuming with rage, shouted at his younger colleague,

"It should all be burned!"

Roerich asked, "You don't really mean all of it, do you?"

"All of it," Botkin replied.

"Even Serov's works?"

"Yes, even Serov's!"

"And Vrubel's?"

"And Vrubel's!"

"Benois's?"

"And Benois's!"

"Even mine?"

"Yes, yours! Yours must be burned as well!"[68]

With this last word, Botkin stalked off, leaving a bemused Roerich on the steps of the gallery.

Others found Botkin difficult as well. He was denounced by Grabar as "a traitor, a turncoat, and an intriguer," and he once provoked Nikolai Wrangel to violence.[69] In 1908, Wrangel arranged a charity auction at the IOPKh, but with the crowd waiting for the doors to open, Botkin canceled the event at the last minute, announcing untruthfully that a fire hazard had been discovered. Such pettiness was too much for Wrangel, who punched the smirking Botkin in the face. The curator pressed charges, and Wrangel spent part of 1909 in prison.

Botkin never landed Roerich in jail, but he caused the painter enough misery. In 1906, he led the clique that opposed Roerich's candidacy, taking the case as far as the Ministry of the Interior. Roerich, however, had his own allies at the IOPKh, among them the Grand Duchess Yevgenia Maximilianovna, Princess of Oldenburg, who preferred a young, energetic candidate who could clear away the cobwebs left by Sabaneyev. Thanks to her lobbying, the directorship went to Roerich. He assumed his new duties at the start of the 1906–1907 academic year, after a summer trip to Europe.

This position established Roerich as an

important functionary in Russia's art world, bringing him into regular contact with the most elevated levels of Petersburg society. His salary increased, and he was entitled to quarters on the Moika Embankment, adjoining the IOPKh building. For the first time in their married life, Nicholas and Helena had their own home, and even a small staff of servants. The IOPKh remained the Roerichs' primary residence until the end of 1916. Material benefits aside, the new position allowed Roerich to put theory into practice on a new scale. As the grand duchess had expected, he brought a reforming spirit to the school, modernizing its curriculum and applying the Ruskinite ideals he shared with Princess Tenisheva. He hired new faculty, responded as much as possible to student desires, and raised the number of scholarships for underprivileged pupils. Results were not long in coming. The school's reputation rebounded, and Roerich basked for years in the resulting acclaim.

On the other hand, opponents like Botkin did not go away, and though the rewards for Roerich's toil had grown sweeter, the toil itself was harder. Roerich enjoyed anything connected with teaching, but had less patience for committee work, particularly because so much of it involved selling ideas to less than receptive colleagues and superiors. With his faculty, he became adept at canvasing opinions and securing one-to-one support before key votes.[70] Meetings of the board, always more contentious, gave him greater aggravation. Throughout the day, Roerich bottled up workplace stress,

maintaining a poker-faced calm. Only after hours did he unburden himself, detailing every slight and insult to Helena, often till well after midnight. Without Helena, Roerich could not have coped for long at the IOPKh. Not only did she provide a sympathetic ear, she advised Nicholas on how to deal with his colleagues, and she firmed his resolve during his spells of despondency. Helena said of her spouse that he was "always wise," but sometimes "indecisive, even weak," and that it fell to her to "embolden" him.[71]

Such spine-stiffening efforts bring to mind the crucial but underappreciated role Helena played in Roerich's life and career. Helena was no simple helpmate, but a full partner, if not the driving force, in everything her husband did. Like Beatrice to his Dante, she guided his spiritual steps; it was she who impelled Nicholas to delve so deeply into the occult, and she, not he, gave Agni Yogist dogma its full shape. She influenced how and what Roerich painted; by 1920, when the family reached America, she was dictating subject, color, and composition to him.[72] Her dreams and visions were the lodestone directing the couple's every action, and the family's most outsized ambitions originated with her.

The Roerichs' marriage lasted almost half a century, and was as affection-filled as it was long. Observing them in a private moment—holding hands during a stroll on Maine's Monhegan Island—Sina Lichtmann averred that "between husband and wife I have never seen such a wonderful and

harmonious love."[73] To be sure, quirks and tensions emerged, as in any relationship. Helena still suffered the dizzy spells and headaches that had been her lot since childhood, and that she now believed were caused by psychic sensitivity. As a consequence, she demanded a great deal of solitude, and Roerich made sure she had an hour or two to herself every morning as time for meditation.[74] When Nicholas's travels kept them apart, Helena grew hysterically angry if more than one or two days went by without a letter from him. During one of his visits to Germany, she scolded him so stingingly for postal delinquency that he begged her in his next letter "not to curse me so—your words made my cheeks burn!"[75] (He depended just as much on Helena's letters, though his response when he failed to hear from her was to feel sorry for himself. "I have sent you fourteen letters in the last two weeks," he wrote from a dig near Novgorod, "but have received only one from you!"[76])

Other concerns intruded. Helena's family took time to warm to Nicholas. The couple sometimes disagreed on how to handle their sons, who, as they grew older, did not always obey as their parents would have liked. Nicholas, remembering his own father's coldness, appears to have been more indulgent. Most important, Helena, to an extent only recently acknowledged, felt herself to be living in her husband's shadow, and more than once resented it. She rejoiced at his fame, but feared that it might engulf her own sense of identity. The constant focus on his triumphs and trials, the endless cycle of accolades and acrimony, caused her to exclaim, "My God, is it going to go on like this till the end of my life, spinning faster and faster, this life in a golden cage?"[77]

And this was under normal circumstances. There were times when Helena, apart from not wishing to play lesser light to her spouse, felt that the men in her life treated her unfairly or without respect. Although the boys adored their mother, they tended, as teenagers and adults, to side with Nicholas during family spats. While Nicholas had his own writing desk, and the sons shared another between them, Helena made do with an armchair. Household chores fell exclusively to her as "women's work." Later, to female followers, Helena related a number of the indignities she thought her husband and sons had inflicted on her.[78] Some were trifling, others serious, but one stands out as truly wounding: during a discussion about music, Roerich took the pedantic position that performance, as distinct from composition, could not be considered art, because it consisted merely of interpreting someone else's creative work. Helena, who regarded herself as artistic enough when she sat down to the piano, protested, but Nicholas refused to yield the point, and the argument deflated her so badly that she rarely played again.[79] Helena had many reasons for leading Nicholas and her sons into the domain of esoteric mysteries, but not least was that it allowed her to assert herself in the face of such rebuffs. According to Helena's confidante Sina Lichtmann, mastering Vedantist and Theosophical wisdom "opened up a new

world for her"; rather than be lost in Nicholas's sphere, Helena drew him behind the veil, because, "there, she was his teacher."[80]

Such quarrels stand out because they occurred so rarely. Whatever spiritual plane they aspired to, the Roerichs had a flesh-and-blood marriage, subject to flesh-and-blood imperfections. By that standard, their partnership was happy and successful. Their letters are sprinkled with endearments like "may bug" and "little mouse." They took pleasure in their children. Yuri, born in 1902, was an active, talkative toddler, fond of roughhousing with his Uncle Borya and fascinated with toy soldiers. Sviatoslav—Svetik, or "little light," as a boy—was still a baby, having just been born in October 1904. Helena's second pregnancy was easier than her first, mainly because she dispensed with the restrictions she had imposed on herself while expecting Yuri. Then, Helena had drunk five bottles of milk a day and eaten only lettuce and vegetable soup. Pregnant with Svetik, she ate anything she wanted.[81]

As Yuri and Svetik grew, family life went on normally. Until 1906, the four Roerichs resided with Nicholas's mother and frequently saw his brother Boris. Nicholas's other brother, Vladimir, was not often in the city, and though his sister Lydia remained in Petersburg, she married a physician, Ivan Ozerov, and had children of her own to care for. Every year, the family summered outside the capital, taking their leisure like characters in a Chekhov play. Nicholas's mother rented a cottage in the Pavlovsk suburbs, but he, Helena, and the boys typically spent less

time with her than with Helena's family at Bologoe or Beryozka. Roerich himself had little patience for idling in the country and wandered afield on his own, either to paint or to do archaeological fieldwork with Boris and his cousins-in-law.

A break in the Roerichs' summer routine came in 1906, when the family decided on a more unusual vacation: a grand tour of Western Europe. Nicholas had not been abroad for any extended period since his post-academy training in Paris, so partly to celebrate his IOPKh promotion, and partly to familiarize himself further with European art, he took Helena and the boys westward at the end of the school year. From Petersburg, the Roerichs went through Finland to Sweden. Sailing from Stockholm to Germany, they toured Berlin, then continued to Paris.

The family spent comparatively little time in France. Roerich conferred with Tenisheva, hatching plans for the upcoming Salon d'Autômne. Accompanied by Helena, he walked the halls of his favorite museums, reacquainting himself with the works of Gauguin and Puvis de Chavannes, and paying closer attention to the color-saturated miracles wrought by van Gogh. But he was more interested in new sights. Recently captivated by the Symbolist dramas of Maurice Maeterlinck, he ventured to Belgium, the playwright's homeland. Wandering the mazy streets of Bruges, he paused to sketch

the city's Gothic towers and cathedrals.

The next stop was Switzerland, where Roerich examined paintings by the Swiss Symbolist Ferdinand Hodler, whom he knew personally. Helena and the boys settled for the summer in Geneva, while Roerich, in June and July, toured Italy. His circuit included Milan, Pavia, Genoa, Pisa, Siena, slender-towered San Gimignano, Rome, Assisi, Florence, Verona, Padua, and Venice; in Milan and Venice, he monitored the progress of his Prague to Paris exhibition. He toured Ravenna and the Adriatic republic of San Marino, then went south to Naples, crossing also to Sicily. After surveying the remains of Sicily's Greek colonies and paying respects to Archimedes's birthplace in Syracuse, he sailed east to the island of Corfu.[82]

Roerich visited the Sistine Chapel, studied frescoes by Correggio and Mantegna, and saw all the Titians and Leonardos one would expect, but he traveled through Italy less to see Renaissance masterpieces than to search for vestiges of the medieval era. Like England's Pre-Raphaelites, whose logic he had absorbed via Tenisheva and Ruskin, Roerich viewed late Renaissance painting as artificial and overly reliant on technical gimmickry. What he sought was spiritually sincere art and the purity of an older way of life: peasants working in sun-kissed fields, barely remembered churches half in ruins, and dusty footpaths that left modern sights and sounds far behind. He found what he was looking for in Ravenna's Byzantine icons, in Assisi, where he felt the serene benevolence of Saint Francis, and in Siena, with its ornate cathedral and red-bricked plaza. As he wrote Helena, "If only you could experience these places' primitive qualities! They are so beautiful. And this primitivism holds the key to so much."[83] Hints of what he meant can be seen in two simple but evocative scenes he produced by memory in 1907: *San Gimignano* and *City on a Hill*, the second of which became a cherished possession of Alexander Blok's.

At several points, Nicholas tried to persuade Helena to bring the boys and join him in Italy.[84] The prospect of shepherding two lively toddlers through the midsummer heat did not appeal to her, so he completed his itinerary solo. After touring chapels and museums, meeting with masons and craftsmen, and sampling the local cuisine—he spoke more than once about aromatic local wines and wonderful seafood—he rejoined Helena and the boys in Geneva. They spent the rest of the summer in the Swiss Alps, returning to Russia in time for Nicholas to prepare for his new responsibilities at the IOPKh.

This second European trip was not as formative or eventful as Roerich's first, but it marked him in several ways. The beauty of the Apennines and the Alps interested him for the first time in painting mountains, whose terrain posed fascinating problems of geometry, light, and texture, and whose majesty invested them with symbolic meanings that intrigued him as a mystic and an amateur mythographer. (When he tried his own hand at mountain

scenes, he reexamined Kuinji's work, but another influence may have been Hodler, whose landscapes strikingly resemble Roerich's.[85]) Being in the West also universalized Roerich's ethnographic and spiritual thinking. Pondering visual similarities between the lions of Saint Mark in Venetian heraldry and those engraved on the coins of old Novgorod, Roerich speculated about Italy's place in the larger arc of trade and interchange that had joined Europe and Asia since the days of Marco Polo.[86] Always eager to find evidence of connectedness between cultures, he placed greater emphasis on Greco-Roman, Germanic, and Catholic traditions as parts of the Eurasian whole.

Moreover, the journey sparked a small revolution in Roerich's technique. Before 1906, he had worked mainly in oil, occasionally with watercolor and pastel. He now turned to tempera, the egg-based pigment used by medieval and early Renaissance painters, and especially favored by icon painters in the Orthodox world. The change was partly practical. Roerich had seen too many oil canvases, even recent ones like Kuinji's, dry up and crack, and he observed in Italy the ravages wreaked by longer passages of time. Tempera holds color better and is less prone to cracking, and Roerich, with the long-term fate of his own work in mind, decided that, if "paintings are destined to change, better to let them fade into dreams than decay into blackened boot leather."[87] Philosophy also mattered. Many neo-Romantics considered that the fifteenth-century rise of oil painting, by enabling the more skillful reproduction of *exterior* reality, had distracted art from its original purpose, which was to convey *inner* vision, beginning the corruptive transformation of art from a craft into a modern profession.[88] To reject oils for tempera, then, was to reject the crass materialism of the present day. Roerich did not abandon oils completely, but tempera now predominated. He ordered his paints from a Munich firm recommended to him by Serov. When World War I cut off that source, he learned to make his own tempera, just as medieval artisans had done.

Another benefit of using tempera, Roerich believed, was a metaphysical, even sacred, unearthliness that proved crucial to the painting he did in 1905 and afterward. Caught up in the Silver Age revival of interest in old icons and church art, Roerich came out with religious pieces in greater quantity. With the mosaicist Vladimir Frolov and architects like Vladimir Pokrovsky and Alexei Shchusev, Roerich produced over thirty artworks and iconostasis panels for seven places of worship between 1906 and 1914, including Tenisheva's Church of the Holy Spirit at Talashkino. He worked at Ternopol's Pochaevsky Monastery; a convent in Perm; a chapel in Pskov; a church in the village of Morozovka, near Shlisselburg; the Cathedral of Saint Theodore in Tsarskoe Selo, with Mikhail Nesterov; and the Church of the Veil of the

Mother of God, in the Ukrainian township of Parkhomovka. During this last project, in 1906, conversations with the Indologist Vladimir Golubev led Roerich to submit a distinctly noncanonical design, *The Queen of Heaven above the River of Life*. This broke from standard iconography and alarmed the Parkhomovka churchmen by giving the Virgin Mary the look of an Asian goddess. They accepted Roerich's other designs, but *Queen of Heaven* remained on the shelf until 1910–1914, when Roerich and Tenisheva used it at Talashkino.

More examples of this eclecticism appeared. *Powers Not of This Earth* (1906), inspired by Roerich's journey to Bruges, nodded to Catholicism with its depiction of medieval nuns; it also paid tribute to Belgium's Maurice Maeterlinck, a translation of whose plays Roerich had illustrated the year before.[89] More permeable yet were the denominational boundaries of *Treasure of the Angels*, a key work from 1905 (see Illustration 8). Ostensibly Slavonic and biblical, this massive canvas, twelve feet by ten and a half, alludes to many bodies of myth. Below the turrets of an ivory-walled kremlin, rows of angels guard a black stone. This rock, inscribed with mysterious signs and a blue-green cross, embodies an archetype that obsessed Roerich for decades, and that he and Helena identified with sacred stones from numerous legends. It was an avatar of the *latyr*, the healing stone of Slavic folklore, but also of the sky-fallen boulder that gave rise to the worship of Cybele in Asia Minor. It represented *chinta-mini*, the "radiant thought-gem" found in Tibetan mandalas, and was later linked in the Roerichs' minds with the Holy Grail.[90] Gradually, the Roerichs came to believe that this "treasure of the world" actually existed, in the form of a meteorite from the constellation Orion, and that its reappearance would herald the onset of a new age.

Also in 1905, Roerich signaled his interest in Eastern religions by publishing the story "Devassari Abuntu" in *The Scales* and in the Czech journals *Volné Smery* and *Modern Revue*. To the text he added two illustrations, reworked in 1906 into full-size canvases. (Because Roerich hoped "Devassari" would someday be performed as a drama, some consider this a first, if unsuccessful, attempt at stage design.[91]) The vignette tells of an Indian woman who, hearing the words of the Buddha, leaves her home to dwell in the forest. She learns the language of birds and, in this state of sylvan grace, ceases to age or suffer bodily ailment. When her time comes to die, the birds inform her, and, yielding to fate, she sets out for the desert realm of death. Prostrating herself, she turns into a rock lit from within by a blue flame. Roerich's illustrations for the story, *Devassari Abuntu and the Birds* and *Devassari Abuntu Transfigured into Stone*, are among his earliest Asiatic works. The former is modeled on the Buddhist paintings in the Ajanta caves near Aurangabad: leaning against a pillar with her left leg bent in a traditional pose, Devassari wears nothing but a headdress and girdle, making the canvas unusually sensual by Roerich's normally demure standards.[92]

Even historical works took on an otherworldly quality, as myth and mysticism increasingly affected how Roerich saw the past. Fairy-tale idealization pervades *Sea Coast Dwellers: Morning* (1906) and *Sea Coast Dwellers: Evening* (1907), based on the folkways of northwest Russia's coastal Pomors, and also the riverside scene *Slavs on the Dnieper* (1905), which shows Varangian boats docking alongside a Slavic settlement (see Illustration 9). A tempera work offering ample evidence of Gauguin's influence, *Slavs* appears in turn to have won over Wassily Kandinsky, whose 1906 *Song of the Volga* borrows the same subject matter and compositional layout and imparts a similarly magical air to archaeological "reality."[93]

Roerich sounded somber notes as well. In *The Battle*, the doom-filled introduction to his six-part "Viking" suite (1906–1910), longboats clash on a nameless, gale-wracked sea. Other works, dealing with shamanism and the supernatural, shift from tragic grandeur to enigma, including *Sorcerers* and *The Conjuration by Water*. The most vivid of these, and the one most stubbornly resisting interpretation, is *The Dragon's Daughter* (1906), a macabre version of the dragonslaying myth that turns storybook convention on its head. A scarlet sky billows with smoke and ash. The dragon—no sleek serpent, but brawny and toadlike—wrestles a black-helmed, faceless knight almost as menacing as the loathsome creature he fights. Most mysterious is the title character: a crowned, unclothed maiden, her feet encircled by the lizard's muscular coils, her nakedness covered by a spill of red-gold hair. She stands entranced, her eyes closed, facing away from the combat. If she is kin to the monster, is she a victim in need of rescue? Or a femme fatale sharing in the dragon's malevolence, perhaps even conjuring it as a manifestation of her evil will? The familial tie between the two figures has long thwarted efforts to identify Roerich's telling of the tale with any of its traditional variants.[94]

How far Roerich intended these canvases to be ethnographic exercises is difficult to say. He remained an avid reader of Alexander Afanasev's *The Slavs' Poetic View of Nature*, aptly described by one scholar as a "Slavonic *Golden Bough*," and the work of researchers like Grigori Potanin.[95] Like several of his fellow artists—Bilibin, Kandinsky, and Dobuzhinsky, to name three—Roerich saw myth and folklore as master keys to a factual understanding of human history; he was a Frazerite and an Eliadist without having read Frazer or Eliade. But unlike these others, Roerich convinced himself at some point that the legends were actually true, and that sorcery and pagan ritual had worked real enchantment in the physical world. Such convictions were nourished by his and Helena's escalating commitment to the occult.

George Orwell once said of the poet Yeats, "One has not, perhaps, the right to laugh at him for his mystical beliefs." But "neither ought one to write such things off as

mere unimportant eccentricities."[96] Orwell's assessment applies as well to Roerich. Silver Age Russia was awash with alternative spiritualities, and occultism, far from being risible, was part of the cultural mainstream. On the other hand, there was nothing mainstream about how it came to dominate the Roerichs' lives after 1905.

Between 1881 and 1918, at least thirty-five registered groups in Russia were interested in esoterica, including the influential Religious-Philosophical Society and its journal *New Path*.[97] Private involvement with the occult cannot be measured, but large numbers of Russians turned to it, and for the same reasons as in the fin-de-siècle West. Some, reeling from the Nietzschean bellow that God was dead, sought spiritual comfort that conventional Christianity could no longer give. For bohemians, fashionably wicked forms of occultism went hand in glove with absinthe, opium, and forbidden lusts as ways to rebel against bourgeois respectability. Greater awareness of Eastern cultures, and the growing availability in translation of texts like the *Bhagavad Gita* and the Lotus Sutra, heightened the appeal of Hinduism and Buddhism. Faddishness and curiosity played their parts as well. The theologian Georges Florovsky later recalled this as a time in Russia when "dreams floated, and the soul, captivated by them, worshipped unknown gods."[98]

Russians had a multitude of heterodoxies to choose from. Freemasonry had arrived in 1731, followed by Rosicrucianism and other secret societies. Tarot, astrology, and hypnotism amused and amazed the public. Spiritualism, or mediumistic communication with the dead, caught on despite opposition from the Orthodox Church and public debunking at the hands of an 1875 commission headed by the chemist Dmitri Mendeleev.[99] In 1881, Spiritualists began publishing *Rebus*, the most successful of Russia's esoteric journals. The Vedantist rhetoric of the Hindu teacher Ramakrishna, who claimed to have had visions of Christ in a state of union with all gods, and his disciple Vivekananda—who preached that "all religions are one"—popularized Indian faiths throughout Europe, including Russia.[100] The celebrity of Shamrazan (Pyotr) Badmayev, a Buryat physician retained by the tsar, made Tibetan and Chinese medicine all the rage. Homegrown schools of thought abounded, such as Georges Gurdjieff's quasi-Sufi system of dance and meditation, and the Biocosmism of the hermit-librarian Nikolai Fyodorov, who proposed that space travel would lead to the divine perfection of humankind and the resurrection of the dead.[101] From abroad came Theosophy, the fountainhead of most of today's new age movements, and Anthroposophy.

Vedanta formed a larger part of the Roerichs' belief system than is commonly thought, but Theosophy went more into its making than anything else. The term "theosophy," or "divine wisdom," has been used since the third century to describe a variety of gnostic traditions seeking full knowledge of God, but modern Theosophy combines Hindu and Buddhist concepts with a

universalist approach to world religions. To this is added a potent infusion of precepts and jargon manufactured by Russia's formidable Helena Blavatsky.

The Theosophical Society (TS) was cofounded in 1875, in New York City, by Blavatsky and Colonel Henry Olcott, an American aficionado of Buddhism.[102] Born in 1831, Blavatsky escaped an unhappy marriage at the age of seventeen by bolting to Constantinople. According to her autobiography, she filled the next twenty-five years with one adventure after another, fighting at Garibaldi's side in Italy, playing piano in a Serbian tavern, giving tips on interior decoration to the French empress Eugénie, and observing the rituals of Egyptian cabbalists and voodoo priests. Separating fact from fabrication here is next to impossible, but it is wise to be skeptical about most of Blavatsky's tales, especially her most crucial claim: that she traveled to Tibet, receiving seven years of spiritual instruction from a Himalayan fraternity of mahatmas called the Great White Brotherhood. When she and Olcott created the Theosophical Society, she took the less glamorous position of corresponding secretary, but soon emerged as the movement's most charismatic—and most controversial—figure.

From its inception, Theosophy was pulled in opposite directions by two competing imperatives. Its initial aims, summed up in the motto "no religion higher than truth," were to foster mutual toleration among all creeds and to reconcile spirituality with empiricism by studying religious and paranormal phenomena on as scientific a basis as possible. Annie Besant, a later leader of the TS, assured readers that "no man in becoming a Theosophist need cease to be a Christian, a Buddhist, or a Hindu."[103] This raised the question, however, of why one would become a Theosophist in the first place, and such vagueness limited the society's growth during the 1870s. To prosper, Theosophy would have to pursue a second and more entrepreneurial goal of presenting itself as a *superior* pathway to the truth—the "origin and basis of all religions," to quote Besant again.[104] Theosophy became a new faith, and Blavatsky took the lead in articulating it. Her principal works, *Isis Revealed* (1877), *The Key to Theosophy* (1889), and *The Secret Doctrine* (1888–1891), laid out a dazzling but hodgepodge cosmology that mixes elements from many known faiths with inventions of her own. She declared these teachings to be divinely revealed. Adepts of the Great White Brotherhood—Koot Hoomi, servant of Maitreya, Buddha of the Future, and Morya, servant of the Hindu lawgiver Manu—transmitted wisdom to her psychically, she said, and *The Secret Doctrine* purported to be an extended commentary on *The Book of Dzyan*, a collection of stanzas written in the lost Senzar dialect and compiled by the Tibetan monk Aryasanga. The eminent Indologist Max Müller pointed out that no such tongue as Senzar had ever existed, and academic consensus follows him in judging the poems "brilliant forgeries."[105]

There is no denying that Blavatsky bolstered the Theosophical Society's fortunes.

Her books attracted a steadily widening readership, and her 1879 relocation to India, with Olcott in tow, brought into being a global headquarters—in Adyar, on the outskirts of Madras (Chennai)—that serves the TS to this day. She convinced an international audience of her gifts as a communer with spirits. She had the presence of a high priestess, reinforced by her colossal girth and heavy-lidded, electric-blue eyes. With her as the society's public face, Theosophy, by the mid-1880s, proliferated worldwide.

But Blavatsky also caused trouble. Olcott, more purely interested in Buddhism, disapproved of her esoteric pursuits. In India, she mocked Christian missionaries and openly aired anti-British sentiments. She volunteered to work for the Russian intelligence service, and while the tsar's spymasters declined her offer, British officials remained convinced that she was a political agent.[106] Finally, her occult extremism split the TS just as it was attaining global success. In 1884, Cambridge University's Society for Psychical Research, intrigued by rumors of her clairvoyant prowess, sent an investigatory team to Adyar. Hoping to be convinced of the veracity of her claims, the chief examiner was doubly disappointed to find what he considered the usual flummery, and issued a scathing report in condemnation of her.

In 1885, Blavatsky resigned her TS post and left India. She settled in London, where she completed her magnum opus, *The Secret Doctrine*, and gained a new disciple, an Anglo-Irish divorcée named Annie Besant. A Fabian socialist who supported home

rule for India, Besant became captivated by Theosophy during the 1880s. She served Blavatsky as aide and companion until the latter's death in 1891, then battled Olcott for control over the Theosophical Society. Olcott retained the leadership until his own passing in 1907, but the Blavatskian line triumphed. Besant became the TS's second president and, with the star lecturer Charles Webster Leadbeater, placed heavier emphasis on occultism and the imminence of a new age, to be ruled over by Maitreya, the messianic World Teacher. She remained in charge until her death in 1934.

Even as Besant took the helm, the Theosophical movement was fracturing. National chapters aspired to greater autonomy. Key figures were discredited by scandal, including Leadbeater, driven into obscurity by accusations of sexual impropriety. Most damaging was Besant's maternal obsession, starting in 1909, with the young Jiddu Krishnamurti, whom she believed to be the latest incarnation of the World Teacher. In time, Krishnamurti established his own mystical tradition in California, but Besant's relentless promotion of him as a universal messiah alienated many Theosophists and splintered the movement further. The angriest defection was that of Rudolf Steiner, head of the society's German-Swiss-Austrian section and creator of the Waldorf system of alternative education. In 1913, after failing to force Besant's resignation, Steiner formed the breakaway Anthroposophical Society. By the eve of World War I, Theosophy had taken root on five continents, but many of

its offshoots were growing independently. From this tangled family tree, the Roerichs' own Agni Yoga would bloom.

First, however, Theosophy had to gain a following in Russia. Doing so took time: Church hostility, disputes with the *Rebus* Spiritualists, and Blavatsky's notoriety stalled Theosophy's progress during the 1880s and 1890s. Individual Russians tended to join foreign sections of the TS until about 1902, when a Blavatskian circle coalesced around Anna Kamenskaya and Anna Filosofova (mother to the *miriskusnik* writer Dmitri Filosofov, and aunt to Sergei Diaghilev). This grew into the Russian Theosophical Society (RTO), which legally chartered itself in 1908 and began publishing the *Theosophical Herald*. A subgroup, led by Anna Mintslova and Yelena Pisareva, sided with Steiner against Besant and left to establish the Russian Anthroposophical Society, but the RTO set up seven main branches and several regional affiliates before the rise of Soviet power. Neither Theosophy nor Anthroposophy matched Spiritualism for numbers, but each had a major impact on Russia's intellectual life. Among those intoxicated by one or both, whether briefly or permanently, were the poets Bely, Blok, and Maximilian Voloshin; the composer Scriabin; and Wassily Kandinsky, author of the 1912 treatise *On the Spiritual in Art*. The mathematician and journalist Pyotr Ouspensky gave Theosophy two of its enduring classics, *Tertium Organum* and *The Fourth Dimension*, before leaving the RTO to stand with Georges Gurdjieff.

What of the Roerichs? They were Theosophically-minded, but not formally committed to the movement. It seems that they never joined the RTO—not all Russian Theosophists did—and Helena and Anna Kamenskaya loathed each other.[107] Nonetheless, Theosophy's catechism became the Roerichs' own. They believed in humanity's degeneration from spirit entities into mortal creatures, blinded by *maya*, or world illusion, and subject to the laws of karma and reincarnation. They accepted Blavatsky's theory that Atlantean survivors, hidden in remote corners of the earth, preserved the legacy of humankind's spirit ancestors and secretly guided the evolution of chosen "root races," whose destiny it was to lead humanity back to a state of grace. Shambhala, the Himalayan kingdom of virtue, would rise again with the end of Kali Yuga, the darkest era of the cosmic cycle. Exhibiting the "promiscuous hospitality to symbols" with which most scholars charge Theosophists, the Roerichs revered thinkers and prophets from nearly every culture as "ascended masters," including Moses, Zoroaster, Plato, Lao Tzu, the Buddha, Solomon, Mohammed, and Jesus.[108] As their spirit mentors, the Roerichs adopted Morya and Koot Hoomi, the adepts said to have tutored Blavatsky, and like Blavatsky, they fell into the habit of attributing every setback, no matter how trivial, to "dark forces" and "Satanic" machinations.

The remaining question is how and when the Roerichs committed to this worldview. Only a short while before, in 1900, Nicholas had insisted to Helena, "If you

read *Zarathustra*, as you absolutely must, you'll see at once that you and I are Nietzscheans by nature."[109] But whether this liking for Nietzsche lasted—and Roerich seldom spoke of him later—it was never about repudiating spirituality. What Nicholas found appealing in Nietzsche was the idea of a new morality promising self-realization through the cultivation of beauty and the exercise of will. The German's skillful use of imagery also struck him ("such deep symbols!" he exclaimed), and the fact that he drew Helena's attention to the "Second Dance Song," a passionate dialogue between Zarathustra and Life, personified as a beautiful woman, makes one wonder whether *Zarathustra*'s chief attraction for Roerich was that it gave him a modern Song of Solomon with which to charm his fiancée.

If, to paraphrase the psychologist William James, there are as many varieties of the occult experience as there are of the religious, the Roerichs passed through all of them, from early exposure before their marriage, to casual interest and serious observance, and then to total immersion. By the middle of World War I, they had enshrouded themselves completely in mysticism. In 1920, they proclaimed themselves Theosophical hierophants. But what about the middle ground characterized by normal devotion? If this is taken to mean enthusiastic familiarity with occultism and Theosophy, then the Roerichs were occultists and Theosophists by 1905. They styled themselves Buddhists as well, and Helena, several years before the world war, earned herself a reputation as a medium. Their occultism was not as consuming as it would later become, but from 1905 onward, practically everything the couple did—be it writing, painting, theorizing about ancient history, even the business of everyday life—bore some stamp of the esoteric.

CHAPTER 5

The Nightingale of Olden Times,
1907–1909

. . . and I could find
Nothing to make a song about but kings,
Helmets, swords, and half-forgotten things.

—W. B. Yeats, "Reconciliation"

On May 19, 1909, the Russian performing arts exploded onto the European stage with the force of a thunderclap. That evening, Sergei Diaghilev's Season of Opera and Ballet—the famed Ballets Russes—gave its first performance, at Paris's Théâtre du Châtelet. Diaghilev offered three ballets: *Le Pavillon d'Armide*, *Le Festin*, and the "Polovtsian Dances" sequence from Borodin's *Prince Igor*. All were well received, but the orientalist exuberance of *Prince Igor* thrilled the audience beyond expectation. The discordant skirling of Borodin's music, the frenzied surge of the dancers, and the deafening beat of drums overwhelmed the Châtelet theatergoers—and brought Diaghilev's troupe to the forefront of world culture. No less a figure than the choreographer George Balanchine, the cofounder of the New York City Ballet, pronounced *Igor*'s open-

ing "one of the most successful *premières* in history."[1]

Not least of the reasons behind this success were the sets and costumes Roerich designed for the performance. For more than a decade, *Prince Igor* remained a cherished part of the Ballets Russes' repertoire, performed dozens of times throughout Europe. And if audiences felt swept back to a mythic past, when Asiatic barbarism clashed majestically with ancient Slavdom, Roerich's designs strengthened the illusion. They gained him international fame and remain one of his signal triumphs.

And this was only the newest of his ventures. Roerich continued to exhibit and write, and did not neglect his archaeological research. He excelled at directing the IOPKh School and earned the title of academician from the Imperial Academy of Arts. In wonderment, his friend Igor Grabar asked,

"What had he not done? In the space of thirty years, he achieved everything that one could dream of achieving in one's career."[2]

But Grabar also recognized that, for Roerich, "all of this was not enough." The world saw him as an unparalleled interpreter of the past, a "nightingale of olden times," as the legendary bard, Bayan, had been called in Russia's old epics. Roerich, however, wanted more. He intensified his efforts to advance artistically and institutionally, and he and Helena pressed on with their spiritual quest, searching for fulfillment on planes more ethereal.

In a letter to Yevgeny Lanseré, Alexandre Benois, Roerich's perennial rival, borrowed a stereotype from Madame de Staël's *The Influence of Literature on Society* to distinguish between artists attracted to southern vistas and those drawn to northern climes. Those like himself, with "Latin inclinations," loved "life and reality," while "northerners" fixated on "the fantastic and the imaginary."[3] Roerich had always been one of the latter, elegizing in words and images the region's "pensive lakes," "wise forests," and "magic-filled gray stones."[4]

And its history. To Roerich thus far, "north" had meant a Slavic, Scandinavian, and Baltic realm, anchored partly in geographic reality, partly in legend and folklore. It still did, as shown in two large projects from these years. First was the "Viking" series, begun in 1906 with *The Battle*. By its completion in 1910, the suite included six fatalistic scenes that sprang to Roerich's mind as he pored over old Norse sagas.[5] *Apollo* reproduced two of these paintings, the Tretyakov Gallery acquired *The Battle*, and in 1918, a young musician, Baron Fittinghoff, composed a "Viking" symphony in the suite's honor.[6] Less forbidding was the "Bogatyr" frieze, a set of twenty ornamental panels installed in a Petersburg townhouse owned by the financier F. G. Bazhanov.[7] Several of these stood over six feet high, and on them, in shades of green, gold, purple, and blue, Roerich portrayed the glorious heroes of Slavic myth: the warrior Volga Sviatoslavich, the stalwart peasant Mikula Selianinovich, the Novgorod merchant Sadko, the minstrel Bayan, and, mightiest of all, Ilya Muromets, guardian of the Russian land.

Already, though, Roerich was shifting from an outlook grounded in historical specificity to one more metaphorically oriented. This transition accelerated in 1907, when Roerich and his family summered in Karelia and Finland, an experience that added new dimensions to his understanding of the north. In June, the Roerichs rented a dacha in Lohja, west of Helsingfors (Helsinki), and spent the next two months touring. They went to Helsingfors, Vyborg (Viipuri), Abo (Turku), the lake towns of Punkaharju and Olafsburg (Savonlinna), and the celebrated Imatra Falls. Around Lake Ladoga, they visited the resort of Serdobol (Sortavala) and the holy island of Valaam, home to one of the north's great

Orthodox monasteries. Traveling to Finland also reconnected Roerich with the country's most famous painter, Akseli Gallen-Kallela, whom he had met during the 1899 World of Art exhibition. Then, the two had stayed up three evenings in a row, talking past midnight about ancient history and old myths.[8] Now, Roerich asked for advice on summer lodgings, and Gallen-Kallela arranged for his niece to guide him around Lohja when he arrived.[9]

Eight Finnish landscapes came out of this trip: lakeshores, waterfalls, and forests, all described by Benois as "dreams of primeval freshness."[10] But as much as the woods and waters delighted him, Roerich was stirred most by his encounter with an unfamiliar northern culture. He lost himself in the pages of the national epic, the *Kalevala*. As a hobbyist ethnographer, he observed the lighting of midsummer bonfires on Saint John's Eve, an ancient ritual sublimated throughout Europe in the form of a Christian feast, and he studied the ways Finnish shamanism had influenced paganism in northwestern Russia.[11] He viewed Finland as a magic-steeped land, suspended in time, and he cast it in this poetic light in a 1908 lecture to the Society of Architects and Artists, later published in *Bygone Years* as "The Most Ancient Temples of Finland." "In Finland," he began, "enchantresses still brew poison from the heads of serpents. Amid the hills sprawl stone labyrinths, laid out in intricate, incomprehensible patterns, mute witness to immemorial rites. Warrior-heroes lie buried in their long tombs.

The music of the *kantele* can still be heard. The splendid northern tale lives on."[12]

Roerich now thought more about that tale's ethnocultural complexities. How should other Finno-Ugric peoples—Sami (Lapps) and Estonians, western Siberia's Khanty and Mansi, and their neighbors, the Komi—be factored into the northern mix? What of the Turkic, Altaic, and Paleoasiatic inhabitants of upper Siberia and the Arctic coast? Increased fascination with the ancient migration of peoples led him to define "northern" more inclusively than before. Even the Celts entered into his calculations. When Ivan Bilibin, hiking through Ireland and England in 1908, wrote him about the bleak but bewitching terrain, Roerich was most interested in the "piles of stones put up by the druids"—whose ritual practices he came to believe were linked with Persian Zoroastrianism and the *bon-po* shamanism of Tibet.[13]

Indeed, geographical and racial distinctions mattered less to Roerich as his work took him farther back in time. To borrow words from his friend Mikhail Rostovtsev, famed for analyzing the interactions of Greeks and Indo-Iranians in Ukraine and South Russia, he pondered the "intersection of influences" in Eurasia and the "very curious" mixtures that resulted.[14] Scholarly and popular theories about the origins of humankind and the wide-ranging movement of peoples like the Huns, Goths, and Aryans

caused Roerich to commit with greater confidence to the hypothesis that all Eurasian peoples had descended from a long-vanished ur-culture dating back to the Stone Age.[15] That lost epoch, Roerich declared, marked "the beginnings of all brilliant cultures."[16] Paintings like *Earthly Spell* (1907), with its antler-headdressed shamans treading a rocky path under a moonlit sky, reinforced this message, just as *Sorcerers*, *Fiery Spell*, and *Conjuration by Water* had done in 1905. The imposing *Heavenly Battle* (1909, second version in 1912) depicts a neolithic community struggling to maintain its precarious balance with nature. Storm clouds loom over grassy hills and the edge of a lake; the sense of impending cataclysm is heightened by the sight of tiny huts, huddled almost out of view in the lower right-hand corner. Here Roerich shows human presence dwarfed by the untamed primordial environment (see Illustration 13).

Yet this was a time, fraught with peril as it may have been, that Roerich preferred to his own. He saw the Stone Age as an era of "clear truth," when humanity lived in harmony with nature and enjoyed a degree of spiritual contentedness and communal solidarity unmatched since.[17] He became convinced of this on several levels. Academically, pioneering figures in ethnography and anthropology—including Durkheim and Frazer—agreed that, in the words of Mircea Eliade, "for the man of archaic society, the very fact of living in the world has a religious value."[18] Aesthetically and philosophically, Roerich, like scores of fin-de-siècle

intellectuals, found the primitive outlook an attractive answer to the agonized question posed by Yeats: "How can the arts overcome the slow dying of men's hearts that we call the progress of the world?"[19] He read with approval Vyacheslav Ivanov's 1905 essay, "The Religion of Dionysus," which spoke longingly of ancient spirituality. In the past, Ivanov averred, "Every form of life was sacred, and there was no action not linked with the worship of divine power. Like a gigantic shadow, the deity was inseparable from man. Truly, everything was 'full of gods.'"[20]

Roerich took up this thread in an essay of his own, "Joy in Art," written in 1908 and published the following spring in the esteemed journal *Herald of Europe*. Discussing Russian art in a global context, Roerich traveled backward in time, excavating in prose the cultural legacy of every historical period, coming at last to his beloved Stone Age. The essay climaxes with a rhapsodic description of a prehistoric settlement celebrating a holiday. This is the world Roerich shows us in *Heavenly Battle*, and that he would bring to life in *The Rite of Spring*:

> Let us turn one last time to the expansive quality of life in the age of stone.
>
> A lake. At the mouth of a river stands a row of houses. . . . Roofs with high chimneys are covered with yellowing reeds, hides, and furs, thatched with some kind of marvelous wattling. . . . Trophies of the best hunts have been

hung from the edges of the roofs. A white skull wards off the evil eye.

The walls of the houses are ornamented in yellow, red, white, and black tones. There are hearths within and without. Above the hearths, pottery, gorgeously patterned pottery, brown and gray-black. On the shore there are dugouts and nets. The nets are woven long and fine. Hides are drying on the kilns: bear, wolf, lynx, fox, beaver, sable, ermine . . .

It is a holiday. Let it be the one commemorating the victory of the springtime. When the people went into the woods, to spend long periods of time admiring the trees. When, out of the first grasses, they made fragrant wreaths and adorned themselves with them. When they played upon horns and *dudki* [pipes] of bone and wood. In the crowd, clothing, furs, and floral garlands intermingle. Beautifully decorated shoes, made of reeds and hides, shuffle side by side. In the *khorovod* [circle dance], amber pendants, braids, stone beads, and white talismans made of animals' teeth flash.

The people rejoiced. Among them art was born. They were near to us. They almost certainly sang. And their songs were heard beyond the lake and on the islands. Enormous fires flicker in yellow patches. Near the fires, the dark crowd moves. The waters, turbulent by day, have calmed and become lilac-blue. And amid the nocturnal rejoicing, the silhouettes of dugouts swiftly glide on the lake.

Roerich assures us that "of the stone age we will someday know more. We will better understand and more justly assess this era. And, better understood, it will tell us much."[21]

Occultism took Roerich farther, persuading him that the terrestrial realm had once been "full of gods" not just in fancy, but in fact. Atlantean myths and Blavatsky's speculations convinced him that the ancients, blessed with a fully awakened consciousness lost to their "civilized" descendants, had led an existence charged with cosmic forces. In other words, their perception of the world as a divine space was no mere mindset, but literally true. If Roerich did not believe this yet, he did so soon. Whatever the timing, contemporaries discerned the symbolic changes in his work, even if they remained unaware of his spiritual evolution. Profiling Roerich in *Golden Fleece*, Sergei Makovsky commented on his broader universality. Examining the human figures in Roerich's historical scenes—people "without names, living with collective mind and collective feeling"—Makovsky asked, "Who are they, these faceless ones? What epoch is reflected in their blind souls?" Conventional wisdom said Roerich was painting Kievan Rus or old Muscovy, but Makovsky replied: "If you like. But that is not important, although it is customary to consider Roerich a 'national painter.' It is not important, because for him the

national-historical theme is only decoration. Roerich's 'man' is not a Russian, or a Slav, or a Varangian. He is Ancient Man, the primeval barbarian of the earth."[22]

Maximilian Voloshin came nearer to grasping Roerich's mystical side in 1909, when he featured the artist, along with Léon Bakst and Konstantin Bogaevsky, in the essay "Archaism in Russian Painting," for the inaugural issue of *Apollo*.[23] Opening with a quotation from the Kabbala—"Stone becomes vegetable, vegetable becomes beast, beast becomes man, man becomes demon. And the demon becomes a god"—Voloshin identified Bakst's ancient Mediterranean tableaux, which recalled Troy and Knossos, with the "element" of man, and Bogaevsky's scenes of the Cimmerian southlands with that of vegetable. Stone belonged to Roerich, the master of a glacier-carved wilderness where lost tribes raised barrow tombs and crude altars. It was here humankind was born, and not just physically. Roerich, Voloshin maintained, was attempting to portray the first and most essential stage in a process of divine metamorphosis, from animal to angel, and ultimately to godhood. It was a shrewd insight, as was Makovsky's. Roerich still sought in his art for the Russia his comrade Blok had written of in 1906, "girdled with rivers and your forests' intricate maze, your cranes, your marshy acres, and the sorcerer's cloudy gaze."[24] But he was searching even harder for a pantheistic garden of eden.

In the meantime, practicalities could not be put aside. Not only did Roerich paint, he was an administrator and educator, an author and critic, and an activist fighting on behalf of artistic preservation. He presented papers at archaeological conferences and went on excavations whenever time permitted. He would soon become a stage designer. Igor Grabar's memoirs describe his seemingly boundless energy:

It often happened that you would visit Roerich in his apartment at the Society for the Encouragement of the Arts. You find him at work on a large panel. He willingly shows you a dozen or so other works that he has done in the month or two since your last visit. Each is better than the last. There is no hack work, nothing banal or boring. After fifteen minutes a secretary brings him a pile of papers to sign. He signs them quickly, without reading them, knowing that no one is about to deceive him: his office has been set up in model fashion. Fifteen minutes later, a servant rushes in: "The Grand Duchess has arrived!" On the run he barely has time to shout out an invitation for me to stay for lunch.

Thus he painted his superb works, signed important papers, received his visitors and guests—enemies and friends alike—with equal joy (the former perhaps even more joyfully), then returned to his paintings, constantly interrupted by telephone calls and all

the usual meetings and problems. Thus passed day after day of his hectic, vital life. Over the course of our acquaintance he hardly changed: the same pink complexion, the same preoccupation in his eyes, even when he smiled. Only his flaxen hair thinned out and his blond beard turned white.[25]

Institutions, Russian and foreign, were just as ready to recognize Roerich's talents.[26] He belonged to the Russian Society for the Protection of Monuments of Art and Antiquity, as well as the board of Saint Petersburg's Architectural Society. Abroad, he was named a fellow of the Rheims Academy and an honorary member of the Vienna Secession. Several times, starting in 1909, the government offered him the civil-service rank of state councillor (*statskii sovetnik*), and also the post of chamberlain. Concerned about time-consuming court duties, Roerich declined both, although he accepted three other state awards: the orders of Saint Anna, Saint Stanislaus, and Saint Vladimir.[27] The most gratifying honor came from the Academy of Arts, which, in 1909, conferred on him the high scholarly rank of academician. The nomination was made in 1907, but delayed by Mikhail Botkin, who mounted an unsuccessful campaign to reverse it. Induction into the academy remained a matter of lifelong pride and later allowed Roerich to style himself "professor" while in emigration.

Having spent the past years becoming established, Roerich and his contemporaries now *were* the establishment. Snapshots from the exhibition scene show this. No more were *miriskusniki* and Symbolists struggling to make room for themselves on a stage monopolized by Wanderers; they had seized the limelight, crowding the older generation to the wings. In turn, younger artists, with even more experimentalist styles, were starting to jostle Roerich's cohort from below. As 1910 approached, major shows in Russia began featuring art from newer schools, just as in Europe. In Paris, recent Salons d'Autômne had admitted groundbreaking Fauvist pieces, and the 1908 Vienna Kunstschau juxtaposed the Secessionist decorativism of Gustav Klimt with unsettling Expressionist works by up-and-comers like Oskar Kokoschka. Similarly, Russia witnessed the emergence of the avant-gardists who, in the decade to come, would shatter artistic conventions with the force of an artillery barrage: the Burliuk brothers, Mikhail Larionov and his partner Natalia Goncharova, Kazimir Malevich, Alexandra Exter, and others. During the first two Golden Fleece exhibitions, held in 1908 and 1909, Symbolist works by the Blue Rose looked lassitudinous and outmoded alongside Neo-Primitivist canvases by Larionov, who went on in 1909–1910 to establish the forward-charging Jack of Diamonds society. Symbolists like Blok worried that their movement was in "danger of putrefaction," and Andrei Bely dismissed the World of Art aesthetic as "the philosophy of a dying century."[28] Dominant for the moment, Roerich and his fellows would soon be shoved to the

margins by a process of change that they themselves had set into motion.

It is easier, of course, to spot trends in hindsight than while living through them, and Roerich concerned himself with his own accolades and advancement. Late in 1907, he took part in two Paris shows, the annual Salon d'Autômne and the Exposition of Contemporary Russian Art. The latter was organized by Princess Tenisheva as the latest salvo in her duel with Sergei Diaghilev. With Roerich's help, she lobbied mightily to recruit as many artists as possible to exhibit with her. Even more mightily, Diaghilev schemed against her, persuading all the major *miriskusniki* and a number of others to turn her down. In November, Roerich went to France to help the nervous princess, full of complaints about Diaghilev's "disgraceful" and "impudent" conduct, attend to details.[29]

The Tenisheva exposition opened on December 4, at the Galerie des Artistes Modernes, and while it did not deliver the blow to Diaghilev the princess had hoped for, it worked out well enough for Roerich. Most of the works shown there were Roerich's, making him the exhibition's "undisputed king," as the poet Nikolai Gumilev called him in one review.[30] Roerich returned to Petersburg after the opening, but Tenisheva's confidante, Princess Sviatopolk-Chetvertinskaya, let him know how things went in December.[31] More than 3,500 people attended on the second day alone, and Russia's ambassador to France honored the exposition with an official visit. Sales were brisk, with ten of Roerich's paintings going on the first day, and another to the Luxembourg Museum afterward. Critics, to Tenisheva's relief, admired the show as much as the public did.[32] One notable exception was the painter Konstantin Makovsky, a Wanderer who scolded Tenisheva in the *Petersburg Gazette* for passing off "disgraceful rags" as art.[33] (One of Makovsky's many frustrations with Russia's art scene was that his son Sergei, as a writer for *Golden Fleece* and *Apollo*, supported every trend he himself deplored—including Tenisheva's projects and Roerich's rise to fame.) Roerich refuted Makovsky in an interview with *Word*: "Every line he writes is riddled with untruth. It is not for me, of course, to speak of my paintings' worth or Bilibin's. But I feel obliged to point out how interested the French are in our work."[34] Roerich earned special notice from Paris-based critics such as Denis Roche and Casimir de Danilowicz in *Art et décoration*, *L'Art décoratif*, and the *Gazette des Beaux-Arts*, and Gumilev praised him as "a Gauguin of the north."[35] After a month in Paris, the exhibition moved on to London's Albert Hall, where it remained until July 1908. Roerich went to see the show there, but did not like Britain, telling Boris that the English were not only cold, but knew little of art.[36] It was an opinion he held to the end of his days.

Much activity followed in 1908 and 1909. In June 1908, he helped Tenisheva move back to Talashkino. July found him in England, then in Bonn, where he consulted with German archaeologists and acquired

art for the IOPKh Museum.[37] He also kept an eye out for purchases of his own, having recently begun to invest time and money into private collecting. He favored Dutch masters and Asian pieces, including prints by Hokusai, and, on advice from his brother Boris, his uncle-in-law Prince Putiatin, and the journalist-connoisseur Arkady Rumanov, he began acquiring archaeological specimens. He planned to continue bargain hunting in August, but Helena, looking after both boys back home, lost patience and ordered him to cut his trip short. The family spent the rest of the summer in the Valdai Hills.

Exhibitions kept Roerich busy as well. At the invitation of the Musée des Arts Décoratifs, he displayed stage designs at the Tuileries Palace, and he won a gold medal at the Milan International Exhibition.[38] At the 1908–1909 Saint Petersburg Salon, arranged by Sergei Makovsky at the Menshikov Palace, with live performances of music by Scriabin and Medtner to set the mood, Roerich was the main attraction. He showed the "Viking" suite and more than thirty other items, creating, as reported by Benois, "the impression that the ship had listed to one side and that the whole Salon served merely as a setting for Roerich's work."[39]

The summer of 1909 brought Roerich back to Talashkino. It was a short stay, and Helena took his absence in better stride than she had the year before, even joking that the princess "spoiled him rotten" like a pampered son.[40] Rain interfered with his painting and his archaeological work, but

he was there mainly for two other reasons. First, the princess wanted him to provide exterior and interior art for her Church of the Holy Spirit; she had broached this topic in 1908, and the two now reached a preliminary agreement about how to proceed. Second, Roerich needed Tenisheva's support for a commission he was forming with Alexander Rostislavov, the Ukrainian archaeologist Nikolai Makarenko, the orientalist Vasily Radlov, and the architects Vladimir Pokrovsky and Alexei Shchusev. This group hoped to build a museum of pre-Petrine art and culture, and Roerich persuaded Tenisheva to bankroll its efforts, starting with an archaeological survey of the Novgorod kremlin, a site containing many secrets about the early interactions of Slavs, Scandinavians, and Balts. In October 1909, this self-styled Pre-Petrine Commission began negotiations with the Imperial Archaeological Commission, Novgorod's municipal authorities, and the Novgorod Society of Antiquarian Enthusiasts.[41] Talks continued over the winter; the excavation began in July 1910.

Also near the end of 1909, Roerich took part in the Union of Russian Artists' seventh exhibition, which opened in Moscow, moved to Petersburg in early 1910, then toured a number of cities in 1910 and 1911, including Odessa, Kharkov, and Kiev. During this pivotal show, the group's last, Roerich's sixty-two paintings and designs were received with special warmth. Even the sharp-tongued Anna Ostroumova-Lebedeva, never fond of Roerich, gave him high

marks. Recalling her impressions of the exhibition, she testified that: "Of the Petersburg group, Roerich was particularly brilliant. His *Heavenly Battle*—the clash of two storm clouds—was magnificent. . . . As I examined his pieces, I could not imagine when and how he had managed to do so much work, and to do it so well. At the time, he was director of the School of the Society for the Encouragement of the Arts, a duty that cannot but have taken up much of his attention, time, and energy."[42]

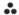

Ostroumova-Lebedeva did not err in guessing that IOPKh obligations filled Roerich's hours. It was work he loved, but living on the school premises, he found it impossible to keep the job from absorbing all his days and nights. Every afternoon and into the evening, he later reminisced, "our house on Morskaya became a club. The entire staff, old and new, would come by, and even on the staircase we continued our debates."[43]

Roerich overhauled the IOPKh curriculum to eliminate what he viewed as the snobbish distinction between "pure" and "applied" art. Citing the example of the sculptor-goldsmith Cellini, Roerich argued that what many looked down on as "craft" was equally as artistic as anything by Michelangelo or Rembrandt.[44] This was partly Tenisheva's influence, but Roerich received added encouragement from others. When Mikhail Nesterov congratulated him on the IOPKh appointment, he added that "the question of whether 'fine' art will subordinate craft or whether craft will be elevated to the status of art has become crucial, and must absolutely be decided in favor of the latter. I expect that you, with your characteristic energy, will bring this about."[45]

Roerich's new curriculum offered courses in graphic design, metalworking, ceramics, glasswork, embroidery, weaving, icon painting, and wood carving.[46] Electives included musical composition, voice lessons, and the manufacture of musical instruments. The school taught so many practical skills that Roerich managed to wheedle a yearly subsidy out of the Ministry of Commerce and Industry.

This larger course of study required a larger faculty. Roerich pruned the school of uninspired and uncooperative teachers, replacing them with a more reliable cadre.[47] Among these were classmates like Viktor Zarubin, Arkady Rylov, and Konstantin Vroblevsky. The architects Alexei Shchusev and Vladimir Shchuko joined Roerich at the IOPKh, as did the engraver Vasily Maté, the sculptor Ilya Gintsburg (with whom Roerich had quarreled, but was now reconciled), and the archaeologist Nikolai Makarenko. Roerich's closest friends on the staff were Zarubin, Ivan Bilibin, and Stepan Mitusov, who took charge of musical instruction; in 1911, he hired his brother Boris. Roerich taught courses on painting and lectured on art history, architecture, and archaeology.

Dealing with students proved fulfilling, but involved many dramas, great and small. Most seriously, Roerich labored under an

obligation to preserve order. Particularly after the 1905 Revolution, the state viewed all educational institutions as potential sources of unrest. Accordingly, Roerich took a firm hand, informing students that, while he sympathized with their ideals, he had, in accepting the school's directorship, promised the authorities that "there would be no disturbances."[48] Any demonstrations or political activities would result in the school's closure and the revoking of all scholarships; the government's wrath would leave him no choice.

This balancing act worked because most students perceived Roerich to be as fair-minded as his position allowed. He opposed the most unreasonable restrictions on academic life. One spring, for example, the city's deputy governor, Oskar Vendorf, ordered that any depiction of nudity would have to be excluded from the IOPKh's student exhibition. Roerich, who, as described in chapter 3, had dealt with such bureaucratic prissiness before, tried reasoning with Vendorf, but won only a small concession: nudes could be displayed as long as body parts that might give offense were covered. Vendorf said nothing, however, about *how* such "indecency" should be concealed, and Roerich proposed a clever solution. When the exhibition opened, the sensibilities of the fainthearted were protected by pantaloons and brassieres cut out of gaily colored cigarette paper. At the sight of these improvised fig leaves, visitors began to titter, then guffaw. Rather than prolong the farce, Vendorf allowed the show to proceed

normally.[49] Occasionally Roerich intervened on a personal level. One pupil, a general's daughter, confided that her father, enraged at her decision to study art, had ceased to speak with her. Roerich, who understood well the pain caused by this kind of parental hostility, included one of the student's paintings in a special exhibit for the royal family, making sure to point it out approvingly to Nicholas and Alexandra. A single letter from Roerich about how much their majesties admired the young woman's work was all it took to restore her to her father's good graces.[50] Roerich's most surreal teaching moment came when another student locked herself in a studio, asking that Christ be brought in to speak with her—although if Christ was unavailable, Professor Bilibin or Professor Roerich would do. A squeamish Bilibin absented himself, leaving Roerich to talk the student out of her delusion.[51]

As much as possible, Roerich democratized artistic education, widening admissions policies to take in students of all classes and income levels. He increased the number of scholarships, though he never had as much money for this as he wished. Striving for an equality that would have pleased Morris or Ruskin, he put the sons and daughters of factory hands and peasants alongside the scions of the well-to-do. Under him, the school's enrollment grew to an impressive two thousand, making it one of Russia's largest.[52] Despite a limited budget, he kept the school in decent physical condition, even if he regarded with envy the attractive facilities of the rival Stieglitz School

of Arts and Crafts.[53] For a time, Nicholas II mulled the possibility of granting the society a larger parcel of property belonging to the Admiralty, but never followed through, much to Roerich's chagrin.[54]

Although traditionalists like Botkin and Ilya Tolstoy fumed about Roerich, most approved of his efforts. The school's student shows in May became a noteworthy part of the capital's artistic calendar—the royal couple generally attended—and Roerich turned the IOPKh hall into an important exhibition venue. The journal *Apollo* applauded his pedagogical changes, and he earned approbation as an instructor from most of the hundreds of artists and craftspeople who passed through the school's doors while he ran it.[55] Yelena Bebutova, niece of the theater director Vladimir Nemirovich-Danchenko and wife of the Blue Rose painter Pavel Kuznetsov, spoke particularly well of him, as did the painter and ceramicist Alexandra Shchekotikhina-Pototskaya, who married Bilibin and later gained prominence under Soviet rule.[56] Even Benois offered this superlative: "The most inveterately outmoded of Russia's artistic institutions has suddenly proved capable of renewal and vitality. This miracle is due to a single person—Roerich."[57]

One dissenting voice comes from a twenty-year-old named Moyshe Shagal, and it is Roerich's misfortune that this single student, as Marc Chagall, won more fame than all the IOPKh's pro-Roerich pupils put together. Chagall moved to Petersburg from his hometown of Vitebsk, arriving at the end of 1906.[58] He failed the Stieglitz School's entrance exam, but had better luck with the IOPKh, which admitted him in April 1907, advanced him immediately to the third year, and awarded him a scholarship of 15 rubles per month, to last from September 1, 1907, to August 31, 1908. This was no regal sum, but it covered lodging and one meal per day at a favorite restaurant on Zubovsky Street.

Chagall remained at the IOPKh through July 1908, and later penned a merciless account of this "lost year."[59] "It was cold in the classrooms," he complained. "To the smell of dampness was added that of clay, paints, pickled cabbage, and stagnant water in the Moika Canal." He sneered at the students, "those cab-driver pupils who dug their erasers into their paper and sweated as if they were using shovels." As for instruction, "the teaching was non-existent . . . I wasted two years [*sic*] in that school." Gintsburg, a fellow Jew, was acceptable, but the rest of the staff were repressive, incompetent dolts. Nor did Chagall spare Roerich: "Our director wrote unreadable poems and books on history and archaeology. Smiling, teeth clenched, he would read fragments of them—I don't know why—even to me, a pupil in his school, as if I understood a word of it." Roerich closely monitored his star pupil's progress, but even this went unappreciated. Chagall regarded such attention as his fair due and took it for granted that the director would "lavish his (somewhat mechanical) smiles [on me], flashing his white teeth."[60]

By the summer of 1908, Chagall had had enough: "To my professors, my

sketches were meaningless daubs." Instructors snorted derisively when they heard he was a scholarship student. Finally, when one teacher reprimanded him by shouting, "What kind of shit have you drawn there?" Chagall left, without even collecting the last disbursement of his scholarship.[61] He found refuge at the Zvantseva School of Painting, directed by Léon Bakst, but quit in 1910 to make his way to Paris.

Chagall tells a vivid, Dickensian story of poverty and disaffection, but many of its details have been exposed as "imaginative and imaginary."[62] Chagall's priority was less to tell the autobiographical truth than to cast himself as a misunderstood genius who narrowly escaped having his talent snuffed out by inept mediocrities. At the least, he omits mention of how Roerich aided him in two moments of vulnerability. First, Chagall, subject to Russia's antisemitic residence laws, could not have remained in the capital without the long-term permit obtained for him by the IOPKh School.[63] Second, in June 1908, Chagall, having forfeited his right to a student deferment by quitting the school, was called up for three years of compulsory army service. Facing conscription in a matter of weeks, he sent Roerich this desperate plea:

Reluctantly, I apologize for disturbing your serenity. Shattered by the course of my fate, I am forced to take the unusual step of asking you the following: I have been called for military service this year. My situation is desperate and the expiration date is approaching. Your artistic authority is indispensable to testify to my participation in school, my success, etc.

I appealed to the administration of our school; they replied that they couldn't do anything without you and that they didn't know me. Perhaps you [remember] me? I hope you will . . . expedite the note necessary for my request, and perhaps you will advise me on this personal matter? I love art too much . . . to accept the idea of wasting three years on military service.[64]

Missing, of course, is the venom Chagall later spewed on Roerich, when he no longer needed his help. In September, Roerich interceded with the Interior Ministry to keep Chagall out of an infantryman's uniform—a favor he need not have bothered with, given the manner of Chagall's departure. Throughout his life, Chagall habitually failed to acknowledge debts properly; while the IOPKh School may not have nurtured his gifts as well as it could have, one can fairly question whether its director deserved such vituperation.

Late in 1907, Roerich set out on a new artistic path: theater design, a medium he committed himself to for almost forty years, creating designs for twenty-one plays, operas, and ballets.[65] The majority of these were never realized, but he won consistently

high praise, even for designs that failed to appear onstage. Two of his efforts—for *Prince Igor* and *The Rite of Spring*—proved monumental.

Roerich's first commission came from Nikolái Evreinov, a mercurial director who experimented widely, if at times rashly. (For a production of *Salomé*, Evreinov proposed building a stage in the shape of female genitalia, a decision that caused the show to be banned before its premiere.) One of his projects in 1907 was the Ancient Theater, which he founded with Baron Nikolai von Drizen to revive medieval, Renaissance, and baroque dramas. To design sets and costumes, he recruited Bilibin, Dobuzhinsky, Benois, and Roerich. Assisting him with direction was Alexander Sanin, one of Roerich's closest allies over the next decade.

For *The Three Magi*, an eleventh-century nativity play, Roerich designed a single set: a medieval city's cathedral square. Evreinov and von Drizen hoped to restore the majesty of public ritual to dramatic performance, but their high-concept approach did not catch on with general audiences. *Magi*, under Sanin's direction, opened on December 7, 1907, but while Roerich's set and costumes were deemed "beautiful," critics observed that "even they could not save this play."[66] Early in the new year, the Ancient Theatre suspended operations until 1911; the *Magi* designs were purchased by the collector Alexei Bakhrushin.

At the same time, but without a commission, Roerich turned to Wagner, designing three sets for *The Valkyries*. With a touch of hubris, he declared to the critic Yuri Beliayev that, "of all Russian painters, I think I am closest to understanding this opera's mystery."[67] He shopped his sets to the Imperial Theaters, but they showed no interest. The Darmstadt journal *Kunst und Dekorazion* praised them, and *Apollo* judged them "the most estimable of Roerich's theatrical works," but neither they nor any of his Wagner-related designs ever graced the stage—a matter of lifelong distress to their creator.

Roerich's second commission held great promise, but turned out badly. At the end of 1907, the Opéra Comique in Paris invited him to design sets for a production of Rimsky-Korsakov's *The Snow Maiden*, scheduled to open in May 1908. Rimsky-Korsakov himself was to supervise the music and Diaghilev the staging, although the latter quarreled with Albert Carré, the Opéra's manager, and left. Costumes were donated by Princess Tenisheva and Savva Mamontov, and both, along with Diaghilev, persuaded Carré to hire Roerich.[68] In November, Roerich worked on five sets, one for each act and the prologue—only for Carré to transfer the commission to two French artists in early 1908. Tenisheva caught wind of this and warned Roerich in January. Hoping that the princess would be able to change Carré's mind, Roerich completed the designs and sent them to Paris. Carré opted for the French sets anyway, infuriating Rimsky-Korsakov, who called the new designs "idiotic."[69] The composer grew more upset about the

production in the spring. Then, just before Good Friday, he suffered a severe attack of asthma and angina pectoris. Additional attacks forced him to return to Russia; he was dead by mid-June.

As for Roerich's unused designs, they succeeded as exhibition pieces, then went to the personal collections of friends like Tenisheva, Zarubin, and Sanin. In a touching coda, Roerich was asked by Rimsky-Korsakov's family to design his tombstone. The finished product, a Maltese cross inscribed with intertwined Cyrillic characters, was installed in Moscow's Novodevichy Cemetery in 1912. When Rimsky-Korsakov's remains were moved to the Alexander Nevsky Monastery in Saint Petersburg, to rest with artists like Tchaikovsky and Dostoevsky, the stone was relocated as well. It remains a lasting tribute to the affection Roerich felt for the composer and his music.[70]

In 1909, Roerich worked on three stage productions. One, which soon ran aground, was a commission from Alexei Remizov, who penned a play in 1908 called *The Tragedy of Judas, Prince of Iscariot*.[71] The text, based loosely on a tale from the Apocrypha, was published by *Golden Fleece* in 1909, and Remizov arranged to have it staged by the actress Vera Komissarzhevskaya, head of the Saint Petersburg Dramatic Theatre. Komissarzhevskaya elected to play the female lead, the cruel princess Unkrada, and set the premiere for February 1910.

Roerich completed a pair of Jerusalem scenes and a forlorn mountain citadel, but his most striking piece was a portrait of Unkrada, Judas's cousin and a femme fatale in the Salomé mold. Aiming for ambiguity, he depicted her not as a seductress, but as a fetching maiden, gathering flowers on the side of a hill, her mask of innocence revealing a hint of slyness. The artist Anna Ostroumova-Lebedeva pronounced the result "magnificent."[72] Komissarzhevskaya, however, changed her mind about *Judas* in 1909, and although Remizov tried to find another backer, the play did not appear onstage until 1916.[73] Roerich exhibited the *Judas* works at the seventh Union of Russian Artists show, and *Apollo* profiled them in its April 1910 issue.[74]

Judas's failure was more than compensated by Roerich's double success earlier in the year with the Diaghilev troupe in Paris. For several years, Diaghilev had been promoting Russian art in the French capital, helping with the annual Salon d'Autômne and introducing Western audiences to the music of Borodin and Rimsky-Korsakov. In 1907, he cast the incomparable Fyodor Chaliapin in Mussorgsky's *Boris Godunov*. He now turned to ballet, which, even more than opera, he thought, had the potential to realize Wagner's ideal of the united art work. Music, grand and irresistible, would combine with storyline to fix the audience's attention and stir its passions; sumptuous sets and costumes would provide a visual feast, while dance added kinetic energy. Diaghilev's timing was excellent. Not only

were the Russians emerging as world leaders in stage design, but Mikhail Fokine was revolutionizing Russian choreography by phasing out the elegant but rigid artifice of Marius Petipa, the previous century's dominant ballet master, in favor of natural beauty and free movement. The era of Anna Pavlova, Tamara Karsavina, and the gravity-defying Nijinsky was at hand.

Diaghilev's new creation, the Russian Season of Opera and Ballet, came to be known more familiarly as the Ballets Russes. At first, Diaghilev had to "borrow" singers, dancers, and musicians from Moscow and Petersburg theaters and orchestras; only in 1911 did a permanent company take shape. For sets and costumes, he relied on his World of Art comrades. He secured a space at the Théâtre du Châtelet, a dilapidated structure requiring a complete renovation, and chose May 19, 1909, as his opening date, with a *répétition générale* to be held on May 18. The first night's program would consist of Nikolai Cherepnin's *Le Pavillon d'Armide*, selections from Borodin's *Prince Igor*, and, after an intermission, *Le Festin*, an assortment of dances set to music by Glinka, Rimsky-Korsakov, and Tchaikovsky. Benois had designed *Le Pavillon* for the Mariinsky Theatre in 1907, and his sets and costumes were used again in Paris. Korovin took charge of *Le Festin*, and *Prince Igor* fell to Roerich. Diaghilev also asked Roerich to create two of the sets for Rimsky-Korsakov's *Maid of Pskov*, which, renamed *Ivan the Terrible* for Western audiences, would open on May 24.

For a time, then, Roerich joined the "committee of friends," as Diaghilev called the circle that planned the Ballets Russes' first seasons with him.[75] In Petersburg apartments, and over festive meals at Larue's or Viel's in Paris, Roerich conferred with Sanin, Fokine, and former antagonists like Bakst and Benois. Also part of the group was nineteen-year-old Vaslav Nijinsky (see Illustration 11), whom Diaghilev had taken as a lover in 1908. The young dancer came to know Roerich well in 1909, and was impressed with his learning. Nijinsky's sister Bronislava notes that "they became great friends and met often in Paris and in Saint Petersburg."[76] Their friendship deepened over the next several years, especially as they labored with Stravinsky on *The Rite of Spring*.

Working on *Igor*, whose libretto had been penned by Stasov, his now-departed mentor, placed Roerich in his element. The opera was a reworking of the twelfth-century *Tale of Igor's Host*, a Slavic epic that narrates the doomed campaign led by the prince of Novgorod-Seversk against the Polovtsians, a powerful tribe of Asiatic nomads.[77] The Borodin-Stasov version meditates on the European–Asiatic duality present in Russia's imperial identity. The Polovtsians are fierce foes—a "brood of leopards," as the original text calls them—but also brave and generous, as witnessed by Khan Konchak's companionable treatment of Igor and his son Vladimir when they fall into captivity. In acknowledgment of Russia's multicultural heritage, a romantic attraction springs up

between Vladimir and Konchakovna, the khan's daughter, and while the opera nods to the virtues of Orthodox Slavdom by having Konchakovna convert to Christianity, it owes most of its appeal to the Polovtsians' exotic barbarism.

Unlike the voluptuous Arabian Nights style popularized by Bakst, *Igor*'s orientalism was harsh and primitive. It fell squarely within the Scythian tradition, a cultural impulse that arose in the nineteenth century and culminated in Prokofiev's "Scythian Suite" (1915) and Blok's rampageous poem "The Scythians" (1918).[78] The concept took its name from Indo-Iranian nomads who, from 700 to 200 BCE, conquered a vast domain ranging from Central Asia to the Black Sea. The Scythians figure prominently in the *Histories of* Herodotus, who associates them with the mythic Amazons, and the discovery of Scythian treasures along the Crimean coast galvanized the field of Russian archaeology. In the later 1800s, many Russian artists and thinkers, defining themselves in contrast to their European cousins, claimed the Scythians as metaphoric ancestors. (Some believed the kinship to be genetic, although the question of actual ethnic ties remains murky at best.) In so doing, they turned the common stereotype of Russians as backward and semi-Asiatic into something more flattering. It was with pride that the Eurasianist ideologue V. P. Nikitin later wrote that "in every Russian, there is a drop of yellow blood," and when Westerners repeated Napoleon's dictum, "scratch a Russian, find a Tatar," Scythian-minded

Russians shot back that this "barbaric" intensity made them more honest and soulful than "civilized" Europeans with their rational but thin-blooded ways.[79] Roerich took this thinking even farther. In "Joy in Art," rather than bemoaning the savagery of the Mongol hordes or Tamerlane's armies, he reminds his readers how Asiatic incursions enriched Russian culture: "These invasions left behind such hatred that their artistic influence is neglected. It is forgotten that the mysterious cradle of Asia nurtured these remarkable people and swaddled them in the gorgeous wrappings of Chinese, Tibetan, and Hindustani culture. And in the ringing of the Tatar sword, Russia heard once again tales of wonder."[80] Like others among his peers who chose to glory in their part-Asiatic ancestry, Roerich saw himself personally as Eurasian. When Golovin painted his portrait in 1906–1907, Roerich asked him to emphasize anything Asian about his appearance, and Golovin agreed. "In your eyes," he decided, "let there be a hint of the Tatar."[81] As Roerich designed *Igor*, he never ceased to feel that Asia was in him, as it was in all Russians.

Roerich worked on *Prince Igor* between the end of 1908 and April 1909, cooperating closely with Fokine, the choreographer, and Sanin, who directed. He enjoyed this commission, regarding it as a chance to wipe the slate clean after the *Snow Maiden* unpleasantness in 1908.[82] Not till the eve of the performance was it certain how many scenes from the opera would be staged in Paris, so Roerich completed more sets than

were needed in the end. These included Putivl, the city from which Igor sallies forth to do battle, and Prince Galitzky's courtyard, where Igor's debauched brother holds court as regent. His prologue sketch features the solar eclipse said to have taken place as Igor's army rode out, while "Yaroslavna's Lament" shows the city walls, where Igor's wife, fearing him dead, sings the heartbreaking aria, "Why then, O Lord, did you scatter my happiness about the feather-grass?"

Roerich's masterpiece, however, was "Polovtsian Encampment," lauded by the ballet historian Richard Buckle as "a superb evocation of the desolate heart of a vast continent."[83] To create the effect of wide-open space, Roerich did away with the traditional side-wings, using instead a single curved canvas (see Illustration 15). Dominating the foreground were brick-red tents. Smoke rose up to fill the air. Every element of the scene—the burning sky, the infinitude of the steppes—exuded primal grandeur. Benois called it "a most apt and poetical setting," and Sanin told Roerich, it "will be the making of your greatness," adding in Voltairean fashion that "if you did not exist, you would, for *Igor*'s sake, have to be invented."[84]

Costuming *Igor*'s Russian characters proved straightforward enough, but the Polovtsians presented more of a challenge, because no one knew for certain what their clothing had looked like. Roerich's answer was to model their costumes on the folk dress of still-extant Asiatic peoples, specifically the Yakut and Kirghiz.[85] Male warriors were clad in tunics and trousers of green, crimson, and ochre, with sabers, bows, and leather accoutrements; the women wore flowing skirts, halters, and veils. In a bit of blackfacing that would not survive scrutiny today, both sexes smeared their faces with soot. A photo of Fokine, testing a warrior's outfit by leaping high in the air, arms outstretched like wings, gives a good idea of the impression Roerich's costumes would soon make on Paris. Benois recalled how Diaghilev, the minute he received Roerich's sketches, "despoiled all the Eastern shops in Saint Petersburg," buying up fabrics and jewelry.[86]

Standout costumes included Prince Galitzky's robe and Khan Konchak's tunic. Designing the latter caused Roerich some worry. Slated to appear as Konchak was Fyodor Chaliapin, a notoriously hard person to please. As Roerich tells it, "two things from Diaghilev's production of *Prince Igor* were unforgettable. First, my friendship with Sanin. Second, the Khan Konchak costume for Chaliapin. Fyodor Ivanovich was a difficult man. You never knew what he would find fault with. He could be very rude, but he was always quite mild with me. He valued the Scyth-Mongol costume I made for him, and he wore it well."[87] Roerich dressed Konchak in an earth-colored tunic, patterned with rectangles, while Galitzky wore a fur-lined cap with pearls, a heavy cross on a chain, and a brown, fur-trimmed surcoat with a repeating motif of leaves and trees. When the season was over, Roerich presented Chaliapin with his sketch

for the Konchak costume; Fokine received a study of a Polovets warrior. Fokine answered with a note saying, "Your drawing will be a pleasant reminder of our first (and, I hope, not our last) endeavor together."[88]

Although Roerich attended rehearsals in Petersburg, responsibilities at the IOPKh School, whose term was ending, kept him from being in Paris, either for the final month of preparation or the premiere.[89] According to Sanin, who updated him by mail, it was just as well that he missed the stress and strain of April and May. With the Châtelet being rebuilt, the dancers and singers barely had room to move, let alone rehearse. Exhaustion and edginess bore down on everyone, and quarrels broke out at the slightest provocation. Boris Anisfeld, hired to convert Roerich's studies into full-sized sets, botched the job and, after blistering reprimands from Diaghilev and Sanin, had to redo everything.[90]

Despite the confusion, *Igor* and its companion pieces were ready by mid-May. Hundreds of placards, bearing Serov's iconic blue-and-white sketch of Pavlova in her costume from *Les Sylphides*, had been posted throughout Paris to advertise the upcoming season. On May 18, the *répétition générale*, a formal dress rehearsal open to critics and invited guests, went smoothly. In attendance were Maurice Ravel and Auguste Rodin.

The following evening, Diaghilev's troupe made history. The audience reacted politely to *Le Pavillon d'Armide*, then swooned with delirium as *Igor*'s first notes rang out. The singing, anchored by Chaliapin and Kapiton Zaporozhets, was magnificent. (On the first night, Chaliapin sang Galitzky's part, and Zaporozhets the khan's, but the two switched for later performances.) The dancers, led by Adolph Bolm as the chief Polovtsian warrior, flawlessly executed Fokine's choreography. During the final scene, Roerich's set gave the Châtelet theatergoers "the strange sensation of being transported to the ends of the earth."[91] The critic Cyril Beaumont remembered how, as the music crescendoed, the dancers "pulsate[d] with a savage exultation," ending the sequence by hurling themselves recklessly toward the stage's edge. *Le Temps* reported afterward on the ecstatic pandemonium that resulted: "There was a moment when the entire hall, carried away by the frenzy of the dances of the Oriental slaves and Polovtsian warriors at the end of *Prince Igor*, was ready to stand up and actually rush to arms. That vibrant music, those archers, ardent, wild, and fierce of gesture, all that mixing of humanity, those raised arms, restless hands, the dazzle of the multicolored costumes seemed for a moment to dizzy the Parisian audience, stunned by the fever and madness of the movement."[92] Watching from the wings, Tamara Karsavina heard the crowd shout for curtain call after curtain call, "I don't know how many times."[93] During the intermission, audience members milled around the stage, hugging and congratulating the players. *Le Festin*, coming after, proved an anticlimax.

Good fortune continued on the twenty-fourth, when the curtain went up on *Ivan*

the Terrible, also directed by Sanin. On this project, Roerich teamed with Alexander Golovin and Dmitri Stelletsky, contributing two sets, including the silk-draped interior of Ivan's crimson tent. Chaliapin appeared as Ivan, and although they did not explode with joy as they had during *Igor*, the French appreciated the opera, with one reviewer praising the Russians as "Impressionists on a grand scale. In one instant, we understand a whole reign, a whole epoch, a whole world."[94] Sanin informed Roerich that *Ivan* had been "a pure and lofty success. I am extremely grateful."[95]

Shortly before Diaghilev's season opened in Paris, the Viennese critic Ludwig Hevesi remarked, "In [Russia's barbarism], we find great artistic advantage. This fund of raw material, nourished by geographic and ethnographic peculiarities, is a national treasure the Russians will draw from for a long time to come."[96] Surveying the scene of their triumph, the Russians themselves picked up this theme of primitive vitality. Benois declaimed that "Barbarians have once again conquered Rome. But these contemporary Romans welcome the conquest, for they feel it will be good for them, that these new arrivals, with their fresh, clear-shining art, will pour new blood into enfeebled Roman bodies. It is not Borodin who has triumphed in Paris, nor is it Rimsky-Korsakov, Chaliapin, Golovin, Roerich, or Diaghilev. Russian culture has triumphed: its urgency, its freshness and

spontaneity, its wild strength."[97] Sanin spoke in the same Scythian vein: "In the twelfth century, we conquered the Polovtsians. Now we are conquering Europe. Russian art brims with a fresh, young, vibrant genius that the self-satisfied, smug, complacent nations of the West do not possess."[98]

Productions like *Prince Igor* made Diaghilev and his company overnight superstars, and everyone understood how much credit Roerich deserved for this all-important first success. Serov telegraphed his congratulations, and Fokine spoke of him as "an outstanding archaeologist" to whom Russian theater was "much obliged."[99] Diaghilev presented him with a 500 ruble honorarium, and Benois conceded that "the most overwhelming success of our first season fell to the 'Polovtsian Camp' from Borodin's *Prince Igor*."[100] (Characteristically, in the next breath Benois describes his own sets for *Cléopâtre* as even worthier.) And this was only the beginning: *Igor* enjoyed a full decade as one of the Ballets Russes' signature productions, and theatergoers readily identified it with Roerich. Tellingly, the next time *Igor* was performed in Petersburg, the audience, having read wonderful things about Roerich's work in Europe, was let down by Korovin's locally done sets and costumes.[101] The opera drew Roerich into the "galaxy of talent," as Tamara Karsavina called the Diaghilev set, and while he remained there, he shone brightly.[102]

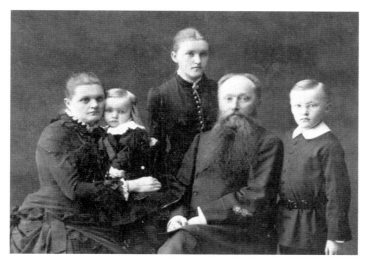

Illustration 1. The Roerich family in Saint Petersburg, ca. 1883–1884. L to R: Maria, Vladimir (in Maria's arms), Lydia, Konstantin, and Nicholas. (Nicholas's other brother, Boris, was not yet born.) Source: NRM Archive, New York, ref. no. 400311.

Illustration 2. Nicholas as a student in 1893, preparing to finish secondary school and advance to simultaneous studies at Saint Petersburg University and the Imperial Academy of Fine Arts. Source: NRM Archive, New York, ref. no. 400322.

Illustration 3. Artistic mentorship. Academy of Arts training in the studio of Arkhip Kuinji, ca. 1895–1897. Nicholas stands in the top row, third from the right. Kuinji is seated, fourth from the left, in the second row from the top. Source: NRM Archive, New York, ref. no. 400333.

Illustration 4. Intellectual mentorship. Nicholas consulting with Vladimir Stasov in the latter's office at the Saint Petersburg Public Library, ca. 1895–1898. Source: NRM Archive, New York, ref. no. 400336.

Illustration 5. *The Messenger. Tribe Has Risen Against Tribe* (1897). Roerich's graduation piece at the Academy of Arts, depicting Slavic tribes on the eve of war. The subject matter—ancient history—remained central to Roerich's work for years to come. The style, more suited to an older generation, did not. State Tretyakov Gallery, Moscow, oil on canvas, 124.7 × 184.3 cm.

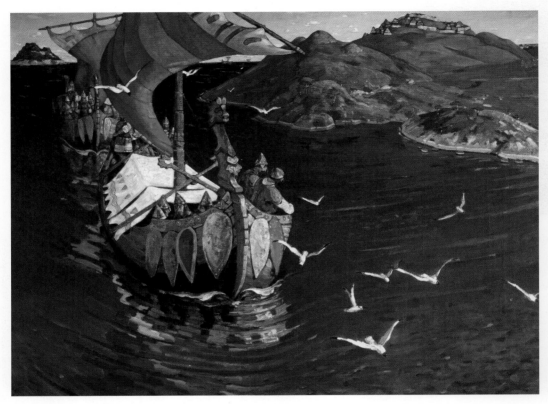

Illustration 6. *Overseas Visitors* (1901). Viking adventurers sail down Russian rivers, seeking trade with the Byzantine metropolis of Constantinople. One of Roerich's many treatments of the cultural fusion between Slavs and Scandinavians in old Russia, and conventionally considered his best-known painting. State Tretyakov Gallery, Moscow, oil on canvas, 85 × 112.5 cm.

Illustration 7. *Rostov the Great (Church of Saint John the Theologian)* (1903). Part of Roerich's acclaimed "Architectural Series" (1903–1904). Most of the works in this series were displayed in Russia's pavilion at the Louisiana Purchase Exposition of 1904, then stranded in America for decades due to the unscrupulous dealings of the agent who handled them. State Tretyakov Gallery, Moscow, oil on wood, 31.4 × 41 cm.

Illustration 8. *Treasure of the Angels* (1905). Nominally Christian, this piece marks Roerich's sharp turn toward pantheistic understandings of myth and religion. Foregrounded prominently is the sacred stone that he and his wife Helena later associated with the Holy Grail and Chintamini, the "thought-gem" from Tibetan lore. Constantine Palace, Strelna, Russia, oil and tempera on canvas, 321.5 × 367 cm.

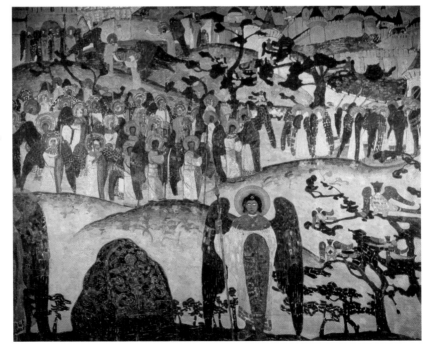

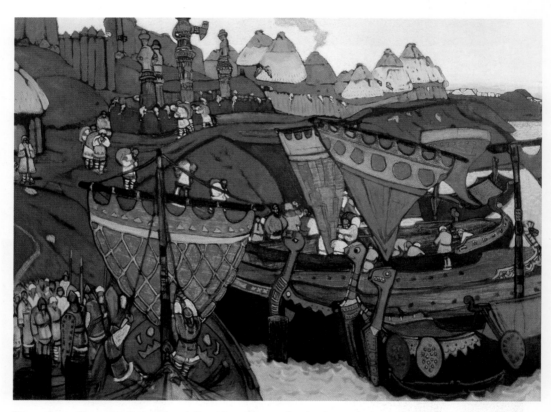

Illustration 9. *Slavs on the Dnieper* (1905). Roerich returns to a favorite theme: the interaction of Slavs and Scandinavians in early Russia. On the hillside, an earthwork adorned with horses' skulls encircles a cluster of idols—a common visual element in Roerich's work from this period. Among those known to have admired this piece was the avant-garde painter Wassily Kandinsky. State Russian Museum, tempera on cardboard, 67 × 89 cm.

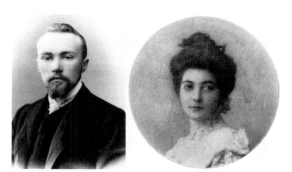

Illustration 10. Nicholas and Helena during their courtship, ca. 1900.

Illustration 11. Friends and enemies. Clockwise from top L: Igor Grabar, painter and close confidant at various stages of Roerich's career; Maria Tenisheva, founder of the Talashkino art colony and Roerich's most devoted patron before the revolutions of 1917; Alexei Remizov, avant-garde author and fellow aficionado of the occult; Sergei Diaghilev, creator of the World of Art and the Ballets Russes, clashing and cooperating with Roerich in equal measure; Igor Stravinsky and Vaslav Nijinsky, the composer and choreographer with whom Roerich cocreated The Rite of Spring; and Alexandre Benois, painter/designer, intellectual leader of the Diaghilev circle, and Roerich's longtime antagonist.

Illustration 12. Roerich with his siblings and mother in Saint Petersburg, sometime between 1910 and 1917. L to R: Nicholas, Maria, Lydia, Boris (standing), Vladimir (seated). Source: NRM Archive, ref. no. 400474.

CHAPTER 6

The Great Sacrifice, 1910–1913

In Paris, the road to fame leads through notoriety. At a real premiere, everyone must leap up from their seats at several points during the evening, and while the majority roars, *"Insulte! Impudence! Bouffonnerie ignominieuse!"* six or seven initiates—Erik Satie, a few surrealists, Virgil Thomson—shout from their loges: *"Quelle précision! Quel esprit! C'est divin! C'est suprême!* Bravo! Bravo!"

—Thomas Mann, *Doctor Faustus*

Sometime during the 1930s, as he prepared his autobiography, Igor Stravinsky reflected on how the idea for his masterpiece, *The Rite of Spring*, occurred to him: "One day [in the spring of 1910], when I was finishing the last pages of [*The Firebird*] in Saint Petersburg, I had a fleeting vision which came to me as a complete surprise. I saw in imagination a solemn pagan rite: sage elders, seated in a circle, watched a young girl dance herself to death. They were sacrificing her to propitiate the god of spring."[1] Inspired by this image to create a new ballet, Stravinsky turned to Nicholas Roerich, his friend, for help in fleshing out the scenario and creating sets and designs. And so, with this flash of insight, one of the century's great musical works sprang into being.

But was it so? Stravinsky's recollections about *The Rite* have never been consistent.

In another story, he attributes *The Rite* to the strength of a childhood memory: "The violent Russian spring, that seemed to begin in an hour and was like the whole earth cracking. That was the most wonderful event of every year of my childhood."[2] At times, the vision is a "dream" in the literal sense, at others, a "daydream" or brief impression. Elsewhere, Stravinsky claims that musical impulse, and no single concept, guided him in creating *The Rite*.

His collaborator tells a different tale.[3] According to Roerich, Stravinsky wished to create a ballet with him, but had no specific subject in mind. Roerich, already at work on two scenarios—one in which the universe's fate is determined by a game of chess, the other depicting an ancient Slavic ritual—invited Stravinsky to consider both.[4] The composer chose the latter, tentatively titled *The Great Sacrifice*. After three years

and several name changes, this "child," as Stravinsky and Roerich called it, was born amid riot and chaos. Years later, when Roerich learned that his erstwhile partner was claiming credit not just for *The Rite*'s music, but for having conceived it on his own, he was incensed.

Whose idea was *The Rite of Spring*? The contradictions between Roerich's story and Stravinsky's have never been resolved. Because Stravinsky is so much better known, his version—repeated everywhere in concert programs and album liner notes—is accepted by the public at large. Opinion among Roerich's and Stravinsky's peers remains split, as it does among scholars, but generally speaking, Stravinsky has long, if undeservedly, enjoyed "unchallengeable authority" in casting himself as *The Rite*'s sole originator.[5] Roerich, if mentioned at all, is relegated to the status of helpful but secondary colleague, as in this passage by Robert Craft, Stravinsky's amanuensis: "[Roerich] was of a caliber to sustain Stravinsky, and to him, painter, ethnographer, archaeologist, designer of Rimsky-Korsakoff's tomb, Stravinsky confided his prefiguration of the new ballet. . . . It was one of the most fortunate coincidences of his life, for Roerich's knowledge, whatever it may have been, inspired Stravinsky and helped to sustain his vision."[6] Flattering, but hardly satisfactory if the "prefiguration" belonged to Roerich in the first place. *The Rite*'s origins are unlikely to be unearthed completely, but Roerich merits having his role better understood and more widely appreciated.

The Rite was merely one of the myriad projects—artistic, institutional, and scholarly—that filled Roerich's hours during this period of imperial twilight. But as many-sided as his activities were, he looked at the world with a definite unity of vision. Whether he painted Christ's apostles or shamans casting their spells, northern glens or the tapestry-lined chambers of an old castle, he aimed to give visible form to a hidden world of esoteric truth and sublime beauty. Here, all of Roerich's interests converged: archaeology and history blended seamlessly with painting and occultism. By now, his faith in the last was strong enough that he thought of his creations not just as artworks, but as portals into an otherworldly realm that someday, he hoped, would intersect with the plane of earthly reality.

Reading the famed memoir *Theatre Street*, one can almost hear the clink of champagne glasses and the exchange of bons mots, half in Russian, half in French, as the dancer Tamara Karsavina portrays Diaghilev's Ballets Russes at its zenith. "Boyish exuberance" prevailed, with Benois's "overflowing benignity" and Bakst's "dandified primness" contrasting with the tantrums of Fokine, who "shouted himself hoarse, tore his hair, and produced marvels." Amid this "indescribable bedlam" stood Roerich, whom Karsavina describes as "all mystery . . . a prophet of impeded speech." Mysterious or not, "he could do infinitely more than

ever he promised," and Karsavina reminds us how much Roerich's peers valued his talents.[7]

Those talents were on everyone's mind in 1910, when the long-defunct World of Art reunited as an exhibition society. Several things prompted this decision, the most immediate being the breakdown of the half-decade merger between the Union of Russian Artists (SRKh) and the former *miriskusniki*. This always uneasy partnership came unglued after the seventh SRKh exhibition. A review by Benois referred to several of the union's Moscow painters as "ballast," and the Muscovites demanded an apology.[8] Benois instead withdrew from the SRKh, and most Petersburgers followed him. Roerich quit too, but had favored collaboration and never ceased to blame Benois for a split he thought unnecessary.[9] Again on their own, the *miriskusniki* saw advantage in banding anew. Also, lesser-known artists painting in transitional, rather than radical, styles had recently been looking to figures like Dobuzhinsky and Roerich for guidance. This informal network provided much of the new World of Art's membership.[10]

For almost six years, Roerich chaired the World of Art. Initially, some thirty artists joined up, and membership grew. This group survived until 1924, staging twenty-one exhibitions. Roerich headed it through the spring of 1916, with Dobuzhinsky spelling him in 1913, when he was overloaded with other commitments. When Roerich stepped down, Ivan Bilibin succeeded him.

Maintaining the group's relevance proved Roerich's main challenge. Even with fresh wind in its sails and a helmsman as capable as Roerich, the World of Art was hardly the flagship it once had been, with avant-garde styles now changing Russian art beyond recognition. In 1910, Mikhail Larionov founded the Jack of Diamonds, with Natalia Goncharova, David Burliuk, Alexandra Exter, Kandinsky, and Malevich. The year after, Larionov and Goncharova left to form the Donkey's Tail, and from then on modernist groups proliferated. Exhibitions like Target and 0.10 brought Cubo-Futurism and Suprematism to the fore. In 1913, Malevich designed Russia's first Futurist opera, *Victory over the Sun*. It was a time for breaking the bonds of artistic convention. The World of Art no longer did such things, even if past achievements and reflected glory from the Ballets Russes allowed the group to hold its own for now.

Roerich, moreover, received only limited support from his peers. The senior *miriskusniki* accepted him as their chair not out of personal regard but because they had only slight interest in such work. In the words of Anna Ostroumova-Lebedeva, "We had to find a suitable [chair]. But this was not easy, because most artists are unwilling, even unable, to deal with everyday matters. In the first year, and almost every year after that, we selected Roerich, in spite of our coolness toward him (no doubt he felt the same about us). Roerich enjoyed his duties—and it must be said that he did quite a good job."[11] So, while they appreciated his administrative

skills, many of Roerich's colleagues cared little for his character or conduct, highlighting once again the striking diversity in how his contemporaries viewed him. In the eyes of some, it was his driven and detail-oriented practicality, precisely the trait that made him an effective manager, which invited scorn. We have seen already how *miriskusniki* such as Serov and Dobuzhinsky disdained him as a "careerist," and though Roerich was obviously not alone in striving for honors and awards, or promoting himself and the groups he belonged to, his way of going about it sometimes felt unseemly. Vladimir Telyakovsky, director of the state-run Imperial Theaters, where Roerich incessantly tried but failed to secure a commission to design for the stage, found the artist's pushiness irksome.[12] From Prince Sergei Shcherbatov comes an even more trenchant indictment, and a surprising one, given how amicably he dealt with Roerich in public. Shcherbatov admired and collected Roerich's art, but judged the artist himself to be insufferably "calculating" and "subtle." He compared Roerich to Tartuffe—the pompous, fake-pious schemer immortalized in Molière's play of the same name—and objected particularly to what he saw as Roerich's shameless toadying of nobles such as himself and Princess Tenisheva. Shcherbatov summed Roerich up as "a clever and sly person . . . well-mannered, smooth-tongued, crafty, and extremely ambitious." He seemed to the prince "as if he had a mask on his face. . . . There was always something concealed."[13]

In many instances, Roerich remained oblivious to such negative estimations. He knew where he stood with Diaghilev, or with Benois and Bakst, but would have been shocked to know what Shcherbatov thought of him, and heartbroken in the case of the much-esteemed Serov, who, despite his true feelings, remained unfailingly polite to Roerich and helped find buyers for his art. Serov also captured Helena's beauty in a portrait that, for many years, remained one of the family's most prized possessions. Roerich was even more taken in by the cordiality of Igor Grabar, whom he considered a trusted ally, only to be disappointed years later by wounding comments in Grabar's autobiography.

Numerous others, however, were genuinely fond of Roerich.[14] Among the Ballets Russes/World of Art set, his best friends were Ivan Bilibin, Alexander Sanin, and (so he thought) Igor Grabar. He considered Alexander Golovin an excellent companion. Between 1909 and 1913, Roerich gained an admirer in the dancer-choreographer Vaslav Nijinsky, and among newcomers to the group, he grew fond of Boris Grigorev, Alexander Yakovlev, and Vladimir Shchuko. He kept on good terms with his Kuinjist classmate Konstantin Bogaevsky and with Sergei Sudeikin, formerly of the Blue Rose and a leading light at the Stray Dog Café, where Petersburg's bohemian elite gathered for poetry readings and theatricals. Roerich never became a Stray Dog habitué, but Sudeikin invited him now and again to join the fun there.[15]

Roerich remained close to Stepan Yaremich, Alexei Shchusev, Viktor Zarubin, Sergei Makovsky, and Stepan Mitusov. As before, his connections with journals like *Apollo* and the *Golden Fleece* strengthened his ties with writers and poets. Roerich had been friendly with Alexei Remizov since 1905, as well as with Vyacheslav Ivanov, Vasily Rozanov, and Nikolai Gumilev. He drew nearer to Sergei Gorodetsky, Valery Briusov, whose *Fiery Angel* he adored, and Arseny Golenishchev-Kutuzov, author of the novel *Hashish*. He embraced the Lithuanian writer Jurgis Baltrushaitis, whose translations into Russian of the *Bhagavad Gita* he valued, and he knew Andrei Bely well enough that they used the familiar "thou" (*ty*) in their exchanges. Roerich also hoped to strengthen ties with Lithuania's Mikalojus Čiurlionis, a Symbolist painter-composer whose fusion of mysticism and art tantalized him the same way Alexander Scriabin's Theosophy-suffused music did. Roerich wrote approvingly of Čiurlionis, and the two likely came to know each other between 1908 and 1911: hoping to make his name in Petersburg, Čiurlionis exhibited with the SRKh there, and Roerich chaired the World of Art when it admitted Čiurlionis to its ranks in 1910.[16] Had Čiurlionis not entered the spiral of depression and poor health that led to his premature death in 1911, one can imagine him and Roerich becoming boon companions, thanks to the ethereal outlooks they had in common.

Other companions from this time included the author Maxim Gorky and the Symbolist poet Alexander Blok. Born in poverty, the rough-hewn Gorky gained fame with gritty depictions of desperate and dispossessed proletarians in works like *The Lower Depths*, from 1902. By the time Roerich came to know him—they met in the offices of the Sytin publishing house—Gorky had been established for years as a lion of Russian letters. A crusading social democrat and a critic of tsarist injustice, the broad-minded Gorky forged personal bonds with artists and activists of every ideological and stylistic stripe, from Chekhov, his onetime mentor, to the pugnacious Vladimir Lenin. Roerich and Gorky enjoyed a decadelong acquaintance until politics pulled them apart in the aftermath of 1917's revolutions.[17] As for Blok, he frequented the same mystical gatherings Roerich did, and the two understood Russian culture in similarly Scythian terms.[18] Blok kept with him a constant reminder of the artist: *City on a Hill*, a landscape from Roerich's 1906 trip to Italy. In 1910, *Apollo* illustrated Blok's "Italian Verses" with a reproduction of *City*, and, hearing how taken the poet was with its simple beauty, Roerich gave him the original as a gift. Blok treasured the painting for the rest of his life, refusing to give it up for even a short time. When Sergei Makovsky asked him to lend it for the 1910 Universal International Exposition in Brussels, he replied: "Roerich's painting has come into my life, and it hangs below my mirror, where I am able to gaze upon it every day. It would be very hard to part with it, even for only a few months. I ask you not to be too put out

by my refusal, which is prompted by feelings I am sure you will understand."[19] The canvas hangs to this day in Blok's apartment, now a museum in Saint Petersburg.

Intriguing as *The Rite of Spring* may be to scholars, archaeology concerned Roerich more in the first half of 1910. The previous autumn, his Pre-Petrine Commission (PPC) had made plans to dig at the Novgorod kremlin. In the winter and spring, Roerich raised money, secured official permission to work in restricted areas, and finalized arrangements with NOLD, the group of Novgorod antiquarians who had agreed to assist with the excavation. Unfortunately, Roerich and NOLD's head, Mikhail Muraviev, disliked each other and differed as to what the dig was meant to accomplish. To everyone's eventual dismay, they left key details unresolved until the dig's opening in July 1910.

Meanwhile, at the IOPKh School, Roerich presided over the end of the academic year. A sad intrusion came in April, when Mikhail Vrubel, after his long struggle with madness, died. On a bleak afternoon, Roerich, with a host of other artists, attended the funeral; a photo shows him comforting Vrubel's widow, the actress-singer Nadezhda Zabela-Vrubel.[20] In May, Roerich grappled more metaphorically with the mysteries of death, for this was the time of his fateful meeting with Stravinsky that begat *The Rite of Spring*. Roerich had been spending more

time in Stravinsky's company; the previous December, he and Benois had taken Stravinsky to an art show featuring Čiurlionis, convincing him to buy one of the Lithuanian's paintings.[21] Now, half a year later, the pair roughed out a basic scenario for their ballet—called, for the present, *The Great Sacrifice*—and while they planned to pitch their idea to Diaghilev eventually, they agreed not to mention it to him or anyone else before developing it further.[22] They then parted ways. Stravinsky headed to his country home near Ustilug, and afterward to France, where he would see Diaghilev. Roerich, with the school year over, took his family to the Estonian resort of Hapsal, where Helena and the boys remained for the summer. At the end of June, he returned to Petersburg.

Roerich did so to prepare for his Novgorod excavation, but tragedy brought him back as well. Arkhip Kuinji, whose heart had begun failing earlier that year, now lay gravely ill, and Roerich wished to make himself as useful as possible. As the first "Kuinjists" on the scene, he and Viktor Zarubin informed other former students of their teacher's plight, collected money to pay for doctors and medicine, and drew up a schedule to ensure the constant availability of students and friends. With his departure date already fixed, Roerich could be present for only half a week, but even that short time disordered his nerves.[23] Kuinji's wife Vera had her own ideas about how to take care of her husband and did not hesitate to scold well-wishers she thought overly meddlesome.

Worse was the patient himself. Bogaevsky said of Kuinji that he died like Prometheus, but while he had epic courage in mind, the analogy describes more aptly the pain—no less excruciating than the chained titan's torment—that lanced through Kuinji's body and could not be dulled even by morphine. At times, the artist raved or slipped into delirium. Roerich recalls one such spell, when Kuinji cried out in the dim light, "Who's there?" "Zarubin and I," Roerich answered. "But how many of you are there?" "Just the two of us." "Then who is the third person behind you?" Kuinji wondered. Moments of lucidity were little better, for Kuinji bickered with those watching over him. "I went to pieces after sitting with Arkhip yesterday," a weary Roerich told Helena. "He abused me awfully, and all good feelings between us have been exhausted."[24] According to the rota he and Zarubin devised, Roerich was slotted to take a second turn with Kuinji in a month's time. For now, on July 4, he found it a relief to leave the sickroom and board the boat to Novgorod. Sooner than expected, he would be back at Kuinji's side—but as a mourner, not a caregiver.

Half a month of disappointment awaited in Novgorod.[25] Roerich and Mikhail Muraviev had never clarified how the Pre-Petrine group—Roerich, his brother Boris, Nikolai Makarenko, Vasily Meshkov, and Iosif Mikhailovsky—would work with their NOLD colleagues, or which team would complete what tasks. Having brought 1,000 rubles to the table, courtesy of Princess Tenisheva, Roerich expected NOLD to contribute funds too. Muraviev, convalescing from an illness, was not on hand to speak for NOLD, increasing the potential for unsettled questions to become serious disputes. The Novgorodians expected the Pre-Petrines to stay until the last week of July. They also envisioned a joint survey of Novgorod's kremlin and the Cathedral of Saint Sophia, with the two parties regularly comparing findings.

It came as a shock, then, when on the sixth, Roerich and his brother decamped to Rurikovo Gorodishche, several miles to the south, where the Volkhov flows out of Lake Ilmen. Although Roerich appreciated the kremlin's importance, he delegated the study of it to Mikhailovsky, who measured the citadel's walls, and to Meshkov and Makarenko, who focused on the Kokui and Prince's towers. For himself, Roerich set the goal of scooping up as many specimens as possible for the PPC's future museum. Sound practice or not, this was most efficiently done by spreading out over as many sites as possible. Besides, Gorodishche, home to Holmgard, one of the earliest Viking outposts in Russia, was older than Novgorod and interested Roerich more.

Several pleasant days went by. Despite occasional showers, the weather proved ideal for open-air work, and Roerich loved the wide vistas, with the lake on one side, rolling hills on the other, and monastery

domes silhouetted against the horizon. He found bracelets, beads, and birchbark documents, and traced the original foundations of the local church, which had been rebuilt after a fire in 1201. Prompted by letters from Stravinsky, he devoted some of his attention to *The Great Sacrifice*. Notebooks from the trip show how Roerich based his early set designs for *The Rite* on sketches of clouds over Gorodishche and stone circles along the Ilmen shore.[26]

Things went wrong after a week, starting with an outcry from the Novgorodians about Roerich's failure to work where he had been asked to. On the tenth, an annoyed Roerich told Helena that NOLD was threatening court action. Digging in Novgorod itself yielded information of scholarly worth, but few museum-quality collectibles. Roerich located some seventeenth-century tiles on the grounds of the Nikolo-Vyazhishchsky Monastery—another unauthorized trip, this time to Novgorod's northwest—but the abbot refused to sell them. Then, on the evening of the eleventh, came terrible news. Kuinji had passed away earlier that day.

Afterward, Roerich spoke of this event philosophically, reflecting on a Russian proverb that "the kindest people die the hardest deaths."[27] With Vladimir Beklemishev and the architect Alexei Shchusev, he would pay tribute to Kuinji by designing the artist's tomb: a black structure suggesting the form of a Greek temple, with a mosaic depicting the tree of life in red, gold, and amber. (It stands near the Alexander Nevsky Monastery, less than a minute's stroll from the tombstone created by Roerich for Rimsky-Korsakov.) At the time, though, there was no such detachment, as Roerich rushed back to Petersburg on the overnight steamer. With Stasov four years dead, both his mentors were now gone, an emotional blow regardless of the conflicts he had had with each of them. Being alone with his memories in the family's empty apartment did nothing to improve his mood, nor did updates from Makarenko in Novgorod about the ongoing "cock-up" with NOLD.[28] Kuinji's *panikhida*, or public memorial, took place on July 12. With Zarubin, Roerich carried a wreath purchased by Kuinji's students, and he observed with relief how peaceful his teacher's face appeared in death. The funeral was held at the Alexander Nevsky Monastery on the fourteenth; immediately afterward, Roerich sped to the harbor. He reached Novgorod on the morning of July 15, drenched by pouring rain.

From then on, the weather worsened, NOLD kept complaining, and the earth turned up nothing suitable for museum display. Makarenko's wife pestered him to come home, and Roerich, who had been expecting Helena to visit, was crushed when she fell sick and begged off. The Pre-Petrine team had spread itself too thin and could not hope to complete all its tasks, even if it dug till the end of the month as planned. Roerich informed NOLD that his group would pack up on the twenty-fifth or twenty-sixth—then, with no warning, left on July 21. "Roerich and his companions have

vanished," a dumbstruck NOLDist reported to Muraviev. "What condition the dig is in, what was done or found, when or whether Roerich intends to return, I do not know, I do not know, I do not know."[29] Muraviev, still confined to his sickbed, was brought to the point of conniption by the Roerichs' next communication, delivered by Boris. Because NOLD had promised material support, but had not delivered, and because city officials had proved so obstructive, the PPC had had no option but to suspend operations. If NOLD provided 150 rubles to keep the trenches open and protect them with temporary roofs, work could perhaps resume next summer.

An infuriated Muraviev spent months accusing Roerich of uncooperativeness and arrogance, but his charges, justified or not, were deflected by journalists and archaeologists sympathetic to the artist. Essays in *Bygone Years* denounced NOLD and Novgorod's authorities as cheapskates, and the *Saint Petersburg News* printed Roerich's tale of a promising start sabotaged by philistine stinginess.[30] This version of the story prevailed at the 1911 congresses of the Russian Archaeological Society and the Russian Architectural Society, and even NOLD overruled Muraviev that May, voting for renewed cooperation with the PPC. By that point, however, Roerich had taken on other commitments. The trenches dug in 1910 were filled in for good by order of the Novgorod governor.

Roerich paused in Petersburg after leaving Novgorod, then caught up with his family in Hapsal. He finished the last pieces of the Viking suite begun in 1906, and other northern canvases followed: *Horses of Svetovit*, *The Viking's Daughter*, and *Across the Seas are Great Lands*. He made side trips to Reval and Riga, then spent the last half of August at Talashkino. There he oversaw the application of plaster to the walls of Tenisheva's Church of the Holy Spirit. He also took the opportunity to dig at Kovshary, a recently opened tumulus near Smolensk. Spearheads, axes, and figurines lay everywhere; as he told Helena, he did more useful work there in two days than he had in two weeks in Novgorod.[31]

The Great Sacrifice moved forward as well, but not smoothly. Infighting racked the Ballets Russes in mid-1910: Fokine quarreled unceasingly with Diaghilev, and Benois, angry with Diaghilev and Bakst, gave up his post as artistic director and moved to the Swiss town of Lugano. Diaghilev, pushed to the point of paranoia, saw plots everywhere. Stravinsky and Roerich had put off telling him about their project precisely because they feared he would think they had been scheming behind his back. But Stravinsky found himself cornered in France, when Diaghilev asked him to follow *The Firebird* with a ballet based on Poe's *Masque of the Red Death*. Stravinsky confessed that he had other plans, and "this touched off an explosion," as he told Roerich in a letter sent from La Baule in July: "'What' [cried Diaghilev.] 'You keep secrets from me, I

who do my utmost for you? Fokine, you, everyone has secrets from me!' Etc., etc. I had to tell him [about *The Great Sacrifice*], but I begged him not to repeat it. As soon as I said that I was working with you, both Diaghilev and Bakst were delighted, Bakst saying that he thought our idea was a noble one. [They] would have been very offended had Benois been involved."[32] ("What does Bakst care?" Roerich wondered as he scanned the letter, which Helena forwarded to him in Novgorod during his dig there.[33]) The tantrum ended, and Diaghilev gave his blessing to the project.

But not completely. Diaghilev loathed it when subordinates acted independently, and he feared Roerich's growing influence over Stravinsky. Moreover, Diaghilev wanted Benois back, and the carrot he hoped to dangle before his sulking compatriot was a commission to design a new production by his star composer, scheduled for 1911. Diaghilev offered this in July 1910, when he visited Lugano to make peace with Benois, but the proposal, however tempting, had no value so long as Stravinsky remained all afire to work with Roerich. Diaghilev could not dictate to his protégé, who, if pressed too far, might bolt to another manager. That August, for instance, Stravinsky threatened to take *Sacrifice* to the Imperial Theaters if Diaghilev did not mend his fences with Fokine.[34] Luckily for Diaghilev, Stravinsky was also toying with the idea of a ballet inspired by folk puppetry. This was the mental germ from which *Petrushka* sprouted, and Diaghilev encouraged it as a way of redirecting Stravinsky's enthusiasm away from *Sacrifice*. In September, Diaghilev promised to include *Petrushka*, designed by Benois, in his 1911 season. It would be a sensation, he predicted, whereas Roerich's project, fine as it was, could be done any time. And so Stravinsky, who had been badgering Roerich in August to start work on their "child," and telling Benois that he would turn to him *after* finishing with Roerich, now put *Sacrifice* on the back burner.[35]

In Russia, the press began in June and July to write about the Roerich–Stravinsky collaboration. The widely read *Russian Word* noted, "Academician N. K. Roerich, I. F. Stravinsky, the young composer of *The Firebird*, and the choreographer M. M. Fokine are at work on a new ballet, titled *The Great Sacrifice*. Subject matter and staging are by Roerich."[36] The *Petersburg Gazette* and *Russian Musical Gazette*, referring like *Russian Word* to the ballet as "Roerich's," reported on the project in August, and *Theatrical Review* interviewed Roerich about it in September. Roerich had this to say:

> To work my subject into an opera would have been impossible, so I turned to ballet instead. Movement will be the dominant element, and there will be little opportunity for singing—although, behind the mound, the sound of prayers being intoned will be audible during the entire production. . . . I want to depict how, under the starlit summer night, on the top of a sacred mound—known to us historically by the example of the stone

labyrinth—a series of ancient Slavic ritual dances took place, culminating in a human sacrifice. The costumes for my ballet should prove of special interest, for this epoch has never before been dramatized in such a way.[37]

When Roerich mentioned the "starlit *summer* night," he did not misspeak. At first, *Sacrifice* was meant to reenact the Kupala festival, celebrated at midsummer. Also at this point, Roerich and Stravinsky were thinking of it as a short one-act piece.

Because of Diaghilev's interference, the ballet took on a different shape. With Stravinsky distracted by *Petrushka*, there was no chance of staging *Sacrifice* in 1911. In an October letter to Roerich, Diaghilev feigned disappointment: "How annoying that Stravinsky will not have our ballet ready for the spring. Still, *ce qui est remis n'est pas perdu* [what is postponed is not lost]."[38] But these were crocodile tears. Diaghilev had exactly what he wanted: Benois back in the fold (for now) and Stravinsky firmly under his thumb. The change irked Roerich, and though he appears not to have been vocal with his displeasure, Stravinsky worried for a while about his temper, as he admitted to Benois in November: "I do not know whether Roerich will be angry at me. He has not written to me. It will not do for him to be offended. After all, it is not as if I have abandoned *The Great Sacrifice* or put it on the shelf. I plan to get to it immediately after I finish *Petrushka*."[39] Fortunately, delay did not mean derailment, and

the two men resumed their effort. Indeed, the extra time made the ballet more than it would have been otherwise. Its seasonal clock was dialed back to the vernal equinox, and it evolved into a longer work, thought out with greater care.

Roerich's theatrical ambitions went beyond his work with Stravinsky. After the success of *Prince Igor*, he desired more than ever to make his mark as a stage designer. He had no luck with the Imperial Theaters—the Mariinsky, the Bolshoi, the Malyi—partly because they were more traditional, partly because Vladimir Telyakovsky, the Ministry of Palaces official in charge of them, disliked him. "Roerich is such a string-puller," Telyakovsky harrumphed. "Everyone keeps pushing his designs on me."[40] But if those doors remained shut, others were easier to open. In addition to the Ballets Russes, Roerich set his sights on Petersburg's and Moscow's many private troupes.

There were false starts and letdowns. In 1910, Roerich joined the composer Alexander Lyadov in trying to adapt the symphonic suite *Kikimora* for the stage. They found no takers, although Roerich sold one study, "Kikimora's Chamber," to a local collector.[41] That October, as consolation for postponing *The Great Sacrifice*, Diaghilev commissioned Roerich to design Rimsky-Korsakov's *Sadko*, which the Ballets Russes put on in 1911. Diaghilev asked him to start with a scene of Lake Ilmen: "A green forest landscape . . .

pines and fir, none of the too-cute, 'poetic' trees we Russians are so fond of painting."[42] For some reason, Roerich sent Diaghilev a sketch of Sadko's boat instead, and when the opera opened, it was Boris Anisfeld, not he, who provided the sets.[43]

Instead, Diaghilev assigned Roerich to *The Tale of the Invisible City of Kitezh*, another Rimsky-Korsakov opera scheduled for 1911. Adapted from the hagiography of Saint Fevronia, *Kitezh* chronicles the city's brave fight against Tatar marauders. Rather than surrender, the people of Kitezh pray for a miracle, which is granted when God showers the city with a golden mist and transports it to Paradise. (An enduring legend has it that, on Saint John's Eve, the pure of heart can see the golden spires of Kitezh in the depths of nearby Lake Svetoliar.) Russian Symbolists attached great significance to the Kitezh myth, associating it with tales of Atlantis and the Holy Grail.[44] So did Roerich, and he was pleased to work on the opera.

Roerich contributed only one design to *Kitezh*, but it proved a showstopper. Golovin and Stelletsky completed the sets. To Roerich fell a special drop curtain that was to be lowered in the middle of act 3. To depict the tragic battle of Kerzhenets, during which Kitezh's young prince perishes, Rimsky-Korsakov composed a symphonic interlude; Roerich's curtain was to hang before the audience at this emotional juncture. He based his composition on a sixteenth-century iconographic scheme known as "The Church Militant," but painted it with the post-Impressionist edge of a Van Gogh or a Matisse.[45] On June 13, *Kitezh*'s opening night, the curtain's riot of greens and crimsons, plus the illusion it created of two moving armies about to collide, astounded Paris theatergoers. The audience gasped in admiration and did not stop applauding until the curtain had been lowered and raised twelve times. Stravinsky wrote Roerich about the design's "great success," and Roerich was asked two summers later to reproduce it in larger format for the new Kazan Station built by Alexei Shchusev in Moscow.[46]

Roerich's last commission from 1910–1911 began with a homecoming, but ended unhappily. The Ancient Theatre, for which Roerich had designed *The Three Magi* in 1907, reopened in 1911, reuniting artists like Roerich, Bilibin, and Dobuzhinsky with directors Nikolai Evreinov and Konstantin Mardzhanov. This new season consisted mainly of plays from sixteenth- and seventeeth-century Spain, and Roerich was asked to design the set for Lope de Vega's *Fuente Ovejuna*.[47] Bilibin saw to the costumes. Belying the common assertion that Roerich avoided the everyday business of theatrical production, the actor Alexander Mgrebov attests to his close work with the troupe during rehearsals: "I remember how carefully and thoughtfully Bilibin and Roerich consulted with the performers. They altered their designs several times, and even invited us to their studios."[48] Despite such efforts, *Fuente Ovejuna* did not live up to expectations. The premiere, held on

November 18, was a red-carpet event, with Nicholas II and the Empress Alexandra in attendance. Comic skits by Cervantes and a demonstration of gitano dancing were prepared as intermission entertainments. But Mardzhanov's direction displeased the audience, and the set—a humble village, with the overlord's castle looming on a mountain ridge—fell short as well. This was no fault of Roerich's, but that of V. V. Emme, the in-house artist who installed the set. When Roerich complained about the shoddy work, Emme retorted that Roerich knew nothing about translating two-dimensional art into three-dimensional reality. This was true of some painters, but not Roerich, and critics, Benois among them, panned Emme for having "squandered" the excellence of Roerich's design.[49] As an exhibition piece, Roerich's *Fuente Ovejuna* met with acclaim, winning praise from Ostroumova-Lebedeva for its "expressiveness," but he was left yearning for a new stage success to match that of *Prince Igor* or *Kitezh*.[50]

Roerich spent so much time designing for the theater during these years, it is easy to forget how much easel work he did. He exhibited at least two or three times annually, both abroad and in Russia.[51] Shows took his work to Brussels, for the 1910 Universal Exposition, to Austria-Hungary, and to London's Second Post-Impressionist Exhibition, where Russians enjoyed a huge success in 1912. He was in Paris three times:

with Bernheim Jeune and Company in 1910, at the Museum of Decorative Arts in 1911, and, in 1913, organizing a display of Russian folk art at the Salon d'Autômne. The foreign press noticed him more, especially in Germany and France. Yakov Tugendhold, the critic who launched Chagall's career in the West, profiled Roerich in a 1912 issue of *L'Art Decoratif.*

Roerich's paintings were included in the Dobychina Permanent Exhibit (Saint Petersburg) and the 1913 Exhibition of Theatrical Art in Warsaw. Then there were the World of Art exhibitions, which, under Roerich's leadership, resumed in 1911. Roerich took part in the 1911 and 1912 shows, contributing to the latter a "vast wall" of canvases, as Alexander Rostislavov put it. Overcommitted in 1913, Roerich opted out of the World of Art that year, although he arranged for the IOPKh to host the show; his presence there was "sorely missed," according to *Apollo*.[52] In late 1912, he helped plan the Second All-Russian Congress of Artists, where Wassily Kandinsky's famous manifesto, *On the Spiritual in Art*, was first presented to a Russian audience. Kandinsky himself returned from Germany for the occasion, hoping to confer with the Jack of Diamonds group. In letters to friends, he expressed an eagerness to meet Roerich, and this is likely the one time that the two encountered each other in person.[53]

All this time, new art flowed from Roerich's brush. Much of it was religious, as Roerich continued fusing biblical imagery with assorted mythic traditions. *The Book of*

Doves (1911), in which a giant tome descends from heaven to teach the will of God to Russia's faithful, is based on a fable collected by Alexander Afanasev, who, like the orientalist Grigori Potanin, believed it to have roots in India's Vedic sagas.[54] Roerich's use of the tree-of-life motif—as in *The Benevolent Nest* (1911), *The Benevolent Tree Bearing the Gift of Solace to the Eyes* (1912), and Kuinji's gravesite—recalls not just the book of Genesis, but also Yggdrasil, the world tree of Norse legend, and the majestic oak held sacred by the pagan Slavs. Roerich used oak trees in early sketches for *The Rite of Spring*, and he mixed Christian and non-Christian elements in his decor for Princess Tenisheva's Talashkino church.[55]

A similar pantheism characterizes Roerich's primeval scenes, which include a second version of *Heavenly Battle* (1912) and, in 1910, new variants of *Idols. The Stone Age* (1910) depicts villagers dancing by a lake, as if to illustrate the essay "Joy in Art" from the year before, while *Starry Runes* (1912) hints at unseen supernatural forces. In such works, as in *The Rite*, Roerich comments on ancient humanity's innate spirituality and social cohesiveness, but strives also to show how Slavic lore arose in a larger Eurasian setting. Two canvases make this point by mixing northern and Asiatic references. *The Chud Departed beneath the Earth* (1913) alludes to a myth in which members of a lost tribe escape tyranny by fleeing underground and founding a kingdom there. "Chud" was an old term by which Slavs called the Finno-Ugric, reindeer-herding Komi of

northwestern Russia, and Komi stories of a subterranean sanctuary were thought by ethnographers like Potanin to have come from the Altai Mountains, on Siberia's southern fringe. Such tales fascinated several Russian poets, among them Roerich's friend, Nikolai Gumilev, and Sergei Yesenin.[56] *Human Forefathers* (1911), in which a piper serenades a group of bears (see Illustration 14), plays on the scholarly theory, learned by Roerich from Stasov, that prehistoric Slavs believed themselves to have sprung from ursine ancestors.[57] Roerich identified his piper both with the animal-taming Orpheus and the flute-playing shepherd Lel, from the tale of the Snow Maiden. He also saw Lel as a Russified avatar of the Hindu demigod Krishna, and in later works on the bear-charming theme, such as *Our Ancestors* (1919) and *The Magic of Beasts* (1943), the musician takes on a more Asian appearance.

Roerich was seized by apocalyptic mysticism as he painted his "prophetic" canvases, which date from 1912 to 1915 and inspire feelings of crisis and dread. (Critics labeled these works "prophetic" during World War I, when, as Alexander Gidoni wrote in *Apollo*, it was tempting to see them as products of premonitory insight. But this was metaphor; only adherents believe they were inspired by actual clairvoyance.[58]) Four of these appeared in 1912, starting with *The Last Angel*, conceived by Roerich upon waking from a dream in which a voice cried out:

> The Angel of the End Times will fly
> above the earth.

Terrible, most terrible,
Beautiful, most beautiful—
The Last Angel.[59]

Like a vision from the Book of Revelation, the crimson-robed angel watches from a cloud as fire consumes castles and churches below (see Illustration 17). Following this were *Sword of Valor*, in which an angel protects a tower whose guards are sleeping, and *The Purest City Proves a Vexation to Its Enemies*, greatly admired by Maxim Gorky.[60] In *Purest City*, demons attack an alabaster stronghold; riding to the rescue is a white horseman representing the King of Shambhala. In *Cry of the Serpent*, a gigantic snake, coiled at the foot of a dark mountain, lifts its head to howl in alarm. To Roerich, steeped in Hindu and Buddhist symbology, the serpent represented *kundalini*, or earthly wisdom, and its warning carried the force of premonition.

More such works, equally grim, were soon to come. In them, Roerich may have been allegorizing specific events or venting less identifiable anxieties. Either way, his esoteric convictions, more strongly than ever, were conditioning how he understood not just art and ideas, but social and political realities.

A crucial episode in this transformation unfolded between 1909 and 1915, as Roerich worked with the Saint Petersburg Temple Commission, which oversaw the construction of a Buddhist *datsan*, or place of worship, in the capital's Staraya Derevnia district.[61] Ground was broken in 1909, on Primorsky Prospect, and the three-story structure, its walls of deep-rose stone flanked by pink marble columns and topped by brightly painted woodwork, went up quickly enough to allow services to be held in celebration of the Romanov dynasty's 1913 tercentenary. Not everyone rejoiced to see the temple open. Right-wing extremists belonging to the xenophobic Black Hundreds picketed the construction site, and the Orthodox Church, warning that the temple's appearance signaled the coming of the Antichrist, damned it as an "idolatrous pagoda."[62] After two years of final touches, the temple was consecrated in 1915.

The Art Nouveau architect Gavriil Baranovsky built the temple, and among the artists completing its decor were Roerich and his friend Varvara Schneider, niece of the Indologist Ivan Minaev. Roerich designed the sanctuary's skylight, a blend of Buddhist iconography and Tiffany-style glasswork. In delicate hues of olive and lilac, the skylight bore the Eight Auspicious Symbols representing the Buddha's Middle Way, along with a pattern of the sacred thunderbolt (*vajra*, or *dorje*). Of greater importance, though, was how Roerich's service on the Temple Commission translated his Buddhist-Theosophical beliefs into political ideology.

The Temple Commission, chaired by Vasily Radlov, an Academy of Sciences expert in Mongol-Turkic philology, included

Fyodor Shcherbatskoi, a professor of Sanskrit and Buddhist studies at Saint Petersburg University, and the Buddhologist Sergei Oldenburg. Also on the commission were Andrei Rudnev and Vladislav Kotvich, lecturers in Mongol studies at Saint Petersburg University, and Prince Esper Ukhtomsky, who directed the Russo-Chinese Bank and edited the *Saint Petersburg News*. Ukhtomsky, a Theosophist, had known Roerich since 1904. The ostensible reason for building the temple was to show goodwill to Central Asian Buddhists—Buryats, Kalmyks, Mongols, and Tuvans—visiting or living in the capital. However, like many orientalists in the 1800s and 1900s, most of the commission's members not only studied Asia, but sympathized with it culturally or practiced its faiths as "neo-" or "theosopho-Buddhists."[63] Their principal, if less public, goal was to bind Russia and Tibet more closely, thereby advancing Russian diplomacy in Asia and consolidating loyalty among Russia's Buddhist subjects, most of whom paid obeisance to Tibet's Vajrayana form of Buddhism. The driving force behind this scheme, politically and spiritually, was the Buryat monk Agvan Dorjiev, the Thirteenth Dalai Lama's plenipotentiary in Russia.[64]

Tibet at the turn of the century struggled to maintain autonomy from China and was also caught up in Britain's and Russia's so-called Great Game, the two countries' duel for influence over the Middle East and Central Asia. Competing factions at the Potala Palace, where the Dalai Lama held court, favored aligning with Britain or Russia as a counterweight to China's regional hegemony. Dorjiev, one of the Dalai's boyhood tutors, stood in the pro-Russian (and pro-Soviet) camp for almost half a century, although he never achieved the alliance he hoped for. "My forty-year-long political activity," he sadly recalled, "was directed toward establishing the best relationship between Tibet and Great Russia, but I was unable to do much for the actual independence of the Tibetan people."[65] Dorjiev met with Nicholas II on several occasions, as did the Buryat herbalist Pyotr Badmayev, whose purported gifts of healing made him the toast of Saint Petersburg. Both proposed the formation of a pan-Buddhist confederacy that would join Mongol, Turkic, and Tibetan coreligionists under Russia's protection. This was hardly a new idea: the explorer Nikolai Przhevalsky had suggested such a plan in 1880, and the conservative philosopher Konstantin Leontiev, in works such as *The East, Russia, and Slavdom* (1886), wrote in a similar vein. Still, despite urging from advisers like Sergei Witte, who opined that "Russia must do everything possible to counteract the extension of British influence over Tibet," Nicholas II wavered on this question.[66]

The British, unaware of the tsar's hesitancy, feared that Russia might outflank them in India by gaining a foothold in Tibet. So, in late 1903, they sent Francis Younghusband and a thousand-strong force to take Lhasa. The following August, after several battles, the expedition reached its goal, driving the Dalai Lama into exile

until 1909, first to Mongolia, then to China. No sooner did the Dalai return than Tibet was invaded again, this time by the Chinese general Zhao Erfeng, and he fled to India in 1910. There, Charles Bell, Britain's political officer in Sikkim, safeguarded him until 1912, by which time the Qing dynasty had been toppled by revolution and replaced by the Chinese Republic. Bell smoothed over the hard feelings left by the Younghusband campaign, and when the Thirteenth Dalai reinstalled himself in Lhasa, his inclination for the moment was pro-British. Meanwhile, a 1907 treaty between Britain and Russia sketched out mutually acceptable spheres of influence in Persia, Afghanistan, and Tibet, creating the Anglo-Russo-French Entente and ending the Victorian phase of the Great Game.

None of this kept Dorjiev from trying to shift Tibet into Russia's orbit, and Russian orientalists were eager to help him. In 1907, he submitted a memo to the Russian Geographical Society—"On Closer Rapprochement between Russia, Mongolia, and Tibet"—echoing Badmayev's proposal, "The Union of Mongolia, China, and Tibet with Russia."[67] The tsarist foreign ministry, anxious to abide by the 1907 treaty with Britain, brushed such plans aside. Still, the archaeologist Pyotr Kozlov, a protégé of Przhevalsky's, supported Dorjiev, as did the Temple Commission, forming a "Tibet lobby" of sorts in Petersburg.[68] The temple, paid for by Dorjiev with funds from the Dalai Lama's treasury, was a tool in that lobby's efforts.

Dorjiev spoke of Russo-Buddhist union not just as a matter of strategic calculation, but in terms of cosmic destiny. Borrowing a propaganda trope that tsarist officials had promoted among Russia's Buddhists since the days of Catherine the Great, he taught the Dalai Lama that Nicholas II was an avatar of the Buddha of mercy. Himself a student of Kalachakra—the "wheel of time" doctrine that entered Tibetan Buddhism in the tenth or eleventh century—Dorjiev foretold that the eagerly awaited land of Shambhala would reappear to the north of Tibet, in lands belonging to Russia. He emphasized the *Shambhala Lamyig*, a seminal text attributed to the Third Panchen Lama and formally compiled in the eighteenth century. According to the *Lamyig*, if ever the Panchen were forced to leave his homeland, barbarian armies would overwhelm the earth. Rigden Djapo, the "wrathful one," would arise as the King of Shambhala and ride his steed into battle, vanquishing these forces of darkness and reigning over Satya Yuga, a new era of perfection and universal enlightenment.

Tibetan and Mongol Buddhists in the early 1900s took comfort from the Shambhala prophecy, which held out hope for deliverance from foreign domination, and many believed its realization was close at hand. Was Dorjiev among them? Or did he use Shambhala rhetoric politically, to manipulate his Slavic partners' Buddhist enthusiasms? Both are likely true, to judge by the parallel example of India, where spiritual leaders such as Ramakrishna and

Vivekananda engaged in heartfelt religious dialogue with receptive Westerners and simultaneously exploited whatever anti-colonial advantages might derive from the resulting friendships. Dorjiev appears to have operated similarly with his Russian associates, although what each of them made of his discourse varied. Some, including Oldenburg, reserved judgment or saw it as symbolically meaningful. Others, more fervent, regarded it as gospel.

As for Roerich, everything Dorjiev said squared with what he had learned from the works of Blavatsky and Besant, who wrote of Maitreya, Shambhala, and a second advent that would unfold not in the Judeo-Christian world, but in Asia. It is likely a mistake to imagine, as some have, that an unbroken conspiratorial effort linked Roerich's Dorjievite ties in the 1910s with the religio-political maneuvers he attempted to carry out during the 1920s and 1930s. However, Roerich maintained contact with Dorjiev into the 1920s, and the people and ideas he encountered while working on the temple had a major impact on his later actions.[69] At a minimum, the temple project filled Roerich's mind with visions of a new Asia: vast, wise, and holy. Before long, he would dream of bringing that Asia into existence himself.

Roerich's esoteric pursuits were not confined to the Temple Commission. Even if he and Helena never joined the Russian Theosophical Society, they interacted with individual Theosophists. Nicholas also attended meetings of the Religious-Philosophical Society (RPS), though he was of two minds about it. There, he moved among likeminded truth-seekers, and many of their ideas appealed to him. But the vagueness of the group's program frustrated him, and he often repeated Alexander Blok's complaint about the RPS's meandering debates: "There, they speak only of the inexpressible."[70]

Many of Roerich's relationships were driven by common interest in unconventional beliefs, as with Blok, Andrei Bely, Viktor Zarubin, and Jurgis Baltrushaitis. Varvara Schneider was likely a Theosophist, and Nicholas and Helena spent one Easter holiday with Alexei Remizov and his wife Serafima, using the author's favorite Swedenborg deck to read the Tarot.[71] (A true eccentric among Russian writers, Remizov, described as a "sorcerer-dwarf" by the author Nina Berberova, shared occultist proclivities with Roerich for years to come.[72]) The poet Nikolai Gumilev, whom Roerich remembers as "burning with goodness," often visited in the evenings; they talked of ancient Tibet and the New Jerusalem, as well as Gumilev's ethnographic expeditions to East Africa.[73] Recent scrutiny has fueled speculation that Roerich belonged to a Masonic or Rosicrucian lodge; one theory has him joining a Martinist circle led by Grigori Mebus and Czesław Czynski, and including Baltrushaitis and Blok, Oldenburg and Shcherbatskoi, the sculptor Sergei Merkurov (cousin to the

mystic George Gurdjieff), and Konstantin Riabinin, who accompanied Roerich to Tibet in the 1920s. Such an agglomeration is not impossible, but nothing beyond hearsay indicates Roerich belonged to it, and even if he did, caution is required—as with the Temple Commission—in guessing how directly its activities were connected with his later ambitions.[74]

From time to time, Roerich involved his more skeptical colleagues in occult activities. Igor Grabar tells of one such moment in 1911, when Jan Guzik, a Polish medium, offered a series of séances in Petersburg.[75] The tall, gaunt psychic, who reminded audiences of Don Quixote in evening dress, attracted much attention; among those who saw him perform were Blok, Pyotr Ouspensky, and Tsar Nicholas himself. The Roerichs hosted one of Guzik's séances, and their guests included Grabar, Nijinsky, Benois, and Diaghilev, who brought a lavish bouquet of roses for Helena. In his memoirs, Grabar professes to have been uninterested in attending, but Benois persuaded him that the event "might be somehow amusing." As it turned out, Grabar created his own amusement by disrupting the proceedings once the séance got underway. Sensing movement under the table, he let go of his neighbors' hands and tried to lay hold of whatever was underneath. As he tugged in the darkness, he was struck hard enough in the spine to make him leap out of his seat. The lights turned back on, and the séance came to a hasty and awkward conclusion.

Roerich's mysticism was not always so melodramatic, or necessarily occultist. Much of his thought falls into the broader category occupied by god-seeking metaphysicians and theologians like Vladimir Solovyov, Nikolai Berdiaev, Pavel Florensky, and Nikolai Lossky—Roerich's friend from university—all of whom blended Christian belief with a conviction that abstract ideas affected the world in concrete ways. As Solovyov affirmed, "I believe in the supernatural; strictly speaking, I believe in nothing else."[76] Elements of cosmism, Sophiology, and Tolstoy's Christian-pacifist spirituality found their way into Roerich's worldview, as did a Dionysian appreciation of ancient ritual's unrestrained exuberance. Roerich also began a career-spanning effort to "prove" the paranormal scientifically valid by befriending the neurologist Vladimir Bekhterev, second only to Ivan Pavlov among Russian psychologists.[77] One of Bekhterev's research priorities—doomed to failure, despite Roerich's hopes for it—was to investigate possible physiological explanations for such phenomena as telepathy and extrasensory perception. After 1917, Bekhterev headed the USSR's prestigious Brain Institute, but came to a bad end. Invited to the Kremlin for private consultations with Stalin, Bekhterev is said to have diagnosed him to his face as paranoid, and many explain his sudden death in 1927 as a murder ordered by the leader.[78]

More than anything else, syncretism now characterized Nicholas's and Helena's faith, a frame of mind illustrated by Roerich's 1911 poem "Sacred Signs":

I. The Father is fire. The Son is fire.
The Spirit is fire.

These three are equal, these three are
indivisible.

Their heart is flame and heat,

Their eyes are fire,

Wind and flame are their mouth.

Fire is the Flame of Godhood.

Fire will sear the evil ones,

Flame will burn the evil ones,

Flame will stay the evil ones,

It will purify the evil ones.

Bend back the demons' arrows.

Let the serpent's poison descend upon
the evil ones!

Aglamide, Commander of the Serpent,

Artan, Arion, pay heed!

Tiger, eagle, lion of the desert wastes,

Guard against the evil ones!

Coil up like the serpent, be burned by
fire!

Disperse, perish, O evil!

II. The Father is peaceful. The Son is
peaceful. The Spirit is peaceful.

These three are equal, these three are
indivisible.

Their heart is the blue sea,

Their eyes are the stars,

The night dawn is their mouth.

The sea is the Depth of Godhood.

The evil walk upon the sea.

They cannot see the demons' arrows.

Lynx, wolf, gyrfalcon,

Guard over the evil ones!

Widen the road ahead!

Keios, Keyosavi,

Let them in, the evil ones.

III. Know, Stone! Guard, Stone!

Fire, conceal! Be lit by fire!

By the red, the courageous.

By the blue, the peaceful.

By the green, the wise.

Know alone. Guard, Stone!

Foo, Lo, Ho, carry the Stone.

Reward the strong.

Compensate the faithful.

En-no-Gyoja,

Hurry here![79]

Contained in these stanzas are allusions to the Christian Trinity, the fire worship of ancient Zoroastrians, Zen meditation, and Taoist ritual (*fu*, *lu*, and *shou*, irregularly transliterated by Roerich, represent the star gods that embody happiness, prosperity, and long life). En no Gyoja is the seventh-century mountain ascetic credited with founding Shugendo, a Japanese tradition that fuses Buddhism and Taoism with Shinto and shamanistic practices. The poem makes evident the remarkable inclusivity of the couple's spiritual views. Could Roerich's art teach the same universal verities? He and Helena believed it could.

The early summer of 1911 found Roerich in Germany, buying art for the IOPKh Museum. He then spent July and August at Talashkino, working on Maria Tenisheva's Church of the Holy Spirit.[80] This visit was doubly important, because Stravinsky

joined him at Talashkino for a short but crucial consultation about *The Great Sacrifice*, which finally took shape as *The Rite of Spring*.

A small brick edifice, surrounded by fir trees, the Church of the Holy Spirit had been built in 1903, as a place for Tenisheva to lay her husband to rest. While she sojourned in Europe between 1905 and 1908, the building's decoration went unfinished. Now, to complete the job, Tenisheva would trust only Roerich. "He lives in the spirit," she said of him. "The fire of God has touched him, and through him God's truth will be spoken."[81] The princess shared Roerich's interest in the movement of ancient peoples like the Goths and Aryans across Eurasia, and she shared as well his pantheistic view of religion. She and Roerich spoke of the building not as the doctrinally correct Church of the Holy Spirit, but as the Church of the Spirit—a purposeful omission.[82]

Roerich took charge of two projects, an exterior mosaic above the entryway and an interior fresco for the church dome. For the former, he chose a Byzantine motif, the Savior Untouched by Human Hands (*Spas Nerukotvornyi* in Russian), which sets the face of a youthful but severe Christ against a white cloth. The fresco was based on a less traditional image, that of the Virgin Mary above a river, praying for the souls of those caught in its spate. Roerich had first proposed this idea in 1906, to the Parkhomovka Church of the Veil, but it had been rejected. Less concerned with scriptural purity, Tenisheva gladly approved it.

Time off from the church went toward archaeological work at neighboring Kovshary. And for two days at the height of summer, Stravinsky visited Tenisheva's estate to work with Roerich face-to-face. In June, with *Petrushka* having premiered in Paris, Stravinsky returned to Russia. *Sacrifice*, which he had put aside for over half a year, was foremost in his mind. "It is imperative that we see each other," he told Roerich, to "decide every detail—especially every question about staging—regarding our child."[83]

So, in the second week of July, Stravinsky went to Talashkino. He would rather have rendezvoused in Smolensk, but Roerich insisted on meeting at the estate. His sketches and materials were difficult to transport, and Talashkino itself, he expected, would inspire their efforts. He was correct on both counts, but Stravinsky had no easy trip. He missed a connection at Brest-Litovsk, and the trains' infrequent running left him with no recourse but to bribe a railway guard to let him board a cattle transport. He spent the next leg of his journey with a nervous eye on his coachmate, a large bull. "As it glowered and slavered," Stravinsky recalled, "I began to barricade myself behind my one small suitcase. I must have looked an odd sight in Smolensk as I stepped from that *corrida* carrying my expensive (or, at least, not tramp-like) bag and brushing my clothes and hat, but I must also have looked relieved."[84]

Talashkino proved more comfortable. The princess lodged Stravinsky in a charming guest house, and in this fairy-tale

cottage, he and Roerich made two key decisions. First, on Stravinsky's suggestion, they enlarged the ballet to two acts.[85] During "Kiss of the Earth" (often translated as "Adoration of the Earth"), Slavic tribes would gather for a holiday festival. "The Great Sacrifice" would culminate in the frenzied nighttime death of the Chosen Maiden, dancing before the tribe's elders. The second change involved the seasons. Instead of depicting the midsummer Kupala rites, Roerich and Stravinsky shifted the action to Semik, the "green week" when winter gives way to spring.

Subdividing each act proved easy. Act 1 consisted of an introduction and six scenes: "Divination with Twigs," "Circle Dance," "Games of the Rival Tribes," "They Are Coming, They Are Bringing Him," "Game of Abduction," and "Dancing-Out of the Earth." "Circle Dances, Secret Games" began act 2, followed by "Glorification—Savage Dance (Amazons)," "The Act of the Elders," and "Sacred Dance." Excepting "Dancing-Out of the Earth," the titles were Roerich's.[86] A few changes were yet to come. Diaghilev asked for adjustments, and Stravinsky, after conferring with Roerich—"I am burning with impatience to find out your opinion," he wrote in September—added a scene to act 1 and shuffled the sequence of events.[87] Act 2 gained an extra scene and its own introduction. Still, the ballet was fundamentally as it would be when it opened in 1913.

As Roerich had predicted, Talashkino's ambience assisted the cocreators in their efforts. Tenisheva's collection of folk costumes helped them decide how the dancers should be attired. They watched peasant dances and listened to performances by the singer and psalterist Sergei Kolosov. Roerich insisted that the sound of the *dudki*, the ancient reed pipes, be somehow reproduced, and it was soon after the July meeting that Stravinsky hit upon the idea of using a bassoon to do so in the introduction.[88] Roerich and Stravinsky discussed set designs, and the composer was impressed by the speed with which his partner "sketched his famous Polovtsian-type backdrops."[89]

Both men were satisfied with what they had done. Roerich stayed on at Talashkino, while Stravinsky left to spend the rest of his summer in Ustilug. Before departing, the composer, at Tenisheva's request, inscribed a few bars of *The Great Sacrifice*'s score on the beam of the house in which he and Roerich had worked; in the future, Roerich often wondered whether any trace of that mark had survived.[90] That fall, he returned to Petersburg for the start of the new school year at the IOPKh. Stravinsky moved from Ustilug to Clarens.

In September, newspapers reported on the duo's progress, with the *Petersburg Gazette* noting *Sacrifice*'s conversion into a two-act piece, and also its renaming.[91] Indeed, what to call the ballet had become a confusing question, and journalists gave it as many as eleven titles until standard usage took hold in 1912–1913.[92] By summer's end, Stravinsky and Roerich were calling "their child" *The Festival of Spring (Prazdnik*

vesny), but they changed again to *Sacred Spring* (*Vesna sviashchennaia*), which remains the standard Russian title. In the West, Léon Bakst's French translation of *The Festival of Spring*—*Le Sacre du Printemps*—had caught on, becoming *The Rite of Spring* in English.[93]

Stravinsky made excellent headway over the next months. In September, he wrote to Roerich about his progress:

> We're all in terrible disorder here and everything is packed up[, but] I have already begun to compose, and, in a state of passion and excitement, I have sketched the Introduction for the *dudki* as well as the "Divination with Twigs."
>
> The music is coming out fresh and new. The picture of an old woman dressed in squirrel skins has not left my mind. She is constantly before my eyes as I compose the "Divination with Twigs." I see her running in front of the group, sometimes stopping it and interrupting the rhythmic flow. I am convinced that the action must be danced, not pantomimed, and for this reason I have connected the appearance of the "painted women" [from "Spring Rounds"] with the "Divination with Twigs," a smooth jointure with which I am very pleased.[94]

Stravinsky completed most of act 1 before Christmas, then finished it, with the Introduction, in early 1912. He moved on to act 2 in March, and reached the second scene,

"Glorification of the Chosen Victim," before the month was out. From April onward, he was traveling or too involved with other business to work on *The Rite*. Only near the end of the year would he push on and complete the score. Roerich barely worked on *The Rite* in late 1911 or early 1912, focusing instead on other projects.

Among these were three commissions for the stage. In October 1911, the Moscow Art Theatre (MKhT), where Anton Chekhov premiered his greatest plays, and where Konstantin Stanislavsky devised the "method" style of acting, invited Roerich to design *Peer Gynt* for its 1912–1913 season.[95] Roerich met Stanislavsky and enjoyed his "skeptical humor," but it was MKhT's comanager, Vladimir Nemirovich-Danchenko. who gave him the job.[96] Nemirovich-Danchenko was swayed in this by two friends who had worked with Roerich before—Alexander Sanin and Konstantin Mardzhanov—and his own niece, Yelena Bebutova, a student at the IOPKh School.[97] "There can be no better candidate," he concluded. "This is his sphere: his style will help director and actors alike understand Ibsen's work more fully."[98]

A daunting task awaited. With a plot covering half a lifetime and a rascally anti-hero gallivanting halfway around the globe, *Peer Gynt* can last up to four hours in performance; Edvard Grieg, whose incidental music is better remembered than the actual play, called it the "most intractable" subject

he had ever worked with.[99] MKhT asked Roerich for a drop curtain, sets for fourteen scenes (three were eventually cut), and more than three hundred costumes. In return, it offered him 3,800 rubles, plus funds to hire six assistants, led by Viktor Zamirailo and Stepan Yaremich. All expenses, including the cost of traveling between Petersburg and Moscow, were paid by MKhT.[100]

The commute took up much of Roerich's time, and he discovered that Nemirovich-Danchenko, in dealing with others, alternated between "reticent silence" and barbed criticisms, "sometimes so abrupt."[101] Still, it was a lucrative contract with one of the world's finest theaters, and Roerich gladly involved himself in the production, attending rehearsals and fittings, overseeing the installation of sets, and offering suggestions about lighting.[102] As he told the journal *Masques* in 1912, "at MKhT you feel the joy of collaborative work. You feel that here and in this moment, art lives. I have been captivated by the friendliness and affection of everyone here; we work as if we had been together for many years."[103]

As Mardzhanov and Nemirovich-Danchenko had hoped, Roerich captured the feel of old Scandinavia. Standout sets included the rustic *Mill in the Mountains*, the eerie *Rondane Cliffs*, and lovely summer and winter versions of *Solveig's Hut*, whose pine-nestled solitude made the poet Sergei Gorodetsky weep with "melancholy and delight."[104] Interestingly, he created these convincing scenes despite passing up a chance to visit Norway with Mardzhanov, who in

1912 took *Peer Gynt*'s cast and crew on a tour of Ibsen's beloved Gudbrandsdalen valley. Roerich declined the invitation, shocking everyone by dismissing the trip as an "exercise in ethnography." MKhT had hired him precisely for his reputation as a stickler for this sort of detail, but as he explained, "I wished first to create the settings and the scenes. Perhaps afterward, I would go to Norway." He wished for now to base his designs on "the inner sources of the author's creative work, rather than composing with local 'realities.'" The MKhT crowd enjoyed their days in the Gudbrandsdalen, but when work resumed in the autumn, Roerich's decision not to join them was vindicated. "As we discussed my sketches for the drama," he writes, "they admitted that my Norway was the real one."[105] If true, the anecdote shows how Roerich had begun favoring intuition over factual reality as a guide to truth.

The MKhT *Peer Gynt* opened on October 9, 1912, featuring Leonid Leonidov as Peer, Roerich's friend Georgii Burdzhalov as the Mountain King, and the Belgian superstar Alisa Koonen as the dancing girl Anitra. The production went through a respectable forty-two performances, then moved in 1913 to Petersburg's Mikhailovsky Theatre. In both venues, critics came down hard on Mardzhanov's direction, though most agreed that Roerich's designs salvaged an otherwise subpar production.[106] (One dissenter, Pyotr Yartsev, felt that Roerich's sets, while beautiful, "played unwillingly in the larger work and stood out too much."[107])

But if the show was undistinguished, it was no flop, and as he usually managed to do, Roerich exhibited his sketches and studies to good effect.

While Roerich worked on *Peer Gynt*, he turned to a second commission, this time from Sergei Zimin, the owner of Moscow's finest private opera. In February 1912, Zimin offered Roerich two shows, both to run in 1914–1915: *Rogneda*, by Alexander Serov, and Wagner's *Tristan and Isolde*. Elated by the prospect of realizing his Wagnerian dream, Roerich handed *Rogneda* over to one of his students, Alexandra Shchekotikhina-Pototskaya, and poured himself into *Tristan*.[108] By 1914, he had completed six set designs and more than twenty costume sketches. All the more heartbreaking, then, that World War I killed the public's appetite for German opera, compelling Zimin to cancel the production.

A more immediate disappointment marred Roerich's third project, a 1912 commission from the Reinecke Theatre of Russian Drama to provide sets and costumes for *The Snow Maiden*—the 1873 play by Alexander Ostrovsky, not Rimsky-Korsakov's opera.[109] In advance of the show's September premiere, Roerich presented the director, Evtikhy Karpov, with an array of sketches in a northern folk style, but a clamor resulted when Karpov had Nikolai Bely, rather than the artists suggested by Roerich, construct the sets. To make things worse, the theater's tailors sewed the costumes according to their own patterns, not the ones given them. As a livid Roerich

told the *Evening Times*, "when I arrived for the final rehearsal, I found that the decor was not presentable, and I had no way of knowing whether the flaws could be corrected in time for the first performance."[110] Roerich demanded that the Reinecke redo the sets or take his name off all programs and posters. There was no time to do either, so he tried at the last minute to dissociate himself from the production by taking out advertisements, like this one from the *Bourse News*: "Having seen my name associated in print with the Reinecke Theater's *Snow Maiden* (although I petitioned the Director to remove my name), I consider it my duty to point out that I provided the Theater only with studies. All other work was completed without my participation."[111] Unaware of this falling-out, several critics, out of reflex, praised what they thought were Roerich's sets. Others, more in the know, distinguished between Roerich's "interesting" and "talented" originals and the Reinecke's "murderously disgusting" knockoffs.[112] It was no improvement over Roerich's experience with the Rimsky-Korsakov *Snow Maiden* in 1908.

One reason Roerich did not go to Norway in 1912 was that he had promised to continue work on Tenisheva's church. (When he was not at Talashkino, he relaxed with Helena, Yuri, and Svetik at a dacha south of Petersburg, near Oredezh.) The *Savior* mosaic was already in place, so what remained was *The*

Queen of Heaven. Assisting Roerich were the mosaicist Vladimir Frolov, the architect Vladimir Pokrovsky, and a number of IOPKh students, including Shchekotikhina-Pototskaya, Pavel Naumov, and Maria Vasilieva. It was a productive summer, although finishing the project would require Roerich to return in 1914.

Taking shape on the church dome was no ordinary madonna, but a pantheistic goddess, Roerich's grandest attempt thus far to visualize the concept of female divinity. He was influenced by the "eternal feminine" motif in Goethe's *Faust*, and by how Russian poets and thinkers—especially Solovyov and Blok—co-opted the Gnostic myth of Sophia, in which holy wisdom takes the form of a woman. Most of all, he was guided by his wife and, through her, Madame Blavatsky, who wrote extensively about ancient mystery religions and the worship of the Great Mother. Just as they believed that Maitreya, Buddha of the Future, was the true source of all messianic legends, the Roerichs identified as his female counterpart an entity they called the Mother of the World. Helena, appropriating language from Blavatsky's *Isis Revealed*, describes her thus: "On Sinai, the Voice of the Mother of the World rang out. She assumed the image of Kali. She was at the basis of the cults of Isis and Ishtar. After Atlantis, She veiled Her Face and forbade the pronouncement of Her Name until the hour of the constellations should strike. She has manifested Herself only partly; never has She manifested Herself on a planetary scale."[113]

Following Blavatsky's proposition that the Holy Spirit was female, Helena argued that the Mother should be considered part of the Holy Trinity.[114]

Roerich concurred, proclaiming that "to East and West, the image of the Great Mother is the bridge of universal unification."[115] He thus grafted Asiatic attributes onto a Byzantine-Slavonic Virgin Mary. His most explicit description of the fresco rings with phrases from the New Testament.[116] Angels, saints, and prophets surround the Mother of God, who prays for the tormented souls adrift in the "dangerous river of life" beneath her. Few doctrinal concepts are as familiar as the Virgin's intercession before God on behalf of the sinful, and the river seems to have been inspired by chapter 22 of the Book of Revelation: "And he showed me a pure river of water of life, clear as crystal, proceeding out of the throne of God and of the Lamb." But a closer look uncovers much that is not biblical. Roerich's queen appears neither with the Christ child nor in any pose typical of Mary. Although her palms are not pressed flat, the position of her hands resembles the *namaste* position more than a Christian gesture of blessing, and the medallion adorning her breast bears the sign of the lotus, a Buddhist sign of enlightenment. The waters have their source as much in the Upanishads, which tell of the ageless river (*vijara-nadi*) flowing past the tree of life, as they do the New Testament. With her Asiatic facial features, the Queen of Heaven may be the Blessed Virgin of the Gospels, but she is also Shakti, the consort

of Shiva; Lakshmi, the Hindu goddess of good fortune; and Kuan Yin, Kannon, and Tara, the Chinese, Japanese, and Tibetan incarnations of the bodhisattva of mercy.[117]

Because of flaws in the plaster beneath the fresco, nothing remains of *The Queen of Heaven* besides photos and impressions recorded by contemporaries (see Illustration 24). The madonna's Tibetan aspect "horrified" Sergei Shcherbatov, who normally admired Roerich's work.[118] By contrast, Maximilian Voloshin, after an advance viewing in 1911, considered it "most attractive." The queen might appear Byzantine, Voloshin noted, "but her character is purely Buddhist; one senses something extremely ancient and oriental."[119] In the end, the person whose opinion mattered most, Princess Tenisheva, was well satisfied, whether she saw the goddess as Christian, Buddhist, or, as the Roerichs saw it, something larger than both.

A rougher-hewn sacrality came to the fore that fall, as Roerich turned again to *The Rite of Spring*. Early in the year, there had been a flicker of hope that the Ballets Russes would include *The Rite* in its 1912 season. In March, an optimistic Stravinsky, pleased with his progress on act 2, spoke to his brother Andrei about the possibility of a 1912 premiere and wrote Roerich to say, "I think I have penetrated the secret of spring's lapidary rhythms and have felt them coupled with the dramatis personae of our child."[120] That month, though, Diaghilev scrapped

any such plan. He and Fokine, who had been assigned *The Rite*'s choreography but would soon quit the troupe for good, were fighting again, and Stravinsky had not finished enough of the score to make *The Rite* a safe bet for spring or summer.

With no deadline imminent, Roerich and Stravinsky let *The Rite* lie dormant for a season. When Roerich picked it up again in the autumn, he still had sets to design, and virtually all the costumes. In 1910, thinking a single scene would suffice, he had sketched an open field near Rurikovo Gorodishche, but now that *The Rite* consisted of two acts, Roerich assumed that at least two sets were needed. Additional ideas for "The Great Sacrifice" included a circle of elders and the ritual enactment of a mock hunt, in which a fur-clad archer stalks a group of dancers wearing moosehides and antlered headdresses (see Illustration 16). For "Kiss of the Earth," Roerich produced three more scenes, each depicting hallowed ground on the edge of a body of water. Two featured a sacred oak, the third a burial mound and a black stone. In December, Roerich and Stravinsky agreed that the last was the best.[121]

To go with the new sets, Roerich designed sixteen costumes in 1912, and more would follow. The elders were to wear skins and furs, with younger characters clad in white tunics and dresses, patterned in orange, yellow, and red. Sun signs associated with the god Yarilo were worked into the trim. Roerich is thought by some to have modeled *The Rite*'s costumes after the dress of Native Americans in the US Southwest,

but this is a fallacy arising from misremembered conversations the conductor Leopold Stokowski had with him in the 1920s.[122] To the extent scholarly expertise permitted, Roerich tried to re-create the appearance of the pagan Slavs' ritual finery. Stravinsky and Diaghilev were thrilled by the results.

What did Roerich wish to accomplish with *The Rite of Spring*? To him, it was at once an artwork, an archaeological research project, and a spiritual manifesto. For Stravinsky and Nijinsky, it has been said that the past served as "a vehicle for conveying the tragedy of modern being." The jarring score anticipates the twentieth century's depersonalized savagery, while the near-epileptic dance steps present the performers as "agents and victims" of machine-age "barbarism."[123] As in the paintings of Picasso and Gauguin, so-called primitivism advances a modernist agenda. What appears to be a journey backward is a leap into the future.

Conversely, the past mattered to Roerich for its own sake, and he shouldered the responsibility of making *The Rite* as true to history as possible. "Truth" was difficult to determine, and artistic license and mysticism colored his view of the past, but he patterned *The Rite*'s key elements on what was known, or at least supposed, about the lives of the Russians' ancestors. Using eighteenth- and nineteenth-century examples from Tenisheva's collections of folk dress, Roerich worked backward to guess how the

ancient Slavs had clothed themselves. The circle dances took inspiration from Russian folk tradition, as did parts of Stravinsky's score, though the composer tried to deny this later.[124] The "Game of Abduction" and "Games of the Rival Tribes" come from the *Primary Chronicle*, whose monk-narrator disapprovingly notes that among pre-Christian Slavs, "there were no marriages, but simply games between the villages," during which each man "took any woman with whom he had an understanding."[125] Alexei Remizov depicted such rituals in his 1907 novel *Follow the Sun*, and while some think these passages influenced Stravinsky directly, it seems just as likely that Roerich, friends with the writer, was the point of contact here.[126]

Rituals not traceable to the Slavs belong to the Scythians, who inhabited southern Russia and Ukraine centuries before the Slavs, and with whom turn-of-the-century Russians, as described in chapter 5, felt a sense of imagined kinship. For tales of the Scythians, Roerich relied on classical commentators, and book 4 of Herodotus's *Histories* informed two scenes: "Divination with Twigs" and "Ritual Action of the Ancestors."[127] An abortive attempt to turn the dancing maidens into Amazons came from Herodotus's descriptions of Scythian women fighting in battle. This idea complicated storyline and stagecraft alike, and was jettisoned.

The ballet's most celebrated episode, the death dance of the Chosen Maiden, has generated the greatest controversy,

because it lies at the heart of two interrelated questions. Was it rooted in historical fact or folklore? And was it Roerich's idea or Stravinsky's? The second question has so far remained unanswerable, but a number of authors have tried to resolve it in Stravinsky's favor by making as much as they can out of supposed uncertainties surrounding the first.

The Chosen Maiden's dance, a propitiation of the sun god Yarilo, represents human sacrifice in idealized form. But did Slavic paganism really include such practices? No one knows for certain, but it is Roerich's bad luck that so much research on his role in *The Rite* was done during a period—the 1960s through the 1980s—when scholarly consensus maintained that, whatever the chronicles might say, no *physical* evidence indicated that the Slavs sacrificed human beings. How, then, dance and music historians wondered, could Roerich, an expert on the past, have made such an inexpert creative decision? Millicent Hodson, who helped the Joffrey Ballet reconstruct *The Rite*'s original staging in 1987, wrote that, "given Roerich's commitment to archaeological authenticity, it is curious that he rewrote mythology for the climax of *Sacre*," and others have confessed themselves similarly baffled.[128] This seeming discrepancy has been seized upon by Stravinsky scholars, who see it as having one irrefutable explanation: the concept behind *The Rite*, they say, cannot have been Roerich's. To quote the leading proponent of this view, the musicologist Richard Taruskin, "the idea about a maiden sacrifice would never have occurred to Roerich spontaneously, for he was too scrupulous a connoisseur of authentic Slavonic antiquity."[129] Such backhanded compliments allow Stravinsky partisans to give Roerich what they consider sufficient due, while still claiming ultimate credit for the composer.

This reasoning, however, rests first on an inadequate awareness of what archaeology meant to Roerich by 1910 and, second, on a static understanding of how archaeological knowledge has changed over time. Archaeology had never been a purely empirical enterprise for Roerich, and by this stage of his life, he no longer saw the discipline as a "secular science," but as "an ecstatic earth cult," in the words of the critic Rachel Polonsky.[130] At no time did Roerich consider himself obliged by his interest in history to forfeit his right to poetic license. After about 1907, there are multiple instances of his willingness to privilege artistic priorities over factual accuracy, and this is to say nothing of how a decade's worth of Blavatskian infusions had affected his view of antiquity. Also, "authenticity" is harder to gauge here than supporters of the "scrupulous connoisseur" thesis care to admit. "Much of the history of human sacrifice remains frustratingly obscure," notes the journalist Barbara Ehrenreich, and academic opinion about how widespread it was in prehistoric times has oscillated throughout the twentieth and twenty-first centuries.[131] From the early 1960s to the late 1980s, social scientists downplayed its prevalence. Especially in the USSR, state-imposed patriotism

pressured archaeologists into denying as much as possible that the Russians' forebears had indulged in customs so grisly. Opinion since, both scholarly and popular, has been less ready to dismiss evidence of such happenings.

To leave things there, though, is to miss the essential point: any attempt to measure the sacrificial motif's anthropological authenticity errs automatically if it uses any yardstick other than what scholars before and during the 1910s—not later decades—believed. In Roerich's day, it was widely accepted, both among academics and the educated public, that human sacrifice had formed part of Slavic pagan ritual. Given this intellectual context, it was in no way incongruous for a historically minded artist to base a plotline on such a premise.[132] The question remains open even now: to quote a respected text on early Slavdom, while "there is little evidence for [examples of human sacrifice] archaeologically, they are evidenced in the written sources."[133] Medieval texts, the *Primary Chronicle* foremost among them, speak clearly and often about how the Slavs and neighboring tribes ritually slew men, women, and youths to bless foundation stones, give thanks for victory in war, or beg the gods to end famines. Arab travelers observed slave girls put to death during Viking funerals in northern Russia and along the Volga, and victims hanged by sorcerers to give their spells greater power. Stories of the Scythians refer even more frequently to human sacrifice.[134] Contemporary researchers apply more skepticism to such passages than in years past, but what matters is how historians in Roerich's own time read them.

Folk tradition, literature, and music likewise stimulated Roerich to think about human sacrifice. In *The Slavs' Poetic View of Nature*, Alexander Afanasev, Roerich's favorite folklorist, recorded a ritual that appears to have been on his mind as he and Stravinsky developed their scenario. To celebrate the midsummer festival of Kupala, the holiday Roerich and Stravinsky originally wanted to depict, peasants often set on fire male and female figures made of hay or straw. Some communities stripped a young woman naked, wreathed her in garlands, and paraded her around the village on horseback. When the midsummer bonfires were lit, she would be burned in effigy.[135] Such rituals obviously mimicked human sacrifice, and it required little imagination to interpret them as vestigial remnants of darker, more brutal practices. Many Russians did, to judge by the number of times ritual sacrifice—even maiden sacrifice—functions as a plot device in literary and musical works familiar to Roerich and Stravinsky.[136] The novel *Askold's Grove*, by Nikolai Zagoskin, and Alexander Serov's opera *Rogneda* both feature characters sacrificed to the thunder god Perun. In Sergei Gorodetsky's verse collection *Yarila* [sic], a wizened priest consecrates an idol of the sun god by killing a maiden with an axe. Paralleling Roerich and Stravinsky, Velimir Khlebnikov, in the 1912 poem "I and Thou," wrote of a young girl offered up to pagan gods after a battle between tribes. The cultural atmosphere

of fin-de-siècle Russia was thick with academic and artistic assumptions that human sacrifice had been part of Slavic prehistory, and while scholars have typically paid attention to the above works as possible sources of inspiration for Stravinsky, Roerich knew them just as well, if not earlier and better.[137]

But to return to Roerich's intentions: whether or not it was his idea, the painter's treatment of the Chosen Maiden's dance differed considerably from Stravinsky's. For the composer, it was a terrifying spectacle that "exposed the cruelty of nature, the savagery of the tribe, the violence of the soul, [and the] godless[ness of the] universe."[138] Roerich, however, saw it as confirming the existence of gods and spirits, and the cohesive strength of primordial society. As in "Joy in Art," and in the dozens of paintings he set in ancient times, "innocence reigns" despite primeval starkness. Humanity, "at peace with god, tribe, nature and self," regains its "spiritual wholeness."[139] To take a page from *The Elementary Forms of Religious Life*, Émile Durkheim's seminal work, "every communion of mind, in whatever form it may be made, raises social vitality."[140] It was this lost virtue Roerich hoped to awaken.

The question of authenticity leads to the related question of *The Rite*'s origins. Most likely, it will never be proved whose idea the ballet really was. But if we dispense with the "scrupulous connoisseur" thesis and ignore the advantage Stravinsky derives from his

fame, we see that the written record favors Roerich. Awareness of Roerich's role in creating *The Rite* has heightened, and he is now routinely acknowledged as the ballet's scenarist and librettist. Most musicologists remain reluctant to credit him as *The Rite*'s originator, although a growing number of historians have gone that far. Orlando Figes, for example, states emphatically that "the idea of the ballet was originally conceived by the painter Nicholas Roerich, although Stravinsky, who was notorious for such distortions, later claimed it as his own."[141]

There can be no doubt that the basic idea would have occurred more readily to Roerich. His thinking, like Stravinsky's, was conditioned by the cultural climate described above. He had dedicated himself for years to studying history and archaeology. In the decade past, he had painted several dozen scenes that could easily have served as backdrops for *The Rite*, and his description of a Stone Age festival in "Joy in Art" (1908–1909) reads like a rough draft of the ballet's libretto. So does this older passage from "At a Tumulus," written in 1898: "They gathered for holidays, the elders seated on the roots of mighty trees. The young people danced circle dances in the forest. The sound of songs drifted from the lakes nearby. . . . On midsummer's eve, the bonfires burned here. Couples leaped through them and were consecrated to eternal union. An age-old custom."[142] In a real sense, Roerich had been designing *The Rite* long before he and Stravinsky brought it into being. Compare this mastery of the subject with Stravinsky's

description of *The Rite* to Florent Schmitt as dealing with "a sort of cult of the Slavic Old Believers"—referring to sectarians who broke with the Orthodox Church in the 1600s, centuries after the ballet takes place.[143] This wild inaccuracy was penned in September 1911, by which point one would expect Stravinsky to have a grasp of the history behind the ballet's plot. This may have been laziness, not ignorance, but the error is on par with calling *Gone With the Wind* a novel about the American Revolution, and it underscores the gap between Roerich's sustained intellectual commitment to the study of prehistory and Stravinsky's less serious approach.[144]

Furthermore, Roerich's testimony has always been more consistent. Stravinsky is notorious for altering his personal history, and, in a manner one biographer labels "deplorable," undervaluing his collaborators' contributions.[145] Taruskin admits that the composer, realizing the *The Rite*'s importance in making his career, "spent the rest of his long life telling lies about it."[146] Stravinsky provided so many stories about *The Rite*'s creation that none can be trusted. We have heard about the 1910 vision of ancient Russia, and also the childhood memories of spring thaws. But then Stravinsky tells us that "the idea came from the music, not the music from the idea," a statement even his supporters brand an "outright lie."[147] Anxious to cement his reputation as a modernist, he disavowed the many ways folk tradition had contributed to *The Rite*'s composition; the ballet, he insisted, was "architectonic," not ethnographically

"anecdotal."[148] Eventually, he claimed that he had been "guided by no system whatever," but "only my ear," and his sententious proclamation in 1960, "I am the vessel through which *Le Sacre* passed," stands out in sad contrast to his earlier and more honest descriptions of *The Rite* as "our child."[149]

Roerich had one tale to tell about *The Rite*, although he provided additional detail in later years, when he found out what Stravinsky was telling the public. In the beginning, Roerich saw no need to spell out how *The Rite*'s subject had been chosen. An idealist, he believed that the ballet—"our child," after all—was a joint creation, and that it would be unseemly to talk about which "parent" had done more to birth it. The Russian press gave him credit for developing the scenario, so his self-interest was satisfied as well. From the summer of 1910 onward, newspapers and journals talked openly about *The Rite* as Roerich's idea. For more than two years, Stravinsky said nothing to deny such reports, although, in fairness, he spent so much time outside Russia that he may not have been aware of them until later.

Only in December 1912 did Stravinsky assert more ownership over the ballet. In a letter to Nikolai Findeizen, the editor of the *Russian Gazette*, he spoke for the first time of *The Rite* as having been his idea. Describing (also for the first time) his dream of pagan elders and a dancing maiden, he told Findeizen how he then turned to Roerich for assistance: "I wanted to work with Nicholas Roerich, to write the libretto

with him. For who, if not Roerich, could help me with such a subject? Who understands, better than he, all the secrets of our forefathers' closeness to the earth? It took us only a few days to work out the details of the libretto."[150] This change appears to have been motivated by wounded pride. In private, Stravinsky grew irritated with the newspapers for "always saying that Roerich has created the new ballet and is developing the scenario, when I have been personally working on it for this entire month!"[151] Whatever the reason, Stravinsky staked his claim further on the day of *The Rite*'s premiere; in an interview with Ricciotto Canudo of *Montjoie*, he blandly thanked Roerich for "the decorative atmosphere for this work of faith," but attributed the creative impulse to himself.[152] (Why Roerich failed to rebut Stravinsky then is not clear, but the article likely escaped his notice.) Months later, as the conductor Serge Koussevitzky prepared *The Rite* for its Moscow premiere, Stravinsky mailed him a handwritten copy of "his" scenario, making no mention of Roerich.[153] And once *The Rite*'s masterpiece status was assured, Stravinsky worked harder yet to associate it with himself and no one else. Diaghilev's revival of the ballet in 1920 gave him an excellent opportunity to do so. Writing about the new production for *Comœdia Illustré*, Stravinsky—in his "most extreme attempt" so far "to divorce the music from its original *raison d'être*"—described the ballet as emerging not from ethnography or history, but from a simple musical theme "that came to me while finishing *The Firebird*."[154]

Roerich, his attention diverted by revolution, emigration, and expeditions to Asia, remained unaware of Stravinsky's assertions until the 1930s. He talked about *The Rite* in America, but said nothing to suggest he knew there was an alternative story he might wish to contradict. In the 1922 essay "Rhythm of Life," he stated matter-of-factly, "I had given the subject for the ballet, taking it from the life of the prehistoric Slavs."[155] In 1930, speaking about *The Rite* to the New York League of Composers, he saw no need even to address the question of origins.[156]

Not till the end of the 1930s did Roerich directly refute Stravinsky and describe the ballet's history as he considered it to have taken place. André Schaeffner's 1931 biography included Stravinsky's claim to have dreamed of a dancing maiden, and Stravinsky repeated the tale in his *Autobiography*, which appeared in 1936. Living by then in the Indian Himalayas, Roerich heard nothing about either book until 1938. That year, Barnett Conlan, an English poet and Theosophist living in France, completed *Master of the Mountain*, a biography that praised Roerich, but followed Stravinsky's line about *The Rite*. Conlan sent Roerich a copy, and while the artist was gratified by the book, he was anything but pleased to read what Stravinsky had said. Roerich mailed a reply to Conlan, titled "The Birth of Legends," in early 1939. The salient points are quoted verbatim:

> I do not know what kind of dreams Stravinsky had or when he had them,

but this is how things really were. In 1909 [*sic*], Stravinsky came to me, proposing to create a ballet together. After thinking it over, I offered him a choice between two ballets: one was *The Rite of Spring*, the other was *A Game of Chess*.

With the exception of some minor changes, [my] libretto for *The Rite of Spring* was precisely the same as the one used in Paris in 1913. . . . I mention this episode only to emphasize how often the facts vary when legends are born. . . . It is said that the peoples of the East are particularly inclined to have their Scheherazades, but in reality, the peoples of the West do not lag far behind them.

It is still not known why such improbable legends are created. Are they created with malign purpose? Or, as the saying goes, just for effect? We will be kind and assume the latter.[157]

Stravinsky's claims vexed Roerich for the rest of his life. In February 1941, he complained to a friend that, "according to another of Conlan's letters, Stravinsky still claims to have gotten the idea for *The Rite of Spring* in a dream. Now there is no place for me at all in his story."[158]

Neither narrative settles things satisfactorily. More flaws mar Stravinsky's account(s), but one would feel happier with Roerich's story had he disclosed its full details before 1939. The possibility that he lied, or that memory played him false after so long, must be considered. Skeptics have highlighted the mistaken year in "The Birth

of Legends"—1909 instead of 1910—but it was Conlan, in *Master of the Mountain*, who first confused the dates, and in responding to him, Roerich likely replicated the error without thinking.[159] Besides, Stravinsky was guilty of similar lapses, referring on one occasion to 1912, not 1911, as the date of his meeting with Roerich at Talashkino.[160] If nothing else, "The Birth of Legends" contradicts no known facts—the scenario for *A Game of Chess* does exist—and none of Roerich's earlier statements about the ballet. On the basis of consistency, Roerich outscores Stravinsky.

A last item to weigh in the balance is the commentary of Ballets Russes contemporaries. Here, opinion is split, with some, like the critic Walter Nouvel, supporting Stravinsky.[161] Nijinsky seconds Roerich's claim, as do his sister Bronislava and his assistant, Marie Rambert, who states flatly that "it was the painter Roerich who first suggested the subject of *Sacre du Printemps*. He then worked on the theme with Diaghilev, Stravinsky, and Nijinsky."[162] The most surprising voice to speak on Roerich's behalf is that of Benois, the one person who can be counted on not to have held any brief for the painter. Discussing *The Rite* in his *Reminiscences*, Benois writes: "The original idea was probably Roerhich's [*sic*]. If, in fact, it came first to Stravinsky, it must have been due to the influence of his painter friend. Roehrich was utterly absorbed in dreams of prehistoric, patriarchal, and religious life—of the days when the vast, limitless plains of Russia and the shores of her lakes and rivers were

peopled with the forefathers of the present inhabitants."[163] Diaghilev never pronounced on this question, but he credited and paid Roerich both as *The Rite*'s designer and its librettist—an implicit indication, perhaps, of where he stood.[164]

In the end, how much does the origins debate matter? No fair-minded person can say with complete confidence that Stravinsky or Roerich had the "eureka" moment that led to *The Rite*'s creation. Perhaps there was no single moment at all, but independent and simultaneous insights, as with Leibniz, Newton, and the system of calculus, or Darwin, Alfred Russel Wallace, and the theory of natural selection. Also, Stravinsky's admirers are correct to insist that, ultimately, his music, not the decor or choreography, gave *The Rite of Spring* its staying power. In that sense, *The Rite* belongs to Stravinsky.

Still, facts are facts, and even if one disbelieves Roerich, one should not accept Stravinsky's diminishment of his contributions. Roerich brought more to the collaboration than sets and costumes. He lent to the creative process a powerful, blood-stirring vision of the past, without which it is safe to say that *The Rite* as we know it would never have taken shape. The question of the ballet's birth will never be fully unclouded. But proper recognition of Roerich's role clears away at least some of the fog.

At the end of 1912, the Ballets Russes began preparing *The Rite* for performance.

An impatient Diaghilev had been urging Stravinsky to finish the music; finally, on November 17, the composer completed the first full draft of the score.[165] A great deal of work now lay ahead: choreography, casting, rehearsals, publicity, and designs. The principal figures were scattered across Europe and constantly in motion—Stravinsky in Switzerland, Roerich in Russia, and Diaghilev with the Ballets Russes, in Berlin, Budapest, Vienna, and London. Also important was Nijinsky, who, after Fokine's angry departure from the troupe, had taken the position of chief choreographer.

After receiving the good news from Stravinsky, Roerich announced it to the Russian press.[166] Then, on November 23, he mailed twenty-four costume sketches and two books of additional designs to Stravinsky's Clarens address. To everyone's annoyance, the package arrived while Stravinsky was in Berlin, consulting with Diaghilev, and because Nijinsky refused to proceed with the choreography until he could see Roerich's designs, the mixup set the production back several weeks. Fortunately, the sketches proved worth the wait. On December 14, Stravinsky told Roerich, "I am deliriously happy about your designs. They are exactly as I had pictured them. My God, how I like them! They are a marvel!"[167]

On another point, Stravinsky was less forthcoming. Roerich could not wait to join his colleagues. "I want to come at the end of December, but where?" he asked in November.[168] In his December 14 reply, Stravinsky, after praising Roerich's designs, complained

about Nijinsky's slow start ("Lord! It's so complicated!"), then reassured Roerich, "Our work will turn out extremely well." But he said nothing about a possible meeting. The omission agitated Roerich enough that he wrote right away to repeat his question: "Thank you for your letter, but it is strange that Diaghilev does not write to tell me where he wants me to come at the end of December. Please ask for the reason; I must know in time."[169]

If Stravinsky was evasive, it was because he did not know Diaghilev's wishes. In fact, there was no December meeting, but one in January 1913. On the second, Diaghilev ordered Stravinsky to join him in Budapest: "If you do not come here immediately, and for fifteen days, *The Rite* will not be given." Bluntly, he added that "Roerich's presence is unnecessary."[170] On the fourth, Stravinsky was unpacking his bags in the Hungaria Hotel; he went to Vienna with the Ballets Russes and met them again in February, this time in London.

Not till March did Roerich join his collaborators in person. Why did Diaghilev exclude him? If the task in January was to jump-start the process of choreography and rehearsal, Roerich's talents were not needed, and Diaghilev may have been sparing the extra cost and complication of bringing him to Europe. Given their history, it is also easy to imagine Diaghilev wanting Roerich at arm's length for as long as possible, so he could make key decisions—and solidify his influence over Stravinsky—without interference from his strong-willed colleague.

Either way, between November and March, Roerich took part only from a distance. In letters and telegrams, he helped settle two questions: the final shape of the libretto and the choice of sets. Until early 1913, Roerich and Stravinsky added new scenes and discarded others. The final version clocked in at thirty-four minutes, and is given below. The synopses following each act are in Stravinsky's words.

ACT I: ADORATION OF THE
EARTH [KISS OF THE EARTH]
 Introduction
 Auguries of Spring [Divination with Twigs]
 Ritual of Abduction [Game of Abduction]
 Spring Rounds [Circle Dance]
 Ritual of the Rival Tribes [Games of the Rival Tribes]
 Procession of the Sage [They Are Coming, They Are Bringing Him]
 The Sage
 Dance of the Earth [Dancing-Out of the Earth]

The spring celebration. It takes place in the hills. The pipers pipe and the young men tell fortunes. The old woman enters. She knows the mystery of nature and how to predict the future. Young girls with painted faces come in from the river in single file. They dance the spring dance. Games start. The Spring Khorovod. The people divide into two groups, opposing each other.

The holy procession of the wise old man. The oldest and wisest interrupts the spring games, which come to a stop. The people pause trembling before the great action. The old men bless the earth. *The Kiss of the Earth*. The people dance passionately on the earth, sanctifying it and becoming one with it.

ACT II: THE GREAT SACRIFICE
 Introduction
 Mystic Circles of the Young Girls
[Circle Dances, Secret Games]
 Glorification of the Chosen Victim
 Evocation of the Ancestors
 Ritual Action of the Ancestors
 Sacrificial Dance [Sacred Dance]

At night the virgins hold mysterious games, walking in circles. One of the virgins is consecrated and is twice pointed to by fate, being caught twice in the perpetual circle. The virgins honor her, the chosen one, with a marital dance. They invoke the ancestors and entrust the chosen one to the old wise men. She sacrifices herself in the presence of the old men in the great holy dance, the great sacrifice.[171]

The design question caused more friction and seems not to have been resolved before the end of March. On the twenty-third, Diaghilev asked Stravinsky to let him see all of Roerich's sketches. Roughly at the same time, Roerich sent Diaghilev a letter describing *The Rite*'s dramatic

action.[172] Portions of this text, speaking of "mystical terror" and "scenes of earthly joy and heavenly triumph," are frequently cited by authors seeking colorful encapsulations of the ballet's subject. Rarely does Roerich's *reason* for writing come under discussion. He is answering a question put to him by Diaghilev in an earlier communication, but what Diaghilev asked him is not known. "I have dedicated twenty years to the study of Russian (Slavic) antiquity," he tells Diaghilev, reminding him how "highly" Paris audiences had valued his earlier designs. The tone of self-praise, combined with Roerich's emphasis on visual differences between the first and second acts, suggests the exchange was part of a larger argument about which set designs, and how many of them, should be used.

If so, Roerich lost the debate. Diaghilev was enthralled by his costumes, but not so much by his sets that he wanted two of them for such a short ballet. One would do, he said. To show that night had fallen in act 2 required only the lights to be dimmed. As background, Diaghilev selected the gloomy tumulus tomb Roerich had painted the previous fall, and he had the entr'acte curtain decorated with the mock-hunt scene from 1910–1911. Roerich, who pushed hard for a second set, was not satisfied by this half measure, and remained furious for years about Diaghilev's penny-pinching.[173]

Even when he was not physically present, Roerich influenced *The Rite*'s evolution, thanks to his relationship with Nijinsky. Rapture fueled Nijinsky as he took over the

ballet's choreography. As he told Stravinsky in January, "if the work continues like this, Igor, the result will be something great. I know what *Le Sacre du Printemps* will be when everything is as we both want it: new, and for an ordinary viewer, a jolting impression and emotional experience. For some it will open new horizons flooded with different rays of [the] sun. People will see new and different colors and lines. All different, new and beautiful."[174] From February through April, though, things went sour. Helping him deal with the ordeal was Roerich.

Why did Nijinsky struggle with *The Rite*? Some have contended that he failed to grasp the ballet's essence. Foremost among these was Stravinsky, who, convinced that Nijinsky had endangered *The Rite*'s chances of being appreciated for the masterwork it was, described the dancer as a "poor boy . . . incapable of giving intelligible form to [the dance] and complicat[ing] it either by clumsiness or lack of understanding."[175] In reality, Nijinsky had more musical training and a sharper intellect than Stravinsky credits him with, and it was a gross injustice for the composer to call him "maladroit" and "saddled with a task beyond his capacity."[176]

All the same, Nijinsky did not manage rehearsals well. For one thing, he called 120 of them. He dealt awkwardly with people and tested the dancers' patience with the novelty of his steps. He applied the Dalcrozian principles of Eurhythmics, a system not to everyone's liking, and his assistant, Marie Rambert, earned the jeering nickname "Rhythmichka." She and Nijinsky compulsively counted out every step in time with the music, causing rehearsals, which the cast and orchestra derided as "arithmetic classes," to drag on interminably.[177]

As the weeks went by, Nijinsky felt hemmed in by hostility and suspicion. The dancers turned sullen and uncooperative, and Stravinsky constantly condescended to him. As he told his sister Bronislava, "I am often exasperated by Igor Fyodorovich. I have great respect for him as a musician, and we have been friends for years, but so much time is wasted, as Stravinsky thinks he is the only one who knows anything about music. In working with me he explains the value of the black notes, the white notes, of quavers and semiquavers, as though I had never studied music at all. . . . I wish he would talk more about *his* music for *Sacre*, and not give a lecture on the beginning theory of music."[178] Diaghilev, busy running the troupe's business, did little to help, and his intimate relationship with Nijinsky, itself the cause of much cattiness, opened the young man to charges of having advanced through favoritism. In other circumstances, Nijinsky would have had an ally in his sister, the original choice for the Chosen Maiden, but she became pregnant, and the role passed to Maria Piltz. Although Bronia consoled her brother during these unhappy months, she could offer little practical help.

This left Roerich, who, Nijinsky wrote, "perceives and understands my work."[179] Roerich provided much-needed affirmation in his letters and, in the spring, took

the dancer's side in debates with Diaghilev and Stravinsky. "Only Roerich supported Vaslav," Bronislava recalls with gratitude, and this friendship was among the few things holding the emotionally fragile Nijinsky together as tensions mounted. According to Bronislava, "the only time Vaslav appeared relaxed during rehearsals was with Roerich."[180]

Also, Roerich's art and ideas affected Nijinsky's choreography, despite the seeming dissimilarity between the former's primordialism and the latter's modernist outlook. Bronislava remembers how her brother "liked to listen to Roerich talking about his studies of the origin of man," and about archaeology and ancient paganism.[181] "Roerich is not only a great artist, but a philosopher and scholar," Nijinsky declared, and his art

> inspires me as much as does Stravinsky's powerful music—his paintings, *The Idols of Ancient Russia*, *The Daughters of the Earth*, and particularly the painting called, I think, *The Call of the Sun*. Do you remember it, Bronia? The violet and purple colors of the vast barren landscape in the predawn darkness, as a ray of the rising sun shines on a solitary group gathered on top of a hill to greet the arrival of spring. Roerich has talked to me at length about his paintings in this series that he describes as the awakening of the spirit of primeval man. In *Sacre* I want to emulate this spirit of the prehistoric Slavs.[182]

This went beyond the conjuring of vague visions. Nijinsky crafted specific poses to mimic the figures in Roerich's paintings and had the dancers wheel about in circular movements patterned after the sun signs decorating Roerich's costumes. Henri Prunières, the editor of Paris's *Revue Musicale*, remarked that "the great revolution accomplished with [*The Rite*] was inspired by looking at archaeological paintings collected by Roerich"—and Millicent Hodson concurred more than half a century later, as she pieced together the original choreography for the Joffrey's 1987 revival of *The Rite*.[183]

Deeper abstractions aside, weighing most on Nijinsky was whether he could ready the ballet on time. In late March, Pierre Monteux began rehearsing with the orchestra, while Nijinsky continued with the dancers. Stravinsky withdrew to Clarens to assist Maurice Ravel in arranging the Ballets Russes' upcoming production of Mussorgsky's *Khovanshchina*. Not until May 13, less than three weeks before *The Rite*'s premiere, would Stravinsky rejoin the company. Roerich appeared on the scene as Stravinsky departed. He checked into Monte Carlo's Hotel Astoria at the end of March and spent April there with the Ballets Russes. He attended rehearsals and checked the quality of the costumes. In May, he relocated to Paris with the troupe and oversaw the set's construction, a job carried out by Orest Allegri and Sergei Sudeikin, and the painting of the entr'acte curtain, done by Mikhail Yakovlev and the IOPKh student Pavel Naumov.

In mid-May, Stravinsky returned. Over the next two weeks, Monteux stepped up the pace, scheduling seventeen orchestra rehearsals, plus five full stage sessions with the dancers. By the twenty-sixth and twenty-seventh, cast and musicians had done all they could to coordinate their efforts. The dress rehearsal was set for the twenty-eighth. On the twenty-ninth, *The Rite* would make its indelible mark on history.

No two accounts of *The Rite*'s premiere are the same. The only certainty about that unforgettable night is that, for a time, the drama of the event threatened to eclipse *The Rite*'s importance as a work of art.

A sense of unease gripped the Ballets Russes as it moved from Monte Carlo to Paris. Despite the grueling rehearsals, no one knew if Monteux would have the orchestra ready by the twenty-ninth, and the public's puzzled reception of Nijinsky's choreography for Debussy's *Jeux*, which opened on the fifteenth, did nothing to boost the dancers' confidence. Also, everyone felt sure Stravinsky's music would cause a sensation, a scandal, or both. This had been the expectation since 1912, when Stravinsky first played excerpts from the score for Diaghilev and Monteux. As Monteux remembers, both listeners were staggered: "Before he got very far I was convinced he was raving mad. . . . The very walls resounded as Stravinsky pounded away, occasionally stamping his feet and jumping up and down to accentuate the force of the music. Not that it needed such emphasis."[184] What might the Ballets Russes expect if it performed such music, accompanied by such radical choreography? Audiences at this time responded vehemently, sometimes with violence, when stageworks crossed certain boundaries. Only six weeks before, a riot had erupted at the Vienna Musikverein during a program featuring Mahler, Webern, and Schoenberg: fistfights broke out, the audience attempted to seize the stage, and the hall's managers had to summon the police. Could something like this happen in Paris? More than one performer nervously recalled the city's incensed reaction the summer before to Nijinsky's overtly sexual rendition of Debussy's *Afternoon of a Faun*.

Diaghilev, reasoning that shock value equaled publicity, may have hoped to engineer a controversy.[185] He handed out free tickets to bohemians and students who could be counted on to pit themselves against cultural conservatives by applauding the ballet. His decision to open *The Rite* on May 29—the anniversary of Nijinsky's performance in *Afternoon of a Faun*—lends additional credence to this view, and Stravinsky later remembered Diaghilev saying that he got "exactly what [he] wanted."[186] On the other hand, Diaghilev appears to have been caught off guard on the twenty-ninth, and it seems best to suppose that, while he wanted some spice to the evening, he got more of it than he bargained for.

Things began well enough. After three seasons at the Théâtre du Châtelet,

the Ballets Russes was moving to Gabriel Astruc's impressive Théâtre des Champs-Elysées. The dress rehearsal, held on May 28, went flawlessly.[187] But how positive a sign was this? The rehearsal was "quiet" rather than successful, and the audience consisted of critics, musicians, and aficionados—types who would make little fuss, whatever they actually thought.[188] Perhaps the rehearsal's smoothness lulled the cast into a false sense of complacency. No matter what, the following evening proved remarkably different.

A full program was given on the twenty-ninth. First came *Les Sylphides*, by Chopin. *The Rite* was next, followed by Weber's *Spectre de la Rose*. *Prince Igor*, with Roerich's sets and costumes, was to round out the evening. The show attracted a full house, with Ravel, the poet-playwright Jean Cocteau, Coco Chanel, the composer Florent Schmitt, and Austria-Hungary's ambassador to France among those in attendance. Roerich and Stravinsky sat with the audience, although the latter did not stay there long. Diaghilev and Astruc had their own box, Monteux was with his orchestra, and Nijinsky stood in the wings to cue the dancers if necessary. Once *The Rite* was over, he would dance in *Spectre*.

Sorting out what happened next is near-impossible: eyewitness accounts vary and contradict each other.[189] All agree that trouble began immediately, as the bassoon solo caused some of the audience to laugh, others to mutter in protest. Then, as the curtain rose, "the storm," in Stravinsky's words, "broke out."[190] The bizarrely posed

Young Maidens provoked catcalls, and the cacophony nearly kept the musicians and dancers from proceeding. Astruc scolded the audience, "Listen first! You can whistle afterward!" (According to others, it was Diaghilev who admonished the onlookers, and perhaps both did so.[191]) Stravinsky remembers that Monteux "threw nervous glances towards Diaghilev," but also describes him as being "nerveless as a crocodile."[192] Seeing that the dancers could barely hear the music, Nijinksy "furiously beat out rhythms with his fists and yelled out numbers."[193] An agonized Stravinsky, unable to tolerate the chaos, left his seat and went backstage before the first act ended. "I have never again been that angry," he attested later. "The music was so familiar to me. I loved it, and could not understand why people who had not yet heard it wanted to protest in advance."[194]

Halfway through the performance, Diaghilev and Astruc regained some semblance of control, turning the lights on and off to quiet the audience. The police arrived and, during the intermission, removed the worst troublemakers. Still, act 2 did not go quietly, and the onlookers' mood ebbed and flowed. The audience grew restless as the curtain went up, but calm was restored by the beauty of the "Mystic Circles" sequence. The stomping of the bearskin-costumed elders stirred up the audience once again, and a last outburst almost spoiled the climax. All along, the poses struck by the Young Maidens, who tilted their heads and placed their hands on their cheeks, had reminded less serious viewers of women suffering from

toothache, and cries of "Call a dentist!" had punctuated the performance. Now, Maria Piltz, playing the Chosen Victim, began the Sacrificial Dance. She stood motionless, then mimed a trembling fit. Shouts from the audience rang out: "Get a doctor!" "No, a dentist!" "Two dentists!" Others yelled back, insisting that the hecklers "Shut up! Be quiet!" Roerich remembers Piltz facing down the audience: "Really, I admired her courage, because she danced not with the music but with the accompaniment of a horrible uproar of the entire audience, and the few attempts of applause were drowned amidst the disturbance."[195] The noise subsided as Piltz moved into her dance, and silence prevailed until she was through.

Much else is said to have happened during the general pandemonium. Did the Austro-Hungarian ambassador disrupt the show with roars of laughter? And did Florent Schmitt call him "a bum" in consequence? We are told that fifty people stripped naked to signal displeasure at the audience's lack of respect for the performers—though why they thought such a tactic would refocus attention on the stage remains unexplained. Faces were slapped, duels declared. A well-dressed woman screamed at Ravel that he was a "dirty Jew." If even a fraction of the anecdotes are true, the Théâtre des Champs-Elysées was, hands down, the most exciting place to be in Paris on the night of May 29.

Dancers and musicians alike were relieved to have *The Rite* over with. Piltz's final dance had quieted the audience, but the furor started up again the second she was through. Supporters and foes shouted their approval or disapproval. Blasted by noise, Stravinsky, Nijinsky, Roerich, and the dancers took their bows—but the troupe was not yet done for the evening. Less than twenty minutes later, a shaken Nijinsky stepped onto the stage to dance *Le Spectre de la Rose*. In what now seemed an afterthought, *Prince Igor* finished out the night.

All the leading figures were stunned. If Jean Cocteau is to be believed, he, Stravinsky, Nijinsky, and Diaghilev hired a cab and drove through the Bois de Boulogne until the small hours of the morning. Cocteau describes an epic scene: the cab careening through the moonlit woods, Stravinsky catatonic with self-pity, Nijinsky distraught and exhausted, Diaghilev—having drunk more than his share of champagne—openly weeping and reciting verses by Pushkin. Stravinsky later denied that any such episode took place.[196]

What Roerich did after the show is not recorded, but he gave his impressions in two essays. In "Sacre," he contrasts the modern public's beastly incivility with the ritual dignity he associated with the Stone Age: "I remember how during the first production in Paris, in 1913, the entire audience whistled and roared so that nothing could even be heard. Who knows? Perhaps at that very moment, they were feeling the same emotions of joy felt by primitive people. But this savage primitiveness had nothing in common with the refined primitiveness of our ancestors, for whom rhythm, sacred

symbols, and elegant gestures were great and holy concepts." Then, more sarcastically, "Well, perhaps it was necessary that thousands of years should elapse, in order that we might witness how humanity could become so conformist, and how much prejudice can divide the listener from what he hears."[197] In "Rhythm of Life," Roerich confesses, "Should anyone ask me what was the reason for this terrific protest, I must sincerely profess my ignorance. To me it remains one of the great mysteries."[198]

No less than the audience, critics and musicians warred over *The Rite*. One review denounced the ballet as "Le Massacre du Printemps," and the composer Pierre Lalo declared, "Never before has the cult of the wrong note been applied with such industry, zeal, and ferocity." Debussy quipped that *The Rite of Spring* was "primitive music with all the modern conveniences." Many pointed out the disparity between Roerich's work and that of his collaborators. Cocteau lauded Stravinsky and Nijinsky but complained that Roerich's "mediocre decor" had kept the production from realizing its full potential.[199] A gentler comparison came from Florent Schmitt, who understood why the music and choreography had met with the crowd's "intransigence," but thought that Roerich's designs deserved "mercy."[200] Roger Fry dismissed Roerich's designs as "fusty," but London's *Times* pronounced them "beautiful," and Cyril Beaumont pointed out that Roerich was "unequalled" at setting the "half-savage, half-mystical" mood the ballet called for.[201] Rimsky-Korsakov's son Andrei,

who excoriated *The Rite* as "rubbish" and "a horror," felt Stravinsky's music had failed to live up to the excellence of Roerich's designs, not the other way around.[202] Either way, *The Rite* fared badly that summer, with only six Paris performances, counting the dress rehearsal, and just three in London. It seemed all too appropriate that, just after the ballet's second performance, Stravinsky ate a bad oyster and had to be hospitalized for an acute stomach disorder.

The premiere's long aftermath included many partings. Roerich went back to Russia; he and Stravinsky never saw each other again.[203] Before the year was out, Nijinsky broke off his relationship with Diaghilev and married Romola de Pulszky. Three months later, Diaghilev dismissed him from the Ballets Russes, whereupon he deteriorated mentally, giving his last public performance in 1917 and ending his days in an asylum before dying of kidney failure. The Ballets Russes adopted a new aesthetic, as Diaghilev saw how the public craving for silk-draped palaces and arcadian groves was passing.[204] Older ballets were kept on as workhorses, but starting in 1914, the main attractions featured avant-gardism. Natalia Goncharova and Mikhail Larionov dominated the 1914 and 1915 seasons, and Cocteau, Picasso, Braque, Matisse, and Miró joined them in short order.

As for *The Rite*, Stravinsky's worries about the damage done by its reception were unwarranted. Moscow and Saint Petersburg concert versions, conducted by Serge Koussevitzky, premiered in 1914. Monteux

braved Stravinsky's music a second time that April. Using Roerich's sets and costumes, still in pristine condition, the Ballets Russes revived *The Rite* in 1920, with more conventional choreography by Leonid Massine. Other orchestras began to perform it, and it was so well established by the late 1930s that the Walt Disney Corporation used the score to accompany the dinosaur sequence from the movie *Fantasia*. Stravinsky had no choice in the matter, since the music had no copyright protection in America.

Upon its release in 1941, Stravinsky ridiculed *Fantasia* as an "imbecility."[205] Roerich, living in the Punjabi hills, never saw the movie, but watching it would have made his sensibilities quiver like an exposed nerve ending. (Ironically, the film's narrator, Deems Taylor, was briefly associated with Roerich's New York museum during the 1920s.) In one important way, though, *Fantasia* helped Stravinsky accomplish what he had been trying to do for more than a decade: to uncouple the music from the idea that had inspired it in the first place. If Stravinsky desired the public to cease thinking of *The Rite* as a reconstruction of the ritual practices of a specific people during a specific era, he could not have asked for anything better than the image of celluloid tyrannosaurs and pterodactyls in a technicolor wasteland. By the 1940s, Stravinsky had established sole custody over *The Rite of Spring*, obscuring from popular memory Roerich's status as one of its rightful parents.

CHAPTER 7

The Doomed City, 1913–1918

The dark world will grow darker yet,
Wilder the whirl of the planets, for centuries hence.

And we shall see the apocalypse,
The last, worst age descend,
Repulsive evil will eclipse the sky, laughter freeze on all lips.

—Alexander Blok, "A Voice from the Chorus"

In 1945, the philosopher Isaiah Berlin accepted a post at the British Embassy in Moscow. There, he took the opportunity to interview members of Russia's literary elite, including Boris Pasternak, the author twelve years later of the novel *Doctor Zhivago*. Over tea, Berlin asked which artists Pasternak thought had been most influential before the revolution—an opinion worth soliciting, with Pasternak's own father having been a painter of note during those years. Berlin reported: "[Pasternak's] artistic taste had been formed in his youth and he remained faithful to the masters of that period. . . . I shall not easily forget the paean of praise [he] offered . . . to the symbolist painter Vrubel, whom, with Nicholas Roerich, [he] prized above all contemporary painters."[1] A testimonial to be proud of and, more to the point, one representing general opinion on the eve of World War I.

Roerich's painterly career reached his zenith as he entered his forties. His timing proved unfortunate, with the twin calamities of war and revolution descending upon his country at that very juncture. The social order that had given him birth, educated him, and nurtured him as an artist vanished, a trauma whose psychological effect cannot be emphasized enough. Nicholas and Helena came to view World War I and its aftermath as a global apocalypse, and this shift in perspective caused them to regard every word of Theosophical doctrine as unimpeachably true and of immediate relevance.

The couple also dreamed more longingly of visiting Asia. Only months before the war, Roerich had praised India as a land of wisdom and antiquity; by 1917, his desire to travel there had sharpened to the point of obsession.[2] He and Helena went on to persuade themselves that, once there, they

would do no less than shape the destiny of the world.

Roerich returned to Russia at the end of May, worn out by *The Rite of Spring* and the commotion attendant upon it. Adding to his exhaustion was family grief, for Helena's mother had recently died after a long psychological and cognitive decline.[3] Parent and child had never seen eye to eye, and coping with an increasingly erratic Yekaterina took its toll, especially on Sviatoslav and Yuri, who found it hard to be near their grandmother in her final months. Still, Helena took her mother's passing harder than expected.

Mourning threw the family's summer plans into disarray. Rather than stay in the northwest, the Roerichs had elected to head south to the Caucasus Mountains, where family friends, the Vlasevs, would host them. But with sadness dulling Helena's appetite for travel, it was decided that Nicholas should go by himself, while she and the boys remained with the Putiatin-Shaposhnikov clan. The family would reunite in Oredezh, where they had vacationed the previous August. In June, Roerich set out for Rostov-on-the-Don, then to the spa towns of the North Caucasus, where the mountains, Europe's tallest, rise up from the Kuban steppe.

Roerich spent most of his time with the Vlasevs in Kislovodsk, named "sour waters" for its carbonic springs. The prettiest of the region's resorts, Kislovodsk housed the Narzan Baths, a national landmark on par with Evian or Baden-Baden. The summer weather stayed warm and dry, gorgeous compared to that in Saint Petersburg. Roerich's sister Lydia wrote about rainy afternoons in the capital, betraying a touch of envy at how much sunshine her brother was enjoying.[4]

The Vlasevs guided their guest to ancient ruins and crumbling castles, which Roerich eagerly painted. He planned a set of canvases based on the life of Saint Procopius. But it was the heart-stopping beauty of the peaks that mesmerized him, and he turned out seven Caucasian studies in 1913. All were reproduced in the journal *Apollo* after Roerich's return to Petersburg, the most noteworthy a depiction of Elbrus, which stood fifty miles south of Kislovodsk. Years before, Roerich had pored over scenes of the mountain painted by his teacher Kuinji. He now trekked down the valley of the Baxan River to observe it for himself.

What resulted was a small canvas, dull in color and lacking panoramic scope, but neither size nor simplicity should deceive the viewer as to its importance.[5] Here, Roerich came to see mountains as more than an attractive visual element. *Elbrus* is a true portrait, in that it peers beneath the summit's ice-coated exterior to reveal its true character. Roerich's idol John Ruskin had once declared mountains to be "the beginning and the end of all natural scenery," and they came to fascinate him more than any other subject: for their awe-inspiring mass and lofty stature, their symbolic weight in faiths and folklores the world over, and the

spiritual qualities he believed they embodied in fact.[6] *Elbrus* remains an early example of the works Roerich would paint by the hundreds between the 1920s and the 1940s.

In August, Roerich traded the apricot-scented breezes of the Caucasus for the groves and gentle streams of Oredezh, where he rejoined Helena and the boys. Yuri and Svetik, budding rockhounds who had a working model of a mineshaft back home, burrowed along the riverbanks like happy badgers, hunting down interesting minerals for their collection. There were kurgans for Nicholas to excavate, and he and Helena took long strolls through the woods, seeking to put the pain of her mother's death behind them.

Refreshed, the Roerichs returned to Petersburg in September. The usual flurry of activity awaited, with the IOPKh School's fall term beginning and exhibitions to prepare. Unusually, Roerich skipped the World of Art show. He had been too busy to chair the society in 1913—Dobuzhinsky stood in for him that year—and too many of his works were committed elsewhere: some on display at the Dobychina exhibition in Petersburg, others at the Warsaw Exhibition of Theatrical Art. In the fall, Roerich helped organize a Russian folk-art exhibit for the 1913 Salon d'Autômne in Paris, and he contributed images from "Vaidelotka," a Baltic folk story, to an anthology celebrating the three-hundredth anniversary of the Romanov dynasty.[7]

In 1914, Roerich took back the World of Art chair and, that March, hosted the society's annual gathering at the IOPKh School. A photo of the assembled group freezes into time the fading elegance of the fin de siècle: the eighteen attendees stand on the school's grand staircase, arranged in a neat diagonal, stiff and formal in high collars and cravats or dark and demure dresses. No one in the picture knew that they were experiencing imperial Russia's last few months of peace, or that they would soon be flung apart, some to Russia's farthest corners, others to the world beyond. (After that scattering, Boris Kustodiev, in his 1920 *Group Portrait of the World of Art*, recalled this cohort in a more relaxed moment, cheerily chatting around a table.)

During this last half year of calm, Roerich was his customarily busy self. One event disrupted his normal routine: in January, his archenemy at the IOPKh, Mikhail Botkin, died. For more than a decade, the two had warred over every conceivable issue, be it the latest artistic style or the minutest point of pedagogical philosophy, and the ill will had become noisomely personal. According to Roerich, Botkin, "much older than I, often said with a smirk on his face, 'In all likelihood, you will see me dead and buried. But possibly I will see *you* buried instead.'"[8] This morbid hope proved futile, and Roerich bade farewell to his longtime foe. In a twist of fate that would have appalled Botkin, his former residence now houses the Saint Petersburg State Museum-Institute of the Roerich Family.

Exhibitions took up more of Roerich's time in 1914.[9] In January and February, he

showed paintings in Rome, with Ostroumova-Lebedeva, Bilibin, Boris Anisfeld, Martiros Saryan, and Boris Kustodiev. He appeared with seventy other Russians at the Venice International Exhibition and took part in the Fifth Vologda Exhibition. In the summer, he sent a number of pieces to the Baltic Exhibition in Malmö, Sweden. These were well received, but the outbreak of World War I trapped them in Sweden for the duration.

In the spring, Roerich worked with his brother Boris in France. Hired to build a villa in Nice, Boris asked Nicholas to create thirteen panels and a ten-meter frieze, each depicting a scene from Russian history. The declaration of hostilities in August kept the brothers from fulfilling this commission, but the job allowed Roerich one last foreign trip before the war. He visited the Nice worksite, then went on to Paris. At the Cernuschi Museum, he viewed an exhibition of artifacts from Japan, Siam, and India, organized by the orientalist Viktor Golubev. Golubev gave Roerich a personal tour, and spoke of returning to India to continue his research. At the time, Nicholas and Helena were reading *Gitanjali*, the 1912 cycle of poems by the Nobel laureate Rabindranath Tagore, and the Indian pieces Roerich saw at the Cernuschi made a particular impression. This Paris journey inspired his 1914 essay "Path to India" and heightened his desire to travel to the east.

Stage design did not go as well as easel work. With *The Rite* behind him, Roerich turned with hope to a fistful of commissions recently offered by Konstantin Mardzhanov, who had recently opened a Free Theater in Moscow. Mardzhanov's chosen emblem, a boy and girl, arms outstretched, signaled youthfulness and hope, but proved too optimistic. Within a year, the Free Theater would go bankrupt.

Still, Mardzhanov had the connections to make an impressive start. In 1913, he asked Roerich to design Rimsky-Korsakov's *Kashchei the Deathless* and Maurice Maeterlinck's *Princess Maleine*, both for the spring of 1914, and both to be directed by Roerich's comrade, Alexander Sanin. That summer, Roerich convinced Mardzhanov to produce Stravinsky's *Nightingale* as well, and to allow him to design it. For *Kashchei*, he completed only a few studies; far more effort went into *Maleine*.[10] Roerich had admired Maeterlinck since 1905, when he illustrated a translation of his plays, and Mardzhanov badly wanted him to accept this commission. "I am worried by the possibility that you might not be with us," the director told him. "It would be good to see a piece of your soul in our *Maleine*."[11]

Maeterlinck's gothic realm of castles and convents took a hypnotically beautiful form as Roerich produced nineteen set designs and over two dozen costume sketches. Maeterlinck's use of female protagonists to represent the human soul allowed Roerich to contemplate further the concept of feminine divinity he had explored in works like *The Queen of Heaven*, and he committed more fully to two other symbolic

associations that remained central to his art. Maeterlinck's dramas commonly show characters descending into caves, grottoes, and underground chambers as a necessary step in their spiritual awakening, and it was around this time that Roerich began to feature subterranean spaces in scenes depicting progress toward enlightenment. Also, projects like *Maleine* influenced Roerich's association of dark blue and violet with sacred virtues. Both colors were important in Byzantine-Slavonic Orthodoxy, and many of Roerich's contemporaries, including Kandinsky, idealized them as possessing moral or spiritual qualities. It is telling, though, that, before *Maleine*, Roerich had combined indigo and purple as dominant tones only in the Maeterlinck-inspired *Powers Not of This Earth* (1906).[12] Describing his 1913 designs as a "tonal symphony," Roerich spoke of how the "deep blue, violet, and purple chords" he discerned in Maeterlinck's plays "resonated deep within me."[13]

Considering the effort Roerich put into *Maleine*, he was understandably grieved by what happened next. At the end of 1913, the Free Theater, on the verge of collapse, tried to economize by canceling many of its upcoming shows, among them *Kashchei* and *Maleine* (although even that did not keep the theater from dissolving in April 1914). Warned by Sanin about the cutbacks, Roerich recovered the *Maleine* designs and sold many to Russian collectors, including Mikhail Braikevich of Odessa.[14] The rest were shown at the Malmö Baltic Exhibition of 1914 and, in 1918–1919, in

Stockholm, Copenhagen, and Helsinki. Though they never appeared onstage, they were well thought of, and Roerich soon had the chance to design another Maeterlinck production: *Sister Beatrice* in 1914–1915.

Bad luck of a different type stripped Roerich of his *Nightingale* commission and dredged up the disappointment left over from *The Rite of Spring*. For some time, Stravinsky had been working with Stepan Mitusov on this opera, based on Hans Christian Andersen's tale about the Chinese Emperor and his mechanical songbird. In the spring of 1913, before *The Rite*'s too-eventful premiere, Stravinsky mentioned the project to Roerich, who, in the composer's words, "flared up strongly and undoubtedly wanted to design it. I pressed him on this."[15] But was Stravinsky enthusiastic about Roerich's art or his contacts at the Free Theater, which, thanks to Roerich's efforts, agreed in July to stage the new opera? Either way, no sooner had the ink dried on the contract than Stravinsky began pulling away from Roerich. On July 30, he confessed to Mitusov that he had been having doubts about Roerich, and "am still doubting."[16] (Given Mitusov's closeness to Roerich, the latter was probably painfully aware of Stravinsky's feelings.) The same day, Stravinsky sent a more frantic letter to Benois: "I have just heard from Mitusov that Roerich has reached an agreement with the Free Theater. But I pray to God that *The Nightingale* is not given to him. I love him and consider him a marvelous artist, but cannot see him designing this opera!"[17]

This change of heart between May and July was due to *The Rite*'s reception in Paris, the thought of which made Stravinsky "miserable" all year long, as he later confessed to Benois.[18] Stravinsky also wondered, not without justification, whether Roerich's epic primevalism would suit the jade-and-porcelain delicacy of ancient China.

Benois, the composer decided, could deliver that sort of refinement, but there was no hope of hiring him if *The Nightingale* was going to premiere at the Free Theater, whose leading figures, Mardzhanov and Sanin, disliked him. In fact, this was how Stravinsky later tried to persuade Benois that he had been the original choice all along: "I wanted you, but . . . Roerich was *persona grata* [at the Free Theater], so I used him. Also, I knew he would at least take [the project] seriously."[19] Not caring if he had been first or second in Stravinsky's thoughts, Benois exploited the composer's anxieties. In September, under the pretense of allaying Stravinsky's fears, he wrote, "I'm sure Roerich will do miraculous things with *The Nightingale.*" Then, after observing that the opera contained "a few details Roerich may not manage well," Benois slyly remarked, "it is precisely those details which would interest me enormously."[20] Stravinsky needed little convincing, but he had to have a stage, and if he stayed with the Free Theater, he was stuck with Roerich. Because the Free Theater had not secured rights to *The Nightingale*'s world premiere, but only exclusive rights for Moscow and Petersburg, Stravinsky tried to convince the Ballets Russes

to perform it first in Europe. But Diaghilev refused to pay a commission for a production not wholly his, and agreed to pay only royalties—if he staged *The Nightingale* at all.[21]

Anxiety took its toll, and Stravinsky ran over his September 20 deadline. He would have denied it, but he worked better when he had a detailed libretto and stimulating designs before him.[22] Roerich had given him that during their collaboration on *The Rite*, but now he was rarely in contact, and only through Mitusov. Contributing further to this "composer's block" was growing speculation about the Free Theater's health. Benois predicted that the theater would survive long enough to stage *The Nightingale*, but twisted the knife by commenting that Mardzhanov would "alternate interesting things with impossible and unbearable shit and monstrous vulgarities."[23]

The Free Theater's closure rendered this moot. In November, Roerich, who already knew the bad news about *Maleine* and *Kashchei*, ceased to communicate with Stravinsky regarding *The Nightingale*. In December, Diaghilev picked up the opera on the financial terms he had set and assigned it to Benois. Stravinsky received only royalties, but at least got the designer of his choice, and Benois, in addition to pocketing his own fee, had the satisfaction of outmaneuvering Roerich. *The Nightingale* opened successfully in June 1914.

Roerich lost out on all counts. His *Nightingale* studies, which Mitusov pronounced "really very interesting," were wasted, and it was disheartening to lose

a commission to his worst rival.[24] If he guessed at Stravinsky's lack of faith in him, or if Mitusov told him about it, so much the worse. Yet another commission fell through in 1914, when the actress/singer Yevgenia Zbrueva tried but failed to produce Saint-Saëns's *Samson and Delilah*. Intending to play the female lead herself, Zbrueva personally asked Roerich to design her costume, but the war's outbreak threw her plans into confusion.

Roerich's one success during these two years came courtesy of Diaghilev. In 1914, the Ballets Russes revived *Prince Igor*, this time performing the whole opera, instead of excerpts as in 1909. Between November 1913 and February 1914, Roerich updated and expanded his designs, adding new costumes, plus sets to represent the fortress of Putivl, the brightly painted timbers of Prince Galitzky's courtyard, and Yaroslavna's secluded tower chamber. The new *Igor* opened in May 1914, with Sanin directing. Fokine, who had repaired his breach with Diaghilev, choreographed the dances, and Chaliapin sang the role of Khan Konchak. Orest Allegri and Nikolai Sharbe turned Roerich's studies into actual sets.

Roerich himself was not present for these preparations, which was just as well. The previous fall, the Théâtre des Champs-Elysées had folded, and only a last-minute intervention by Sir Thomas Beecham allowed the 1914 season to take place. But this meant relocating to London's Drury Lane, and Beecham admitted that the consequent chaos made the new venue seem "more like a railway station than a theater" on the eve of the first performances.[25] Also, with Roerich still smarting over *The Nightingale*, it would not have done to have him anywhere near Benois, who harbored hard feelings of his own, over what he saw as Sanin's too aggressive attempt to push *Igor* to the forefront.[26] With the season safely launched, Sanin informed Roerich how fortunate he was to have missed the furor. "Remember how I asked you to come here?" he wrote. "Now I can tell you—secretly, but with complete candor—that I am glad you did not. Much would have distressed and affronted you."[27]

And yet, Sanin continued, "the blaze of your talent burned mightily—*Igor* went forth in triumph." Allegri sent a souvenir program and told Roerich how much the London audience had enjoyed the opera. Among the spectators was a young Arthur Rubinstein, and the pianist records what an impression the production made on him.[28] Over the next years, the Ballets Russes could always count on excellent results from Roerich's *Igor*.

Home in Russia, Roerich finished the 1913–1914 academic year and prepared for another summer at Talashkino. In May and June, he and Tenisheva took part in a tour led by the Russian Archaeological Institute, visiting sites near Moscow, Vitebsk, and Smolensk. From Smolensk they went to Talashkino, and this time Helena, Yuri, and Sviatoslav came as well. So did Boris, who

aided Nicholas's and Frolov's crew with the final push to complete *The Queen of Heaven* for the Church of the Holy Spirit. Even the boys lent their father extra pairs of helping hands (see Illustration 24).

The family was at the estate when Gavrilo Princip plunged Europe into crisis by killing Franz Ferdinand and his wife Sophie in Sarajevo, and they were still there on August 1 (NS), when Germany declared war on Russia. The poet Anna Akhmatova later remembered this as the moment when "the whole world [was] smashed to smithereens," and Roerich, at work in the church's sanctuary, likewise never forgot it.[29] Tenisheva's companion, Yekaterina Sviatopolk-Chetvertinskaya, rushed through the door with the bad tidings, and Roerich took a second to reflect how he and his fellows, sheltered in a divine haven, surrounded by the glorious art they had created, were now confronted with the horrific reality of war.[30]

Patriotic fervor swept through Moscow and Saint Petersburg—soon renamed Petrograd, to rid the word of its Germanic sound—but initial optimism was dispelled in the first week of September at Tannenberg and the Masurian Lakes, where the Russians paid a butcher's bill of more than 280,000 killed, wounded, and taken prisoner. Turkey's November entry into the war cut Russia off from the Mediterranean, effectively placing Russia under blockade before Christmas.

Approaching his fortieth birthday, Roerich was technically young enough for military service, but age and status made it unlikely he would be called up, and his lung ailments precluded active duty. Instead, he dedicated himself to fundraising and war relief.[31] He donated money to the families of troops killed or injured in combat and, like many artists, auctioned his paintings to benefit the International Red Cross and the Saint Yevgeny Society, one of Russia's largest benevolent associations. For the same purpose, he gave up pieces from his private collection of art. Most of these auctions took place on Mars Field in Petrograd, with journals like *Apollo* and *Bygone Years* recording how many rubles each earned, but Roerich organized additional sales at the IOPKh. In 1915, to raise money for war victims, the Saint Yevgeny Society issued special postcards, each bearing the art of a well-known painter, and Roerich was among the first to participate. He chaired the Council of Red Cross Workshops for Disabled Soldiers and the Commission of Masters of Art for the Maimed and Wounded in Combat, both of which gave invalided troops handicrafts training and found jobs for them.

The war also rekindled Roerich's passion for safeguarding art and architecture. Sympathy for Belgium ran high in Russia, as Germany occupied the small country and committed atrocities that, even allowing for Allied propaganda exaggerations, were Hun-like enough: execution of noncombatants, destruction of civilian property, and the illegal use of forced labor. One early shock came when the Germans assaulted Louvain in August 1914. The city burned for five days, and hundreds of Belgian civilians

died. Louvain's magnificent cathedral went up in the blaze, as did its university and library.

To Roerich, the sack of Louvain proved that the Germans had descended into barbarism, and he feared more such devastation. In late 1914, he drafted a treaty proposal to protect artworks, libraries, museums, places of worship, and monuments of antiquity during times of war. At the same time, he petitioned the United States, the world's most powerful neutral, to persuade belligerent nations to show restraint.[32] He made only limited progress. His fame gained him access to the highest levels of leadership, and at the end of 1914, he reported to Russia's commander in chief—Grand Duke Nicholas, the tsar's uncle—on how the war threatened Europe's artistic heritage. In 1915, he spoke with Nicholas II himself. The tsar expressed sympathy, but took no action.

This failure did not end Roerich's preservationist efforts. He continued his fundraising and kept calling attention to the dangers posed to art by the fighting. In 1915, he helped found the Society for the Rebirth of Russian Art. Ultimately, he devoted the rest of his life to bringing his treaty into existence.

Even with a war on, the fall of 1914 found Roerich back at the IOPKh School. Deteriorating material conditions and the loss of male students to the front made it a struggle to keep the school open, but Roerich managed until the summer of 1917, when illness forced him to step down as head. Similarly, Roerich chaired the World of Art until the spring of 1916, then turned the post over to Ivan Bilibin. Meanwhile, he had three exhibitions—one in early 1915, a second at the end of the year, another in 1916—and other activities to organize.

As for his own art, Roerich took part in a fall exhibition sponsored by *Bygone Years* in 1914 and designed a production of Maeterlinck's *Sister Beatrice* (see Illustration 20). This, the last theatrical project he completed in Russia, was a gift from Sanin, meant to compensate for the failure of the Free Theater's *Maleine*. For months, Sanin had been lobbying Saint Petersburg's Theatre of Musical Drama to stage a Maeterlinck work. When World War I began, pro-Belgian sentiment made the playwright more popular than ever, and the theater head Iosif Lapitsky agreed to put something on by him and donate the earnings to Belgian refugees. What resulted was no conventional staging, but a curious two-part composite. The director Nikolai Arbatov began with a pantomimed abridgment of *Princess Maleine*, set to a symphonic poem by Maximilian Shteinberg, then presented *Beatrice* in operatic form, with music by A. A. Davydov.

The Lapitsky–Arbatov *Beatrice* premiered on December 18, 1914, continuing into January and meeting with a tepid reception. Critics faulted the hybrid format, with one complaining that "the opera is not an opera, and the drama is not a drama."[33] By contrast, Roerich's designs—costumes and

seven sets—were proclaimed "outstanding," and *Apollo* wrote that only they had saved the production from outright failure.[34] They were shown at the 1915 World of Art Exhibition and reproduced in *Apollo* that spring.[35] Fokine commented that Roerich's style "harmonized well with Maeterlinck's poetry," and even Benois praised the designs.[36] *Beatrice* was Roerich's last theatrical success during the war. He entered into talks with the Zimin Opera in 1915, but nothing came of this. In 1916, he toyed with a preliminary libretto for Mussorgsky's *Night on Bald Mountain*, although here, too, he got no further.[37]

Two architectural projects that had involved Roerich over the past several years were finished in 1915. The Buddhist temple described in chapter 6 opened for worship. Also, since 1913, Roerich had been working on decor for a new railway terminus built by Alexei Shchusev in Moscow. This was the Kazan Station, Russia's newest gateway for travel to Asia. Benois coordinated the interior design and selected Roerich, Dobuzhinsky, Bilibin, and Pavel Kuznetsov for the job.[38] Roerich designed two panels for the grand vestibule, each depicting Russia's long history of war in the east. *The Conquest of Kazan* recalls the days of Ivan the Terrible, who defeated the Tatar khanate of Kazan in 1552, paving the way for Muscovy's expansion into Siberia. Two armies clash on the battlefield, while an armored, sword-wielding hand—the mailed fist of God—reaches out from a cloud above. The second panel, *The Battle of Kerzhenets*, was modeled on the wildly successful curtain Roerich had

designed in 1911 for Rimsky-Korsakov's *Invisible City of Kitezh*. Both were installed in 1915. Even now, Kazan Station has the look of a fortress from some long-forgotten fairy tale, an effect reinforced by the *miriskusnik* style and well received by some, but disparaged by avant-gardists who felt the station's appearance should have mirrored its modern function. "The locomotives themselves are ashamed," cried out a mortified Kazimir Malevich. "They blush at being surrounded by these fauns, naiads, and Greek gods."[39] Appropriate or incongruous, Roerich's panels survived the Russian Revolution, but were taken down in the early 1930s.[40]

Roerich's most enduring legacy from the war's early years is *Collected Works*, a compilation of forty-eight essays and vignettes—some new, most already in print—issued in 1914 by Sytin, Moscow's most prestigious press. At 330 pages, with an ornate interlocking pattern gracing the cover, *Collected Works* contained three sections, the first of which, "A Prayer for the Past," contained essays like "From the Varangians to the Greeks" and "Joy in Art." Reviews and journalistic pieces made up the middle section, while the third part featured nineteen tales and poems, including the "Sacred Signs" verses, parables like "Italian Legend" (presented here as "The Great Gatekeeper"), and stories set in the ancient north, such as "Grimr the Viking" and "Liut the Giant." "Devassari Abuntu" and "Lakshmi the Conqueror" reflected Roerich's interest in India, and "Leader," a poem praising Genghis Khan, added an Asian touch of a different

sort. Supernatural tragedy pervades "Horrors," the Maeterlinck-influenced "Towers of Sorrow," and "Myth of Atlantis," a symbolic warning about modern civilization's impending demise.

Roerich dedicated *Collected Works* to Helena and gave it the subtitle "First Book." In volumes to come, he expected to include more poetry and new essays. Thanks to the war, these additional collections did not appear.

In an autobiographical sketch depicting World War I–era Petrograd, the author Isaak Babel turned to Roerich as a useful element in setting his story's scene: in a banker's drawing room, "decorated in ancient Slavonic style," the artist's "blue paintings, prehistoric stones and monsters," are described as hanging next to more commonplace icons and china cabinets.[41] It was a narrative detail instantly recognizable to any reader. Midway through the war, Roerich's stature in Russia had grown as great as it ever would during his lifetime—a fact that made his subsequent misfortunes all the harder to bear.

Early in 1915, Roerich made a good showing at the World of Art Exhibition, with eleven works on display. In May, he was featured in *Apollo*, which published almost thirty reproductions, many in color, of his recent art. Accompanying these was an essay by Alexander Gidoni, "Roerich's Creative Path," which stressed the artist's

versatility and profundity.[42] In *Russian Bibliophile*, Nikolai Wrangel lauded Roerich's gift for comprehending the past: "From a high peak, with his keen vision, Roerich gazes upon a faraway truth. The gray mists that conceal the secrets of lost centuries are no obstacle to him."[43]

A greater honor came at the end of the year. To celebrate Roerich's twenty-five years of artistic activity (measured loosely from 1891), the Free Arts Press issued a jubilee volume edited by Jurgis Baltrushaitis, Alexander Gidoni, Stepan Yaremich, Alexei Remizov, and, remarkably, Benois.[44] Georgii Narbut designed the cover and illustrations. Ten of Roerich's stories were reprinted, as was "Leader," his poem about Genghis Khan. One hundred seventy-eight reproductions of his paintings and designs—thirty-seven in full color—graced the pages of this gorgeous book.

Each editor contributed an essay, with Gidoni offering his *Apollo* piece from the year before, and Yaremich comparing Roerich to Viktor Vasnetsov. Remizov spoke of the "literary" qualities of Roerich's work, and Baltrushaitis saw in his use of line and color a counterpart to the rhyme and meter of epic poetry. Most striking was "Roerich's Path," by Benois, who, in this complex exegesis, offers respect but not adulation. Benois refers openly to his battles with Roerich, remembering that they were once "almost religious enemies." Even now, he admits, "Roerich and I are not close as individuals (with someone so self-sufficient, it is impossible to become truly close)." However, he

is happy to say, "We have become closer as artists."

Then, in a widely quoted passage, Benois contrasts his own outlook with his colleague's. Referring to Roerich and himself as "twin poles of Russian culture," Benois observes, "We belong to completely different races. I am almost a pure Latin southerner. Roerich, unless I am mistaken, is almost a pure Scandinavian northerner":

My soul is drawn to slender cypress trees, to alpine citadels blocking out the horizon, to the radiant azure of the sea. Roerich is a bard, inspired by the north's rugged, glacier-worn hills, hardscrabble birches and fir trees, the play of shadows upon the boundless steppe. We also part ways concerning our inborn cultural sympathies. Roerich literally trembles with love for moss-covered huts, and even dearer to him are the yurts of the nomad. I would not for anything exchange the holy grandeur of Saint Peter's or the lordly harmony of the Escorial. We are different even in our very means of expression. I gravitate toward clear definition and distinctly outlined forms. Roerich loves roughness of form: touches of chaos, a certain incompleteness, a deliberate lack of clarity. To give only one example, how characteristic it is that, so often, the buildings he paints have the appearance of having been molded from clay—a feature resulting not from any lack of ability, but from an irresistible preference fixed in his mind.

Roerich and I have different interpretations of human history, of the nature of humanity itself. Our worldviews are *organically* different. I find worth in all things that have reached their culmination, in which perfected ideals have already been realized. Roerich is drawn to the wilderness, to the distant, to primitive peoples, to unformed shapes and ideas. In all of his art, in all that inspires him, he affirms that good is to be found in strength, that strength is to be found in simplicity and open space, and that only by starting anew can these things be found.

Anticipating by fourteen years Freud's plaint from *Civilization and Its Discontents*—"How has it happened that so many people have come to take up this strange attitude of hostility to civilization?"—Benois goes on to say that:

I treasure the language of Pushkin, and I would that everyone spoke that language of the gods. There is such truth in that harmonious speech. For Roerich the artist, for Roerich the dreamer, with his primordial taste, it would be nothing terrible to return to the impoverished language of savages, as long as instincts were expressed clearly and forthrightly, as long as there were none of the falsehood and confusion inherent in "civilization," such as it is. As always, however, the real truth lies in the middle, and Roerich and I

approach it from diametrically opposed extremes.[45]

Mindful of their homeland's wartime plight, Benois talks of his and Roerich's fervent hopes for Russia's survival: "In a time beset by the demons of enmity and falsity, he has gone into his wilderness, just as I have retreated to my temple, both of us to offer prayers to the God of peace and beauty."

Imprinted with the date 1916, *Roerich* was released in November 1915, with a December celebration to accompany its launch. Pupils from the IOPKh School saluted Roerich in a series of testimonials, while Remizov and Sergei Gorodetsky composed a fulsome paean, "The Choir of Colors":

> Glory to Roerich, the ruler
> Of multi-colored beauty,
> In a many-voiced choir of acclaim
> We glorify his dreams.[46]

The jubilee touched off a flood of congratulatory telegrams and letters.[47] Gorodetsky wrote, as did Bely and the psychologist Vladimir Bekhterev. Blok sent "warm congratulations to my favorite painter, sternest of masters." Roerich's reply was a reminder of wartime grimness: "In these ice-cold days I greet your tender words. Thank you for remembering me."

Roerich sold quickly, and a second edition came out in 1917. Biographies also appeared: two in 1916, by Alexander Rostislavov and V. N. Levitsky, and one in 1917, by Sergei Ernst at the Hermitage. These were the first major studies of Roerich's life and art. (Igor Grabar had attempted to commission one in 1912, as part of his "Artists of Russia" series, but the author, Alexander Ivanov, was still writing away in 1916 and refused to make any cuts to his ever-expanding text. "Not one line can be removed!" he told Grabar, words no editor has ever enjoyed hearing, and Ivanov's book was never published.[48])

At this point, Roerich was in the same position as a Repin or a Vasnetsov ten or fifteen years before: an authority and a mentor, no longer on the cutting edge, but still in vogue and famous enough to enjoy the fruits of respectability while emerging artists broke new ground. Roerich saw himself as benefiting from a natural process of change, in which he and his colleagues would encourage the up-and-coming generation. He respected the work and liked the company of several forward-looking painters. Among these were Konstantin Yuon, whose cosmic themes and cheerful demeanor Roerich enjoyed, and the more radical Kuzma Petrov-Vodkin, along with *miriskusniki* such as Alexander Yakovlev and Boris Grigoriev, who experimented with Cubist techniques.[49]

Unfortunately, such evolution did not unfold as Roerich anticipated. Art was already changing on a greater scale than he had once imagined, and in the crucible of war and revolution, the bursting forth of avant-garde energies would catch him and those like him even more off guard. Dissatisfaction with the *miriskusnik* style was cresting: Russia's cultural reaction "against

the *vin triste* of Blok, the sombre madness of Vrubel, [and] the pathos of Scriabin," as the writer Nina Berberova described it, had been gathering force for half a decade, and its triumph was now at hand.[50] At the 1915 World of Art exhibition, even the normally friendly *Apollo* complained that "this show made us remember past ones with sorrow. We recall when it was considered an honor to display your work beside that of Serov, Somov, or Roerich."[51] Had Roerich and his cohort gone stale? The feeling that they had became more prevalent as the war progressed.

⁂

Roerich stated during the war that art should "defend the joy of the spirit against all forces of darkness."[52] He created a successful propaganda poster, *Enemy of Humankind*, printed in 600,000 copies and depicting Wilhelm II as a goat-legged devil.[53] Only rarely, though, did he deal with the conflict explicitly, using his easel work instead to meet his own psychological needs. On one hand, he painted an idyllic eden, where he could take refuge from the dangers of the day. On the other, he vented anxiety by conjuring visions of dread, in the mold of his earlier "prophetic" works. Between these extremes lay a landscape of pagan mystery, imbued with a supernaturalism that became more real to Roerich as the war went on.

In the first category were saints' lives, a genre that emphasized divine protection. In *Procopius the Righteous Praying for the Unknown Travelers* (1914), the saint, seated on a bluff, blesses tiny boats navigating the river below (see Illustration 19).[54] One of Roerich's own favorites was *Panteleimon the Healer* (1916), in which a kindly sage gathers curative herbs. Images of sanctuary appeared as well. *House of the Spirit* (1915), *The Hiding Place* (1915), *Repentance* (1917), and *The Holy Island* (1917)—set respectively in a clifftop chapel, a honeycomb of hermits' cells, a snow-covered church, and an isle of jagged rock—speak to Roerich's yearning for security and solitude. Celebrating the wholesomeness of Russian life is *The Three Joys* (1916), at whose center stands a wooden house. A peasant family watches as two musicians approach the gate, left open to welcome visitors. Helping the farm to prosper are Saint Nicholas, tending the cattle, Saint George, seeing to the horses, and Saint Elijah, harvesting the crop. This is a latter-day icon, a portal to a Slavicized paradise.

Try as he might, Roerich could not keep wartime realities from creeping into his art, making many of his canvases brooding and apocalyptic. One image used repeatedly, in works like *Conflagration* (1914), *Human Deeds* (1914), and *Shadows* (1916), was that of the medieval stronghold, menaced by destruction. In Roerich's artistic vocabulary, the castle represents not just protection, but cultural attainment, and for it to be torn down signifies barbarism's triumph. *Crowns* (1914) presents a visual parable in which three kings, battling each other on the shore of a vast sea, fail to notice how their crowns, emblems of wise government, have

vanished into the sky and become clouds. In *The Herald* (1914), a black-sailed ship, bearing news of war, approaches the barren cliffs of a large island. *Arrows of Heaven, Spears of the Earth* (1915) depicts a lava-red sky, under whose glow an armored warrior surveys a great host as it marches off to confront some unseen foe.

Similarly themed was *The Doomed City* (1914), one of the most remarked-upon pieces at the 1915 World of Art Exhibition.[55] The setting—a hilltop citadel and rocky pond beneath a dark sky—is modeled on El Greco's *View of Toledo*. While the city slumbers, an enormous viper coils around the walls (see Illustration 18). Oblivious to their peril, the inhabitants are trapped. Several of Russia's leading authors found *The Doomed City* compelling, among them Gorodetsky, Baltrushaitis, Blok, and Leonid Andreyev, but the most enthusiastic reactions came from Alexei Remizov and Maxim Gorky. The former composed a verse in honor of the canvas:

> Doomed in the coils of the serpent
> stands the city.
> Yet, for so long, no one knew of or
> suspected the misfortune to come.
> People drank and they ate,
> They married and wed.
> And when the hour came to sound the
> alarm—
> There was nowhere to escape to![56]

Gorky purchased *The Doomed City* for his own collection, reputedly exclaiming to Roerich, "You as an artist feel what is needed. Yes, yes, precisely you feel—you are an intuitivist. Often one should grasp the very essence—above reason!"[57] The painting's appeal crossed generational lines, and among those drawn to it over time were Arkady and Boris Strugatsky, the USSR's most acclaimed writers of science fiction. The two brothers were so "astounded" by *The Doomed City*'s "somber beauty" and "sense of hopelessness" that they gave its title to one of their novels, a morose tale about an isolated experimental community of the future.[58]

Roerich also painted unearthly landscapes: some Asiatic, others pagan, all esoteric. *The Summoned* (1916) and *The Hunter at Rest* (1916) are associated with Roerich's *Flowers of Morya* poems, in which the hunter represents the truth-seeking soul. *Boundaries of the Kingdom* (1916), like Roerich's short story of the same name, is set in the Himalayas, while *The Wisdom of Manu* (1917), commissioned by the Russian Theosophical Society, portrays the great lawgiver of Hindu tradition.[59] The mythic north receives its due in *Tomb of the Giant* (1915) and *Krimgerd the Giantess* (1915, 1917–1918). In *The Omen* (1915), a man gazes at the sky, reading portents in the clouds overhead. *The Hidden Treasure* (1917) shows a boat gliding across a mountain lake, into whose depths a mysterious object is lowered. In *Meheski— People of the Moon* (1915), the dwellings of a desert settlement lie open to the night sky. Perched on a ziggurat, robed priests worship the moon's gentle beams.[60]

Revelation and incantation take a more active role in works like *The Command* (1917), where a fur-clad wizard bends a rushing river to his will, and *The Commands of Heaven* (1915), in which nine elders stand in a volcanic desolation, propitiating the eldritch presence that manifests itself in the angry, cloud-covered sky. In this hyperborea of the imagination, coursing with elemental magic, sorcery and ritual preserve the balance between humanity and the untamed environment. In desperation, Roerich now looked to these enchantment-filled epochs in hope of finding a solution to the crisis destroying his own age.

Despite occasional encouragements—the capture of Przemysl, victory over Turkey at Erzerum, the Brusilov Offensive's initial success against Austria-Hungary—the war was all but lost by the end of 1916. Nicholas II, at the front since 1915, left power in the hands of Empress Alexandra, whose reliance on the scandal-ridden Rasputin evaporated what little popularity remained to the Romanovs. In the field, Russia had taken more than 7.5 million casualties. Daily rations for a ten-man squad consisted of two pounds of bread and a pot of bean-and-potato soup, and new recruits, ordered to scavenge from fallen comrades, were often sent to fight without boots or rifles. Soldiers deserted en masse while a paralyzed government failed to resuscitate a dying home front. The French ambassador reported during these weeks that "the Russian Empire is being run by lunatics," and Rasputin's assassination in December 1916 did nothing to restore order. As the year wound down, Russia's top generals pleaded with the tsar to abdicate, or at least give up direct command of the army. He refused, but would soon have no more say in the matter.

During the war's middle years, Roerich strove for as much normality as possible, keeping up with his classes, exhibits, and charity auctions. Yuri and Svetik, now fourteen and twelve, studied at the May Gymnasium, and Nicholas, with Lydia and Boris, cared for his aging mother (see Illustration 12). He continued to agitate for architectural preservation, protesting for much of 1916 against the running of a military railroad through the environs of Gorodishche and Novgorod. (Construction went ahead, despite his opposition.[61]) Eventually, wartime pressures ground him down. The IOPKh School was hemorrhaging money. *Miriskusniki* like Roerich faced obsolescence as avant-garde trends gained strength. Worst of all, Roerich's health suffered. In mid-1915, he was diagnosed with pulmonary inflammation. Doctors urged him to leave Petrograd, with its pollution and damp climate. For months, he ignored this advice, staying close to the artistic center of things, and to his family, his books, and his treasured collections. But it soon became a question of when, not whether, poor health would force him to leave.

Such stress thrust Roerich into a state of supernaturalist gloom. He read and reread tales of cosmic strife and world-shattering

battles, ranging from the *Kalevala* and the Eddas to the *Mahabharata*. With Helena, he pored over the Book of Revelation, the *Bhagavad Gita*, and the mystical verses of Rabindranath Tagore. The Roerichs saw in World War I the "deepening shadows" and the "monsoon weather, all around humanity," that Tagore writes of in *Gitanjali*, and one imagines them seeking comfort in the poet's lines: "O Lord, who knows my being . . . indeed you know how I long for you at heart."[62]

Such millenarian anxieties, Christian or esoteric, became the norm among Russia's intellectuals during the war. They are evident in Natalia Goncharova's lithograph series "Mystical Images of War," in which angels dodge airplanes and shellbursts, and Vasily Rozanov's cri de coeur, "The Apocalypse of Our Time." An extreme reaction came from Scriabin, who, in the months before his death, labored feverishly to complete the oratorio *Mysterium*, laden with Theosophical significance. Scriabin dreamed of staging *Mysterium* in India, with the Himalayas in the background. A cast of two thousand would perform for seven days, and the final note, he believed, would end the world as humanity knew it. A fatal blood infection cut his effort short in 1915; of the composer's death, Roerich later observed that "the fire of Prometheus has been extinguished."[63]

Scriabin "had full consciousness of what he was creating," the Roerichs maintained in years to come.[64] In 1915, they had not yet succumbed to such doomsday literal-mindedness about the occult, but they were moving toward it, as evinced by a set of letters Nicholas exchanged with Remizov that December. The latter, writing about *The Purest City Proves a Vexation to Its Enemies*, told Roerich, "Your city of stone will safeguard the Russian people and earn much glory in the years to come."[65] The next day, Roerich sent Remizov an assortment of flints he had collected near Novgorod and, with them, this letter:

> Greetings to one who wields secret powers, commands bright spirits, and searches for hidden signs. . . . We have pronounced the words of enchantment inscribed in stone, in red flint. We have taken possession of the arrow of thunder, the arrow of black flint. With a sign of high grace, we have consecrated the spear of white flint. The stone has spoken. It has revealed a path to one who knows what is good, who has loved the earth, and who, in the quiet corners of Pesochnaya Street [Remizov's address], has hidden himself from evil. Beyond the ramparts that path leads, across the mountains' white towers, beyond the ice and snow.
>
> We send you items of enchantment: a round red flint for the foundation of your house. Likewise the arrow of thunder as a protection against thieves, hidden devils, and wandering demons of slander. There is also the white spear, a weapon that defends the glory of the Motherland and fights for Rus, which you have loved with all your strength. May the spear shine brightly as it guards

against all enemies . . . Saint Nikola guard you, and Procopius the Righteous bless you, as you tread the paths of goodness and truth. Let Procopius bless also Serafima Pavlovna [Remizov's wife], for her kind words and tender gaze. We in the city will forge the armor of war and repel the enemy.

From Nikola, an exile from the Varangians. Items of enchantment from Novgorod![66]

Such exchanges, with their hints of secret ceremonies, lend credence to the assertions some have made about Roerich's involvement in Masonic or Martinist-Rosicrucian circles. Either way, Remizov wrote back the same day to thank Roerich for "these enchanted gifts."[67]

The same tone of mystery permeates Roerich's wartime writings, especially the *Flowers of Morya* cycle, which took firmer shape in 1915 and 1916. Of the sixty-four poems in the collection, at least twenty-four date from this time, with five having been completed earlier. Together, they tell a story of pilgrimage and spiritual evolution. In part 1, "Sacred Signs," a great lord has departed, leaving his kingdom in confusion, but has left clues that will allow the most loyal of his subjects to find him. The scenario allegorizes Roerich's wish to visit Asia, but also his understanding of the modern dilemma: divinity's presence is felt but dimly in the mundane world, and only through spiritual discipline can one reconnect with it. Part 2, "To the Blessed One," shows

the seeker venturing forth to find his lost master. He tells his companion that a path has been revealed:

Awaken, O Friend. A message has come.
You may rest no more.
Now I have learned
Where one of the sacred signs is
 guarded . . .

Before sunrise we must be on our way.
Tonight we must make ready.
Look at the night sky—
It is beautiful, as never before;
I do not recall another such night.
Only yesterday, Cassiopeia was sad and
 misty,
Aldebaran twinkled fearfully,
And Venus did not appear.
But now they are all ablaze.
Orion and Arcturus are shining.
Far behind Altair, new starry signs are
 gleaming.
The mist has cleared, and the constellations
 shine clear and bright . . .

Do you not see the path?
The East is aflame.
For us
The time has come![68]

Many of the poems take the form of dialogues, as the seeker imagines conversations with his hidden master and grows increasingly confident in his wisdom. By part 3, "To the Boy," the narrator has become capable of guiding others, as in "The Scepter" (1915):

All I have learned from my grandfather
I repeat to thee, my boy.
To his own grandfather, my grandfather
 listened.
Every grandfather speaks; every grand-
 son listens.
To thine own grandchild, my beloved
 boy,
Thou wilt relate all that thou knowest.[69]

The fourth section, "To the Hunter Enter-ing the Forest," speaks of the journey's final stages, but was not completed until 1921.

Whether Roerich's gifts as a poet match his painterly talents is for the reader to judge, although anthologies of Russian verse now frequently include selections from *Flowers of Morya*.[70] Roerich's style is likely to remind Western readers of Kahlil Gibran, and in fact, some of Roerich's biggest US fans were the same Theosophists who helped boost *The Prophet*'s popularity when it was released in America. But the true influences are Tag-ore's *Gitanjali* and Blavatsky's "Stanzas of Dzyan," with possibly a tinge of Nietzsche, who employed a hunter motif in *Zarathus-tra*, so admired by Roerich in his youth.[71] *Morya*'s archaic language conveys a sense of timelessness, as does its constant alternation of parable and paradox.

At the end of 1916, illness drove Roerich from Petrograd. The pain in his lungs had grown unbearable, and better air was a must. On the evening of December 16 (OS)—the night Rasputin was murdered—Nicholas, Helena, and their boys boarded a train at the Finland Station, bound for the town of Serdobol (Sortavala), on the northern shore of Lake Ladoga.[72]

The Roerichs spent much of the next two years in Karelia or Finland, both still part of the Russian Empire.[73] Their De-cember trip was neither well planned nor comfortable. It fell to twenty-five degrees below zero the night they left, and the heat in their train car did not function. Hotels in Serdobol were overcrowded, and the Ro-erichs sought more suitable accommodation. Helped by friendly Finns, they arranged to rent a house on the beach of nearby Yhin-lahti, or Unity Bay. This was the home of Oskar Relander, rector of the Serdobol Seminary. Relander had protested the gov-ernment's decision to turn the seminary into a cadet training school, and was exiled to Siberia for his pains. To earn extra income in his absence, his family leased their house to the Roerichs, who lived there until Re-lander's release the following May.

Roerich finished a great deal of paint-ing at Yhinlahti, while also maintaining ties with the capital. Administration of the IOPKh School he left to his deputy, Nikolai Khimon, but he remained director, traveling back and forth to see how the school fared. Boris, also on staff, served as an extra pair of eyes. Roerich was on hand for IOPKh auc-tions in October 1916 and January 1917, and took part in three shows in February 1917: the Academy of Arts' spring exhibition, a fiftieth-anniversary jubilee for the Sytin

publishing house, and the World of Art Exhibition.[74] The last had enjoyed a successful opening in Moscow, where it ran from late November to early February. It opened in Petrograd on February 19 (OS), 1917.

At first, the show did well, with more than six thousand visitors on the first day, and critics reacting favorably on the whole. Roerich was a commanding presence, displaying forty works, enough to require a separate room. *The Three Joys*, *The Commands of Heaven*, and *Meheski* attracted special attention, and Boris Grigorev's slightly Cubist portrait of Roerich himself, heavy-lidded and contemplative, looked over the hall. One reviewer wrote about Roerich as "one who sings of unearthly beauty," and another spoke of how his 1912–1914 paintings—the canvases labeled by some as "prophetic"—appeared to have foretold the war.[75]

Such opinions, however, were not unanimous, and an unmistakable death knell sounded in January, when *Apollo*, for years a booster of Roerich and the *miriskusniki*, called for bolder change in the arts. Most strident was Nikolai Radlov, who compared the rising Futurist movement with the World of Art and complained that the latter had led Russian art into a dead end. He singled Roerich out for criticism: "Fifteen years have gone by, and we are within our rights to ask, where is the special, inspirational, significant art we were promised? How is the art of today different from that of the past, and where can we say it is taking us? We are within our rights to ask whether it was worth waging a fifteen-year war against the Academy and its clichés, struggling to create something new, if the only result is a 'newness' constrained by conditions and limits—like the 'new' art Roerich and his ilk have created."[76] Such sentiments had been welling up for years; they now spilled over in full flood.

By sheer bad luck, the World of Art Exhibition coincided with the outbreak of revolution. In a momentous week and a half starting on February 22 (OS), the imperial regime was toppled by a series of strikes and rallies that crystallized into full-fledged political action. On the twenty-third, angry protestors marked International Women's Day by taking to the streets. Authorities in Petrograd lost control, and when Nicholas II tried to return from the front, rebellious soldiers took him into custody. On March 3 (OS), the tsar abdicated, and the Romanov dynasty, after three centuries on the throne of Russia, was no more.

This February Revolution temporarily exhilarated the country, but left it in a state of uncertainty. Power passed to a hastily formed Provisional Government. Key figures included the foreign minister, Pavel Miliukov, the leader of the Constitutional Democratic (Kadet) Party, and the moderate socialist Alexander Kerensky as minister of justice. Challenging the government was a second institution: the Petrograd Soviet, where the left-wing parties—the agrarian populist Socialist Revolutionaries (SRs), the

Mensheviks (gradualist and democratically inclined Marxists), and the Mensheviks' radical cousins, the Bolsheviks—found their voice. The Soviet lacked the government's official status and political professionalism, but had a broader base of support, and it soon became evident that neither could govern without the other's consent. Both agreed to share power until the autumn, when a new legislature, the Constituent Assembly, could be elected. This "dual power" regime guaranteed freedom of speech and the press, abolished capital punishment, and gave women the vote, but it was a fragile arrangement, weakened by mutual distrust, and how long it could last, no one knew. Nina Berberova, a teenager at the time, later remembered the events of February as "a light that sparkled for an instant" before "the bloody collapse of everything."[77]

As in 1905, Roerich had difficulty deciding what to make of February 1917. The following summer, he would decry as an abomination the 1918 execution of Nicholas II and his family, but he appears for the moment not to have mourned the passing of tsarism. What he did fear was the untrammeled fury of the lower classes and any potential for mass violence. Roerich had long avoided aligning himself with political movements, and he proved reluctant to commit himself now; as Vladimir Nemirovich-Danchenko of the Moscow Art Theatre said of him, "Roerich belonged neither to the right nor the left."[78] If pressed to affiliate himself with a party, the artist would probably have chosen the liberal Kadets, although enough

of his friends leaned farther to the left—Remizov belonging to the SRs, Gorky to the communists—that some sort of moderate socialism would not have been out of the question. (Boris, his favorite sibling, had leftist sympathies and may have pulled him in that direction.)

Although culture and national unity mattered more to Roerich than the workings of government, the revolution affected both, so he followed the lead of Maxim Gorky, who, as the country's foremost writer, coaxed Russia's intelligentsia to address a set of problems that cut across ideological lines and artistic doctrines.[79] Would the arts remain free, or would censorship smother them? What was to become of the theaters, operas, museums, and schools once administered by the now-abolished Ministry of the Palace? And how could the wanton destruction of tsarist-era monuments and art be stopped? Looting was a straightforward problem, but symbols of the old regime were also being vandalized. With distress, the Gorky-run newspaper *New Life* noted that "the mob, in its ignorance, sees old treasures as nothing more than remnants of the previous rulership and treats them as it would rubbish."[80]

On March 4 (OS), Gorky invited fifty of Russia's most prominent artists, authors, musicians, and architects to his Petrograd apartment. Among them were Benois, Bilibin, Dobuzhinsky, Petrov-Vodkin, Chaliapin, Stanislavsky, and the poet Vladimir Mayakovsky. Also present was Roerich. They styled themselves the Commission on

Artistic Affairs—informally, the Gorky Commission—and pressed both dual-power authorities to prioritize cultural concerns. Gorky chaired the commission; his deputies were Benois and Roerich. A twelve-person subcommittee was struck to devise protections for art and architecture, and Roerich served on this as well.

In March and April, the Gorky Commission persuaded the Provisional Government and the Petrograd Soviet to speak against the theft, destruction, or defacement of any architectural or artistic work. On March 6 (OS), the government allowed the commission to occupy the offices of the former Palace Ministry, and both it and the Soviet convened special conferences on artistic affairs. Roerich took part in both, and his brother Boris hosted several of the Soviet-sponsored meetings in his own apartment. On the table in each case was the possibility of creating a Ministry of Fine Arts, a particular goal of Benois's.[81] Among the party notables Roerich negotiated with during the coming weeks were Anatoly Lunacharsky, the Bolsheviks' point man on cultural affairs; the Bolshevik engineer and trade expert Leonid Krasin; and the Menshevik Georgii Plekhanov, father of the Russian Marxist movement and a onetime mentor of Lenin, athough the two had long since fallen out.[82] In contrast to most Petersburg intellectuals, Roerich did not care for Lunacharsky. He was more impressed with Krasin, and he especially liked the open-minded Plekhanov.

At the end of April, Gorky disbanded his namesake commission in favor of a larger and more inclusive Union of Practitioners of Art (SDI, or Arts Union). The SDI set up eight subcommittees, one to handle legal affairs, the others dealing with theater, architecture, music, state manufactories and presses, public celebrations and the mass popularization of art, museums and the safeguarding of public monuments, and artistic education. Roerich was most heavily involved with the last two. In May, he joined Gorky and Benois on the thirty-eight-person Council on Artistic Affairs formed by the SDI to advise the Provisional Government.

Thus, during the spring and much of the summer, Roerich divided his time between Serdobol and the capital, 150 miles away. By any standard, and definitely for a middle-aged man who had been ordered to watch his health, he kept busy. In addition to his SDI work, he continued to direct the IOPKh School, where the tumultuous times took their toll. Soldiers had been quartered in the society's buildings, and students and staff wondered how the school would fare under the new regime. Would it still attract students? Would it be allowed to stay open? Despite its rundown condition, Roerich hoped to transform it into a Free Academy of Arts. He also helped to open two shows in April. First was the Exhibition of Free Arts, which he, Gorky, Benois, and the curator Sergei Ernst had been organizing for months. The second was an exhibit of Finnish paintings, whose premiere he attended with Gorky, Benois, Mayakovsky,

and Sergei Prokofiev. There, he renewed his acquaintance with Akseli Gallen-Kallela.

Roerich found it gratifying to be so involved, and, early on, he shared Gorky's faith that Russia's best talents could set aside their differences to create a common artistic vision for a new society. But signs of political and military breakdown unnerved him, and he was demoralized by the Arts Union's fragmentation into competing cliques. Then there was his own condition. Overtaxed by his trips to Petrograd, he suffered a relapse in May, severe enough that he redrafted his will.[83] He did not give up politics completely, but worsening health forced him to spend most of the summer in Karelia.

Meanwhile, the state of affairs worsened in Petrograd. Dethroning the tsar was not enough to end food shortages, reenergize the economy, or turn the tide of war, and the thrill of February quickly faded. In April, Lenin returned from his exile in Switzerland, declaring Bolshevik opposition to the Provisional Government with his inflammatory slogan, "All power to the soviets!" In May, the government, rocked by controversy, experienced a cabinet shake-up: Pavel Miliukov, who precipitated the crisis by reaffirming Russia's commitment to the Allied war effort, was forced to step down, as was the minister of war, whose place was taken by Alexander Kerensky.

Shuffling cabinet posts improved little. June and July witnessed the failure of Russia's last major offensive. The Germans counterattacked and, in the months to come, advanced along the entire front. Then came the "July Days," when violent pro-Bolshevik demonstrations roiled the capital. In response, the Provisional Government drove the Bolsheviks underground: Trotsky went to jail, while Lenin fled to Finland. The disturbances caused a second reorganization of the cabinet, bringing Kerensky to power as prime minister, though his moment of triumph was short-lived. As summer turned into fall, Kerensky faced threats from right and left. He fended off the former, but in less than a season, the latter, in the form of a resurgent Bolshevik Party, would prove his undoing.

Back on the shores of Yhinlahti, Roerich took up his brush again. It relaxed him to paint the trees and cliffs dotting the lakeside, and from his vantage point on the Relanders' veranda, he turned out a set of landscapes called the "Karelia" suite. Also that summer, he began the eight-piece "Heroica" suite. Several of these were based on the Elder Edda and the *Kalevala*, and two, *The Hidden Treasure* and *Lord of the Night*, depict Asiatic locales: a high mountain lake and a desert caravan road. Roerich wrote more poetry as well.

He was not completely at leisure. When Relander returned from Siberia, the Roerichs had to find new lodgings. (At summer's end, they were taken in by the family of the scholar Arvid Genets, with whom they would stay until the middle of 1918.) Moreover, Roerich worried constantly about

events in the capital. He visited when he could and received a steady influx of messages from friends there. These made him regret being sidelined by illness. In June, for example, he wrote Zarubin in Petrograd and mentioned in passing his "Karelia" and "Heroica" projects. In return, Zarubin accused him of self-absorption: "I have just received your letter. You write about your paintings. Here, such things are no longer of concern. Can one really care half a cent for one's work at a time of such great upheaval? We live not for our own sake, but for that of Russia's people—and we experience in our souls all the grand events history has fated us to witness. To describe this is impossible. You must see it yourself."[84] Zarubin's reproach stung all the more because Roerich already half believed that history had passed him by.

Other letters brought discouragement. The IOPKh School had entered financial free fall, and most of its administrators, thinking this a short-lived problem, proposed running deficits to weather the storm. This "unwarranted optimism" appalled Roerich: "Taking a long view of things has destroyed my hopes. The Society is generating no more income than before, but expenses have increased sixfold. The starkness of this formula is terrifying in its clarity."[85] The war continued to go badly. Angry crowds filled Petrograd and Moscow, and palaces and estates throughout the country were looted and destroyed. In June, Nicholas and Helena received the grievous news that Bologoe, the home of Helena's uncle, Prince Putiatin, had been burned to the ground. Irreplacable

artworks and artifacts were lost forever, and the journal *Apollo* reflected on the "irony of fate" by which so many treasures had been evacuated "out of the range of German bombshells," only to face destruction at the hands of Russians gone berserk.[86] The Arts Union seethed with factionalism. A traditionalist wing, unhappy with the revolution, resisted change. A radical bloc, carried away by the anarchic glee of Mayakovsky's Futurist declamation that "it's time to pepper the old museums with new bullets!" thought there should be nothing *but* change.[87] Centrists had no unified policy to offer. Among their proposals were the raising of a special militia to guard galleries and monuments, the creation of a Red Cross of culture, even the transfer of artworks to a neutral country for safekeeping.

Roerich was relieved to be apart from this. The solitude of the Ladoga woods soothed him, and he relished the opportunity to concentrate on his art. But while his hopes for an acceptable political outcome were waning, they had not disappeared, and he still felt obliged to combat civic and artistic extremism. As he reminded Benois in a July letter,

> I live on the bay of Yhinlahti, which means "unity." The very name of this place reminds me that, in order to save culture, we must first save the hearts of the people. Can it really be that we will return to the days of public indifference to culture? Can we really conceive of a free life in which there is no place for

learning, no place for the joy that art gives us? Is the choice before us really to allow art to descend to the level of the masses? Or, by force, to elevate the masses to the point that they appreciate the known limits of art? I have faith in humanity, but am always fearful of the mob, which gives off such vulgar, evil emanations. So much about the mob is baleful and inhuman.

As for why he felt bound to stay politically active, despite the worsening outlook, he told Benois, "Our true purpose is to create art. But perhaps it is necessary after all to sit on these commissions. Who knows? Whatever the case, it is imperative that all of us pool our resources to struggle on behalf of culture and art. No matter what kind of treatment we may encounter, we must pledge ourselves to defend those things for whose sake we exist. You and I are already accustomed to withstanding blows from the enemy; in that, our fates have been similar."[88] Roerich may have been weary, but he was still ready to battle for what he thought right.

In a matter of days, though, Roerich was taken out of the fight. He grew sicker in July and, for the next several months, could no longer travel to Petrograd. In August, with great sorrow, he stepped down as director of the IOPKh School, a post he had held for eleven years. The school's health was failing as quickly as Roerich's. "It is breaking apart," he wrote, "and should it fall to me, its builder, to take part in its dismantling? The committee considers this a temporary crisis, but I know full well there is no returning to the way things were."[89] The directorship went to the trustworthy Khimon, and Roerich remained on the board of advisers. Still, the resignation dampened his mood as autumn approached, all the more so because illness kept him for a time from painting. As for Helena, family woes—the dislodging of Uncle Pavel and Aunt Dunya from their Bologoe estate, plus the death of her Aunt Lyudmila—left her disconsolate. Nor did she take cheerfully to managing a household without hired help. Having to shop, cook, and clean proved a huge comedown for someone so highborn, and until the family's fortunes revived, she resented how the domestic chores fell to her without question.[90]

Such duties were made more onerous by the skyrocketing cost of living and the increased difficulty of finding food. Only two years before, Roerich's paintings had been fetching a healthy average price of 2,500 rubles apiece.[91] Now, as he moaned to a friend, "the rise in prices is killing everything. Like all Russians, we have outlasted—or, more precisely, eaten through—our reserves, and what lies ahead? I have been advised to sell my collection of Dutch masters. But is it even appropriate to consider doing such a thing?"[92] Neither did political news bring comfort. Having become prime minister, Kerensky, once the darling of the revolution,

was consumed by self-importance and increasingly out of touch. A crippling blow came at the end of August, when a coup attempt by General Lavr Kornilov compelled him to call on all left-wing groups, the Bolsheviks included, to save the capital. The Kornilov affair isolated Kerensky; neither the left nor the right trusted him now, and whether the Provisional Government could last until the Constituent Assembly elections, scheduled for November, seemed doubtful. The Bolsheviks experienced a September upswing, as discontent with the government grew, and soldiers, sailors, and workers gave allegiance to them in large numbers. Trotsky was released from prison, and, at the end of the month, Lenin returned in secret from Finland. In October, the Bolsheviks began plotting to overthrow the government.

The Bolsheviks' rise discomfited Roerich. Socialism per se was not incompatible with the communitarian elements in his own thinking, and he could probably have lived under a government run by the Mensheviks or the center-right wing of the Socialist Revolutionary Party (as distinct from the leftmost SRs, who were splitting off to stand with Lenin). However, the Bolsheviks in his eyes were nihilistic savages, not true socialists. He could not abide Lenin's disdain for democracy or his militant hatred, fierce even by Marxist standards, of religion in any form. As for Russia's cultural legacy, Roerich saw the Bolsheviks as the worst possible caretaker of this "unspilled chalice."[93] In a mid-October essay titled

"Unity," he inveighed against the swelling Bolshevik tide: "What do these wild hordes of 'Bolsheviks' have to do with socialism? They and their ilk, with their propensity for robbery and violence? All socialists must rise and exterminate these brutal mobs, these barbarians who combat women and children! Where did this self-destruction come from? This insurrection against knowledge and this intention to spiral downward to squalor and ignorance? You are killing the soul of the people. But for this killing you will pay—eternally and without limit."[94] Roerich focused on painting as much as he could in October, but fear for his country's future gnawed at his nerves.

Two letters from the fall reveal Roerich's deflated frame of mind. The first, from September, was a melancholy outpouring to the art historian Alexander Ivanov: "See how we have all been scattered. I am now living in Serdobol. I am ill—once again, the inflammation creeps into my lungs. When it will pass, God only knows. . . . The rain hammers on the window. Before my eyes is a scene straight from a Knut Hamsun novel, embodying the low cultural level of the places he writes about." After detailing his economic difficulties, Roerich turned to more abstract concerns:

Until the sun rises again, my tears are like drops of dew melting my eyes. Where, where is the freedom and unity we hoped for? What dark force has devoured those ideals? I have recently written an essay entitled "Unity," de-

scribing the current situation. Of course, I doubt it will ever be published. . . . In it, I explore the concept of the anonymity of art. In a time when life is being so radically restructured, I think this is a useful principle. After all, the passage of time tends to obliterate individual personalities. We ourselves are only temporary watchmen over creations of the spirit. No matter what we think, no matter how we cast in our minds the events of our lives, the fact remains that even the brightest things in our lives will eventually stand as nothing more than anonymous creations. Inscriptions and signatures will appear as nothing more than illegible scrawls.[95]

In October, he sent a similar letter to Benois: "The natural beauty here is wonderful, but this half-culture—or more properly, middle culture, with nothing of particularly low quality, but nothing of high quality, either—is painful to bear."[96] He recounted the story of his IOPKh resignation, talked about his "Heroica" suite, and expressed his hope that "unity," as reflected in the name of his current home, would prove a political watchword in the coming months.

But it was not to be. On the night of October 25/26 (OS), the Bolsheviks stormed the Winter Palace and deposed the Provisional Government.

Whatever Roerich later thought about Lenin, he felt nothing but hostility for him now—a fact that long embarrassed Soviet biographers and still leaves scholars struggling to square his vociferous anti-Bolshevism with his 1926 visit to the USSR and his pro-Soviet patriotism in the 1930s and 1940s. Roerich insisted in 1917 that "if someday, unwise chroniclers tell you the Bolsheviks desired to create something new and good, know that they are lying. The dark tyranny they have called into being has nothing in common with the higher understanding of socialism, or with the touching dream of world unity and brotherhood."[97] Roerich saw an immense darkness descending on Russia like the shadows of winter. *Mercy*, a play he penned in November, allegorizes the fate he feared the country would suffer under Lenin.[98] A beautiful kingdom is toppled by foreign invasion, and the masses, crazed by rage, rise up. Grand castles are pulled down, innocents are assaulted in the streets, and criminals are freed from the prisons.

The despair communicated in *Mercy* triggered a life-changing spiritual and psychological crisis in Roerich's household. Before, Theosophy and eastern teachings had been important elements in his and Helena's worldview. They now became the worldview itself—the prism through which the pair perceived everything, from tiny details to globe-shaking events. It is no coincidence that *Mercy*'s heroine, Gayatri, who brings peace to a frenzied world, takes her name from an ancient Vedic mantra, or that the play ends with a recital of a Tagore poem, "Where the Mind Is without Fear." Roerich

tried to persuade friends and colleagues that Asiatic wisdom could better Russia's lot. In December, he wrote Benois to talk about the upcoming World of Art exhibition, but turned the conversation to his recent reading: "When you have some quiet time, there are several indispensable books you should turn to. Especially crucial is *The Sayings of Sri Ramakrishna*. This is a serious teaching, and has much to say about humanity's present state."[99] (What Benois thought about this advice can only be guessed at.)

A crucial question now faced Roerich. Should he cooperate with the new regime, stand apart from it but stay in Russia, or leave the country? This was no easy decision for any Russian, and over the long haul, not all stuck with their initial choice. Reasons for leaving included dictatorship, danger, and deprivation. If Roerich hoped that the Constituent Assembly elections, held in November, would unseat the Bolsheviks, he was disappointed. Lenin, his party having come in second place, forcibly dispersed the assembly in January 1918. Just as dire, the threat of violence hung in the air. Russia agreed in mid-December to a cease-fire with the Central Powers, but no actual treaty was signed until the following spring, and the situation on all fronts remained uncertain. More ominous were clashes between Bolshevik forces and military units loyal to the Provisional Government or the tsar. Sporadic fighting broke out as early as December 1917, and the coming year would draw even sharper lines between Red and White. The poet Maximilian Voloshin gloomily predicted that

Russia's lot in the next months would consist of "terror, civil war, men turned to beasts, and blood, blood, blood."[100]

That said, was emigration the answer? Thousands thought so and departed, but many stayed, because even among those who felt antipathy for the Soviets, a surprising number had little inkling in 1917 how untenable life under communism would become for them. "Could we at that time foresee?" asks Nina Berberova. "Of course not," she answers, explaining why she and her husband, the poet Vladislav Khodasevich, waited until 1922 to flee to Europe.[101] Many things would have tempted Roerich to reason similarly, starting with his family. His mother refused to budge, and while his brother Vladimir fought for the Whites in the Civil War, Boris and his wife Tatyana planned to remain in Petrograd, as did Lydia and her husband Ivan. On Helena's side of the family, the Mitusovs decided to stay, and Prince Putiatin was too ill to travel. If the Roerichs bolted, they might be separated from their kin for years, if not for good. They also risked dispossession: Roerich's art collection and archaeological specimens could not be easily transported, and countless other valuables would have to be abandoned. (Balanced against this was the possibility that the Bolsheviks would expropriate them anyway.) And what of Roerich's career? He enjoyed a reputation in the West, but could he hold his own there in the long term, especially with the European appetite for Ballets Russes–style exotica having passed its peak? It would be a difficult test.

And perhaps an unnecessary one, because the new regime had opportunities to offer. Handling cultural affairs for the new Bolshevik state was the people's commissar of enlightenment, Anatoly Lunacharsky, whom Roerich had known for some time. Both had attended meetings of the Religious-Philosophical Society, and both were friends with Gorky and Stepan Mitusov. Comparatively moderate, Lunacharsky respected his country's cultural heritage and wanted as wide a variety as possible of artists and writers to stay and work in Russia. Gorky stood by him for a time, as did others—even some who distrusted the Bolsheviks generally—including Benois, Grabar, Shchusev, and Mitusov, who took a post in the commissariat's Musical Section. If Roerich joined them, he might be able to influence policy and prevent excesses. As a further inducement, the Bolsheviks seemed to be floating the idea of a People's Commissariat of the Arts, with high places for Gorky, Benois, and Roerich. No such body materialized, but Roerich could certainly have played a prominent role in the Soviet art world had he so desired.

Instead, he chose to emigrate. He could not stomach Soviet rule, and, unlike many of his peers, he did not trust Lunacharsky, whom he called "the worst of the Bolsheviks," on the grounds that "while Lenin and Trotsky are content to control your flesh and blood, Lunacharsky aims for your soul."[102] Besides, Roerich was no longer content just to learn from Asia, but yearned to go there.

His diary from October contains this entry: "I prostrate myself before the Teachers of India. Into the chaos of our lives they have brought works of truth, a joyfulness of the spirit, and a fruitful silence. At a time of extreme need, they have sent us a summons: one that is serene, full of conviction, and wise."[103] He wanted nothing more than to answer that call.

That journey, however, lay half a decade in the future. In the meantime, the phrase "chose to emigrate" deserves emphasis. Later, whenever they spoke to or wrote for Soviet audiences, the Roerichs claimed that they had not left voluntarily, but had been trapped outside Russia when its borders closed. The Russo-Finnish periphery was indeed an unpredictable place in 1917, but evidence points to a deliberate departure. After every visit to Petrograd over the course of the year, Nicholas and Helena brought back to Karelia as many of their heirlooms as they could. In one instance, Helena went to Petrograd on her own, "to pick out the best things" from her husband's office. ("Otherwise," she recalled, "they would never have been seen again."[104]) Also, the February Revolution had touched off a nationalist firestorm in the Grand Duchy of Finland, and when the country declared independence in December, the Roerichs knew full well that they were living on contested ground and risked being cut off from Russia at any moment. Finally, we have George

Roerich's word from late in his own life that, at the end of 1917, his father believed himself to be in danger of arrest or worse.[105]

In January 1918, then, Roerich, Helena, and the boys traveled to Petrograd, ostensibly for the opening of the latest World of Art exhibition, but really to take their leave for good. Roerich visited the IOPKh School, where he gave a final speech to his former students and staff. He and Helena said farewell to friends and family, and they put their domestic affairs in order, relying on Boris, Stepan Mitusov, and Arkady Rumanov (who would soon leave Russia himself), to watch over their possessions. Colleagues tried convincing him to remain, and Boris, who thought a tolerable future awaited under the Soviets, argued the point with him angrily.[106] But Roerich could not be turned aside: before the month was out, he and his family returned to Serdobol. He would never again see the place of his birth. If he thought of *The Doomed City*, his painting from four years before, as he passed through checkpoints and barricades and gazed up at the dark winter sky, he does not say so—although one can imagine the image crossing his mind.

The Roerichs' train was one of the last to cross before the frontier became a war zone. Fighting between pro- and anti-Soviet forces erupted throughout Finland in the late winter and spring, and travel became next to impossible for civilians. In May, the border formally closed. By design or by chance, the Roerichs were now refugees.

CHAPTER 8

The Exile, 1918–1920

Once again, tears welled up in my eyes, and awareness of my country, of Russia, with all its ancient darkness, overshadowed me nostalgically and mournfully.

—Ivan Bunin, *Lika*

Since his youth, Roerich, whenever he published anonymously, had favored the pseudonym Izgoi, meaning "outcast" or "the exile." It had a dashing sound to it, and it reinforced his romantic self-image of the creative soul set apart from others by genius. But there was nothing romantic about the exile he experienced in 1918. Shut out of the country he cherished, watching a despised government establish dominion over it, Roerich reflected more than once on the heartrending verses of Dante, who describes in his *Paradiso* the "bitter taste" of being banished by unscrupulous foes from a much-loved city. Whatever name it bore—Petrograd during the war, Leningrad under the Soviets—Saint Petersburg would forever be Roerich's Florence.

The next three years were an unsettled and unhappy time. Roerich and his family were not penniless, but their circumstances were strained. And despite his and Helena's faith in themselves as agents of a fast-awakening destiny in the East, the "path to India" Roerich had written of with such hope proved long and roundabout. For a year and a half, the family remained in Finland, no closer to their new goal. A sojourn in Sweden followed, then another year and a half in England. From there, the Roerichs planned their long-awaited passage to India, but fate decided otherwise. Though the family left England in the fall of 1920, it traveled to the New World instead.

This extended detour disappointed the Roerichs, but did not daunt them. By the spring of 1920, they had a new creed to sustain them: Agni Yoga, or the "system of living ethics," a movement founded by Nicholas and Helena while they resided in London. To the propagation of this self-created doctrine, the couple dedicated the rest of their lives.

In 1918, the Roerichs were still in the lake-shore hamlet of Serdobol. Charmed at first by its natural beauty, Nicholas and Helena now thought it dull and uncultured, and the boys were bored by the local school.

The new year brought more serious concerns. Finland had just declared freedom from Russia, and now had to fight for it. Lenin's regime, eager to make peace with the Central Powers, had recognized Finnish independence at Germany's request. But after March 1 (NS), 1918, when Finnish communists rose up against Carl Manner-heim's new government, the Soviets backed them as much as they could without sab-otaging their negotiations with Germany. Over the next months, White Finn fought Red Finn, and as the Germans shifted more attention to combat on the Western Front, the Soviets intervened more boldly. Helsinki fell briefly into Bolshevik hands, but Man-nerheim struck back, retaking the city by mid-May. By summer, the entire country, including large parts of Karelia, was under his authority.

This struggle shut down the Rus-so-Finnish border and left the Roerichs stateless. It is often assumed that the fam-ily swapped their invalid tsarist papers for "Nansen passports"—League of Nations documents devised for displaced persons after World War I—but they were reluc-tant to resort to this expedient.[1] Instead, they received new passports from the Pro-visional Government's consul general in Stockholm and made do with those as they could. Either way, the elder Roerichs never again held citizenship in any country. (In 1930, the French government issued Roerich a passport for travel purposes, but not the status of citizen.)

Nor did the Finnish war improve the Roerichs' financial situation, and they lost most of their possessions for good. They had no practical way to bring with them cumbersome objects like furniture or books. Nicholas particularly missed a six-piece Fabergé desk set that depicted scenes from *Boris Godunov*. Much of his own art had to be left behind, as did the Dutch masters and other paintings he had acquired over the years. His superb collection of archae-ological artifacts, some ten thousand items, likewise remained. Personal and profession-al correspondence went missing, and while many of his papers were recovered by Soviet archives and museums, Roerich never rec-onciled himself to their loss. Even the few boxes he had arranged to ship to Finland were intercepted and looted by Red forces.

Roerich worked a theme of disposses-sion into two melancholy poems from these months, "Tomorrow" and "I Left." The lat-ter is quoted below:

I am prepared for the road.
All that was mine I renounce.
You will take it, my friends.
Now for the last time I shall survey my
home.
One more time I shall view my
possessions.

Upon the faces of my friends I shall
 gaze one more time.
For the last time.

I know already that nothing of mine
 remains.
Possessions and all that impeded me I
 give away freely.
Before the One who calls me, I shall
 appear, liberated.

Now once more I shall look upon my
 house.
I shall view once more that from which
 I am released.
Free and liberated and firm in resolve.
The image of my friends and the sight
 of my former possessions
Do not confuse me. I am going. I am
 hurrying.
But once more—for the last time—
I shall survey all that I have left behind.[2]

In this poetic version of events, impoverishment becomes a voluntary act of renunciation, the first step in a quest for wisdom, in the tradition of Saint Francis or the Buddha.

The same logic informs "The Flame," a story from 1918 that attaches metaphysical significance to every event in the life of a character that Roerich modeled on himself.[3] Several canvases from 1918, when Roerich's health improved enough for him to paint, are similarly self-referential. *Karelia—Eternal Expectation*, in which three men and a woman, representing Nicholas, Helena, and their sons, stare out from a deserted shore toward the horizon, conveys Roerich's desire to travel to Asia, as does *Not Gone Yet*, where a husband and wife look upon longboats harbored in a snowy bay.[4] In *Ecstasy*, an aged guru emerges from a long hibernation in the mountain wilds. He has been encased in stone, but his spirit now awakens, liberated from the rocky shell confining him. The figure unmistakably resembles Roerich, and this was not the last time he gave his saints, monks, and sages his own appearance. Roerich saw these Karelian months as a time of inward turning. There, he recalled, "I finished a variety of paintings that had taken shape in my mind. After twenty years of working and struggling against life's vicissitudes, I set myself apart from any kind of casual or chance social interaction. I gave up my positions, even though they brought me honor. I put aside the noise and bustle we so often mistake for real life. I walked away from many of my friendships."[5] In Roerich's semi-autobiography, "The Flame," the protagonist's feelings of anger and frustration are soothed by the solitude of the north.[6] Only dimly aware of the Germans' springtime assault on the Western Front and their summer setbacks, Roerich, sequestered in Finland, dreamed his dreams and painted his paintings.

Still, he could not shut out the world. In mid-1918, the Roerichs had to move again, this time to Tulola Island, an hour by ferry from Serdobol. Rubles could be converted only at a ruinous rate of exchange, and the family's resources dwindled. Summer brought the threat of deportation, as the

Finnish government ordered large numbers of Russians to leave the country. In August, Roerich received word that he might be caught up in the next wave of expulsions, and he turned for help to Akseli Gallen-Kallela.[7] Under such circumstances, Gallen-Kallela was an excellent friend to have: Mannerheim had appointed him a governmental aide-de-camp, with responsibility for the national printing press and the design of state insignia. Roerich wrote him on August 29:

> My dear friend! I urgently need you to recommend me to the Governor of Vyborg. There is a distinct possibility I will be forced to leave Finland. Starting on September 1, another expulsion of Russians living in Finland will begin, and, this time, no one will be allowed to remain. Only those who have a job or fixed address will be permitted to stay, and, having neither one nor the other, I will be among those deported. There you have it: a well-known personality—a famous name, someone of position in society—faces exile, simply on the basis of nationality. . . . When I first heard this news, I laughed, it seemed so ludicrous, but I have just received a letter from someone I trust very much. This person suggests that I gather letters of recommendation from particularly esteemed people in Finland, and I immediately thought of you. I feel awkward troubling you again, but what is to be done?[8]

Gallen-Kallela intervened, and the Roerichs were allowed to remain.

Before the autumn frost set in, the Roerichs relocated once more. Vyborg, on the Gulf of Finland, was farther from the unstable Russian border. It was a more comfortable spot to pass the winter and an easier place from which to arrange passage to Europe. Recovering the paintings he had sent to Sweden for the 1914 Baltic Exhibition, he began planning a new show. Gallen-Kallela spoke on his behalf to collectors and curators in Helsinki, and then came an unexpected encounter. One of Roerich's admirers, the timber magnate Samuil Gurevich, hearing that the family had arrived in Vyborg, combed the city until he came face-to-face with Helena. Gurevich, with business connections throughout Scandinavia, had gotten much of his money out of Russia, and he threw his support behind Roerich's exhibit.

What took shape was a three-city tour of more than a hundred works. It opened in November 1918, in Stockholm, where it ran for three weeks. In early 1919 came a longer stay in Copenhagen. Spring found the exhibition in Helsinki. This third stage began in March and ended in April, and served as a farewell to Finland. Not long afterward, the Roerichs would be on their way to England.

Two things stand out about Roerich's time in Finland: his Civil War activities and his friendship with the author Leonid Andreyev.

During Russia's Civil War, Roerich remained an outspoken opponent of the Bolshevik regime. He had already equated Leninism with "dark tyranny," and he poured more vitriol on the Soviets in 1918 and 1919. In *Russian Life*, he called them "a socialist horde," bent on "theft and rapine."[9] In England, he damned them as "violators of art," guilty of looting, destroying churches, and executing or starving dozens of intellectuals. (Some of these claims—that Viktor Vasnetsov had been shot, or that the concert pianist Alexander Ziloti had died of hunger—turned out to be false.) "Vulgarity and bigotry, betrayal and promiscuity, the distortion of humanity's sacred ideals. That is Bolshevism," Roerich asserted. "It is the impertinent monster that lies to humankind."[10]

Roerich provided illustrations and the cover image for Leonid Andreyev's 1919 volume *S.O.S.*, an anti-Bolshevik political diary and literary miscellany.[11] He supported the brief-lived intervention of foreign armies against the Leninist regime, and he served as secretary of the Committee of the Scandinavian Society for the Assistance of Russian Troops, whose purpose was to raise funds for anticommunist White armies. In 1919, the committee donated a sum of 15,000 Finnish marks to Nikolai Yudenich's Northwestern Army, a major White force operating in the Baltic region and aiming to retake Petrograd.[12] In England, Roerich would join another anti-Bolshevik association, the Russian-British Brotherhood.[13] As late as 1921, after they reached America,

the family considered the possibility that Yuri—now styling himself "George" in the West—might return to Russia and serve in one of the remaining White armies. Edward Denison Ross, head of the University of London's School of Oriental Studies (now the School of Oriental and African Studies) and one of George's instructors there, affirmed that the young man and his family firmly opposed communism.[14]

As for combat, Roerich saw none of it. His brother Vladimir, however, fought for the Whites in the Urals, then in the Transbaikal and Mongolia. Vladimir's military service affected his brother's career in two ways, one trivial, the other more meaningful. Starting in 1920, Roerich was repeatedly mistaken for his brother and told that he could not be who he claimed, because "Roerich" had died in Siberia during the Civil War.[15] This was a twofold error: not only did reports of "Roerich's" death confuse one brother with the other, they were premature. Vladimir made it through the war alive, emigrating to Manchuria after the fighting.

Vladimir's experience affected his brother in the long term as well. After service with the Cossack leader Alexander Dutov, he fought under one of the most enigmatic and egregiously violent generals of the Civil War, Roman von Ungern-Sternberg, commander of the Asiatic Division.[16] A tall, red-haired Baltic German with a vivid saber scar on his forehead, Ungern clad himself in Chinese silk jackets and Mongol cavalry boots, and gained notoriety as one of the so-called atamans heading Cossack

detachments on the eastern frontier of the crumbling Russian empire.

Nominally part of the White coalition, the atamans were in reality freebooting warlords. Ungern and his superior, Grigori Semyonov, controlled the quarter-million square miles stretching between Lake Baikal and the Amur River. To whose benefit, however, was anyone's guess. To tighten his grip on the Transbaikal, Semyonov accepted Japanese assistance and hanged hundreds of civilians from telegraph poles as an example to potential dissidents. William Graves, commander of the US contingent supporting White forces in Siberia, said of Semyonov—theoretically his ally—that he was "a murderer, robber, and most dissolute scoundrel."[17]

Ungern, the "mad baron," was arguably more dangerous and without question more unbalanced. Pyotr Wrangel, who led White armies in south Russia, described him as "invaluable in wartime and impossible in peace," and his own staff physician called him "a megalomaniac" with "the diseased brain of a pervert" and "a thirst for human blood."[18] Vladimir Roerich served as a supply officer in the baron's Asiatic Division. Also riding with Ungern, as chief of intelligence, was the Polish occultist Ferdynand Ossendowski, whose 1922 *Beasts, Men, and Gods* remains a classic of esoteric literature and later influenced Nicholas and Helena.

Like a meteor, Ungern flared brightly but briefly. In 1920, after breaking with Semyonov, he went south to Mongolia and, in October, descended on the city of Urga, as Ulaanbaatar (Ulan Bator) was then known. Driven away by the local Chinese warlord, Hsu Shu-tang, he attacked again and triumphed in February 1921. He was welcomed at first as a liberator—both the Jebtsundamba Khutuktu, Mongolia's ranking cleric, and the Dalai Lama declared him a "protector of the dharma"—but then carried out an unimaginable reign of terror.[19] Victims were raped and whipped to death. Others were doused with water and, their legs and hands bound, left in the winter snow to freeze. Some were burned alive or crucified. To oppose Ungern, the Mongolian leader Sukhe Bator established a rival government in Kyakhta and appealed to the Bolsheviks for help. With Red Army backing, Sukhe Bator took Urga in July 1921, and the Soviets put Ungern to death that September. Mongolia went on to become Soviet Russia's first satellite, renaming itself the Mongolian People's Republic in 1924.

The most incredible thing about Ungern's hegemony was his grandiose plan for future expansion. He claimed to be the reincarnation of Genghis Khan, a "god of war" whose appointed task was to revive the old Mongol Empire. He envisioned a confederation of Mongols, Chinese, Buryats, Tibetans, Kalmyks, and Kirghiz sprawling across eastern Eurasia. "The tribes who descend from Genghis have awakened," he proclaimed. "Nothing can extinguish the flame blazing up in the hearts of the Mongols. Taking shape is an enormous state that will extend from the Volga to the Pacific."[20] To further this goal, he married

a Chinese princess and declared himself a living Buddha.

This was a far cry from simply resisting communism. Did Ungern truly think he was campaigning on behalf of a higher divinity? Or was he cynically manipulating the beliefs of the peoples he hoped to rule? Either way, Roerich's brother had direct experience of a military-political exercise in which a mystically inclined leader sought to gain sway over a portion of Asia by rousing indigenous messianic passions. The spiritual geopolitics that Roerich strove to realize in Asia during the 1920s and 1930s—with Vladimir's help—resembled Ungern's in basic conception, though not in the details of execution. This unusual chapter of the Civil War did much to set Roerich's future course, even if he was half a world removed from it.

Also during the war, Roerich strengthened his friendship with the author Leonid Andreyev, whom he had known before the revolution. Best remembered in the West for the story "Seven Who Were Hanged" and the play *He Who Gets Slapped*, Andreyev defies easy categorization. A court reporter by profession, he began his literary career as a realist, adopting over time a moody style that many have characterized as Symbolist. An anti-tsarist liberal, he turned politically rightward during World War I. A resident of Finland since 1908, Andreyev had two unhappy years left to live when revolution came to Russia in 1917. A self-diagnosed "melancholic neuropath," Andreyev had long been declining in mind and body.[21]

Anguish over Russia's fate worsened his condition.

One of Andreyev's consolations was that Roerich shared his exile, even though the two did not live near each other and communicated only through the post. "Just the fact that you are here, in the same circle of hell," the author wrote, "makes hell itself less gloomy, less black."[22] Increasingly metaphysical in his last years, Andreyev believed after the October Revolution that humanity's only hope lay in the unfolding of some divine verity. "When *the times* themselves have entered the fray," he wrote, "and not just peoples, rulers, and laws," humankind, battered by "commotion and displacement," would have to seek out the "secret, *majestic* paths of truth . . . at whose end, perhaps, lives God himself."[23]

Andreyev saw in Roerich's art a reflection of that higher truth. The two also aided each other materially. Roerich illustrated Andreyev's book *S.O.S.* In return, Andreyev threw his support behind the Scandinavian exhibition. For this event, he would produce one of the most heartfelt testimonials ever written about the emotional and spiritual impact of Roerich's work.

The Scandinavian exhibition began on November 10, 1918, in Stockholm. Samuil Gurevich took care of expenses, while another admirer, Oskar Bjork, handled local arrangements. For three weeks, Roerich displayed 105 items at the famed Gummesons

Gallery. The event was somewhat eclipsed by news of the war. Austria-Hungary had dropped out of the fighting the previous week, and Wilhelm II gave up the German throne the day before Roerich's opening. All hostilities were to end at 11:00 a.m. the following morning, the eleventh.

General good spirits contributed to Roerich's success in Stockholm. The catalog played up the northern aspects of his art, with a promise that, "gazing at Roerich's paintings, the viewer will feel himself in a familiar milieu: the world of the old Scandinavian sagas."[24] The Swedish government awarded Roerich the Order of the Northern Star, and it was here that the exhibition performed best financially. High-profile sales included *The Chapel of Princess Maleine*, to the Swedish National Museum, and *Ladoga*, to Olaf Palmstierna, a government minister. The Roerichs obtained new passports from the still-functioning consulate of Russia's Provisional Government, and they met with a chapter of Swedish Theosophists.[25]

From Stockholm, the exhibition moved to Copenhagen, where it remained in January and February 1919. It did well there, but that joy was outweighed by news that Helena's uncle, Prince Putiatin, had died in January, destitute and infirm in a Petrograd charity hospital. (Helena's widowed aunt, Dunya, emigrated to Paris, only to die in an almshouse six years later.) Also, anxiety about where to go next was mounting. Although Europe's largest centers of Russian emigration were Berlin and Paris, Roerich wished to go to London, from which, he reasoned, it would be easiest to secure transport to India.

While in Denmark, then, Roerich sent a request to Diaghilev, who was arranging shows in England and France. "I have done much to propagandize on Russia's behalf, and in many quarters," he wrote with pride, but he would be glad to leave the north: "There is not much more for me to do in Finland; I need a wider stage on which to make my mark. Please inform me, dear friend, whether you can help me get to England and find work there. I await your reply with great impatience. After all we have been through, it would hearten me to see you again. It is our duty to hold true to each other and support the Russian arts abroad."[26] Diaghilev gave his compatriot the help he required, and in half a year's time, Roerich and his family would be in London.

First, however, came the final stage of the Scandinavian tour. Roerich's spring show at the Salon Strindberg in Helsinki was to be the exhibition's crowning moment. Instead, it proved an anticlimax. A second show followed in May, at the Hörhammer Gallery, but the Roerichs had left Finland by that time.

Roerich did not lack for positive reviews. Local critics praised him, and most compared his work with that of Gallen-Kallela, who himself was on hand for the March 29 opening.[27] The most glowing endorsement came from Leonid Andreyev,

who celebrated the exhibition with a long essay, "The Realm of Roerich." Andreyev was not wholly pleased with the text, admitting privately that it had been "very difficult for me to concentrate my thoughts on anything besides the thrice-cursed Bolsheviks."[28] Whatever Andreyev's dissatisfaction, Roerich had no cause for complaint. *Russian Life* and the Finnish paper *Otava* published "The Realm of Roerich" in March, and translations were reprinted widely. In 1921, the essay appeared in the *New Republic* as follows:

It is impossible not to admire Roerich. One cannot pass by his precious canvasses without experiencing a deep emotion. To see a Roerich picture means to see something *new*, something you have never and nowhere seen. . . . Roerich is not a servant of the earth—he is the creator and the sovereign of a whole enormous world, of an extraordinary dominion. Columbus discovered America, another sliver of the old familiar earth, and he is still being glorified and praised. Then what shall one say of a man who *amidst the visible discovers the unseen*, and bestows upon us not the continuation of an old world, but an entirely new, most beautiful world?

The genius of Roerich's fantasy reaches the border of clairvoyance. Yes, it exists, this beautiful world, this realm of Roerich, of which he is the sole tsar and ruler. Though charted on no maps, it is real and exists no less than the province of Orel or the kingdom of Spain. And as people journey to foreign lands, one may journey thither. . . . Another, most important thing may be said about the world of Roerich—it is a world of truth. What the name of this Truth is I do not know, but then who knows the name of Truth? Such is the realm of Roerich. Any attempt at transmitting its enchanting beauty through words must be fruitless. That which has been thus expressed in color will not tolerate the rivalry of words and stands in no need of them.[29]

Opening day, however, did not go as Roerich hoped. "Every force imaginable militated against my exhibition," he told Andreyev the following week.[30] A three-day snowstorm discouraged visitors. Anxiety about the Spanish flu ran high. Political events grabbed much of Helsinki's attention: elections to the Finnish parliament were coming up soon, and the country was abuzz with news from Hungary, where a communist republic, allied to Lenin's regime in Moscow, had been established by Béla Kun. Neither did Helsinki's Russian colony come out to support Roerich. The artist had recently quarreled with Prince Gorchakov and Madame Orlova-Davydova, leading members of the White committee supporting Yudenich's army, and they may have arranged the snub.[31] An incensed Roerich cried out to Andreyev that "almost every single one of them is trash! When Mannerheim sent his representative, it was

extremely embarrassing, because practically the entire Russian community was absent. No matter—to the devil with them."[32] Reasons for this falling-out remain unclear, but likely had to do with ideological splits within the anti-Bolshevik coalition, whose centrist and leftist elements found it difficult to cooperate with unreconstructed monarchists and reactionaries. This failure of unity proved greatly discouraging to Roerich.

Neither did his art sell well in Helsinki. In April, he looked again to Gallen-Kallela for help. "My dear friend," he wrote on the sixth: "Be so good as to advise me about my exhibition. Relations with everyone who has attended have been good, even brilliant. But no one from the Atheneum [Finland's national gallery] has appeared, and all potential buyers seem to have vanished. Perhaps I myself need to approach the Atheneum, but I fear a personal appeal would be out of place. Give me some friendly counsel."[33] Gallen-Kallela took the hint. Within days, the Atheneum purchased one of Roerich's *Maleine* designs.[34] The Historical Museum acquired a Stone Age scene. But Gallen-Kallela had his limits, and no other major sales came through.

The Helsinki exhibition marked Roerich's final meeting with Gallen-Kallela. It was not a happy encounter, although the two parted on good terms. The Finn seemed to be undergoing some sort of crisis. Roerich later recounted:

> The last time we saw each other was in Helsingfors, during my exhibition.

Afterward, I wanted to give him one of my Finnish studies as a memento. He was touched, but told me, "Keep all your work together. Right now, your art wells up as though from a spring. But we, as artists, never know when that spring will dry up."

I smiled. "Why these melancholy thoughts?" I asked. "The mind functions, the imagination creates."

But Gallen bowed his head. In a whisper, he said, "No, we must not be arrogant. It is always possible for an artistic gift to be cut short. It is a type of psychosis. One's hands are prepared with a complete understanding of technique. One's mind is strong. And yet one's creative talent has simply departed. Yes, yes, it happens, and there is no helping it."

It was evident that the master was in a gloomy mood. No matter how hard he tried to smile, his mouth twisted into a wry curl. I sensed that something had happened to my friend. We never saw each other again.[35]

Gallen-Kallela is known to have suffered from depression, so Roerich's recollection rings true.[36]

Additional leave-takings followed, for the Roerichs were scheduled to leave Finland in mid-April. They said a sad goodbye to the philologist Andrei Rudnev, who had served with Roerich on the Buddhist Temple Commission, then found himself neighbors with the artist in Finland. The

parting was especially hard for Yuri: in his free time, Rudnev had taught Yuri the rudiments of Mongolian, unlocking his aptitude for Asian languages and playing no small part in his choice to become an orientalist.[37]

The most wrenching farewell was with Andreyev, who had fallen ill and become more doleful than ever. "When you leave," he told Roerich, "I shall feel as though I have gone blind in one eye. You are my one living connection with the wider world."[38] After Roerich departed, he and Andreyev continued to correspond, the latter eager to relieve the tedium of his exile with news of his compatriot's travels and accomplishments. "I am glad, my friend, that you live so boldly and make yourself so indispensable," he told Roerich in June.[39] He wrote of his failing health, his frustrated plans, and the fading of his creative powers. "I am an exile three times over," he mourned. "From my home, from Russia, and from my art. I feel the last loss most keenly."[40]

Roerich could not rest easy while his friend deteriorated. Once in London, he arranged to return to Finland on an English ship and bring Andreyev to the West. By September, he was ready to sail, but the author's death on the twelfth of that month forestalled his plans. Two days before dying, Andreyev sent Roerich a last message, telling him not to come, but thanking him for his "much-appreciated attention and concern."[41] Roerich remembered Andreyev as "a charming and distinguished man" who "never betrayed" his essential goodness.[42]

All of that, however, lay months ahead.

On April 19, 1919, the Roerichs left Helsinki for Stockholm. The paperwork that would allow them to enter England had not yet cleared, so they spent May and June waiting in rented rooms in the suburb of Stocksund. Finally, in July, after a brief time in Norway, they boarded the *King Haakon*—and, after a stormy passage, found themselves in England.

The Roerichs spent over a year in London, a pivotal time in many ways. Roerich's plans for the coming months fell through, and he came to despise Britain. Still, he succeeded at making connections there. Several of these changed the course of his career, and one or two became lifelong friends. The boys were teenagers, with George, at seventeen, approaching adulthood and advancing his education in the field of Asian languages. Most dramatically, it was in London that the Roerichs experienced a spiritual quantum leap, establishing their own school of occult doctrine.

In July 1919, the family took up residence in Queen's Gate Terrace, in South Kensington. A more elegant setting could hardly be wished for, with the Royal Geographical Society and the Victoria and Albert Museum among the nearby landmarks. The apartment was less posh than its surroundings, but it gave Nicholas enough room to paint, saving the expense of separate studio space. Roerich busied himself with his art, although less with easel work

than with stage design. His first task—the reason Diaghilev had arranged for him to come to London—was to restore his old sets and costumes for *Prince Igor*, the Ballets Russes version of which had been performed more than four hundred times.

Roerich, however, no longer worked for Diaghilev, but for Thomas Beecham, the conductor of the Royal Opera and manager of his own private company, both of which sang at Covent Garden. Beecham, an admirer of the Ballets Russes, had bankrolled several Diaghilev productions in London and decided in 1919 to put on his own season of Russian opera at Covent Garden. He purchased the Ballets Russes' sets and costumes for *Igor* and, on Diaghilev's suggestion, hired Roerich to retouch them. Roerich wanted to create new designs from scratch—this would have meant a higher fee, though he also felt a fresh approach was needed—and he asked Diaghilev to persuade Beecham to reconsider. Diaghilev reminded Roerich that this was his best opportunity to get to London, assuring him that, once he began working for Beecham, more commissions would follow.

At first, Diaghilev appeared to have forecast correctly. With the help of his sons, Roerich restored the sets for *Igor*, which, as it had since 1909, attracted large audiences. (While he was still in England, the opera as designed by him was performed for the five-hundredth time, prompting Diaghilev to send a congratulatory telegram from Paris.[43]) Beecham offered more jobs to Roerich, who wrote Stravinsky in August to describe

his good fortune: "I have been in London a month, and will soon be putting on *Tsar Saltan* and *Kitezh* for Beecham."[44] But as the autumn wore on, things went awry. London's climate proved as harmful to Roerich's lungs as Petrograd's, and bronchial infection laid him up more than once.[45] His mood was not improved by the cheerful letters he received from Boris Grigorev and Sergei Sudeikin, both living in Paris and enjoying it hugely.[46] Most of all, he lost patience with Beecham's managerial ineptitude. He had arrived on the eve of the Beecham company's collapse, and while this was not yet apparent, a disturbing sign came in October, with the cancellation of *Saltan*, for which Roerich had already finished three dozen designs.

His disillusionment was complete by November. Backstage chaos plagued most Beecham productions, a fact that appalled Roerich as much as the *Saltan* disappointment. "In Russia," he told Princess Tenisheva, now living in France, "I never witnessed such disorder as I see at Covent Garden."[47] He described things even more harshly to Stravinsky: "Beecham's enterprise is a pigsty—and that is not the worst I could say about it."[48] He sneered at Beecham's singers and at his attempt to capture the spirit of old Russia. Even *Prince Igor* was a "profanation" in the Englishman's hands. "It is no longer a ballet," he griped to Tenisheva, "but a circus, complete with can-can."[49]

By November, Covent Garden was "a dead loss," as he put it to Stravinsky. "To continue working here is inconceivable."[50]

But there was no exit yet, for Roerich depended on Beecham for money and status. The conductor promised more work for 1920, so Roerich remained at Covent Garden. As the year ended, though, he began focusing on other pursuits.

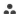

If Roerich had any use for Beecham, it was that his personal ties allowed the painter instant access to artistic and intellectual circles in London.[51] In this, Roerich was aided by the fact that Russian expatriates, with their exotic air and political pathos, were much in fashion. Emil Hoppé, one of Britain's premier celebrity photographers, lost little time asking Roerich to sit for a portrait. Beecham introduced him to the conductor Albert Coates, and Roerich came to the attention of Bernard Pares, a professor of history at London University and Britain's leading Russia expert. Another Russophile befriending Roerich was Charles Hagberg Wright, head of the London Library since 1894.

Hagberg Wright was better connected than Beecham; he had known Tolstoy personally and counted Gorky, Thomas Hardy, and George Bernard Shaw among his friends. Through him, Roerich came to know a number of famous Britons, several of whom helped him in England or in years to come. Roerich met the author John Galsworthy, of *Forsyte Saga* fame, and enjoyed the company of the Art Nouveau muralist Frank William Brangwyn, who had apprenticed with William Morris and shared

Roerich's admiration for him. The archaeologist Cecil Harcourt-Smith, director of the Victoria and Albert Museum, was a useful acquaintance; he acquired some of Roerich's art for the museum and provided letters of reference. Especially impressed with the artist were the Theosophist poet-playwright Gordon Bottomley, who went on to form the British Roerich Society, and another Theosophist, the judge Christmas Humphreys, later a founding member of Britain's Buddhist Society. Humphreys named Roerich one of the six most "highly developed" men he had ever met, comparing his "high serenity" with that of the Zen master D. T. Suzuki.[52] In the 1930s, Alan Watts, one of Buddhism's foremost popularizers in the West, would correspond with Roerich on Humphreys's advice.

Nor was that the extent of Roerich's socializing. Lord Glenconnor, Bishop Bury, and Lady Diane Paul, the last known for her interest in spiritualism, came to know him. Also friendly were Maude Hoare and her husband Samuel—a rising star in the Conservative Party who piloted the Government of India Act through Parliament, then came to grief over his and Pierre Laval's mishandling of Italy's invasion of Abyssinia. The most celebrated figure Roerich met was the author H. G. Wells. In 1920, Wells assisted in sponsoring a spring exhibition of Roerich's work; with George Bernard Shaw, he would lend his name to Roerichs's peace movement in the 1930s.

Roerich did not spend time just with the English. His diaries speak of a group

of Serbian friends, and he and Helena met many Russian expats. As exhausting as he found the political factionalism that divided his fellow émigrés—monarchists against constitutionalists, various socialist camps against each other, and so on—Roerich joined the anti-Bolshevik Russian-British Brotherhood, and it was in England that he published his aforementioned manifesto against Lenin, "Violators of Art." In 1920, he struck up a cordial relationship with the Cossack general Pyotr Krasnov, who had led some of the first military actions against the Bolsheviks in late 1917 and fought in the Don region until evacuating in 1919. In cultivating these ties, Nicholas and Helena were particularly anxious that their boys associate only with those of like mind politically. In fall 1919, George began studying Asian languages at the University of London, and Roerich fretted that his son might fall under the spell of Bolshevism, which had caught on there as an intellectual fad. "Where does this stupidity come from?" he fumed in a letter to Tenisheva. "Whence this tendency towards self-destruction?"[53] George remained staunchly White, but this would not be the last time Nicholas and Helena sought to control how their sons thought or acted.

Mysticism, not just political affiliation, drew the Roerichs to their fellow Slavs. If Nicholas was a Martinist, as some have thought, the "splendid" Serbs he mentions in his journals may also have been, given the movement's popularity in the Balkans. Among Russians, the Roerichs grew close

to the circle of Vladimir Krymov, who hosted séances in his London flat. Krymov could perceive Roerich's "deep melancholy" and concluded that Helena brought him to spiritual gatherings to improve her husband's mood.[54] The couple began a longtime friendship with Alexander Aseyev, the publisher of *Occultism and Yoga*, but were less amicable with Russian Theosophists—at least those loyal to Anna Kamenskaya. Also present at these séances was the feminist and journalist Nadezhda Jarintsova, who had emigrated from Petersburg to Oxford in the 1890s and, like Roerich, enjoyed an acquaintance with the writer Alexei Remizov. Jarintsova introduced Roerich to the Anglo-Russian Society when he gave a talk there, and profiled him in *Studio*.[55]

For practical assistance, the Roerichs turned to the Russian Economic Association, founded in London by the Odessa businessman Mikhail Braikevich. Braikevich had patronized Roerich before World War I and owned some of his *Princess Maleine* designs. In England, he commissioned Roerich to design the cover for the association's journal, the *Russian Economist*. To help the family further, Braikevich paid a good price for an artwork in their possession. This was a study for Serov's portrait of Helena from years before, a pastel-and-chalk sketch that showed Helena's dark hair and hazel eyes to great advantage. Only with reluctance did the Roerichs give it up; eventually, it found its way to Oxford University's Ashmolean Museum.

While in Britain, Roerich saw Sergei Prokofiev on more than one occasion. He

fraternized as well with members of Russia's Constitutional Democratic (Kadet) Party, many of whom he had known in Petersburg before 1917. Closest to him personally was the journalist Iosif Gessen, editor of the twenty-two-volume *Archive of the Russian Revolution*, and he kept company with the Kadet jurist Vladimir Nabokov, father of the émigré novelist Vladimir fils (and only months away from his assassination in Berlin at the hands of right-wing monarchists). The most eminent of Roerich's Kadet ties was with the party's leader, the scholar-politician Pavel Miliukov. As a professor of history at Moscow University, Miliukov had praised Roerich more than once as "a unique and original artist of mystery."[56] In exile, Miliukov lived mainly in France, but had business in England at the same time as Roerich, and the two met several times, including at a memorial service for Leonid Andreyev. Miliukov spoke at Roerich exhibitions in Worthing and Brighton; during the train ride back from Brighton, Roerich recalled how the historian proved "an inveterate materialist" when they and the companions traveling with them began to argue about supernatural phenomena.[57]

The longest-lasting friendship Roerich made among London's Russians was with Vladimir Shibaev, a half-Russian, half-German expatriate afflicted with a humped back. Originally from Riga, Shibaev now worked for a Fleet Street publisher. Roerich

met him in the fall of 1919, while searching for a firm to print his *Flowers of Morya* poems.

Like Roerich, Shibaev admired Asiatic spirituality and everything Indian. He belonged to the English Theosophical Society and had once studied with Pyotr Ouspensky. The most plausible understanding of his and Roerich's relationship is that the former, an impressionable twenty-one-year-old, drifted into the artist's orbit, where he stayed for the next two decades. "I did not understand," he later reminisced, "how this meeting would alter my life's course!"[58] In June 1920, he began attending séances led by Helena. By the fall, he was shaping his most fundamental plans—where he traveled, how he made a living, how he conducted his romances—to accord with what those séances revealed.

Some, by contrast, have proposed that Shibaev was no innocent, but a Comintern agent, charged with making common cause with Indian radicals in Britain, and now ordered to monitor the Roerichs' activities and, if possible, bring them into the Soviet fold.[59] Such a possibility cannot be dismissed out of hand. The Kremlin maintained a global network of operatives to infiltrate expatriate communities and surveil noteworthy Russians abroad. Roerich himself alleged that several attempts were made to suborn him between 1918 and 1920, first in Finland and Sweden, then in England. In 1919, he told Princess Tenisheva that an "Internationalist journal"—a front for Red propaganda—was dangling before him "a considerable amount of money" to join its

editorial staff. "The Bolsheviks are intensifying their intrigues," he grumbled. "Their arrogant posturings never cease."[60]

None of which, however, proves anything about Shibaev. Indeed, one has to consider that Roerich may have spun such tales about himself to burnish his anti-Bolshevik credentials. It is impossible to say that Shibaev was *not* a Soviet agent, but nothing concrete has emerged to indicate he was. (He could have been a person of interest *watched* by the Soviets, an entirely different thing from working for them.) What can be said for sure is that Shibaev brought Roerich into closer contact with English and Indian Theosophists, including the Madras labor organizer Bahman Pestonji Wadia and Curuppumullage Jinarajadasa, the vice president of the Theosophical Society (TS) itself. During the 1920s, Shibaev performed invaluable services for the family in Europe, and he joined them in Asia during the 1930s, living with them and working as Roerich's secretary. Not until 1939 would the two part ways.

While in London, Roerich wished to meet as many Indians living or studying there as possible. This he did, thanks partly to Shibaev, partly to the Theosophical Society, and partly to George's acquaintances at London University's School of Oriental Languages. His primary motivation was cultural and spiritual; he was eager to discourse with Indians about the philosophies he had studied so intently. He sought as

well any contacts or practical information that might prove useful in his future travels.

Invariably, though, these relationships took on a political dimension. Many of the Asians who popularized their religions in the West supported national-liberation efforts and used their teachings with great savvy to generate political sympathy among Europeans. Ramakrishna and Vivekananda acted thus on India's behalf, and Badmayev and Dorjiev did the same for Tibet. The Theosophist Annie Besant's affinity for the Indian National Congress illustrates the point further. Most of the Indians Roerich came to know were involved with Indian freedom movements or one degree separated from them. How much these causes attracted him now is not clear, though Indian independence became important to him later.

Whatever the case, three of Roerich's friends from 1919–1920 played roles in the formation of Indian nationhood, and a fourth had already made his mark as India's most recognized writer. Kedarnath Das Gupta gained fame during the 1930s and 1940s as a founder and organizer of the World Fellowship of Faiths. The Bengal linguist Suniti Kumar Chatterji, who later taught at Calcutta University and served as president of the Asiatic Society, was studying in England while the Roerichs were there, and came to know George at London University. Also part of this group was the historian Kalidas Nag, who corresponded with Romain Rolland and Herman Hesse, influencing the latter's masterpiece, *Siddhartha*.

Nag, Chatterji, and Das Gupta, all relatively young, were under the wing of Rabindranath Tagore, the Bengali poet, educator, and Nobel laureate. For years, Tagore had been a hero to Roerich, who never forgot the "clarion call" that seemed to sound whenever he read *Gitanjali*. In June and July 1920, the two men met in person.[61] Touring England and France that summer to solicit donations for Visva-Bharati, the university he was in the process of establishing in West Bengal, Tagore heard from Chatterji that Roerich, whose work he had seen before, was in London. He and Chatterji paid a call on June 17, and the poet returned for a second visit, accompanied by Das Gupta, whom he told, "Come with me. Today I am going to give you a rare treat." Roerich showed the two men paintings from his India-inspired "Dreams of Wisdom" series, which the poet, according to his son Rathindranath, found "remarkable." Das Gupta was impressed by how these canvases "superbly" captured the "beautiful ideal of the East."[62]

Nicholas and Helena found this moment so magical that "it made our hearts palpitate."[63] For his part, Tagore regarded Roerich as one of the two most interesting people he met that season, along with T. E. Lawrence, the famed "Lawrence of Arabia."[64] "Their genuine simplicity and unaffected manners were charming," Tagore told his son. "So different from the stiffness of the English. We should like to know them better."[65] Indeed, this was no fleeting encounter: once living in India, the Roerichs spent time with the poet whenever possible.

How much they talked about politics when they first met, as opposed to art and philosophy, remains uncertain, although Tagore was already committed by this time to self-rule and had founded the Self-Government League only a few years before. Whatever they discussed now, Tagore eventually introduced his Russian friend to some of the most important political figures in India, including the country's prime minister-to-be, Jawaharlal Nehru. Years later, Sviatoslav Roerich would marry Tagore's grandniece. Little did either man guess, as they met in a makeshift London studio, that they were gaining not just new comrades, but new kin.

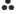

While Roerich earned his keep at Covent Garden and arranged his family's trip to India, he produced many paintings, nearly all of them spiritual in nature. *White Lady* (1919), a tribute to Alexander Blok, reflected the ideal of feminine divinity, and there were icon-like portraits of Russian saints, including Nicholas of Mozhaisk, George the Bearer of Victory, the martyrs Boris and Gleb, and Mercurius, who perished in the struggle to protect the city of Smolensk from Tatar invaders. Other canvases featured shamanic or mystical motifs. *Call of the Sun* (1919), a ritual dance on the shore of a mist-covered lake, brings to life the primeval northland found in earlier works. Like *Human Forefathers* from before the war, *Our Ancestors* (1919) revisits the ancient Slavic belief that humans were descended from bears.

Works such as *Daughters of the Earth* (1919) and *Dream of the East* (1920), which shows a massive stone in the shape of a human face, eyes closed in meditation, remind the viewer of Roerich's goal of journeying to Asia. The same is true of an architectural project from 1920. L. M. Skidelsky, a member of the Russian Economic Association, commissioned Roerich to design nine panels for the interior of a country house. Halfway through, Skidelsky canceled construction, leaving Roerich with five pieces, set in jungles and mountains, that he called "Dreams of Wisdom." Unifying this series is the image of women in states of spiritual awakening. *The Language of Birds* shows a woman, likely the Vedic goddess Gayatri, who features in Roerich's play *Mercy*, turning to speak with a parrot.[66] In *Song of the Waterfall*, a woman admires a flower, her concentration unbroken by the rush of waters around her (see Illustration 21). *Song of the Morning* depicts a woman dancing with a deer. Behind them is a temple, possibly Bodh Gaya, where Siddhartha Gautama is said to have become the Buddha. When Tagore and Das Gupta visited the Roerichs in London, it was these last two pieces that most pleased them.

As for theatrical work, it is kindest to say that 1920 was a year of mixed results. At Covent Garden, Beecham staged the "Polovtsian Dances" from *Prince Igor*. In Paris, Diaghilev revived *The Rite of Spring* in Paris, dropping Nijinsky's controversial choreography in favor of a new arrangement by Leonid Massine, but using Roerich's sets and costumes. Roerich was glad for the added publicity, but did not otherwise benefit. His last successful commission for Beecham was *Khovanshchina*, Mussorgsky's saga about religious schismatics in seventeenth-century Russia.[67] This was the only Mussorgsky work Roerich designed, and also his last completely new theatrical project; any sets and costumes in the future would be for operas and ballets he had worked on before. *Khovanshchina* went over well, and the *Daily Telegraph* praised Roerich's efforts as "an example of perfect disposition and colour harmony."[68]

However, there would be no more stage work for him in England. Bowed under by conflicting commitments to the Royal Opera and his own company, and facing insurmountable debts, Beecham liquidated his opera in the spring of 1920. Roerich's artistic disappointment was tremendous; suddenly gone were plans to design *Sadko* and *The Snow Maiden*. Far worse was the financial fallout. Beecham repaid IOUs at a depreciated rate, but Roerich needed full value to cover the costs of his trip to India and to sustain his family once they got there. In his hyperorganized way, Roerich had finished many scenes for the upcoming operas, and money was still owing to him for work on *Igor* and *Khovanshchina*. He spent anxious weeks wondering whether he would be compensated, and he never forgave Beecham for this setback.[69]

In the spring and summer, Roerich salvaged his situation somewhat with a series

of exhibitions in London and other cities.[70] In this, he was assisted by friends among the British elite, including Brangwyn, Lord Glencannon, the Hoares, and H. G. Wells. Diaghilev lent a hand as well. At a banquet held on the exhibition's first evening, Wells delivered a spirited toast to peace and cultural progress. He sat next to Helena and was treated to a conversation about "progressive Russian minds" and dreams she had had about Asia while in Finland.[71]

The London show opened late in April, under the title "The Spells of Russia." Also included were works by Georgii Yakulov, a *miriskusnik* who now painted in the Constructivist style, but shared Roerich's mystical interests. Diaghilev had hoped to book Brown's Leicester Gallery, but it was taken, so he rented the Goupil Gallery instead. Settling for a second-choice venue did not harm Roerich's prospects: he displayed 198 works, which moved in May and June to Brighton, Leeds, and Worthing. The mammoth canvas *Treasure of the Angels*, from 1905, had pride of place, but Roerich's recent designs for the unrealized Covent Garden productions also featured prominently.

Visitors attended in large numbers; among them was Sergei Prokofiev.[72] Critics from *Studio*, the *Daily Telegraph*, and other papers wrote about the magical beauty of Roerich's work, and Pavel Miliukov spoke at the Brighton and Worthing openings.[73] Miliukov emphasized Roerich's originality, as he always did, and thus described his place in Russian art: "Then came the uncompromising Roerich. Roerich's

cosmogony rather reminds one of Wagner. It begins like that of Wagner in deep and elemental tones, telling of the world's chaos, and ends in the clarified apotheosis of a *Parsifal*."[74] Sales partly offset the blow dealt Roerich by the Covent Garden bankruptcy. Private collectors stepped in, and Cecil Harcourt-Smith acquired a *Prince Igor* study and a northern landscape for the Victoria and Albert Museum. The show's success attracted invitations from galleries elsewhere in Britain—including Liverpool, Sheffield, and Edinburgh—as well as Venice. Eager by now to leave for India, Roerich declined them all.

Another invitation came in the weeks to follow and dramatically redirected Roerich's career. One of the visitors most drawn to his art was a professor at Pittsburgh's Carnegie Institute of Fine Arts, Robert Harshe, who had just accepted a new job as assistant director of the Chicago Art Institute.[75] With unwittingly perfect timing, Harshe wrote to ask if Roerich was interested in a US exhibition. Had he done so sooner, Roerich, still expecting to go to India, would have refused. By chance, Harshe's letter arrived precisely when Roerich needed an acceptable alternative. In this way, the artist and his family found themselves traveling to America instead of Asia.

Early in 1920, the Roerichs crossed a metaphysical Rubicon, establishing their own esoteric doctrine on March 24 and calling

it Agni Yoga, after the Vedic god of fire.[76] They conceived it as a Theosophical offshoot, but eventually asserted its greater autonomy.

Two events marked March 24 as Agni Yoga's founding date. On that day, the Roerichs maintained, spiritual adepts began visiting them psychically for the purpose of revealing a "system of living ethics." Helena started a diary, and these notebooks, kept over twenty-four years, show how she, often with Nicholas and carefully chosen friends, consulted these unseen mentors on a clockwork basis, typically more than once per day. The initial communication, titled "The Call," is given here:

> I am your goodness.
> I am your smile.
> I am your joy.
> I am your peace.
> I am your fortress.
> I am your courage.
> I am your learning.

> Safeguard what is virtuous in life—the unique and precious stone.
> AUM, TAT SAT, AUM.
> I am you, you are I, and I am part of the Divine *I AM* . . .
> Do not withdraw from life, but take the higher path.
> There will be a church for all people. There will be One [God] for all.
> The House of God contains within it many worlds.
> And over all soars the Holy Spirit.[77]

The second reason for the day's importance is Helena's claim to have met physical manifestations of these teachers during a stroll in Hyde Park.[78] She describes herself as wandering, lost in her thoughts, when the crowd around her fell away, revealing two tall Asians clad in white. Smiling, they approached, their bold gaze taking Helena aback. No words were exchanged, but the pair supposedly visited the Roerichs' flat later that evening, meeting Nicholas, George, and Sviatoslav. For the rest of her days, Helena insisted that these were Morya and Koot Hoomi, Madame Blavatsky's spiritual masters from the previous century, and it remains an article of faith among Agni Yogists that this encounter took place. Skeptics point out that Blavatsky spoke of meeting Morya and Koot Hoomi under the exact same circumstances, and readers must judge the truth of this tidy coincidence for themselves.[79] Helena named many astral entities as her tutors, including one Allal-Ming, but Morya and Koot Hoomi predominated. Over the years, the Roerichs and their followers transcribed utterances from these ethereal messengers into two compilations: *Leaves from Morya's Garden* and the multivolume "Agni Yoga" collection.

Initially, the Roerichs fit Agni Yoga into Theosophy's larger framework. They applied in June for membership in the TS's English-Welsh branch; on July 6, they received certificates signed by Annie Besant.[80] They are typically said to have "transferred" from Russia's chapter, but as discussed in chapter 4, no documentation shows that

they actually belonged to the Russian Theosophical Society (RTO). Either way, why not join the Russian branch now, since it remained active in emigration? Some have interpreted this decision as an early sign of sympathy for the USSR, based on an argument that the TS's English branch was less anti-Bolshevik than the RTO.[81] However, personality, prestige, and convenience better explain the Roerichs' choice. Helena had never gotten along with Anna Kamenskaya, the RTO's head, and the two did not warm to each other in exile. England's Theosophists were more closely connected to Annie Besant, compared to whom Kamenskaya was small fry, and to the world headquarters in India, where the Roerichs wished to go. More prosaically, the Roerichs were living in England, and most of the Theosophists they knew there, mainly through Shibaev, belonged to that country's chapter. Even as Agni Yoga developed its own identity, the Roerichs kept up ties with individual Theosophists and occultists of other stripes.[82] Many of these revered Helena for her decades-long effort to translate Blavatsky's *Secret Doctrine* into Russian. The Roerichs disapproved of Ouspensky and Gurdjieff, but remained on good terms with the Anthroposophist Yelena Pisareva, and Helena credited Rudolf Steiner's books with "teaching me much."[83]

If the Roerichs' creed was still amorphous, so too was their program of action, which involved getting to India . . . and then what? The couple's Great Plan, to the extent it existed at this stage, was ill-defined, but no less ambitious for that. Following "The Call" of March 24 came a directive that the Roerichs regarded as Morya's "First Message to the New Russia":

> You who have been given a church,
> You who have been given two lives,
> raise up the church.
> Builders and warriors, strengthen your
> stride.
> You who read—if you do not under-
> stand, read once again,
> until you have understood.
> What has been fated does not happen
> by chance, and leaves
> fall from the trees in their own time.
> But winter is the harbinger of spring.
> All has been revealed, all can be
> achieved.
> I shall protect you with my shield—
> continue to strive.
> Thus have I spoken.[84]

On April 4, the Roerichs recorded a similarly themed fragment called "Knights of the Grail."

What accounts for the stepped-up intensity of the family's mysticism? The psychiatrist Anthony Storr observes that self-declared spiritual visionaries typically claim their most crucial "revelations" soon after, and largely because of, "a period of mental distress or physical illness, in which the guru has been fruitlessly searching for an answer to his own emotional problems. This change is likely to come in the subject's thirties or forties."[85] Nicholas and Helena fit

Storr's profile by virtue of their age and their poor health at the time, but of chief importance was the psychological toll taken by the unceasing dislocations and disappointments of refugee life. Add several years of living at close quarters—sometimes in deep isolation, as in Finland—and one may also have a case of folie à deux, or shared psychotic disorder. Certainly between 1917 and 1920, the conditions endured by the family were textbook-ideal for the transmission and mutual reinforcement of delusions and other forms of behavioral imbalance.[86]

Be that as it may, if we read "sendings" like "First Message" and "Knights" as semiconscious expressions of the fears and hopes haunting the Roerichs' minds, we see obsession over Russia's fate intertwined with an acute version of the pantheistic mysticism that had guided them for years. Messianic ideas, planted in Roerich's worldview by Dorjiev and his brother's Civil War adventures under Baron Ungern, were stirring within him. His fixation on a sacred stone, and his identification of it with various objects from world mythologies, now grew into a core element of the Great Plan. So did the emphasis on building a church. The hero of "The Flame," Roerich's thinly disguised autobiography, discovers that his destiny is to erect a temple that will serve humankind as "a hidden source of learning."[87] This same message is painted into *Nicholas of Mozhaisk* (1920), in which the saint—whose face resembles Roerich's own—holds in his hand a miniature cathedral.

Where was this church to be built? And what would it mean for Roerich to assume the position of high priest? Both questions went unanswered for the moment; the one clear task was to reach Asia. During a séance on June 2, the family's spirit masters repeated their order that the Roerichs make their way with all possible speed to India.[88]

Alas, in this case it was the spirit who proposed, but man who disposed, and there would be no journey to Asia that year. By June, the Roerichs' preparations were all but complete. With Shibaev's assistance, they had planned their itinerary and reserved tickets for their voyage. Helped by a formal invitation from B. P. Wadia of the Theosophical Society in Adyar, they had been issued visas to enter British India. All that remained was to get the balance of the salary Beecham still owed Roerich for his work at Covent Garden. Over the next weeks, though, the extent of Beecham's bankruptcy became clear, and when his opera's assets were liquidated, nothing was left over for Roerich. Without that money, the family might reach India, but they would not last long there.

Some have argued that Roerich's change of plans came about because of British political interference.[89] The assertion is not illogical. The British would certainly have refused him a visa had they suspected him of being a communist, and Theosophy was nearly as bad in their eyes, especially after Annie Besant's arrest during World War I for agitating on behalf of Indian

home rule.[90] But India Office records show that Roerich's visa application, vouched for by Cecil Harcourt Smith of the Victoria and Albert Museum and Denison Ross of the University of London, was approved in June 1920.[91] At this point, the British remained unaware of Roerich's spiritual proclivities and saw him as reliably anticommunist. By mid-decade, the British would have changed their minds, coming to view the artist as a dangerous Bolshevik, but for now it was financial, not political, difficulty that impeded the Roerichs' travels.

Roerich was lucky, then, to have Robert Harshe's invitation as a fallback option. Harshe offered to sponsor Roerich's entry into the United States and to put him in touch with galleries, dealers, and museums across the country. In a transcontinental series of exhibitions, Roerich's art would be shown in New York, Chicago, San Francisco, and more than two dozen other cities. It was an enticing enough proposal that, as early as May, Roerich, already unsure of Beecham's ability to attend to his debts, filed papers to obtain US visas for himself and his family.[92] His application was approved on June 11, and once it became clear that the India trip was impossible, Roerich accepted Harshe's offer. On September 23, 1920, the Roerichs left England on the SS *Zealand*, carrying with them several hundred paintings and innumerable hopes. On October 3, after ten days of sailing, they arrived in New York City.

CHAPTER 9

The Watchtowers of America, 1920–1923

The Zenith branch of the League of the Higher Illumination met in the smaller ballroom of the Hotel Thornleigh. . . . Having bought houses, motors, hand-painted pictures, and gentlemanliness, [they] were now buying a ready-made philosophy. It had been a tossup with them whether to buy New Thought, Christian Science, or a good standard high-church model of Episcopalianism.

—Sinclair Lewis, *Babbitt*

Roerich spent only four years in the United States, yet his tale is nearly as much an American one as it is Russian. His dearest hopes, including the Great Plan that brought him to Asia's far reaches, took full shape in America, and it was there that he gathered his most devoted disciples. From refugee anonymity, he rose to international fame, earning praise and recognition from senators, ambassadors, and presidents. Openly and in secret, he had a greater impact on US public life than do most natural-born Americans.

To his delight, Roerich gained renown in America not just for his art, but for his new age evangelizing. His time in the States coincided with one of the greatest success stories in the history of "inspirational" writing: the 1923 publication of the prose poem collection *The Prophet*, a source of undying fame for the Lebanese American mystic Kahlil Gibran,

and a clear sign of interwar America's bottomless thirst for exotic-seeming profundities unmoored from traditional dogmas. Driven by this same impulse, enough spiritualists, Theosophists, and others seeking "higher illumination"—as satirized in the above quote from Sinclair Lewis—flocked to Roerich's shows and lectures that he felt moved to deliver this assessment in his 1923 essay "Watchtowers of America": "America is not purely materialistic. This country gave birth to Emerson and Whitman . . . [and] here, you shall hear Vedanta and Bahai teachers. You will hear men discussing openly the union of religions and nations, of moon people and Atlantis. Here you will find people interested in astrology and cosmic consciousness."[1] The United States seemed a perfect place to create the kind of "visible church" that T. S. Eliot, another deplorer of the modern condition, hoped would "go on

to conquer the world."[2] At the same time, Roerich aimed for a larger congregation still, on the other side of the globe.

There is no anticipation in "Watchtowers" of what a graveyard America would become for Roerich's ambitions. Scandals and betrayals awaited in plenty. But that bitterness lay ten years and more down the line, and Roerich was pleased for now to view America with the satisfaction of a newcomer who, after months of struggle, had apparently made good.

Rough weather marked the Roerichs' passage from London, and the family was relieved to put into New York harbor on October 3.

Roerich's exhibition was not scheduled to open till mid-December, so he and Helena used the next weeks to get settled. They and the boys lodged at the Hôtel des Artistes, a boardinghouse on West 67th Street. George and Sviatoslav, eighteen and sixteen years old, enrolled at Columbia University, George continuing his study of Asian languages, Svetik entering the architecture program. Preparing for the show took up time as well. Although Robert Harshe of the Chicago Art Institute had invited him to the United States, the person on whom Roerich most relied during these early days was Christian Brinton, a brash Pennsylvanian who had moved to Manhattan and positioned himself as North America's leading promoter of Russian art.

Dozens of Roerich's acquaintances had preceded him to this alien land, among them Boris Anisfeld and the Ballets Russes dancer Adolph Bolm, who feted the Roerichs in grand style. Helena's cousin Ksenia, with her husband, Colonel Ilya Muromtsev, and their daughters Ksenia and Galina, were in New York, as was Roerich's friend, the journalist and collector Arkady Rumanov. The family took up with the pianist Alexander Ziloti, cousin to the composer Sergei Rachmaninoff; the sculptor Gleb Deriuzhinsky, a former student from the IOPKh School; Osip Dymov, who wrote comedies for the Yiddish theater; and Avrahm Yarmolinsky, head of the New York Public Library's Slavonic Division. Present as well were the zoologist Andrei Avinoff, an explorer of Central Asia and an acclaimed painter of wildlife, and Ivan Narodny, an Estonian-born colleague of Gorky's who now reported on the Manhattan arts scene. In time, the Roerichs turned to a different set of friends, but it was among these individuals they found their earliest sources of gossip, emotional comfort, and survival tips—and even spiritual companionship, for some in this group took part in Helena's first American séances.

Roerich's exhibition opened on December 18, 1920, at the Kingore Gallery on Fifth Avenue; it ran for a month and featured almost four hundred works.[3] Two thousand people overran the gallery in the first two days—one paper noted that the elevator operator "went crazy from overwork"—and thousands more visited over the next four weeks. Sales proved sluggish, a problem that

dogged the entire tour, but the *New York Herald* judged his work "strong and original," and the *Detroit News*, anticipating the exhibit's arrival in Michigan, deemed it "the sensation of the season." In mid-January, the show moved to the Boston Art Club, where it stayed half a week before traveling west. According to the *Boston Globe*, the event was popular; it also led to an illustrious encounter. Near the end of the Boston run, Roerich noticed "a tall, melancholy man who had spent the entire three days intently examining one of my paintings." Roerich asked Charles Pepper, one of his new American friends, who this compulsive visitor was. With a smile, Pepper answered, "He loves your work. By all means, let me introduce you to him."[4] The admirer turned out to be the country's greatest living portraitist, John Singer Sargent.

Robert Harshe now took over from Brinton, and two hundred of Roerich's canvases and designs spent the rest of 1921 on the road, heading for the West Coast and back, stopping in twenty-eight cities along the way.[5] Nicholas and Helena traversed the country as well, pressing the flesh with curators and potential buyers, granting interviews, and seeing as much of America as the trip allowed. Before tracking their progress, it is worth pausing to look at two relationships they forged in 1920. One was with a young reporter named Frances Grant. Born in 1898 in Abiquiu, New Mexico, Grant attended Barnard College and the Columbia School of Journalism, landing a job after graduation with the journal *Musical America*. She met Roerich through Adolph Bolm, who announced to her in the fall, "Our Roerich is coming to America! You must meet him!" Bolm arranged an interview, and, as Grant later put it, "my life's tide found its course."[6] Raised by Democratic Jews in a Southwestern "world of Republicans," Grant developed a strong idealistic streak, although spells of self-doubt periodically overwhelmed her. A galvanic attraction drew her to the Roerichs, and what began as an ordinary journalistic assignment turned into twenty years of spiritual and personal thrall.

Grant's dedication to the Roerichs was surpassed only by that of Zinaida Lichtmann, née Shafran, who went by the nickname "Sina." An olive-skinned brunette with a graceful, oval-shaped face, Sina was born in 1894 or 1895 to a Jewish family in Odessa.[7] Her father, a pianist and teacher, held an academic post in Vienna, and she followed his career path by studying piano there and in Germany. She married into the profession as well, taking as her husband Maurice Lichtmann, a pianist from the Ukrainian town of Kamenets-Podolsk. Upon her father's death in 1912, Sina and her mother Sophie emigrated to New York, where she and Maurice opened the Lichtmann Piano Institute. During and after World War I, the couple, joined by Maurice's sister Esther, eked out a living as teachers until the Roerichs arrived to give them not only employment, but a higher purpose. The Lichtmanns met the Roerichs on the day of the Kingore Gallery opening, a moment Sina never forgot: "There he was,

of middle height, with bright eyes, pointed beard, a noble brow—which radiated a powerful, unseen goodness—and an extraordinarily penetrating gaze. It seemed as though he had the ability to see into one's soul and perceive its very essence. His wife stood next to him, so beautiful that it took my breath away."[8] Sina considered Roerich's erudition a marvel. "To be close to [him]," she wrote, "was like studying at several universities at once."[9] Her devotion to Nicholas and Helena lasted sixty-three years and proved stronger than any marital or family ties. She became an archdeaconess of unshakable faith and bulldog loyalty.

The exhibition's next major stops were Buffalo in March and Chicago in April and May. As the Roerichs traveled with it, they did so not just for the sake of Nicholas's art, but with a sense of divine mission. In 1920 and 1921, the pair kept up with their séances, both on their own and with friends and admirers. While many of these communications described the afterlife and other planes of existence, an increasing number purported to map out Russia's future. In January 1921 came a prophecy that, "between one and seven years from now, a constitutional monarchy will arise in Russia . . . Ukraine, Bessarabia, Finland, and Poland will be reunited with Russia, the land of future glory."[10] Allal-Ming informed the Roerichs that their "karmic duty" was to "raise up the most holy land of Russia," while Morya

promised that, "in your lifetimes," when "lilies grow from the rock" and "my spear manifests itself in the east," true churches would reappear "on the pure soil of Russia."[11] Such oracular injunctions were more than vague reassurances. They were calls for political action.

At the same time, the Roerichs had their immediate future to think about. The need for cash nagged at them hardest, but they also took genuine interest in new possibilities. Could Nicholas transplant his educational methods to America? The Lichtmanns' piano institute might serve as the nucleus for a new version of the IOPKh School. Could a global federation of right-minded thinkers turn culture and beauty into the guiding principles for a just and peaceful post–Great War era? In Scandinavia and England, Roerich had spoken about the need for a "Fourth International" to unite the world's leading artists and scholars against the Bolshevik-dominated Third, or Communist, International. America seemed an excellent headquarters for such a body, as he told the press in 1921.[12] Was America ripe for new age consciousness raising? Nicholas and Helena most definitely thought so.

Whether the Roerichs saw such prospects as part of a larger whole that included their plans for Russia, or as a fallback if those plans fell through, they required money, new contacts, and the support of influential parties. Much effort went into fundraising and network building. In Buffalo, Roerich sought out the industrialist

Spencer Kellogg Jr., who had a passion for traditional bookbinding—he owned the handpress with which William Morris created the Kelmscott Chaucer—and Theosophy. Allal-Ming urged Roerich to inform Kellogg that he had been a Nubian prince in a past life. Whatever Kellogg thought of this revelation, he purchased one of Roerich's paintings, *Sons of Heaven*, and donated to the family over several years.[13] In Chicago, Roerich attracted the attention of an even more useful patron, the diplomat and businessman Charles Crane.

Chicago kept Roerich busy the entire month he was there, from April 13 to the close of his show on May 15. The Chicago Art Institute attracted over one million visitors in 1921, its largest annual total to that date, and Roerich both benefited from and contributed to that success. The city's papers responded eagerly to the exhibit, with the *News*, the *Evening Post*, and the *Tribune* describing Roerich's art as "virile" and "full of conviction."[14] Reporters, dignitaries, and cultural clubs begged Roerich for interviews and speeches. Marshall Field, Chicago's landmark department store, invited him to lecture in honor of a new line of clothing, based on "prehistoric" motifs, which it planned to introduce the following year.[15]

Roerich, anxious for publicity, accepted all such offers, presenting two sides of himself to America. Some saw the grim exile, carrying the weight of historical tragedy, as described by Paul Horgan, the artistic director of the Rochester American Opera Company: "[He was] a rather short, stocky man, with a sallow bald head, a composed presence, mournful eyes [and] a frown. He wore a thickish tweed suit in the colors of heather. I thought he resembled Lenin, but this was heresy, for my 'Russianism,' like that of my associates, was imperialistic and White. But there was nothing of the proletarian in M. Roerich . . . in his receiving line, he greeted everyone with aristocratic courtesy."[16] Then there was the utopian mystic. Asked what he thought about Chicago's skyscrapers, Roerich called them "beautiful castles of the future"—a 180-degree pivot for someone with such traditional architectural tastes— and said of them, "They are alive . . . [when they] brace themselves against the wind, you see in them the cosmic force at work."[17] On women, he spoke not about their role in society or the new rights they had won after the world war, but about how "they learn the cosmic language more quickly than men, because it comes not through the brain, but through the heart."[18] His Marshall Field lecture veered away from the topic at hand, the store's upcoming fashion line, toward an abstruse discussion of auras and unseen emanations.

If Roerich's digressions baffled some, they struck a chord with others. Several critics reviewed his exhibition from an explicitly esoteric perspective, with one praising him for his "prophetic example" and his lucid "expression of the Inner Life."[19] The Theosophical Society (TS) embraced him as "our famous Russian brother," a workmate "ploughing and sowing and reaping in his own patch of the Cosmic Field."[20] Roerich

made his way through America's cities desiring to be known as a seer of the coming new age.

While in Chicago, Roerich, by means of automatic writing, completed the fourth and final section of his *Flowers of Morya* collection, "To the Hunter Entering the Forest."[21] He submitted the compiled verses to Slovo, the émigré publishing house established in Berlin by the Nabokov family. Slovo printed the poems later that year, and Roerich authorized it to donate all proceeds to the relief effort that ended the terrible Volga famine of 1920–1922.[22] In 1929 the poems appeared in English translation, under the title *Flame in Chalice*.

Artistic networking went well in Chicago, or so it seemed at first. Roerich wanted back into the stage-designing game, and he aggressively pitched his talents to performing-arts venues in America. With an eye on New York's Metropolitan Opera, he sent the following note of introduction to Norman Bel Geddes, the Met's star designer: "My Dear Friend! I wish meet you and speake with you! How is it possible? When are you at home? Greetings! Yours sincerely, N. Roerich."[23] Notwithstanding the broken English (another reminder of the obstacles Nicholas and Helena faced in exile), Roerich befriended Bel Geddes, though without much tangible benefit. More useful, or so Roerich thought, was the relationship he began with Mary Garden, the Chicago Opera Company's director and leading soprano.

The Scottish-born Garden rose to worldwide fame in 1902 by starring in Debussy's setting of Maeterlinck's *Pelléas et Mélisande*. She made her American debut in 1907, in Massenet's *Thaïs*, and she thrilled New York audiences with the wickedness of her Salomé when Oscar Hammerstein premiered the controversial Strauss opera there. Roerich came to her attention thanks to Nina Koshetz, who sang at the Chicago Opera but had known Roerich in Russia. A Theosophist herself, Garden adored Roerich's philosophy along with his art, and purchased one of his paintings, which she believed had the power to stave off illness and protect her voice.[24] On a more businesslike plane, she hired Roerich to design three productions over the next two years: *The Snow Maiden*, *The Maid of Pskov*, and, to his joy, Wagner's *Tristan and Isolde*. Unfortunately, Garden's propensity for overly optimistic planning meant that only the first of these commissions paid off, and the longest-lasting legacy of this collaboration would be a fierce lawsuit.[25]

Before leaving Chicago, Roerich partnered with another group of artists to form a new society, Cor Ardens, intended as a worldwide union of creative talents. Among its cofounders were Raymond Jonson of the Chicago Academy of Fine Arts and the German American painter Carl Hoeckner, and it took its name—Latin for "flaming heart"—from one of Roerich's favorite cycles of Silver Age poetry, the 1911–1912 collection by Vyacheslav Ivanov.[26] Of Roerich's American enterprises, Cor Ardens was the most vaguely defined, and archival evidence suggests that he did not establish it, but was

asked to join and help lead it.[27] The process of inviting potential members, such as Gallen-Kallela, Tagore, Maeterlinck, Richard Strauss, and the Spanish painter Ignacio Zuloaga, allowed Roerich to renew old ties and make new ones, but his attention was diverted from Cor Ardens by the Corona Mundi initiative he began in 1922.

It is tempting to wonder whether Roerich considered settling in Chicago instead of New York. He had supporters in Robert Harshe and Mary Garden, and the prospect of long-term associations with the Chicago Art Institute and the Chicago Opera. Indeed, when New York's Metropolitan Opera asked him to design its own production of *Tristan*, he refused out of fealty to Garden—a decision he later rued. Chicago was home to a prominent Russian-language newspaper, *Rassvet*, which provided almost twenty years of pro-Roerich coverage. If Nicholas and Helena broached the idea of making Chicago home, they left no record of it. Nonetheless, had one or two things gone differently, they might have spent the next two years not as Manhattanites, but as Midwesterners.

From Chicago, Roerich's exhibition went on to Madison, Wisconsin, then St. Louis, where it spent part of July. In August, it proceeded to Santa Fe, and the Roerichs had their first experience of the US Southwest, a place captivating to many artists and authors of the day. Georgia O'Keeffe and Willa Cather remain the most famous, although D. H. Lawrence remembered his time in New Mexico as "the greatest experience I have ever had."[28] Lawrence was there not long after Roerich, as was one of Roerich's younger Russian colleagues, Nicolai Fechin, who, after emigrating to America in 1923, became a noted member of the Taos arts community.[29]

The Roerichs rented a house on Galisteo Street in Santa Fe. The *Santa Fe New Mexican* made much of their arrival, and Roerich befriended Edgar Hewitt, the director of the city's Museum of Fine Arts, predicting accurately that "in a short time, Santa Fe will be a real art center with the greatest future."[30] Roerich left an artistic and spiritual imprint on *Los Cincos Pintores*: Josef Bakos, Fremont Ellis, Walter Murk, Willard Nash, and Will Schuster, all major figures in the Canyon Road art colony. The Transcendental Painting Group, which emerged in Taos in the 1930s—counting among its members the abstract painter Agnes Pelton and Lawren Harris, one of Canada's famed Group of Seven—was founded by Emil Bisttram and Cor Ardens's Raymond Jonson, both influenced by Roerich in the 1920s.

With their sons, who joined them until the start of the academic year, the Roerichs toured many sites in New Mexico and Arizona. Two things above all caught their eye. First was the extraordinary terrain. The desert's haunting starkness—its mesas, arroyos, and gorges—formed a landscape as primordial as any forest or steppe Roerich

had painted in Europe. And this is to say nothing of the Grand Canyon, which left him and Helena speechless. Equally of interest were the region's Native Americans, both living and long-departed. Roerich had read in his youth about the cliff dwellings built by the Southwest's prehistoric tribes, and he would not miss the chance to visit these fascinating sandstone aeries.

Roerich saw the Southwest through ethnographic and esoteric lenses simultaneously. In his eyes, the anthropological fact of shared ancestry between Asians and indigenous Americans gave him license to apply the same universalizing logic to the New World that he had once applied to Eurasia. Here, commonality trumped difference—a view reinforced by occultist speculations such as Blavatsky's theory of "root races"—and any similarity between peoples, no matter how superficial, held greater meaning than the countless divergences in language, customs, and ethnicity that occur when groups break apart and evolve separately for thousands of years.[31] To Roerich, then, Mongols and aboriginal Siberians were practically indistinguishable cousins to New Mexico's Native Americans, and when he showed photos of the former to the latter, he claimed to have elicited cries of joyful recognition: "Oh, they are Indians! They are our brothers!"[32] (The same thinking fueled his reflections on the totem poles of the Pacific Northwest, which in his mind were near-identical to ancient Slavic idols.) Also at this time, he began comparing Slavic folk embroidery with the decorative elements found on traditional Southwestern attire, creating easily misinterpreted impressions about what had inspired him when designing costumes for *The Rite of Spring*.[33] As noted in chapter 6, Leopold Stokowski and others in America who spoke with Roerich about *The Rite* came to believe he had been guided by examples of Native American dress during his efforts of 1910–1913. They themselves then cemented this error into place.

Natives and nature both spurred Roerich's creative efforts. *Blue Temple* captures the majesty of the Grand Canyon in cool, shadowy tones, and the Southwest's arid mountains form the background for *The Atlantean*, which revisits the Theosophical tenet that the world's eldest civilizations were seeded by refugees from the drowned city. The region's apocalyptic harshness moved Roerich to pen essays like "Paths of Blessing," which discussed the parlous state of present-day affairs. "War has inundated the world with blood," he wrote. "Droughts and floods have disturbed human welfare. Lakes have dried up. Peaks have crumbled, famine has revealed its face." The only way to counter such frightful trends was to contemplate the divine and make it manifest in the world: "Verily, verily, Beauty is Brahmin. Art is Brahmin. Science is Brahmin. Every Glory, every Magnificence, every Greatness is Brahmin."[34]

These Vedic meditations came courtesy of Morya and Koot Hoomi, whom the Roerichs consulted during weeks of séances in the Southwest. To these communions they

invited the closest of their acquaintances in America. Frances Grant came out from New York to spend time with the Roerichs in Santa Fe, as did Sina Lichtmann, her husband Maurice, her sister-in-law Esther, and her mother Sophie. Accompanying them was a college friend of Frances Grant's: Nettie Horch, the wife of a Manhattan financier. No one knew it as the group toured dusty plazas under the late summer sun, then gathered after dusk to call up the spirits, but Grant, in introducing the Roerichs to the Horches, had forever changed both families' fates.

In September, Roerich interrupted his Southwestern idyll for a trip to California. His exhibition made its westernmost stop in San Francisco, which he long remembered as "that joyous city."[35] He was received with special warmth, as much for his mysticism as for his paintings' appeal. Vedanta, Theosophy, and other such movements took strong hold in interwar California, and Roerich found appreciative audiences there. He made contact with the Pacific Lodge of Theosophists in San Francisco and a smaller group in Carmel.[36]

Roerich gave two major talks in the San Francisco area: one at the opulent Palace of Fine Arts, the other on the University of California's Berkeley campus. On both occasions, he based his lecture on the 1908–1909 essay "Joy in Art," splitting it into two parts and updating it with observations made in Arizona and New Mexico.[37] Somewhat on the lengthy side, the lectures went down well enough, and Roerich left California with one durable contact. This was Alexander Kaun, a young Berkeley professor of Russian and Hebrew. Kaun lauded Roerich as "an indefatigable pilgrim questing on behalf of harmony and beauty" and later supported his public enterprises.[38]

Roerich went back to Santa Fe before the end of September and readied himself for the journey eastward. He and Helena left for Chicago on October 12, and, after a week and a half there, returned to New York. The exhibition followed more slowly, stopping in Denver, Colorado Springs, Omaha, Kansas City, and Des Moines. It then swung through Minneapolis, Detroit, Ann Arbor, Cleveland, Indianapolis, Columbus, and Rochester, returning to New York City in April 1922. Media coverage of the show continued, with sympathetic profiles appearing in magazines like *Architectural Record* and *Theater Arts*. The *New Republic* printed an English translation of Leonid Andreyev's tribute, "The Realm of Roerich," and *Art and Archaeology* published the text of Roerich's Berkeley speech.[39] Praising his gift for recapturing the spirit of lost epochs, Erikh Gollerbakh proclaimed in *The Twentieth Century* that "Roerich quaffs from his drinking horn the thick sharp wine of thousands of years, black as dried blood."[40]

October's homecoming brought the Roerichs to a crossroads. They had been in America for a year and found it a

stimulating place. Getting by financially, however, was proving more of a challenge than anticipated. Roerich's exhibition had six months left to run, but he knew already that it would not be a moneymaker. With dozens of émigré Slavs competing for attention and sales, it was no wonder that, while Roerich's art attracted admiration, it succeeded less in opening up checkbooks. Nor were plans with the Chicago Opera going as hoped. Two of Roerich's three commissions there had been canceled, and though he kept working with Mary Garden on *The Snow Maiden*, to be staged in 1922, he filed suit against the Opera, demanding (in vain) $3,500 to compensate for lost income.[41]

At this point, the Roerichs needed revenue from somewhere. George and Sviatoslav transferred from Columbia to Harvard that fall, with Sviatoslav taking extra courses at MIT, and tuition at none of these schools came cheap. In October, Nicholas and Helena fell behind in their rent, and $3,000 of miscellaneous obligations hung over them. The two had already put up as collateral a set of Old Masters, Nicholas's diamond cufflinks, his pocket watch, and Helena's jewelry; they now turned to the Fifth Avenue Bank for another $8,300, offering more paintings to guarantee this second loan.[42] The situation worsened in November, with the Hôtel des Artistes complaining about the $552.12 owed it, and the firm that had printed posters for Roerich's 1920 show dunning him as well.[43] Constant reassurances were needed even during the family's séances. "Great good will come," Morya said

soothingly. "November will pass, and we will move forward. There is no other path for you . . . go where Christ summons you." And, more plainly, "Do not fear—you will receive money."[44] If we continue to view such passages as outpourings from the Roerichs' collective subconscious, we see that financial questions preyed incessantly on their minds. They managed one improvement before year's end, locating a more affordable living space, in a West 82nd Street pension near West End Avenue. But the new rooms would not be ready until mid-January, and the Hôtel des Artistes was not about to forgive the family one penny of its debt.

The season's money woes threatened not just the Roerichs' livelihood, but their larger ambitions. While in New Mexico, they had agreed to work with Sina and Maurice in transforming the Lichtmann Piano Institute into a more versatile Master Institute of United Arts. The institute opened in November 1921—but, lacking funds, seemed unlikely to survive the next fourteen weeks, much less the fourteen years it remained in operation. And what of Asia, where the Roerichs still aimed to go? Throughout 1921, the family kept in contact with Annie Besant and Krishnamurti, seeking permission to visit the TS headquarters in Adyar and offering to dedicate a new painting, *The Messenger*, to Helena Blavatsky.[45] Money was needed for a journey to Tibet, where Morya and Koot Hoomi now summoned

Nicholas and Helena, and the couple hoped to join the East's fate with Russia's—a tall order for even the most powerful warlord or statesman, much less a small family on the brink of poverty.[46]

What the Roerichs lacked in means, they made up for in messianic self-confidence. Their Great Plan became more nakedly geopolitical in late 1921, when an acquaintance from Russia, P. A. Chistyakov (not to be confused with the artist Pavel Chistyakov, Roerich's Academy of Arts instructor), visited Nicholas and Helena in New York.[47] With Roerich's brother Vladimir, Chistyakov had fought for the Whites in the Far East. After the Civil War, both made their way to the Manchurian city of Harbin, whose importance as a railroad hub had attracted numerous Russian émigrés since the 1800s. There they took jobs with the Chinese Eastern Railway.

By May 1924, the USSR would persuade Chinese authorities to recognize it as the proprietor of Russia's assets and interests in Harbin. Until then, the city, its political situation exceptionally fluid, drew thousands of Russians not yet ready to cease their struggle against Soviet communism. Chistyakov was one of these, and while he came to New York to raise money for building a Russian university in Harbin, and perhaps to recruit Roerich to serve on its faculty, his conversation turned to larger concerns. In Russia proper, he conceded, immediate hopes of overturning Red power were gone. In Siberia and Manchuria, however, anti-Bolshevik prospects remained less

dire. Fighting continued throughout the east, and though the Soviets would eventually win their way to the Pacific, fear of antagonizing the Japanese, who had their own gains to consolidate in mainland Asia, kept them for the moment from pressing claims in Siberia too vigorously. White generals, including Grigori Verzhbitsky and Mikhail Diterikhs, still threatened and at times controlled such key ports as Khabarovsk and Vladivostok, and since the summer of 1920, Lenin's regime had been prevented by the terms of its truce with Japan from asserting direct authority over Russia's Transbaikal, Amur, and Maritime regions. Here, a reluctant Kremlin ceded governance to the Far Eastern Republic, an unstable buffer zone based first in Verkhneudinsk (now Ulan-Ude), then in Chita. While this short-lived state operated as Moscow's puppet, the need to maintain the fiction of its independence indicated Red weakness in the east. Only after October 1922, upon defeating White forces in Vladivostok, would the Soviets feel bold enough to disband the republic and take over in their own right. In the interim, Harbin saw its Russian population swell to 72,000, up from 43,500 in 1914, filling the city with Cossacks and White Russians chafing to drive north and tear down Red rule at the earliest possible opportunity.[48]

Another potential weapon against the Bolsheviks, noted Chistyakov, was the religious devotion of the region's native populations. Linked in most cases by faith in Tibetan Buddhism and a common Mongol heritage, these groups might be induced

to rise up against Soviet power, especially if they perceived their way of life to be threatened by Leninist hostility toward religion. As seen earlier, the notion that Buddhist peoples might be united to Russia's advantage was hardly new: explorers such as Nikolai Przhevalsky and Pyotr Kozlov, joined by the monks Pyotr Badmaev and Agvan Dorjiev, had long proposed the encouragement of pan-Buddhist tendencies on Russia's Asiatic periphery. And now, four years of civil war had triggered several attempts to mobilize religious fervor as a way to influence the region's politics. Baron Ungern's campaign in Mongolia, described in chapter 8, remains the most memorable, but in 1918–1919, Grigori Gurkin, a painter of native Altai origin, used indigenous Oirot prophecies to help motivate a brief nation-building effort in the Karakorum.[49] In 1919, before his arrest by the Soviet secret police, the monk Lubsan Tsydenov declared himself the Transbaikal's "king of the dharma," and that same year witnessed the creation of a Mongol-Buddhist federation, proposed by the White general Grigori Semyonov, backed by the Japanese, and headed by the lama Neisse-Gegeen.[50] The foreign minister of this failed government, Tsyben Jamtsarano, grew close to Roerich in 1926–1927 and may have known him in pre-revolutionary Petersburg, through Dorjiev and the Temple Commission orientalists.

With these examples in mind, it was tempting to think that, given proper leadership, at least some of Siberia might be secured and held in defiance of the Reds.

Military skills were not the prime consideration; there were generals by the dozen among the Russian diaspora. What mattered most was finding someone of sufficient stature to unify the White factions exiled in Asia and conversant enough with Buddhism to rally Mongols, Tuvans, Kalmyks, Yakuts, and Buryats to the cause of anti-Soviet confederation. Could Roerich be that person?

If the Roerichs had not thought so before, they did now, as they invited Chistyakov to join them in a series of séances in November and December.[51] Already for a year and a half, Nicholas and Helena, with their dreams of erecting a universal church in a purified Russia, had been conceiving of Roerich as a pantheistic archbishop, bestowing wisdom upon occident and orient alike. Now Helena went further, issuing prophecies that fused the Shambhala myth with émigré politics, Russia's fate, and a mystical variation on the "Great Game" in which mastery over a third of Asia was at stake. The time was nigh, she said, for the earthly incarnation of Maitreya, Buddha of the Future, and, with it, the reappearance of Shambhala. "I have begun the task of joining India with Russia," Morya assured the Roerichs, and Harbin had been chosen as "the center for the construction of Russia's cultural future."[52] Before any of this came to pass, the Roerichs would have to venture to the Himalayas. "You must bring the Stone"—identified by Morya as Solomon's ring—"to the Church of the Living God," which sat proudly in the mountains

of Tibet.[53] "There, to the north of Everest, you will come to know my teachings," said Morya, following this promise with the pronouncement that Roerich was "fated to rule Russia."[54] (George paralleled these efforts at Harvard, leading the Russian friends he made there in séances of his own in 1921 and 1922. Allal-Ming assured this anti-Bolshevik "Cambridge circle" that Russia would soon throw off the communist yoke.[55])

Such audacity might seem startling, but Roerich had already spent the past half decade associating himself with symbols of political and ecclesiastic authority. The growing frequency with which he gave the holy men in his paintings his own face has been noted, and he now made a greater habit of signing certain paintings with the labarum cross, formed by superimposing the first two letters of Christ's name in Greek, *chi* ("X") and *rho* ("P"), on top of each other. Roerich had used this signature occasionally during World War I; it was a clever formalistic touch, in that *rho* and *chi* are the first and last letters of Roerich's surname in the Cyrillic alphabet, and it could be read symbolically as an appeal for holy protection at a time of national peril. However, the link between the Chi-Rho and the person of Jesus raises the question of whether Roerich also meant to claim divine inspiration for his work—or even a measure of divinity for himself. Moreover, based on the phonetic similarity between his name and that of Rurik, the semimythical founder of Russia's first dynasty, Roerich had idly wondered for years whether he was distantly

descended from royalty. Now, with Russia in the grip of a power he considered illegitimate, he ruminated more seriously about this possibility.[56]

Chistyakov returned to Harbin in 1922, after seven months in the United States. At the Roerichs' urging, he and Vladimir Roerich joined the Harbin Theosophical Society; over the coming months, they monitored the strategic lay of the land and quietly gauged the potential level of White support for Roerich's venture.[57] They were not as quiet as they thought. Japanese intelligence, always curious about White Russian activity in Asia, began monitoring Vladimir's and Nicholas's correspondence, and indiscretion caused the Roerichs' schemes to become a staple subject for White gossip from New York to Shanghai. Much of this talk was inaccurate or fragmentary, but some of it hit nearer the mark. Among the better informed seems to have been the White general Pyotr Krasnov. Krasnov emerged as a prolific fictioneer after the Civil War, and his 1922 novel *Beyond the Thistle* may have been influenced by advance knowledge of Roerich's plans. In Krasnov's tale, an idealistic artist named Korenev, exiled from his homeland and mourning its despoliation by communist tyrants, embarks on a far-ranging quest that brings him to the distant east and leads to Russia's revival as a Eurasian "new country." Roerich spoke of *Beyond the Thistle* with approval, and some have supposed that he served in part as its protagonist's model.[58] As noted in chapter 8, Roerich and Krasnov had been friendly in

England, so the general may have heard the details he needed straight from the source. Still, the airing of Roerich's intentions, even in literary disguise, indicates how hearsay about them had begun to flutter through White communities everywhere.

For reasons discussed in chapter 10, Roerich attempted a different version of this plan in 1925–1928, but even this early iteration contained the same core elements: belief in a fundamental cosmic shift, a conviction that this transformation required Roerich's elevation to the status of spiritual and secular hegemon, and the determination to win a homeland for his Eurasian theocracy, containing as much of Russia as possible. But which Russia, and whose? For the moment, this was an anti-Bolshevik crusade. Before long, political orientation came to matter less to Roerich than his millenarian visions. If the Great Plan (hereafter, the Plan) originated as a way to achieve White victory, ends and means soon reversed themselves—and the question of how the Whites *or* Reds were to be dealt with became important only insofar as it increased the Plan's chances for success.

Roerich hinted at his future direction in a letter from this time to Ivan Bilibin, who had written from Cairo, seeking advice about whether he should remain in Egypt or go back to Europe. Roerich suggested to Bilibin that he put the West behind him. "There, the twilight of the gods is drawing nigh," he foretold, evoking Wagnerian operatics and Spenglerian gloom in one breath. "At this moment," it would be better "to draw inspiration from the east."[59]

Colorful counsel, though Roerich himself was hardly in a position to act on it in early 1922. He had confederates around the world: Chistyakov and Vladimir in Harbin and, in Petrograd, his brother Boris and the Mitusov family. Shibaev, having returned to Latvia on the Roerichs' orders, facilitated communication with friends and family in Russia, a task made easier by the end of Civil War hostilities in European Russia. But while Roerich could scheme on a global scale, circumstances compelled him for now to concentrate on efforts in America.

This meant tending to the new Master Institute of United Arts. Housed in a Greek Orthodox Church on West 54th Street, the institute was to be another School for the Encouragement of the Arts, resurrected in the New World. And though the Roerichs wished more than anything to go to Asia, they envisioned a place for America in the age of Maitreya—and a role for the institute in raising America's level of cultural and spiritual awareness.

As the institute's name implied, its guiding principle was the Wagnerian "united art work," and it eventually offered classes in painting, sculpture, handicrafts, and architecture, as well as music, drama, and ballet. Students paid a registration fee of $5 and then, depending on the number and type of courses, tuition ranging from $7 to $40 per month. In time, pupils would take

a variety of courses in a comfortable setting with some of New York's most famous artists and designers. During this first winter, though, the institute held its handful of classes in a whitewashed, uncarpeted room. The academic staff consisted of Roerich, Sina, Maurice, and Maurice's sister Esther, plus an assortment of Russian émigrés paid on a course-by-course basis. Until summer 1922, when money poured into the institute more freely, Roerich impressed upon Sina and Maurice the need to economize by hiring "those teachers who will lecture for free and not be offended by the small enrollments."[60] Most of the Lichtmanns' piano students transferred over, and their tuition helped to cover overhead.

Still, there were few students to teach at first, and in 1922, the institute was limping toward an early exit if it failed to generate more income. On January 24, Nicholas and Helena moved into their cheaper quarters on West 82nd Street, but creditors continued to badger them, and the Fifth Avenue Bank, concerned that Roerich would default on his $8,300 loan, made ugly noises about auctioning off the paintings he had handed over as collateral. From Harvard, George wrote that he had "only one dollar to his name."[61] Nicholas and Helena felt uncomfortable turning to other Russians for support, hesitating mainly for fear of Red infiltration. In every center of Russian exile, Soviet operatives spied on White émigrés, and even someone whose heart was in the right place politically might have too loose a tongue to trust. If Roerich is to be

believed, Red agents approached him twice in 1922. First, in Sina Lichtmann's earshot, a Madame Strindberg promised Roerich "money, as much as you need," if he shifted his allegiance to communism. Later, the Soviets offered to publish a second volume of Roerich's writings, a sequel to his *Collected Works* from 1914.[62] Thus it was that Morya ordered them that year not to discuss their plans with Russians in America or Europe, including Princess Tenisheva, Alexei Remizov, and Sergei Rachmaninoff, whom the Roerichs knew through Alexander Ziloti, the composer's cousin.[63] (Better "fervent enemies" than "friends touched by corruption," Morya advised.[64]) Ironically, the more circumspect the Roerichs' dealings, the more their fellow exiles wondered whether they had gone over to the Reds. One rumor, aired years later by their onetime follower Ivan Narodny, spoke of Roerich being offered half a million in gold rubles by a Soviet representative in New York if he lobbied for US recognition of Soviet Russia.[65]

Luckily, infusions of cash came from two sources in the spring and summer of 1922. First to step up was Charles Crane, whom Roerich had met the previous year in Chicago. The Crane Corporation was a profitable supplier of fittings and plumbing equipment—its fixtures had graced Russia's Winter Palace in the days of the tsars and are still found in washrooms everywhere—but after years as vice president, Crane sold the controlling interest to his brother, freeing himself for a life of public service in the Middle East, Asia, and Eastern Europe.

An expert Arabist, Crane served Woodrow Wilson not only in that capacity but also as US minister to China and as a member of the Elihu Root commission that assessed the Russian Provisional Government's chances of survival in 1917. He was present at the Paris Peace Conference and supported Czechoslovak independence. A passionate admirer of Slavonic culture, Crane gave Alphonse Mucha, best-known in the West for his Art Nouveau posters, the years of backing he needed to finish *Slav Epic*, a set of murals presented as a gift to the Czechoslovak nation in 1928. Crane did not lavish as much money on Roerich, but he liked the Russian's art and approved of the institute's mission.[66] (It seems he was also charmed by Helena, who described him to Esther as a boyish flirt.[67]) During a 1921 journey from Peking to Prague, Crane had traveled across the USSR and fallen in love with the medieval town of Rostov Velikii. He now asked Roerich to paint the Rostov fortress from a photograph snapped during his visit there, and purchased additional works in 1922. He donated enough money to the institute that it had a few hundred dollars in its account at the Corn Exchange Bank by spring. Partly due to this solvency, the Rehn Gallery loaned the institute $200,000 worth of Dutch and Italian paintings to display.[68]

Crane's assistance was a pittance, however, compared to the backing Roerich received from Louis Levy Horch, a successful New York businessman, and his wife Nettie, whom Frances Grant had introduced to the Roerichs the summer before.[69] Louis, born in New Orleans in 1888, received his education in Mannheim, Germany, after his father's death and mother's remarriage. Returning to America at age seventeen, he moved from one job to another in New Orleans, Chicago, and New York, where he landed an entry-level position with a Wall Street firm. When he turned twenty-five, he and Curt Rosenthal opened a foreign-exchange brokerage, doing well enough that he was able to bankroll the auto-manufacturing enterprise of one of his German relatives, Augustus Horch, one of the four founding members of the Audi conglomerate. Nettie came from New York and attended Hunter College, during which time she befriended Frances Grant. The daughter of strict traditionalists, she defied convention by marrying Louis while her two older sisters were still single.

The Horches met the Roerichs at a time of strain in their own lives. Nettie suffered painful attacks of asthma, and the Horches' two-year-old daughter, Jean, was ill as well. Louis took a leave of absence from business and, to give Nettie and Jean relief from Atlantic weather, temporarily moved the family to California; it was from there that Nettie met Frances and the Roerichs in New Mexico, in August and September 1921. Nettie wished to know more about eastern philosophy, and while she found Nicholas somber, she was allured by Helena's talk of Buddhism and Theosophy. When the Horches returned to New York in spring 1922, Frances gave them a guided tour of the Master Institute. Roerich's art

they thought glorious, and both agreed that the institute deserved a new home to match the nobility of its goals. The couple started sitting in on the Roerichs' séances—Nettie enthusiastically, Louis with greater reluctance, at least initially.

Although he had much skepticism yet to overcome, Horch released substantial amounts of money to the Roerichs, clearing their debts and redeeming the paintings that the Fifth Avenue Bank had threatened to sell. He took care of George's and Sviatoslav's bills at Harvard and agreed to pay for the postgraduate work George would begin at the Sorbonne that fall. He also put the Master Institute on a solid footing, allowing it to hire more faculty and offer more courses.

"Be not afraid—Horch will provide," Morya vowed. Roerich therefore set optimistic sights on a new and larger space for the institute on the 300 block of Riverside Drive. He also attached another organization to the institute, called Corona Mundi, or "crown of the world." Conceived in the spring of 1922, Corona Mundi was to be a global union of creative luminaries, much like Cor Ardens, except better organized. Most important, a clear path to India and Tibet appeared to have opened up, if only the Horches could be kept in the Roerichs' orbit. An excited Nicholas informed Vladimir in Harbin of his improved chances of reaching Asia, and he started arranging to bring Boris and his wife Tatyana to America, to work as the Institute's archivists. As he wrote on July 3: "You *must* come. We

have collected the necessary money ($3,000). A company has been formed. When can you get your things together? We must know for the visa." Hoping to stock the institute with more objets d'art, he ordered Boris to fetch as many items as possible from the collection he had left behind in Russia.

Whatever you bring must be *exceptional*. Nothing of middling quality will do. Bring a good selection from the Stone Age collection. Are there any of my jubilee books? Where are the Masonic badges? The primitives? The good Japanese and Chinese pieces? We will be terribly glad to see you. Around me are some excellent Americans who love Russia. Kisses from all of us to everyone back home. We impatiently await your answer. Hurry!

Yours, Kolya
P.S. Study your English![70]

In the fall, Boris applied for a US visa.[71] But by the time the State Department processed his paperwork, the Roerichs' plans had progressed, and Boris's presence in America was no longer called for. When the siblings next met, it would be on Russian soil.

The turning point in the Roerichs' courtship of the Horches came near the end of July 1922, not in New York, but off the weatherbeaten coast of Maine.

That summer, Nicholas and Helena took a monthlong vacation with Sina and Maurice. Roerich's friend Charles Pepper had recommended Monhegan Island, whose rugged beauty lured many artists, including N. C. Wyeth and Edward Hopper, to paint there. Both couples arrived in Maine on July 6 and stayed till August 10. George, having finished his exams at Harvard, came out to enjoy some time with his parents before taking up his studies in Paris.

The first two and a half weeks passed happily, forming a powerful bond between the two families.[72] Each day, the group went hiking and berry-picking. Over picnic lunches and sunset dinners, the Roerichs regaled the Lichtmanns with stories about things they had done and people they had known in Russia. Maurice and George played chess, while Nicholas, spellbound by Monhegan's cliffside vistas, painted his "Ocean" series of seascapes. Every night climaxed with an automatic-writing session or a lesson from Helena about chakras or reincarnation. The couples met a pleasant Russian, M. N. Kolokolnikova, vacationing on the island. She, too, valued Asian spirituality and became a longtime friend of the Master Institute.

This tranquil time, however, was merely a prelude to the four-day period between July 24 and July 28, when Frances Grant and the Horches joined the group in Maine. If Nicholas and Helena wanted full commitment from their American friends, this was the time to secure it. Grant's employer, *Musical America*, was about to transfer her to Paris,

and if she went, who knew when or whether she would return? As for the Horches, Nettie's sympathies seemed assured, but Louis needed more coaxing. He would soon enough embrace the Roerichs' supernaturalism, but for now he still doubted them, both as spiritual tutors and as caretakers of what looked to be a sizable outlay of money.

No sooner did Louis and Nettie step off the Monhegan ferry than the Roerichs began chipping away at those doubts. A five-hour business discussion ensued. Partway through, Horch confessed that he had been hearing a voice in his dreams telling him not to believe in Morya and to have nothing to do with the institute; he was scolded for his lack of faith but forgiven.[73] On the second day, the twenty-fifth, Horch pledged an additional $7,500 to cover the institute's expenses, plus several thousand more for Corona Mundi, and he agreed in principle to sponsor the institute's future expansion. Hearing that Roerich was about to take the sad step of selling off more of his paintings, Horch, impressed by the sum being offered, decided to purchase them himself, vowing to keep them together as the Roerichs wished.[74]

Not every moment on Monhegan went toward negotiations and balance sheets. Frances and the Horches joined in the daily routine of nature walks, tale swapping, and companionable meals. Then came the evening séances, revealing wonders and prophecies in profusion. Now and through August and September, Morya urged his "seven children of light" to "prepare the way for the Coming Avatar." Protected by Morya's spear

and sword, and marching under the banner of the Archangel Michael, the group was to raise up a school in America—"a sacred source from which all may drink"—and a church in Russia. To Grant: "Let thy devotion be unswerving." Horch was entreated to "look for a house. I shall indicate which I wish for my dwelling . . . now search!" (This last dictation accompanied a sketch of a tiny house, bearing the caption "101 West.") The school, Morya insisted, must be built by 1929.

Such utterances had their intended effect. Grant turned down the *Musical America* job in Paris. "The promise of [continued] association with the Roerichs," she decided, "made other plans inconsequential."[75] Horch reaffirmed his financial commitments. After he, Nettie, and Frances left Monhegan on the morning of the twenty-ninth, Sina noted with satisfaction, "They will devote their money, their faith, and their very selves to the cause."[76] That night, Morya declared to the Roerichs and Lichtmanns, "I have provided. Now you must act."[77]

On August 10, the Roerichs and Lichtmanns returned to the mainland and took the train to Boston. Sina and Maurice went back to New York the next day, while George remained to pack for his move to Paris. Nicholas and Helena spent the next two days as guests of Charles Crane and his wife at their country home in Woods Hole, Massachusetts. (The nearby marine biology lab that eventually grew into the famed Woods Hole Oceanographic Institution was run by Crane's brother-in-law and owed much to Crane's financial generosity.)

With everyone back in New York, Roerich's enterprises intensified their public efforts. Particularly visible was Corona Mundi, grafted onto the Master Institute that August.[78] Corona Mundi urged artists and intellectuals to take a more dynamic role as philanthropists, activists, and educators. Here, both aesthetic and spiritual convictions were at work. Roerich had always subscribed to the Arts and Crafts truism that refinement of taste detached from worldly affairs was of little value. Atop this axiom, he now layered the *Bhagavad Gita*'s teaching that seekers of enlightenment must walk the path of earthly action, not just that of contemplation.

Thus, in an essay written to celebrate Corona Mundi, Roerich spoke of art's power to rescue politics and commerce from sterility and emptiness: "Art must flourish, and the spiritual call of music must ring out independently of the state of the Stock Exchange and meetings of the League of Nations. . . . When we proclaim: love, beauty, and action, we know verily that we pronounce the formula of the international language. And this formula, which now belongs to the museum and the stage, must enter everyday life. The sign of beauty will open all sacred gates. Beneath the sign of beauty we walk joyfully. With beauty we conquer. Through beauty we pray. In beauty we are united."[79] Quixotic such language might seem, but Roerich's idealism heightened

Corona Mundi's appeal. Numerous artists endorsed his initiatives, and while few of them participated actively—joining instead as a personal favor, or out of vague affinity for worthy-sounding causes—the institute's letterhead grew steadily more impressive. Its list of board members and honorary advisers included Maeterlinck, Gallen-Kallela, Alphonse Mucha, the French Symbolist Maurice Denis, and the Croatian sculptor Ivan Meštrović. Tagore, touring America at this time, visited the Roerichs in New York and agreed in person to join.[80]

The institute, now operating out of the Riverside Drive quarters acquired by Horch, grew into a respected school, chartered by New York's Board of Education in 1922. With a wider selection of courses and a larger body of instructors, it attracted more students. Thanks to Grant's media connections, it could count on friendly reportage from outlets like the *Sun*, the *Tribune*, the *Times*, and *Musical America*, all of which spoke of Roerich's "inventive power" and his "arresting and formidable genius."[81] (Often, these papers allowed Grant to contribute her own copy, making such articles even more effusive, and syndication ensured that many were picked up coast-to-coast.) Roerich enjoyed cordial ties with several Russian-language papers in the States, especially the Chicago-based *Rassvet*, and the Theosophical press was keen on him as well. Corona Mundi began publishing volumes of Roerich's writings in translation, starting with *Adamant* in 1922, and it commissioned an English-language biography, to be authored

by Nina Selivanova, a fellow émigré. Her book, *The World of Roerich*, went to press in 1923—although by that point, embarrassingly enough, she had fallen out of favor with the Roerichs.[82]

As these institutions matured, they sought external funding more systematically. Additional benefactors, some of them associates of the Horches, others aficionados of the mystical, included Chester and Maud Dale, Leo Stern, Walter Rosen, Lionel and Florentine Sutro, the Reverend Dr. Robert Norwood of the Saint Bartholomew Episcopal Church, and Horch's business partner, Curt Rosenthal. Nettie's brother-in-law, the broker Sidney Newberger, provided legal advice and donated some of his own money.

The Roerichs set their sights even higher, petitioning the country's leading philanthropists. Here, however, they met with less success. Although Charles Crane and Spencer Kellogg continued their support, applications to the Carnegie Foundation proved fruitless, as did requests to meet with Henry Ford. Pursuing Rockefeller funding with particular obsession, Roerich met with similarly futile results.[83] He hoped that émigré fellowship and mutual friendships would persuade the aviation engineer Igor Sikorsky to back him, but here again he was disappointed. He had marginally better luck with George Eastman, the inventor of the Kodak camera, who chose not to donate money, but met with him several times and gave him a sympathetic hearing. Roerich was genuinely saddened when Eastman killed himself in 1932.[84]

With his money problems seemingly solved, and the institute's day-to-day practicalities falling more to Grant and the Lichtmanns, Roerich was freer to paint in 1922 than he had been for some time. Canvases like *Last Path*, a scene of nighttime pilgrimage, and *The Messenger*, intended as a tribute to Blavatsky, remind the viewer of his desire to be in Asia.

Thoughts of returning gods were also on Roerich's mind, as reflected in the "Messiah" series, consisting of *Legend*, *Vision*, and *The Miracle*. The last, set in a Southwest-inspired desert, is the most dramatic: on one side of a canyon, seven robed figures prostrate themselves as a divine presence, visible only as a radiant glow, crosses toward them on a natural bridge of arched stone. Roerich also looked to Russia's moral redemption, returning to the Book of Doves motif he had used in 1911 and turning out several scenes from the life of Saint Sergius. The saint stands under the northern lights in *Bridge of Glory*; in *Language of the Forest*, he speaks to a bear.

Also in 1922, Roerich produced the "Sancta" series, six images of Russian monks as they work and pray. Influenced in composition, though not in style, by Mikhail Nesterov's depictions of monastery life, each "Sancta" painting bears a title beginning with the words, "And We . . . ," both to emphasize the monks' communal existence and to invite the viewer to share in it. Ever-present is the motif of labor—fishing, building a cabin in the woods, hauling water—an expression of Roerich's conviction that the soul sanctified itself as much by active toil as by seclusion and meditation.

At the end of 1922, Roerich discharged his commission with the Chicago Opera by furnishing sets and costumes for *The Snow Maiden*, produced by Mary Garden and directed by his Ballets Russes colleague Adolph Bolm. The moment proved awkward, thanks to the lawsuit Roerich had brought against the Opera over its cancellation of *Tristan* and *Maid of Pskov*, the other commissions promised him by Garden. (There was talk of offsetting this loss by having Roerich design the Chicago production of Prokofiev's *Love for Three Oranges*, but while he and the composer met about this in February, the job went instead to Boris Anisfeld. Sometimes Roerich still mistakenly receives credit for it.[85]) In October, the artist attended several rehearsals in Chicago, and he returned for the November 16 premiere. This was the last time Roerich would be present when new designs by him appeared onstage, so it was all the more fortunate that *The Snow Maiden* proved the "striking success" of the season, "both artistically and financially."[86] Roerich took a bow during the multiple ovations, and the *Chicago Daily Journal* raved about the "veritable Fairyland" he had created.[87] He returned to New York on the eighteenth, having enjoyed his last great theatrical triumph.

From 1922 onward, the Roerich enterprises existed at once in a world of openness and

another of concealment. In September, Roerich decreed to his followers, "Our School must have two histories. The one revealed to the world will be an illusion, for there is much that cannot be told. The other history, the reality—that is to say, all the miracles and wonders—will be known only to us."[88]

By now, the Roerichs had pared down and carefully sorted their acquaintances, leaving themselves at the center of a series of concentric rings. Spiritual window-shoppers deemed uncommitted or untrustworthy were kept at a distance. (Relegated to this category were Helena's Muromtsev relatives; Yarmolinsky of the New York Public Library; Ziloti, who went on to teach piano at Julliard; and the artist-explorer Avinoff, who found work at the American Museum of Natural History.) Next came casual admirers, small donors, and those with useful contacts, followed by friends, colleagues, and certain institute employees. These socialized with the family, shared their ideals, or worked on projects Roerich held dear, but remained mostly or wholly ignorant of his ultimate intentions. Much closer were those who knew about some or most of the Great Plan, but never rose to Agni Yoga's topmost rank. Among these were Shibaev, Stepan Mitusov, and both of Roerich's brothers; others drifted in and out over time. Nearest of all were the Roerichs' sons, plus the acolytes comprising their self-described "inner circle" (see Illustration 26): the Lichtmanns, the Horches, and Frances Grant. Intimates received an esoteric name from Morya. Nicholas became "Fuyama," Helena "Urusvati," Sanskrit for

"star of the morning." Maurice and Sina were called "Avirakh" and "Radna," Louis and Nettie "Logvan" and "Poruma." Frances was "Modra"; Esther, "Ojana"; Shibaev, "Yaruya"; and Mitusov, "Kai." George and Sviatoslav became "Udraya" and "Liumou"—though the latter, being so young, was kept in the dark for several years about many details.[89]

During the last half of 1922 and the early months of 1923, Nicholas and Helena guided this flock through a miscellany of readings from Vivekananda, Ramakrishna, and Steiner, as well as Blavatsky's *Secret Doctrine*, Ouspensky's *Tertium Organum*, and Ossendowski's *Beasts, Men, and Gods*.[90] This curriculum also included *Magic, White and Black*, by the Bavarian Theosophist Franz Hartmann, and *Phenomena of Materialization*, by the parapsychologist Albert von Schrenk-Notzing. Such ecumenicism, however, went only so far. For example, Roerich disavowed any formal connection with America's Rosicrucians, no matter how "dear and sympathetic" he thought them.[91] Also, much of this study reflected his and Helena's curiosity about potential rivals. When Steiner's headquarters in Switzerland, the Goetheanum, burned down in December 1922, the Roerichs considered it karmic retribution for Anthroposophy's distortion of Blavatsky's truths. The sacred dances advocated by Gurdjieff might seem lovely, but were in fact dangerous seductions. "Was not the garden of Klingsor"—the evil wizard from the opera *Parsifal*—"also beautiful?" warned Morya.[92]

In their séances, the Roerichs unveiled secret upon secret. The task of channeling

the Masters typically fell to Helena or Nicholas, though others took turns on occasion, especially Esther and Sophie, whose psychic gifts Helena considered nearly equal to her own. The mode of transmission was most often automatic writing: Nicholas, for example, according to Ingeborg Fritzsche, a latecomer to the group, "would turn his head slightly to the side, sometimes covering his eyes with the palm of his hand, and immediately began to sketch."[93] In such fashion, the Roerichs taught their votaries cosmic history. The White Brotherhood existed without bodies on the planet Venus, while the souls of Pythagoras, Plato, and Vivekananda resided on Jupiter. Earth, the "silent planet," was ruled by Lucifer. On the astral plane stood an academy of spiritual and creative arts that the Master Institute should strive to emulate, and Morya spoke of wise leaders who would guide the Roerichs as they created their "united church."[94] This roster included Sergius of Radonezh, Solomon, and Akbar the Great, the religiously tolerant emperor of Mughal India. Also important was the third-century theologian Origen Adamantius, whom the church proclaimed a heretic for views that some new age enthusiasts have interpreted as endorsing the concept of reincarnation. Roerich saw Origen as the last Christian thinker unsullied by "corrupting errors," and it was in his honor that he gave his first English-language book the title *Adamant*.

Helena read the inner circle's auras and related details of their past lives.[95] Her aura was the color of lilies, Nicholas's the richest shade of indigo. Sina's shone blue, Frances's yellow, George's rose, and Svetik's green. All of them had tended holy fires in the Temple of the Sun on Atlantis. Louis and Nettie had kept an eternal romance alive through dozens of incarnations; Frances had been a priestess in ancient Egypt and again in old Tibet. George had walked the earth as the Mongol warlord Tamerlane and as Mikhail Lomonosov, the scientific genius of eighteenth-century Russia. Helena had lived variously as a German princess, Joan of Arc, the wife of the last khan of Kazan, and a daughter of the Buddha. Nicholas had been an Icelandic hero and a Chinese emperor. Even more remarkable, in June 1922, he was revealed to have been the Fifth Dalai Lama, the pivotal leader who built the Potala Palace and set Tibet's theocracy into place in the seventeenth century. That fall, Morya also stated, "I want to give to the paintings of Roerich the gift of healing diseases."[96] Roerich had pushed this idea on others before, especially Mary Garden of the Chicago Opera, but it took on added resonance in 1922, because of the Horches' daughter's worsening health.

With such revelations, the Roerichs aimed to fix their disciples' minds entirely on the Great Plan's fulfillment. "Before thee is the path of sacrifice and martyrdom," Morya intoned.[97] Considering the magnitude of what the Roerichs required, it must be asked: How much chicanery seeped into these persuasive efforts? Years later, the Horches angrily testified that "under the guise of Art and Culture, Professor and

Madame Roerich enshrouded themselves with a mystic and spiritualistic cult which they imposed upon [their] followers and associates." Nettie compared this to the zombified state of beguilement found among groups "like the Moonies."[98] Even if one accepts that the Roerichs truly thought of themselves as servants of a larger godhead, history shows how commonplace it is for new age leaders to be strategically sincere about their ideals and tactically duplicitous in how they pursue them. One has to assume that at least some elements of the Roerichs' séances were stage-managed, and that not all of the automatic writing was wholly automatic. On the other hand, Nicholas and Helena held back from this group little if anything about their real ambitions, and the beliefs they professed now were the ones they had clung to in earnest for many years. This by no means absolves them of having exploited Grant, the Horches, and the Lichtmanns, but more than a little of their deception was self-deception. Put another way, they seem to have caught themselves in the same net with which they ensnared their closest adherents.

Indeed, the most useful way to view the Roerichs may be less as puppetmasters and more as eccentric foster parents to a highly dysfunctional family. For a group devoted to universal harmony, the inner circle proved astonishingly prone to quarrels. The Roerichs' authoritarian ways rarely helped

and more than once amounted to emotional abuse. Like a mother and father who care for their children but freely manipulate their emotions, Nicholas and Helena preyed on insecurities and withheld affection to punish "improper" behavior. They issued constant reminders of how former followers had been cast aside for insubordination and warned of the terrible destinies awaiting the wayward.

They also played a constantly changing game of favorites. Sina and Esther competed for Helena's maternal attention. A jealous Sina, often joined by Frances, mocked Esther's blonde hair as having come from a bottle, even though, by all indications, it was natural. Caught between spouse and sister, Maurice retreated further into his usual taciturnity. Frances, regarded with contempt by Esther and frequently at odds with Sina, fared worse. More emotionally fragile than her take-charge exterior suggested, Frances struck Sina and Esther as unbearably bossy when she tried to impose a professional system of office management, but dissolved into a nervous wreck when confronted by the others' scorn. Her "heavy character," as Sina described it, had to be constantly buoyed up, and Helena wondered during the autumn whether the effort was worth it. "We no longer understand her role in our affairs," she told Sina in an unguarded moment. "All we know is that she was the instrument by which fate joined us and the Horches. Possibly her significance will be made clearer. At the moment, it is difficult to work with her."[99] Nicholas dealt more patiently with Frances, but even he grew weary

of the "carelessness and negligence" caused by her moody spells.[100]

More troublesome yet were the Horches. Everyone appreciated Nettie, but Sina and Frances found Louis abrasive, as did Nicholas and Helena. Worse, the Roerichs worried about the couple's commitment to Agni Yoga. Concern for their daughter's health preoccupied Louis and Nettie, and Louis's faith wavered on a weekly basis.[101] Morya importuned the pair, "Keep my Name as a talisman within your hearts," and warned of horrific consequences if they strayed.[102] Only the masters could shield Horch from the "evil energies" threatening him, and if disobedience caused that protection to be withdrawn, he would die within one to three years.

By the end of 1922, the Roerichs quelled the worst of this infighting. "Let not a single second pass in anger," they pleaded. "Ye are brothers and sisters. Love each other, for hand in hand must ye fight."[103] Still, resentment simmered, ready at any moment to boil out of control. Other difficulties piled up. In December, Nicholas endured several weeks of headaches and fever. New ructions within the Theosophical movement, including B. P. Wadia's break with Annie Besant, heightened the family's paranoia about "dark forces," which Helena believed had been unleashed by foes like Anna Kamenskaya. (Wadia's defection caused extra distress because of how much the Horches admired him, and Morya therefore lost little time in denouncing him as an enemy of virtue.[104])

Generating added friction was the question of how far the inner circle could depend on Charles Crane, a useful source of money and connections. Esther Lichtmann considered Crane spiritually unreliable and was deeply unsettled by a dream she had of him giving Helena a bunch of grapes whose ripeness concealed worms and inner rot. Louis Horch shared her distrust, though his concern was more worldly: he suspected Crane of antisemitism. He based this conclusion partly on gut instinct, but also on the written record. Crane's political work as an Arab specialist had led him to pen various memos critical of political Zionism and the 1917 Balfour Declaration, by which Britain pledged to support a "national home" for Jews in Palestine. Maurice disagreed, insisting that he could not detect a whiff of bigotry about Crane. "Even many religious Jews do not necessarily favor Zionism," he commented after reading Crane's essays. Louis's assessment was more on target. Crane's private papers make it clear that he regarded Russia's Jews as alien, subversive elements, and that his broader anti-Jewish feelings stemmed not just from policy stances, but from a pronounced personal disdain for "that race."[105] Crane was too genteel to voice such sentiments openly, and Roerich—who, as discussed in chapter 3, was not spotless in this regard—chose like Maurice to ignore evidence of them. Besides, Crane's value as a backer made the point moot: "Even if he were against Jews," Roerich noted cynically, "we would still need to deal with him and persuade him to work on behalf of the School." If anything about this debate went Louis's and Esther's way, it was that Crane

did not penetrate far into the Roerichites' central ranks.

Family matters weighed on the Roerichs as well. In Russia, Boris grew frustrated by Nicholas's failure to obtain him a US visa.[106] Worse yet, Sviatoslav and George both chose this time to defy parental authority. Sviatoslav's rebellion consisted of late-teen hijinks, as he fell in with a crowd of young Russian expats whom Nicholas and Helena regarded as boors. It was bad enough when he misbehaved at university, but altogether intolerable when he brought his friends home to lounge in the Roerichs' apartment, filling the air with loud talk and cigarette smoke. (One member of this roisterous crew was Vladimir Dukelsky, who, after changing his name to "Vernon Duke" on George Gershwin's advice, went on to a glittering career as a songwriter, composing the smash hit "Autumn in New York" in 1934.) Tearfully confiding to Sina that "Svetik" had always been her favorite, Helena worried that his "once-bright nature [was] changing" and wished she could keep him a twelve-year-old boy forever.[107] This "war in the home" lasted only a few months, but Sviatoslav would always be less biddable than his older brother.

That said, it was George, by daring to love unwisely, who did more at this juncture to twist his parents' emotions out of joint. Having completed his Harvard degree in the spring of 1922, George was now in Paris, working toward his MA at the Sorbonne's School of Oriental Languages. Under Charles Lanman at Harvard, he had studied Pali, Sanskrit, and Chinese; in Paris, he kept up all three, adding Tibetan and, with the famed Paul Pelliot, resuming Mongolian. In France, George also formed political ties. He lodged with a family friend, Georges Chklaver, a fellow Russian who taught international law at the Sorbonne and fraternized with White émigrés who still hoped to drive the Bolsheviks out of Moscow. Among these was General Nikolai Golovin, who had fought under Alexander Kolchak in Siberia and now offered military science courses at the Sorbonne. Applying geopolitical theories voiced by Otto Spengler and the geographers Halford Mackinder and Karl Haushofer, Golovin predicted that only two outcomes were likely in the strategic "heartland" to the east: a "Red Eurasia" ruled by communists, a possibility he contemplated with horror, or a somewhat preferable "yellow empire" governed by Japan. George attended the general's lectures, although whether he connected with him personally remains unclear.[108]

Crisis arose when George started to mix with Russian Theosophists in Paris. He soon fell in with the Manziarly clan, a Franco-Italian-Russian family prominent among the city's occultists and known for its friendship with Annie Besant's protégé Krishnamurti. Initially, this seemed a welcome acquaintance, but the Manziarly matriarch, Irma, was also close to Anna Kamenskaya, the Roerichs' longtime rival, and she made a disastrous personal impression on Nicholas and Helena during a brief visit to New York. It was to their horror,

then, that George left the Chklavers to live with the Manziarlys. With almost fairy-tale predictability, George had fallen in love with Irma's daughter Marcelle, an accomplished pianist almost five years older than he.[109] In late 1922, George asked Marcelle to marry him; she agreed, and the news reached the Roerichs in January 1923. In March, George and Marcelle announced their wedding plans in *Herald of the Star*, the Theosophical monthly.

Earlier, Helena had thought Marcelle a sweet girl, "cruelly neglected" by her "she-dragon" mother. Now, she saw her as a wicked temptress, and while Nicholas initially leaned toward letting George have his own way, he, too, came to view the romance as a Kamenskaya-led plot to entangle George in a web of sexual allure and false doctrine. The fact that Irma approved of the romance and began talking gaily of how the two families could now travel together to India infuriated the Roerichs all the more. In a telling psychological irony, Nicholas and Helena either forgot or ignored the passionate war they had fought years before to overcome family opposition to their own courtship. Helena cried herself to sleep on a nightly basis until Chklaver informed her that, George, only twenty at the time, was not of an age to marry without his parents' permission. Armed with that knowledge, Helena pressured George as much as she could, warning him that Master Morya forbade the marriage, and that he himself might die if not freed from the Manziarlys' clutches.

In early 1923, George, with immense reluctance, gave up his fiancée as commanded. The two exchanged heartbroken letters until 1925, but Marcelle moved to California, where she taught music—it was to her that Aaron Copland dedicated his setting of the Emily Dickinson poem "Heart, We Will Forget Him"—and involved herself with Krishnamurti's Ojai colony. George pulled himself out of despondency by finishing his MA and preparing for his parents and brother to collect him that summer en route to India. The affair badly upset the equilibrium that George constantly struggled to maintain between his parents' spiritual teachings and his commitment to fact-based scholarship. Only with tremendous self-repression did he surmount this crisis, as he told Nicholas and Helena during the romance's sad denouement: "If everything that has happened to me was, in truth, a trial, then it was undeserved and very cruel. . . . Don't think that I have ceased to believe in the Teacher's guidance; it is too great a thing to have doubts about, yet I no longer dare to plunge into the misty sea of occult experience. I do this because of my work, which I value above all, and which requires tranquility. Now, as never before, I need complete solitude. It is difficult to live among people."[110] Over time, George reconciled with his parents, but this was not the last time family disputes called his internal conflicts back to the psychological surface.

During these same months, the inner circle experienced a tragedy, compared to which George's melodrama seemed but a

trifle. Over the winter, Jean Horch entered into a state of rapid decline.[111] By the first week of February, she had become dangerously ill and required emergency surgery. Esther and Helena tried to revive Nettie's hopes by describing their visions of white-winged archangels hovering protectively over Jean. Privately, though, Helena relayed to Sina the ominous results of a horoscope she had just cast for the ailing child: with all the calculations completed, the chart came up empty. Nicholas, who had gone to Boston to consult with Charles Crane, sped back to New York the instant he heard the bad news.

Everything suggests that the Roerichs felt real affection for Jean. As always, though, their fond sentiments were interwoven with a practical desire to maintain emotional control over their followers. In this instance, there may be extra blame to lay at their feet: Louis and Nettie, convinced that Nicholas's paintings were imbued with Morya's curative powers, hung one in Jean's bedroom. They later accused Roerich of claiming that his art was the *only* treatment Jean needed, thereby dissuading them from seeking medical care until too late—an assertion dismissed by Frances as "fantastic and slanderous," but unprovable either way.[112] Jean had a breathing tube inserted on February 7, but was too weak to withstand the shock of the procedure and passed away on the thirteenth. The Lichtmanns and Roerichs had gathered for a vigil that evening and were together when the dreaded phone call came from Louis. The next morning,

and in the days that followed, the inner circle comforted Louis and Nettie as best they could. Sina praised their courage—"what great souls they have," she noted—and wept at the funeral to see Jean in her white dress, laid out like "a doll of wax."

In addition to grief, an unspoken fear now weighed upon the Roerichs. Would Jean's death cause the Horches to discard Agni Yoga? Or would their craving for solace make them cling to it more closely? Faith won out, to the Roerichs' relief.

The family's survival in America depended on keeping Louis and Nettie in harness. Litigiousness had harmed Roerich's Chicago Opera relationship, and no other stage-design opportunities materialized. His one-man exhibitions, including Detroit in January and Boston in February, were small affairs, and he shied away from larger shows for fear of not standing out. Hence his absence from the massive Russian exhibit—362 works by twenty-three painters, including Kandinsky, Goncharova, and Bakst—organized by Christian Brinton at the Brooklyn Museum in January 1923. It was excellent company, but to be one among many did not suit Roerich's purposes. On Morya's advice, he turned down Brinton's invitation, looking instead to the Horch-funded Master Institute to boost his own star power.[113]

The Roerichs likewise needed the Horches' money to take their Great Plan to

the next level. The new year of 1923 brought with it a heightened sense of urgency. Circumstances in Russia and Siberia were in constant flux, and Nicholas and Helena felt compelled to alter the Plan after each new communication from Shibaev in Latvia, or Boris in Petrograd, or Vladimir in Harbin. Annie Besant had recently proclaimed 1936 as the date of the Buddha's return to the earthly plane, and to the Roerichs' way of thinking, no such advent could take place until they completed their own work. Accordingly, Helena now prophesied that the consecration of the Roerichs' New Country would precede Lord Maitreya's return. Nicholas—recognizable as the Great White Brotherhood's envoy by the moles on his cheek, which formed the star sign of Ursa Minor—would communicate Morya's will to Annie Besant and the Dalai Lama, erect a temple in Siberia, and secure Russo-Buddhist union throughout the east.[114] Then, in 1936, "the Hour of the Constellation" would strike, and "the Banner of Shambhala [would] encircle the central lands of the Blessed One."[115] Tidings from abroad made the family even more eager to act on these sibylline pronouncements: a fragment of Chintamini had resurfaced, and Roerich was to use its divine magic to heal Russia. Shadowy caretakers would deliver this "gift of Orion" to him in Paris.

More will be said in chapter 10 about what, in practical terms, the Roerichs expected the Great Plan to achieve. What stands out from these months is their determination to keep the inner circle from faltering. Regardless of how infighting troubled the group, or how painfully the acid of sorrow ate away at the Horches, the Roerichs continually reminded their followers that Morya had called them to arms: "Young knights—America is thy battleground! When the Leaders are gone you must continue. Remember that a mighty temple rests upon thy efforts. Prepare and rejoice!"[116]

Adjurations like this did their job. In early 1923, Horch agreed to foot the bill for the Roerichs' upcoming expedition and to expand the Master Institute by purchasing the two properties adjacent to it. On top of the $195,000 he had paid for the original 310 Riverside lot, he spent $110,000 in March for the new parcels, and custodianship of this ever-expanding facility became his life's work for the next quarter century.[117] As for the trip to Asia, Roerich began speaking publicly about it as early as February. In a lecture on the eleventh called "The New Age," given at St. Mark's Church in-the-Bowery, he talked of using his eastern journey to promote global unity, so desperately needed at this time. "We have such superb poisons and such all-destroying explosives," he observed, "and our knives are so keenly sharpened." Humankind's only hope of avoiding destruction was "to accept the blessed gifts of Religion, Beauty, and Power."[118]

A curious incident is said to have occurred during this talk. Because Roerich was to be followed by Karl Necht—"a known Bolshevik," in Sina's disapproving

words—pleading for assistance to the famine-stricken Volga, representatives of the Soviet government were present at St. Mark's. Roerich criticized the artificiality of national boundaries, opining that, in a better world, if someone wished to cross from one country to another, it would be preferable to present not a passport, but something reflective of character or talent, such as a work of art. Supposedly, one of the Soviet officials broke in to say that "a painting by Roerich would be the best credential."[119] In her 1923 biography of Roerich, Nina Selivanova fastened on this odd detail. While she inserted it as a brag, to show how even the Soviets had come to appreciate his genius, some have read it as a hint that his political complexion was already taking on a reddish tinge.

By the spring, the Roerichs had laid out their itinerary. Nicholas and Helena, accompanied by Sviatoslav, would sail for Paris, where they would reunite with George and pry him loose from Marcelle Manziarly's unwholesome embrace. They would visit friends, make plans with Chklaver and Shibaev, and await the arrival of the sacred stone that Morya wished them to convey to Russia and the Himalayas. Louis and Nettie would join them over the summer, to revive their spirits after Jean's death and to learn from Roerich how to appraise art and build a collection. They would return in the fall, while the Roerichs went south to Marseilles and boarded their ship to the east. If all went well, the family would reach India's northern frontier before the end of the year.

The journey's high price escaped no one's notice. For the Roerichs to voyage to Europe and India, maintain themselves in comfort, and stay in contact via cable would take around $10,000. The actual expedition was projected to cost more than $100,000—too low a guess, as it turned out—and this did not begin to touch the piles of cash Horch would pour into the institute.[120] To put things on a more businesslike footing, Horch incorporated Corona Mundi and the Master Institute, with seven shares for now: one apiece for himself, Nettie, Nicholas, Helena, Sina, Maurice, and Frances. The board of trustees included all seven shareholders, plus George, Sviatoslav, Esther, Sophie Shafran, and Sidney Newberger.

Horch and Roerich also settled on a financial arrangement whose spirit each later accused the other of violating.[121] While on expedition, none of the Roerichs would receive a salary, but they would have full authority to pay for supplies and lodging, hire porters and guides, and dispose of funds as they saw fit. In exchange, any art Roerich produced during his travels would become the property of the Master Institute and sold to select clients or placed in the Roerich Museum's collection; the same was true of any artifacts or curios obtained during the journey. Roerich put his signature to Horch's terms on May 1: "Herewith, I am accepting the proposal of the Master Institute of United Arts and Corona Mundi International Art Center, to grant them the exclusive right to purchase all the artistic rights of the Expedition, such as any

paintings, drawings and sketches, as well as such paintings as I may complete thereafter."[122] Roerich also granted Horch full power of attorney, allowing him to conduct all business and legal transactions in his absence, including the filing of tax returns. Not for a moment did he hesitate to place himself so entirely in Horch's hands. It was a decision he had ample cause to regret.

These last weeks, though, were a time of trust and camaraderie, and the Roerichs did not look beyond the excitement of setting off for the east. On the eve of departure, Helena gathered the women of the inner circle—her "daughters"—and presented them with pieces of her own jewelry as gifts of parting. Frances received an opal brooch, Nettie a heart-shaped amethyst, Sophie a gold chain, and Esther a ring with pearls. To Sina, Helena gave the watch that she herself had worn since her youth, as a reminder to remain vigilant.[123] As for Roerich, he penned a cheery letter to his mother in Petrograd, reporting on the boys' progress at university, passing on good wishes to his sister, and describing with delight the journey that lay ahead.[124] At last, on the morning of May 8, 1923, the *Mauretania* sailed out of New York, bound for France. Nicholas, Helena, and Sviatoslav stood on deck, watching the shores of America recede before their eyes.

CHAPTER 10

The Messenger, 1923–1925

I felt the impact of the dreamlike world of India. My own world of European consciousness had become peculiarly thin, like a network of telegraph wires high above the ground, stretching in straight lines all over the surface of an earth looking treacherously like a terrestrial globe.

—Carl Jung, *Memories, Dreams, Reflections*

Before 1923 came to a close, Roerich stood in the shadow of the Himalayas, the long-overdue realization of his most cherished dream. "Here resounded the sacred flute of Krishna," he marveled. "Here thundered the Blessed Gautama Buddha. Here originated all Vedas . . . the Himalayas [are the] Jewel of India [and] the Treasure of the World."[1]

Roerich had not come to Asia just to admire it. Like missionaries, he and Helena were there to instruct and transform it. But rather than importing a foreign creed, the Roerichs, believing they possessed purer insight into Buddhism than did its natural-born adherents, sought to teach the people of Asia their *own* faiths. Among the paintings Roerich brought to India was *The Messenger*, which he donated to the Theosophical Society in Adyar. The canvas shows a woman opening her door to a man in blue robes, his palms pressed together in greeting, and is typically understood to symbolize the passing on of wisdom from master to initiate. As with so many of Roerich's paintings, though, *The Messenger* is best read as a self-portrait: here, the artist becomes a neo-Buddhist John the Baptist, bringing news of Maitreya and preparing to awaken a spiritually somnolent Asia.[2]

Unpromising as the Roerichs' ministry might seem, the force of it impressed a surprising number of Asians and Europeans alike. Just as remarkable was the family's political metamorphosis. The Great Plan still aimed to rally Asia to the cause of pan-Buddhist union. But for whose sake? It had emerged as a way to oppose, and someday *de*pose, the Bolsheviks. In 1924, however, Nicholas and Helena executed a philosophical about-face, convincing themselves that Agni Yoga could reconcile Soviet power

with Buddhism, heal the scars from Russia's Civil War, and remake Bolshevik ideology by adding to it a sorely needed spiritual dimension. Over the next years, the couple came to believe that when they raised their banner over the new Shambhala, it would be red, not white—and the truest red of all, symbolizing a higher stage of communism than even Marx or Lenin had been able to imagine.

⁙

After leaving New York, the Roerichs took half a year to get to India. They reached Paris on May 11, 1923, with a lengthy list of things to do before continuing eastward.

First on the family's agenda was to extricate George from his ill-fated romance. Nicholas and Helena kept a watchful eye on their crestfallen son as he nursed his broken heart and wrapped up his academic affairs at the Sorbonne. Another priority was to rid Sviatoslav of the hellion ways he had picked up at college. Morya promised to "restore" the Roerichs' sons to them, and this moral remolding was accomplished soon enough.

The Horches were due to join the Roerichs in June. While waiting, Nicholas and Helena reconnected with Russian émigrés living in France. Among the more memorable of these reunions was with Diaghilev. Whatever hard feelings had passed between the two, Roerich reports that he came away from this encounter with "a feeling of special peacefulness and amity."[3] If true, it was a high note on which to end the relationship;

Roerich never saw Diaghilev in person again.

Not all his meetings proved so amicable. Among their compatriots, the Roerichs labored to create a Paris Circle of Living Ethics, but converts were in short supply. Russian occultists in France not already belonging to the RTO or the Anthroposophists tended to favor the guru Georges Gurdjieff, whose Institute for the Harmonious Development of Man had just opened near Fontainebleau. ("Do not meet with Gurdjieff," Morya warned Roerich. "There is no need to make another enemy."[4]) Politics further limited the family's options. They shied away from suspected Reds, but were also estranged from a growing number of Whites. Like other constitutionalist Whites, Roerich coexisted uneasily with the movement's right-wing diehards, and he had quarreled with enough of them that his proposals, anti-Bolshevik or not, met with indifference or ridicule. It did not help that rumors from New York about fishy behavior on his part crossed the Atlantic before he did, or that rivals from his World of Art days, including Benois and Filosofov, had settled in France and were happy to traffic in hearsay about him. Nettie Horch later noted that "while in Paris, Roerich was always complaining about persecution from the White Russians there."[5]

Despite this, a Roerichite network coalesced in Europe, anchored by Chklaver in Paris and Shibaev in Riga. Most famous among the Paris members was the author Alexei Remizov, with his wife Serafima.

The musician Vasily Zavadsky joined in the fall, as did the publisher Zinovy Grzhebin, a friend of Gorky's and Remizov's. Zavadsky composed a suite based on Roerich's "Flowers of Morya" poems, and Remizov produced a story collection, *Echoes of Zvenigorod*, about a medieval fortress town that symbolized old Russia's sanctity. The Zvenigorod concept became central to Roerich's Great Plan, and it was he who arranged the publication of Remizov's book in 1924.[6] Arkady Rumanov left New York and attached himself to Shibaev's Riga group, which also included the homeopath Felix Lukin. Even with such successes, Nicholas and Helena came away from their recruiting effort appalled by how ideologically riven the Russian diaspora had become. This was not imagination: the satirist Nadezhda Teffi described Russia's interwar émigrés as "all hating each other so much that you couldn't put twenty together, of whom ten were not enemies of the other ten."[7] Roerich himself, remembering how lack of unity had hamstrung anti-Leninist opposition in 1917, observed of the Russians in France that "all the revolution's lessons have been wasted on them."[8]

In the first week of June, the Horches arrived in Paris. From the seventh through the twenty-sixth, the two families took the waters at Vichy, then toured Lyon, Rome, Siena, Florence, Bologna, and Milan. In mid-July, they headed north to Switzerland, stopping in Geneva on their way to San Moritz, where they spent time admiring the glaciers. Shibaev met them in Switzerland, to discuss how Horch might fund two ventures: a press to publish Roerich's works in Russian and an import–export firm called World Service. More alpine glory awaited the group in Chamonix, which offered splendid views of Mont Blanc. After two weeks, on August 26, the travelers returned to Paris, and the Horches sailed to New York on September 8.

The Horches hoped that being in Europe would dull their grief after Jean's death. In addition to learning from Nicholas about art collection and museum management, they took spiritual instruction. At the Vichy spa, Helena lectured the group about auras, breathing techniques, and proper diet. According to her, the masters recommended no tobacco, alcohol in moderation, and meat very seldom, if at all.[9] (Nicholas, though not a habitual smoker, indulged in the occasional after-dinner cigar and enjoyed a good wine or cognac with his meals, and George never completely gave up meat.) Most exciting were new revelations about the Great Plan. Helena foretold the imminent arrival of the sacred stone that the family would carry with them to Asia, and she experienced recurring visions of a new Zvenigorod, the future capital of the Roerichs' Buddhist commonwealth. The Roerichs and their "warriors of light" would build this "city of bells" at the foot of Belukha, the holiest peak in southern Siberia's Altai Mountains. On Belukha itself, at an altitude of seven thousand feet, would stand a monasterial dwelling, with a white church above it, at twelve thousand feet.[10] Ordered to take this happy news back to New York,

the Horches returned with renewed confidence and, for now, a sense of closer fellowship with Nicholas and Helena.

New followers found their way to the Roerichs as the Horches left for the States. One was the novelist Georgii Grebenshchikov, author of the "Churaev" cycle, a seven-book series about the family of a Siberian archpriest, and an occasional lecturer on Siberian subjects at the Sorbonne's School of Oriental Languages. As active occultists, Grebenshchikov and his wife Tatyana knew about the Roerichs and were excited to hear they were coming to France. However, they were vacationing in Germany when the Roerichs arrived, so only in October did the couples finally meet. The son of an Altai miner, Grebenshchikov had dreamed of an independent Siberian republic since the Civil War and was fascinated by Roerich's Great Plan. In turn, Roerich found the author an invaluable source of knowledge regarding Siberia, "about which he knows *everything*," he told Sina excitedly.[11] Both men admired the ethnographer Grigori Potanin and were influenced by him in their understanding of Asiatic Russia. Roerich placed Grebenshchikov in charge of his new press, and it was the Siberian who gave the press its name: Alatas, meaning "white stone" in Kazakh. Grebenshchikov and Tatyana received the esoteric cognomens Tarukhan and Naru.

The season's other newcomer was Nikolai Kordashevsky, a Lithuanian colonel who saw action in Mesopotamia and Persia during World War I, and with the Whites in Siberia. In 1919, he traveled to Mongolia and China, then back to Europe. Soviet Russia was barred to him, so he settled in the new state of Latvia, but not before cultivating a taste for esoterica and a love of war that verged on the mystical. ("There is so much beauty in battle," he once told Roerich. "The music of the drums has a great and sorrowful majesty."[12]) Kordashevsky came to Paris intending to study with Gurdjieff but, in September, fell in with the Roerichs instead, dedicating himself like a chevalier to their heavenly cause. Nicholas and Helena hoped to win their dominion with as little violence as possible, but they welcomed the colonel's military expertise, dubbing him Chakhembula, after a general who served the warlord Tamerlane. In 1927–1928, Kordashevsky would take part in the last stage of the Roerichs' Tibetan expedition; meanwhile, he helped Shibaev run World Service in the Baltic states.

Kordashevsky and the Grebenshchikovs entered the Agni Yogist community in time to celebrate a crucial event: the Roerichs' reception on October 6 of the long-awaited Stone, the meteoric "gift of Orion" that would serve as the base of the pillar for their church in the Altai. Where this object came from, and what the Roerichs truly believed about it, cannot be said with certainty. What they told their followers was that the Stone was a shard of the "radiant thought-gem" the Tibetans called Chintamini, whose main body lay enshrined

in Shambhala. The smaller fragment, attuned to the larger mass, was said to have traveled back and forth between Asia and Europe—resting on Ararat with Noah's ark, inspiring the Arthurian myths of the Grail, succoring Cathar heretics during the siege of Montségur, vanishing into the treasure house of Akbar the Great—until falling into the hands of Josephine, Napoleon's empress. After Napoleon's downfall, a secret society supposedly hid the Stone, waiting for its appointed wielder to claim it.[13] This was the same object, Helena said, that she and her husband had dreamed of since 1905, when Roerich featured it in *Treasure of the Angels*, his most important painting from that year. A prosaic denouement indeed, then, when the Stone was simply delivered to the Roerichs at their suite in the Hotel Lord Byron by the representative of a Paris bank. George signed for the parcel, and Nicholas telegraphed the New York circle with the news that "today the promised gift was given. Much joy."[14]

The Roerichs carried the Stone in a reliquary box decorated with the shapes of a man and woman, the stylized images of kingfishers, and four letters "M" in gothic script. If we exclude the most extreme possibilities—that the Stone had the provenance and powers the Roerichs claimed for it, or that they picked it up for a few francs in a Paris curiosity shop—we are left to wonder who gave it to them and why. Guesses have been made about Freemasons, Theosophists, the Martinist-Synarchist circle that some believe Roerich belonged to before

the revolution, and Agvan Dorjiev, who was still in Russia trying to forge a Soviet–Tibetan alliance.[15] However they procured the Stone, the Roerichs invested it with a significance nothing short of totemic and kept it with them over a journey of thousands of miles. To judge from their writings, they viewed the Stone as a paranormal transmitter, capable of extending the range of their psychic communications with the Great White Brotherhood.

With this talisman in their possession, the Roerichs made ready for their voyage to India. They alerted the Harbin circle that they would soon be in Asia, and Chistyakov rejoiced: "India feels much closer to us than Paris or New York, and we continue to hope that, before long, you will be here to lead us."[16] In Riga, Shibaev and Kordashevsky expanded World Service, and at the Roerichs' request, the Grebenshchikovs prepared to move the Alatas press to New York. They did so against the advice of several White colleagues, including the author and future Nobel laureate Ivan Bunin.[17] Whether Bunin saw Roerich as no longer sufficiently anti-Soviet, or simply thought him a dodgy character, his opinion was not enough to dissuade Grebenshchikov, who sailed to New York with Tatyana in April 1924.

The Roerichs themselves, their visas secured and their tickets to India purchased, went on to Marseilles in mid-November. On the seventeenth, they boarded the *Macedonia*, bound for Bombay (now Mumbai), with stops in Port Said and Aden. On the

thirtieth, they stepped onto the shore they had ached to reach for so long.[18]

After passing through Bombay harbor, the Roerichs treated themselves to a three-week, continent-traversing tour. While visiting Bombay, they cruised to the nearby island of Elephanta, with its eighth-century temple honoring Shiva. Originally, they had planned to visit the Theosophical Society (TS) headquarters in Adyar, far to the south. But now that Tibet factored so heavily into their calculations, they instead trekked northeast to Jaipur, then to Agra, where they drank in the loveliness of the Taj Mahal. Proceeding from Delhi along the Ganges valley, the family stopped at Benares (Varanasi), where Hindu faithful come to the bankside ghats to bathe in the river's blessed waters, as well as the holy cities of Gaya, where the Buddha is said to have attained enlightenment, and Sarnath, in whose deer park he preached his first sermons. Before turning north to the Himalayas, the family visited the Bengal metropolis of Calcutta, sprawling across the tangled rills and channels of the Ganges delta.

Many sights pleased the Roerichs during these first weeks—a tiger in the forest, moonlight on the Ganges—and Nicholas produced a sublime nocturnal scene of Benares for Charles Crane. Still, because they had fantasized for so long about a transcendent and beauteous Orient, they felt let down by their first actual encounter

with Asia. "A thin shore. Meager little trees. Where are the palaces and pagodas? Is it really India?" Nicholas asked. The root-race Aryanism prevalent among Theosophists also shone through. "The black Dravidians," Roerich complained, "do not remind us of the Vedas and *Mahabharata*."[19] The "desecrations" of poverty and prostitution shocked him, and, noting with melancholy how "Sarnath and Gaya, where the Buddha performed feats of glory, lie in ruins," he concluded that spiritual vitality in these parts of India had dried up like sap in a drought-withered tree.[20] Would-be pilgrims with visions of sacral perfection often suffer cognitive dissonance when their chosen Shangri-La fails to meet expectations, and the Roerichs' reaction mirrors almost exactly the disillusionment suffered in China by a fellow seeker, the Jesuit scholar Pierre Teilhard de Chardin. There, he believed, he would meet "the new currents of thought and mysticism . . . which were preparing to rejuvenate and fertilise our European world." After his 1923 arrival, though, "I am forced to admit that in that direction my quest has been in vain. Nowhere among the men I met or heard about have I discerned the smallest seed whose growth will benefit the future of mankind. I have found nothing but absence of thought, senile thought, or infantile thought. Sleep on, ancient Asia . . . your night has fallen and the light has passed into other hands."[21] So the Roerichs felt about the districts they traveled through now.[22] They held out greater hope for the Himalayan north, but this was not the last

time they would compare reality to the Asia of their dreams and find it wanting.

In Calcutta, Roerich expected to meet Rabindranath Tagore, but the poet had left the city to prepare for his 1924 tour of China and Japan. Greeting Roerich instead were Tagore's brother and nephew, the painters Abinandranath and Gogonendranath. A familiar face from London was the linguist Suniti Kumar Chatterji. Roerich also came to know Asit Kumar Haldar, director of the Lucknow Art School, and the distinguished physicist Jagadis Bose. When Roerich met Bose, the scholar was investigating the response of plants to electromagnetic stimuli, and Roerich, who had believed since the days of his acquaintance with Vladimir Bekhterev that research into radio waves and similar emanations was the key to understanding psychic phenomena, found Bose's studies enthralling. The pair shared an enthusiasm for the teachings of Vivekananda, and their relationship proved a long one. In the late 1920s, when Roerich founded his Himalayan research center, Bose was one of the first people he enlisted to lend credibility to it.[23]

Roerich and his Calcutta friends spoke of politics—the relative merits of home rule versus full independence, the latest doings of the Indian National Congress, and so on— even if such talk remained off the record. Only the blindest observer could have failed to notice anti-colonial frustrations building to the point of explosion, and Roerich commented in a letter to Sina that "revolution here is unavoidable."[24] While the Tagores and their set were not the most radical of national liberationists, they desired freedom for India and shared their feelings with their Russian visitor.[25] They also knew others more "tactically" involved in the struggle (to use Roerich's term), leading to the question of whether, at this stage, the artist was simply making conversation and gathering news or already seeking a more active role in Indian political affairs. His later dealings with Congress are well documented, and over the years he sympathized with Indian nationalists of many stripes, although details of when, whether, or how far he acted in concert with them remain difficult to determine. For their part, British officials soon came to fear that Roerich was conspiring with dangerous elements, including the Indian Communist Party and its famed leader, Manabendra Nath ("M. N.") Roy. And while many of Britain's specific concerns regarding Roerich turned out to be overblown, its growing distress about him was not unwarranted.

In the meantime, it may have been during this time that Roerich encountered a pair of pan-Asianist ideologies he later wrote of approvingly. One was the "Asia is one" philosophy proposed by Okakura Kazuko, dean of the Tokyo Fine Arts School and author of the much-admired *Book of Tea*. A friend of Tagore's, Okakura envisioned a future in which unity allowed Asia to coexist peacefully with the West as its equal, not as its subject. More radical was the "religion of love" preached by Mahendra Pratap, the notorious "Red Raja." Pratap, a Marxist member of a princely family, desired

to incorporate Mongolia, Tibet, China, Japan, Korea, and India into a "Golden District" that "merg[ed] nations and races into one human brotherhood."[26] In his quest for Indian independence, Pratap sought Soviet aid several times, without much success, and journeyed to Tibet in a failed attempt to win support from the Dalai Lama—courses of action strikingly parallel to those Roerich soon followed. Indeed, Roerich praises Pratap's "wonderful" insights, which likely affected the Great Plan's evolution during these months, and may have known him personally.[27]

With the end of 1923 approaching, the Roerichs left Calcutta for Darjeeling, arriving in late December. There they made a haven for themselves, a mere eagle's flight from the mountain kingdoms of Nepal, Bhutan, and Sikkim. This northern zone, flanked by the Himalayas and fragrant with the aroma of orange pekoe, was the India Nicholas and Helena had pictured in their minds for so many years. Their impressions, though, will be recounted later, because only days after their arrival, two seismic shocks shifted their attention to global politics. In December, news came that Chöki Nyima, the Ninth Panchen Lama, had abandoned the seat of his power in Tibet and fled to Chinese-controlled Inner Mongolia. The following January, Lenin died in Moscow.

Both of these events, otherwise unrelated, offered practical chances to advance the Great Plan, and the former, according to the Roerichs' worldview, was prophecy come true.

In the Gelugpa, or Yellow Hat, theocracy that had ruled Tibet since the 1600s, the Panchen Lama, head of the Tashilhunpo Monastery in Shigatse, ranked second behind the Dalai Lama, who governed from Lhasa's Potala Palace. (The Panchen is sometimes called the Tashi Lama, a title preferred by the Roerichs themselves, though this text follows the more common nomenclature.) Both lamas were venerated as incarnations of the Buddha, with the Panchen embodying Amitabha, the Buddha of Infinite Light, and the Dalai manifesting Avalokiteshvara, or Chenrezig, the bodhisattva of compassion. Custom and circumstance placed temporal power in the hands of the Dalai, with the Panchen enjoying slightly higher spiritual status.

In theory, the two acted as Tibet's twin caretakers, but this dyarchy did not always function in practice, and it broke down badly in the early 1900s. The Dalai feared that the Panchen was overstepping his rightful authority, and he was alarmed by the latter's decision to stay in Tibet when he himself suffered exile in 1904–1909 and 1910–1912. Imperial China, taking advantage of the Dalai's absence to intervene in Tibet's domestic affairs, installed the Panchen in the Potala Palace, transferring to him many of the Dalai's privileges. The order of precedence righted itself after the fall of China's Qing rulers in 1911–1912, but the Dalai Lama—who declared independence from the new Chinese Republic in 1913—continued to

worry that the Panchen might compromise Tibet's autonomy by placing himself at the disposal of foreigners. The Panchen also resisted the Dalai's modernization efforts, especially when asked to help upgrade Tibet's army by forfeiting his traditional immunity from taxation. Tensions mounted until late 1923, when the Dalai threw a team of the Panchen's negotiators into a Lhasa prison. Afraid of arrest and possibly worse, the Panchen left the country.

This exodus destabilized Tibet internally and opened rifts easily exploited by outside powers like China, which hungered to regain its former possession. Its spiritual reverberations were felt not just in Tibet, but wherever Tibetan Buddhism was practiced in Mongolia, the Himalayas, and Russian and Chinese Turkestan. The region's ecclesiastical hierarchy suffered another blow in May 1924, when the Jebtsundamba Khutuktu, Mongolia's chief cleric and another "living Buddha" ranking just below the Dalai and Panchen Lamas, died and went unreplaced by Mongolia's communist regime. The Khutuktu had given himself the added title of Bogdo Khan in 1911, claiming secular authority over newly independent Mongolia between the collapse of Chinese rule and the imposition of communism in 1921. Suddenly, this crucial position no longer existed. Such power vacuums stirred up millenarian anxieties throughout Central Asia, and many who adhered to Buddhism's Kalachakra tradition took the flight of the Panchen as a sign that the King of Shambhala would soon come riding to save the faithful.

As for Lenin's demise, it appeared to offer the Roerichs more flexibility in dovetailing their Asiatic ambitions with their Russian ones. On the spiritual and mythological level, this was an easy problem to solve. By the second half of 1923, the Great Plan hinged not just on Tibet but also on Russia's Altai range; Roerich saw both as mirror images of each other. Each was home to a sacred peak—Kailas in Tibet, Belukha in the Altai—that embodied in terrestrial form the legendary Mount Meru from Buddhist and Hindu scripture. The Altai's native peoples venerated the White Burkhan, whom Roerich regarded as a messianic counterpart to Maitreya. Even Shambhala had an Altaic twin: Belovodye, the land of white waters, a realm of utopian purity that had been the subject of Siberian and Central Asian tales since the 1600s.[28] Roerich further believed that Tibet and the Altai were connected by a vast tangle of tunnels that honeycombed Asia's depths, a notion springing both from Finno-Ugric myths of the Chud tribe, said to have escaped an evil ruler by retreating underground, and Himalayan tales about the subterranean kingdom of Agartha. Stories of the Chud had been familiar to Roerich for years; he had encountered them in ethnographic works by Potanin and Przhevalsky, and he featured them in several paintings. The Agartha legend he learned from Blavatsky and the final chapters of *Beasts, Men, and Gods*, by Ferdinand Ossendowski, who had served with his brother Vladimir under Baron Ungern.[29] This concept, one of the

many "hollow world" theories that pervade new age thought, gave Nicholas and Helena a way to bind into a single whole the far-flung geographical components of their New Country. The couple spelled out these hopes to the Grebenshchikovs in January 1924:

> Before the snows of the Himalayas, an extraordinary commandment has been given to us. We are told that Christ said to Buddha, "It is not fitting that we ourselves build churches, that by our own hands we make the belltowers ring. Brother Buddha, gather those people who are capable of awakening the third eye. Help them to pass through the desert. Set a star to shine clearly before them. As a mark of our trust, let us allow our Church to be raised by human hands. . . . Let us think upon where we should send the Builder and with what measure of honor we should reward the One who, on our behalf, will issue a summons to the entire world. So it will come to pass in Zvenigorod."[30]

The following month, they proclaimed with pride that "the Treasure of the World"—meaning the Stone they had carried from Paris—"has returned from the West. The fire of joy will soon blaze from the mountains to signal Maitreya's return."[31]

Such abstractions worked well as poetry and prophecy, but they said little about political reality. By the time the Roerichs reached the Himalayas, many of the assumptions on which they had premised the Great Plan had been nullified. Roerich had imagined a White storm sweeping forth from Harbin, liberating Mongolia from communist rule and retaking Siberia and Central Asia from the Bolsheviks. After this, he hoped, Buddhists throughout Asia would confederate with his Altai-based Union of the East. Instead, the USSR kept gaining strength in Siberia, as evidenced by its reabsorption of the Far Eastern Republic in late 1922, and any realistic chance of White aid for Roerich had vanished by the end of 1923. No help was coming from Russians in France, and Chistyakov and Vladimir had drummed up only minimal support among Harbin's émigrés. Worse yet, China, in May 1924, would recognize the USSR as its rightful partner in coadministering the Chinese Eastern Railway, leaving Harbin's White Russians to exist in a state of hostile proximity with their Red rivals as the Soviet presence in the city increased.

Roerich's conundrum was that, if Morya and Koot Hoomi spoke true, Russia had a crucial role to play in making the new age happen. Small wonder, then, that with Lenin dead, Nicholas and Helena began to ask themselves whether the Russia enmeshed with their destiny might be *Soviet* Russia. Was it now possible that their theocracy-to-be could be diplomatically and doctrinally aligned with an atheistic state they had so deeply hated? Before they could answer that question, other priorities came first. Sometime in 1924, Roerich intended to present himself as a herald of Maitreya to

the region's chief lamas and ask their blessing for his Great Plan. The disappearance of the Panchen, whom he had hoped to petition, made this task more challenging. But by adding extra unpredictability to a game whose rules were already in flux, it boosted the odds that Roerich, a new wild card, might decide the final outcome.

Politics aside, moving from the Ganges to Darjeeling's highlands was like voyaging to a new planet. There, on land ceded by the kings of Sikkim to the East India Company, the British had created a luxurious hill station, far from the southern heat. to supervise the mountain passes linking northeast India and Tibet. The Roerichs, who approached Darjeeling from the wrong angle and in poor weather, were underwhelmed by their first glimpse of the mountains, but it took only the clearing of the skies and a visit to the city's best vantage points to lay before them the Himalayan grandeur they had dreamed of. Most thrilling was the sight of Kanchenjunga, whose painted image Roerich had fallen in love with as a child at Isvara.[32]

Nicholas and Helena picked a storied place to live. This was Talai-Pho-Brang, an estate four miles outside the city, near the settlement of Ghoom. The locals believed that a devil in the shape of a black pig haunted the house (making it easier to obtain a lease), and the Dalai Lama had once stayed in it during his 1910–1912 period of exile. The Roerichs' time here did not pass without difficulty. Domestic arrangements took weeks to figure out, thanks to confusion about who among the hired help could do which jobs without breaking caste, and heavy rains in June caused white mold to form on Roerich's tempera paintings. The only way to dry the canvases enough to scrape off the residue was to heat the entire residence, making for several days of intolerable warmth. Still, the house was comfortable and conveniently located, and Ghoom was home to the Yiga Choeling monastery, a repository of rare texts. George spent pleasurable hours there conducting research.

The family did not confine itself to Darjeeling. The Roerichs toured neighboring districts as well, venturing to Kurseong, Kalimpong, and the Takdah valley, with its rainbow cascade of orchids and rhododendrons. From Sandakphu, they could look upon four of the five tallest mountains in the world: Everest, Kanchenjunga, Makalu, and Lhotse. And for two weeks in February, they crossed into Sikkim, which Roerich pronounced "a blessed country."[33] Here, the artist believed, was the dividing line between earth and heaven: "Nowhere else on earth is one so struck by the impression of being in two different worlds. Below is a terrestrial realm with abundant flora, brilliant butterflies, pheasants, leopards, raccoons, monkeys, serpents, and all the countless animals that inhabit Sikkim's eternally green jungles. Above the clouds, at a stunning altitude, shines forth a land of snows that has nothing in common with

the teeming anthill of the jungles."[34] In all these places, the Roerichs visited monasteries dedicated to Tibetan Buddhism. Carrying testimonials from the Ghoom Monastery, they stopped in at Pemayangtse, Sanga Choeling, Daling, Chakong, Dubdi, Namtse, Robling, and Moru, observing services, studying tantric iconography, and perusing sacred texts in the "secret recesses" of monastery libraries.[35] At Sikkim's Tashi-Ding Monastery, the Roerichs celebrated the Tibetan New Year, marveling as drums and gongs sounded into the night. They purchased manuscripts, carvings, and tanka banners decorated with mandalas and images of the gods, all for the Master Institute in New York. In the hills and forests, Roerich, a devotée of herbal medicine, searched for healing plants. "Nature awaits full of gifts," he exclaimed. "Come hither and be healed!"[36]

Roerich accomplished two things during these pivotal weeks. First, he experienced a massive burst of creative intensity. The time had come to furnish Louis Horch with paintings, as per their 1923 agreement, but it was ecstasy, not mere necessity, for Roerich to record what he saw. His "Himalaya" and "Tibetan Path" series, comprising forty-one and eight works, respectively, depict the great peaks in every kind of light and from every possible perspective. These were no straightforward landscapes, but spiritual exercises. Every mountain, Roerich asserted, was holy: "All teachers journeyed to the mountains. The highest knowledge, the most inspired songs, the most superb

sounds and colors are created on the mountains. On the highest mountains there is the Supreme. The high mountains stand as witnesses of the great reality. An inner impulse irresistibly calls people toward the heights."[37] Roerich reinforced this theme in the "Sikkim" and "His Country" series, featuring seekers of wisdom (see Illustration 34), mountainside stupas and temples, and depictions of Chintamini, the "treasure of the world." These last scenes allegorize the Roerichs' acquisition of their sacred stone. In *Burning of Darkness*, a procession of mahatmas carries a fiery gem up from its place of concealment beneath the peaks. The lead bearer's face, illuminated by the jewel's glow and the stars of Orion above, is that of Nicholas.

The nineteen-canvas "Banners of the East" series (1924–1925), depicting gods and gurus from many faiths, was guided by Vivekananda's precept that "all religions are one." Among its subjects are Christ, Confucius, Moses, the Buddha, Mohammed, Taoism's founder Lao-tse, and Russia's Saint Sergius. With them stand En no Gyoja, the originator of the Japanese doctrine of Shugendo; Padma Sambhava, who brought Buddhism from India to Tibet in the eighth century (see Illustration 22); Tsong-kha-pa, the founder of Tibet's Gelugpa sect; and the poet-hermit Milarepa, famed for his mystic duel atop Mount Kailas with the head of the shamanic Bon-po sect that predated Buddhism in Tibet. "Banners" includes some of Roerich's most visually arresting works. One such is *Dorje the Daring One*, in which

the three-eyed visage of the guardian deity Mahakala—wreathed in flames, crowned with skulls, fangs bared—materializes before a calmly seated lama (see Illustration 23). Another shows the sage Nagarjuna taming a thirteen-headed serpent god, and the moonlit *Oirot—Messenger of the White Burkhan* depicts the herald of the Altaic messiah figure, riding through a glacier-ringed wilderness.

"Banners of the East" includes one female figure: *Mother of the World* (see Illustration 25). This, a Romano-Gothic variation on Roerich's *The Queen of Heaven*, was inspired in the spring of 1924 by one of Helena's visions, in which the happy news was revealed that Mary Magdalene, Saint Teresa, and Catherine of Siena had decided to bless the Roerichs' enterprise.[38] Its rich blues and purples offset by the bright nimbus radiating from the goddess's head and shoulders, *Mother of the World* remains a superbly transcendental work. Related canvases similarly address the concept of feminine divinity, and Roerich put an explicitly Asian face on it in *She Who Leads*, from "His Country." Here, a lissom maid—modeled on the *dakini*, or "sky maiden," from Buddhist cosmology—guides a lama through the mountains. Roerich painted many versions of *She Who Leads* over the next twenty years; they can be read as tributes to Helena's spiritual leadership.

The second task Roerich managed was to open up dialogue with Buddhist clergy from Himalayan India and its borderlands. In general, he talked a great deal with the native population, both during his monastery visits and at Talai-Pho-Brang, which sat near the pathways linking Darjeeling with three of Tibet's largest cities: Gyantse, Shigatse, and Lhasa itself. Paradoxically, while Tibet remained highly inaccessible to Westerners—fewer than two thousand are known to have visited it before 1979—it was a vital conduit for trade and travel between China in the north and India in the south; letters and newspapers could be conveyed from Calcutta to Lhasa in a mere ten days, and an experienced native courier took only seventy-two hours to cover the 175 miles separating Gangtok, Sikkim's capital, from Gyantse.[39] Being domiciled at Talai-Pho-Brang put the Roerichs in an excellent position to speak with pilgrims and passersby. The two questions were whether the family could correctly assess the region's religious and political mood, and whether they could sell their vision to an Asian audience.

They succeeded to the degree that, in early 1924, Buddhists of importance proved willing to receive Roerich as a self-styled "ambassador of Western Buddhists"—although how seriously and to what effect is less clear. In books like *Altai-Himalaya* and *Heart of Asia*, Roerich describes such moments with maddening imprecision, partly to lend his narrative a touch of mystery, but at times because he himself was in the dark about key details. He had little idea where the Panchen Lama had gotten to or what was transpiring in Tibet, and there is nothing feigned about his complaint that "behind the mountain ramparts, events are stirring,

but secrecy is great [and] information is contradictory."[40] Nor did he find communication easy. As interpreter, George was still accustoming himself to the many confusions of real-time field translation, and his father noted more than once with annoyance, "The languages remain difficult for us."[41] Nonetheless, Helena's journals show that she and Nicholas believed themselves to be winning trust and generating goodwill. Of the family's February liaisons in Sikkim, Master Morya declared himself "well pleased with our efforts."[42]

Most auspicious of all, Roerich was ordained as a Buddhist lama sometime that spring, likely in April, receiving the spiritual name Reta Rigden. By his own account, he was also recognized as a reincarnation of the Fifth Dalai Lama—a claim less easy to credit.[43] The ceremony took place at Sikkim's Moru Monastery and was overseen by Geshe Rinpoche of Chumbi Monastery, a trusted associate of the Panchen Lama, and Lobsang Mingyur Dorje, who taught at the university in Darjeeling and had been assisting George with his research on Tibetan grammar and literature. In attendance was Laden La, a high-ranking courtier with ties to both the Dalai and Panchen Lamas. Roerich considered Laden La a supporter, but he was in reality an informant friendly to the British, to whom he reported this unusual event. Other Tibetan elites said to have been present or to have met with Roerich during these weeks include Kusho Doring and Tsarong Shape, commander in chief of the Dalai Lama's armies.

It is not easy to judge this episode's significance, which Roerich held up, both to himself and to the Soviet officials he would soon deal with, as validating the Great Plan's viability. Two possibilities present themselves. In one, this story can be taken at or near face value, revealing Roerich to have been a shrewd and persuasive operator who earned a full-throated endorsement of his scheme from an impressive roster of religious heavyweights. And if the Panchen indeed approved Roerich's ordination, or if the presiding clerics understood him to be soulbound to the Fifth Dalai Lama in some consequential way, the Great Plan begins to look less like an impetuous folly and more like a realizable course of action. In *Trails to Inmost Asia*, George Roerich cryptically declared that "learned abbots and meditating lamas are said to be in constant communication with this mystic fraternity that guides the destinies of the Buddhist world."[44] Was he referring to a real and potent network of coreligionist intriguers? And had his father managed to place himself at its center? Just as easily, though, one can imagine a second scenario in which Roerich, whether on purpose or out of naïveté, overinterpreted the meaning of a ritual that his hosts intended merely as a gesture of courtesy.

Favoring the first possibility is the fact that Buddhist clergy in interwar Asia, including the Panchen Lama, are known to have colluded politically with sympathetic foreigners. Roerich, assuming he had already decided to take his Plan in a Red direction, could plausibly claim to bring

three attractive items to the table: American money, Soviet support in resolving Tibet's triangular relationship with China and Britain, and the means to persuade communist leaders to curb anti-Buddhist excesses in Mongolia and the USSR. Roerich also had an influential name to conjure with: that of the monk Agvan Dorjiev. Exactly how Roerich and Dorjiev cooperated after 1917 has never been fully determined, but they were provably in communication by no later than 1925 and are thought to have met in person in the USSR sometime in 1926. If Roerich was coordinating some kind of political effort with Dorjiev in 1923 and 1924—or could at least create that impression—it would have gone a long way toward securing high-level support from ranking Buddhists.

The alternative, however, seems likelier. For one thing, had the lamaist hierarchy backed Roerich as avidly as he claimed, his expedition would have yielded better results. For another, the Moru ritual was almost certainly more symbolic than Roerich supposed. Over the decades, numerous Westerners, from scholars to movie stars, have been similarly honored for devotion to Buddhism or friendliness to Tibet, even to the point of being identified as reincarnated lamas. The most prominent example is that of the French adventuress Alexandra David-Néel, who in 1916 stole into Tibet to study at the Tashilhunpo Monastery and was invested as a lama by the Panchen himself. However, neither David-Néel nor any of the other Tibetophiles so blessed had actual authority conferred upon them, religious or

temporal.[45] Roerich, then, was hardly being confirmed as some sort of Buddhist cardinal, and it is entirely conceivable that Geshe Rinpoche and his fellows accepted Roerich's spiritual bona fides without feeling moved to heed his political proposals or his talk of destiny. As for the Panchen, whose ally and compeer Roerich now regarded himself, he never, so far as can be told, met the artist in person or communicated with him in real time; the safest conclusion is that his commitment to Roerich's agenda was at best provisional and partial.[46]

If Roerich mischaracterized the Moru interlude, it appears to have been as much to himself as to others. When he related the event to Soviet officials later that year, he spun it as positively as he could, but not just as a matter of salesmanship. He shows every sign of believing that the ordination would set him on the path to brotherly cooperation with the Panchen and Dalai Lamas, and documents show that he expected Tsarong Shape and Kusho Doring to aid him in his travels. What tempted him into these misapprehensions? Genuine assurances that later proved false or fell through? Errors in translation? Or did wishful thinking overpower his judgment? Increasingly during his middle years, Roerich tended to overestimate the favorability of situations vital to his concerns—a failing we shall have cause to revisit.

During these weeks, the Roerichs enjoyed a brief reunion in Gangtok with Charles

Crane, who traveled through India in 1924–1925 and came north to climb the lower slopes of K2. The family chatted about their upcoming journey, but they had never shared their more clandestine goals with Crane, and they did not do so now. They moved among the British as well. They started awkwardly, violating several social conventions upon their arrival in Darjeeling.[47] They waited too long to call on the governor. Invited to join the English club, they declined membership. And in this race- and status-conscious outpost of empire, everyone observed with a disapproving shudder how much time they spent in the company of Asiatics.

Nevertheless, the bald, bearded Slav who spouted aphorisms from the *Bhagavad Gita* made a colorful addition to Darjeeling's white community, and he boasted recent acquaintance with some of London's most distinguished personages. One caller during these months was Emily Bulwer-Lytton, granddaughter of the statesman-novelist Edward Bulwer-Lytton, famed for lurid yarns of adventure and his oft-parodied opening line, "It was a dark and stormy night." Bulwer-Lytton's books left a huge imprint on many occultists, Blavatsky included, and Lady Emily herself was a Theosophist. She admired Nicholas's paintings, conversed with Helena about *The Secret Doctrine*, and provided the family with letters of reference as they applied for travel documents in 1925. Also visiting Talai-Pho-Brang that summer were the ten surviving members of the 1924 British Everest Expedition. Reeling from their failure to reach the summit and from the deaths of George Mallory and Andrew Irvine, the group recuperated in Darjeeling and viewed Roerich's art while they were there. They were much taken with *Burning of Darkness* and praised the realism of Roerich's Everest scenes. Like John Ruskin, who had castigated nineteenth-century alpinists for "ma[king] racecourses of the cathedrals of the earth," Roerich considered sport climbing a form of shallow egotism, but he was nonetheless pleased by the mountaineers' positive comments.[48] Yet another Everest veteran made Roerich's acquaintance during these months: the Australian chemist and mountaineer George Finch, a pioneer in the use of oxygen for high-altitude ascents and a participant in Mallory's 1922 Everest expedition. Coincidentally, Finch's mother Laura, an ardent Theosophist, would become one of Helena's closest friends in India from 1928 onward. Considering how bitterly Finch regarded his mother's occult preoccupations—he reviled Theosophy on scientific principle and blamed it for causing his mother to abandon his father—one wonders what he made of Nicholas and Helena, with all their mystical airs.[49]

In March, the Roerichs began a very different and eventually fateful relationship with Lieutenant Colonel Frederick Bailey, the British political officer in Gangtok. A shrewd soldier and spy, Bailey served with Francis Younghusband during the 1904–1905 assault on Lhasa and on several fronts in World War I. He then turned to

intelligence work in Persia, secretly crossing into Russian Central Asia on several occasions.[50] The Gangtok post he inherited from Charles Bell, who, as one of the Dalai Lama's closest friends, had not only watched over Sikkim but magnificently advanced Britain's interests in Tibet.

Like Bell, Bailey was tasked with keeping Tibet well disposed toward Britain and warding off any encroachments Russia might make toward the Himalayas. And encroachments there were. Between 1921 and 1925, the Kremlin sent two expeditions to Tibet—one led by the Kalmyk cavalryman Vasily Khomutnikov, the other by Sergei Borisov (also known as Tsering Dorje), an Oirat Mongol from the Altai—to ask the Dalai Lama to open a Soviet embassy in Lhasa, complete with military advisers.[51] Neither mission gained this hoped-for foothold, but Britain could not take Russia's continued failure for granted. The Dalai Lama remained fond of Dorjiev, who now lived in the USSR and agitated on its behalf, and Tsarong Shape, the head of Tibet's armed forces, favored closer ties with Russia. The Dalai himself appears to have wavered in the early 1920s, and Khomutnikov's optimistic expedition report quotes him as being resentful of British high-handedness and open to "neighborly relations with Russia."[52] On the other hand, the USSR's antireligious campaigns, especially the persecution of Buddhists, perturbed the Dalai Lama, and the British found that keeping him up to date about them was an excellent way to foil Soviet diplomacy. When the Borisov

mission reached Tibet, Bailey traveled to Lhasa with news of more such repressions.

With this in his background, Bailey was predisposed to regard any Russian, Red or White, with distrust, and Roerich's talk of trekking through the Asian interior roused his suspicions. Nor did spiritual professions move him, for few things irked Bailey more than Theosophists and neo-Buddhists who dreamed of sacred mountains and audiences with the great lamas. This was an attitude widely shared in British intelligence, as attested to by Desmond Morris of MI6, who sneered that "nearly all these theosophists are connected in some way with Bolshevism, Indian revolutionaries, and other unpleasant activities."[53] Bailey kept a hawk's eye on Roerich for half a decade and, in ways that the artist never discovered, halted his final push toward Lhasa.

For all the deception underneath, the two men enjoyed each other's company. Roerich believed that most British officials were acting against him, but he saw in Bailey a genial host and a solicitous public servant. And while Bailey considered Roerich's paintings dreadful and suspected that Roerich himself was up to no good, he could not bring himself to dislike the artist.[54] It helped that Charles Crane, who knew Bailey and called on him while sightseeing in the Himalayas, attested to Roerich's good character. Bailey found Roerich a fascinating conversationalist, and he grasped better than most of his colleagues that Roerich's outlook could not be easily categorized as White or Red. Still, whatever affection he

conceived for Roerich, he kept it tightly reined in. In all his dealings with the artist, Britain's interests came first.

Bailey's wariness was justified. In early 1924, as the colonel came to know them, the Roerichs were moving toward their own private Sovietization. Even with hindsight, it remains a mystery as to when the family underwent this internal revolution, and some, especially the conspiracy-minded, are convinced that it occurred as early as 1920 or 1921. At various points between 1921 and 1923, one sees hints of a changing mindset, but also signs indicating the opposite, and if the Roerichs wavered back and forth during those years, they would hardly have been alone among their émigré peers in doing so. As for the crucial turn, the weight of the evidence suggests that it came in 1924, and only after much deliberation.

This transformation was less atypical than one might think, and proceeded first of all from an "emigration fatigue" felt by many of Russia's expatriates. With the Civil War over and the gradualist New Economic Policy (NEP) of 1921 restoring a measure of prosperity to the USSR, homesickness converged with a growing sense that the Soviet regime was in place to stay, and that its worst years were behind it. Several prominent figures returned to their homeland, among them Andrei Bely and Sergei Prokofiev. Gorky, who had departed angrily in 1921, began the series of homecomings

that brought him back for good a decade later. The "new tactics" of Pavel Miliukov, leader of the liberal Kadets, took a softer line toward the USSR, and the Change of Landmarks (*Smena vekh*) movement among émigré intellectuals argued the need to reconcile with a Soviet state that, like it or not, represented Russia's political future. Even among Russian Theosophists, some came to view Soviet tyranny as part of Russia's karmic burden. Roerich's friend Ivan Bilibin soon went back, and Alexei Remizov is known to have wanted to. Roerich himself ached to see his mother and his brother Boris again.

It also bears reminding that Roerich's anti-Bolshevism had been principally about Lenin—not just his ruthlessness, but his rough handling of the arts and his uncompromising hostility toward religion. With Lenin gone, it seemed possible that new leaders might moderate or reverse policy in both spheres. Much of the NEP period coincided with a relative cultural liberalization, and Roerich knew that many of his former colleagues—Grabar and Shchusev, to name two—were making good careers for themselves under the new order. Also, while every Bolshevik agreed that religion was the opiate of the masses, not all shared Lenin's intense hatred of it. Many thought believers could be rationally persuaded, rather than forced, to give up religion, and for years among Russian Marxists, there had existed a "god-building" school of thought, which proposed that the religious *impulse* could be harnessed to communism's benefit. Chief

among these "god-builders" stood Anatoly Lunacharsky, the commissar in charge of education and culture. Beyond that, a number of Soviet officials sympathized more actively with certain forms of spirituality than one might suppose.

There appeared to be special hope concerning Buddhism, which suffered under the Soviets, but was not perceived as an institutional foe on the order of Orthodox Christianity. While most Reds condemned Buddhism and Islam as socially and culturally backward, some saw limited toleration for them as a way to increase communism's appeal among Asiatic minorities, both in the USSR and outside the country's borders. Arguing a similar position, but from the perspective of practicing Buddhists, were Dorjiev and the Temple Commission orientalists, still trying to interest the Kremlin in stronger ties with the Buddhist world, just as they had under the tsars. Taking a cue from the Living (Renovationist) Church, the Russian Orthodox offshoot that collaborated with the Soviet state, Dorjiev strove from 1922 onward to adapt Buddhism to Soviet reality by assuring the regime that if it were reformed into a progressive *philosophy*, with superstition pared away, it could be harmonized with Marxist doctrine. This effort was doomed to fail, but it failed slowly enough that Roerich had time to learn of it and become persuaded of its chances for success.

Not to say that this transmutation happened quickly or easily. The family spent the summer at Talai-Pho-Brang, where Nicholas recovered from a spell of illness, and there they aligned their earlier dreams with the information they had gleaned during their half year in Asia. This proved a challenge, if the Roerichs' record of Morya's "revelations"—best understood as distillations of their doubts and desires—is anything to judge by. A jumble of ideas spilled onto the pages of Helena's diary. The Lichtmanns, for example, were to ask their relatives in the USSR to preach to the Jews of Russia and Ukraine that Roerich was the prophet Amos, reborn. Under Roerich's guidance, Russia would ally with America, eliminate political boundaries in the east, and reach out a hand of friendship to Africa, especially to Abyssinia, the continent's cradle of culture. Orphans from Russia, China, and Kirghizia would rise up to join Roerich; to minister to their souls, he would build them a seminary in Urga, Mongolia's capital, and to school them in the arts of war, he would build a military academy.[55] The prospect of violence troubled Roerich, but he swore to shed as little blood as possible. He took comfort in Morya's assurances that Akbar the Great had gone to war when necessary, and that Saint Sergius had blessed Russian troops before battle.[56]

After months of weighing options, three propositions emerged. First, Roerich was to restore religion to Russia, purging it of "mechanistic" dogma and "vulgar" sectarian prejudice, concentrating instead on ethical and spiritual purity. This made good Theosophical sense, but was probably influenced as well by Dorjiev's "renovationist"

approach to Buddhism in the USSR.[57] Second, Tibet, like India, appeared ripe for political realignment, with the Panchen Lama in flight and the Dalai Lama "tormented" by the British. Although Roerich favored the former and came to despise the latter, he felt for the time being that Tibet could be saved only by repairing the breach between them. His own role was not precisely spelled out, but he appears to have wanted to expand the dyad into a trinity, with himself as the third partner—a Dalai Lama of the West, so to speak—installed in the Altai Mountains. Conveniently enough, the recent death of Mongolia's ranking cleric, the Jebtsundamba Khutuktu, had created a seemingly ideal vacancy; remarks to his followers about the need for a new Bogdo-gegen (one of the Khutuktu's titles) indicate that Roerich imagined himself a suitable replacement, if only he could win approval from the other two lamas.[58] Whatever the case, Roerich foresaw Russia riding to the rescue of India and Tibet. Before its "thousand thundering cannon, other nations would fall into perturbation," and its mighty host of horsemen would charge through the "snow-blanketed passes" of the Himalayas.[59]

Third, the Roerichs now pinned their hopes on the USSR.[60] Helena's journal speaks repeatedly during the summer of 1924 about the need to meet with Soviet officials. In August, the family began planning their "Beluha" cooperative, a mining-agricultural concession to be built in the Altai with Soviet permission. And just before Christmas, Roerich would find himself in the USSR's

Berlin mission, face-to-face with Soviet diplomats. This new profession of faith in Marx may have been a ploy to secure Soviet support, but it appears to have been heartfelt. In the fall, Roerich praised Lenin as "a truly great communist" and expressed relief that Morya's will no longer required him to take up arms against the Russian land. The following May, Helena would proclaim in her journal that "Lenin is with us."[61] This was no figure of speech to the Roerichs, who by 1925 believed themselves to be in spiritual communication with the departed leader. Even more stunningly, they anticipated that the souls of Marx and Lenin would soon ascend to join Master Morya in the ranks of the Great White Brotherhood. This would take extra time for Lenin, who required a cleansing period to atone for the blood staining his hands. But he too would someday take his place in the Theosophical pantheon.[62]

More pressing at the moment than Lenin's ghostly penance was the shoring up of support from New York. By the end of the summer, Nicholas and Helena had been away from America for over a year, and though they had exchanged scores of letters with their disciples, this was no substitute for personal contact. An appearance by Roerich seemed in order. Sviatoslav had to return to school in any event, and there were a thousand arrangements to make for the upcoming expedition. On September 22, 1924, Nicholas and Sviatoslav left Darjeeling for Calcutta, from which they would voyage to Europe.

Though brief, the landbound part of this trip proved eventful. En route to Calcutta, in the hill station of Kurseong, Nicholas and Sviatoslav were privileged to meet the grande dame of Western Buddhists. This was Alexandra David-Néel, recently returned from her most recent Tibetan journey (soon recounted in her 1927 book *My Journey to Lhasa*) and touring in the company of the Japanese monk Ekai Kawaguchi. Many of our modern impressions of Tibet still come from David-Néel, and Roerich felt starstruck by her presence. It was in her footsteps he now hoped to follow, so he pumped her for as much advice as he could get. He was delighted to hear from her that Tibet was abuzz with tidings of Shambhala and talk of Maitreya's return. Such news, he told Helena, augured well for their own designs.[63]

Emboldened by this interview, Roerich made the rest of his way to Calcutta with Sviatoslav, then sailed onward to France. After a brief stop in Paris and some meetings with Georges Chklaver and Alexei Remizov, father and son crossed the Atlantic on the *Aquitania*. They reached New York on October 24.

During his seven weeks in Manhattan, Roerich lodged at the Hotel Alexandria, but spent every day in the inner circle's company. Some things pleased him, including the fast clip at which his US enterprises were growing. In September, Grebenshchikov and the Alatas press published *The Call*, the first volume in the "Agni Yoga" series; in production for next year were *Illumination*, the second "Agni Yoga" book, as well as the newest installment of Grebenshchikov's Churaev saga. World Service, financed by Horch, was trading in fur, wool, Latvian flax, and East Indies tea, and also kept Roerich in communication with colleagues and family in Russia. (A second firm, Pan-Cosmos, was soon formed for similar purposes.) Corona Mundi's membership had expanded, and Grebenshchikov, with Horch's help, established a Roerich-inspired—though never Roerich-controlled—fiefdom seventy-five miles from New York, in Connecticut's Naugatuck Valley. This was Churaevka, a themed community designed by Grebenshchikov and his cofounder, Count Ilya Tolstoy, the son of Leo Tolstoy, to capture the feel of an old Russian village. Churaevka's nostalgic charm appealed to many émigrés, among them Sergei Rachmaninoff, Fyodor Chaliapin, and the inventor Igor Sikorsky, who donated money to enlarge the site. Its landmark attraction remains the Saint Sergius Chapel, designed in part by Roerich.[64]

Most important was the Master Institute, which had come into its own as a school and exhibition space, and, at the moment of Roerich's return, was about to open a full-fledged museum. Student numbers had increased, and a more accomplished staff, eventually growing to over a hundred, was on board. Among those who taught or lectured there were Norman Bel Geddes of the

Metropolitan Opera; the composer Deems Taylor, remembered as the narrator of Disney's *Fantasia*; the theater designers Lee Simonson and Robert Edmund Jones, who cofounded the Provincetown Players with Eugene O'Neill; the *New York Times* drama critic Stark Young; and the Ashcan School painter George Bellows, famed for his iconic boxing scenes. Other standouts include the socialist printmaker/illustrator Rockwell Kent and the architect Claude Bragdon, a Theosophist who translated Ouspensky's *Tertium Organum* into English and boosted Kahlil Gibran as *The Prophet* began making its literary mark. The institute also served as a social hub for New York's Russian émigrés, many of whom attended cultural events or sought companionable company there. It even ran a Russian Sunday school for émigré children.[65] After its opening, the Roerich Museum would host a smorgasbord of concerts, lectures, poetry readings, and exhibitions by artists from around the world.

Yet problems awaited. The institute remained stuck in intermediate quarters, with several more years to go before the skyscraper Roerich dreamed of could be built. Money flowed less readily than the artist would have liked. Roerich excelled at coaxing small donations face-to-face, typically from friends of those already supporting him or from society matrons fond of high art or new age utopia. Certain patrons, including Charles Crane, continued to purchase his paintings. Still, the Horches remained his sole source of major funding, and Roerich, mindful of how vulnerable this

left him, sought to diversify his streams of income. He visited Chicago to raise funds there, and, as during his first time in America, he ventured to Detroit and Rochester to persuade Henry Ford and George Eastman to bankroll him. In each case, the outcome was the same as before: Ford refused to see him, and Eastman listened politely but gave no money. Roerich also met with Spencer Kellogg, who had expressed a willingness to join the institute's board and to fund its arts magazine, *Orion*, but was now having second thoughts. Roerich dressed Kellogg down "to the point of tears," but did not pry his wallet open as much as he would have liked.[66]

Nor was Roerich at ease about the circle's interpersonal dynamics. Already on the way back to America, dealing with his Paris followers had set his nerves on edge. Rumors about him continued to circulate among Russians in France, and loose talk among his allies troubled him as much as slander from his enemies. Among those most inclined to gossip was Serafima Remizova, who blabbed to fellow émigrés about the "white church" Roerich planned to erect in Siberia. Remizov himself was drifting away from Agni Yoga, and while Roerich retained his personal affection for the couple, he never again trusted them.[67] He fought with Vasily Zavadsky and briefly doubted Chklaver's loyalty as well.

Coping with strife in New York proved even worse. Esther, Frances, and Sina remained locked in their triangle of mutual loathing. Sina watched Louis for signs of

spiritual weakness and feared that Nettie was becoming "too ambitious."[68] The Grebenshchikovs' arrival had thrown the group even more off balance. Tatyana seemed decent enough, but while the Horches liked Georgii, Sina and Frances found him "lazy" and selfish.[69] The Roerichs hoped Nicholas's return would have a calming effect, but he had his own difficulties with the circle, expressing loud dissatisfaction with Grebenshchikov over the order in which he had arranged to publish new books in 1925, and with Horch about his "lack of initiative" regarding the institute.[70] For their part, Frances and Louis were appalled by Roerich's willingness to commingle the Alatas, Corona Mundi, and Master Institute budgets, a bookkeeping practice that even the soft-spoken Maurice denounced as "irregular."[71]

Still, Roerich rekindled the circle's sense of purpose. He led séances on a near-nightly basis, and Helena sent word from India about the messages that she, George, and Shibaev were receiving from Morya and Koot Hoomi. The spirits counseled fast action, to keep abreast of an impending global crisis. "A bloody hand hangs over India, China, Turkey, and Egypt, and Romania and Poland too," Morya pronounced. "The world is breaking apart, and a new time is on its way."[72] Morya also called for an institutional, though not philosophical, divorce from the Theosophical Society, which he felt was being ruined by Annie Besant: "She is treading a false path. Nothing remains at Adyar but empty walls, as you

will see yourself if you go there." Charles Leadbeater was an even worse perverter of the truth, and the TS vice president Jinarajadasa was likewise to be shunned. "Only Blavatsky understood correctly," Morya said, although Ramakrishna and the Vedantists had merit as well.[73]

On the worldly plane, Roerich packed much activity into these months. He sat for a bust by the sculptor Gleb Deriuzhinsky—one of his former students in Russia and briefly an attendee at Helena's séances—and also for a large canvas, *Christian Brinton and His Circle* (1924), by the avant-garde painter David Burliuk. He worked with Sina and Esther to translate his and Helena's writings into English. He lectured at the Boston Art Club and, in mid-November, went on his fundraising trip to Detroit, accompanied by Sviatoslav and the Horches, stopping on the way back in Buffalo and Rochester to see Kellogg and Eastman. Immediately afterward, on November 23, came the Roerich Museum's official opening, with an exhibition of four hundred Roerich works in the new Helena Roerich Hall. The Spanish painter Ignacio Zuloaga called this collection "lofty and profound."[74] Four hundred fifty guests attended the dedication, among them Christian Brinton, who had launched Roerich's first New York show in 1920, and the journalist Abraham Merritt, who enjoyed a second career as a pioneer of American pulp science fiction. Merritt collected occultist literature and received several volumes from Roerich as a gift.[75] Also present were the former *miriskusnik* Boris

Grigorev; the sculptor Sergei Konenkov, recently arrived in New York with his wife Margarita (whose later romance with Albert Einstein has led some to suspect she was in America as a Soviet spy); and David Burliuk. Reviewing Roerich's show for *Russian Voice*, Burliuk called him "a songster of the primeval, a summoner of the wise past," and contrasted the otherworldliness of his works with the tumult of the metropolis: "In this phantasmal world, there live special people, dear reader, unlike you or me. This realm, which Roerich has transported to the midst of America, land of bookkeepers, has been called into being for those who think deeply, for those whose hearts beat in time with the rush of water down mountain cascades. In that realm you will find no Wall Street men, no Fifth Avenue girls. It is inhabited only by those who are as pure, refined, and tranquil as a mountain peak glowing in the dawn light."[76] On the thirtieth, Burliuk led a hundred Russians on a tour of the exhibition, with Roerich available to answer questions, and he would pen his own biography of the artist in 1930.

Gratifying as this was, Roerich cared most of all at the moment about paying for his expedition and reaching a practical understanding with the USSR. In his own right and with the help of various associates, Horch secured approximately $1,000,000 to underwrite Roerich's journey; half the money was his own, and Frances Grant contributed the not inconsiderable sum of $25,000.[77] On the Soviet front, Roerich acted decisively. He appears to have applied for a Soviet visa at this time, and, confirming to Horch and the rest that "we must do business with the Bolsheviks," he ordered the creation of the Beluha Corporation, a venture meant to develop the Altai region jointly with the USSR's Main Concessions Committee (GKK).[78] The timing for such an enterprise was good. Since 1923, the Kremlin had been soliciting foreign capital to exploit resources and build industrial capacity in the USSR, and the GKK, headed by Leon Trotsky, considered hundreds of applications from abroad. The list of American proposals takes up fifty-five pages, including a Standard Oil bid to sink wells in Siberia, an RCA plan to build radio transmitters, and a pitch by the Remington Company for a new typewriter factory. The Beluha prospectus, bolder than most, called for the "general cultivation of all products for rural, urban, and commercial economies" in the territory surrounding Mount Belukha in a sixty-mile radius, plus four nearby districts. Beluha's negotiations with the GKK would last more than four years; for now, in October and November, it drew up bylaws and registered a New York State certificate of incorporation.[79] The seven directors—Nicholas and Helena, Louis and Nettie, Sina and Maurice, and Frances—divided thirty thousand shares equally, with Louis, as president, receiving the five left over. Horch put up $3 million to back the company, and Beluha, like World Service and Pan-Cosmos, was headquartered in the Manhattan offices of Horch and Rosenthal, on the thirteenth floor of 27 Pine Street. The directors held their first meeting

on December 9 and agreed to submit their prospectus to the Soviet government by no later than the spring of 1925.

Louis and Maurice acted as Beluha's primary spokesmen and, in dealing with Soviet authorities, discussed the company strictly in businesslike terms. Roerich pursued a parallel course in October and November, speaking more frankly about his religiopolitical intentions with a seemingly minor figure from the USSR. This was the agriculturalist Dmitri Borodin-Poltavsky, posted in America to head the Russian Agricultural Bureau, an agency affiliated with the Soviet government and established on the advice of the botanist Nikolai Vavilov to keep Russian plant science current with developments in the West. (A victim of Stalin's crackdown on Soviet science, Vavilov, before his death, corresponded several times with Roerich about plant research in Asia.) In New York, Borodin had come to know Maurice Lichtmann, who introduced him to Roerich on October 29.

Between then and the first week of December, Roerich met with Borodin at least five times, trying to gauge Soviet interest in the Great Plan.[80] Asked whether the USSR would back Roerich's expedition, Borodin answered that it might, if he presented the Plan as a way to heighten communism's appeal in the east and weaken Britain's presence there. Roerich felt especially anxious that the Kremlin understand how important Buddhism was to the plan. Sina, present for Roerich's conversations with Borodin, remembers how "Nikolai Konstantinovich asked Dmitri Nikolaevich whether he understood that religion might be used to achieve the union of Asia? D. N. replied that he did. And did he understand that Buddha's name could bring this to pass? D. N. agreed. And would the [Soviet representatives] N. K. intended to meet in Paris agree? B[orodin] answered that they were not stupid. And so the two came to a complete and mutual understanding."[81] Part of this understanding involved Borodin's willingness to vouch for Roerich in testimonials to Soviet officials in Berlin, Paris, and Moscow. Sources do not reveal whether Borodin acted privately or as an agent of the USSR, or what specific impact his assistance had, but it seems to have been significant. As recently as September, the Roerichs had lacked a feasible way to get back to Russia. "All will be made clear en route," Morya had promised, but such vague assurances brought the family no closer to obtaining Soviet visas.[82] Now, for the first time since 1918, the Roerichs could hope realistically for a Russian homecoming.

As he prepared to return to India, Roerich tended to last-minute details. Sviatoslav stayed in Manhattan to continue studying at Columbia. (Acting in loco parentis, the Horches promised to keep him from reverting to his earlier bad habits.) Roerich instructed the group as to what they should or should not disclose to the institute's staff, and he set up ciphers to control the flow of

information. A triangle on the envelope indicated that a piece of mail was nothing out of the ordinary, while a circle meant it could be opened and read only by the institute's officers. The lexicon of code names was further expanded. If anyone got wind of how Roerich was meeting with Soviet officials in Europe, the institute was to explain this as an innocent inquiry into the state of the paintings he had left behind in Petrograd.[83]

The time to sail came on December 10. With Roerich was Maurice, chosen to aid him in negotiating with the Soviets in Berlin and Paris. Shibaev would join Roerich in France and travel back to India with him. One thing Roerich did not know as he left New York was that some of his recent actions—perhaps his application for a Soviet visa, perhaps his talks with Borodin—had attracted the attention of US authorities, who wondered why a self-declared White Russian suddenly seemed so eager to reconnect with the USSR. After Roerich exited the country, the Passport Control Office of the US State Department looked into his record and concluded by May 1925 that he had associated with a number of known and suspected communist sympathizers. Closer supervision, but no actual sanction, was recommended. As a courtesy, the Americans forwarded the report to their British colleagues, who buried it in their files until it was too late to act on it.[84]

Oblivious to this, Roerich and Maurice proceeded to Berlin, which they reached on Christmas Eve. They checked into the glamorous Adlon Hotel, not far from the Brandenburg Gate and conveniently near the Soviet mission. Roerich arranged to meet with Nikolai Krestinsky, the USSR's ambassador to Germany, and Krestinsky admitted him without delay, likely due to Borodin's letters from the fall. As he consulted with the artist, Krestinsky brought in Georgii Astakhov, a specialist on Asian affairs for the OGPU, as the Soviet secret police was then known.[85]

No formal record of this meeting is available, so the clearest picture of it comes from Krestinsky's report to the people's commissar of foreign affairs, Georgii Chicherin, and from Roerich's follow-up correspondence. Acting on Borodin's advice, Roerich sold the Great Plan as a political undertaking that could hugely expand Soviet influence in Asia. He promised to share whatever intelligence he gathered during his upcoming expedition; referring to his meetings with Colonel Bailey, he hinted that he had already learned much about British plans for Tibet. Most critically, he presented himself as uniquely qualified to fuse Buddhist faith and Marxism-Leninism in ways that would cause Asia's millions to favor the Kremlin. When he spoke of spirituality, it was to remind Krestinsky and Astakhov how much benefit could be gotten out of even a small measure of religious toleration. As he cautioned Astakhov,

It is imperative that the name of Buddha not be insulted in Soviet Russia. Likewise, Maitreya's name must not be insulted. . . . Our idea that Buddhism

can be the most scientific of teachings has been received [by the people of Asia] with joy and reasoned understanding. They readily agree that Buddhism has been corrupted by accretions and superstitions added to it over the years. The idea of purifying the Buddha's teachings is regarded favorably by the populace. But for the moment, the most important thing is that the names of Buddha and Maitreya not be insulted. Otherwise all the work we are doing in the south will be ruined by what happens in the north.[86]

Roerich mentioned the many clerics and worshippers he had met in India and Sikkim and, with no great modesty, spoke as though he had already won them over to socialism. He implied that he would be able to do the same with the Panchen Lama, and perhaps the Dalai as well, if his expedition received adequate support from the USSR.

Krestinsky responded politely but carefully. On his own authority, he was unwilling to issue a visa to a possible provocateur or crank. But if there was any substance to what Roerich had to say, he might prove useful. Krestinsky asked Roerich to remain patient while he consulted Moscow, and sent the following memo to Chicherin on January 2, 1925:

Dear Georgii Vasilevich,

About ten days ago, I met with the artist Roerich. From 1918 onward [sic], he has been living in America. He and his family have spent the past year on the border between India and Tibet, where he has been sent by an American art company to paint pictures. Now, after a brief time in America and Europe, he is preparing to visit other places in northern India over the next year. His disposition is thoroughly Soviet and somehow Buddhist-Communist. His relations with the Hindus and especially the Tibetans are, he tells us, very good, thanks to the assistance of his son, who knows twenty-eight Asian dialects.

In Asia, Roerich has agreed to agitate cautiously on behalf of Soviet Russia, and he has pledged to send us information from there by means of his American correspondents (Lichtmann and Borodin). I asked Comrade Astakhov to speak with him in more detail, because, of course, it is difficult for me to judge the value and truthfulness of Roerich's impressions of Asia. At Roerich's request, I am informing you of his visit and sending you a few books about him (not Asian, unfortunately, but American) that he left with me.

With comradely greetings, N. Krestinsky[87]

It took almost three months, till March 31, for Chicherin to answer Krestinsky's note. Roerich would have been pleased by the reply had he waited for it, but by the time it reached Berlin, he was back in India. The letter is worth examining, because it says much about how the Soviets perceived

Roerich and puts paid to some widespread but flawed assumptions about their interactions with him. Chicherin authorized Krestinsky to grant Roerich a visa and urged him to continue cultivating the artist: "Please do not let slip the half-Buddhist, half-Communist you wrote about and whom you put in contact with Comrade Astakhov. So far, we have never had a solid bridge to these important places, and we cannot allow ourselves to lose such an opportunity. However we use it, it will demand extremely serious discussion and preparation. Exactly who will deal with this, now that Comrade Astakhov has left Berlin? We must place this in the hands of someone who is interested in Eastern affairs and understands the East well."[88] Chicherin's excitement is explained by his country's aims and difficulties in Asia. Since coming to power, the Soviets had dreamed of Asia's revolutionary potential; the road to London and Paris ran through Peking and Delhi, insisted Lenin, hence his famous injunction to "set the East ablaze!" Chicherin saw closer ties with Tibet as an important step toward that goal, and he planned to follow the aforementioned Khomutnikov and Borisov expeditions with at least one more mission to Lhasa. Two things, however, constrained him. First, Tibet experts were thin on the ground in the USSR, and because most were closet Buddhists and so-called bourgeois specialists educated before the revolution, the regime did not wholly trust them. Second, Chicherin's hands were tied by Stalin's China policy, which involved the controversial decision—adopted after

rancorous debate with Trotsky—to back Sun Yat-sen's Nationalist Kuomintang (KMT) Party in its effort to reunify that broken land. One of Sun's core principles was the restoration of Chinese suzerainty over the former empire's outlying possessions, and the USSR could hardly arm and equip the KMT while treating openly with Tibet as if it were an independent state. Therefore, anyone capable of subtly improving relations between the Kremlin and the Potala was worth a second look.

Along with excitement, the dominant tone of Chicherin's and Krestinsky's letters is surprise. Both men viewed Roerich as a windfall, which goes a long way toward disproving assertions that he had started spying for the Soviets in America, if not earlier.[89] Chicherin was of sufficiently high stature to know or find out whether the artist was a Comintern or secret police operative, and in their correspondence, neither he nor Krestinsky, nor the OGPU's Astakhov, spoke of Roerich as a known Soviet asset. These letters also cast doubt on the belief held by some that Roerich and Chicherin had been friends at Saint Petersburg University, a point raised in chapter 2. The two men's exchanges in the 1920s contain no sign of familiarity, much less amity, and if they knew each other at all during their school years, it was most likely in passing.[90]

After meeting with Krestinsky and Astakhov, Roerich dashed to Paris, where he did a great deal in a very short time. He met Ivan Bilibin, and the two of them went to the suburb of Vaucresson, where Princess

Tenisheva had relocated after the revolution. Roerich kept silent about the recent change in his political persuasion, but spoke with gusto about life in India and his upcoming expedition. Tenisheva, long interested in the migration of peoples, particularly wished Roerich "to find, in the depths of Asia, the necessary data" to prove the then-fashionable theory that Tibet was the ancient homeland of the Goths—something Roerich later claimed to have accomplished.[91] Tenisheva died in 1928, while Roerich was on the trail in Asia, making this their final encounter.

More practically, Roerich convinced the French government to provide him with a temporary passport, even though he did not hold French citizenship. From the ambassador of the Chinese Republic, he received a visa to enter the frontier province of Sinkiang (Xinjiang), known then as Chinese Turkestan.[92] Also in Paris, Roerich met with Bolshevik stalwart Leonid Krasin, the USSR's plenipotentiary in France. This session he enjoyed more than the one with Krestinsky. An engineer and veteran diplomat, Krasin was one of the Party's "god-builders" and a fervent believer in Biocosmism, which envisioned a future when space travel would unlock the secret of universal immortality. Roerich had known Krasin in 1917, and the two had many acquaintances in common, including Gorky and Lunacharsky. Krasin was more likely than most Bolsheviks to give the artist an open-minded hearing, and Roerich considered their conversation to have been a

success. Even so, when he left Paris, he did not have the Soviet visa he wanted.

Roerich's next destination was Marseilles. There, on December 28, he boarded a Japanese liner, the *Katori Maru*, sailing to Yokohama with ports of call in Egypt and Ceylon. Maurice returned to America; keeping Roerich company now was Vladimir Shibaev.

The voyage passed without incident. When their ship docked in Port Said, Roerich and Shibaev toured the Great Pyramids at Giza, and they visited Djibouti, the capital of French Somaliland. Roerich's hopeful mood is captured in this letter, written to Vladimir while crossing the Indian Ocean: "I cannot entrust to paper a description of all that has taken place lately, except to say that we are on the verge of achieving something unprecedented. The word 'Beluha' has been set down in writing, and an invisible stride toward Siberia has been taken. Everything is coming to pass as it should, and you would not believe it if I were to tell you everything that has happened in New York, Chicago, Paris, and Berlin."[93]

Roerich and Shibaev left the *Katori Maru* when it put into the Sri Lankan port of Colombo. After viewing sites of Buddhist worship there, they crossed to India's eastern shore, entering via Dhanushkodi on January 15, 1925. They made three stops en route to Darjeeling. In the French enclave of Pondicherry, Roerich called on the philosopher

Aurobindo Ghose, a controversial figure in India's independence movement. Years before, in 1905, the Cambridge-educated Ghose had advocated political violence and spent months in prison on charges of sedition. Claiming to have been visited in the spirit by Vivekananda, Ghose dedicated himself to yoga and placed himself outside British jurisdiction by moving in 1910 to Pondicherry. There, he founded an ashram and achieved fame for his commentaries on the *Bhagavad Gita*. When Roerich met him, he was a year away from giving up public life, and whether the two spoke more of politics or spirituality is impossible to know. They saw each other several times in the future, and Roerich spoke at Ghose's seventieth birthday in 1942.[94]

Next came Adyar and the TS headquarters. On January 18, Roerich and Shibaev attended the opening of the Adyar Collection of Spiritual Art, to which Roerich donated *The Messenger*. Annie Besant was not present, but Roerich met the vice president, Jinarajadasa, and the twenty-year-old Krishnamurti, visiting from his new home in California. In public, Roerich accepted Jinarajadasa's praise and spoke of the new Blavatsky Museum as a "House of Light." Privately, he mocked Krishnamurti's pious insistence on sitting on the ground as they talked (which did no favors to the artist's aging knees) and related with amusement how Shibaev almost knocked over the urn containing Blavatsky's ashes.[95] Given Helena's recent repudiation of Besant's leadership, these jibes come as no surprise. Up

the road lay Calcutta, where Roerich paid a visit to Soumendranath Tagore, the poet Rabindranath's grandnephew.[96] A radical with ties to M. N. Roy, the head of India's Communist Party, Soumendranath may have met with the artist on a purely social basis, though they likely talked politics as well. The British placed a note about this meeting in Soumendranath's file, and a copy in the dossier they were now keeping on Roerich.

Once Roerich and Shibaev reached Darjeeling, the family spent February preparing a move to Kashmir, on the northwest frontier. From there they hoped to enter the mountain state of Ladakh, or Little Tibet. Having sublet Talai-Pho-Brang, the Roerichs departed on March 5, crossing northern India and arriving in Srinagar, the Kashmiri capital, a week later. They stayed at the Hotel Nedou, strolled through the magical Shalimar gardens, and took houseboat tours of lakes Vular and Manasbal. Roerich painted the local scenery and the Gilgit Path leading into the mountains, but the modern city, with its "hideous" new architecture, proved not to his liking.[97]

The next months were a time of making ready and waiting fretfully. Kordashevsky, to whom the Roerichs mailed a Kashmiri sword, was told in July to await orders for a rendezvous in Asia.[98] Shibaev went back to Riga, then to Paris, where Horch and Lichtmann were to join him in May and submit the Beluha prospectus to Krasin. Chapter 11 will describe how these talks fared, but it can be said here that Nicholas

and Helena spent the entire spring worrying about them. Equally anxious about his still-nebulous arrangments with the USSR, Roerich sent letters to Astakhov, Krestinsky, and Chicherin, trying without success to settle on a concrete plan. He and Helena were sure by now of the rightness of their cause. In May 1925, they experienced their "Lenin is with us" moment.[99] Also that month, they had a "most interesting" letter from Agvan Dorjiev, seeming to confirm the renovationist strategy of synchronizing a more "modern" Buddhism with communism.[100] In July, Roerich told Chicherin that "the advice and sympathy of the mahatmas, along with a remarkable confluence of prophecies, has provided new solutions to the question of how the East will evolve."[101] He also mentioned, "At [Lenin's] behest, I have been working for a number of years on how to apply religious belief to communism." This remark no doubt astonished Chicherin, who knew how Lenin abhorred this kind of "god-building."

But a sense of rectitude was no adequate guide to action. Nor did the Roerichs, rushing faster than the cogs of Soviet bureaucracy, receive any reply to their letters. Forced to strategize without guidance from Moscow, they opted first to go to Ladakh. From there, they would shift to Chinese Turkestan, then see what circumstances dictated. ("If we are not allowed into Turkestan, where are we to turn?" Helena asked Morya. "To China itself," Morya answered, "but let us not speak of such a possibility."[102]) George would go to Moscow if further coordination with the

Kremlin proved necessary, while Nicholas and Helena, hoping to meet the Panchen on the way, traveled to the Altai, Mongolia, and Tibet. If they located the abode of the Great White Brotherhood, Helena would remain there; Nicholas would continue configuring the Union of the East. Tibet and Mongolia were to be set aside as a special preserve for prayer and spiritual development. China, India, Afghanistan, and Ferghana—part of Russian Turkestan—would be kept open for commerce and travel.[103]

Before any of this, the Roerichs needed permission from the Government of India (GOI) to enter Ladakh. They were initially opposed by an uncooperative Major Hinde, but Roerich then went to John Barry Wood, the British resident in Srinagar, asking if he and his family could spend a year in Leh, Ladakh's capital, "to visit monasteries, paint panoramas, and translate original manuscripts and folklore."[104] He pledged to return to India by no later than September 1926, and he offered three testimonials: one from Lady Lytton, a second from Cecil Harcourt-Smith of the Victoria and Albert Museum, and another from Mitchell Carroll, the director of the Archaeological Society of Washington. Louis Horch and Frances Grant appealed to the State Department, and the US Embassy in London passed along the department's opinion that "this undertaking is bonafide and financed by American capital for artistic purposes."[105] On April 20, Wood cleared Roerich to travel to Ladakh. In June, Roerich petitioned to modify his route: instead of coming

back to India, he wished to go to Chinese Turkestan in October 1926, then return to America via China and Japan. The GOI acceded.

Here, bureaucratic compartmentalization worked in Roerich's favor. The State Department spoke up for Roerich only days before the US Passport Control Office generated its May memorandum about his possible communist sympathies. And when State forwarded that memo to London, the Foreign Office and the Raj failed to communicate with each other. No one cross-referenced Roerich's Ladakh application with the reports filed about his January meeting with Soumendranath Tagore. As one rueful official later explained, it appeared in the spring of 1925 that "nothing was on record against him, and he was well vouched for."[106] It was the last time British authorities would regard him so benignly.

In April, the Roerichs left Srinagar for the Pir-Panzal foothills, setting up a base near Gulmarg and waiting for their request to be approved. Snow still lay on the ground, and hailstorms and downpours described by George as "terrific[ally] violent" pounded the camp until the arrival of summer.[107] Nicholas completed more landscapes, and the family assembled its caravan, hiring porters and more than eighty ponies to haul their gear to the Ladakh side of the Zoji Pass. Foodstuffs included Washington's instant coffee and packets of powdered milk, while George stocked the first-aid kit with bandages, jars of aspirin, disinfectants, a set of syringes, a stethoscope, and a sphygmomanometer for reading blood pressure. The family purchased fur-lined sleeping bags, and Nicholas and Helena had a large waterproof tent made specially by Abercrombie and Fitch. Among the other supplies were George's dictionaries and grammars; Nicholas's paints, brushes, sketchpads, and canvases; and a portable Victrola, complete with an assortment of records.[108] The family converted much of their cash into various currencies, especially Mexican dollars, which, thanks to their high silver content, were enthusiastically accepted as coinage throughout Asia.

Permission to travel came early enough to allow Roerich to depart when he needed to: during the late summer, after the monsoon rains began to subside, but before snow started closing the high passes to Ladakh. In August 1925, the time came to set forth. With an open road before them and a sense of destiny in their hearts, the Roerichs took the first steps on a journey that would last almost three years and cover a distance nearly equal to two-thirds the circumference of the earth. They expected nothing less than epoch-changing results.

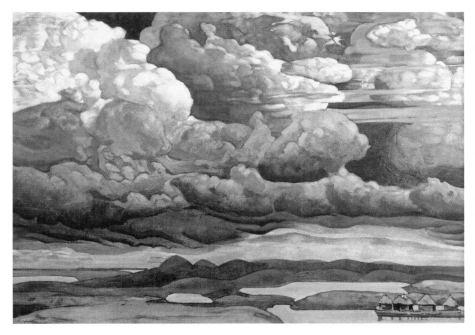

Illustration 13. *Heavenly Battle* (1912). In this second version of a canvas from 1909, a prehistoric community is dwarfed by the natural world's primordial grandeur. Here and in dozens of related works, Roerich idealizes the Stone Age as a robust era of spiritual purity and communal solidarity, whose physical perils are to be preferred to the decadence and alienation of modern times. State Russian Museum, Saint Petersburg, tempera on cardboard, 66 × 95 cm.

Illustration 14. *Human Forefathers* (1911). The bear-charming piper in this canvas recalls Orpheus from Greek mythology and Lel, the flute-playing shepherd from the Russian tale of the Snow Maiden. The scene alludes to a Slavic folk belief that human beings descended from bears. State Museum of Oriental Art, Moscow, tempera on canvas, 85 × 156 cm.

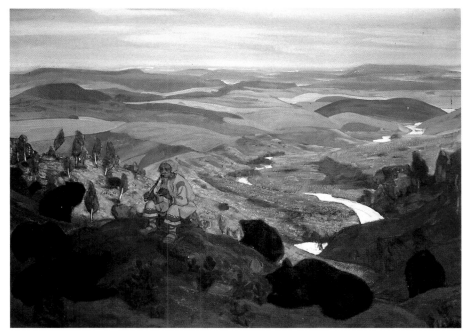

Illustration 15. Study from 1908 for "Polovtsian Encampment," set design for *Prince Igor* (1909). The infinitude of steppe and sky, and an untamed vibrancy wholly in keeping with the orientalizing, "Scythian" impulses of Borodin's opera. Roerich's first major triumph as a stage designer, and a significant factor in the spectacular success of Diaghilev's Ballets Russes when it opened its first season in Paris. State Russian Museum, Saint Petersburg, tempera and pastel on cardboard, 43 x 60 cm.

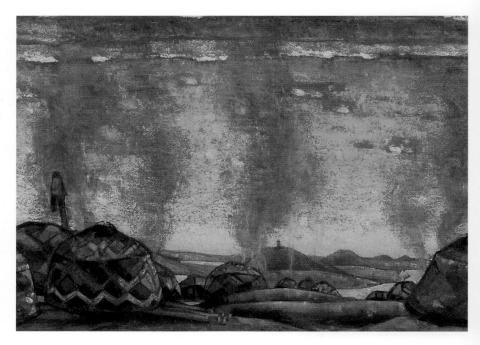

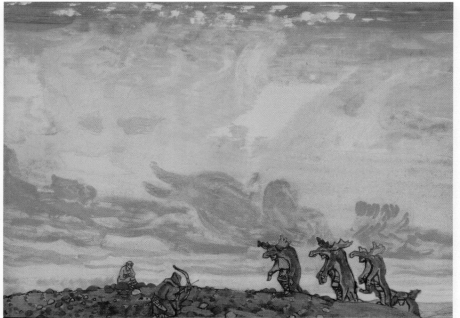

Illustration 16. "The Great Sacrifice" (second variant), set design for *The Rite of Spring* (ca. 1912). Ancient Slavs stage a mock hunt as part of their springtime rituals. Roerich hoped to turn this scene into one of several sets for The Rite's first act, but it was used instead to decorate the entr'acte curtain. Last held by International Center of the Roerichs, Moscow, tempera and pastel on cardboard, 54 × 75 cm.

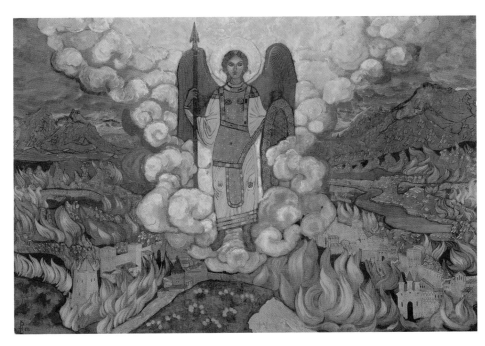

Illustration 17. *The Last Angel* (1912). The first of Roerich's "prophetic" canvases, so called by critics for how they captured the anticipatory dread haunting Europe before World War I. Roerich was prompted to paint this apocalyptic tableau after waking up from a dream about the end times. Nicholas Roerich Museum, New York, tempera on cardboard, 52.5 × 73.8 cm.

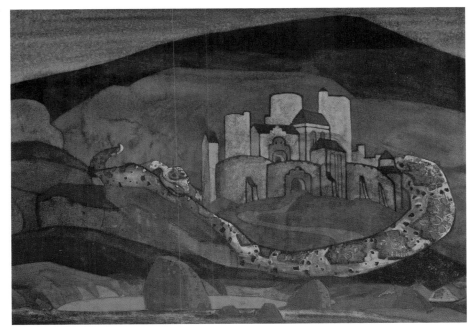

Illustration 18. *The Doomed City* (1914). Another of Roerich's "prophetic" paintings, and one of many scenes in which a medieval city—frequently used by Roerich to symbolize civilization and its attainments—is threatened by danger. This eerie piece was owned for a time by Maxim Gorky and later inspired a novel of the same title by the renowned Soviet science fiction authors Boris and Arkady Strugatsky. Private collection, tempera on cardboard, 51 × 75.6 cm.

Illustration 19. *Procopius the Righteous Praying for the Unknown Travelers* (1914). The most serene of the religiously themed canvases that Roerich painted to ward off despair during World War I. The equation of river travel with spiritual progress became a standard metaphor in his work. State Russian Museum, Saint Petersburg, tempera on cardboard, 70 x 105 cm.

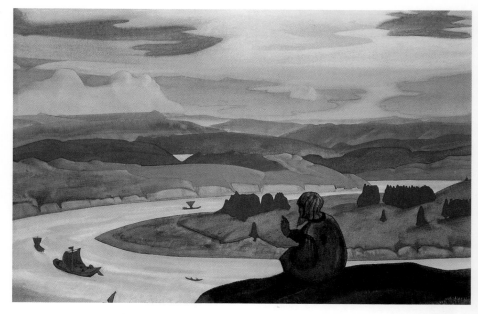

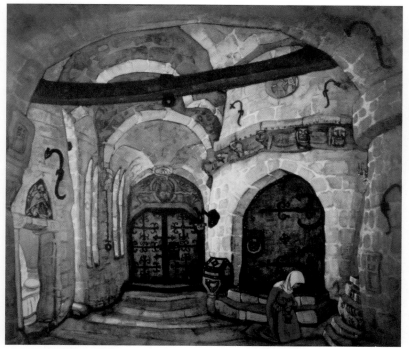

Illustration 20. "In the Monastery," set design for *Sister Beatrice* (1914). A scene from the 1901 play by the Belgian Symbolist Maurice Maeterlinck, for whom Roerich felt great affinity. This 1914 production was staged to rally support for Russia's World War I effort and to raise funds for Belgian refugees displaced by German invaders. State Russian Museum, Saint Petersburg, tempera on cardboard, 75.5 × 86 cm.

Illustration 21. *Song of the Waterfall* (1920). Part of the Indian-themed "Dreams of Wisdom" series Roerich completed in London. A particular favorite of the Nobel Prize–winning poet Rabindranath Tagore, who began his long acquaintance with the artist's family at this time. Nicholas Roerich Museum, New York, tempera on cardboard, 235.2 × 122 cm.

Illustration 22. *Padma Sambhava* (1924). The "Lotus-Born," considered by tradition to have played a leading role in bringing Buddhism to Tibet. Part of Roerich's "Banners of the East" series. Nicholas Roerich Museum, New York, tempera on canvas, 73.8 × 117 cm.

Illustration 23. *Dorje the Daring One* (1925). A lama sits calmly as the Tibetan guardian deity Mahakala materializes before him. Part of the "Banners of the East" series. Nicholas Roerich Museum, New York, tempera on canvas, 74 × 117.5 cm.

Illustration 24. Roerich finishing *The Queen of Heaven* in the Church of the Holy Spirit at Talashkino (1914). Roerich sits to the left, his younger son Sviatoslav beside him. His brother Boris stands in the middle, while his older son, George (Yuri), rests on the floor. This remarkable image, ostensibly the Madonna, is a pantheistic goddess blending Christian, Buddhist, and Hindu elements into a syncretic whole. Roerich was working in this church when he received news of the outbreak of World War I. NRM Archive, New York, ref. no. 400455.

Illustration 25. *Mother of the World* (1924). Arguably Roerich's finest apotheosis of feminine divinity, following the same universalist pattern established while working on the Talashkino *Queen of Heaven*. Part of the "Banners of the East" series. Nicholas Roerich Museum, New York, tempera on canvas laid on cardboard, 98 × 65.4 cm.

CHAPTER 11

Searching for Shambhala, 1925–1928

Writing in 1925 about the Shambhala prophecies she claimed were surging through Asia like a stormfront, the French Buddhist Alexandra David-Néel insisted to her fellow Europeans that "we can smile at these illogical dreams, but in the immense regions where they are accepted with unshaken belief and with the greatest reverence, their influence gains power and foreshadows events completely unforeseeable by the most skillful of politicians."[1]

Only months before, Roerich had conversed about these very omens with David-Néel herself. They were the undeclared reason he and his family would trek for thirty-four months through eight thousand miles of the world's most rugged terrain (see Illustration 27).[2] Exactly what he thought they portended, though, remains unknowable. Did they merely symbolize for him a

transfer of power to a new state that, however theocratic, would function like any other polity? Or did he anticipate a truly cosmic transformation of physical reality? In any faith, eschatological questions—those pertaining to the end times—are among the most challenging to comprehend in concrete terms. As the priest-scientist Teilhard de Chardin, another explorer who roamed Asia with humanity's fate on his mind, once asked, "How does it operate, this gradual conquest and assimilation of Earth by Heaven?"[3] All that can be said for sure is that, when Nicholas and Helena proclaimed that "the sphinx of Asia remains safeguarded by the great deserts . . . and its hour has come," they expected incredible changes to flow from their secret attainments.[4]

Contrast this with the prosaic intentions Roerich spoke of publicly. He wished to paint scenes of Asia, he told the press.

As scholars, he and his son would study "ancient monuments," "observe the present condition of religions," and trace the "migration of nations."[5] Nothing, of course, about strategic or mystical goals, an omission that explains the odd sense of purposelessness pervading the story Roerich eventually revealed to wider audiences. For all the self-praise heaped upon it, Roerich's expedition resulted in few tangible accomplishments: it broke no records, unearthed no important archaeological treasures, and mapped no uncharted territory. Examined closely, the ethnographic insights attributed to him are a mishmash of anecdotes assembled not for any academic purpose, but to manufacture the impression that millions of Asians were awaiting the appearance of a new messiah. Even as an act of adventure, the expedition, though not without risk, hardly represented a death-defying plunge into trackless wilds. It was the sort of outfit that Roerich's contemporary, Percy Harrison Fawcett of England—famed for his fatal search in the Amazon for the lost city of "Z"—scorned as "top-heavy" and "pampered . . . linger[ing] on the fringe of civilization and bask[ing] in publicity."[6]

The towering conundrum, then, is that what mattered most about this chimerical venture are the things that could not be said about it openly. During the expedition, Asia revealed itself to Roerich in his art—the journey's truest legacy—but not one component of his plan *for* Asia was realized. Holy lands remained hidden, the Union of the East was stillborn, and reconciliation with

Soviet Russia proved futile. "Pilgrims are going to Shambhala and Belovodye," Roerich had pronounced with joy. "Behind the White Mountains, the bells of the abodes are ringing. The Radiant City stands upon a pure lake."[7] But such tidings proved premature. All his wanderings brought him not a step closer to his grand ambition.

On August 8, 1925, after three months of preparation at Gulmarg, the Roerich Central Asian Art Expedition began marching into the mountains, on the eastern road from Kashmir to Ladakh. Riding on horseback, but using vehicles and pack animals to shuttle gear through the passes, the Roerichs expected to reach Leh, Ladakh's capital, in two and a half weeks.

Trouble struck on the first day, at Tangmarg. There, where the Roerichs' equipment was to be loaded onto trucks, a minor dispute spun out of control, causing British authorities to question whether they should have approved Roerich's plans. As Roerich describes the event, "a band of ruffians attacked our caravan and began to beat our men with iron rods; seven of our men were hurt. It was necessary to preserve order with revolvers and rifles."[8]

This Hemingwayesque terseness hides a less dignified reality and alerts us—not for the last time—to the unreliability of *Altai-Himalaya* and Roerich's other accounts of the journey. According to John Wood, the British resident in Kashmir, the quarrel

began when the drivers hired by the Roerichs objected to the overloading of their trucks. They and Roerich's servants came to blows, and although no one was hurt, Roerich panicked. As the local Political Department reported: "Roerich, who was never in the slightest danger of assault or molestation, completely lost his head, produced firearms and despatched [a] series of ridiculous telegrams demanding armed police protection from [an] organised mob. [The] Magistrate, Residency Surgeon, and police hurried to the spot and found that [the] very ordinary fracas, as described above, had occurred."[9] Roerich "came to his senses" and, in a telegram to Wood, "stated that he had no complaint to make . . . he gave as an excuse for his behaviour his defective knowledge of English."[10] Wood permitted the expedition to proceed, but added his personal opinion that Roerich had been "extremely foolish," asking whether "so unbalanced an individual should be given facilities for visiting frontier districts."[11]

After Tangmarg, the stifling humidity of August, with its lingering rains, tormented the Roerichs, as did clouds of biting insects. The threat of cholera weighed on their minds, and they feared looters. Near Ghund, the horses fell sick after eating poisonous grass, but recovered when fed bicarbonate of soda. The family struggled to acclimate to higher elevations; the Zoji Pass, the gateway to Ladakh, took them above eleven thousand feet. Still, the route was lined with resthouses and stables, and passage through the Zoji brought relief. The

rain stopped. Cool, dry air carried the scent of mint and sage. Best of all, the Roerichs were now in the Himalayas, and with every turn of the road, a new vista presented itself: the quiet depths of ice-cold lakes, the crystalline torrent of water falling to the rocks below, and the upthrusting peaks. One evening, Roerich unpacked his gramophone to play selections from the Ring Cycle. He never forgot the moment: "Over the mountains rings out 'The Forging of the Sword' and the 'Call of the Valkyrie' and the 'Magic Fire Music' and the 'Roar of Fafner.' I remember Stravinsky once was ready to annihilate Wagner. No, Igor, this heroic realism, these harmonies of achievement, are not to be destroyed. And the music of Wagner is also true, and rings remarkably in the mountains . . . his sweep is fit for the heights of Asia. Humanity still lives by beauty."[12] At the Maulbeck, Lamayuru, and Basgo monasteries, Nicholas and George examined temple art for signs of Maitreya and Gesar Khan, the beloved warrior-king of Himalayan sagas. The expedition stopped at Spitug Monastery on August 26. That evening, it entered the city of Leh.

As the Roerichs neared Leh, George noted that its multitiered palace, dominating the skyline from miles away, resembled the Potala, the Dalai Lama's great citadel. Indeed, because it had long been governed from Lhasa before passing under Indian rule, being in Ladakh was, culturally and

spiritually, the next best thing to being in Tibet itself. The family looked forward to visiting the local monasteries, Sheh and Hemis.

Not that they wished to tarry. Roerich had lied when he told the British he meant to stay in Ladakh for a year. His plan all along had been to get to Chinese Turkestan as soon as possible, and from there to Mongolia, the USSR, and Tibet, in whichever order events permitted. For now, he had his eyes on the Chinese city of Khotan (Hotan), three hundred miles away on the other side of the Karakoram Range, and if he wished to get through the mountains before snow closed the roads, there was no time to waste. He commissioned two teamsters to rent animals and hire porters. In mid-September, the expedition was joined by an unnamed Tibetan lama who knew Russian and, in the weeks to come, played the roles of scout and translator. It has been supposed that this was either a pupil of Dorjiev's or, less probably, the assassin-spy Yakov Bliumkin, sent in disguise by the Soviets to monitor the expedition.[13]

Not till the third week of September would the caravan be ready, so the family toured the area and admired the scenery. They conversed with Tibetan envoys and Mongolian monks, receiving a "wave of news" and, if *Altai-Himalaya* speaks true, a happy message that "they await our arrival in Lhasa!"[14] In addition, Roerich hoped to use the archives of Hemis Monastery to verify a belief cherished by new age adherents since the late 1800s—namely, that Jesus Christ,

at some point in his life, had traveled to the Himalayas and studied with Buddhist sages there. Thanks to a natural process of religious syncretism, a sizable body of folklore had grown up about Christ in Central and South Asia, but what most seized the imagination of Western occultists was the 1894 publication of Nicolas Notovitch's *The Unknown Life of Jesus*. The author, a Russo-Polish journalist, claimed to have discovered in the Hemis library a new gospel called "The Life of Saint Issa": a Tibetan document translated from a centuries-old Pali original, detailing how Jesus spent his teens and twenties—the "lost years" unaccounted for in the Bible—in India, Nepal, and Tibet. Despite a savage debunking by Max Müller, the doyen of Indological scholarship in the 1800s, as well as follow-up interviews with monks and abbots at Hemis who contradicted Notovitch's story, *The Unknown Life* went through eight printings in its first year and has never lost its popularity.[15]

Sina had acquainted Roerich with *The Unknown Life* in 1924, and while in Leh, he was eager to validate its thesis on two levels.[16] First, he sought to confirm the Issa tale as an authentic example of Asiatic myth. More ambitiously, he hoped to prove that the tale was true in substance and that the historical Jesus had indeed walked the high roads to Tibet. In Ladakh, he painted canvases such as *Signs of Christ*, *Chalice of Christ*, and a majestic rendering of Sheh Monastery, pointedly titled *Crossroads of the Paths of Christ and Buddha*. Most stunningly, after visiting Hemis, Roerich credited

himself with a mammoth scholarly coup. "Definitive proof has come to us," he wrote, "that an ancient manuscript about Issa is contained in the Hemis Monastery. The chain of witnesses has been established, and all fairy tales about the document being false have been shattered."[17] Roerich scoffed at the academics and missionaries who had "slandered" Notovitch, and, in an essay called "Banners of the East" (an early draft of *Altai-Himalaya*'s opening chapters), he conveyed to American readers the dramatic tale of how Christ had "secretly left his parents . . . and turned toward the Indus to become perfected in the highest teaching [and] the laws of the Great Buddha."[18] Frances Grant sent the news forth: the *Chicago Tribune*, *New York Sun*, and *Boston Globe* were among the many papers that ran stories about Roerich's find, and "Banners of the East" was reproduced in *Roerich-Himalaya*, a luxurious album released by Brentano's in 1926.[19]

All the more startling, then, to see how sharply Roerich backed away from these first claims. Not that he ceased believing that the Issa tales were true, but he gave up insisting that he had located Notovitch's manuscript. For this misunderstanding, he blamed not his own exaggerations, but the "Sunday-story sensationalism" of the press.[20] By the early 1930s, he dismissed with asperity the "absurd rumors that in Asia, I seemed to have discovered an original document dating almost from the time of Christ. I do not know for whom and for what purpose such a version of the story was necessary."[21]

This not-so-subtle backtracking began even before *Altai-Himalaya* was edited into a coherent text, and between the book's clumsy organization and the alterations made while translating its Russian original into English, what actually happened at Hemis remains a riddle. In *Altai-Himalaya*'s final English draft, Roerich delivers a welt-raising diatribe against the "half-literate" monks there and imagines with outrage the priceless tomes "lying down below, out of sight, probably feeding the mice [and] perish[ing] in dusty corners"—implying, but not saying outright, that he was denied access to the monastery's library.[22] On the other hand, George is said to have confided to academic colleagues in the 1950s that he and his father *were* shown an Issa text at Hemis, but that it was fake.[23]

Why such inconsistency? One possibility is that Roerich, finding nothing, decided to say he had anyway, then lost his nerve at the prospect of keeping up such a pretense. Another is that he found some sort of text and convinced himself it was real, only to be persuaded otherwise by George. Tellingly, George says not one word about Christ-related myths in his own book, *Trails to Inmost Asia*, and he is said to have fallen out with his former teacher, the French orientalist Paul Pelliot, over the Issa claims made during the expedition. Either way, in the English version of *Altai-Himalaya*, Roerich substitutes vague terms like "legends" and "tales" where he had first spoken of "manuscripts" and "documents." Scrambling to save face, he adopts the tone, though not the

methodological rigor, of an anthropologist, speculating that the Issa myth might have been engendered by the eastward migration of Nestorian Christianity and detailing the different forms it took among various Buddhist and Muslim groups.[24] Ultimately, Roerich contended that his own analysis of "this wide literature" held more significance than a single text like Notovitch's. "In the end," he wrote, "the manuscript as such is less important than the vitality of this idea in Asian minds."[25] It was a final bit of salvage—or a classic case of sour grapes.

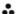

On September 18, the Roerichs left Leh with the goal of reaching Khotan in twenty-four days. The going was now much harder. The Karakoram range boasts the second-tallest peak in the world, K2, and the roadway through it crosses seven passes at an altitude of fifteen thousand feet or higher, leading the Swedish orientalist Sven Hedin to call it the "via dolorosa" of Central Asia.[26] (Not all agreed: Aurel Stein, Hedin's archrival—and no great friend of Roerich's—described the road more phlegmatically as "a tour for the ladies.")

Less than thirty miles from Leh waited the first obstacle, the Khardong Pass. Approaching over a "naked Arctic plain," the party transferred its cargo from packhorses to slower but surer-footed yaks, then climbed through on September 20.[27] Attempting to paint the Khardong glacier, Nicholas numbed his fingers so badly that he

barely avoided frostbite. Once through the pass, the Roerichs descended into the Nubra Valley, a sandstone ravine abloom with briar roses and tamarisks. They stopped at Sandoling Monastery, which had just dedicated a new altar to Maitreya.

The last days of September, which saw the expedition through the Karaul, Sasser, Debsang, and Karakoram Passes, proved the most difficult yet. Icy winds made each crossing an ordeal. The bones of long-dead animals littered the trail, and rock cairns dotting the pathway reminded everyone that the mountains claimed human victims as well. The Roerichs spied the peak of K2 from the crest of the Debsang Pass, but mist and snow more often obscured their view. On September 30, they traversed the "black throne" of the Karakoram Pass, a notch cutting through the mountains at over eighteen thousand feet. Another week brought them through the Suget Pass into Sinkiang and past the Chinese outpost of Suget Karaul. Following the Karakash River along the edge of the Taklamakan Desert, they encountered temperatures so hot that their stirrups burned their feet through the soles of their boots. The final pass, Sanju-La, was crossed on October 7, and the party rested at an oasis afterward. Here, a "kind and obliging" customs official welcomed the Roerichs, but advised them to bypass Khotan, with its capriciously cruel governor, and go on to Kashgar (Kashi). Too exhausted to cover the extra three hundred miles, they decided—imprudently—to try their luck in Khotan.[28]

The caravan spent four days riding to the city, within sight of the Kunlun Mountains and the Taklamakan's pink sands. They arrived on October 14, only two days behind schedule. Once a prime center for the mining and sale of jade, Khotan was less prosperous now, with "long dirty bazaars and demolished clay houses."[29] Slavery was common, as the Roerichs found when Helena set up house and asked neighbors how much she should expect to pay her servants. To her horror, she was told to "buy a dozen girls"—only 30 rupees each—"instead of hiring help."[30] The family hoped to be here no longer than it took to replenish supplies and move northwest to Kashgar.

Instead, three and a half months passed before they were allowed to leave. In a China wracked by civil war, the travel permits so carefully collected from the republic's embassy in Paris carried little weight, bearing as they did the stamp of a Peking too weak to impose its will. Warlords ruled Manchuria and much of the east coast and central plain, while the Kuomintang, led by Chiang Kai-shek and aided for the moment by Soviet Russia and the Chinese Communist Party, controlled the port of Canton (Guangzhou). As for Sinkiang, it was a notoriously hard place at the best of times for foreigners to travel. "To waste weeks on end is the common lot of anyone who adventures into these parts," Teilhard de Chardin said of it, and two extra factors worked against Roerich.[31] China's civil war was entering a new and more violent phase, raising added concerns about security. Moreover, Yang

Tseng-hsin, Sinkiang's governor-general, had been a rock-ribbed Russophobe since coming to power in 1911.

On Yang's orders, then, Khotan's governor, the Taotai Ma Ta-jen, denied Roerich permission to proceed farther into China, suggesting that he return to India through the Karakoram—an impossibility this late in the season. Fearing that Roerich was a spy sent to map Turkestan for nefarious purposes, the Taotai forbade him to take photographs or paint outdoors. No member of the party was allowed to go beyond city limits or move about without escort, and all weapons were confiscated. The Taotai's men searched the family's quarters several times, amusing themselves on one occasion by pawing through Helena's lingerie. Echoing frustrations voiced by Sven Hedin, Aurel Stein, and Roy Chapman Andrews, Roerich wearily commented, "Dear friends, if you want to try out your coldbloodedness and patience, go to Khotan."[32]

No telegraph was available to Roerich, nor was there foreign representation in Khotan. For help, the family contacted the two nearest consulates, both in Kashgar. Secretly, Roerich sent word to the Soviet consul, Max Dumpis, asking him to relay messages to Moscow, and to intercede with Yang and Taotai Ma.[33] Openly, he relied on the good offices of the British, against whose interests he was plotting. In December, referring to himself as the leader of an American expedition, and hinting that he himself was a US citizen, Roerich persuaded Major G. V. B. Gillan, Britain's Kashgar consul, to

wire a call for aid to Louis Horch. Horch forwarded this transmission to the US State Department, asking for help.[34] Adding his voice to Horch's was Charles Crane, who wrote Nelson T. Johnson of the Division of Far Eastern Affairs, affirming that "Professor Roerich . . . is probably the greatest living painter, of vast power and a rare sympathetic understanding of Eastern people. His present journey is entirely an artistic one and there is no reason why he should not be allowed to continue his work."[35] Crane invited Johnson to view Roerich's paintings in New York, while Horch sent him a copy of the artist's book *Adamant*.[36] What Johnson made of such courtesies can only be guessed at, but he moved the case forward. Gillan was better positioned to intervene directly, but "averse to further utilisation of Governor [Yang's] unusual favor" without knowing whether Roerich was really an American—and without knowing why he was several hundred miles from where he had told the Government of India he would be spending the winter.[37]

While wires hummed and papers shuffled, the Roerichs languished. Taotai Ma offered one alternative: the expedition could leave, but only if it surrendered its weapons and went east to Peking through Gansu Province via the Silk Road oasis of Tun-Huang (Dunhuang). The Roerichs refused on the ground that bandits and warring armies made Gansu unsafe, though their real objection was that such a course would draw them away from the Sino-Soviet border and any chance to reach Moscow.

The family then tried, but failed, to escape. The Taotai placed the Roerichs under house arrest, making the city's "gloomy medievalism" all the more depressing.[38]

To distract himself, Roerich caught up on his painting, which he was allowed to do indoors. Working from sketches, he completed scenes of Ladakh and the Karakoram road. He also began his "Maitreya" series: seven pieces dedicated to the Kalachakra prophecies. Dominating his palette was the color red, generally understood as a symbolic attempt to associate the Shambhala myth with Soviet communism.[39] In print, he linked these concepts even more explicitly, and for two years would write of Asia's faiths as if they were quasi-Marxist creeds of social justice. This spiritually themed propaganda was a clear attempt to encourage renovationist thinking about Buddhism among Soviet leaders; that Roerich was guided in this by Agvan Dorjiev is hinted at in an October reference to "Lama D." as a teacher of "true Buddhism."[40] Roerich claimed to know Indian mahatmas who "deny God both as philosophers and Buddhists" and Vedantists who did the same.[41] Moses, Zoroaster, and Confucius were "law-givers of communal welfare" who defended the wretched and powerless, while Buddha was "the great communist who preaches against property, against killing, [and] against intoxication."[42] The Russian original of *Altai-Himalaya* portrays Christ as even more of a proto-socialist: in India, he incurred the Brahmins' wrath by standing up for the lower castes, just as he would enrage privileged Pharisees

and Sadducees upon returning to Jerusalem. Roerich then avers that "Jesus was killed not by the Jewish people, but by the Roman state [and] wealthy capitalists" because he was a "Great Communist who carried light to the workers and the poor."[43]

The passages above were composed during Roerich's time in Ladakh. In Khotan, he and Helena translated tracts about communism and Buddhist unity into Kalmyk, Tibetan, and Mongol.[44] To appeal to Turkestan's Muslims, they spoke of an Islamic messiah as well: Muntazar, the "hidden imam" expected to return someday as the Mahdi, or "savior." Anyone who had lived through the late 1800s knew of the Mahdist holy war that British forces had spent nearly twenty years suppressing in Egypt and the Sudan, and the Qing dynasty had almost lost western China to a series of Muslim uprisings between 1856 and 1877. The specter of Islamic separatism terrified Sinkiang's masters, and, had any of them known Roerich was preparing to purvey Mahdist dogma there, he would have fared worse at their hands than he did. (Soon, the Roerichs expanded their prophetic discourse to include the Kalki-avatara, the future incarnation of the Hindu deity Vishnu.)

The Roerichs continued in this Marxist-messianic vein until the fall of 1927, after which they found themselves embarrassed by much of what they had written. To an extent, attempts to expunge awkward language from new editions of their work succeeded. By 1929, when English-language versions of *Altai-Himalaya* and *Heart of Asia* went to

press, Buddha and Christ had been transformed from "great communists" to "great teachers." Disapproving language about "capitalism" and "property," not to mention positive references to the USSR, vanished. There was, however, no sanitizing what had already been published. In America, every copy of *Roerich-Himalaya* was forever tainted by the ideological blemishes marring "Banners of the East." As for the pro-Soviet Russian texts that Nicholas and Helena completed in 1926 and 1927, the family went to extraordinary lengths to halt publication or recover copies already printed. But this proved a lost cause, and the price they paid for failure is revealed in chapters to come.

Liberation from Khotan came in January 1926. Permission to leave was granted on the nineteenth, and after reassembling their caravan, the Roerichs exited on the twenty-eight. Ostensibly for protection, but really for supervision, the Taotai assigned five armed horsemen as an escort. The expedition passed through Yarkand on February 6, and on the twelfth, the eve of the Chinese New Year, drew up to the walls of Kashgar.

The Roerichs spent two busy weeks here. Money had been cabled to them from New York, and there was mail to receive and send out. The caravan had to be resupplied, and the Roerichs saw to their health, visiting a Russian physician, Anton Yalovenko, and the medical staff at the city's Swedish mission. Nicholas needed dental work, and

there were concerns about Helena's constant headaches and fluctuating blood pressure. The family visited the city's landmarks, the most intriguing of which was the Miriam Mazar, held by local Muslims to be the tomb of the Virgin Mary.[45] A pleasant bonus was the company of Russian émigrés, most of them attached to the Russo-Asiatic Bank, once privately owned, now Soviet-controlled. Its employees treated Roerich with courtesy, both here and farther down the road.

Roerich's main task in Kashgar was to ensure continued progress, this time toward Urumchi (Ürümqi), Sinkiang's capital. Here he played a double game with the diplomats who had gotten him out of Khotan. Reassured by the United States that Roerich's expedition was bona fide, Major Gillan, the amiable Scotsman who represented Britain in Kashgar, felt easier about helping him.[46] Helena found Gillan "very friendly"; for his part, Gillan thought the Roerichs amusingly eccentric, though after listening to Nicholas go on about what an "ignoramus" Taotai Ma had been, he warned the artist against voicing such "intolerant attitude[s]" too loudly.[47] He also thought it foolish for Roerich to leave Kashgar when the military situation ahead was so unstable. But Roerich insisted, and Gillan negotiated permission for him to go to Urumchi, believing like the Raj and the State Department that he planned to make haste from there to Peking by the safest route.[48]

Gillan would have been slack-jawed with shock to read five years later in George's *Trails to Inmost Asia* that "the Consul and all the Europeans were of the opinion that it was absolutely necessary [for us] to go to Urumchi, [meaning] quite a change in our previous plans."[49] What he did not know was that Roerich was meeting simultaneously with the Soviet consul, Max Dumpis, working out how to pass into Soviet Turkestan and then to Moscow. Soviet officials still had little idea what to make of Roerich—Dumpis's superior, the consul general Alexander Bystrov, noted how difficult it was "to clarify the exact nature of this strange enterprise"—but the artist was awaited in the capital with a degree of excitement, a fact that would have highly discountenanced Major Gillan.[50] So would any of the other Roerich-related notes that were piling up in Washington, London, and Delhi, but had not been properly collated, such as the Passport Office's 1925 report on Roerich's possible communist ties, or the GOI memorandum about his meeting with the Marxist Soumendranath Tagore. That February, British intelligence in India picked up rumors from Bengali revolutionaries about a Russian painter who had come to India with "a large sum of money for Bolshevik propaganda."[51] Had Gillan known any of this, he might have clapped Roerich in irons instead of setting his feet on the road to Urumchi. But he did not, and Roerich moved on.

Not that the artist appreciated this good luck. The trip's next leg would cover nearly a thousand miles and last a month and a half, and the difficulty of planning it threw him into a temper at every turn.[52]

Money had been wired from America, but the wrangling needed to persuade the Kashgar post to hand it over led Roerich to compare travel in China with being stranded among primitives in the Solomon Islands.[53] He could not find supplies or horses except at obscene prices, and the authorities placed irksome restrictions on the expedition: its cache of weapons was to remain sealed, and Roerich was not to paint outdoors. The caravan would again be shadowed by an armed guard. The half-month lost in Kashgar meant that the party would have to cross wetlands and several rivers just as the spring thaw brought floods of snowmelt down from the Tien Shan and Pamir.

The expedition took leave of Kashgar on February 26, heading east-northeast, with the Taklamakan, dubbed by Roerich "the apotheosis of lifelessness," on the right.[54] During the grueling first weeks, "sandy gray hopelessness" alternated with weed-choked, river-swollen marshes and patches of quicksand.[55] Helena fell sick, and not a day went by that Roerich did not rage about "the Sinkiang dance of death" or curse the Chinese government for its "buffalo"-like obstinacy. Ready for the moment to trade the antimodern ideals of his younger years for a speedier journey, and telling himself that there could be such a thing as "too much Ruskinism," he daydreamed of importing Western technology to eliminate the toil of traveling through "this dusty cemetery." "This is especially absurd," he wrote, "when you realize that a whole day of exhausting travel is equal to two hours'

ride by automobile or to an hour by aeroplane. I remember reading that Sir Aurel Stein was afraid the building of railroads and other signs of civilization would disturb the primitiveness of this country. And I have always been against the ugly evidences of civilization. But this country is so paralyzed that it needs a supermeasure of enlightenment."[56] This was not simply a question of comfort. It stemmed from the Shangri-La reflex that caused Westerners to blame Asia itself whenever its human reality fell short of their unrealistic preconceptions. Roerich was also envisioning what Asia would be like under his New Country's jurisdiction. Soon, he anticipated, there would be one community, governed by a single authority and speaking a single language—George recommended Hindustani—with no poverty, no graft, and no injustice. Before him now, Roerich saw a broken kaleidoscope of nationalities "dispersed in an unfathomable manner," divided by three hundred dialects in need of "reconciliation," and ruled abominably by corrupt tyrants or rapacious imperialists.[57] Every day he spent in China convinced him all the more that some firm hand was needed to set things right in Asia. "Who will be the one to clean these Augean stables?" he asked.[58] The Hercules he had in mind, of course, was himself.

Aggravation in Karashahr, which the party reached in late March, confirmed Roerich further in this thinking. Here, he hoped to propagandize among the local ethnic minorities, but most of the city was declared off-limits to him, and the one

important meeting he managed to arrange—with the Toïn Lama, the spiritual leader of the region's Torgut and Kalmyks—yielded unimpressive results.[59] Fluent in Russian, the lama listened with interest as Roerich described what he had learned and done in Sikkim and Ladakh, but hesitated to involve himself in the artist's plans. Asked to rouse his people on Shambhala's behalf, the elderly cleric grew thick-tongued with fear, mumbling "only when the time comes." The time *had* come, Roerich complained, but the Kalmyks and Kirghiz, he noted sadly, were too timid to throw off Chinese oppression, and the Torgut were "far from awakening."

The expedition suffered another disappointment as it prepared to depart. Two roads led to Urumchi, and if the Roerichs went directly north through the Tien Shan, they could shave four days off their travel time and enjoy cooler weather. But Karashahr's governors, wishing to keep the caravan in the lowlands for easier surveillance, ordered the family to proceed northeast along the Taklamakan Desert, then north across the Turfan Depression. Comparing himself to a motorist obliged to drive through New Orleans on his way from New York to Chicago, Roerich grew angrier with every step of this twelve-day journey. "We could have gone amidst the far-off snows, though the solitary mountains," but the "despotism of a stupid monster" compelled them "to drag [them]selves along this burning, stony desert."[60] Nor did things improve in the Turfan Depression. A swampy catchpocket for drainage from nearby streams, the Turfan may have been a "green island in a sandy wilderness," but it was the sickly green of decay.[61] The Roerichs found the fetid air "suffocating," and the area teemed with scorpions, mosquitoes, lice, and tarantulas the size of "pigeon's eggs."

By the second week of April, the party made its way clear of this unhappy place. Ahead was the Bogdo-olo, a mountainous spur cut off from the eastern Tien Shan by a wide valley. In that valley lay Urumchi, whose outskirts the caravan reached on April 11. The Roerichs were now within easy reach of the Soviet border—and would be in the USSR in just over six weeks.

In Urumchi, Roerich came face-to-face with Sinkiang's governor, Yang Tseng-hsin, a ruthless autocrat who had assassinated his way to power a decade and a half before. With his foreign minister Fan Yao-han, he received Roerich with gleaming smiles and elaborate courtesies. But at that same moment, his secret police were ransacking the Roerichs' quarters, in search of incriminating evidence—or anything worth pocketing. Roerich protested this abuse, but while he received unctuous apologies, no reparation was made.

Roerich endured more meetings with Yang and Fan, but his real business was no longer with the Chinese. For the next year and a quarter, he would be on soil controlled by the USSR or its ally Mongolia—all part of his original plan, however much he and

George later explained it with half-truths about having to abandon their original route through China in favor of one through Siberia.[62] He now entrusted his political fate to the Soviet consul general, Alexander Bystrov, who, fed by reports from Red Army intelligence and Max Dumpis in Kashgar, had been expecting him for weeks.[63] In April and May, Roerich spent hours in conversation with Bystrov, whom he describes in the English-language version of *Altai-Himalaya* as an unnamed but insightful interlocutor who discoursed with him about "the evolution of humanity and the movement of nations."[64] In his own diary, Bystrov says much about his meetings with the artist.[65] He listened patiently as Roerich expounded on such topics as cosmic effulgences and the fall of Atlantis, or offered to use a tanka bearing Morya's image to answer questions about the future. More remarkable still, Roerich claimed to have in his possession a casket containing soil that had nourished the bodhi tree beneath which Buddha had gained enlightenment; this he hoped to place in Lenin's tomb. (Helena's diaries indicate that the soil came from the less exalted site of Burhan Bulat, near Khotan.[66]) Of the Great Plan, he spoke as candidly as he had with Krestinsky and Astakhov. As Bystrov noted:

> Today I was visited by Roerich, with his wife and son. They told me many interesting things about their travels. They say they are students of Buddhism, in contact with certain mahatmas [Morya and Koot Hoomi], from whom they frequently receive directives. Incidentally, they tell me that they are carrying letters from these mahatmas to Comrades Chicherin and Stalin. It seems that the mahatmas have set them the task of joining Buddhism with Communism and creating a great eastern union of republics. Among Tibetans and Indian Buddhists, there is a popular belief (or prophecy) stating that liberation from foreign oppression will come precisely from Russia, from the "red ones" (Northern Red Shambhala). The Roerichs are traveling to Moscow to convey a number of such prophecies. They also have with them Indian and Tibetan paintings on this theme. From Roerich's words, it is clear that they are journeying to India, Tibet, and western China to fulfill the mahatmas' commands, and they must turn to the USSR, then to Mongolia, where they are to liaise with the Tashi [Panchen] Lama (the Dalai Lama's second-in-command in charge of spiritual matters), who has been exiled from Tibet to China. The Roerichs are to bring the Tashi Lama to Mongolia, and from there put into motion a spiritual movement for the liberation of Tibet from the English yoke.[67]

Apprised by Bystrov, military officers reported to their own superiors that Roerich, "calling himself an American, purports to have some relationship with the Buddhist

world and that a vast effort has begun to unite all Mongols from Lake Baikal to Khotan and Tibet."[68]

Such language raised eyebrows in Moscow, and these hours of conversation left Bystrov almost as puzzled as when the artist first arrived. "All this is rather obscure," he confessed, "and I still cannot grasp what kind of man Roerich is."[69] But however baffling the Soviets might find him, they had to consider that he might be telling the truth. And if he was an American or British spy, or a random element capable of interfering with their own ambitions in Asia, they needed to know. In mid-May, Georgii Chicherin authorized Bystrov to supply the Roerichs with visas and arrange their passage to the capital. Lengthening this process was the family's demand that Maurice and Sina Lichtmann be allowed to join them in Moscow. (There was talk of bringing Esther along, but, to her indignation, her paperwork did not clear in time.[70]) There also appear to have been arguments about citizenship. Rumors persist that the Roerichs applied for Soviet citizenship, but were denied. Others say that Chicherin tried to withhold the family's visas unless they accepted Soviet citizenship, but that Bystrov let the family in without pressing that point.[71]

Meanwhile, the Roerichs lingered in Urumchi, watching Easter and Ramadan come and go. As gifts to the Soviet people, Nicholas assembled a set of nine paintings: his "Maitreya" series from the previous fall, plus *Red Horses* and *The Time Has Come*,

which depicts a huge stone in the shape of a human head bearing Lenin's features. For companionship, he depended on expatriate Russians and the local postmaster, a gregarious Italian named Cavalieri. Periodically, he went through the façade of "consulting" with Yang and Fan, and he lunched a time or two with another explorer detained in Urumchi, the German geographer Wilhelm Filchner. Filchner, a veteran of journeys to Tibet, Antarctica, and the Pamir, was attempting a second trip to Tibet but encountered difficulties similar to Roerich's. Roerich found Filchner standoffish and resented how the German, while also failing to reach Lhasa, met with far less suspicion than he did.

Finally, a date of departure was fixed for May 16, though the slowness of communications meant the Roerichs would leave without knowing whether the Lichtmanns would be meeting them in Moscow. If they felt trepidation about returning to their homeland, it does not show in their writings, but on May 8, Roerich took the exceptional step of filing a will with Bystrov. Whether he did so freely or was coerced into it by the Soviets is difficult to guess, as are Roerich's thoughts about the disparity between the will's terms and those spelled out in his 1923 agreement with Louis Horch. The stipulations speak for themselves: "I hereby bequeath my worldly effects, paintings, and literary copyrights, and any and all shares in American corporations, to my wife, Helena Ivanovna Roerich, if I am survived by her. If I am predeceased by her, I bequeath the aforementioned effects to the

Communist Party of the USSR, asking only that my artworks be disposed of properly, in a manner befitting the higher goals of communism. This testament supersedes all others. I ask that it be executed by Comrades G. V. Chicherin, I. V. Stalin, and A. E. Bystrov, or someone chosen by them. (Signed) Nicholas Roerich, artist."[72] In return, Bystrov placed the Roerichs' baggage under the protection of his diplomatic seal, allowing them to pass through customs without inspection. He also kept Roerich's journals safe, forwarding them to the family later, when the expedition resumed its eastward course.

The day of leave-taking came as scheduled. As they bade Bystrov farewell, Nicholas, Helena, and George presented him with a horse, a fur coat, a sketch of a Ladakh fortress, a ring blessed (as they said) by Morya, and their much-treasured gramophone. Driven northwest in a trio of horse-drawn carts, they went two hundred miles through the Jair Mountains and the steppe province of Dzungaria to the border zone of Chuguchak, reaching the boundary on May 28. They entered the USSR on the twenty-ninth, setting foot in the country of their birth for the first time in eight and a half years. Two more weeks saw them in Moscow.

Once across the border, Nicholas, Helena, and George were taken to Lake Zaisan in eastern Kazakhstan. On June 1, they boarded a riverboat to Omsk; during a short stay there, they stopped in at the district museum, where two of Roerich's paintings were displayed. After a transfer to the Trans-Siberian Railroad, they reached Moscow on June 9 and remained there for approximately a month and a half.[73]

For even a mention of what happened there, readers will search the pages of *Altai-Himalaya* in vain, and the Roerichs' official expedition map (see Illustration 27) gives no hint that they went anywhere north of Omsk or the Altai on their way from Sinkiang to Mongolia. There was little point to these excisions: before they completed their journey, their Soviet side trip had been reported in the *New York Times* and other papers.[74] Still, Roerich saw no advantage in mentioning Moscow more than he had to, so for any sense of what went on there, one must look to other sources.

One of the most important is the diary of Sina Lichtmann, who, with Maurice, arrived in Moscow on June 13 and reunited with the Roerichs later that day.[75] Installed in the Hotel Metropole, the two couples spent their first days touring Saint Basil's Cathedral, the Russian Historical Museum, and the Bakhrushin Theatre Museum. They viewed the recently nationalized Renoirs and Matisses that had formed the private collection of Sergei Shchukin, and took scenic outings to Sparrow Hills and Ostankino. These were happy moments. The Roerichs rejoiced to be out of China; they would soon see friends and relatives they had not seen for years, and they were impressed by what

they saw of Soviet Russia. "Verily, this is a new country," Helena declared, "and over it, the Star of the Teacher shines brightly."[76]

There was business as well. Chicherin greeted the Roerichs on the tenth and opened their weeks-long round of meetings. On the thirteenth, he wrote to Vyacheslav Molotov, secretary of the Central Committee, informing him that Roerich was in Moscow to pass on the greetings of forward-thinking "Buddhist societies that have renounced official lamaism" and to propose "worldwide union between Buddhism and communism." On Roerich's urging, he asked whether the artist could place his holy casket from India in Lenin's mausoleum. (Roerich further suggested that the tomb be inscribed with the words "Lenin—The Great Teacher" in seven languages, including Tibetan.) The Central Committee opted to leave their leader's rest undisturbed.[77]

Two items dominated discussion over the next six weeks: the Beluha concession and Roerich's pan-Buddhist schemes. The former had not fared well over the past thirteen months. In May 1925, Maurice Lichtmann and Louis Horch had traveled to Paris to submit their prospectus to the Soviet trade delegation there. They had banked on having ready access to Leonid Krasin, who had spoken with Roerich the previous December, but found themselves waiting for days on his doorstep, and in the end met only with his secretary. The prospectus went before the Main Concessions Committee (GKK) that summer, and its representatives in France and America, L. A. Perlin and

Isaiah Khurgin, assessed Beluha's suitability as a possible partner.[78] Their reports, filed in the fall of 1925, were not encouraging. The company, they noted, existed only on paper, and while Horch had impeccable credentials, everyone else on the board was an amateur. The corporation's overconfidence and unreasonable demands created an "unfavorable impression," as did its intention to trade with Mongolia and western China—places into which the Commissariat of Foreign Affairs (Narkomindel) did not wish to see American capital make economic inroads.[79] By March 1926, while the Roerichs were idling in Urumchi, the GKK had all but decided to toss out the proposal.[80]

That month, two things caused the Soviets to reconsider. Maurice sailed back to Paris, this time with Sina, and bombarded the trade mission with additional proof of Beluha's stability and Horch's qualifications, including references from the Equitable Trust Company and US senator Sam Bratton of New Mexico. Perlin, once so skeptical, recommended in April that the Lichtmanns be granted Soviet visas and the chance to argue Beluha's case in Moscow.[81] At the same time, Roerich's connection with Beluha, which to that date had not been emphasized, was becoming clearer to the Soviets, who now wondered how these separate facets of the artist's plan fit together.

With everyone gathered in Moscow, the Beluha negotiations began, paralleling Roerich's meetings with Narkomindel and the secret police about larger possibilities in the east. For the GKK, Mikhail Yapolsky took

charge of the talks, delivering regular up-dates to his superiors, Adolf Ioffe and Leon Trotsky, as well as to Chicherin. Mikhail Trilisser, head of the OGPU's Foreign Department, received reports about Beluha and spoke directly with Roerich about his wider goals. Also present were officials from the Supreme Council of the National Economy (VSNKh) and the Soviet Geological Committee. Roerich and Maurice spoke for Beluha, as did Roerich's brother Boris, who came down to Moscow from Leningrad.

The Soviets were not greatly interested in the terms originally proposed.[82] Beluha's prospectus of May 1925 asked for a fifty-year lease allowing comprehensive development of the region surrounding Mount Belukha in a radius of sixty-five miles, plus half a dozen parcels of nearby land, for a total area of more than fifteen thousand square miles. Agriculture and mining—mainly for silver, but also for coal, marble, and perhaps oil—were Beluha's top priorities, but the company requested fishing rights too, plus permission to trap and breed furbearing creatures, musk deer, and sheep. Lichtmann spoke of building roads, canals, reservoirs, and an electric power station, not to mention "educational institutions, institutions of public welfare, [and] centers of scientific experimentation." Finally, he demanded "provision for free trade with China and other Asiatic countries," and also with Europe and the United States. In exchange, Beluha would turn over 50 percent of all profits to the USSR, keeping 49 percent and using the rest for community betterment.

Neither Narkomindel nor the GKK had any intention of surrendering so much control over Soviet territory to a foreign entity. They were, however, more than glad to use American money to test the economic potential of the remote and rugged Altai.[83] On July 7, they agreed to let the Roerichs conduct a preliminary survey of the Belukha district in August.[84] The Roerichs would "lead" the venture (which meant footing the 14,500-ruble bill), but scientific work would be carried out by a Soviet engineer, Terenty Ponomarev. Boris Roerich was named Beluha's official USSR representative, and discussions would resume once the survey's results were known. Yapolsky summarized these dealings for his chief, Leon Trotsky:

> Roerich, the famous painter, has recently returned from a long journey through Central Asia, having also visited the inaccessible reaches of Tibet [sic, probably confused with Ladakh, or "Little Tibet"], as well as India and America. He has connections with wealthy American patrons, who follow and admire him. He sympathizes with communism, although from a purely idealistic standpoint. He wishes to be useful to us. Any conversation you have with him will not be wasted time (although be prepared to take at least half an hour, maybe longer). Roerich is not a businessman, and he is a little amusing, even bumbling, when he talks about percentages and dollar amounts. But that does not detract from his charm.

By the way, it is likely that he will speak of the Beluha Corporation (Citizen Lichtmann et al.)—a group of American intellectuals who wish to be granted a concession in the Altai. We have given them permission to visit the region.[85]

By the time Trotsky received this note, Roerich had left Moscow. If the great revolutionary was tempted by Yapolsky's suggestion, he missed the chance to act upon it.

Beluha-related business fell principally to Maurice. Roerich's time went toward the contemplation of Asian geopolitics, in the company of officials from the Commissariat of Foreign Affairs and the organs of intelligence. He opened these talks by presenting two letters he claimed (dubiously) to have brought from "the mahatmas." The longer reads as follows:

In the Himalayas we know what [the Soviet people] have accomplished. You abolished the church, a breeding ground for falsity and superstition. You destroyed philistinism, which encourages prejudice. You tore down schools that were like prisons. You destroyed hypocrisy. Your army is no longer one of slaves. You stamped out profiteers, spider-like in their greed. You closed the brothels' doors. You delivered the land from wealthy traitors. You recog-

nized the truth of religion as the teaching of universal matter. You recognized the vanity of personal possessions. You preached the evolution of the commune. You pointed out the significance of knowledge. You bowed down before beauty. You have placed the full power of the cosmos at the disposal of your children. You opened the windows of the palaces and perceived the need to build new homes for the sake of the Common Good!

We prevented an uprising in India when it was premature, but we recognize that your movement's time has come. We send you all of our strength, in support of a United Asia! We know that much will be achieved in 1928, 1931, and 1936. Greetings to you, who seek the Common Good![86]

How did Roerich construe this astounding text to those interrogating him? As a practical offer of partnership from real-life clergy willing to accept Soviet leadership, or something more utopian? Did he speak of his New Country solely as a geographical entity? Or did he divulge more freely his occult-driven hope that it would soon evolve into a celestial kingdom?

The answer seems to have depended on which Soviets he was dealing with at the time. In the main, he appears to have stuck to his line from 1924 and 1925—minimizing talk of mysticism and pitching his plan as a political exercise in which religious faith served secular ends. He rehashed the same

key points: the ongoing effort of reformers like himself to synchronize Buddhist values with Marxist-Leninist ideology; the impossibility of winning allegiance from the denizens of Central Asia and Mongolia, much less China and India, unless the USSR halted its antireligious campaigns; and the exploitability of the apocalyptic rumors circulating through the East about Maitreya and Shambhala. Played upon properly, Roerich argued, the widespread expectation that the King of Shambhala would return from the north—meaning Russia—could reposition every piece on the Asiatic chessboard in the USSR's favor. And of all possible emissaries, Roerich alone carried enough weight with Inner Asia's leading clerics to pull them into the communist sphere of influence. He made much of the large and loyal following he had supposedly gathered in India, Sikkim, and Ladakh, and assured his questioners that an alliance with the Panchen Lama was soon to follow. Roerich's "embassy of Western Buddhists" would restore the Panchen to his partnership with the Dalai Lama. In turn, they would support Roerich's installation as a theocrat—a replacement, perhaps, for Mongolia's Jebtsundamba Khutuktu, who had died in 1924?—over a new Mongol-Altaic state on the USSR's eastern fringe. If the Soviets desired, this could be the friendliest of neighbors, and an excellent platform from which to export the revolution to the east and south.

Roerich shared these thoughts with Chicherin, Trilisser from the OGPU, and Anatoly Lunacharsky of the Commissariat of Enlightenment.[87] Felix Dzerzhinsky, the head of the secret police, was ill to the point of death and not present, but his deputy, Vyacheslav Menzhinsky, is thought by some to have attended.[88] Another tantalizing possibility is that Roerich may have visited one of the OGPU's most clandestine subsections: the Spetsotdel, or Special Department, one of whose functions was to determine whether ESP, precognition, and other paranormal phenomena could be applied to intelligence work. Officially, the Spetsotdel's interest in these subjects was clinical, but its director, Gleb Bokii, and its leading researcher, Alexander Barchenko, were genuinely devoted to occultism. Bokii admired the teachings of Gurdjieff; Barchenko, a medical school dropout who ran an experimental "neuro-energetics" lab for Bokii, gravitated toward Martinism and believed that the mythical kingdoms of Shambhala and Agartha had perfected the concept of socialism. By the mid-1920s, both belonged to a secret Gurdjieffian circle called the United Brotherhood of Labor. Like Roerich, Barchenko yearned to lead an expedition to Tibet, where he hoped to discover a Red paradise and learn the secrets of telepathic communication. Bokii supported him, but Chicherin, persuaded by specialists like Fyodor Shcherbatskoi and Sergei Oldenburg that Barchenko's Asian studies qualifications lay somewhere between laughable and useless, refused to sign off on this venture.[89]

Nothing is more natural than to imagine these two conversing with Roerich

in 1926 and reveling in their shared interests. Helena notes in her diaries the need to communicate with Bokii.[90] Barchenko had at least two acquaintances in common with Roerich: he was friendly with Agvan Dorjiev and had worked in 1920 under the brain scientist Vladimir Bekhterev. If Roerich indeed belonged to the Martinist circle described in chapter 6, he would have known Barchenko himself since before 1917. The most seemingly dispositive evidence that Roerich conferred with the Spetsotdel comes from 1937, when Bokii and Barchenko, arrested by the secret police, confessed under torture to having formed a shadowy "Great Brotherhood of Asia" with the artist and several others, including Khayan Khirva, the head of Mongolia's security services, and Naga Naven, the governor of Western Tibet. The story of this "Shambhala-Dunkhor" conspiracy is known partly from interrogation transcripts, but also because Bokii was father-in-law to the famed GULAG survivor and memoirist Lev Razgon.[91] Testimony taken by force can be trusted only so far, but even if some of the charges brought against Bokii and Barchenko were exaggerated, it does not necessarily mean every detail was invented. Furthermore, a striking entry from Sina's diary describes "a most wonderful meeting at the [O]GPU . . . where the name of Maitreya was pronounced."[92]

Assuming the trio met, the subjects of their colloquy remain unknowable. Some see this moment as verifying the most radical of the conspiracy theories surrounding

Roerich: that he had begun spying for the Soviets before reaching America, or that he had been working in concert with a supremely organized cabal since at least 1910, or both. Those interested principally in the mechanics of Roerich's occultism focus on details like the meteoric Stone he and Helena had carried with him from Paris, which some believe Roerich handed to Barchenko for testing. (According to this scenario, both were convinced that the Stone could transmit psychic messages over great distances.[93]) Most likely the three covered the same ground Roerich did with Chicherin, with the added pleasure of comparing their neo-Buddhist enthusiasms. Or perhaps Stalin's police guessed right after all, and the three in fact harbored their own mystico-political agenda, independent of what the regime had in mind.

Whatever the case, the Spetsotdel had little say in what happened next. Narkomindel and the OGPU's upper echelons made that decision, and while their interests marched with Roerich's, they did so only part of the way. They wished to shift Tibet and its neighbors into Russia's orbit, they comprehended the Panchen Lama's influence over the region, and some of them were flexible enough on religious questions to show Buddhism the kind of forbearance Roerich called for. But that was as far as the convergence went. Even if the Soviets could forgive Roerich's earlier anti-Bolshevism and trust that he was not a British or American spy, they had no way of knowing whether his contacts in the Buddhist world

were as extensive or as highly placed as he boasted. Lunacharsky, for instance, derided the mahatmas' letters as the most ludicrous diplomatic credentials he had ever heard of.[94] Just as worrisome was Roerich's vagueness on the delicate matter of how to cultivate the Panchen without driving the Dalai Lama into Britain's arms. Like Roerich, the Soviets dreaded the possibility that the Panchen might seek protection from Japan or one of China's more reactionary warlords. Their preferred alternative, however, was to bring him to the USSR or Mongolia, rather than return him to Tibet—an aggressive action that might alienate the Dalai Lama for good.[95]

Instead of reassuring his hosts, Roerich made demands of his own. He lectured them not just about freedom of worship, but the deplorability of using violence to modernize the USSR, and while this can be counted to his credit, such moralizing irritated his handlers.[96] Also, whether Roerich suggested that his New Country stand as an independent ally of the USSR or as a federated unit within it, his breezy expectation that the Kremlin would help raise him to a position of national or near-national authority was a huge presumption.[97] Neither did it help when Roerich insisted that he be given the right to travel in and out of the USSR whenever and however he pleased. All these were reasons to doubt whether working with Roerich was worth the effort, especially because the Soviets already had another arrow in their quiver: Arashi Chapchaev, a Kalmyk revolutionary who

had been preparing for half a year to venture to Tibet on Chicherin's behalf. Chapchaev was in Mongolia, awaiting orders, and more ideologically reliable.

Still, could the Soviets pass up even the slightest chance that Roerich, however erratic, might bring them closer to their goals in Asia? They permitted him to survey the Altai. They agreed to transport him to Mongolia and to arrange his reentry into China. If he made it to Tibet and somehow won over either of the chief lamas there, the Soviets would be glad of it. If the Beluha negotiations panned out, the infusion of foreign cash would be welcome as well. Essentially, the USSR was hazarding the tiniest of wagers for a chance at a huge—albeit unlikely—payoff.

Roerich spent time in Moscow on things other than politics and practicalities. He was a guest of the regime, and he and Helena had a long list of friends and relatives they wished to see. Six weeks gave them time for many social calls.[98]

Protocol brought the Roerichs into the presence of several political luminaries, the highest-ranking of whom was the Politburo member Lev Kamenev. That Kamenev was the most powerful figure Roerich met did not bode well, considering the setbacks he and his allies had suffered over the past year at the hands of the steadily ascendant Stalin. Kamenev's wife Olga headed the All-Union Society for Cultural Relations with Foreign

Countries and sounded Roerich out about strengthening ties with India. The Roerichs hoped to consult with Trotsky, but made do instead with his wife, Natalia Sedova, the museum affairs director for the People's Commissariat of Enlightenment. They also met Lenin's widow, Nadezhda Krupskaya, a shaper of Soviet educational policy and another of Stalin's opponents. Krupskaya listened with only half an ear as Roerich chimed on about Buddhism in Siberia, then vented her own concerns about the growing bureaucratization of the Soviet state.

Her bleak mood was matched by that of Anatoly Lunacharsky, the People's Commissar of Enlightenment. Roerich had known Lunacharsky since before 1917, but had ceased to trust him, despite his relative moderacy, when he joined the Bolshevik government. Lunacharsky accompanied Roerich to several of the deliberations described above and looked after him more generally. He helped Roerich recover some of the paintings he had left behind in 1917. There was talk of arranging a Moscow exhibition of Roerich's recent work, but the family was already attracting more publicity than was wise if they wanted to keep the next stage of their expedition secret. Roerich settled for presenting his "Maitreya" series to Lunacharsky and Chicherin, with a request that these be gifted to the Soviet people.[99] (They went instead to Maxim Gorky, who hung them in his Moscow flat. According to Valentina Khodasevich, Gorky considered them "curious things" not up to the level of Roerich's earlier work.[100])

There are conflicting reports about what passed between Lunacharsky and Roerich in private. Igor Grabar makes the commissar out to have been amused by, if not contemptous of, Roerich. Roerich himself describes a somber Lunacharsky, willing to voice dissatisfaction with his country's political direction. At one point, he supposedly complained about an official denunciation of prerevolutionary culture as "poison for the proletariat," lamenting to Roerich that, "listening to such people, I wonder whether we are students of Marx or Savonarola," recalling the zealot who tormented Renaissance Florence with his bonfires of the vanities. Whether or not Lunacharsky spoke these words, he was indeed bowed down by struggles to save old art (and sometimes the artists themselves) from destruction by party extremists, and Roerich seems to have sensed the pressures that would drive the commissar from office by 1929. Lunacharsky is said to have kept a number of books by Roerich in his library, but whether he read them, or what he took from them, is not known.[101]

A photograph shows Roerich with the architect Alexei Shchusev, whose Kazan Station he had helped decorate, and with whom he had shared several commissions from monasteries and cathedrals.[102] Shchusev now served the Soviet state, and had recently designed Lenin's ziggurat-like tomb on Red Square. What he thought about Roerich's desire to inter his casketful of Indian soil there cannot be guessed from the bulldog stare he directs at the

camera. Roerich had a brief reunion with Konstantin Stanislavsky of the Moscow Art Theatre, and may have met with the sculptor Sergei Merkurov, cousin to the mystic Georges Gurdjieff.[103] Agvan Dorjiev was in Moscow that June, and if Roerich did not encounter him then, he is generally thought to have done so in September, on his way to Mongolia.[104] But whether they saw each other sooner or later, the lama—as noted below—had only bad news to relay. Roerich appears to have visited with the USSR's leading botanist, Nikolai Vavilov, and the pair corresponded several times in the future about medical flora.[105]

In mid-June, Roerich spent time with a number of young artists led by Boris Smirnov-Rusetsky and Vera Runa-Pshesetskaya.[106] Attracted to Theosophy and Rosicrucianism, these painters had long admired Roerich and named their group Amaravella on his suggestion. Roerich arranged for their work to be exhibited in New York the following year, but several Amaravellists later paid for associating with him, suffering imprisonment in the 1930s and 1940s. (Smirnov-Rusetsky survived into the 1990s to become the first post-Soviet chair of the Moscow Roerich Society.) Roerich also met with two Freemasons while in Moscow, V. V. Beliustin and the diplomat Yevgeny Teger, both of whom underwent secret police questioning about the encounter in 1937.[107]

Particularly well documented is the encounter between Roerich and Igor Grabar, then teaching art history at Moscow State University. Early in 1926, Grabar had heard from Lunacharsky that Roerich might be coming to Moscow. After replying that the USSR could only benefit from a visit by someone as distinguished as Roerich, Grabar put the conversation out of his mind. He was then away from Moscow for some time, only to find upon returning that Roerich had been in the capital for several weeks, trying repeatedly to reach him. Phoning back, Grabar learned that the Roerichs were leaving Moscow the following afternoon, so he agreed to meet them at the Metropole right away. Grabar puts a droll spin on what followed, although part of this is due to having written about it in 1937, a dangerous time to admit any sympathy with Roerich or his aims. He describes himself as mystified by Roerich's talk of Buddho-Communist synthesis, and notes that he and Lunacharsky laughed about the whole affair once Roerich had left. He was most bewildered by what followed the visit. As part of a strange cover-up discussed momentarily, Roerich told Grabar that his next destination was Africa, where he planned to search for "a marvelous lake." Grabar was surprised to read later that Roerich had turned up in Mongolia instead.

Roerich's most meaningful moments in Moscow are the ones we know least about. He and Helena saw family members, but not as many as they wished. A regular companion during these weeks was Helena's cousin, Stepan Mitusov, who had been working since the revolution as a choirmaster and concert organizer in Lunacharsky's commissariat. When they were not occupied by

Beluha work, Nicholas and his brother spent hours reminiscing and planning for the future. Nicholas relied on Boris for contact with the rest of his kin, because the Soviets, much to his grief, refused him permission to travel to Leningrad, where his mother and sister still resided. Infirmity kept Maria Vasilevna from journeying south to see him; what prevented Lydia is less clear, but likely involved the emotional distance that often arises between adult siblings with little in common. Roerich never again saw either. Maria passed away the following July, and Nicholas, unaware of her death, continued sending her letters for more than a month after her passing. His last contact with Lydia appears to have been in 1931.[108] Nicholas and Helena tried to make up for the lack of a homecoming by loading Mitusov and Boris down with gifts for loved ones in Leningrad—but it was a poor substitute for the warm embrace of family.

The Roerichs' time to depart came on July 22. A long-standing but probably false impression persists that they left Moscow suddenly after a quiet warning from Lunacharsky that it was no longer safe for them to stay. But the manner of their leaving was consistent with the plan they had agreed to with the authorities, and it defies logic to imagine that any amount of haste could have kept them free had they actually been in danger of detention—especially considering that they stayed in Soviet territory for another month and a half. The illusion of a narrow escape originated with the Roerichs themselves, who channeled the following sending from Morya while in the Altai: "In delivering My Message to such fearsome people, you showed true bravery. While in Moscow, you were in unspeakable danger; the least doubt or hesitation could have been fatal."[109] Whether the Roerichs, always timid about their safety, believed this to be true or exaggerated the point to impress their followers, this passage likely says less about reality than it does about the couple's dawning awareness that things between them and the Kremlin had not gone as well as they had hoped.

Not that their departure was completely free of drama. Two days earlier, the secret police chief, Dzerzhinsky, had died of heart failure, and the day of his funeral fell on the twenty-second. The Roerichs and Lichtmanns watched the cortège pass beneath their hotel balcony, then rushed to the station to catch the eastbound Trans-Siberian. On July 26, they detrained in Novosibirsk, and from there made their way to the Altai.

Before leaving, the Roerichs covered their tracks in an unusual way. It was too late to hide that they had been in Moscow. (Western papers also reported that Roerich had visited Leningrad, an error that caused him much inconvenience in time to come.[110]) They could, however, plant false stories about where they were going. Maurice cabled Louis Horch on July 15, asking him to tell the press that the Roerichs were leaving Moscow for Africa, not Asia.[111]

Horch dutifully passed this fiction onward, and within weeks, newspapers in America and Europe informed their readers that Roerich, driven north to Russia by unexpected difficulties in Turkestan, had been "compelled to abandon his work" in Asia. He would continue instead to Abyssinia and "adjacent countries in Central Africa" to study humankind's "cradle of civilization."[112] It was this fabrication Roerich had tested on Grabar before leaving, and while it was not meant to hold up under scrutiny, Roerich would hardly have to answer for himself in the long run if the rest of the expedition went as he hoped. (The choice of Abyssinia may have been a silent tribute to the poet Nikolai Gumilev, who, during the time of his friendship with Roerich, had gone there on several ethnographic expeditions.)

From Novosibirsk, the Roerichs and the Lichtmanns proceeded by steamboat to Barnaul, where they were greeted by Alexei Borisov, a former pupil from the IOPKh School, and Biisk, which they reached on July 30. Here, the party switched to horse-drawn carriages, winding through the villages of Oirotia toward the Katun River valley. It was a difficult journey, with the summer heat giving way to pounding rains that turned the roads to muddy paste. On August 7, the group reached the hamlet of Verkhnii Uimon, their base of operations for the next half month.[113] The Roerichs lodged with the Atamanovs, a family of Old Believers, occupying the second story of a charming wooden house, now preserved as a museum. Vakhramei, the paterfamilias, was

a famed guide with an encyclopedic knowledge of the region. His daughter Agafia proved such an excellent housekeeper that Nicholas and Helena asked permission to hire her for the rest of the expedition. But as much as Atamanov admired the couple, he insisted that Agafia belonged at home.

Every morning at six, Atamanov took Roerich and his companions up to the heights. There, in a state of beatification, they beheld glistening peaks and the icy stillness of the Batun glaciers. The beauty of Mount Belukha, "so clear and reverberent," flared in the distance.[114] Here was the center point of Roerich's metaphysical topography, the holy ground on which the shining city of Zvenigorod was to be built, and where "all that had been written and unwritten, spoken and unspoken," would be revealed.[115]

While in Verkhnii Uimon, Roerich spoke openly about Zvenigorod, as attested to by Atamanov, the local artist Natalia Nagorskaya, and others.[116] He claimed to have heard stories there about sunspots, magnetic storms, and other strange occurrences.[117] In the two weeks allowed to him, he studied the region's folklore, collecting legends of black stones (mythic cousins, he believed, to Chintamini and the meteoric fragment he bore), fire blossoms, Belovodye—the Altaic counterpart to Shambhala—and the long-vanished Chud tribe, with their mysterious realm of caverns.[118] He noted the complex array of religions practiced in this "melting pot of nations": Buddhism, shamanism, and more than a dozen Christian sects that had broken from Orthodoxy,

including Old Believers, Molokane, and the flagellant Khlysty.[119] Also present was Burkhanism, or *ak jang*, the "white faith" indigenous to Oirotia and of special interest to Roerich. Not only did Burkhanism feature a messiah figure whom he interpreted as a manifestation of Maitreya, but in 1904, *ak jang* prophecies had ignited a short-lived rebellion against tsarist rule.[120] Roerich hoped to harness such fervor on behalf of his own ambitions.

Of greatest urgency was the economic survey that had brought Roerich to the Altai in the first place. Starting on August 8, all five members of the expedition collected rock and soil samples, made maps, and tabulated data about local plants and animals.[121] In mid-month, they scouted the Ust-Koksa valley on the left bank of the Katun, as well as the shores of the Akkem River. Twice they encountered N. N. Padurov, a geologist who encouraged them by mentioning the traces of molybdenum he had found during earlier trips to the district. They then rendezvoused with their research partners, Terenty Ponomarev and his assistant, B. N. Gimmelfarb. The two scientists, accompanied by an economic-feasibility expert, Sergei Perevozchikov, set up camp with the intention of working from August 20 through the end of September. The Roerichs, needing to press on, left matters in Ponomarev's hands and said farewell to Verkhnii Uimon on August 19. At Biisk, they and the Lichtmanns boarded the steamer *Zhores* on the twenty-sixth and docked in Novosibirsk the next day. Boris arrived from Moscow on the thirtieth to help decide how to proceed.

As with their departure from Moscow, a hint of mystery clings to the Roerichs' last days in the Altai. Certain authors have theorized that Roerich left the Altai on August 17, traveled in an OGPU convoy to Peking, and conferred there with the Panchen Lama and representatives of Chiang Kai-shek, rejoining his family on August 24.[122] Roerich would have jumped at any chance to meet the Panchen, and such a scenario is physically possible. But aside from being based on surmise, it would have required Roerich to travel nearly two thousand miles each way, without a single mishap or delay in a country convulsed by civil war, and it would have left the road-weary artist with barely a few hours to conduct a complicated set of negotiations before having to leave again. The only thing that keeps it from being dismissed out of hand is a story told by the Sinologist Boris Pankratov to his students, more than forty years after the fact, about having met Roerich in Peking, where the artist supposedly talked to him about his dream of entering Lhasa in the guise of the King of Shambhala.[123] Pankratov's claim is weakened by the fact that he talks of this encounter as occurring in 1928, a year Roerich is known not to have been in China. Advocates of the Altai-to-Peking theory argue that Pankratov meant to say 1926, not 1928, but if one starts allowing for slips of the memory, the misremembered date could just as easily be 1935, when Roerich actually was in Peking. Less probably, it could have been Vladimir Roerich, not Nicholas, whom

Pankratov met in 1928 or 1926. Unless more material comes to light, the safest supposition is that Roerich spent his August days where he tells us he spent them.

If the Roerichs' ears were not burning by now, they should have been, because their summer movements had become the subject of much angry discussion in Delhi, London, and Washington. Official awareness of Roerich had reawakened in America and Britain after the press coverage of the past two months. Asked to comment on the artist's unexpected appearance in Moscow, a flabbergasted Major Gillan admitted in a September memorandum that "conditions to the east may well have made the continuance of his journey through China difficult and dangerous." Still, "that an anti-revolutionary ex-Russian subject should be permitted, or should apply, to return to Soviet Russia appears to throw some doubt upon the complete innocence of Professor Roerich's expedition."[124] Concluding now and for good that Roerich was a Comintern spy, the Foreign Office collated all the information it had about him and asked its Moscow mission to get to the bottom of his Russia visit.[125] This effort gave rise to mistaken assumptions that prejudiced the British against him even more: they believed that he had accepted Soviet citizenship and that he had spent several weeks, even two or three months, in Leningrad. (This was a case of mistaking Boris for Nicholas,

and Maurice Lichtmann's representation of Roerich in Leningrad confused things further.) The British also formed the impression, most likely unfounded, that Roerich, after leaving Moscow, had attended a parapsychology conference in the Urals city of Sverdlovsk (now Yekaterinburg). When Roerich returned to India in 1928 and told British officials that during his time in the USSR, he had only visited Moscow and the Altai, they fixated on this supposed lie as decisively damning—even though the discrepancy arose from their own faulty intelligence and was, ironically, one of the few things about which Roerich told them the truth.[126]

In the meantime, letters of complaint went out to the US Embassy in London. The British warned the Americans about Roerich's possible communist affiliation and blamed them for having vouched for him in 1925. Characteristic is this note from Stephen Gaselee of the Foreign Office, whose bad luck it was to have charge of the Roerich file over the next decade:

> We cannot but think that we have been rather hardly used in this matter. It is true that you never claimed that Roerich was a United States citizen, but you told us that his expedition was "financed entirely by American capital for artistic purposes." Roerich was always a person of questionable political leanings, and the Government of India would never have allowed this journey through disturbed and doubtful coun-

try but for your recommendation. . . . I do hope you will point out to the State Department the trouble that has been caused in Central Asia by their recommendation of this Bolshevik to our good offices. Without such intervention he would never have been allowed to pass at all, and he may have done, and be doing, much harm in those easily disturbed countries.[127]

Gaselee's anger is easy to understand: Anglo-Soviet relations worsened steadily in 1927, leading to a suspension of diplomatic ties in May and a protracted "war scare" lasting the rest of the year. The merest hint that Roerich might be part of a communist plot, especially if it had to do with destabilizing an already unquiet India, was enough to frighten any British official.

The Americans remained more sanguine, thanks to Nelson Johnson of the Division of Far Eastern Affairs, who had dealt with the Roerich case in 1925. Queried by the assistant secretary of state who had to respond to the Londoners' cries of dissatisfaction, Nelson chuckled, "The British surprise with regard to Roerich does not surprise me at all." Yes, the artist had entered unsafe territory "upon his own responsibility," and the State Department, which had "washed [its] hands of him after he got to Hotan," was as startled as anyone to see him pop up in Moscow. Still, there was probably nothing to worry about. After consulting with Charles Crane, Nelson summarized the situation as follows:

As is usual with Russians, [Roerich is] entirely in the hands of a group of Jews. They have set up a kind of museum in New York City dedicated to Roerich's artistic productions and appear to be able to get plenty of money from sources unknown. . . . I think it might be worthwhile and interesting if some investigation could be made of the organization known as "Corona Mundi." I have had no information that it was interested in politics. Roerich appears to have traveled about considerably in the United States, particularly in the Southwest, where he made some rather interesting and, from a layman's point of view, somewhat startling pictures.[128]

The State Department eventually investigated Roerich's enterprises, but not for some time. For now, US officials tried to mollify their colleagues across the Atlantic. The British, however, were not so easily put off. Once they located Roerich, and once they determined where he was going, they acted decisively to bar him from ever gazing upon the Potala's ramparts.

The second week of September brought the Roerichs to Mongolia. Before that, in Novosibirsk, they made a number of decisions with Boris and the Lichtmanns. They anticipated a positive outcome from Ponomarev's Altai survey, and Boris was to keep lobbying on Beluha's behalf. They were

less satisfied with how things had gone in Moscow. They continued their pro-Soviet course for another half year, but felt slighted by the Kremlin's treatment of them and by the meagerness of the aid on offer. They compensated by coaching the Lichtmanns on how to describe their time in Russia to Frances, Esther, and the Horches. Sina and Maurice were to report on the Roerichs' "marvelous" reception and the "enthusiasm" with which their proposals were heard. "We are ordered," as Sina recalled, "to say that the minute we arrived, N. K.'s name opened every door. We are to underscore how Yampolsky [and the rest] told us that, if not for N. K., they would never have bothered to speak with us."[129] The Lichtmanns carried another message as well: Nettie had recently gotten pregnant again, and Sina was asked to remind the Horches that this was Morya's "repayment" for services rendered.[130] (Helena added that the baby, if a girl, should be named "Oriole.") With Soviet support so flaccid, Roerich could scarcely afford to have his chief benefactor lose faith in him.

For now, all that could be done was to move on and hope for the best. Perhaps the Soviets' disposition would improve, and every step that brought the Roerichs closer to possibly meeting the Panchen Lama—rumored to be moving soon to Mongolia—was to be welcomed. On September 3, Boris, Maurice, and Sina boarded the train to Moscow; from there, the Lichtmanns made their way to New York. It was Roerich's wish that they return to the USSR in 1927, both to

aid Boris with the GKK negotiations and to bring new provisions from America before the expedition left for Tibet.

Their good-byes spoken, the Roerichs resumed their eastward journey. The Trans-Siberian took them through Irkutsk to Verkhneudinsk (now Ulan-Ude), the capital of Soviet Buryatia. There they stayed three days, loading their gear onto Soviet trucks, and it is there that Roerich likely consulted with Agvan Dorjiev.[131] If so, he took little comfort from the conversation. Already, Dorjiev's reform efforts were failing, having gone too far for traditional Buddhists and not far enough for atheist Soviet officials. Whether he felt any presentiment of Stalin's coming persecutions of religion, the careworn monk had put aside all illusions about making Buddhism compatible with Bolshevism. Whatever advice he gave Roerich about Tibet, he surely added to the artist's growing pessimism about dealing with the USSR.

The Roerichs left Verkhneudinsk on September 3, buffeted by heavy rain and cold winds. They exited the USSR at Kyakhta, and from the Mongolian frontier town of Altin-Bulak, it was an easy ride to Urga— or, as the new regime called it, Ulaanbaatar (Ulan Bator), city of the red hero. Here, the family spent more than seven months, from September 1926 to April 1927, delayed partly by the turn of the seasons, partly because of how long it took to get permission to enter China and Tibet. There were only so many times per year one could cross the Gobi when it was not dangerously hot or

cold and still arrive in Tibet without being blocked by snow. Nor were travel permits easy to obtain. The Chinese refused at first to give Roerich a visa, relenting only after much persuasion. Lobzang Cholden, the Tibetan representative in Ulaanbaatar, took nearly four months, from November to the end of March, to issue the Roerichs a pilgrim's passport and a letter of introduction to the Dalai Lama. Similar bottlenecks held up other explorers. Also waiting in Ulaanbaatar were Wilhelm Filchner, the German scholar who had shared Roerich's Urumchi confinement earlier that year; Pyotr Kozlov, Russia's most respected archaeologist of Inner Asia in the early twentieth century; and Arashi Chapchaev, the Soviet agent acting as Chicherin's official envoy.

Political factors may have delayed Roerich as well. Still suspicious, Narkomindel wanted more time to divine his true purpose, and reports filed by Pyotr Nikiforov, the USSR's plenipotentiary in Mongolia, and Lev Berlin, the embassy's chargé d'affaires, show how puzzling the Soviets still found him. "He speaks urgently about the need to return the Panchen Lama to Tibet," Nikiforov told Chicherin. "When I ask why this must be done, he replies with theological mumbo-jumbo. I believe he is working for someone—for whom, I am trying to ascertain—and perhaps he is trying to figure out our thinking on this question."[132] Chicherin, too, wondered if Roerich was "perhaps a fraud or a provocateur" as he considered whether to let the artist proceed.[133] Roerich would have had to wait no matter what

for his Chinese and Tibetan documents, and for new supplies from Horch, but the Soviets may have asked the Mongolians to hold him up further while they continued to assess his trustworthiness. Chicherin and Trilisser did exactly that to Kozlov, whose independent-mindedness and past career as a tsarist officer raised doubts about his political reliability, and one can contrast his experience and Roerich's with the speedy progress made by Chapchaev, whose expedition left in November and reached Lhasa the following March—a full month before Roerich was allowed to put Ulaanbaatar behind him.[134]

Whatever kept them there, the Roerichs dwelled their half year in the capital, hosted first by Pyotr Vsesviatsky, part of the USSR's advisory personnel in Mongolia, then renting a four-room house built around two courtyards. As they waited, they kept their ears open for any news of the Panchen Lama, who, that September, had quit Peking and taken shelter in Mukden with the Manchurian warlord Chang Tso-lin—but who many believed was on his way to Ulaanbaatar. They visited the famed Ganden Monastery, northwest of the city, and collected folktales about Rigden Djapo, the King of Shambhala. One song in particular, said to have been chanted by the troops of Sukhe-Bator as they rode against Baron Ungern in 1921, served in Roerich's mind as proof that freedom-minded Mongolians expected momentous changes to come soon. "Chang Shambhala Dayin," went the chorus:

The war of Northern Shambhala!
Let us die in this war,
To be reborn again
As knights of the Ruler of Shambhala.[135]

Father and son also researched lore connected to Gesar Khan, the legendary ruler of the kingdom of Ling. Popular in numerous versions throughout the Mongol-Tibetan cultural sphere, Gesar myths were brought to Roerich's attention by Alexandra David-Néel in 1924, and he immediately saw in Gesar a reflection of the Maitreya archetype. George focused on academic debates: Was the Gesar epic of relatively recent origin, or, as George believed, had it arisen autochthonously among Tibetan nomads?[136] Of the townsfolk he and his son interviewed, Roerich recalls with humor that many were delighted by the gold fillings in his teeth and reasoned that he must be not just an ordinary American, but a rich "Ameri-khan."[137] (As an aside, he mentions that the names of "Ford" and "Borah," the Idaho senator who favored diplomatic recognition of the USSR, were revered throughout Mongolia. This, however, was an egregious bit of flattery meant to further his own goals back in America.[138])

While in Ulaanbaatar, Roerich fraternized little with Filchner, whom he found unpleasant, seeking instead the company of Kozlov, his fellow Russian. Kozlov found Nicholas and Helena "very interesting," although his wife Elizaveta was less taken with them.[139] She was shocked to see how many clothes Helena had brought along—"I could not understand what kind of expedition this was, having such a great amount of luggage"—and Nicholas's prophetic pretensions annoyed her. The Roerichs worked with Asian colleagues as well. Aiding George's academic research was Lama Shakju, a Tibetologist with the Mongolian Scientific Committee. Of greater consequence was the committee's secretary, Tsyben Jamtsarano, a linguist and activist who played key roles in Mongolia's transition to nationhood from the 1910s onward.[140]

Roerich may have associated with Jamtsarano before 1917. An ally of Dorjiev's, Jamtsarano taught at Saint Petersburg University and knew all the Russian orientalists the artist befriended while working on the Temple Commission. As described in chapter 9, Jamtsarano served as foreign minister in a pan-Mongol government that arose briefly during the Russian Civil War, but attached himself afterward to the Soviet-friendly Mongolian People's Republic as a figure of intellectual and political influence. Whether or not they had met before, Roerich's and Jamtsarano's core convictions now aligned in two key ways: both favored the creation of a greater Mongolian state, and both, like Dorjiev, considered it imperative to integrate socialism and Buddhism. This idea would fail as miserably in Mongolia as in the USSR, but Jamtsarano had not yet succumbed to hopelessness as Dorjiev had, and he advanced Roerich's interests as far as he was able.

Jamtsarano was an affable companion during the artist's time in Ulaanbaatar. One

photo from the fall of 1926 shows him with Roerich, Kozlov, and Gomboidchin, the Mongolian official who nominally headed the Soviets' Chapchaev mission to Tibet. He proved an invaluable fount of knowledge about Asia and laid out plans with the Roerichs (never realized) to build a museum of Buddhist artifacts in America and to produce a documentary film about Genghis Khan. He helped Roerich deal with the Mongolian customs office and appears to have used government contacts on his behalf. One of these may have been Khayan Khirva, a member of Mongolia's Central Committee and later the head of its secret police. In *Altai-Himalaya*, Roerich refers to "unexpected help from the Esperantist," and the study of Esperanto was one of Khirva's passions.[141] Whatever practical use Jamtsarano was to Roerich, his aid and friendship were welcome.

The Roerichs' half year in Ulaanbaatar gave them ample time to paint and write. Nicholas completed many landscapes, including the "holy king mountain" of Bogdo-ula, and continued injecting Marxist-Leninist elements into the Shambhala myth. Prophecy-themed canvases from 1926 and 1927, such as *The Great Horseman*, *Shambhala Is Coming*, and *The Command of Rigden Djapo*, feature communist symbols, including five-pointed stars and dominant tones of red.[142] Helena put the finishing touches on two books, *Foundations of Buddhism* and *Community*, the third volume in the "Agni Yoga" series. Published in Ulaanbaatar, both were even more pro-communist than

the "Banners of the East" essay Nicholas had mailed to the States from Leh. "The Great Gautama gave to the world an understanding of communism in its highest form," Helena wrote, stating with pride that "our contemporary concept of 'community' forms a perfect bridge between the Buddha's thinking and that of Lenin."[143] Readers were also informed that Morya and Koot Hoomi had visited Marx in London and Lenin in Switzerland, imparting to them all the secrets of Shambhala.[144] (Such passages later proved awkward. Reissued in Riga in 1936, *Community* underwent a comprehensive revision, and the Roerichs hid or recovered as many of the Ulaanbaatar copies as they could.[145]) Jamtsarano arranged for the volumes' release, and the Soviet embassy tried to gauge the effectiveness of this spiritual agitprop. For similar reasons, Nikiforov persuaded Roerich to present *The Great Horseman* to the Mongolian government in March. (Sina considered this foolish, and Roerich was not happy to part with the painting.[146]) Many of the essays Roerich later published in *Shambhala the Resplendent* were composed at this time.

February and March brought encouragement and discouragement at the same time. Nikiforov and Berlin, whatever they personally thought of Roerich, signaled more willingness to follow through on the deal Moscow had struck with him. An even friendlier face was shown him by the recently arrived

OGPU resident, Yakov Bliumkin, a notorious figure from the regime's early days. A Left Socialist Revolutionary (SR) during the revolution, Bliumkin, in 1918, shot Germany's ambassador to Russia to protest the Treaty of Brest-Litovsk. He survived Lenin's purge of the SR Party and worked for the secret police until his own execution in 1929. A master of disguise, he is alleged by some (as noted above) to have traveled with Roerich's caravan from Ladakh to Sinkiang, posing as a Russian-speaking lama. While this remains unprovable, Bliumkin is known to have "courted" the artist in Ulaanbaatar.[147] One of the OGPU's many Tibetophiles, Bliumkin found Roerich's venture fascinating, and likely wished to join it, though it seems he did not do so in the end. In March, the Soviets assembled a fleet of vehicles for Roerich, including five Dodge trucks, and issued him several pistols, eight Mauser carbines, and some rifles.[148] They updated the family's travel documents, issuing temporary foreigners' passports, of far greater use than the old Russian passports the Roerichs still carried.[149]

Meanwhile, the Lichtmanns were back in Russia, having sailed to France in February and continued to Moscow by train. With Boris, the couple spent most of March in the capital, with occasional trips to Leningrad. Talks with the GKK and Narkomindel's Far Eastern Department opened congenially, and Trilisser of the OGPU proved attentive, escorting Maurice and Sina to the ballet and accepting copies of the Roerichs' books with apparent, albeit feigned, eagerness. The

possibility of a second concession—the Ur Cooperative, in the Soviet protectorate of Tuva—was mooted as well.[150] The negotiations would soon break down, but seemed to be on a solid basis at the end of March, when Boris, Sina, and Maurice took a recess and journeyed from Moscow to join Nicholas and Helena.

The trio reached Ulaanbaatar on the twenty-ninth, carting with them three crates, three steamer trunks, and eight suitcases, full to overflowing with medicine, extra clothing, paints and brushes, winter tents manufactured in Canada, a new gramophone, and a movie camera.[151] Included were three medallions of gold, silver, and blue-green enamel, crafted in New York by Tiffany's for $700 apiece. These were "Orders of the All-Victorious Buddha": one to be worn by Roerich, the other two meant as gifts for the Panchen and Dalai Lamas. The Lichtmanns also brought from New York the cheerful news that Nettie had given birth to a baby girl, named Oriole—as per Helena's suggestion—earlier that month. Finally, they had in tow the expedition's newest member, the physician Konstantin Riabinin, who, before 1917, had treated Helena and been drawn in by her mysticism. Still living in Leningrad, Riabinin had kept in touch with Boris, but the sudden invitation to go adventuring in Asia caught him off guard. After some hesitation—he was recovering from a heart ailment and had never ridden a horse in his life—he agreed to join the expedition as its doctor and secretary-accountant.[152]

Others were added to the European contingent. Kordashevsky, summoned the previous fall, was on his way from Riga and would reach the China coast in April. In Ulaanbaatar, the family gained a new disciple in Pavel Portniagin, a young technician from Vladivostok. Described by George as a man of "considerable physical courage," the lively redhead served as mechanic and caravaneer.[153] Finally, to Helena's relief, the family found her a suitable maidservant. This was Lyudmila Bogdanova, a Siberian Cossack in her early twenties who had lived her whole life on the Russo-Mongolian frontier, but was now orphaned in Ulaanbaatar with her thirteen-year-old sister Iraida. Mila and Raya, as they were nicknamed, remained attached to the Roerichs for the rest of their lives. An attraction sprang up between Lyudmila and George, and the two lived as common-law spouses in years to come.

The Roerichs also recruited native guides and herdsmen, having lost a number of their retainers during the months they were away in the USSR. In the process of doing so, they came to know a Tibetan commercial agent named Chimpa, bound for Lhasa with his own caravan, but delayed in Ulaanbaatar due to injury. Some of the lamas accompanying Chimpa had studied with Dorjiev, and the elderly trader claimed to have ties with the Dalai Lama's court, so when he asked to join the Roerichs, he seemed a desirable companion. It so happened that Chimpa was secretly hauling a "special cargo" of twenty-nine rifles and some thousands of cartridges. While it is generally supposed that the Mongolian government hired him to ship these to its embassy in Tibet, some have wondered whether gunrunning was one of the duties Roerich had agreed to in Moscow.[154] Either way, Chimpa, who had other stops to make first, left Ulaanbaatar separately, promising to meet Roerich in the fall, on the far side of the Gobi.

Gratified as the Roerichs were to have the outfitting underway, serious doubts nagged at them. Helena herself was ill. The more Nicholas reflected on his meetings in Moscow, the more poorly they seemed to have gone, and he was not blind to the ambivalence shown him in person by Nikiforov and Berlin. In April, he confessed to Sina that Lunacharsky had not seemed interested in the Great Plan, and he feared that others in the capital felt the same way. (Had he known of the September 1926 article written about him in the Leningrad press by Erikh Gollerbakh, who praised his art, but deemed it "tragic" that Roerich was painting "not for the sake of his country, but for American billionaires," he would have felt even worse.[155]) "Lenin's spirit is with us," Morya cautioned, "but there is no one in Moscow we can consider ours."[156] With good reason, as the summer would show, Roerich worried about the upcoming Beluha-Ur talks. So it was only a partial relief when, on April 8, Nikiforov told the family to pack up and prepare to be gone within the week. Sandstorms were sweeping through the area, making it difficult to decide when

to leave, but the weather cleared on the thirteenth. That afternoon, the convoy drove to the Tola River, south of the city. Nikiforov, Berlin, and Jamtsarano accompanied them that far, as did Boris and the Lichtmanns, to exchange handshakes and good wishes. For the first time in a year, Nicholas, Helena, and George were back on the open road.

Under an unusual banner—improvised by lashing the US flag and a tanka bearing Maitreya's image to the shaft of a Mongol spear—the Roerichs' self-styled "embassy of Western Buddhists" took twelve days to cover the next four hundred miles. Their destination was Yum-beise, the monastery town from which they planned to descend into the Gobi. The journey was difficult. Hard winds blew, and the nights grew cold. The Soviets had provided second-rate drivers, like "American cowboys," thought a disapproving Portniagin, and third-rate vehicles incapable of traversing any kind of uneven ground.[157] The promise of motorized transport now seemed worthless.

The expedition camped for five days outside Yum-beise, within sight of the Tsagan Obo's granite ridge. Portniagin procured the camels and horses needed for the desert crossing. In addition to visiting the monastery, the group took time to practice their marksmanship—except for Nicholas, all the Russian males went armed—and to size up the native staff, a mixed bunch of Kalmyks, Torguts, Buryats, and Tibetans

that would number more than two dozen by the end of August. On earlier legs of the trip, the Roerichs had coped with interracial tensions, opium abuse, and general rowdiness among their Asian servitors. Here again, they were less than satisfied with some members of their crew. The more devout Buddhists behaved with decorum. Konchog, a Tibetan, served reliably as Roerich's valet, and the two young men who assisted Lyudmila with the cooking and washing were pleasant. Many of the rest, however, struck Roerich, George, and Riabinin as ruffians: "perfidious," prone to drunken brawling, and not to be trusted with weapons.[158]

On April 30, the expedition entered the arid vastness of the Gobi, aiming for the town of Anhsi (Anxi) in China's Gansu Province. To their knowledge, they were the first Europeans to travel this road, and George was eager to compare his observations with the research done by Roy Chapman Andrews and others elsewhere in the desert. This route had the advantage of being relatively safe, passing as it did through quiet parts of Inner Mongolia and north-central China. The Roerichs hoped to reach the desert's far side in no more than three weeks.

Through this wasteland of black gravel, the party passed smoothly enough. They encountered none of the bandits they had been warned about, and their one moment of gunplay came about by accident. One night, a nearby merchant caravan, mistaking the Roerichs' group for brigands, opened fire from afar. George, standing watch at

the time, kept his own men from shooting back and cleared up the confusion after a few minutes of shouting back and forth in Chinese. Temperatures were rising, but the party had contrived to avoid the worst of the summer heat, and while they were swarmed by spring-awakened mosquitoes, they seem not to have been plagued by the noisome brown vipers that Andrews recalls with a shudder of disgust in his Gobi diaries. Sweet-toothed George even managed to obtain a supply of chocolate from another caravan at the Shura-Khulusun oasis. The only harm done by the Gobi was to Nicholas's and Helena's sensibilities, which were offended by the erotic art ("so repulsive amidst the majesty of the desert") interspersed with the religious inscriptions they examined when they came across Buddhist ruins.[159]

Paradoxically, being at what George called the "dead heart of Asia" rekindled Roerich's hopes.[160] The Gobi held tremendous significance for Western occultists. Of it, Blavatsky had written that "the time will come when its dreadful sands will yield up long-buried secrets," and Gurdjieff claimed to have gone searching there for a lost city of immense antiquity.[161] Nor were such suppositions beyond the academic pale. Since the 1870s, scholars like Sven Hedin, Aurel Stein, and Ferdinand von Richthofen—uncle to World War I's Red Baron—had uncovered archaeological evidence of ancient habitation in and near the Gobi. The geographer Karl Haushofer believed the Aryan race might have originated there, and Roy Chapman

Andrews and Teilhard de Chardin thought it the possible birthplace of humanity itself. Did its bleak surface overlay the remains of an advanced culture from centuries past? This theory had been presented to the Royal Geographical Society by Douglas Forsyth and promoted vigorously by Sven Hedin, who thought he saw in the desert terrain signs of large-scale irrigation by a technologically adept civilization.[162] Friendly with Hedin till the late 1930s, Roerich ran even farther with this idea than the Swede himself, envisioning bounteous orchards and graceful, tree-lined avenues. Might this landlocked Atlantis have been part of Shambhala's domain? And could it be made to bloom again? Morya had promised that "when the New Country is built, we shall say to these dead places, 'Be Reborn!'"[163] Revitalizing the Gobi, a task Roerich hoped to carry out with his agronomist brother Vladimir, remained a lifelong aspiration. The Roerichs documented this segment of the trip extensively, taking photos and making movies, and Nicholas relaxed each evening with his record player, inviting everyone to listen to Wagner and Mussorgsky under the bright desert stars.

In the third week of May, the expedition entered China's Gansu Province. Bypassing Anhsi, they moved on to Shih-pao-ch'eng (Shibochen), in the shadow of the Nan Shan. For several reasons, they rested here for the next month. Kordashevsky had yet to catch up with them. More pack animals were needed as the party reached higher elevation, where each beast's carrying capacity

diminished. The Roerichs also wanted an update on the Beluha-Ur talks in Moscow, and they may have hoped for one last chance before entering Tibet to coordinate their plans, at least through intermediaries, with those of the Panchen Lama. While the rest of the party caught its breath, Portniagin journeyed to Soochow (Suzhou), more than a thousand miles away, on the outskirts of Shanghai. There he collected mail, sent cables to New York, and left poste restante messages, dispatching copies to Peking and Tientsin for good measure.

No sooner did Portniagin return than the Roerichs sent him back out again, this time on June 16, to acquire horses, mules, and camels. At the same time, they moved closer to the mountains. The Shibochen oasis proved too hot and humid for Helena, who came down with a sore throat and fever. The Sharagol valley, tucked into the Nan Shan foothills, promised cooler weather and adequate pasturage to satisfy the growing number of animals, so between June 18 and June 26, the expedition relocated to its high meadows. While Portniagin darted around the countryside, purchasing animals and carrying mail back and forth to the camp, the main party stayed at Sharagol till August 18. Only by the late summer, Roerich's guides told him, would the wetlands to the south be dry enough to cross safely, and the camels' coats needed time to thicken up after the summer shedding.

Roerich kept the group busy by celebrating July 5 as the Day of Maitreya, then by constructing a suburgan, or Mongolian shrine, in Maitreya's honor. Beginning with a tin base made from flattened gasoline cans, the Roerichs transformed this structure by covering it with brightly painted wood and encrusting it with beads and gems donated by the locals. George studied the culture and dialects of the Kurluk and Kokunor Mongols, and Nicholas had ample opportunity to paint. Even so, the summer days seemed to drag. Thunderstorms pounded the camp, fog choked the valley every evening, and mosquitoes proved a constant irritation.

News from the Lichtmanns and Horches, brought back by Portniagin, did not lighten Roerich's mood. As he had feared, the Beluha-Ur talks were stalling, and while two more years would pass before their formal termination, it was already clear they would end badly. This was not because of the Main Concessions Committee, which was delighted to hear that Ponomarev's Altai survey had turned up signs of gold, copper ore, and molybdenite. In May 1927, the committee recommended approval of both concessions, Beluha and Ur.[164] However, an uncharacteristically hot-tempered Maurice burned away this goodwill by accusing the GKK of shortchanging the Beluha group. Instead of the comprehensive report it had paid for, he argued, Beluha had received a bare-bones preliminary assessment, cobbled together by an inexperienced junior scholar. At a minimum, one more survey was needed before real work could begin, delaying operations for at least another year. The GKK apologized for the slow progress but defended Ponomarev and objected to

Maurice's "wild exaggerations" about its supposed underhandedness.[165] (Esther, who felt she would have done a better job had she been present, blamed Sina for pushing Maurice too far and ruining the transaction. According to Esther, Sina "insulted" the Soviets with her suspicions, "spoil[ing] every connection" with them.[166])

Just as serious was the setback the USSR had suffered in China that spring. In April 1927, the Kuomintang leader Chiang Kai-shek, aided over the past several years by the Soviet regime, turned with sudden ferocity on the Chinese Communist Party and his own party's left wing, massacring thousands and, by the following June, seizing control of Peking. Aside from embarrassing Stalin—who had supported the pro-Kuomintang line over the objections of rivals like Trotsky—this bolt from the blue left the USSR's Asia policy in ruins and made the Kremlin exceptionally sensitive about whom to trust in the east. As a result, the Commissariat of Foreign Affairs stepped in to oppose Roerich's Ur proposal. Allowing outsiders into the Altai was one thing, but Tuva was too close to the scene of the recent catastrophe. Scholarly turf wars got in the way as well, with the Academy of Sciences arguing that Ur would crowd out its own Tuvan research center.[167]

In spite of Ur's cancellation and Lichtmann's rude manner, the Soviets consented to a formal agreement with Beluha, although on significantly altered terms. The Americans retained right of first refusal over development in the Altai and were given permission to carry out a thorough survey there in 1928. They were, however, assigned a much smaller territory, under more restrictive terms, including a shorter lease. Boris and the Lichtmanns, "tired and very worn out" by the bargaining, signed the papers on July 1.[168] Sina and Maurice returned to New York. Neither Roerich nor Horch followed through with the next stages of the agreement, and the GKK put the application aside for good in May 1929.

None of this made for uplifting news as the Roerichs summered in Sharagol. "Moscow is decaying," mourned Helena, and Nicholas voiced his own dismay at the Kremlin's heedlessness.[169] The couple was beginning its second divorce from Soviet Russia. Morya had warned in June that the Reds "cannot comprehend your path." In August, he went further, ordering Nicholas and Helena to jettison the Soviet side of the Great Plan when they arrived in Tibet. "If you should reach Lhasa," he declared, "do not utter the words 'Bolsheviks' or 'Moscow.' Present yourselves simply as Western Buddhists."[170] It was a major shift in attitude, and the estrangement would only deepen in the months to come.

The Sharagol interlude was enlivened on the night of July 28, when Kordashevsky rode into the valley at full gallop—an event made more memorable by the flash flood that washed through the camp after his arrival, bringing down several tents and the dining

pavilion. The colonel had reached Peking in April, just a week after Chiang Kai-shek's anti-leftist purge. The resulting chaos, combined with the absence of clear directions from Roerich, delayed his progress and led him on a series of false starts, including a June trip to the fringe of the Gobi. Finally, in mid-July, in the Soochow Central Post, Kordashevsky came across the note Portniagin had left him, giving the caravan's location, and rode out to join it. With him was a Russian companion he had acquired in Peking: a former White officer, now a freelance interpreter fluent in Chinese, named Alexander Golubin. (Riabinin and Portniagin, mishearing his surname, refer to him in their diaries as "Golovin.") The Roerichs saw the sense in having a backup translator and agreed to let Golubin join the expedition.[171]

Drier weather in August allowed the group to complete their suburgan, which was festooned with prayer flags and consecrated on the seventh; to memorialize the event, Roerich painted *The Great and Holiest Thang-ka*. The clear skies had also made possible a strange occurrence two days before. At 10:30 on the morning of August 5, a mysterious object streaked across the sky at an estimated altitude of 1,500 feet.[172] Kordashevsky believed this to be a large bird or a Chinese airplane, but the rest maintained that they had seen "a huge oval," glowing golden-white. Roerich determined that it must have been a superpowered "flying apparatus" ferrying members of the Great White Brotherhood to

Shambhala. (According to Esther, the Roerichs later claimed to have spoken with the emissary piloting this "aerostat."[173]) It has been established that Soviet scientists were releasing weather balloons at this time from the Mongolian outpost of Sanchan, and if Kordashevsky's guess was not correct, it may have been one of these the group spotted.[174]

Tensions with the local authorities as well as his own impatience made Roerich keen to be off before the end of August, rather than in September, as his herdsmen advised. On the ninth, the local prince sent messengers to Sharagol offering his "assistance" in putting together a caravan, but for a fee. This offer, politely declined, was followed by a threat to search the foreigners' baggage, on the grounds that they might be carrying weapons without a permit. When Roerich refused to allow the search, the prince sent a squad of militia to collect a "camel tax" amounting to 120 Mexican dollars. To spare further trouble, Roerich relented, handing over the bribe.[175] (Kordashevsky praised this handling of "Asian psychology" as indicative of Roerich's tact and firmness.) Having heard from passing travelers that the Tsaidam lowlands were dry enough for a crossing, Roerich decided to forestall additional shakedowns by breaking camp as soon as possible.

On the morning of August 19, the expedition debouched from the valley. Ten days out, it met up with Chimpa's procession of lamas, as prearranged in Ulaanbaatar, although Riabinin noticed with alarm that the old Tibetan had fallen dangerously ill with

pleurisy. Twenty-seven in total now, with nearly a hundred animals between them, the combined parties spent two weeks plodding through the Tsaidam Basin. Dodging vipers and red-furred tarantulas, the travelers picked their way through a maze of bogs and brackish ponds, after which they entered Tsaidam's salt flats: a waterless expanse covered with a thin, bleach-white crust that made walking difficult for beasts and humans both.

On September 4, the expedition began climbing again, this time toward the Neiji and Dumbur passes, which would take them into Tibet. At the Koro-aral oasis, they learned that another group of foreigners, probably Filchner's party, was ahead of them. The narrow road zigzagged through menacing basalt cliffs. The rocks provided perfect cover for the robbers known to roam these hills, and on the thirteenth, George and the others, by shouldering their weapons and making as if to fire, drove off a group of Panag raiders who approached within three hundred yards.[176] The party sighted antelope, wild yak, and the occasional bear, but also cast an apprehensive eye to the gray herons overhead, flying south to escape the coming winter. To Riabinin's distress, Helena's heart was beginning to race fast and hard, and he expected Chimpa to die at any time. Death claimed two other victims first: one lama succumbed to cardiac distress in the Neiji Pass, another a few days later. Due to the high elevation—over sixteen thousand feet by mid-September—all the Europeans were experiencing shortness of breath,

insomnia, and loss of appetite. The onset of the snowy season made it all the more important that the party find shelter soon.

Fortunately, with the Dumbur Pass in view, the expedition was only a week and a half from the Tibetan fortress town of Nagchu. Several of the lowland animals were dropping dead in their tracks, so the party stopped at a way station near the border to exchange some of their horses and camels for hardier yaks. Pressing on, the group trudged through the Dumbur on September 23, reaching the first Tibetan outpost, near the Olun-nor lakes, on the night of the twenty-fourth. At long last, the Roerichs were in the fabled land of snows.

In 1925, the French surrealist Antonin Artaud penned this prayer-like appeal to the Dalai Lama: "O Great Lama, grace us with your illuminations . . . and [turn us] toward those perfect summits where the Human Mind no longer suffers."[177] By the time they reached Tibet, the Roerichs had spent years under this same spell, picturing the Dalai Lama as the patriarch of a transcendental land where snow leopards glided ghostlike over starlit icefields, and where the sonorous drone of *dungchen* trumpets lifted the listener's spirit closer to the godhead.

Disenchantment came quickly, soon leading Roerich to denounce Tibet as a "land of monkeys and fools."[178] The guards at Olun-nor, an "unkempt lot" in filthy sheepskin vests, allowed the foreigners

across the border, but assigned Hor-pa "guides" to "escort" them into the interior.[179] The Roerichs viewed this as an insult, but still trusted that their travel permits, plus Nicholas's acquaintance in India with notable Tibetans like Tsarong Shape, Laden La, and Kusho Doring, would see them the rest of the way to Lhasa. What Roerich now intended to achieve there remains hard to figure. Having made no direct contact with the Panchen, he could hardly claim the right to mediate with the Dalai on his behalf, and he no longer judged it feasible to win influence at the Potala by posing as a representative of Soviet interests. It seems that he felt his only choice at this stage was to press on and hope that, once in the Dalai's presence, he could win some sort of support on his own merits as a Buddhist.

The end of the month found the group inching across the tundra-like emptiness of the Chantang Plateau. Here, everything went awry. On October 2, Chimpa suffered a near fatal heart attack. On the sixth, George was struck down by altitude sickness and atrial arrhythmia so severe that Riabinin had to dose him with digitalis. That same day, Tibetan guards asked the party to make a brief halt that they promised would last only a few days. This instead became a five-month period of detention.

The British were exacting revenge. Earlier, they had gotten word that Roerich was in Mongolia, heading south. On October 1, the Government of India issued orders to arrest him on sight if he showed himself anywhere under British jurisdiction.[180]

In Sikkim, the British resident, Frederick Bailey, recalled Roerich's talk about Tibet and guessed that he was en route to Lhasa. He warned the Dalai Lama about Roerich's possible arrival and potential Bolshevism, thus sealing the artist's fate.[181] Tibet's authorities viewed all outsiders with suspicion: Chapchaev failed to gain an audience with the Dalai, and Filchner did not reach Lhasa at all. But with so many rumors in the air about the Panchen Lama possibly returning at the head of a foreign army, the Tibetan government, heeding Bailey, treated Roerich with extra caution. His caravan was searched on October 7 and, on the ninth, ordered to proceed to the riverbank settlement of Chu-nar-gen and await further instructions.

On October 10, the commissioner of the Hor District, General Kusho Kapshö-pa, came to question the Roerichs, though George's illness made translation difficult. The general seemed genial enough, and the Roerichs thought it likely that he would let them proceed at least to Nagchu. That hope, however, ended on the thirteenth with Chimpa's death, a painful affair preceded by delusional fits, which convinced the nearby villagers that the old trader was possessed by demons. Closer inspection of Chimpa's baggage revealed his hidden cache of weapons, a development that seemed all the more alarming when his companions immediately fled. The guns were confiscated and several of the runaway lamas apprehended; in due course, the Lhasa police took the shipment's suspected recipients, the staff of

the Mongolian embassy, into custody. Kap-shöpa, now noticeably frostier, returned to Nagchu to consult with the city's governors. He commanded the expedition to remain at Chu-nar-gen until further notice, and assigned an "honor guard," led by a Major Sö-nam Thop-jyel ("Major Kh." in the Russians' memoirs), to keep the travelers "safe."

No one charged the Roerichs with wrongdoing or used the word "arrest" in their presence, but this was incarceration without walls, where the wilderness did more than the six bored soldiers and the major's plump, smiling wife to keep the party glued to the spot. Every route was easily watched, and no one, not even George with his languages, had the skill to pass for anything but an obvious outlander. The group was not allowed to trade or communicate with other caravans, nor were the Roerichs permitted to take photographs or use their movie camera. (When Roerich heard in November that Filchner, detained at Tsomra, had been given permission to film the monasteries there, he went livid with rage.[182]) Only with the help of their captors could they maintain contact with the outside world, but although Major Kh. promised to forward their letters, he did not do so.

True misery began after October 20, as winter conditions set in for good, and it worsened three weeks later, when Major Kh. announced that the expedition was henceforth banned from buying food or fuel from the Chu-nar-gen locals. Till now, Roerich's concerns had centered on his mission. By November, he and his family began to

realize that they might well die. Not having bargained on being out of doors for any length of time during the winter, they were equipped mainly with three-season gear, and they had no fodder for their pack animals. Nighttime temperatures dropped to minus twenty degrees Celsius and below, with worse to come, and the lack of fuel to burn made the weather all the more dangerous. Awaking one morning, the family was astonished to find that a bottle of cognac had frozen solid overnight, and the cold spoiled much of the movie footage shot thus far. Monitoring the Europeans' poor diet, elevated heart rates, and occasional snowblindness, Riabinin confided to Portniagin, "From a medical and physiological point of view, our position is catastrophic. We will all perish. Only a miracle can save us now."[183]

By mid-November, the campsite—which the Roerichs nicknamed "Riverside Drive," when they had enough strength for gallows humor—was a sorry sight. Each morning, the light of day revealed the gruesome pile of pack animals that had passed away overnight. Eventually, 90 of the original 104 died, although the fresh meat went some way toward blunting the desperate need for food. Flocks of ravens and lammergeiers, the bearded vultures of the Himalayas, fed on the carrion, and wild dogs harried the camp. When the native expedition members were not fighting among themselves, they were fraternizing with Major Kh. and his men, swapping cigarettes for flasks of barley wine. (When

Roerich pointed out that "good" Buddhists were not supposed to smoke or drink, the major laughed in his face.[184]) Most days, boredom and poor health kept the Russians huddled in their tents. Helena grew so fevered at times that, while her husband slept in a fur coat under heavy blankets, she wore only a silk nightgown under a thin sheet.[185] Nicholas, laid low by angina, dictated letters to Tsarong Shape, as well as an angry screed to the Dalai Lama, stating that, in light of Lhasa's indifference, the "Embassy of Western Buddhists" no longer had any reason to stay in Tibet and should be allowed to go on to India. On November 10, George sent an urgent cry for help to Colonel Bailey in Sikkim: "The Mission is detained by Tibetan Government pending an answer from Lhasa, already 32 days. Have to stay in summer tents with scanty food supplies and fodder. Almost no fuel, cold about −30°C. . . . Half our caravan animals already perished. . . . The forcible stay bears hard on all members of the Mission. Madame Roerich has been unwell during the whole trip . . . I myself nearly died of an acute attack of mountain sickness. . . . The presence of women and children makes the situation very critical."[186] Ironically, the "children," meaning Lyudmila and Raya Bogdanova, remained in perfect health the entire time.

Neither of these messages, nor any of the Roerichs' earlier missives, reached their destination, as the party soon discovered. In late November, to the Roerichs' horrified surprise, Major Kh. returned to them a packet containing all the pieces of mail that they had thought were en route to Lhasa, New York, and elsewhere. December's cold killed a fourth member of the Asian contingent, and the Roerichs now pleaded every day with the major to let them move on. After one such quarrel, Helena shrieked in fury that "these are not human beings, but beasts!"[187] The major, whose own wife was ill, had little sympathy to spare, but his own self-interest made him just as eager as the Roerichs to relocate. Kordashevsky volunteered to put on native dress and slip away to fetch help, but he was too tall, too pale, and too unfamiliar with the roads for this plan to have any hope of succeeding.

The sense of doom lifted somewhat in mid-December, when Roerich and his companions received permission to shift their camp to Sharugön Monastery, a day's ride to the south. Sharugön was no palace, and the expedition remained under Major Kh.'s watch, but the new site provided shelter during the year's most frigid nights. Shortly after Christmas, Nagchu's governors lifted the ban on trade that had kept the party from purchasing food, and they came out on January 6 to speak with Roerich in person. They interrogated him about his politics, seeking to determine whether he was a communist. Roerich querulously replied, "You let pass the real Reds," referring to Chapchaev, "but are halting me, an actual Buddhist.[188] The governors allowed the Roerichs to post letters to the outside world, and, observing the caravan's pitiful condition—temperatures after sunset now dipped below minus forty-five degrees Celsius, and

the major's wife died on January 5—they invited it to come to Nagchu, which it did between January 19 and 23. The transit caused the expedition's fifth and final death, as the Buryat lama Malonov, drained by illness, fell from his yak and died where he lay. Nagchu was the only population center of any size that the Roerichs visited in Tibet. They could resume their journey in the spring, they were told, but they were to proceed directly to India, and under no circumstances were they to approach Lhasa, Shigatse, or Gyantse as they left.

Whether in Sharugön or Nagchu, the weeks of waiting took their emotional toll. Golubin got into a round of fisticuffs with the native crew, and Riabinin grew sulky and argumentative. Kordashevsky swung between depression and mania, picking fights with Raya and, on one occasion, emptying his pistol into the sky, shouting all the while that a mysterious force was compelling him to do so.[189] Helena staved off boredom by keeping her journal and rereading a book of essays by Vivekananda; George examined the paltry selection of religious texts available at the Sharugön and Nagchu monasteries, dismissing them as "old Chinese stuff which the Chinese themselves have rejected."[190] If Portniagin is to be believed, the person least touched by the prevailing despondency was Roerich, who "did not for a minute lose his thirst for ceaseless activity."[191] Roerich planned out a new series of paintings—"Land of the Buddha," which he completed after the journey—and continued his half-ethnographic,

half-Theosophical speculations about the diffusion of cultures.[192] Were all Europeans descended from the ancient Tibetans, he wondered? Had the country's indigenous Bön-po faith given birth to druidic paganism? Did the Eddas and the legends of Siegfried stem from the same common source as the tale of Gesar Khan?

Most of all, Roerich cataloged the many ways Tibet had fallen from its former glory. The local Hor-pa he compared to the misshapen Nibelungs of Germanic myth.[193] He ranted for hours about tantric and shamanistic "impurities" that, like a cancer, were "destroying" Tibetan Buddhism from within, and he accused Lhasa of plunging the country into poverty and primitivism. The blame for illiteracy, alcoholism, and the persistence of "barbarities" like polyandry and sky burial—leaving bodies in the open to be devoured by birds of prey—he lay at the feet of Tibet's government. "All the best lamas have fled the country," Roerich told his followers, and the Dalai Lama, privileged to hold court so near to Shambhala, had betrayed both the Buddha and the Great White Brotherhood.[194] "A drunken monk," Roerich called him, likening him also to "a gigantic spider."[195] If ever he returned to civilization, Roerich vowed, he would reveal to the world the vile corruption befouling the halls of the Potala.

On March 4, 1928, Tibet unclenched its icy fist and allowed the Roerichs to depart.

"At last we are leaving this disgusting hole behind," sighed a relieved Portniagin. Early in the morning, the caravan—restored to a strength of 155 yaks, horses, and camels, and dubbed the "great fleet" by Kordashevsky—took the westward road out of Nagchu.[196] To keep the Roerichs as far away from population centers as possible, the assigned exit route was long and roundabout, but to the extent the expedition substantively contributed to the field of Tibetan exploration, it was by journeying through these barely known southern districts.

Nagchu's governors had assured Roerich that any group traveling at normal speed would reach the border in twenty-eight days. But sapped as it was by leftover fatigue, the expedition took nearly three times that long to cover the distance. In mid-March, the Roerichs stopped for three days in the town of Namru, where they picked up a travel permit that had been mailed to them from Lhasa, complete with a letter requesting that locals extend the foreigners every possible courtesy. Roerich asked if he could be allowed to visit Gyantse, if not Lhasa, but permission was denied, and the party moved on.

The Roerichs next entered the Do-ring ("long stone") Valley, named after megalithic ruins that recalled to George and Nicholas the standing stones found in Brittany's Carnac region. Speaking poetically about the "druidic" practices that supposedly tied ancient Tibetans to Goths and Scythians, Roerich concluded—rather audaciously—that "this discovery rounded out our

search for traces of the great migrations."[197] ("Gothic Traces Discovered in Tibet," and "Druids Ruled Old Continents," Roerich later claimed in the *Philadelphia Inquirer*, the *New York Herald*, and the *Los Angeles Times*.[198]) The first week of April brought "Macbeth-like storms," but after that, the party found itself surrounded by blooming flowers and grasses.[199]

Better weather did not improve the party's mood. Kordashevsky grew "gloomy in the soul" at the thought of parting from the Roerichs, especially Helena, whom he idealized as a reborn Joan of Arc.[200] Portniagin had fallen ill, and Helena's heart still troubled her. All this coincided with a difficult southward turn through the Himalayas, which took the party back to altitudes of eighteen thousand feet and more. Frustration mounted as faulty maps led the caravan into blind alleys and forced it to backtrack more than once. Climbing through the Gyelong Pass on April 18, Golubin screamed out, "Oh God! There is no end to these mountains!"[201] Such despair prompted a drastic bit of action later that day, as the party, exhausted by the crossing, entered the village of Bum-pa and demanded extra provender for their animals. The headman refused, even when Roerich brandished his "aid where possible" letter from the government. Acting as though Lhasa had authorized him not just to ask for assistance, but to enforce the law of the land, Roerich instructed George "to follow strict measures for our protection"—which meant seizing the headman at gunpoint and

placing him under "arrest."[202] Eager to have the Roerichs out of Tibet, the militia at the nearby fort of Saga-dzong overlooked this lapse into vigilantism and sent the group on its way after a three-day rest.

On April 25, a welcome sight greeted the Roerichs' eyes: the banks of the Tsang-po, as the Tibetans call the Brahmaputra. The expedition crossed the river by ferry on the thirtieth and, on May 6, came to the imposing Shekar-dzong, a citadel overlooking the crossroads to Nepal. Twelve days later, atop the Sepo Pass, they spotted the stone cairn that marked the Sikkim border. "Farewell, land of winds and gales and inhospitable rulers!" George exclaimed as they passed over.[203] Safe haven lay just ahead.

Once in Sikkim, the Roerichs made straight for Gangtok, which they reached on May 24. There, they cabled the news of their return to the Horches, instructing them to send communiqués to the press. They were to write President Calvin Coolidge as well, describing how "courageously" the party had faced the "hardships of an exceptionally hard winter" and enumerating the "many scientific results" they had come away with.[204] The *New York Times* spread the word with the bombshell headline, "Tortured in Tibet, Roerich Is Safe."[205]

Most immediately interested in Roerich's exploits was Britain's Colonel Bailey, who interrogated the artist at length about his journey. He did so craftily, acting the part of a sympathetic host and giving away nothing about his suspicions—or his role in stranding Roerich in Tibet. Reporting on these interviews to the Raj, Bailey stressed the difficulty of determining whether Roerich was truly pro-Soviet, much less an actual spy for the USSR.[206] Although he had taken no chances in advising Tibet how to handle the artist, the colonel understood better than most the conflicted feelings that émigré Russians often had for the Soviet Union. As he put it in a letter to his mother, written while he waited for the Roerichs to straggle into Gangtok, "they were not Bolshie [in 1923], but like so many Russians, they made peace with the Bolshies and are now working for them."[207] Days of debriefing, however, led him to conclude that, if there had been a flirtation between Roerich and the Soviets, it was now over. "The party gave me the impression of being anti-Bolshevik," he told his superiors. The Roerichs talked about rude treatment in Moscow and were happy to give Bailey all the information they could about the "very dangerous communist Shipshaeff" (by whom they meant Chapchaev). "[Their] whole conversation was to the effect that they had done with Russia," Bailey wrote in summation. "From a literary and scientific point of view," Roerich was, in his opinion, "a humbug, a bad painter, [and] afflicted with megalomania." But he was "in character rather agreeable in a vague way," and—most important of all—"almost certainly not a Bolshevik agent."[208]

Bailey missed the target as often as he hit it. He guessed correctly that Roerich's

anti-Soviet sourness was genuine, but had no way of knowing how recently the artist had changed his mind on that count, or how close a bond with the USSR he had tried to forge. Nicholas and George disclosed their itinerary accurately to Bailey, admitting that they had been in Russia, but they prevaricated about their reasons for having gone there. (One bit of honesty—Roerich's insistence that he had not visited Leningrad during his weeks in the USSR—did more than any lie to damage his credibility with British officials, who remained convinced that he had been there.) Roerich passed Riabinin off as a White Russian living in Ulaanbaatar and, when asked about his future plans, assured Bailey that he would return to America for good, just as soon as Helena had recuperated. Based on Bailey's judgment that Roerich represented no real threat, the Government of India lifted its arrest-on-sight order from the previous autumn and granted permission for the family to remain in India temporarily, although they were to be kept under "unobtrusive observation."

From Gangtok, the Roerichs and their companions crossed into India proper, arriving in Darjeeling on May 27. With the Bogdanova girls, the Roerichs set up house, while the other four left quickly, never to see their mentors again. Golubin sailed to China, then vanished. After journeys to Burma and Italy, Portniagin became a Catholic priest and settled in Harbin to do missionary work. Repatriated to Russia after the victory of communism in China, he spent seven years in a prison camp, then worked

for the Uzbek Institute of Lambswool Production. He died in 1977. Kordashevsky took priestly orders in the Uniate Church, married his fiancée Yevgenia, and lived in Jerusalem from 1934 until his death in 1948. For years, he begged the Roerichs to accept him back into their service. In 1929, under the pseudonym N. Dekroia, he published his account of the expedition in the émigré newspaper *New Russian Word*.

When Portniagin went to prison, it was on charges of helping Roerich spy for Britain, and Riabinin's fate says much the same about the dangers of associating too closely with the artist. Initially, the doctor thought he might derive some advantage from his adventures; he reported back to Trilisser of the OGPU and even sought to publish his travel diary, *Tibet Unveiled*, with Gosizdat, the USSR's state publishing house. Then, in 1930, he was arrested for counterrevolutionary activity and espionage "under the flag of studying Buddhism." His property was confiscated, and he spent most of 1930–1947 in the GULAG. After his release and until his death in 1956, he worked as a pediatrician in his hometown of Murom.[209] Others thought to have plotted with Roerich were suppressed more forcefully. As noted above, Gleb Bokii and Alexander Barchenko of the Spetsotdel were executed during Stalin's purges. For hosting "the American spy" Roerich during his time in Ulaanbaatar, Pyotr Vsesviatsky was shot in 1938. Touching Roerich most closely was the plight of his brother Boris, questioned in 1927 and jailed in May 1931. Boris escaped hard labor and

was confined instead to a Leningrad *sha-rashka*: a special type of prison, familiar to Western readers from Aleksandr Solzhenitsyn's novel *The First Circle*, where engineers and other skilled professionals worked on state projects. As part of "Special Construction Bureau No. 12," Boris was one of the architects who designed Leningrad's secret police headquarters, the universally feared "Big House" that still stands on Shpalernaia Street. Sentenced at first to three years of confinement, Boris was restored to liberty halfway through his term, in January 1933, and relocated to Moscow.[210]

As for the Roerichs in 1928, a hard reckoning awaited. The fateful year of 1936 was less than a decade away, but the expedition had failed to bring the Great Plan any closer to fruition. The people of Asia had not answered their call. Their earlier assumptions about the balance of power there had been made irrelevant by the Dalai Lama's continued loyalty to Britain, the Panchen's failure to pursue his own aims resolutely, and the unpredictability of China's civil wars. Roerich had overestimated the Soviets' ideological flexibility on the question of religion, and during the short time between his visit to Moscow and his return to India, the comparative liberalism of the mid-1920s had given way to renewed radicalism. Stalin had achieved his final victory over Trotsky and abandoned the New Economic Policy in favor of agricultural collectivization and the Five-Year Plan in industry. Moderates like Chicherin and Lunacharsky were exiting the political scene. Intolerant times lay ahead for all religious believers, and Stalin expressed particular contempt for the notion that Buddhism and communism were in any way compatible. Both the USSR and Mongolia began systematically persecuting Buddhists in the late 1920s, and the Soviets outlawed all occult doctrines, Theosophy included, in the mid-1930s. Agvan Dorjiev and Tsyben Jamtsarano fell victim to Stalin's terror. Both were arrested in 1937, and both died in prison hospitals: Dorjiev in 1938, Jamtsarano in 1942.

Confronted with such setbacks, a less determined individual would have surrendered to frustration. But not so Roerich. If his leftward tack had failed to carry him to Shambhala, he and his family would bear to the right once again—relying more than ever on their disciples in America.

CHAPTER 12

The Silver Valley, 1928–1930

Audacity succeeds as often as it fails. In life it has an even chance.

—Napoleon Bonaparte, *In His Own Words*

What happens when the end times one foretells do not come to pass? Does the prophet stand exposed as false? Do followers start to doubt their cosmological assumptions? Does everyone simply lose faith and scatter?

These were the questions facing the Roerichs as they limped back to India in the spring of 1928. Neither Nicholas nor Helena wavered in their conviction that they were the instruments of providence, but great effort would be needed to keep their adherents loyal. This the Roerichs did, managing against all odds to maintain multiple bases of support—among them a safe haven in northwest India and, in America, the magnificent Manhattan museum built and paid for by their New York circle.

With the possibility of aid from the USSR gone, this was also a time of political recalibration. Roerich reverted to the anti-Soviet position he had held a decade before. He sought to renew ties with White Russian émigrés, and he pondered alliances with any government that seemed willing to act against the USSR. To garner further goodwill and renown, he relied on his ongoing Banner of Peace campaign, a treaty-making effort that attracted worldwide attention, though actual results came slowly.

Despite the mundane concerns before them, Nicholas and Helena never lost sight of their Great Plan and, once recovered from the rigors of their journey, began forging ahead with what would be their third attempt at it. It was an audacity in defeat to rival Napoleon's—even if it led in the long term to much the same outcome.

No sooner did the Roerichs return to India than they began scheming to stay there permanently. Roerich repeatedly postponed his date of departure, then cajoled the British into letting him remain till 1929. He also persuaded them to issue visas to Sviatoslav, Sina Lichtmann, and Frances Grant, all of whom came to India in August 1928, and to Vladimir Shibaev, who sailed from London in October, leaving behind the bride he had married that summer. The Government of India (GOI) balked at allowing Roerich's guests into the country and worried that Sviatoslav's arrival would remove any incentive for the family to leave.[1] But Roerich maintained that extra help was needed to prepare for the long trip home, particularly with Helena's health so frail.

Even as they relented, the British regretted doing so. "Roerich has been consistently rude and tiresome," noted the GOI in June, "and our expectation that he would be anxious to go straight back to America has been disappointed."[2] Still, they had enough respect for due process not to expel someone without cause, and try as they might, they could not prove Bolshevik affiliation on Roerich's part.[3] Moreover, Roerich pilloried the Dalai Lama in the press that summer, demonstrating how much trouble he could stir up when his wrath was roused. To the Calcutta correspondents of the *Statesman* and the London *Times*, and in a five-thousand-word bulletin sent to the Manhattan Buddhist Center, he poured forth a "lamentable account" of conditions in Tibet, accusing its leaders of leaving the poor to wallow in "unimaginable filth" and to feed on "raw carrion, like beasts." In a July issue of *Time*, he repeated these charges in an article titled "Bad Buddhists."[4] (Simultaneously, Roerich demanded a formal apology from Lhasa, plus $150,000 for material losses, but received only a token payment of 1,826 rupees for the pack animals lost on the Chantang.[5]) The British, not wishing this sort of publicity turned against them, or for Roerich to guess at the role they had played in his incarceration, elected to handle him gingerly, consoling themselves with the thought that "discreet surveillance" would keep him from doing any harm.[6] "If he starts disseminating pictorial propaganda in India," one official jested, "he can always be invited to try his hand at sea-scapes instead."[7] Had the British known the aggravation he would continue to cause, they would have sent him packing on the next available boat.

The summer reunions brought many happy moments. Seeing Sviatoslav again, after three years of separation, was an enormous joy. Sina and Frances carried welcome news from Nettie, who was expecting a second child after having given birth to Oriole in March 1927. Frances responded with delight to India's exotic charms. Daily, she walked for miles through the Darjeeling hills, moments remembered fondly in her poem "Himalayan Etching":

Here, this solitary pilgrim
Traces her downward way
Through monumental pines and cedars
Amid the rising obbligato from below
Of temple bells and trumpets . . .[8]

Helena resumed her séances and delivered disquisitions about the White Brotherhood—which she and Nicholas were to join in the fateful year of 1936—and the vast interplanetary battles that pitted the White Masters against the perfidious will of Lucifer. She read auras, cast horoscopes, and preached the virtues of vegetarianism.[9] A frequent guest at these sessions was the English Theosophist Laura Finch, who met the Roerichs in June 1928 and considered Helena "a marvellously gifted soul."[10] "We were in and out of each other's houses daily," Finch later reminisced, and other admirers joined her in welcoming the family back.

Still, these were months of hard work and hard decisions. The dozens of paintings Nicholas had completed during the expedition needed to be inventoried and packed for transport to New York, as did the objects collected by the family. These included ritual masks and robes, scrolls and books, mandalas, and one genuine treasure: a 335-volume set of the *Kanjur-Tanjur*, the complete Tibetan Buddhist canon, supplemented by commentary dating back to the fourteenth century. Reams of written material had to be translated into English and prepared for publication. Nicholas's travelogue was shaped into the texts that became *Altai-Himalaya* and *Heart of Asia*. Sina transcribed

portions of Helena's diaries, with much of this material going into the newest volumes of the "Agni Yoga" series. Most of the typing fell to Frances, who got to work by 6:00 every morning.

Sina and Frances also helped the Bogdanova sisters tend to Helena's many ailments. Exactly how sick Helena was remains impossible to verify. It served the family's interests to give British authorities the worst possible impression of her physical state, and the only doctors who examined her were friends or followers. It seems, however, that Helena indeed spent the autumn in chronic pain and believed herself to be mortally ill. Due to turn fifty in February 1929, she recalled how her parents had died in their fifties, and a voice she thought was Koot Hoomi's told her in her dreams that death stood at her shoulder. To Frances and Sina, she gave instructions for an "Atlantean" funeral: they were to anoint her body with oil, cover it with flowers and let it lie for three days in a circle of lamps, then take it to a cave for cremation. Happily, no one had to honor this request.[11]

Hardest of all for the Roerichs was charting a new direction and ensuring that their disciples followed it. First, they had to recover from the USSR's rejection of the Great Plan, an embarrassment that called into question the couple's credibility. For this setback, they blamed the Kremlin, which, in turning away from their proposals, had failed the test put to it by the White Brotherhood. In 1929, tales of Stalin's brutality soured the group further on

the USSR. Russia, Morya declared, was to be "temporarily set aside—let them live without us."[12] The Roerichs then took up the task of reining in the inner circle's animosities. Sina, Frances, and Esther hated each other no less than before, and Sina and Frances found it increasingly uncomfortable to interact with the Horches. Such conflicts, the Roerichs insisted, were worthy "only of dogs," and they set off negative vibrations that blocked Helena's communications with the Masters.[13] Helena coaxed Sina and Frances to make peace. "My little ones," she cried. "How can I bring you closer together? You must not fight—each of you is wonderful in your own way!"[14] The two never came to like each other, but over the next decade, they operated as reluctant allies.

Even George and Sviatoslav added to these tensions, comporting themselves at times like unruly princes.[15] George, ever the scholar, sometimes found it hard to contain his skepticism about Agni Yoga. "I can only accept provable facts," he would declare, disturbing the household's mood and causing Helena to scold him for apostasy. More sunnily irreverent, Sviatoslav went along with his parents' teachings, but without much conviction. Having become fond of Louis Horch over the last several years, he baited Horch's foe Sina whenever possible, mocking her with the nickname "crocodile" and undoing his parents' efforts to maintain good relations within the inner circle. Also of concern to Nicholas and Helena was Svetik's propensity for inappropriate romances. A skilled seducer, Sviatoslav began affairs

with many women, many of them older. One of them—Katherine Campbell, introduced below—was increasingly important to the Roerich enterprises' continued success. Fearing scandal or emotional blowback if Sviatoslav angered any of his paramours, Nicholas and Helena disapproved on practical grounds as well as moral ones, but soon discovered that no amount of nagging would persuade him to forgo his dalliances. An unhappy Helena concluded of her son's lustiness that "it is his karma."

As always, keeping the Horches faithful was paramount. On one hand, Louis and Nettie were excited about the baby they had on the way and proud of the improvements they had made to the Roerich Museum and the Master Institute. On the other, Louis had doubts that needed assuaging, as demonstrated by his request that Roerich sign a stack of newly drafted documents brought to India by Sina and Frances. Among these was a reconfirmation of the Horch–Roerich agreement from 1923, by which all "paintings and drawings from Finland," plus all works completed "from 1924 to 1928, including the paintings sent from Darjeeling, Kashmir, and Urga, and cited in the catalogue of the Roerich Museum," were named Horch's property.[16] This assurance, Horch explained, was needed to secure loans for the new museum's construction; according to Frances, he promised to tear it up afterward. Roerich signed it in August without a second thought, but in light of the way Horch repudiated him in the mid-1930s, the transaction raises questions. Years later,

Frances testified that she had always considered Horch's request "very strange," and while this may be a case of memory invented after the fact, it is tempting to wonder whether Horch—who had spent over half a million dollars of his and Nettie's money on the Central Asian expedition—was exercising due caution before investing further in Roerich, or already feeling the distrust that shattered the inner circle in 1935.[17] It struck Frances as odd that, in June 1928, when Horch renewed the Master Institute's educational charter with the New York Board of Regents, he left the Roerichs' names off the board of directors, and it has always been a mystery that Horch, who had power of attorney over Roerich's affairs and employed him—paying him a "salary" amounting to 4 percent of the appraised value of all paintings received—failed at any time to file tax returns on his behalf.[18] These may have been oversights, or they may have been expressions of latent or actual hostility. Either way, dire legal consequences flowed from them in time.

At the moment, all seemed well, for Horch agreed that summer to finance Roerich's newest undertaking: the establishment of a Himalayan research institute named Urusvati, or "morning star" in Sanskrit. Archaeology, botany, and linguistics were but a few of the fields to be represented, with George coordinating this multidisciplinary effort. Roerich proclaimed Urusvati's birth in July (although operations would not begin until 1929) and readied publicity pamphlets for worldwide distribution

in September. Letters went out to potential colleagues and partner institutions, and Roerich scored an early coup in October by persuading Jagadis Bose, one of India's most esteemed scientists, to join Urusvati's board of directors. What remained was to find the institute an actual home.

The Roerichs set their hearts on the remote Kulu region, in the Punjab's Kangra district, where the waters of the Beas roll down to join the Sutlej. This "silver valley," so named for the apple blossoms that grace its orchards every spring, afforded easy access to the Himalayas and to ethnographically and environmentally interesting parts of India's northwest, among them Kashmir, Lahul, Spiti, and the Zanskar range. It occupies an honored place in Indian lore. Vyasa, the legendary compiler of the epic *Mahabharata*, is said to have lived there, and the settlement of Manali is claimed as the spot where the lawgiver Manu returned to dry land after surviving, like Noah, a flood sent by the gods. Three hundred sixty deities, as constant and benevolent as the deodar trees rising majestically from the valley's escarpments, are believed to watch over Kulu's terraced farmsteads and tiny hamlets. Conveniently, a property was available for purchase: the Hall Estate, an eighteen-room villa nestled in the hills above the village of Naggar and offered for a price of 100,000 rupees by the Maharajah of Mandi.

Thanks to Horch, the Roerichs had the means to buy Hall Estate, but would the British permit them to do so? Between the ninth and twentieth of September, Nicholas,

George, Frances, and Sina traveled to Calcutta, where they took advice from the US consul, Robert Jarvis, then to Simla, the summer capital of the Raj. There, Roerich pitched the Urusvati proposal to William Peel, the secretary of state for India, and Muhammad Habibullah, the minister of education, health, and land. Peel turned Roerich's request down, although perhaps more tactfully than he should have, because Roerich later claimed to have come away with the impression that Peel thought highly of Urusvati and was simply warning him that foreigners were not allowed to purchase land owned directly by the Raj.[19] Nothing stood in the way of acquiring privately owned property, a point Roerich discussed with Robert Frazer, the US consul general, and with four attorneys, three English and one Punjabi. What Roerich did not know, or professed not to know, was that the Maharajah of Mandi had been given Hall Estate only three years before by the GOI, and on condition that he not transfer ownership without permission. In October, while Roerich spoke with lawyers about whether he could buy Hall Estate, Sina and Frances arranged for him to use Horch's money to do so. With that, the time came for the pair to leave, Sina to resume work in New York and Frances to embark on a tour of Latin America, generating publicity on the Roerich Museum's behalf. After a tear-drenched farewell with Helena, the two departed on November 1. Taking their place in the spring would be Esther, whose qualifications as a nurse, it was hoped, would ease Helena's physical ailments.

In December 1928, Roerich approached the Maharajah with an offer to purchase Hall Estate for 93,000 rupees. Unaware of how the GOI felt about the artist, the Maharajah agreed, and the papers were signed in January 1929. Roerich was to pay 20,000 rupees as earnest money in February, and another 20,000 on March 1, at which point possession would transfer to him. The remaining 53,000 rupees would be held by the Imperial Bank of India and released to the Maharajah in July. The Roerichs handed over their first two payments and moved to Naggar in March, helped by Shibaev and the Bogdanova sisters. Esther arrived in April, and the group set up house, shoring up walls, applying fresh paint, and digging new wells and drainage trenches. Observing local tradition, they invited a *gur*, or priest, to invoke the blessing of Kulu's many gods, and the *gur* assured them that the guardian spirit Guga Chohan—a statue of whom still stands on the estate's grounds—was pleased to have the Roerichs settle in the valley.

Not so the Raj, which refused to register the transaction and, starting in January, fired off a barrage of letters to Roerich, with copies to Robert Frazer at the US Consulate, explaining the encumbrance on the Maharajah's title to Hall Estate and stating emphatically that under no circumstances would the Roerichs be permitted to own land in India.[20] Roerich later swore that he was told none of this until the late summer of 1929, but even if one accepts the possibility that Secretary Peel had left room for confusion when he spoke with Roerich in

the fall of 1928, there was nothing ambiguous about the messages the British sent in January and February. Only a catastrophic failure of the mails could have left the Roerichs unaware of the legal shakiness of their position before they committed fully to the purchase on March 1, and one has to conclude that they proceeded with full awareness of the legal perils facing them.

As for why they did so, it may be that they considered their reading of the law to be more correct than the GOI's. But it is likelier that Roerich was dealing with the British as he had before: Doing as he pleased, then trusting that a stubborn show of righteous indignation would keep the British from undoing his fait accompli. Astonishingly, he succeeded, even if doing so took months of bureaucratic struggle. That fight, however, was not on his mind in early 1929. His attention shifted instead to developments in America.

In March, Louis and Nettie Horch celebrated the first birthday of their daughter Oriole and the arrival of their baby boy Flavius. Also that month, on the twenty-fourth, they lay the cornerstone of the grand edifice that would house the new Roerich Museum. The properties once standing on the corner of 103rd and Riverside had been torn down, and to fill the vacant space, Horch had hired one of New York's leading architects: Harvey Wiley Corbett, the designer of the Metropolitan Life Building and one of

Rockefeller Center's key developers. To the groundbreaking ceremony, Horch invited the local press and the head of the New York State Education Department, as well as the recently inaugurated president, Herbert Hoover, and several members of Hoover's new cabinet. James Davis, the secretary of labor, did not attend, but sent the following letter, which was read out loud during the proceedings: "As we grow in material wealth it is all the more necessary to keep alive our knowledge and love of the beautiful things of the spirit and mind, otherwise we are in danger of gaining the world and losing our souls. It will gratify every high-minded American who has the destiny of his country at heart, to see enlisted in this preservation of culture and intellect a body of people and an organization as influential, vigorous, and enthusiastic as yours."[21] Horch's invitation to William Mitchell, the attorney general, elicited a different response. Mitchell forwarded the curious missive to the Federal Bureau of Investigation, asking J. Edgar Hoover to find out more about the museum. Hoover's penciled note—"The Atty. Gen. asks 'What is it?'"—is scrawled in the margin, and Hoover dispatched Agent C. A. Appel, posing as a journalist, to investigate. Appel was shown around the museum's temporary offices by Maurice and Frances, but found little to excite comment.[22]

Whatever America's crimefighter in chief made of it, the museum and Master Institute had been transformed during Roerich's absence into professionally run outfits, abuzz with activity and perpetually

in the public eye. The number of students measured in the hundreds, and the faculty complement had grown in size and quality. Alongside its permanent collections of Russian icons and Asian art, the museum, even in interim quarters, displayed works by Gauguin, El Greco, Ferdinand Hodler, and Félicien Rops. Special shows featured sculptures and paintings by Master Institute instructors, including Rockwell Kent and Isamu Noguchi. Thirteen canvases by the Amaravella group—the "cosmic" painters Roerich had recently met with in Moscow—hung in the museum, bearing titles such as *Hindu Fantasy*, *Hymn of the Orient*, and *Mountain of Light*. A host of Russian painters, dancers, and musicians, both émigrés and visitors from the USSR, attended gala events at the institute or performed there, including Fyodor Chaliapin, Mikhail Fokine, Sergei Rachmaninoff, Vladimir Nemirovich-Danchenko of the Moscow Art Theatre, the ballerina Lydia Nelidova, and the acclaimed folk chanteuse (and Soviet spy, as it later turned out) Nadezhda Plevitskaya.[23]

The museum also engaged in large-scale outreach. It lent paintings to the New York City public library system and to elementary schools throughout Brooklyn and Manhattan, and arranged radio lectures on New York's WOR and WNYC stations. It taught sculpture to the blind and offered courses on music therapy. One of its most ambitious, if eccentric, ventures came in spring 1927, when it loaned nineteen Old Masters and a set of more modern works to the Sing Sing and Leavenworth prisons. Horch sought to test Roerich's ideas about art's ability to cure society's ills, as well as progressive psychiatric theories regarding the therapeutic effects of color. Unfortunately, his dreams of rehabilitative edification were dashed on the first day of the Sing Sing exhibit, which was attended by only 50 inmates, while the other 1,600 opted to watch a baseball game in the prison yard. Nor did Horch attract many lovers of art when he himself ventured to Sing Sing to talk about the modern pieces. The chaplain at Leavenworth assured Horch that the prisoners there greatly admired the canvases, but one suspects this was more courtesy than fact.[24]

More worryingly, acclaim and attention did little to pay the bills. Admission to the museum was free, Master Institute tuition was cheap, and, as Frances admitted, the two bodies "did not bring much profit up to 1929."[25] Many hopes, then, were riding on the new museum, whose twenty-nine stories and 2.5 million cubic feet were designed to generate income in a number of ways.[26] The museum and institute would occupy the first three floors, along with a Tibetan Library and a Hall of the East to house the *Kanjur-Tanjur* and curios brought back from Asia. Conference rooms could be booked for a fee, as could the auditorium and theater. A luxurious restaurant would attract diners from around the city and induce museumgoers to spend more time (and money) on the premises.

Above all, Horch hoped to fill the building with long-term residents.

Twenty-four stories of one-, two-, and three-bedroom apartments were available, complete with kitchenette and a balcony or terrace. Premium suites looked out over the Hudson, and many came with corner windows. (These were an architectural novelty at the time, and the Master Building is said by some to be the first New York skyscraper to feature them.) Residents were promised not just high living, but a new life altogether, in "a monument of the New Day when home life will partake of the substance of beauty." They were entitled to a gratis membership in the Society of Friends of the Roerich Museum, a complementary subscription to *Archer*, the society's journal, and admission without charge to all exhibitions and performances (hardly a major selling point, since these events remained free to everyone). Prospective renters were reminded that this "Home of Art and Culture" was "one of the most important additions to the group of cultural institutions"—including Columbia University and the Museum of Natural History—"which have transformed the upper west side of Manhattan Island into a center of art and education." This temple of the arts, providing spiritual and aesthetic sustenance to a village of futuristic dreamers, was to be nothing less than an art deco commune.

Utopia, however, did not come cheap. Construction and related expenditures ran to more than $2 million, above and beyond the cost of buying and clearing the lots. The inner circle's pleas to philanthropists like Ford, Eastman, and Rockefeller proved

no more successful than they had in the early 1920s, and while the group solicited a number of small and midsize donations, these were but grains of sand compared to the mountain of money needed.[27] Success hinged on a $1,999,000 loan taken out by Horch in 1928 from the American Bond and Mortgage Company—and on the Horches' continued fealty, which the Roerichs understood they were taking too much for granted. Sina, Maurice, and Frances had been privileged to spend substantial amounts of time with the Roerichs since the couple's 1923 farewell to America, but the Horches had gone more than four years without setting eyes on Nicholas, and almost six without seeing Helena. Eventually, Louis and Nettie came to see this "unapproachability" as a deliberate tactic of evasion that kept the Roerichs from "having to . . . answer questions and face people directly."[28] They had not yet become this suspicious, but Roerich sensed that the cords binding him to his benefactors had frayed. With that in mind, he chose this exciting but delicate time to journey back to New York.

Roerich returned to America on June 18, 1929, after a monthlong voyage with George and Sviatoslav. The Lichtmanns, the Horches, and Frances Grant, joined by New York's mayor, Jimmy Walker, stood at the pier to welcome Roerich and his sons as they disembarked. A mayoral motorcade took the group up Fifth Avenue and Riverside Drive

to examine the half-completed Roerich Museum. Two days later, Walker awarded Roerich the title "ambassador of goodwill" in a ceremony at City Hall. There were press conferences and a five-hundred-person luncheon hosted by Charles Crane; a reception at the White House was scheduled for the following week. Also before the end of June, Roerich likely met Franklin Delano Roosevelt, then serving as governor of New York State.[29]

However, a succession of disappointments followed, starting with Roerich's June 24 visit to the White House. In the company of Sol Bloom, one of New York's US representatives, Roerich, George, and Horch took the train to Washington, hoping to charm President Hoover into supporting the artist's Banner of Peace initiative. To Roerich's disgust, Bloom monopolized the conversation, leaving time for just a brief chat about Central Asian customs. The painting he had selected as a present for Hoover was so large that it had to be shipped separately, leaving him with nothing to give the president in person. The whole affair, he decided, was an opportunity squandered.[30]

Roerich was just as sensitive to his mixed press coverage. He received more fanfare than he had a right to expect, with the newsworthiness of his journey more than a year in the past. Some have proposed that Roerich's saga prompted James Hilton to write *Lost Horizon*—the 1933 novel that made Shangri-La a household word—but Hilton's main inspirations are documented as having come from elsewhere. If anything,

it was Roerich who benefited from the same general Tibetophilia that vaulted *Lost Horizon* to bestseller status.[31] Roerich's supporters worked hard to prime the publicity pump. In March, Georges Chklaver nominated Roerich for the Nobel Peace Prize. Frances placed pro-Roerich stories in the *New York Times*, *Musical America*, and the émigré paper *Rassvet*. Reuters compared Roerich to Herodotus and Richard Francis Burton, and *Literary Digest* praised his "far quest for beauty."[32] Still, enough papers and magazines dissented to give Roerich cause for alarm. The *Kansas City Star* admitted that "there can be no question of his talent," but in ominous language fit for a broadcast of *The Shadow*, asked "What has he been doing for six years among the deserted foothills of the Himalayas? At least one government would like extremely well to know." The "incoherent adulation" of Roerich's "fanatical" followers, it concluded, meant few if any answers would be forthcoming.[33] *Time* chose tongue-in-cheek mockery over melodrama, poking fun at Roerich's "dank, uncompleted museum" and depicting it as a white elephant offered up to the artist by deranged "acolytes" with no idea how to handle money.[34] ("Topping all is a flamelike pinnacle. Enveloping all is a heavy mortgage.") In a final bruise to the ego, Roerich was chagrined to find that *Who's Who* had failed to include him in its latest edition, an omission pointed out to him anxiously by two of his donors, Chester and Maud Dale.[35]

Nor was Roerich pleased by how his

museum was taking shape. He disliked Corbett personally and complained that the restaurant had been designed with more care than the museum space. He clashed with the architect over one decision in particular: Roerich had wanted to crown the skyscraper with a giant stupa, according to sketches provided by Sviatoslav in 1928 (see Illustration 28). Corbett opted instead for a more conventional spire, pointing out that the building's frame might not be able to bear the stupa's weight (though one imagines he feared artistic embarrassment as much as he did the engineering risks).[36] Lecture tours that Roerich had expected to go on with George fell through, a disappointment to the latter, who was counting on the expedition to launch his academic career. Settling on a politically acceptable version of *Altai-Himalaya* as it went to press proved surprisingly hard. Most vexing was continued strife within the inner circle. Frances, newly returned from Latin America, was reintegrating poorly. Sina, pained to see Esther described in Helena's letters from India as "a real treasure," fretted to see her rival pushing herself forward as their teacher's favorite. Georgii and Tatyana Grebenshchikov were absorbed by their own interests, especially their Churaevka project in Connecticut, and the Horches acted so aloof that Roerich feared that "spiritual infection" had wormed its way into their household. Maurice, normally the group's peacemaker, was sick with high fever and recuperating at a lodge in New Hampshire's White Mountains.[37]

Roerich's presence had a calming effect, at least for a while. ("What will it be like when I am gone?" he worried more than once.[38]) Letters from Helena, communicating the Masters' will, backed him up. "Fuyama must be the judge among you," commanded Morya. "It does not become you to act like schoolchildren while doing my work."[39] Morya seemed to manifest his wishes in the physical world as well, during séances led by Roerich: twice that summer, Roerich somehow caused the table around which the group was seated to rise to the ceiling and cling so tightly that even Louis, tugging with all his strength, could not pull it down.[40] The Horches' doubts and resentments vanished. As Louis noted in a letter to Esther, "In two minutes, Professor Roerich explained to me the work of the last five years. The word 'no' disappears; the idea 'it must be done this way only' is quickly followed by a better idea."[41] Prodded constantly by Roerich, the rest of the group fell into line until late in the year.

The circle renewed its faith none too soon, because a triple crisis struck in the late summer and early autumn. Near the end of July, the Urusvati sale fell through. When the balance of the money owed to the Maharajah of Mandi was transferred to him, the British, as they had threatened to do since January, blocked the final registration of the sale. An abashed Maharajah refunded Horch's payment on July 31. Roerich, who had planned from the start to visit the

British Embassy in Washington to extend his family's visas to stay in India, now insisted on meeting personally with the ambassador, Esme Howard. Having been warned by London that Roerich was "a rather cranky person prone to harbor suspicions," Howard fended the artist off while he gathered more information.[42] In August, the US State Department assured Howard that although Roerich was not an American citizen, there was "nothing to indicate that Professor Roerich is not running a bona fide educational institution, and nothing to indicate that he has had undesirable activities in the United States."[43] Even British opinion was divided: India's secretary of state, William Peel, writing from Simla, told the Home and Foreign Offices, "We have no evidence that Roerich has misbehaved in India, and, whatever he may be, I feel sure that he is not a dangerous political conspirator."[44] However, Roerich's most dogged foe, the foreign service officer Stephen Gaselee, took this opportunity to build a case against him, causing the British position, as described below, to harden in the fall.

The museum itself fell into jeopardy in August, when the American Bond and Mortgage Company, which had loaned Horch nearly $2 million for construction, went bankrupt. Before the end of autumn, Horch persuaded the Manufacturers Trust Company to service the debt, but uncertainty in the meantime nearly sent the entire project tumbling. Corbett's firm and all the contractors working on the building demanded proof of Horch's financial stability,

and he was obliged to advance more than $165,000 of his own money to keep them on the job. "Only this prompt action saved the building," the Horches later recounted, and even those in the circle who were less fond of Louis praised his heroic efforts.[45]

That success, though, meant little to the Horches as they suffered the third and most terrible of the season's disasters, the death of their daughter Oriole. Since birth, Oriole had been tortured by asthmatic attacks, and in April 1929, doctors recommended that her tonsils be removed. From afar, the Roerichs doted on Oriole, but, like domineering godparents, felt free to criticize parenting methods and meddle in medical decisions. Lack of discipline, they felt, had turned Oriole into "a hysterical princess."[46] The suggested surgery, they believed, was a barbarity, and they urged the Horches not to allow it unless Oriole became so ill that there was no other choice.[47] That time came in late June, and the child underwent a successful tonsillectomy. She seemed to recover, but on September 24, both she and Flavius were rushed to the hospital with cases of bronchial pneumonia. Flavius, after several days in an oxygen tent, pulled through. Oriole, weakened by her illness from the spring and summer, died on the morning of the twenty-fifth. She was laid to rest on the twenty-sixth, after which Nettie took Flavius to convalesce in the drier climes of Santa Fe.[48]

The Roerichs provided as much consolation as they could, as did Sina and Frances. Nicholas sat with Nettie all day on the

twenty-sixth, and Louis remarked to Esther how "simply wonderful" he was with her.[49] Helena, haunted by dreams of Nettie huddled in misery, murmuring "it is infernal, it is infernal," sent word on the thirtieth that the Masters had promised to return Oriole's soul to earthly life soon. For this reason, when Nettie gave birth for the last time, in 1931, she used the name again for her new daughter.[50] Still, expressions of sympathy went only so far, and for the second time, the Roerichs found themselves in the position of priests trying to speak convincingly of God's mercy to parishioners hollowed out by bereavement—a position made even less tenable by the way they had guaranteed divine protection for the Horches' children in exchange for spiritual allegiance. In the absence of anything more comforting, the Horches clung to Agni Yoga, and Nettie dreamed of seeking solace in India with Helena, something she would soon do, between March and October 1930. But while the couple's faith was not yet broken, it had sustained grievous damage.

⁘

None of this kept Roerich from the tasks before him in the summer and fall. New and potentially useful followers had recently befriended the inner circle, and Roerich drew them closer in. One was Winifred Kimball Shaughnessy Hudnut, a stage designer and amateur Egyptologist better known as Natacha Rambova, the sultry ex-wife of the screen idol Rudolph Valentino. An avid Theosophist, Rambova associated herself with the Roerich Museum until 1934— when she relocated to the Balearic Islands with her second husband—but her loyalty belonged less to the elder Roerich than to Sviatoslav, one of her lovers at this time.[51] A more faithful congregant was Katherine Campbell, who took the esoteric name Amrida and rose to the vice presidency of the Agni Yoga Society by the end of the 1930s. She, too, joined Sviatoslav's list of sexual conquests, though she was six years his senior.[52] Ingeborg Giselle Fritzsche, a former secretary to Tomáš Masaryk, the first president of Czechoslovakia, brought with her a range of useful contacts in that country, as did the tragedienne Maria Germanova, who had acted with the Moscow Art Theatre before 1917 and now taught at New York's Laboratory Theatre. By January 1930, she had embraced Agni Yoga and adopted the spiritual name Albina. Her husband, Alexander Kalitinsky, headed the Kondakov Seminar in Prague, an archaeological research institute with which Roerich hoped to join forces. Ironically, Roerich paid scant attention to the most important neophyte of all, a spiritually inquisitive agronomist from Iowa recruited to Agni Yoga some months before by Frances. This was Henry Wallace, the future vice president of the United States. Roerich met him briefly in August 1929 and casually suggested that he stay in touch. This Wallace did—a choice he later paid for dearly.

Roerich also had to decide whether to pursue ties with the esoteric groups that

courted him in 1929. Acknowledging his frequent contributions to their magazine, *The Mystic Triangle*, the American Society of Rosicrucians certified Roerich as a chevalier in their order.[53] He turned this honor down, however, and similarly backed away from Alice Bailey's neo-Theosophical Arcane School and the curious "religion of love" movement launched by the Grand Duke Alexei Mikhailovich, brother-in-law to the now deceased Nicholas II.[54] Cooperation meant possibly attracting new followers and more money, but Roerich, having forsworn his allegiance to Annie Besant, was in no hurry to share authority with anyone else. Given the pleas for help he would soon make to White Russian communities, Roerich was tempted to trade on the Grand Duke's regal standing, but ultimately there was room in his schemes for only one charismatic Russian. The sole group with which he made common cause was a tiny society led by Frederick Kettner, an Austrian scholar who revered the Dutch philosopher Spinoza and was pledged to the cause of global disarmament. Calling themselves Biosophists, Kettner and his students labored on behalf of Roerich's Banner of Peace project.[55]

Roerich continued his face-to-face fundraising, reconnecting with the donors who had backed his expedition and recruiting new patrons at luncheons, spiritualist gatherings, and artistic galas. Admirers were encouraged to join the Society of Friends of the Roerich Museum, which, from its offices in New York, New Jersey, and Paris, informed members about Roerich's activities and reminded them to keep the contributions coming. Final adjustments were also made to *Altai-Himalaya*, whose autumn release formed part of the publicity buildup for the museum's October opening. Editing the text had been a trial, due partly to the gruntwork of translation, but more to the quandary that arose when deciding what, if anything, to say about the family's interactions with the USSR. Roerich could reasonably hope that the encomiums he and Helena had delivered to Marx and Lenin in their Russian-language publications of 1927 would go unnoticed in America. But the radicalism of *Roerich-Himalaya* had been widely aired in 1926—with the *New York Times* noting that "gushing adulation and communist propaganda make a medley of [this] monograph"—and the US press had not been silent about Roerich's Soviet side trip.[56] Roerich's rightward drift made it awkward to remind readers of such things, so all direct references to Soviet officials and the expedition's weeks in Moscow were scrubbed out. Roerich substituted "Great Teacher" for the provocative description he had given in *Roerich-Himalaya* of Christ as "the Great Communist," and, by his own admission, he removed a third of his diary material for fear that "it might not be to the liking of many readers."[57] As noted elsewhere, Roerich backed away from his 1925–1926 claims to have "proven" that Christ had visited Tibet in his youth. (These continued to be taken seriously by some of his followers, and one admirer, the

Episcopalian rector Robert Norwood, titled his collection of spiritual verses *Issa* in honor of Roerich's "lost years" thesis.[58])

This fudging of details hid what needed to be hidden. Unexpectedly, it also heightened the text's appeal by imbuing it with a sense of meditative detachment. "Days and dates are readily forgotten," Roerich mused. "The character of each day becomes more important than its number or name."[59] Such imprecision reduces *Altai-Himalaya*'s reliability, but has gained it a place among works like Robert Graves's *The White Goddess* and Carlos Castañeda's "Don Juan" books, which frustrate those who seek empirical facts, but thrill others by mobilizing the semblance of deep learning in support of potent mythopoetic visions.[60] *Altai-Himalaya* was published by Frederick Stokes, who had a deep interest in yoga, and pronounced "incomparable" by the Maha Bodhi Society. At the same time, the museum's own press, with some of the costs borne by Spencer Kellogg, issued a shorter travelogue called *Heart of Asia*, several volumes of the "Agni Yoga" series, and a translation of the "Flowers of Morya" verses, rendered into English with the help of the poet Mary Siegrist and retitled *Flame in Chalice*. Also in 1929, followers in Paris arranged for the publication of Helena's *Cryptograms of the East*, under the pseudonym J. Saint-Hilaire.

Then came political preparations for the Banner of Peace Pact. Roerich's White House reception had not gained him the insider access he wished for, but he had other assets to mobilize. The pact's text had been drawn up in 1928 by Georges Chklaver. Starting in 1929, additional expertise was provided by the Russian jurist Baron Mikhail Taube, a former consultant to the tsarist Ministry of Foreign Affairs and now a professor at the University of Münster and the Hague's Academy of International Law. Taube had excellent contacts in France, Germany, and the Vatican, as well as in the League of Nations, and he took on the task of convincing diplomats that the provisions of Roerich's pact did not simply duplicate existing clauses in the Hague and Geneva conventions. In the States, Charles Crane's advice and connections with the State Department proved useful, and Roerich consulted with him, both in New York and in Woods Hole. However irritating Roerich found him, Congressman Sol Bloom backed the Banner of Peace to the hilt, and added support came from the US senator Royal Copeland, a New York Democrat and a leading figure in America's homeopathic movement. Thanks to Frances Grant's public relations work in Latin America, Leo Rowe, the president of the Pan-American Union, boosted the pact as well. Roerich hoped for similar reactions from William Borah, the Idaho Republican who chaired the Senate Foreign Relations Committee, and Hoover's secretary of state, Henry Stimson, but received no comment from either until the end of the year.

Finally, it was during these months that Roerich definitively turned away from the USSR. Even after 1927, the Soviet Concessions Committee had continued to express

interest in his Beluha project, but the violent radicalism of Stalin's "Great Turn" between 1928 and 1932, which reversed the moderate policy lines that had led Roerich to think he could do business with the Kremlin, killed any remaining desire he might have had to cooperate. The dynamiting of churches, the confiscation of icons and altarpieces to fund Stalin's Five-Year Plan, and the renewed persecution of worshippers horrified Roerich. So too did tales of the brutality that accompanied the regime's collectivization of agriculture: executions, mass arrests, and one of the deadliest famines in world history. Equally appalling was the class war launched by Stalin against intellectuals and professionals of "bourgeois" origin. Caught up in this cultural revolution were many of Roerich's former colleagues and, worst of all, his brother Boris, who, as noted in chapter 11, spent the turn of the decade in state custody.

Western opinion regarding Stalin's modernization drive was split, with many prepared to accept artfully crafted images of happy tractor drivers and mighty hydroelectric dams at face value and to dismiss less favorable reports as malicious rumor. Charles Crane, however, convinced Roerich that the tales of abuse were true—as they indeed were—and the artist was further persuaded of this by Metropolitan Platon, head of the Russian Orthodox Church of America and Canada, whose blessing Roerich sought for the Banner of Peace. Word also reached Roerich in 1929 that his art was being removed from Soviet museums,

and in some cases actually destroyed.[61] The inner circle's private papers reveal the steady deepening of Roerich's anti-Soviet attitude in 1929. He worried about émigré acquaintances, including David Burliuk and Sergei Sudeikin, who seemed to display unhealthy sympathies for Stalinism. He complained that US authorities were not doing enough to protest Soviet crimes against the church. He dismissed USSR-friendly events in New York—a screening of the Soviet film *Storm over Asia*, for example, and even a lecture on current trends in Russian art by his onetime tour manager, Christian Brinton—as "the lamest of propaganda."[62] This anticommunist impulse lasted over half a decade and took the Great Plan in yet another new direction.

By October, the Roerich Museum stood tall and triumphant, its corner windows sparkling and its exterior bursting with the colors of sunrise. In an effect meant to symbolize spiritual evolution, the walls of the lower stories were washed in purple, fading to red-orange, blue-gray, and white as the eye traveled upward. (Sandblasted to gray, the structure has a more demure look today.) On the seventeenth, the museum threw open its doors in a celebration that attracted more than five thousand, among them the conductor Leopold Stokowski; Stokowski's wife, the aviatrix and heiress Evangeline Love Johnson; Kermit Roosevelt, the son of Theodore Roosevelt and a fellow explorer

of Central Asia; and the adventurer-naturalist Roy Chapman Andrews.[63] Other guests included Harvey Wiley Corbett, the ever-fashionable Natacha Rambova, Charles Crane, Christian Brinton, and Mayor Jimmy Walker, who presented Roerich with a medal commemorating his "contributions to world culture" and paid tribute to him in this speech: "It is men like Professor Roerich who make us come to the realization that there are no foreigners, no alien races in the world, but that humanity represents one great brotherhood. Professor Roerich is teaching the world to achieve peace and happiness through art and the appreciation of beauty. We in America feel signally honored that he has chosen New York as the permanent abode of his remarkable collection of paintings."[64] Testimonials from the presidents of Mexico, Czechoslovakia, and France were read after Walker's moment onstage. (One unwelcome party was the agriculturalist Dmitri Borodin-Poltavsky, who had encouraged Roerich's leftward shift in 1924. Dropping by to ask how the expedition had gone, he was barred by Sina, who suspected he was inquiring on the USSR's behalf and suggested icily that, if he truly cared, he could buy a copy of *Altai-Himalaya*.[65]) In Paris, the French Society of Friends of the Roerich Museum held a simultaneous fete at the Salle d'Iéna, presided over by Georges Bonnefous, France's minister of commerce and industry.

The press conferred instant landmark status on the museum. *Time*, always ready to take Roerich down a notch, dismissed those present as "turbanned Indians, grave Chinese, eager intellectuals, and esoteric prattlers look[ing] for cheese wafers to nibble."[66] More typical, though, were the *Evening Post*'s description of the museum as "culture's new cathedral" and the *New Yorker*'s promise that any visit to this "amazing" site would be the "thrill of a lifetime."[67] *Outlook* called the museum "the world's first skyscraper palace of art" and "the triumph of a remarkable personality."[68] A reporter for the *Birmingham News*, guided through the museum by Roerich himself, gushed about the artist's eyes, full of "an age-old knowing" that "besp[oke] the seer, the priest, and the poet."[69] In the three months that followed, nearly forty-seven thousand visitors viewed the museum's collections.[70]

Any sense of accomplishment, however, quickly vanished. The Nobel Peace Prize that Roerich had hoped for went instead to Frank Kellogg, the former secretary of state. And a mere week after the museum's opening, the economic boom that had made Horch and the others so confident about investing in the Master Building crashed to a halt. Prices on the New York Stock Exchange entered free fall, leading to the "Black Thursday" nightmare that began the Great Depression. The plummet did not spell immediate ruin for Roerich's enterprises, but it dulled the public's appetite for everything the Master Building had to offer—be it art, artistic education, or luxury apartments—and presented the inner circle with new financial anxieties. More bad news came in November, courtesy of

the British. That month, Roerich was informed that neither he nor his sons would be granted the visas they needed to return to India. By threatening to separate them from Helena, the British hoped to end the Hall Estate dispute and, with a single stroke, force the entire family off the subcontinent.

How to counter this brute-strength maneuver was not readily apparent. As a first step, Roerich, aided by Louis Horch, completed the first stage of an application for American citizenship. Hoping to strengthen US support for his case against Britain, he called attention to his "numerous works for the Good of America" and promised the country his "friendship and devotion."[71] During this emotionally trying winter, Roerich was an ungenial master, alternating between flashes of temper and periods of icy curtness. To rid themselves of stress, Roerich, his sons, and the Lichtmanns took drops of valerian oil—a mild herbal sedative—with their evening tea. Although not particularly hallucinogenic, the valerian no doubt lent extra flavor to Roerich's séances. Svetik experimented more than once with lithium.[72]

More practically, it fell to everyone in the circle to seek out additional sources of income. In January 1930, Horch took out new loans with the Chemical Bank and the National City Bank. This short-term fix placed the Roerich enterprises further in debt, so more had to be done. Members of the Society of Friends of the Roerich Museum were pressed to donate money; checks of any size, from $10 to $10,000, were welcome. Once again, the museum appealed to the nation's top philanthropists—Ford, Eastman, the Carnegie Foundation, the Rockefellers—and, as before, these pleas failed. In March 1930, Roerich and Horch took the drastic step of auctioning off almost 200 paintings, many of them European masterpieces that the Horches had purchased on Roerich's advice during their 1923 tour through Europe.[73] Among these were works by Rubens, Fragonard, El Greco, Bosch, and Renoir, but the artists' star quality proved of little help. Unseasonably snowy weather kept attendance low: 172 lots were sold, but netted only $114,165, a total regarded by everyone as a disappointment. Also in March, Roerich invited a group of dignitaries to a private screening of movie footage he and George had shot while in the Kulu Valley.[74] The guests included Charles Crane, the collector Solomon Guggenheim, the *New York Times* magnate Adolph Ochs, and the French consul general, Maxime Mongendre. This effort opened no purse strings, although Crane and the *Times* remained favorably disposed toward Roerich and his ventures.

By now, the most newsworthy of these was the Banner of Peace campaign. Roerich may have lost out on the Nobel Peace Prize, but this did not keep him from presenting the text of his "Treaty for the Protection of Artistic and Scientific Institutions and Historic Monuments"—as the Roerich Pact was officially known—to the State Department and the White House in February 1930. Charles Barnes, who headed the

department's Treaty Division, met with Roerich, Horch, Frances, and Maurice, gently pointing out that, while their goals were praiseworthy, no instrument beyond the Hague Conventions, the new Kellogg–Briand Pact, and the "generally accepted rules of international law" was needed to realize them.[75] To Hoover, State recommended that the Oval Office refrain from supporting such "futile, weak, and unenforceable" agreements.[76] Hoover concurred and, in April, conveyed his polite regrets to Roerich and Horch.

Roerich, however, had not waited on Hoover. On March 11, he published a utopian manifesto, "The Banner of Peace," in the pages of the *New York Times*.[77] Reminding readers of the atrocities committed during World War I, Roerich declared it "imperative to take immediate measures to preserve the noble heritage of our past. The creations of culture, after all, belong to no one nation but to the world." His new Banner of Peace, a flag of white, would bear the image of three crimson orbs, banded by a circle of the same color, and it was to be flown over every museum and monument that fell under the pact's protection. "As the Red Cross flag needs no explanation to even the most uncultured mind," Roerich went on, "so does this new flag, guardian of cultural treasures, speak for itself. It is simple enough to explain, even to a barbarian." Pax Cultura, or "peace through culture," became Roerich's new slogan. Five days later, the *Times* printed another piece by Roerich, claiming that the Pax Cultura symbol was age-old and universal: it decorated Circassian swords, Tibetan jewelry, medieval icons of the Madonna, Coptic artifacts, Mongolian rock carvings, and Indian temples.[78] In fact, the sign is more readily traceable to early Theosophists like Blavatsky, but leaving aside the veracity of Roerich's archaeological assertions, it came to stand not just for the Banner of Peace, but for Agni Yoga overall, as it does today.[79] Meanwhile, Hoover's refusal to back the treaty did not leave Roerich without recourse: he turned instead to the League of Nations as well as to various groups and individuals in the international peace movement. Over the next few years, support poured in from many sources in the United States, Europe, and Latin America. And the presidential elections of 1932 would give Roerich and his circle sudden access to the highest political authority imaginable.

In the midst of this, Roerich remained active on the cultural front. He had little time for painting, but lectured at New York University and the Dalton School in the spring of 1930, on links between Western and Eastern thought.[80] He sat for a bust by the Japanese American sculptor Isamu Noguchi—who reached the heights of his fame after World War II, but was now supplementing his income by teaching at the Master Institute—and helped to open the new museum's first exhibits, which featured modern French paintings, designs by Corbett, and works by two Russians: David Burliuk and Alexandra Shchekotikhina-Pototskaya, one of Roerich's IOPKh students and the wife of his friend Ivan Bilibin. Nicholas

and George also visited New Haven, Connecticut, several times in early 1930. Roerich sold an early version of *She Who Leads* to a private collector there and showed his film footage of Kulu to audiences at Yale University. George submitted a draft of *Trails to Inmost Asia* to Yale University Press, which eventually published it in conjunction with Oxford University Press. Also at Yale, the pair spent time with two figures associated with the Kondakov Seminar in Prague. One was the renowned archaeologist Mikhail Rostovtsev, a colleague of Roerich's from before the revolution; the other was George Vernadsky, a leading historian of ancient and Kievan Russia, now teaching at Yale. It was likewise at Yale that Roerich met the linguist and theorist Roman Jakobson, who, with Rostovtsev, had come over from Czechoslovakia for a brief US visit.[81]

Most of all, Roerich busied himself with a new production of *The Rite of Spring*, conducted by Leopold Stokowski and put on jointly by the New York League of Composers, the Philadelphia Orchestra, and the Martha Graham Ballet Company. US concertgoers were familiar with music from *The Rite*, but the ballet had never been staged in America, and Stokowski took it as a stroke of good fortune that one of its cocreators was so readily available. Moreover, Sergei Diaghilev had died in Venice the previous August—Roerich penned a long eulogy for him titled "A Wreath for Diaghilev"—and Roerich viewed this production as a tribute to the departed impresario.[82] Roerich contributed a new set of stage designs, but

these were virtually identical to those he had created in 1913, and his main roles were to advise Stokowski and publicize the upcoming event.

Roerich would not be in the States long enough to see *The Rite*'s premiere, but he spent much time with Stokowski in early 1930. It is during these weeks that one of the most famous misapprehensions about the ballet arose, as Stokowski, listening to Roerich's free-ranging discourse about the universality of ancient religions, came away with—and repeated—the erroneous impression that the artist's costume designs had been influenced by the ceremonial dress of Native Americans in the Southwest. In March, Roerich gave a well-attended lecture at the Wanamaker Auditorium in Philadelphia, reminiscing about his creative partnership with Stravinsky (no hint yet of the bitter debate to come regarding whose idea *The Rite* had been) and proclaiming the ballet's deeper significance to be not just Russian or even Slavic, but "more ancient and pan-human."[83] The performance took place on April 11, with Graham herself starring as the Chosen Maiden. The orchestra opened with another brashly modernist piece, Schoenberg's fifteen-minute "Hand of Fate," subjecting the audience to nearly an hour of what *Time* described as "primitive, pornographic music."[84] No one, however, was truly scandalized. Almost seventeen years had passed since the Paris premiere, and it helped that Graham's company had opted for the more viewer-friendly Massine choreography. Artistically, the production

served as a successful send-off for Roerich, who had already departed for India.

There was a muted tone to that departure, as Nicholas and George—leaving Sviatoslav in Louis Horch's care—boarded the *Majestic*, bound for London, on April 4. Still with no visa to enter British India, the artist had no legal way to return home or rejoin his spouse.

Since the previous November, the US State Department, prodded into action by Horch and Charles Crane, had been trying to convince the British to reconsider Roerich's visa application. Whatever it thought of the artist himself, the department insisted on fair treatment for any American organization pursuing legitimate aims abroad, and its Division of Western European Affairs viewed Roerich as having suffered "petty colonial persecution" from "proverbially hyper-suspicious Anglo-Indian authorities."[85] "We do not wish to wound the susceptibilities of the British Government," the division instructed the US Embassy in London—whose Anglophile staff shared their British counterparts' low regard for the artist—but it felt obliged to stand behind "a normal request [made by] an American educational institution of standing."[86] Extra emotional flavor was added by Helena's claim to have fallen seriously ill, rendering her unable to leave Hall Estate.

The British dug their heels in harder, a posture explained by the thunderous

political crises brewing in India during these months. Led by Nehru and Gandhi, the Indian National Congress declared independence from Britain in January 1930. In February, Gandhi announced his intention to engage in nonviolent disobedience by flouting the Raj's prohibition against the private manufacture of salt. On March 12, he and a throng of followers set out from the Sabarmati ashram and proceeded on foot to the Gujarat shoreline, 240 miles away. By mid-April, they had reached the seaside village of Dandi and begun to dry salt. An electrifying moment in Indian history, the salt march galvanized the national liberation movement. Protests and demonstrations rocked the country through the rest of April, and the Government of India responded with harsh reprisals: martial law in Peshawar and other districts, a number of shootings, and the arrest of more than sixty thousand agitators. On May 4, Gandhi himself was taken into custody.

It was a less than opportune time, then, to appeal to British generosity, especially on behalf of a suspected communist thought to be in league with anti-colonial seditionists. To make things worse, a new but mistaken bit of intelligence concerning Roerich unsettled the British further. In 1930, the Citroën Corporation sponsored a grand motorcar adventure, led by Georges-Marie Haardt and including the paleontologist-philosopher Pierre Tielhard de Chardin.[87] This Trans-Asia Expedition, or Croisière Jaune, was scheduled to leave Beirut in April 1931 and make an eighteen-thousand-mile run

to the East China Sea. As Haardt applied to Moscow and Peking for permission to cross Turkestan, a rumor reached the ears of the British Foreign Office that the USSR had demanded the right to attach an extra member to the expedition: none other than Roerich, who was to travel "as a member of the Comintern."[88] Haardt indeed planned to bring along a Russian painter, but it was Alexander Yakovlev he had in mind. Coincidentally, Yakovlev was a *miriskusnik* friend of Roerich's from before 1917, so London's confusion here is understandable. But on this count at least, its fears were unfounded.

Being in England made it no easier for Roerich to plead his case. He and George arrived on April 11 and stayed in London a month and a half. Using the Hotel Carleton as their base of operations, they mobilized as much support as they could. Roerich called upon Charles Dawes, the US ambassador to Great Britain, armed with testimonials from Senator Royal Copeland, Congressman Sol Bloom, the New York Board of Regents, Senator Hiram Bingham of Connecticut, and James Bennett, the vice president of the Westinghouse Corporation.[89] Talbot Mundy of the British Roerich Society labored on his behalf, and Roerich asked an old friend, the Russia expert Sir Bernard Pares—no stranger to diplomatic or military affairs—to intercede with the Foreign Office.[90] The authorities brushed Pares off with assurances that the Roerich question had been "carefully considered," but after much insisting, he gained access to the relevant case files. In July, Pares admitted that "the matter lies entirely outside my scope and knowledge," but added in Roerich's defense that "the papers, it seemed to me, contained nothing very definite, and some points, I thought, were pressed too hard in view of the almost impossible position of all Russians abroad at this time."

Whatever Pares's opinion, British authorities remained obdurate. Bolshevik or not, they argued, "[Roerich] seems to be something of a charlatan, or at best a person of unbalanced mentality, and there would be a certain risk in allowing such a person to establish a centre for vague and undefined activities in India."[91] On May 23, Stephen Gaselee informed Roerich in writing that the Foreign Office and the Government of India regarded as closed all questions relating to him. The purchase of Hall Estate was null and void, and the Roerichs, who had been duly warned not to proceed with it, had only themselves to blame for their difficulties. As for Roerich's visa request, Gaselee pointed out: "India in its present state is not the place for archaeological, artistic, or scientific work. I should think you would do best to return to the United States and devote yourselves to the American end of the work until better times come."[92] Left unspoken was the Raj's hope that Helena and her coterie would pull up stakes and go back to America as well.

In June, Roerich shifted his headquarters to France, settling in Paris for the next four months. Here he met with a friendlier reception. As the US ambassador in Paris, Walter Edge, reported, the French

government was "particularly to the fore" in its support for Roerich, and the president himself, Gaston Dommerge, expressed open sympathy for him.[93] The respectability of Roerich's associates in France—Georges Chklaver of the Sorbonne, Baron Mikhail Taube, and now the ethnographers Marie de Vaux-Phalipau and Louis Marin (also a member of the French legislature)—lent force to his public-relations drive. By July and August, outlets such as Reuters and the *New York Times* were painting British stubbornness in an unflattering light with headlines like "Scientists Barred from India," "Artist's Aides Amazed at Refusal of Visa," and "Nations Ask Britain to Lift Roerich Ban."[94] From America, Metropolitan Platon begged the British on behalf of his Orthodox parishioners and "Our Lord Jesus Christ to assist Professor Roerich to join his sick wife."[95] Esther Lichtmann, keeping abreast of events from India, observed in her journal how the governments of Czechoslovakia, Yugoslavia, Sweden, Brazil, and Peru—along with Queen Wilhelmina of the Netherlands—lodged formal requests that Roerich's visa be granted.[96] On July 24, Roerich wrote Herbert Hoover, imploring him to intercede directly with the king of England.[97]

This last letter never reached Hoover's desk, but as the summer progressed, the State Department had to decide whether to continue pressing Roerich's claim. Luckily for Roerich, Ambassador Edge was more favorably disposed toward him than Dawes had been in London (although he joked about not having a paperweight "heavy enough to keep the various communications I am receiving from Mr. Roerich from day to day from blowing out the window").[98] The embassy official Prentice Gilbert accompanied Roerich and George on a visit to a contingent of White Russian officers living in Paris, and seeing how well received the artist was, decided he could not possibly be a Bolshevik.[99] As noted in chapter 13, the State Department, when it canvased Asian-studies experts about the Urusvati center's academic merits, received more than a few negative assessments, but by July, it was firmly convinced of Roerich's political innocence, due to an investigation of the Roerich Museum carried out in June by Special Agents R. C. Bannerman and Hall Kinsey. The department ordered this inquest not just because of Roerich's fracas with the British, but to satisfy the US House of Representatives, where the Hamilton Fish Committee—an early precursor of the House Un-American Activities Committee—had come to suspect the Roerich Museum of being "a center of Communist propaganda" with "a very large Communist membership."[100] Kinsey had probed the question of Roerich's possible Bolshevism once before, in 1925, but now, after interviewing Louis Horch and looking over the museum's papers, he and Bannerman came away persuaded that "not one single established fact connect[s] Professor Roerich personally or the Roerich organizations in general with any communistic body."[101]

This was, of course, a less than perfect

evaluation of what Roerich had been up to until recently. Still, it was enough to lead William Castle, the undersecretary handling the artist's case in Washington, to conclude in July that, while "Mr. Roerich is a very curious person," he was "entirely free from any taint of bolshevism."[102] What was more, he wrote, "the British have acted peculiarly in this matter. There is no doubt that Mrs. Roerich is seriously ill and I think we should make another attempt to get permission for her husband to join her."[103] It was this recommendation that prompted the secretary of state himself, Henry Stimson, to order the US Embassy in London to inform the British Foreign Office that Roerich's museum was genuinely American and that British fears about his communist ties were unfounded.[104]

Over the next months, the visa debate centered on the question of Helena's health. The Roerichs' trump card here was the international sympathy stirred up by the idea of an apparently sick and helpless woman being evicted from her home by a star chamber of callous bureaucrats. As Stephen Gaselee of the Foreign Office sourly remarked, "it would be a nuisance if she died and the family could protest that they were prevented by a stony-hearted Government from being with her during her last years."[105] But how ill was Helena in actuality? Vladimir Shibaev and Esther Lichtmann attested that she was wracked by fevers and dangerous elevations of the pulse, and that her limbs often swelled alarmingly. In mid-August, Helena claimed to have suffered a "severe

heart attack," at which point Roerich and George made a public pilgrimage to Notre Dame to pray for her health.[106] Under no circumstance, the Roerich camp insisted, could Helena travel any more than the shortest of distances. Indeed, because her symptoms worsened at lower altitudes, it was imperative that she remain in Naggar and the nearby mountains.

Helena's papers and those of her followers make it clear that she perpetually believed herself to be ailing. That said, the family had every incentive to falsify Helena's symptoms or exaggerate their seriousness, and the British held it as an article of faith that the Roerichs were lying. If only they could have Helena examined by a doctor of their own, the British reasoned, they could expose the Roerichs' deceit and expel the lot of them. H. L. Phailbus, the Kulu deputy commissioner and the official who interacted most regularly with the Roerichs, relayed multiple requests from the Raj to allow a British-selected physician to visit Hall Estate and work up a diagnosis. Laura Finch and other local Britons friendly to the Roerichs advised Helena to comply and were puzzled by her refusal. Even closer followers like Shibaev and Talbot Mundy were open to the idea, but Esther, like a wrathful shieldmaiden, rebuffed any suggestion that her mistress be pawed over by a hostile party's appointee.[107] To resolve the impasse, the Roerichs proposed that a doctor of their own choosing—a Russian émigré named Konstantin Lozinsky who had settled in Italy under the name Constantino

Lozina—accompany Nicholas and George back to India and report on Helena's health from Naggar. Roerich also submitted an affadavit from a French cardiologist, one Dr. Lapeyre, who claimed to have treated Helena in the past and warned that any travel by sea would likely kill her.[108]

In October, with public perception shifting in their favor, Roerich and George traveled with Dr. Lozina to French India. Father and son now carried French passports, issued in July. (Roerich henceforth kept his as his primary travel document.) From the French-controlled port of Pondicherry, Roerich continued negotiating with the British. On December 6, the Raj finally capitulated, granting Roerich, George, and Lozina a set of visas good for three months, with the possibility of renewal. Privately, British officials had already decided not to press for expulsion after the probationary period. "A ton and a half of paper" had been expended on Roerich's case, complained the British ambassador to the United States, and

as the GOI reassured itself, "if the Roerichs misbehave, we can expel them using the Foreigners' Act."[109] For its part, the State Department sighed with relief to have the matter settled. "Just because some people are a little queer or fanatical is no reason why they should be subjected to queer or fanatical official behavior," wrote the head of the Division of Western European Affairs. Still, Roerich had by now become a "nuisance" and should be helped in the future only "sparingly."[110] Roerich, George, and Lozina left Pondicherry on the night of December 6, heading for Pathankote, where Vladimir Shibaev came out to meet them. From there the group went by car and horseback to Naggar, returning to Hall Estate on December 11. "Our White Guru!" exclaimed Esther upon the artist's arrival. "What light and strength, what purity, his whole being emanates!"[111] With Nicholas and Helena reunited, the family and its circle could resume with confidence their attempts to propel the Great Plan forward yet again.

CHAPTER 13

The Banner of Peace, 1931–1934

I am not only a pacifist but a militant pacifist. I am willing to fight for peace. Nothing will end war unless the people themselves refuse to go to war.

—Albert Einstein

I t was to be the Red Cross of Culture. It would lay the foundation stone for a new diplomatic order in which art and beauty held more suasion over the conduct of states than global commerce or the force of arms. Realized properly and soon, it would transform human consciousness itself.

So Roerich described his Banner of Peace movement, which pushed for a global agreement to safeguard art and architecture in times of war. Like other utopian treaties of the interwar period, the Banner of Peace was scoffed at by some as the product of well-meaning but futile idealism. From others, though, Roerich earned praise, with King Alexander I of Yugoslavia proclaiming him an "apostle of peace and universal understanding."[1] Roerich received multiple nominations for the Nobel Peace Prize, and in 1935, the United States and the member nations of the Pan-American Union signed

the Banner of Peace into law. After World War II, the pact's text was incorporated into the UNESCO conventions that to this day protect artistic and cultural artifacts.

How much of this, though, was humanitarianism, and how much of it self-promotion? Not entirely for its own sake did Roerich care about the pact. To move his Great Plan forward, he required money, a home base, and the sort of political muscle found only at the national level. Could he parlay international renown into support for his less public aspirations? Headway here was slow and halting until early 1933. Then, Roerich scored an unexpected success, achieving spiritual mastery over a key figure in Franklin Roosevelt's new presidential administration.

During this time, Roerich rose to greater heights of fame and influence, but it was the ascent of an aerialist treading a

skyward-angled tightrope. With every step he took, many were prepared to accuse him of charlatanry or ulterior motivation. Eventually, his high-wire act between respectability and notoriety failed, and when he fell, he fell quickly and hard. This chapter chronicles his upward progress; the next describes the plummet that followed.

Not every moment in 1931 went toward grand schemes. Even with Roerich safely returned to India, anxiety lingered for months over the question of the family's visas, due to expire on March 7. H. L. Phailbus, the Kulu region's deputy commissioner, kept poking around, outwardly polite, but unmistakably trying to find a weak spot in the family's self-presentation. Not yet aware that the Raj had already elected to let them stay, Nicholas and Helena continued to fear expulsion. Only in April did the British signal their willingness to allow the Roerichs to remain in India. That summer, Hall Estate officially became theirs.

Roerich spent the next months settling into his new home. He and Helena played host to several British well-wishers, most of whom were devotees of spiritualism or Theosophy. Among these were Laura Finch, as well as Captain Hubert Benon and his brother Hugh, half-Indian, half-English siblings from a family that had been close to Blavatsky herself.[2] For practical assistance, the Roerichs relied on Colonel A. E. Mahon, who lived with his wife in the nearby town of Manali. The Mahons appear not to have cared about mysticism, but considered the family a refreshing addition to a white colony hidebound by social conventions and race consciousness. Mahon offered the family his services as "agent and adviser," and frequently sparred on Roerich's behalf wth Phailbus and other Raj officials. Starting in 1930, the Mahons and Benons helped arrange the Roerichs' summer trips to Lahul and Kyelang.

Others felt differently about the Roerichs, and since they were more prone to express themselves to the authorities, their complaints stand out more in the public record. Most Westerners in the valley owned large estates that produced apples, plums, and persimmons, and their class prejudices stand out clearly. An English neighbor by the name of Pool believed the Roerichs to be "Russian and American spies," while a Colonel Schomberg, another Kulu planter, referred to them as "undiluted Buddhists" and "most undesirable" additions to the community.[3] Even more strenuous were the objections of G. F. Waugh, a US Army lieutenant colonel who had retired to support missionary work in Kulu.[4] To the US consul in Calcutta, Waugh moaned that the Roerichs, who were "considered a huge joke" by Kulu's English population, were damaging America's reputation. He repeated all the assertions made by British officials about the family—they were up to no good, Helena's tale of illness was "a pathetic mass of lies," and so on—but to him, the blackest mark against them was their easy familiarity

with the Indian locals. "They are obviously out to popularize themselves with the native element," Waugh wrote, and he was horrified to have seen them "putting their arms around the commonest natives and patting them on the back." Much of this distress was economic and religious; the Roerichs had the temerity to pay their servants more than other whites paid theirs, and their admiration for Buddhism undermined Christian missionaries in the valley. But what angered Waugh and his bunch most of all was Nicholas and Helena's upending of the Raj's carefully constructed racial hierarchy. Those carping about the Roerichs resemble in every detail the colonial elites satirized in George Orwell's novel *Burmese Days*, in which a self-satisfied sahib criticizes the liberal-minded protagonist, Flory, by describing him as "a bit too Bolshie for my taste—I can't bear a fellow who pals up with the natives."[5] Here, at least, the Roerichs' so-called eccentricities show them off to better advantage than their decriers.

One last report deserves notice. In September 1931, Hilary Donald, the daughter of another English landowner, traveled with her mother to Hall Estate, ostensibly to pay a neighborly visit, but actually at the Government of India's request, "to form an opinion as to whether or not Professor Roerich was a spy."[6] Admitting that she "had not the slightest idea how to conduct a spy test," Donald treated the "mission" as a lark, and quite enjoyed herself in the process. She recalled Roerich, "then in his middle fifties," as "completely bald but

wearing a white two-pronged beard. Had he been dressed in silk robes instead of tweed breeches and a Norfolk jacket he could easily have passed off as a Chinese sage." Donald and her mother entered into a "fascinating conversation" with the artist on Indian philosophy, and both were struck by how "deeply versed" he was on the subject. Donald's impressions did little to help the government build a case against Roerich, but they later appeared in a book about Kulu published by Penelope Chetwode, the wife of the poet John Betjeman.

During this time, Roerich resumed his painting. While Helena busied herself with new volumes in the "Agni Yoga" series—*Infinity I* and *II*, *Hierarchy*, *Heart*, and *Fiery World I* and *II*—Nicholas completed several dozen canvases. Among these were his trademark mountainscapes, and also his pantheistic sages, gods, and heroes. As before, his subjects ranged from Arjuna to Zoroaster, but he gave special attention to Maitreya, Rigden Djapo, and Gesar Khan, signaling continued commitment to the Great Plan. The same intent lay behind the revelatory scenes he set in the Asian wilderness. In *Lumen Coeli*, also called *Guru-Guri-Dhar: Path of the Teacher of Teachers* (1931), a robed hierophant, looking like Roerich himself and walking as if on air, carries a flaming chalice into a mountain cave. *Star of the Hero* (1932) shows a monk observing a meteor—a sign of Shambhala's reawakening—arcing across the night sky. *Fiat Lux*, a triptych from 1931, features Morya with the sacred stone of Chintamini in his hands.

A major change from the way Roerich had handled such themes in the mid- to late 1920s was the excision of all imagery that could be construed as communist. Gone were the red stars he had used in his "Maitreya" series in 1925–1926 and the Lenin-like visage that had dominated canvases like *The Time Has Come* (1926). Christian themes proliferated, aiding Roerich, or so he hoped, in two goals. First, his next attempt at the Great Plan would depend on White Russian military officers, and religious idealism was central to this group's worldview. Works like *Saint Panteleimon* (1931), several versions of *Sergius of Radonezh* (see Illustration 31), and *Glory to the Hero* (1933), a tribute to Saint George, were meant to play on this community's Orthodox sensibilities. Second, the Banner of Peace campaign relied heavily on Christian symbology, most of all on the Madonna, whose intercessionary attributes made her an apt emblem for the pact's purpose. Many works on this theme were displayed at the sumptuous Exposition des Villes d'Art Ancien, held in Bruges in the summer of 1932.

Roerich had a long-standing affinity for the "eternal feminine" archetype, and some of his best-loved renderings of female divinity date from this period. In rich tones of blue and violet, *Madonna Laboris* (1931) shows the Virgin on the parapets of a holy fortress, extending a lifeline to damned souls separated from her by demonic guardians and a mist-choked abyss. The haloed queen in *Madonna Oriflamma* (1932), her Asiatic features fixed in an expression of utter calm,

sits on a throne carved with the Christian Chi-Rho symbol, holding a flag stamped with the artist's three-orbed peace symbol (see Illustration 29). In *Sancta Protectrix* (1933), used to publicize Roerich's pact, the Madonna, wearing the Banner of Peace sign on her breast, shelters castles and churches with the folds of her outstretched cloak. Most resplendent was *Sophia—Wisdom of the Almighty* (1932). On a canvas nearly six feet wide, this universal goddess takes the guise of a purifying spirit, galloping through the heavens on a fiery steed and unfurling a scroll that bears Roerich's sign of the ringed orbs (see Illustration 30). Her righteousness safeguards the walled city below. One can imagine this Sophia springing forth from the Book of Revelation; she is also a counterpart to the King of Shambhala, riding forth to battle at the end of days. She carried with her the dreams and desires that Nicholas and Helena held most dear over the next half decade.

A more tangible concern at this time was the management of Roerich's far-flung enterprises. The first question at hand: How should the Master Institute, with its new Roerich Museum, factor into the artist's plans? Hard as it may be to imagine, Roerich seems to have contemplated loosening ties with it. His true interests lay in Asia, and it would not have bothered him greatly to pass the rest of his days without setting foot in America again. He did not like the

final shape the museum had taken in 1930, nor was he pleased by its reversion to the old pattern of harnessing impressive (if often eccentric) cultural energies, but failing to make money or win a fuller measure of respectability.

More was the pity, because the institute launched a panoply of intriguing exhibitions and performances in the early 1930s. The New Composers' Group staged songs by Charles Ives, and Martha Graham danced with the Russian balletmeister Mikhail Fokine. The Vanderbilt family sponsored an exhibit by the Spanish painter José Segrelles, and Elinor Morgenthau, the wife of the future Treasury secretary Henry Morgenthau, organized a show for the Australian Impressionist Mary Cecil Allen. In 1932, the Roerich Museum featured Canada's most famous painters from the twentieth century: the Group of Seven, beloved for their northern landscapes. The moving force here was Lawren Harris, the member of the Seven most attracted to Theosophy and a sublime painter of mountains whose approach to the subject resembles Roerich's. Luminaries of the German and Austrian avant-garde were spotlighted, with Kathe Köllwitz and Oskar Kokoschka finding their way onto the museum's walls.

More broadly, the institute served as a point of intersection for countless cultural notables. World-famous figures who came there in support of Roerich's Banner of Peace Pact—including Eleanor Roosevelt and Pearl S. Buck—were legion. Franz Boas of the American Museum of Natural History, a towering figure among modern anthropologists, helped arrange the institute's exhibitions of German art. The novelist Heinrich Mann lectured on German literature in 1933, sharing the stage with Sigmund Freud's onetime collaborator, the psychologist Alfred Adler of Vienna University. The poet Ezra Pound petitioned Rabindranath Tagore, hoping to use the writer's influence with Roerich to secure a teaching post at the museum for a friend. ("There are one or two Roerich vice-wub-blebubs who would knife anyone I recommended," Pound confessed, "so better not mention me."[7]) Nothing came of Pound's efforts, but among those who did teach at the institute were the acclaimed sculptor Isamu Noguchi and his friend Arshile Gorky, an exile from Soviet Armenia and a prime figure in the creation of Abstract Expressionism. Also on staff was a young lecturer not long graduated from Columbia University: Joseph Campbell, a specialist in medieval literature with a strong interest in world religions. Campbell soon took up a professorship at Sarah Lawrence College, where he produced such classics of comparative mythology as *The Hero with a Thousand Faces*—to say nothing of his iconic TV miniseries *The Power of Myth*—but it was at the Master Institute, in 1931–1932, that his teaching career began.[8]

Another figure pulled into the institute's orbit was H. P. Lovecraft, America's master of modern horror fiction. Lovecraft, the literary bridge between Edgar Allan Poe and Stephen King, came to know Roerich's

art through a fellow purveyor of interwar pulp fiction, A. Merritt, and it exercised a lifelong fascination on him. The Roerich Museum became one of Lovecraft's favorite places to visit whenever he traveled to Manhattan from his hometown of Providence, Rhode Island. "Better than the Surrealists," he enthused in one letter, "is good old Nick Roerich, whose joint at Riverside Drive and 103rd Street is one of my shrines. . . . There is something in his handling of perspective and atmosphere which to me suggests other dimensions and alien orders of being—or at least the gateways leading to such."[9] Roerich-inspired imagery features prominently in one of Lovecraft's best-known works: the novella *At the Mountains of Madness*, written in 1931 and published in 1936, and one of the seminal treatments of the elaborate mythology Lovecraft built up around the forbidding elder god Cthulhu. In the story, which narrates an ill-starred Antarctic expedition sent out by the fictional Miskatonic University, the polar terrain is repeatedly likened to "the strange and disturbing Asian paintings of Nicholas Roerich."[10] (As a tip of the hat to this bit of literary influence, the game-design company Chaosium included a cameo appearance by Roerich himself in its 1999 adventure module, Beyond the Mountains of Madness.)

Such things, though, signified little to Roerich, who saw only the institute's shortcomings. Indirect brushes with people destined for future fame were of no utility, and even the museum's successes meant more to the Horches, Sina, and Frances

than to their master. Moreover, despite Horch's best efforts, the institute never shook the aura of weirdness that clung to it so stubbornly. If leading lights gravitated to it, it was frequently out of momentary sympathy for occultism or oddball utopianism, or, more prosaically, because any source of income was welcome during these economically parlous times. Arshile Gorky and Isamu Noguchi, for instance, labored at the museum for no reason beyond filling their pockets with a few dollars and their bellies with the occasional square meal. The two became friends at the museum, but both were made uncomfortable by all the "spooky" supernaturalist talk about "the other side." Noguchi, who had sculpted a bust of Roerich in 1929, incurred the artist's wrath by failing to later include it in a show at the Marie Steiner Gallery. "Roerich was furious," Noguchi later recalled, "and this is how my teaching career ended—never to be resumed."[11] Gorky simply left as soon as he was able. By the same token, and despite his own Theosophical leanings, the industrialist Spencer Kellogg, who continued to fund some of the institute's operations, warned that students and faculty might start to fall away if too much esoterica was "stuffed down their throats."[12] In 1931, the journal *America* reported on a tour of the institute taken by the poet George Sylvester Viereck, highlighting Viereck's comment that the Master Building "might well be called the Museum of Natural Mystery."[13] This was meant as a compliment, not mockery—the article spoke of the museum as a "mighty

temple . . . beautiful and stately"—but characterizations of the institute as "strange and eerie and wonderful," even if positively intended, did not lend it the air of propriety the Horches would have preferred.

The blackest mark against the institute was its overall unprofitability. Whether one faults the Depression or the inner circle's administrative failings, neither the institute's new premises nor its tenth-anniversary gala in November 1931 improved the balance sheet one whit. Money was still owed to Corbett and a host of contractors. General admission and most events remained free of charge. Apartment space was rented out well below capacity, and what tenants there were complained about the commotion caused by concerts, lectures, and the kindergarten run by the institute. The restaurant was a dead loss, and upkeep for the elevators and ventilation system proved more costly than anticipated (nor could it be deducted from taxes to the extent Horch had hoped). Renting the Roerich Hall as a space for musical and theatrical performances brought in some money, but not enough, and the circle would then squabble afterward about who deserved credit for the bookings—Louis and Nettie as the ranking directors, or Sina and Frances, with their network of cultural connections?

Frances Grant later noted that, after 1930, the Roerich enterprises in New York were generating a gross income of $30,000 to $35,000 per year, but annual expenses swallowed that up and more. Grant also found it disconcerting how readily Horch

commingled the various funds related to Roerich's activities—diverting money from the Roerich Museum Press, for example, to pay Master Institute teachers or to keep up with the interest on one loan or another—an accounting practice that struck her as desperate, if not deliberately shady. In 1931, Horch was forced to reduce, then postpone, the dividends owed to Master Institute investors: payments shrank from 5 percent to 2 percent, then to nothing at all. Horch swore this interruption was temporary, but soon admitted that it might last up to five years, disgruntling shareholders who did not belong to the inner circle. Once-keen allies, such as Lionel and Florentine Sutro and Major J. G. Phelps Stokes, withdrew their financial support, and several would sue the institute in 1934–1935. A further sign of straitened circumstances: in 1931, Frances, Sina, and Katherine Campbell began using their own money—at least $40,000 in Campbell's case—to help pay the teachers and keep the lights burning.[14]

More dire yet, in the spring of 1932, Manufacturers Trust, the company holding the $2,075,000 mortgage that Horch had taken out to finance the construction of the Master Building, attempted to foreclose. The building was placed into receivership by the New York Supreme Court, and though the institute was allowed to continue its work while the dispute was resolved, the outcome seemed foredoomed, with the Appellate Division of the Supreme Court stating in December that "this venture has never been a financial success" and that "its

ability to continue" was "extremely doubt-ful."[15] Horch dug in for almost two full years, and against expectations, he would triumph over Manufacturers Trust, winning back ownership by the spring of 1934. But in the meantime, no one dared hope that the receivership crisis would end in anything but defeat, and the months-long struggle, which Esther Lichtmann compared to Christ's time on the cross, wore Horch down to a husk of his usual self.[16]

Little surprise, then, that Roerich felt tempted to assign higher priority to other undertakings. Topmost on his list was Urusvati, the Himalayan Research Institute (HRI) he now determined to put on a solid footing. In retrospect, many have dismissed Urusvati as a Potemkin academy, a sham meant to shelter Roerich's more self-serving activities behind a façade of scholarly respectability. Such charges are not entirely fair. True, the Roerichs used the HRI as a base of operations for the next stage of their Great Plan. Scientifically, it achieved less than it intended or claimed. Nonetheless, its academic aims, however unorthodox, appear to have been in earnest, especially where George, who headed it, was concerned.

As with the schools Roerich had run in the past, disciplinary diversity was a guiding principle, and he and George envisioned Urusvati as a center for studying fields as disparate as botany, linguistics, meteorology, archaeology, medicine, and

ethnography. Roerich took inspiration from the West Bengal college of Visva-Bharati, founded in the 1920s by his friend, Rabindranath Tagore, who prized holistic learning over pedagogical rigidity. Roerich went even farther in regarding all modes of inquiry as equally valid, be they empirical, spiritual, or parapsychological. Decrying what he saw as obdurate skepticism on the part of European and American academics, Roerich insisted in the 1930 essay "Realm of Light" that "approaches to the One Knowledge are manifold. One may never know whence the useful seed will come: the physicist, bio-chemist, botanist, physician, priest or historian or philosopher or a Tibetan lama, or Brahmin-pandit, or Rabbi-kabbalist, or Confucian or an old medicine woman."[17] Whether one sees such sentiments as open-minded or gullible, the institute looked impressive enough on paper. It was subdivided into a Department of Archaeology and Related Sciences and a Department of Natural Sciences, and maintained a museum and library. It published its own periodical, the *Journal of Urusvati*, under George's editorship. India's most accomplished scientist, Jagadis Bose, had consented in 1928 to be on its board of directors, and Charles Lanman, George's teacher of Sanskrit at Harvard, was named vice president in 1929.

During the early 1930s, Urusvati formed working relationships with a rich assortment of academic institutions and individual scholars. These included the Paris Museum of Natural History, the Archaeological

Institute of America, whose president, Ralph Magoffin of New York University, greatly respected Roerich, and the Pasteur Institute, where one of Roerich's university friends, Sergei Metalnikov, now worked. Urusvati's most enthusiastic partner was the New York Botanical Garden, whose director, Edgar Merrill, was elated to have a supplier of specimens from such an understudied region. Among those pledging to cooperate with Urusvati or join it as corresponding members were Sven Hedin of Sweden (also an honorary board member of the Roerich Museum), Louis Marin of the Paris Society of Ethnography, Giuseppe Tucci of the Royal Italian Academy, the University of Chicago physicist Albert Michelson—the first American to win a Nobel Prize in the sciences—and Robert du Mesnil du Buisson, an archaeologist with the École du Louvre. The Soviet botanist Nikolai Vavilov provided informal advice from afar, and from Visva-Bharati, Tagore donated materials to Urusvati's library. With his associates in France, including Baron Mikhail Taube and the ethnographer Marie de Vaux-Phalipau, Roerich began planning the creation of an allied Institute of Oriental Studies in Paris. He and George also attempted to unite with the Kondakov Seminar, an association of Russian émigré scholars in Prague.[18] Roerich had known this group's founders, including Kondakov, since before 1917, and the director, Alexander Kalitinsky, was not only friends with Georges Chklaver, but married to one of the Roerichs' recently acquired disciples, the actress Maria Germanova. This cash-strapped body welcomed Urusvati's attentions, which came with promises of financial support, but the outcome would not be to anyone's liking.

Profiling the HRI in August 1931, the *Illustrated Weekly of India* spoke of the "illimitable scope" of its activities.[19] In actuality, its foundation was flimsier than the parade of names above suggested. As with all his organizations, Roerich manufactured an illusion of solidity by gathering testimonials and vague assurances of support, but most of those "associated" with Urusvati served on an honorary basis or had only loose dealings with it. Moreover, among scholars internationally, impressions of Urusvati ranged from ambivalent to emphatically negative. Of the interwar period's leading orientalists, the only one with any true regard for the Roerichs was Sven Hedin, and much of that was based on his enthusiasm for George's research into languages. Roy Chapman Andrews (like Hedin, an honorary adviser to the Roerich Museum) and Russia's Pyotr Kozlov were well-enough disposed, but more tempered than Hedin in their liking for Roerich.

Others took a dimmer view. As noted in chapter 11, the French Sinologist Paul Pelliot, one of George's teachers at the Sorbonne, broke with him over the family's imprudent claims in 1925–1926 to have proved the presence of Christ in the Himalayas.[20] Aurel Stein loathed Roerich, denouncing his publications as "ridiculous and worthless."[21] Even Charles Lanman, despite his own affiliation with Urusvati and his admiration for George's "exceptional promise as a

scholar," admitted to the State Department during the Roerichs' 1930 visa struggle that the elder Roerich was widely thought of as as an unprofessional and unsavory publicity-seeker. Similar opinions were held by the Smithsonian Institution's Bureau of Ethnology and the East Asian specialists at Harvard's Fogg Museum, including Paul Joseph Sachs, Langdon Warner, and Edward Waldo Forbes.[22] Some objections were less soberly grounded than others. Truman Michelson of George Washington University was well within his remit when he warned State that the Roerichs were the subject of "unfavorable gossip" in the field and that, "with the exception of its work in Sanskrit, [Urusvati's] scientific standing was dubious." He went too far, though, in adding salaciously that the HRI raised money "in part by spiritual dances in which it was believed that immorality was rampant."[23] While it says little about what the Roerichs were actually up to, this bit of prurience shows what people were willing to believe of them because of their undeniable oddness.

In the end, the bulk of the institute's work was completed by the Roerichs and their closest confederates. Hefty issues of the *Journal of Urusvati* began to emerge in mid-1931, but much of the content was authored by George himself. Similarly, it was in George's favored disciplines—linguistics, archaeology, and ethnography—that Urusvati most distinguished itself. The best fruit of these labors was the progress George made on his Tibetan dictionary and grammar, a well-regarded project he pursued

with assistance from Lobsang Mingyur Dorje. Esther Lichtmann, an unexpectedly insightful chronicler of the Kulu Valley's folk practices, published an article on them in the *Bulletin de la Société d'Ethnographie* and a 1931 monograph titled *In the Realm of the Gods: Mores and Customs of the Kulu Valley.*

Progress in the "hard" sciences was limited, despite Roerich's longtime interest in X-rays and electromagnetism as possible explanations for supernatural phenomena, and despite his hopes for discovering herb-based treatments for cancer and asthma. He and George sketched out plans to build a biochemical laboratory, to be run by Vladimir Pertsov, one of George's Harvard friends, but Pertsov went to the University of Montpellier instead. Equally distressing was the arrival, then sudden departure, of B. E. Read, a Canadian physician who left the Rockefeller Medical College in Peking to work at Urusvati. Right away, the young doctor was taken aback by what he perceived as a cultlike atmosphere hanging over Hall Estate, and because he came to Naggar when the Roerichs' fight to bring Nicholas and George back to India reached its most fevered pitch, Read was subjected to heavy doses of anti-British invective. Worried by July 1930 that he had gotten wrapped up in "something not *bien vu* by His Majesty's Government," Dr. Read extricated himself and reported his suspicions right away to Government of India officials.[24]

In one branch of science at least, Urusvati produced quality results. Botany and its

medical applications had fascinated Roerich for years, and for many seasons running, Urusvati collected plants in the Kulu region, the nearby Chandra and Bhaga valleys, and the upland districts of Lahul, Spiti, and Rupsha. In this, the Roerichs were aided by Walter Norman Koelz, an American zoologist who came to Urusvati in May 1930 at the suggestion of Edgar Merrill of the New York Botanical Garden. After receiving his PhD from the University of Michigan, Koelz accompanied the Byrd–MacMillan Expedition to the high Arctic in 1925, then moved on to a job with the US Bureau of Fisheries. Longing to return to exotic climes, he eagerly took employment with the HRI. For a year and a half, Koelz gathered and cataloged plants; he thrilled Merrill with the samples he sent back to New York, and Urusvati's atlas of Himalayan medicinal flora could never have come into being without the data he compiled.[25] He also fit in well with the Roerich household—better, in fact, than he later cared to admit. Esther grew fond of him, praising him as a "bold *Naturmensch*," or outdoorsman. Her diaries speak repeatedly of long hikes and longer conversations with Koelz, and according to her, he received "the teaching" from Helena, willingly involving himself in the family's spiritual activities.[26]

This state of affairs ended in early 1932, with the botanist's abrupt rejection of the Roerichs. Koelz befriended a young Lahuli named Rup Chaud, and the two men relocated to the University of Michigan, where Rup Chaud taught Tibetan and for whose

museum Koelz went on to assemble a substantial collection of Indian and Tibetan antiquities. Koelz complained to Merrill about the Roerichs' unsuitability as employers and, like Dr. Read in India, reported on them negatively to the authorities. Questioned by the State Department in 1932, Koelz "was pretty careful not to say anything definite" about his interactions with the Roerichs— embarrassed, obviously, by his temporary attraction to Agni Yoga—although he offered his opinion that the family's "artistic and scientific and humanitarian and religious projects [were] really blinds to cover their money collecting activities." Interestingly, Koelz believed Helena to be genuinely ill and not shamming her need to live at high altitude. This bit of testimony convinced State that, even if Roerich was more of a humbug than it had thought, backing his visa appeal had been the correct thing to do.[27]

By 1933, Urusvati's viability had run its course. Along with Koelz and Lanman, other supporters lost interest or backed away as they learned about the HRI's shadier side. The Kondakov connection fizzled out as well, with each party desiring different things from the relationship: the seminar wanted Roerichite money without sacrificing autonomy, while the Roerichs hoped to turn it into a pliable affiliate, with George elevated to its governing council. Kalitinsky, the seminar's director, quoted Laocoön about the folly of trusting Greeks who come bearing gifts, and George Vernadsky at Yale, who ran the seminar from afar

after Kalitinsky fell ill in late 1930, wanted even less to do with the Roerichs.[28] In March 1932, the Roerich camp severed all ties with the Kondakov group. (Kalitinsky's wife, Maria Germanova, was accused by Helena of "Satanic" treason and drummed out of the Agni Yoga elite.[29]) The *Journal of Urusvati*, which published its second issue in January 1932 and would release a third in January 1933, was increasingly a solo act featuring George's research and little else. In March 1934, Sina Lichtmann admitted in her diary that Urusvati was academically and financially defunct.[30]

As the mid-1930s approached, approximately seventy Roerich-related groups and organizations had taken shape throughout Europe, the Americas, and parts of Asia. After New York, the most important hubs were in Paris, Riga, Prague, and Harbin, and smaller circles formed in Bulgaria and Yugoslavia. (Roerich also served on the board of Alexander Aseyev's Belgrade-based journal, *Occultism and Yoga*.) But quantity did not translate into strength. Many of these "associations" existed only on paper or consisted of one or two people, and lack of a unified purpose made for unwieldy management. Scholars, art mavens, and peace activists were attracted to Roerich for reasons alien to those drawn to occultism or anti-Soviet political adventurism. Even with better leadership skills, Roerich would have found it impractical to coordinate these diverse and frequently competing agendas. Not that this was his chief intention: horizons wider and more exciting than

commonplace questions of administration beckoned. As the sting of his previous failures faded, Roerich intensified his work on the Banner of Peace—and dedicated himself to reactivating the Great Plan.

Both of these efforts, one overt, the other clandestine, were intertwined, even if it remains hard to tell how Roerich understood their symbiosis. Did he see the pact as an organic part of the larger destiny that would culminate in the Plan's fulfillment? Or was the pact just a tool, merely a way for Roerich to mobilize contacts and resources for the Plan's benefit?

Either way, setbacks outweighed successes in 1931 and 1932, although early signs gave cause for hope. Roerich's New York faithful and his Paris supporters, the so-called European Center, appeared to partner well as they promoted the Banner of Peace. In September 1931, they assembled four hundred delegates for an international conference to benefit the pact—the first of three such events—in the Flemish city of Bruges, whose magnificent medieval architecture, loved by Roerich for years, epitomized the sort of cultural treasure the pact was intended to protect. A second conference followed in 1932, in Montevideo, Uruguay, where Frances Grant's Latin American contacts proved helpful. Initially, the campaign seemed to yield results. The Bruges conference, with sessions held at the fifteenth-century City Hall and the

Basilica of the Holy Blood, was lauded by Pope Pius XI, the League of Nations, and the Académie Française. Under the headline "Bruges Runs Short of American Flags," the *New York Times* described the entire city as "anxious to show her approval of the plans of Professor Roerich."[31] A mountain of endorsements was piling up. Maurice Maeterlinck, whose Symbolist dramas had so powerfully influenced Roerich, was on hand for the Bruges conference. Pearl S. Buck, cresting to fame on the strength of her Pulitzer Prize–winning *The Good Earth*, lunched at the Roerich Museum in 1932 to support the pact, and soon-to-be First Lady Eleanor Roosevelt wrote that same summer that "the Roerich Pact cannot but appeal to all who hope that the best of the past may be preserved to guide and serve future generations."[32] Albert Einstein, an increasingly visible presence in the international peace movement, publicly voiced his approval for the pact, confiding his opinion to the poet George Viereck that "Roerich is a genius."[33]

Such accolades, though, carried little beyond symbolic weight. Governments were hardly lining up to consider the pact for adoption. Moreover, to Roerich's annoyance, his New York circle—already riven by its own internal feuds—soon found itself at odds with his Paris-based group. In recent months, this European Center, built around the Paris Society of Friends of the Roerich Museum, had grown in size and taken on a different complexion. The author of the pact, Roerich's longtime partisan Georges Chklaver, remained active, but proved less

satisfactory as an administrator than as a jurist. This led Roerich to rely increasingly on supporters who, in contrast to his New York and Riga cohorts, were less invested in his mysticism and in some cases unaware of it. Those of Chklaver's type were elbowed aside by newcomers like the Belgian archaeologist Camille Tulpinck, who organized the Bruges conference, and the French ethnographer Marie de Vaux-Phalipau. Both were drawn to Roerich's academic and humanitarian causes, not as much to Roerich himself. Also important was Baron Mikhail Taube, whose relationship with Roerich had begun in 1929, for reasons entirely unrelated to the pact: seeking to prove that he had somehow descended from nobility, Roerich hired Taube to conduct genealogical research for him in Europe. Nothing definitive resulted from these investigations, but they led to friendly discussions about Asian studies, ancient history, and medieval crusading orders (Taube headed the Russian Grand Priory of the Order of the Knights Hospitaller). Before long, the baron had established himself as a ringleader in the artist's European Center.

Inconveniently for Roerich, Taube and his coworkers in Europe felt little love for their New York counterparts. Esther Lichtmann struck them as charming and capable, but they considered the Horches crass and loathed Frances Grant's management of the *Roerich Museum Bulletin*. This transatlantic rancor boiled over in late 1931, thanks to a series of letters sent to Roerich by Lotus Dudley, an expatriate Roerich supporter

living in Paris and assisting Taube and de Vaux. Enthusiastic boosterism might play well in New York, Mrs. Dudley wrote, but in Europe, "our work is based on a noble and disinterested idealism." The Parisians' principled appeals, she went on, were drowned out by "the American business campaign for great sums of money" and Grant's "propagandist editorial touch."[34] Madame de Vaux seconded Mrs. Dudley's opinion, comparing the *Bulletin* to a Yankee salesman parading in a sandwich board and warning that such "ridiculousness" could only harm the pact's prospects.[35] (For her part, a wounded Grant shot back that Mrs. Dudley, rather than stir up enmity, might do better to set aside her "picayune prejudices" and apply her supposed understanding of France's and America's "different psychologies" to facilitate the group's work.[36]) With Esther's help, Roerich smoothed things over, but a year later, Baron Taube was still complaining about the "systematic undermining" of his group's efforts by what he considered the Americans' bumbling interference.[37]

Also facing hurdles between 1930 and 1932 was the Roerichs' reformulation of the Great Plan. Cooperation with the USSR was no longer viable or desirable. The Dalai Lama stood in the way of the family's intentions for Tibet, and although Roerich, via Charles Crane, made a halfhearted overture to Chiang Kai-shek in 1931, he viewed China with disdain after his experience there in the 1920s.[38] Roerich still dreamed of a pan-Buddhist alliance with the Panchen Lama, currently residing in Inner Mongolia,

but for state-level support, he now hoped to assemble an anti-Soviet coalition consisting of the United States, Japan—itself seeking to use the Panchen for its own ends—and White Russian émigrés, principally in Paris and Harbin. His political sway in America, however, had melted away: the Hoover administration had zero interest in the Banner of Peace, and the State Department had exhausted its patience with him. Complicating matters further was Japan's invasion of Manchuria, which began in 1931 and culminated in 1932 with the creation of Manchukuo: a pro-Japanese client state under the nominal rule of Henry Pu-yi, the Qing boy-emperor deposed by the Chinese Revolution in 1912. Tokyo's aggression, combined with subsequent incursions into northern China, earned near-universal condemnation from the international community and scrambled Roerich's calculations by ending for now any chance of US–Japanese cooperation in Asia. Also potentially damaging to Roerich's plans was the growing chance that America might extend diplomatic recognition to the USSR—a step the artist had encouraged in the 1920s but now found intolerable.

Nor did Roerich find it easy to ingratiate himself with the White Russian diaspora. Through his brother Vladimir, he reestablished contact with his émigré followers in Harbin and, with them, outlined plans for a Three Rivers Cooperative: an agricultural and manufacturing venture in Manchuria, organized similarly to his now obsolete Beluha project. With intelligence provided by Vladimir, he and George tried to gauge the

relative strength of pro- and anticommunist forces in southern Siberia and Mongolia. Among Parisian Whites, he made connections with such influential figures as Father Georgii Spassky, a spiritual pillar of the émigré community; Prince Nikolai Obolensky, a member of the Russian general staff during World War I; and Prince Sergei Volkonsky, once a director of Russia's Imperial Theaters and now head of the Conservatoire Rachmaninoff in Paris. Roerich reached out to the Russian All-Military Union (ROVS), the most active of the anticommunist groups still agitating against the USSR, and also to soldiers' unions that had served in Asiatic Russia or had regional ties there, including the Siberian Society, the Far Easterners, and the Kalmyk Cossacks.[39]

It was no hard thing to bond socially with White powerbrokers. Securing their aid in a high-stakes military venture was a different matter. Princes Volkonsky and Obolensky, for instance, were attracted to Roerich's ideas for a Paris-based institute for Oriental studies; what they would have made of his geopolitical goals is anyone's guess. Furthermore, to stay in his compatriots' good graces, Roerich had to conceal from them an impossibly large part of his recent past. Could he really hope to hide his earlier praise of Lenin, or his description of Christ as "the Great Communist," from a gossipy cohort consumed with hatred for the USSR and obsessively wary of infiltration by Red provocateurs? In January 1930, the ROVS chairman Alexander Kutepov had been abducted in Paris by Stalin's secret police, leaving all White officers in a heightened state of anti-Soviet suspiciousness. To make things worse, the Russian Orthodox Church in Exile unleashed a crusade against "heresies" such as spiritualism and Theosophy, formally anathematizing both in 1932. This compelled the Roerichs to disavow core components of their worldview, despite the visibility of their previous occult activities and associations. Already in 1931, Baron Taube (who as yet knew nothing of Roerich's alternative beliefs or his temporary leftward shift in the 1920s) informed Esther about distressing rumors that had reached his ears in Paris and Rome, to the effect that Roerich was either a Bolshevik, a Satanist, or a Freemason.[40] Esther assuaged Taube's fears for the moment, and over the next several years, Roerich proved surprisingly effective at convincing his countrymen of his Orthodox and anticommunist bona fides. But harmful accusations never ceased to dog him, and they would prove his undoing by the mid-1930s.

Even were this not the case, Roerich in 1932 pulled nowhere near the motivational weight he needed to persuade White forces to ride with him as he sallied forth to Shambhala. He had no means to influence Japanese or American policy, and with progress on the Banner of Peace similarly stuck in the doldrums, he felt a deep sense of frustration as the year drew to a close. Then, in a matter of weeks, he gained newfound cause for hope.

This turn in Roerich's fortunes came without expectation and from halfway around the world. In November 1932, Franklin Delano Roosevelt was elected president of the United States. Soon after that, Roosevelt chose his first cabinet, and in that body stood Henry Wallace of Iowa—the secretary of agriculture during FDR's first two terms, vice president during his third, and secretary of commerce during his fourth (see Illustration 33). Unbeknownst to the president, or to anyone else in the Democratic Party leadership, Wallace was firmly under Roerich's influence.

Wallace first met Roerich in the summer of 1929, but had been caught in his gravitational pull for some time before that: likely since April 1927 and by no later than early 1928. During a spring trip to Manhattan, Wallace, who had heard about Roerich from the Soviet agronomist Dmitri Borodin-Poltavsky, decided on a whim to see some of his paintings. Frances Grant was at the museum that quiet Sunday, and, informed by a guard of the solitary visitor, offered him a personal tour of the building. She proved a capable docent: Wallace was captivated by her description of Roerich's ideals, and he adored the artist's work. (He later said that Roerich's paintings gave him "a smooth feeling inside," demonstrating if nothing else what a small loss his entry into politics was to the world of art criticism.[41]) The two parted warmly, with Wallace promising to stay in touch and expressing his eagerness to someday trade words with Roerich in person. Wallace joined the Society of Friends of the Roerich Museum and, in August 1929, as described in chapter 12, he realized his wish of meeting the artist. His half-decade commitment to the Roerichs' causes soon went far beyond this puppyish admiration.[42]

Wallace's infatuation with the Roerichs was wholly in keeping with his character. A gifted economist and plant geneticist later nicknamed "Old Man Common Sense" by FDR, Wallace had an unconventionally spiritual side to him as well. Rejecting the Episcopalianism of his youth for its "wishy-washy goodness" and "infantile irrelevancy," he spent his adult life searching for an "Inner Light" of higher consciousness. By the time he encountered Agni Yoga, he had already taken guidance from astrologers, mystical poets, and a Native American medicine man who gave him the totemic name "Cornplanter." He probed the mysteries of Theosophy and Freemasonry, and to him, as one scholar notes, the New Deal itself was "a harbinger of impending spiritual revolution, a kingdom of social justice."[43] But to no other spiritual mentor was he ever in thrall as strongly as to the Roerichs.

Although Roerich paid Wallace little mind upon meeting him in 1929, the newly appointed secretary, like a pawn reaching the far side of the chessboard, now possessed immense value. Could he provide the missing spark needed to kindle official Washington interest in the Banner of Peace? Might his ready access to the White House be used to get the Great Plan moving again? Or to stabilize the Roerich Museum in its time of financial weakness? These were

tantalizing possibilities, and Roerich, eager to capitalize upon them, told Frances to take Wallace firmly in hand. He received the spiritual name "Galahad," to signify purity of heart, and was encouraged to contact Nicholas and Helena directly. He did so no later than March 12, 1933, adopting wholeheartedly the vernacular of oracles and omens: "I have been thinking of you holding the sacred, most precious casket. And I have thought of the New Country going forth to meet the seven stars under the sign of the three stars. . . . We await the Stone and we welcome you again to this glorious land of destiny, clouded though it may be with strange fumbling fears. Who shall hold up the compelling vision to those who wander in darkness? In answer to this question we again welcome you. To drive out depression. To drive out fear."[44] Thus began the "Dear Guru" correspondence, a collection of nearly two hundred letters, all in the same mystical vein, sent to the Roerichs by Wallace between the spring of 1933 and sometime in 1935. The couple's replies were relayed by Grant, mainly in oral form. Not all of Wallace's letters are dated, and a handful have never been authenticated. Still, the bulk are recognized as genuine by experts on Roosevelt-era history, and the letters—or copies of them—are preserved by several key archives, including the FDR Presidential Library in Hyde Park, New York, and the Henry A. Wallace Papers at the University of Iowa.

By September 1933, Wallace had promised the Roerichs to "obey the Gita and F.R.G[rant], who is as remorseless as Krishna. We shall fight [for] the predestined future."[45] He was entrusted with the spiritual names of the Roerichs' inner circle. To a larger extent than he later let on, he shared their beliefs about the impending new age. And while not privy to every detail, he knew a great deal about their geopolitical goals and was committed to their realization. "We think of the People of Northern Shambhala and the hastening [feet] of the Successor of Buddha," he wrote in March 1933, as he pledged his loyalty to Nicholas and Helena. "I await your convenience prepared to do what I am to do."[46]

At the end of the year, another development added to Roerich's optimism. In December 1933, the Thirteenth Dalai Lama died, not to be formally replaced until 1939. This tore a gaping hole in the hierarchy of Mongol-Tibetan Buddhism and set off millenarian shock waves throughout Inner Asia. What better time for someone like Roerich to assert once again that he deserved a place among the region's leading theocrats? And might he himself be the rightful inheritor of the Dalai's throne? Roerich had maintained for years that he was the Fifth Dalai Lama's reincarnation, and during his more recent condemnations of the Thirteenth Dalai, he made much of supposed irregularities in the chain of succession that followed the death of the Fifth Dalai in 1682. It was obvious to Roerich that the Thirteenth Dalai had held his office on false grounds—and equally obvious that only he could restore legitimacy to the Potala Palace.[47]

So he hoped to argue if he got the proper chance. The main thing now was not to squander these fortuitous circumstances. Roerich was so desperate to avoid doing so that he cultivated not just Wallace in 1933, but several potential backers at once, without any regard for how their agendas might clash. There was no hiding from Wallace Japan's role in the Great Plan, or that of émigré Russians in Asia, even if Roerich understated the importance of the latter and concealed much of what he had in mind for the former. But the secretary would have been aghast to know that Roerich was also considering cooperation with Europe's fascist powers, which Master Morya identified as "possibly useful."[48] Such accommodations were not uncommon among anti-Stalinist Russians. They arose in some cases from ideological affinity—the White general Yevgeny Miller stated openly that "we members of ROVS are natural fascists"—and in others from a more Machiavellian pragmatism.[49] Already since 1929, Major Carmelo Rapicavoli, a member of Italy's Fascist Party and a personal acquaintance of Mussolini's, had interacted in a friendly fashion with the Banner of Peace movement.

More nettlesome was the question of whether to approach Germany's recently installed Nazi government. Roerich took counsel here from various White Russians, but seems to have been guided most directly by Charles Crane, whose startlingly positive view of Nazism placed him at odds with most of his fellow Democrats. Some of this stemmed from the same anticommunist logic that led others in official circles, including not a few in the State Department, to regard Hitler's regime as a lesser evil than Stalin's, and as a useful safeguard against possible Soviet expansion. The Nazi government was "the real political bulwark of Christian culture," Crane told FDR, urging him in the fall of 1933 to "on no account be drawn into any critical attitude toward Germany. She is in the healthiest state of any country in Europe, going along quietly, minding her own business, menacing no one."[50] Sheer antisemitism also conditioned Crane's views. Readers will recall that, years before, Louis Horch had suspected Crane of hostility toward Jews, and had he been able to read Crane's private correspondence, he would have seen the worst of his fears borne out. One of the USSR's greatest failings in Crane's eyes was its transformation of a once-virtuous Russia into "a Jewish empire."[51] Closer to home, Crane confided to Edward House, the famed Wilson-era diplomat, his distress that "professional Jews" had gained too much sway over President Roosevelt. Bemoaning the influence that the ACLU founder and future Supreme Court justice Felix Frankfurter appeared to exercise over FDR, Crane voiced to House his concern that "it looks as though Franklin has fallen entirely into their hands . . . and the race's enormous capacity for mischief will be exercised everywhere."[52] As late as 1934, Crane met Hitler in person, reporting the encounter as "a very good interview" and describing the Führer as "a man of great power with a definite, clear

program"—ignoring the plain fact that official persecution of Jews already formed a visible part of said "program."[53]

Whatever effect Crane's thinking had on Roerich's, the artist had by that point parted ways with it and given up his search for "suitable" fascists, whether German or Italian. The thuggishness of Hitler's and Mussolini's regimes was by then self-evident, and other advisers besides Crane, most notably Baron Taube, persuaded Roerich of the incompatibility between their aims and his own.[54] Compared to the many expatriate Russians whose anti-Stalinism enmeshed them with Nazism during the 1930s and 1940s, Roerich's flirtation was blessedly short-lived and inconsequential.[55]

Wallace, then, turned out to be Roerich's only playable card. The secretary was malleable and highly placed. Despite the pro-Soviet stance that gained him such notoriety in later years, he stood for the moment as a firm opponent of recognizing the USSR. Stalin's forced collectivization of the Soviet peasantry had horrified him, and he viewed Moscow's practice of dumping cheap grain on the international market in exchange for industrial machinery as economically harmful to US farmers. Freshly optimistic with Wallace behind them, Nicholas and Helena charted a new course of action in 1933 and early 1934. In broad outline, it went as follows: in addition to working with Grant and the Horches to secure passage of the Banner of Peace, Wallace would arrange to send Nicholas and George to Asia in some sort of official capacity. This would spare the inner circle the cost of the undertaking and invest Roerich with enough political standing to be taken seriously by potential followers and confederates. Using the rail hub of Harbin as an initial base of operations, Nicholas and George would rally the supporters who had cohered around Vladimir Roerich.

After that, in whatever order events permitted, the two would recruit White Russian exiles to recapture Siberia from the Soviets; track down the Panchen Lama and ally with him as Roerich had desired since the 1920s; and, with their faithful, proceed into the interior to establish their cooperative—the embryo of their New Country—at "a place to be determined in Inner Mongolia or the Altai."[56] (How Roerich meant to reconcile his Orthodox Christian and neo-Buddhist constituencies was left unanswered for the moment.) There they would gather their strength and prepare to launch, no later than the apocalyptic year of 1936, the long-prophesied war of Shambhala. Bringing to life the messianic legends of Rigden Djapo, Gesar Khan, and Maitreya, Roerich would upend the geopolitics of Asia, liberating Siberia, if not all of Russia, from communist tyranny and breaking British hegemony over South Asia. He would govern his New Country in conjunction with the Panchen, and Helena would leave India to join her husband in glory.

Wallace's familiarity with this plan, though not complete, was considerable. In letter after letter, with terms enciphered to hide their meaning, he wrote of helping the

Roerichs to reach "Kansas" (the code for Mongolia, also referred to as the "Land of the Masters"). With Nicholas and Helena, whom he addressed as "Father" (or "Guru") and "Mother," he concocted stratagems for contending with the malice of the "tigers" (the Soviets) and the antagonism of the "monkeys" (the British), who would resent the New Country's rising influence over Tibet and India. Closer ties between America and "Our Friends" (the Japanese, also called the "rulers") would maintain the balance of power in Asia. Cordell Hull, the secretary of state who opposed the Banner of Peace Pact, was derided as "the Sour One." FDR was praised as the "Flaming One" or rebuked as the "Wavering One," depending on his current level of support for the Roerichs' causes.

The chief difficulty for Wallace was that, on several fronts, fealty to the Roerichs put him at odds with his boss's foreign policy. Wallace shared the Roerichs' distress when, in November 1933, FDR extended US diplomatic recognition to the USSR. In this case at least, he disagreed with Roosevelt openly and on his own initiative, and was not alone among Democrats in doing so. It was the Roerichs' other priorities that placed him in truly precarious positions. The scorn Nicholas and Helena felt for Britain and China compelled him to lobby against the interests of countries the US government viewed with sympathy. And even that was a mere inconvenience compared to the jeopardy he would have to risk if he embraced Japan, whose actions in Asia the FDR administration deplored, the way the Roerichs wished him to.

Nicholas and Helena felt no qualms about splitting Wallace's loyalties. "Japan will be among our friends," Roerich told Sina in March 1934. "America could have had pride of place, but has lost it."[57] To offset what the Roerichs considered FDR's political misdeeds, Wallace would have to correct the president's current course—persuading him to act more like the "Flaming One" than the "Wavering One"—or replace him altogether. With remarkable boldness, Nicholas and Helena stoked Wallace's ambitions, hinting at first that Master Morya would be delighted to see "Galahad" succeed Roosevelt in 1940, and then suggesting that Wallace accelerate the process by challenging Roosevelt for leadership of the Democratic Party during the 1936 election cycle.[58] (Conversely, the Roerichs did not hesitate to circumvent Wallace when doing so seemed useful, and Helena would soon attempt to establish her own direct link with FDR.) Such intoxicating prospects both excited and unnerved Wallace. Scheming against one's superior might be part of the Washington game, but Wallace faced humiliation, if not ruin, if he were caught trying to outflank Roosevelt. And while supporting a private diplomatic venture that ran contrary to the president's policy preferences might not amount to treason, it definitely qualified as gross insubordination. Would obeying the Roerichs bring reward or hazard? Wallace tortured himself over this question for the next year and a half.

For the moment, it fell to Wallace to launch Roerich upon his newest adventure.

By the first weeks of 1934, a plan had come together: Wallace would use the good offices of the US Department of Agriculture to send Nicholas and George, in the capacity of regional experts conducting scientific work, to China and Mongolia. Father and son were to set off in the spring. But rather than travel from India, the duo would return once more to the United States to make final preparations.

Despite this new sense of opportunity, Roerich's time in America was fraught with tension. His New York followers had labored hard over the past half decade, but Roerich's leadership had not brought them any closer to their lofty goals. Louis Horch was bowed down by the receivership crisis in which the Roerich Museum had been mired since early 1932. Also, unlike the female members of the inner circle, who had enjoyed visits to India since the Roerichs' return from Central Asia, he had been deprived of Helena's consoling presence for almost ten years. Maurice had not seen Helena for nearly seven, and even among the women, only Esther—currently living in India, except for a brief journey back in late 1933—had been in sustained contact with her since 1930. Despite his periodic trips to New York, Nicholas, too, remained a remote presence. To guarantee a succesful push toward Shambhala, he and Helena needed to shore up morale.

Nicholas and George left India in March, traveling through France and arriving in New York on the fourteenth. They would stay in New York a month and a half, departing by train for the West Coast in late April. This proved a more subdued occasion than Roerich's triumphant return in 1929. He gave a battery of lectures, on art and on the Banner of Peace, in New York and Boston. In Washington, DC, Howard University displayed color prints of his work. In April, he opened the first Washington Square Outdoor Exhibition, a new annual show organized by the Roerich Museum employee Vernon Porter and the offices of Mayor Fiorello La Guardia. Frances Grant timed the release of several of Roerich's books to coincide with his time in the States. Most important was *Fiery Stronghold*, a volume of essays issued by Boston's Stratford Press in 1933. Reviewers did their best to assess the collection charitably, but could not conceal their feelings of puzzlement. The *Pittsburgh Press* called it "an outstanding contribution to literature," while the *Times Literary Supplement* in London noted that "Mr. Roerich has evidently a background of considerable out-of-the-way erudition."[59] But the former feared the book would have "no direct appeal to the ordinary reader because of its high intellectual tone," and the latter observed more bluntly that Roerich's "literary style is not attractive." The *New York Times* concurred, granting that Roerich had struck "a note that can prove only salutary in an era of obliterated lights such as our own," but making it clear that he had "at best achieved an anomalous position as an essayist . . . a moment's glance at any of

his papers will show that he is not a skilled writer."[60] A Denver newspaper chimed in to insist that "the world needs to hear what this man has to say," but conceded that "there is much repetition . . . and we wish that he had seen fit to actually organize his material."[61]

This split reaction proved characteristic of the entire US sojourn. As a result, Roerich's mood was sour—so much so that the Horches' daughter Oriole, only two and a half years old that spring, remembered his surly demeanor decades afterward. He found much in New York to merit his displeasure. Good news came in March, when the New York Supreme Court ruled in favor of Louis Horch in the matter of the receivership crisis, saving the museum from bankruptcy. But the inner circle remained as divided as ever. Already on the eve of Roerich's voyage back from India, Frances Grant had warned him in a long letter of the "slander and gossip" driving a wedge between her, Sina, and Katherine Campbell on one hand, and Louis, Nettie, and Esther on the other.[62] Faraway in India, Esther railed against the others in her diaries, mocking "the Cuties" (her nickname for Sina and Frances), damning Campbell as "a doublecrosser," and fuming about George's seeming ill-will toward her ("I should like to ask what evil I have done to him that he maligns me so behind my back").[63]

As during his previous trips to New York, Roerich wore his patience thin trying to restore the group's unity. He agreed with Sina that Esther, transparently campaigning to become Helena's favorite, was sowing "discord, not peace."[64] But he also lashed out at Frances, the group's publicist, for losing the friendship of the papers that had once supported him.[65] Tatyana and Georgii Grebenshchikov, he felt, were feigning what little loyalty they continued to profess. And everyone, in his view, was to blame for allowing "the pulse" of the Roerich Museum "to grow so faint" and the institute's enrollments to slip so badly.[66] Further disorienting was the growing number of unfamiliar faces who had attached themselves to the New York circle. Relative newcomers such as Katherine Campbell and Ingeborg Fritzsche had proved their worth (whatever reservations Nicholas and Helena might have had about Campbell's romance with Sviatoslav), but what connection could Roerich feel with cohorts even greener? Hardworking they might be, but the sight of figures such as Vernon Porter, who organized exhibitions for the museum, or Dudley Fosdik, a young musician now busy helping with translations and editorial work, could only remind Roerich of how much his New York enterprises had grown in his absence, and how detached from them he and Helena had become.

Worst of all, other supporters were melting away. The rift between Roerich's New York and Paris partisans yawned wide, and the latter would soon abandon him. The head of the British Roerich Society, Gordon Bottomley, went silent. The death in March 1934 of Felix Lukin, the grand elder of Latvia's steadfast Roerich community, left the artist feeling adrift. As for his American operations, Alexander Kaun, the Berkeley

professor who had advocated for Roerich in California during the 1920s and as recently as the fall of 1933, now wanted nothing to do with him. A host of once-reliable donors cut ties with Roerich's enterprises during the receivership crisis, and in April 1934, Charles Crane—reversing a pledge he had just made to help with the upkeep of the Roerichs' home in India—suddenly withdrew financial support.[67]

Of all the stateside developments Roerich had to cope with, most disquieting was the Horches' increasingly unfriendly disposition. Within hours of reaching New York, the artist confessed his worries to Sina about the "painful" frostiness that had arisen between him and the couple.[68] Louis and Nettie had not stopped believing in the Roerichs' visions, but were growing less happy with their place in them. When Louis, for example, asked George what his role in the New Country would be and heard that he was to be its ambassador to the United States—which meant remaining in America—he grew, as Sina noted, "visibly dissatisfied."[69] If Frances Grant is to be believed, another point of contention rankled: both in letters to Roerich and in written testimony during lawsuits years later, Grant described Horch as constantly exasperated by her failure to exploit her friendship with Henry Wallace for beneficial insider information. "For some time," she told Nicholas in December 1933, "L[ouis] has approached me with the following request . . . [he] feels that if he knew certain confidential facts, especially concerning gold and silver, he could

spec[ulate] and make money, and has urged me to ask my fr[iend] for this information. . . . It seems to me that this proposal has the greatest peril . . . [and] such things are against my entire scruples." Frances added, "[I do] not wish later to be reproached that, because I failed to do this, I prevented L[ouis] from making money. It is a difficult predicament and I feel I can do nothing until your word comes to me, Beloved Father."[70] Allegedly, Horch also called Frances "very foolish" for not having used her connection with Wallace to "personal advantage to herself, and to a definite financial enrichment"; he supposedly repeated many times "in the presence of all trustees, 'If I were his friend, I would get a good position, well paid in the government. You could easily get such a position. He could give me a great deal of tips pertaining to the stock exchange, and lots of money could be made in this way. You are very stupid that you did not use his friendship to help yourself and to help all of us.'"[71] Whether or not Louis conducted himself in such mercenary fashion, Roerich rued more than ever his financial dependency on the Horches, and he secretly advised Sina of the need to secure alternative sources of funding in case tensions with Louis and Nettie came to a head.[72]

Fortunately for Roerich, the Horches remained biddable, and Wallace had devised a way to get him back to Asia: Nicholas and George were to be attached as regional specialists to a Department of Agriculture expedition. The expedition's purpose was to find drought-resistant grasses that

might withstand the dry conditions that had tormented the American and Canadian Midwest since 1930 and would soon spark the Dust Bowl crisis. Roerich's interest in botany was genuine if amateurish, and he and George in the end collected a sizable quantity of specimens. In truth, though, this was merely their pretext to move through China, Manchuria, and Mongolia in search of the Panchen Lama, and in pursuit of their long-dreamed-of New Country.

In the spring of 1934, Wallace met with Roerich three times: in Washington on March 15–16, again in the capital on March 28–30, and in New York on April 14. (Roerich visited Washington once more on April 9–11, but did not see Wallace on this occasion.) During this interlude, the secretary vacillated between fevered excitement and abject fear. His anxiety is easily understood: not only was he preparing to obstruct the work of a scientific venture sent out by his own department, he was undermining his president's foreign policy. Though he later disowned Roerich as a rogue element and professed to be shocked by his actions, Wallace understood full well that he was helping to advance a pro-Japanese agenda on which the Oval Office would assuredly frown if it came to light. Balancing these risks against Helena's and Master Morya's assurances, Wallace complied with the Roerichs' wishes, although he voiced his misgivings at every opportunity. In private, Nicholas complained to Sina and George that Wallace was "too fearful" and marveled that "such a man, a future president,

could be so weak."[73] On April 16, to soothe the secretary, Roerich presented him with a portrait of Morya, a ring supposedly possessing mystical qualities, and, to promote relaxation, powdered deer musk, sent from the Himalayas by Helena.[74] Wallace thanked his masters for the musk several times in his letters—"a pinch of it cleared up my vision like magic"—and assured them of his resolve to "make over my mind and body to serve as fit instruments for the Lord of Justice."[75]

During their times together, Roerich and Wallace discussed the Banner of Peace Pact, which the latter, with help from Horch and Grant, would continue to promote while Roerich was out of the country. On March 15–16, when Roerich made the first of three trips to Washington, Wallace introduced him to a number of Latin American dignitaries, including the Venezuelan scholar-diplomat Esteban Gil Borges, the Pan-American Union's acting director general. All viewed the Banner of Peace with enthusiasm, and Roerich thought well of Borges. Wallace offered to set up a meeting with Franklin Roosevelt, but Roerich, still angered by the "Wavering One's" recent policy decisions and the lack of respect shown so far to the Banner of Peace by FDR's secretary of state, Cordell Hull, declined. (In months to come, the Roerichs changed their minds and sought a stronger connection with the president, but to no avail.)

Also in Washington, Roerich and Wallace finalized arrangements for the artist's upcoming journey to Asia, although much

friction arose from this. During Roerich's March 15–16 visit to the capital, Wallace hosted a light lunch in his Wardman Park apartment to acquaint him with the Department of Agriculture official tasked with overseeing the Central Asian expedition. This was Knowles Ryerson, the director of the Bureau of Plant Industry, and he took an instant dislike to Roerich. (George remained in New York, sick with a head cold, but it is unlikely that even his academic credentials and better command of English would have impressed Ryerson.) Without warning, Wallace upended all of Ryerson's assumptions about the expedition. Ryerson had already chosen Howard G. MacMillan, one of the bureau's senior botanists, to lead the venture, with James L. Stephens, a specialist in grasses and legumes, serving as second-in-command. He saw Nicholas and George as support staff—possibly possessing useful knowledge, but hardly of central importance—and was confounded to hear that Wallace meant to place them in charge. "I felt almost shell-shocked," he recalled, "and could hardly believe my ears."[76]

Outraged at his superior, and mystified that anyone would choose a foreign national with no relevant credentials to head a government-sponsored scientific mission, especially to such a diplomatically troubled part of the world, Ryerson spent the next days trying to undo Wallace's decision. His sense of unease worsened when colleagues in the State Department's Far Eastern Division described the Roerichs as "shysters." "Don't have anything to do with them,"

they warned. "They're crooks . . . out to get whatever they can for their own institution—that money-making racket in New York."[77] Ryerson's mood plummeted further when the Roerichs informed him that they would be departing before the end of April, weeks ahead of MacMillan's and Stephens's timetable, and that they would be sailing on a Japanese ship, and visiting several Japanese cities, before crossing to the Asian mainland. Apart from how strange it seemed for the head of a research expedition to avoid meeting any of the researchers, Ryerson had been apprehensive from the start about sending his staff to "the hottest diplomatic area in the world at the moment," and he begged Wallace—in vain—to minimize risks by ordering Roerich to have as little to do with Japan as possible.[78] The final confrontation came at the end of March. As Wallace related in a letter to George, a "panicky" Ryerson, "on the point of crying," asked one last time for MacMillan to be put in charge, or for the whole enterprise to be abandoned. "I assured him in the most solemn and gentle way possible that only with the Guru [Roerich] in charge could their safety be preserved," Wallace wrote. "He said when he left that he would be a good sport, but that if anything should happen to his men he would never forgive me. He is behaving now only because I have asked him to rely on my judgment. Therefore, I trust you will gain the confidence of [MacMillan and Stephens] so that they are happy."[79] Ryerson remembered this moment differently, with an *un*gentle Wallace yelling, "Knowles,

I forbid you to discuss these people with anybody!"[80] "Well, the fat was in the fire," as Ryerson put it, and all that remained was to hope that the actual expedition worked out better. In New York, an exasperated Roerich expressed amazement that Wallace seemed so incapable of exercising control over his subordinates.

Ryerson's fears were not merely justified, they fell far short of reality. While he worried that Roerich might endanger the expedition by dealing carelessly with the Japanese, he had no way of imagining how actively the artist meant to collude with them. Nor was Roerich idle in this respect: in America, he met at least three times in person with high-ranking Japanese officials. (On his way back to America, he had done the same in Paris, consulting with ambassadorial staff at the Japanese Embassy there.[81]) On March 19, he conferred with Renzo Sawada, the Japanese consul general in New York, and the Roerich Museum held a reception in Sawada's honor eight days later, on the twenty-seventh. During his final visit to Washington, between April 9 and April 11, Roerich called upon Japan's newly appointed ambassador to the United States, Hitoshi Saito. While the exact substance of these conversations remains a riddle, we know from Roerich's comments to followers that he did not confine himself to mechanical details of travel and transport.[82] In addition to hashing out permits and possible itineraries, he arranged goodwill tours of Tokyo and Kyoto, ostensibly to take in the delights of Japanese culture

and to promote the Banner of Peace. More rashly, Roerich sought and received permission to call formally upon Henry Pu-yi, the Chinese ex-emperor whom the Japanese had installed as the puppet ruler of Manchukuo. Japan's so-called protectorship over Manchuria was abhorred by most of the international community and not recognized by Washington as legitimate. For anyone connected with the US government to visit it in anything resembling an official capacity would be irregular to the point of scandalous. Roerich gave such complications barely a second thought.

Most provocative was Roerich's open discussion of his larger political plans for Asia. While he surely avoided complete frankness, he spoke to Sawada about their common interest in working with the Panchen Lama to secure the loyalty of Central Asian and Mongolian Buddhists, and he broached the idea of using his "Siberian Center"—his White Russian followers in Harbin and elsewhere in the east—as a nucleus for mutually beneficial anti-Soviet operations.[83] Even more indiscreetly, he intimated that, through his influence, a more pro-Japanese president would soon occupy the White House. As with the Soviet authorities Roerich dealt with in the 1920s, we are left to wonder what Sawada and Saito made of his assertions. But however the Japanese saw him—whether as a threat, a possible asset, or an unbalanced nuisance—they were bound to pay attention to him once he reached Asia, either to take advantage of what he had to offer or ward off whatever

hazard he might pose. For Wallace, who implored Roerich not to represent himself to the Japanese as speaking for the United States generally, or for Wallace specifically, such clumsiness proved frustrating in the immediate term and would assume disastrous proportions once Roerich arrived in Asia.

The date for Nicholas's and George's departure from New York was fixed for April 21. Until that time, Roerich kept in regular contact with Wallace, either through letters or during their face-to-face talks, alternately dressing him down for timidity and emboldening him with praise and encouragement. Although Wallace appeared optimistic after March 28–30, when Roerich coached him on how to conduct himself once he became president, he grew despondent again in April, much to Roerich's irritation. Adding to Roerich's anxiety was the palpable tension hanging over the table whenever the New York circle gathered to discuss finances. The museum and institute were losing money, sources of funding were drying up, and Roerich could discern the Horches' waning faith in him in the hollow tone of Nettie's laughter and in the significant glances she exchanged with Louis.[84] In a callback to his earlier New York visits, Roerich relied on frequent doses of valerian to help him relax—sometimes with a glass of port or cognac to fortify himself further.[85]

Still, the cogs of the Great Plan seemed to be meshing together. Roerich and his brother Vladimir in Harbin, plus other followers there, such as the poet Alexei

Gryzov (also known as Achair), were laying plans for the artist's arrival and fine-tuning their Three Rivers project. In Paris, Georges Chklaver and Baron Taube, joined by Ivan Kirillov, a Siberian friend of Georgii Grebenshchikov's, kept working to sway White Russian opinion in Roerich's favor. Even from the USSR, Boris Roerich, still vaguely supportive of his older brother's schemes, managed to send telegrams to New York in February and March. Now living in Moscow after his year-and-a-half imprisonment, Boris was limited by Soviet censorship when it came to speaking of practical affairs. Nevertheless, any word from him was greeted with joy by Nicholas, who fretted endlessly about his brother's well-being and worried, not without justification, that he might be arrested again at any time.

In mid-April, Roerich said his New York farewells. On the seventeenth, he reminisced about Russia's past with the painter Boris Grigoriev, a comrade from his World of Art days, and he attended an April 19 orchestral performance conducted by his onetime admirer, the composer Vasily Zavadsky. He paid his respects to Metropolitan Platon, the Orthodox hierarch who had supported him in the past, but now lay dying. With him, he brought a banner of Saint Sergius, intended as an emblem to inspire White Russians in Asia, and Platon, weak as he was, ceremonially blessed it. As a further sign of approval, Platon's regent, Veniamin, came to the Master Building the following day, several deacons in tow, to pray for Nicholas's and George's safety. On

April 21, Nicholas presented Sina, Frances, the Horches, Ingeborg Fritzsche, and Katherine Campbell each with a small painting as a keepsake. On the twenty-second, he and George proceeded to Penn Station, where they boarded a train to Seattle, from which they would sail in May, heading for Yokohama. (MacMillan and Stephens, they told Wallace, would have to catch up with them in Asia.) As chapter 14 will tell, the two were voyaging toward catastrophe, though this would not become apparent until too late.

Even in Roerich's absence, Wallace remained an obedient disciple, wielding his political authority on the artist's behalf in 1934 and the first half of 1935.

This was the case even in matters beyond his purview. Years later, FDR's secretary of state, Cordell Hull, queried by *Time* magazine about Wallace's conduct as a cabinet member, dryly responded that Wallace had been "so active that his tendency at times was to trench upon the jurisdiction of his colleagues."[86] If rumor holds true, one of the quirkier consequences of this habit lives on in the wallets and cash registers of all Americans. In 1935, the one-dollar bill underwent a major redesign, and among the changes was the addition of the Great Seal of the United States to the bill's reverse, complete with the symbols of the Unfinished Pyramid and, hovering overhead, the Eye of Providence. According to the Bureau of Engraving and Printing, the pyramid and eye represent "strength and durability" instructed by "divine guidance," but the emblem has also been linked in the public mind with various secret societies—especially the Freemasons—since its inception. Henry Morgenthau, who, as secretary of the treasury, oversaw this process, has stated that he included the Great Seal on Wallace's advice, and it is widely supposed that the notion was first planted in Wallace's mind by Roerich. This did not actually have to be the case: the Great Seal has been part of American iconography since the 1780s, and to the extent it has Masonic connotations, Wallace himself was a Mason, as was Roosevelt. Nonetheless, the eye-and-pyramid symbol was known to Roerich and cherished by him as a sign of enlightenment; it appears in several of his canvases, most prominently in his 1932 *Saint Sergius of Radonezh*, where the Eye of Providence floats above the saint's head (see Illustration 31). It seems probable, then, that even if the idea occurred to Wallace independently, Roerich encouraged it. Either way, Morgenthau found himself unprepared for all the talk of Masons and Illuminati—and of a certain eccentric Russian—that arose once the new bill entered into circulation. "It was not till later," he noted ruefully, "that I learned that the pyramid had some cabalistic significance for members of a small religious sect."[87] But by that point, legal tender was legal tender—whether it bore Roerich's imprint or not.

Apart from getting Roerich to Asia, Wallace's principal task was to win the

widest possible acceptance for the Banner of Peace. He presided over the Roerich Pact's peak surge, and while no European or Asian governments adopted the treaty, it became law in the United States and much of the Western Hemisphere in 1935. However hard Roerich's followers in New York and Paris worked to make this happen, the rightful credit for the pact's passage—agreed to by FDR in August 1934 and signed into effect the following April—belongs to Wallace. It was not a success he would relish for long.

It is worth some backtracking, to the summer of 1933, to appreciate Wallace's yeoman efforts. Franklin Roosevelt proved more amenable to Roerich's proposals than Herbert Hoover, but his secretary of state, Cordell Hull, regarded the artist no more highly than had his predecessor, Henry Stimson. None of this kept Wallace from blitzing Hull with letter after letter, starting in August 1933, and going over Hull's head to Roosevelt when Hull demurred. On August 31, Wallace sent Hull a copy of *The Roerich Museum: A Decade of Activity*, along with several issues of the *Roerich Museum Bulletin*, and asked that State throw its official support behind the upcoming Third Banner of Peace Convention.[88] This was to be take place in Washington, in mid-November, as a follow-up to the Banner of Peace conferences held in Bruges and Montevideo in 1931 and 1932. Louis Horch and Frances Grant petitioned Hull separately.

Hull's reply, which came on September 15, was polite but negative. He assured Wallace that he "personally" had "the most sympathetic leanings" toward the pact's principles, but stated that "this Government cannot, nor can I as Secretary of State, become associated with this movement." Wallace was free to involve himself with the Banner of Peace on an individual basis, but Hull wanted it "clearly understood that your association with these activities does not in any way commit this Government at this time to any action with regard to the proposals contained in the suggested pact."[89]

Wallace, with Nicholas and Helena prodding him, was not waved off so easily. In October, he urged Hull to reconsider, reminding him (in pedantic tones that Hull surely found infuriating) of how abominably slow the State Department had been to recommend joining the Red Cross in the 1860s and 1870s. "At that time," Wallace pointed out, the department "took very much the same attitude which you are now taking." Such wrongheaded caution was not worthy of the present government, he concluded, leaving Hull with this last thought: "I really think that the objectives of the Banner of Peace and the Roerich Peace Pact against the background of the present day are even more important in some ways than the Red Cross. I am trusting that the attitude which characterized the Hoover administration in this matter will now be changed and that we can begin to make some real progress toward doing our part in holding up international ideals in the way that is so dear both to your heart and to mine."[90]

Nor did Wallace stop with words. As during Roerich's first Banner of Peace push

in 1929–1930, the New York circle amassed an enormous quantity of endorsements that, while soft in their level of commitment, looked impressive on paper. Among the institutions of higher education that voiced approval for the pact were George Washington University, Mount Holyoke College, the University of Chicago's Oriental Institute, Duke and Vanderbilt Universities, and the Massachusetts Institute of Technology. Even schools as far apart in orientation as the United States Military Academy and the Union Theological Seminary were joined in support for the pact. August bodies spoke in its favor, including the League of Nations International Museums Office, the Salvation Army, the Pan-American Union, and the Carnegie Endowment for International Peace. Artists and intellectuals did the same. Some, like Maurice Maeterlinck, Alphonse Mucha, Ivan Meštrović, and Ignacio Zuloaga, were acquaintances or admirers from earlier decades. Others carried great heft, including H. G. Wells and George Bernard Shaw, both habitual backers of utopian causes, and Albert Einstein, a tireless crusader for peace during the 1930s. Einstein never formally associated with Roerich, but the activist Frederick Kettner—who sometimes served as Einstein's translator—housed his Biosophical Society and Spinoza Center in the Master Building and helped convince the scientist of the pact's merits. Einstein also corresponded with Louis Horch, declaring himself a fan of Roerich's art. "I can say without exaggeration that never have landscapes made such a great impression

on me as these," he wrote in 1931.[91] Eleanor Roosevelt had lauded the Roerich Pact in 1932, and more than two dozen US congressmen and senators, including longtime supporters like Sol Bloom and Royal Copeland, gave it their mark of approval, as did many state governors. Wallace also pointed to praise from Tomáš Masaryk of Czechoslovakia, King Alexander of Yugoslavia, and high-ranking politicians from France and Latin America, among them Esteban Gil Borges of the Pan-American Union.

Wallace also circumvented Hull and took his arguments straight to FDR. The president was better disposed than Hull toward the Banner of Peace concept, helped by the fact that his wife already favored it. In addition, Louis Horch managed to establish friendly contact with Roosevelt's mother Sara, a relationship to be discussed in chapter 14. Hull was horrified, then, when he called on Roosevelt in October 1933 to complain about Wallace's trespasses on his domain, only to find himself ordered to name Wallace an official US delegate to the upcoming Washington Banner of Peace Conference and to help him prepare for it. On October 17, Hull, swallowing his pride, drafted an address to the convention for Wallace to deliver in his stead. Hull's tepid language betrayed his lack of enthusiasm ("While there are in existence certain agencies for the protection of [artworks threatened by war], I am in entire sympathy with the objects for which the meeting you are now attending was called"), and in his accompanying note to Wallace, he registered

his continued skepticism about the pact. "I am not convinced that the practical measures which would be necessary for the carrying out of such a plan would be acceptable to all of the nations of the world," he told Wallace. But deferring to FDR's wishes, he conceded that "this is not a time for the United States even to seem to withhold its approval from such a Plan."[92]

Hull's hedging meant nothing to Wallace as he hosted the Washington Banner of Peace Convention, which opened on November 17 at the Mayflower Hotel and lasted through the following day. To all appearances, the gathering was a success, with Senator Robert Wagner of New York serving as honorary chairman and thirty-four countries besides the United States represented. The rhetoric was fulsome. Partisans cheered to hear Roerich's wish read aloud that "if the Red Cross protects physical health, then may the Banner of Peace preserve spiritual health." James Brown Scott of the Carnegie Endowment for International Peace predicted that the Roerich Pact would "set a universal standard for culture . . . and merge us all in a common humanity."[93] For two days, the Mayflower marinated in the juices of high-minded altruism.

All of this gratified Roerich as he readied himself to return from India to the United States, and more good news came in December 1933, from the Seventh Pan-American Conference, held in Montevideo, Uruguay. There, the Pan-American Union unanimously agreed that all member states should sign and ratify the Roerich Pact as soon as possible. Immediately afterward, Congressman Sol Bloom, assisted by Mikhail Taube in Paris, recommended Roerich for a Nobel Peace Prize—the second of the artist's four nominations. In early 1934, as Roerich and George made their way back to America, more endorsements poured in, and both the State Department and Britain's Foreign Office were inundated with inquiries from other governments about whether they intended to sign the pact.[94] As home to some of the world's most irreplaceable antiquities, Greece and Egypt seemed especially eager to make the pact reality.

Roadblocks emerged in the spring and summer. The rift dividing Roerich's New York circle and his supporters in France continued to widen. Among European states, official interest in the Banner of Peace was lower than attendance at the November conference in Washington had seemed to promise. (Jay Moffat of the State Department noted in his diary that most European governments had sent only minor officials to the conference and regarded its proceedings as "a good joke."[95]) Britain remained inflexibly hostile to Roerich and spoke against the pact at every opportunity. Nazi Germany viewed the Banner of Peace with contempt, and while Pope Pius XI's apparent sympathy for it caused the artist to hope for support from Italy, Mussolini's bellicosity trumped all. Even in France, where backing for Roerich was typically strong, the entire country was reeling from the apparent suicide (some say murder) in January 1934 of Alexandre Stavisky, a naturalized citizen

of Ukrainian Jewish descent and a known embezzler with ties to the leftist Radical Party. This "Stavisky Affair" triggered a government shakeup—including the fall of Prime Minister Camille Chautemps—and a wave of xenophobic, right-wing riots. In such a climate, anyone of Slavic extraction faced popular suspicion, and even had the French government been willing to face that risk, it was too distracted to devote attention to causes like the pact.

Whatever the cause, demurral on the part of Europe's powers dampened the willingness of smaller states to sign on with the Banner of Peace. In America, the pact's opponents seized upon this hesitation to undercut the progress Wallace had made with FDR and the Pan-American Union. The idealism behind the pact, and the high-flown language used to promote it, were easy to mock, and Wallace came in for an added bit of ridicule in 1934, thanks to an ill-timed printer's error. When Wallace published his political treatise *New Frontiers*, he showed pro-Roerich solidarity by adorning it with the three-orbed Banner of Peace emblem. The publisher, however, spoiled the effect by reproducing the symbol upside down, two orbs on top of one, causing jaded readers to think more of Mickey Mouse's ears than of the New Deal.[96] The State Department, perceiving that direct opposition to the *idea* of the pact would antagonize Roosevelt, wore Wallace down instead—like harpoon-ers exhausting a great whale—with legalis-tic points of order. The department would feel more comfortable about the pact, Hull's

undersecretaries told Wallace, if more European governments committed to it. Was it absolutely necessary, the department asked, to attach Roerich's name to the treaty? Did association with the artist not distract from the pact's higher purpose? (This was not a groundless concern. As a foreign national of unusual background and colorful con-victions, Roerich was a perfect target for unfriendly journalists at the best of times. Even James Brown Scott of the Carnegie Endowment, one of the pact's most vocal backers, quietly communicated his unhap-piness at linking the treaty so closely to a single personality.[97])

In 1934, Wallace hammered back against the naysayers in State. It was "en-tirely natural," he countered, for treaties to bear the names of their originators, and as-sociation with Roerich could only "enhance the value of the measure."[98] Wallace kept up this fight after Roerich's April departure for Asia, and the stress of it took a steady toll. His own staff had come to notice—and re-sent—the agitation caused him by contact with the Roerich circle. Jim LeCron, Wal-lace's aide, dreaded every communication from Frances Grant, whom he described as "hatchet-faced" and "unpleasant," and Wal-lace's secretary, Mary Huss, fumed whenev-er she saw a letter or took a call from "those people" in New York.[99]

Wallace's exertions failed to satisfy his ever-imperious masters. Nicholas continued to hector him while on his way to Japan, and Esther Lichtmann made note of Hele-na's "deep aggravation" in her diaries from

May 1934.[100] All the same, the secretary scored his first palpable success that summer. In late July, Franklin Roosevelt swung around decisively in favor of signing the Roerich Pact. Better yet, the United States would adopt it as part of a grand regional initiative: the nations of the Pan-American Union would collectively sign the pact as a gesture of hemispheric fellowship. Roosevelt made his intention official on August 10, investing Wallace the following day with the plenipotentiary power necessary to arrange for signing the Inter-American Convention for the Protection of Artistic and Scientific Institutions and Historic Monument.[101] The date of the actual event was set for April 15, 1935, allowing it to coincide with Pan-American Day.

This was not the global triumph the Roerichs had dreamed of, nor were they as grateful for it as Wallace might have wished. Still, it was the best that any of the activists or diplomats serving them had yet achieved. Unfortunately for all, by the time the treaty was signed, everything was changing at a cataclysmic rate for the Roerichs and those who had followed them. At the very moment of winning such a signal victory for his "Guru" and "Mother," Wallace would begin to repent of having done so.

CHAPTER 14

The Black Years, 1934–1936

A prince may be seen happy today and ruined tomorrow without having shown any change of disposition or character. The prince who relies entirely upon Fortune is lost when it changes . . . he whose actions do not accord with the times will not be successful.

—Niccolò Machiavelli, *The Prince*

In 1934, two Roerichs, father and son, set forth a second time to master the heart of Asia. Far to the south, the clan's matriarch, perched in her mountain aerie, summoned all the spiritual strength she believed herself to possess in hopes of blessing their journey.

More so than during their first Central Asian expedition, the Roerichs appeared to have all the necessary pieces in place: funding, highly placed political support, and potential allies on the ground. Was the Great Plan's fulfillment finally nigh? The family believed it was. As Roerich had recently insisted to Father George Spassky, an eminent Orthodox cleric, "so many omens surround us. Only the blind and the deaf remain oblivious." Failure to perceive these signs would lead to "a second sinking of Atlantis," but Roerich had faith that his efforts, aided by the good Father and all virtuous Russians, would guide humanity through apocalyptic trials to a holy "Land of Culture," graced by new churches as far as the eye could see.[1]

And yet this "coming age of fire," as Roerich described it to Father George, never came to pass. Indeed, only sixteen months after his departure from America, all his plans and prospects lay broken: his sources of patronage gone, his reputation on three continents ruined, and his millenarian dreams dashed. Not without reason would Helena describe 1935 as "a black year with seven eclipses."[2] To her follower Rihards Rudzītis, she likened her experience of these months to choking down a bottomless "chalice of poison."[3] Before autumn's end, Nicholas and George would return to India, dejected and in defeat.

Leaving New York on April 22, Nicholas and George crossed the country by train, heading for Seattle. There, the pair set sail for Yokohama, disembarking in early May and installing themselves in Tokyo's Imperial Hotel. Thus began the Department of Agriculture's botanical expedition to Central Asia (see Illustration 32), which was by now a matter of public knowledge. As *Time* reported, "Secretary of Agriculture Wallace has pushed his land reclamation program ahead another notch by organizing a party to search for grass hardy enough to grow in the drought-made deserts of the Midwest." "Grave, goat-bearded Roerich" was "to guide two experts from the US Bureau of Plant Industry through Central Asia to the rim of the Gobi Desert" and to "choose grasses and shrubs which can grow in the baking, shifting midlands of the United States."[4]

Roerich, of course, viewed this commission merely as a springboard for his own agenda and had no regard for the American scientists—Howard MacMillan and George Stephens—theoretically in his charge. He and George sprinted ahead and, during their half-month in Japan, saw exclusively to their own affairs. They toured shrines and temples. Roerich met with Japanese painters and gave a lecture at Tokyo's Buddhist College, while George perused the Tibetan book collection held by Otani University in Kyoto. In arranging travel to Japanese-occupied Manchuria, Roerich bypassed US diplomatic channels and made no provision for the colleagues trailing in his wake. Not

till near the end of his time in Japan did he take the elementary step of checking in with the US Embassy in Tokyo, which was expecting the arrival of Department of Agriculture personnel, but had not been told of Roerich's connection to the venture. Ambassador Joseph Grew was astounded to hear the artist claim not just membership in the expedition, but leadership of it, and even more surprised when Roerich produced letters from Henry Wallace to back him up. In the absence of State Department guidance, Grew remained noncommital, suggesting that Roerich use his own "personal connections" to organize passage to the mainland.[5] This was in line with the orders that came from Washington more than two weeks later, on June 11, from Secretary Hull himself. A flustered Hull confirmed that "it now appears Roerich is the leader of [the] research group sent out by the Department of Agriculture, which fact was not, repeat, not previously known to [the State] Department." Hull advised the embassy not to place too much trust in the Roerichs or render them any "unusual assistance."[6]

By the time Hull's wire reached Tokyo, Nicholas and George had left Japan for Manchuria, arriving in Harbin by May 30. Grew may have congratulated himself on getting Roerich out of his hair so easily, but would have been less pleased had he known what "personal connections" the artist exploited while in Tokyo. Roerich dealt so cavalierly with the US Embassy because his goal from the start had been to negotiate directly with Japanese officials, continuing

the earlier talks begun with Consul General Renzo Sawada in New York and Ambassador Hitoshi Saito in Washington. In May, Roerich met with the Japanese Ministry of Education and Culture, and with Teiji Tsubokami of the Japanese Foreign Office's Cultural Works Bureau. Roerich explained these as innocent parts of the Banner of Peace effort, but the same could hardly be said of his visit to the Ministry of War, where he conferred with the army minister himself, Senjuro Hayashi—an encounter captured in a May 23 photo in the paper *Asahi Shimbun*. Roerich praised the general, already notorious for his role in Japan's Manchuria takeover, as a "great leader" in the *Japan Advertiser*, and even his reception at the Cultural Works Bureau takes on a different complexion when one realizes that Tsubokami was deeply involved with Manchurian colonial administration.[7]

Without transcripts or minutes, scholars remain as much in the dark about Roerich's Tokyo proposals as about his discussions with Sawada and Saito in the United States. It is known that he outlined an itinerary—starting with Harbin and continuing to Hailar, capital of the Inner Mongolian province of Hsingan (Xing'an), which abutted Soviet Siberia, and then to the south—and secured an invitation to appear before Henry Pu-yi, the former emperor of China who now "governed" Manchuria on Japan's behalf.[8] As for larger schemes, it can be supposed that Roerich revealed as much to Hayashi and Tsubokami as he had to their counterparts in America: his

dream of an anti-Soviet coalition uniting Japanese forces with White Russian émigrés and Mongol-Tibetan Buddhists, with the Panchen Lama harnessing the last group's religious passions. If he learned anything from his experience with the Soviets, he kept his apocalyptic convictions to himself, but allowed his interlocutors to form the impression that he was somehow positioned to swing FDR's opinion in Japan's favor.

What were the Japanese to make of Roerich? Here they faced the same difficulty that had confronted Soviet officials in 1925 and 1926: however dubious it might seem, the artist's overture was too enticing to reject out of hand. Japan, eager to present itself as a religious liberator to Mongols living in the Chinese provinces bordering Manchuria, had long sought to ally with the Panchen along the lines suggested by Roerich, and anything that improved the country's standing in American eyes was to be welcomed. On the other hand, only a fool would take at face value someone so obviously fishy. Roerich might be acting on behalf of any number of hostile parties, and even if just a loose cannon, he could harm Japan's interests through clumsiness alone.

Best, then, to turn an outwardly friendly face to Roerich's plans and see where they led—although within limits and under supervision. The Japanese allowed Roerich to travel where he wished, and the Foreign Office cheerfully provided him with an interpreter, one Shikazo Kitagawa. However, the army denied Roerich's request to arm his expedition while in Manchurian territory,

and whether Roerich perceived it or not, the offer of Kitagawa's services had nothing to do with generosity and everything to do with monitoring the expedition. As a further sign of caution Roerich knew nothing of, the Foreign Office sent a representative to the US Embassy to check the validity of his letters from Wallace. Personal missives from cabinet-level officials were well and good, the Foreign Office noted, but hardly a substitute for real credentials.[9] The Japanese had their guard up but, for now, allowed Roerich to proceed.

So it was, at the end of May, that Nicholas and George crossed over to the state of Manchukuo, where Japan's Kwantung Army reigned supreme. Sailing to Korea, they then sped north through Mukden to their long-awaited destination of Harbin. Roerich later wrote that before leaving Tokyo, he had done everything necessary to ensure that "his" scientists, MacMillan and Stephens, could follow him expeditiously once they reached Japan. In fact, Roerich's haphazard diplomacy landed the botanists in a bureaucratic tangle that required extra effort from the US Embassy to iron out in June and July.

None of this was on Roerich's mind as his train rolled into the Harbin station on May 30. Greeting him despite bad weather and the early hour of 6:40 a.m. was a crowd of dozens, among them Roerich's brother Vladimir. The two had not laid eyes on each

other for seventeen years, the poignancy of which was not lost on Harbin's Russian-language papers. Among these were *Russian Word*, *Dawn*, and *Megaphone*, which hailed Roerich as "the pride of Russian scholarship and art," as well as the fascist daily *Our Path*, the *Harbin Times*, and *Rebirth of Asia*, the last two published by the Japanese.[10] Although his half year in Harbin would end badly, Roerich spent the spring and summer charmed by the city, which, with its Russian population of seventy thousand, resembled a miniature Petersburg, whisked by magic to the Chinese borderlands. It enlivened Roerich to walk the length of Bolshoi Prospect, the thoroughfare bisecting the Russian-dominated "New Town," and to stroll down China Street in the Wharf District, whose neoclassical buildings reminded Roerich of his childhood hometown.

He was stimulated further by the opportunity to mobilize supporters and allies. Earlier chapters have mentioned the Harbinites who, like Vladimir, had been loyal to Roerich's cause for over a decade. Among these were P. A. Chistyakov, Vladimir's longtime comrade-in-arms; the Latvian-born author and Theosophist Alfred Heidok; and Achair, pen name of the poet Alexei Gryzov, the coleader of the Harbin YMCA. Helped by this dedicated core, Roerich worked to broaden his appeal among Harbin's Russians. Some took more persuasion than others, and the cleavages dividing this community complicated Roerich's task. Even so, by summer's end, he had won

over the city's archbishop, Nestor, as well as Vsevolod Ivanov, a young writer and one of Roerich's earliest biographers; the law professor Georgii Gnis; Nikolai Nikiforov, the dean of the Harbin Law School; Alexander Shchelkov, the director of the Harbin Polytechnic Institute; and Yevgeny Kaufman, the editor of *Megaphone*.

What Roerich needed most, though, was tangible support from anti-Soviet military men. In Paris and other European centers of Russian emigration, Roerich had cultivated White veterans' groups, particularly the Russian All-Military Union (ROVS), which still dreamed of overthrowing the Soviet government. He now focused his persuasive efforts on ROVS's Far Eastern branch, offering a potent brew of nostalgia-soaked patriotism and messianic religiosity. In interviews and public talks, he described counterrevolution as nothing less than destiny. He invoked the name and image of Sergius, Russia's patron saint, and railed against Soviet godlessness, exhorting all honest Russians to rise up against the "hydra of atheism."

Such language, overwrought as it sounds, resonated with ROVS leaders, who, as one historian notes, "regard[ed] their organization as a sort of religious-military order."[11] It helped that Roerich received endorsement from Archbishop Nestor and that he promised direct action, in the form of strategic coordination between White Russians and the Japanese. In 1934, Roerich solicited position papers from key members of the anti-Soviet emigration and published

them in a volume called *Siberian Collection*. In its foreword, he wrote the following:

Fifteen years have passed since our country was torn from the rest of the world by the bloody hands of thieves. Russia, once possessed of enormous riches, once a vast granary, has been reduced to hopeless poverty and terrible famine. Now, the Bolsheviks, arrogantly waging a policy of aggression against their neighbors, are trying to set Asia ablaze with the flame of communism. Realizing that Japan has the means to interfere with such plans, the Bolsheviks, aided by the press and diplomatic intrigue, are attempting to persuade the world that Japan's actions—intended exclusively to defend Asia from communism—are somehow the first steps in the usurpation of the Pacific coast.

All along these Pacific expanses, an unseen struggle between the forces of destruction and the forces of order is unfolding.[12]

An immediate response was called for, and Roerich's solution mirrored that of General Nikolai Golovin, a geopolitical theorist deeply respected among White commanders. George, as a student in Paris, had attended Golovin's military-science lectures, and the general himself contributed an essay to *Siberian Collection*—"Contemporary Strategic Circumstances in the Far East"—recapping his long-held conviction that Russians faced a choice between

submitting to a "Red Eurasia" or allying with a "Yellow Union" of China, India, and Japan. To Golovin's logic, Roerich added an extra refinement: an affirmation that the United States would join such an alliance. As he continued in his foreword, "after communism, the common enemy of the entire civilized world, has been annihilated, a firm and friendly collaboration among the three great nations of Japan, America, and Russia can be established on the shores of the Pacific."[13]

For the moment, such talk found a ready audience among White commanders in Asia. Grigori Verzhbitsky, who headed the Harbin branch of ROVS, admired Roerich, as did Dmitri Horvath and Mikhail Diterikhs, the chairs of ROVS's Peking and Shanghai chapters, respectively. Not all of Harbin's Russians embraced Roerich, however. Many of those employed by the Chinese Eastern Railway were apolitical. From the left, the intellectual Nikolai Ustryalov, a former White who came to believe in the 1920s that only a "National Bolshevik" reconciliation of Russian exiles with the Soviet regime offered hope for the future, listened with aversion to Roerich's anti-Red rhetoric. From the other end of the spectrum, Harbin's Russian Fascist Party, led by Konstantin Rodzaevsky, scorned the artist even more. Either way, Roerich lived in constant fear that embarrassing aspects of his recent past—his occultism, so offensive to Orthodox sensibilities, and his pro-Soviet sympathies from the 1920s—might at any time come to light.[14] Nothing harmful had yet

emerged, but Roerich had émigré enemies aplenty in New York and Paris, and there was no guessing when or whether the wrong rumor might make its way to Asia. For now, opposition remained muted, and Harbin's perception of Roerich trended favorably.

Also at this time, Roerich took what he considered a concrete step toward Japanese–White Russian–US entente. He and George traveled south to Hsinking, Manchukuo's capital, and, on June 21, visited with the nominal ruler, Henry Pu-yi. In a ceremony reported on by papers ranging from the *Manchurian Daily Press* to the *New York Times*, Roerich presented the puppet emperor with the Order of the Banner of Peace (First Class), declared him an honorary Friend of the Roerich Museum, and discoursed with him about art and the international peace movement.

This, Roerich's supporters insisted, accorded perfectly with the artist's quest for global amity. In official quarters, though, his interchange with Pu-yi caused puzzlement. Japanese authorities, both in Tokyo and Manchuria, continued to wonder if he was genuinely speaking for US interests and signaling an American willingness to pursue warmer relations with Japan. The reaction from US diplomats, detailed below, proved nothing short of volcanic.

Whatever headway Nicholas and George made with their fellow Russians in Harbin, they were spectacularly mishandling

their American responsibilities. Roerich's meeting with Pu-yi, implying as it did that an enterprise associated with the Roosevelt administration looked upon the Manchukuo regime with approval, elicited howls of frustration from the US Embassy in Tokyo and the State Department's Division of Far Eastern Affairs. Although the United States maintained consulates in Manchuria, it did not recognize the Manchukuo government or Pu-yi's legitimacy as "emperor," and as the Far Eastern Division griped to Secretary Hull on July 5, Roerich's experiment in personal diplomacy had "place[d] the Department . . . in an embarrassing if not ludicrous position."[15]

This was to say nothing of the misfortunes suffered by the Department of Agriculture botanists, MacMillan and Stephens, who had been following Roerich since his hasty departure in April. The two scientists arrived in Yokohama on June 1 and, having had weeks to nurse their resentments, exploded upon encountering the mess left by the artist in Japan. Disregarding protocol, Roerich instructed MacMillan and Stephens to bypass the US Embassy and the Japanese Foreign Office and proceed directly from Tokyo to Harbin. He also ordered them to collect and convey the weapons the Japanese had refused to let him bring to Manchuria. But contrary to Roerich's blithe assurance that he had obtained all the permissions needed for MacMillan and Stephens to move forward, the botanists found themselves smothered in a welter of red tape. Leaving aside the formalities

Roerich had not attended to, Japanese uncertainty about the artist caused Tokyo to place MacMillan and Stephens under strict scrutiny. It took a month and a half, and much effort on the part of the US consul in Harbin, to clear up the confusion Roerich had caused. As MacMillan told Knowles Ryerson at the Department of Agriculture, "had I [had] no connection with the Roerich name, I would have had no trouble at any point, and would have been in the field long ago. So down to the present moment I have yet to discover the most minute contribution which [the Roerichs] have made to the expedition, except to hold us back for the better part of six weeks . . . and put us and the government to considerable expense and irritation."[16] All this time, the growing season was slipping by, leaving MacMillan and Stephens at risk of falling a year behind in their research. Neither was their mood improved by the deluge of officious communications sent by George, urging them to hurry.

The pair finally reached Harbin in late July. Here, more indignities awaited. The expedition plan called for MacMillan, Stephens, and the Roerichs to travel next to Hailar, several hundred miles to the northwest, before the end of summer. Roerich, however, despite the need to move quickly, refused for almost two weeks to see the Americans, delegating all conversations with them to George. In fact, he had hired his own botanists—Taras Gordeyev and Anatoly Kostin—from among the Russian exiles living in Harbin, and for protection,

he assembled a small squad of Cossacks and White Army veterans under the command of Colonel Viktor Gribanovsky. Accompanying this party would be Gordeyev's wife and son, as well as the translator Kitagawa. Only on August 1—the actual day of departure—did Roerich, like a potentate receiving petitioners, deign to meet with MacMillan and Stephens. As MacMillan wrote the night before, "it looks as though I will finally see Papa Roerich tomorrow, and see what yarns he has to tell, after the lies that have gone before. Papa Roerich rates a Cossack guard at his door at all hours, armed. It makes a great show. What tripe!"[17]

Both halves of the expedition set out for Hailar on the same train, but in different cars. Nor did they coordinate efforts over the next month. The "pearl of the grasslands," Hailar straddled major routes linking northern China with southern Siberia and the eastern tip of Mongolia proper. It afforded ready access to one of China's largest lakes, the Dalai Nor (Hulun-nur), and the Argun River, which divides Russia from China. For MacMillan and Stephens, the district, so similar to North America's prairie in terms of climate and terrain, presented an excellent chance to find usefully transplantable seeds. The Roerichs, as we know, were more alive to the geopolitical possibilities offered by the region.

The expedition divided right away, as each group checked in separately with the Japanese authorities. To the district commander, named Saito, Nicholas and George submitted a plan confining MacMillan and Stephens to specimen gathering within a limited radius, assigning themselves a larger arc to Hailar's west and south. Hesitant at first, Saito signed off on this proposal, but his reaction, especially after conferring with the botanists, betrays the skepticism that now darkened Japan's view of Roerich. MacMillan described his talks with Saito to the consul general in Tokyo and related how the commander, mystified by the expedition's odd divisions in purpose and character, "wanted to know what I had to say about [this disparity] . . . and what action I wished to take."[18] MacMillan deduced that Saito and his fellows felt "the Professor was claiming more than he was entitled to do, and they doubted the genuine character of what he had to show." Saito also regarded Roerich's credentials with "amusement." On the other hand, the interpreter Kitagawa interceded on the artist's behalf, mentioning the many powerful figures who had given him their blessing in Tokyo. MacMillan guessed that Kitagawa was no mere translator, but someone acting in a grander capacity with Japan's Foreign Office: "There is some mystery about [him] which I cannot clear up." All this was of little consequence to MacMillan, who, as he told Saito, "merely wished to be left alone to do [my] work. . . . Also, the Roerichs were friends of Secretary [Wallace], and I had no wish to interfere with their program in any way. As far as I was concerned, they could go on."

And so it seemed to happen, at least at first. MacMillan and Stephens remained in the area to work and were glad to see

the Roerichs depart. "They had a big automobile for the principal members of the party," MacMillan reported to Ryerson, "and a truck for the equipment and musical comedy army. All were in Cossack uniform, which seems about as bad taste as anything under the circumstances."[19] His satisfaction, however, was tempered: "I know there are going to be loud reports about lack of cooperation. I anticipate any amount of trouble after I get back over this affair, and of course they have the inside track in the matter. If I get fired it will be nothing more than I expect."[20] Indeed, the State Department, fully sympathetic, tried to shield MacMillan from the consequences of his frankness, opting not to let Henry Wallace see what he had written. "Such action on our part would, I fear, create some embarrassment for Mr. MacMillan within the Department of Agriculture," warned Arthur Garrels, the consul general in Tokyo, as he forwarded the botanist's messages to Washington.[21] His well-meaning precautions did little good in the end.

As for the Roerichs, they spent the next month in Manchuria's Barga district. They stopped for some time at Ganjur Monastery, roughly a hundred miles southwest of Hailar. More directly to the west—close to the juncture of Manchuria, Mongolia, and Siberia—they surveyed the arid flatlands separating the lakes of Dalai Nor and Buir-nur. To the south, they meandered through the piedmont zone where Manchuria's steppes rise up to the Greater Khingan (Hinggan) Mountains, which run diagonally from Inner Mongolia to the Amur. For two weeks they ascended, camping on a plateau near Barim, on the range's eastern slope. The party gathered numerous specimens, seemingly discharging its botanical duties, although with a lopsided emphasis on flora Roerich believed to have healing properties, rather than the drought-resistant strains requested by the department employing him. The detour to Ganjur was explained as a desire on George's part to transcribe valuable Tibetan manuscripts. But the real goal here, as with the rest of these travels, was to advance the Great Plan by seeking news of the Panchen Lama and gauging levels of potential support from Buddhist clergy. The Roerichs' records from these weeks remain coy on this subject, but it can be assumed that they made little progress.

As August gave way to September, the Roerichs returned to Hailar. By now, Japanese military patrols were openly shadowing their cavalcade. Military and diplomatic reports indicate that, as late as September, Japan's official posture toward the Roerichs was not yet hostile but becoming more mistrustful.[22] Also in September came the decisive showdown between the Roerichs and the Department of Agriculture botanists. By mid-month, a large enough pile of State Department memos, angry screeds from both sides about expense reports and late paychecks, and conflicting reports of where the expedition was and what it was doing had

landed on Wallace's desk that he demanded of the Roerichs a full accounting. (The feud between State and Agriculture prompted a simultaneous inquiry from Roosevelt himself.[23]) Roerich accused MacMillan and Stephens of insubordination, with George adding coolly that "it seems the two men have not a clear picture of the organization of the expedition."[24] The axe fell hard. On September 20, still reposing his full trust in Roerich, Wallace detached MacMillan and Stephens from the expedition and ordered them to return to Washington. As for Ryerson, their superior at the Bureau of Plant Industry, Wallace demoted him to the Division of Subtropical Horticulture, where he languished for several years before accepting a post at the University of California at Davis. In September, Wallace officially apologized to Roerich for MacMillan's and Stephens's conduct and assured him, "You have my complete confidence and approval for all your actions in regard to the expedition."[25] To assist the Roerichs with day-to-day matters, he appointed Earl Bressman, one of the department's scientific advisers.

September, as well as October and November, saw Nicholas and George back in Harbin. Though they had triumphed over MacMillan and Stephens, they had only a short time to savor their victory before discovering how Pyrrhic it was. With his first reconnoiter complete, Roerich switched back to consolidating support among Harbin's White Russians. He and George lectured at the YMCA, the university's law school, the Dostoevsky Gymnasium, the "Russia House" orphanage, and the Institute of Saint Vladimir. Donating a thousand dollars for the purpose, they arranged with General Verzhbitsky to purchase the newspaper *Russian Word* as a propaganda organ for the Harbin chapter of ROVS. They said little about science or discovery. Instead, George linked the White cause in Asia to the past glories of Cossack warrior hosts, and Nicholas doubled down on the anti-Soviet pietism he had spouted earlier that year. His talk of sanctified struggle crescendoed in November. On the eighth, *Russian Word* printed a long Roerich essay that took its title, "Let God Arise, Let His Enemies Be Scattered," from Psalm 68. Hurling prose thunder, the artist declared: "Every time the threat of godlessness has reared its poisonous head, the ancient truth—that Light will always conquer Darkness—has been confirmed. Under the glorious radiance of the sun, no one may slumber, and mankind will find itself arising, emboldened to accomplish new works, to turn itself to the task of creation. And thus will the enemies of God be scattered." Expatiating further about the coming struggle, he wrote, "The Weapons of Light, given to us according to the Apostle's command, will be forged in the Smithy of Cooperation. Those who go forward in the name of God must not let themselves be dispersed. The radiant host may put its armor to the test, but the movement dedicated to Good and Construction cannot perish. In the appointed hour, which soon approaches, the trumpets of war will sound as the bright command is given: 'Let God arise,

and let his enemies be scattered!'"[26] Such language had the desired effect. Already in September, General Verzhbitsky, Archbishop Nestor, and other leading Whites had formed a Russian Committee for the Roerich Pact, and more tangible support appears to have been in the offing.

This apparent upswing made the sudden blow that followed all the more shattering. Cultivating ROVS had automatically gained Roerich political enemies in Harbin: the city's Russian Fascists, bristle-mustached and brownshirted in emulation of their Nazi prototypes, loathed ROVS and anyone associated with it. (Individually, certain ROVS officers sympathized with fascist principles, but the group rejected institutional fascism.) Unfortunately for Roerich, the Fascists were the Russians Japan preferred to work with in Manchuria. Not only were they more ideologically in tune, they were more pliant, and as the ROVS general Pavel Kusonsky snidely remarked, "the Japanese value only those who lick their arses."[27] So when the Fascists turned on Roerich, as they did in November, it meant that the Japanese were turning on him too.

What brought Japan to this decision? By the fall, Japanese intelligence had acquired a large batch of Roerich's papers from the mid-1920s—including many letters to Vladimir and his Harbin cadre—laying bare his Theosophical avidities and his earlier pro-Soviet sentiments. How the Japanese got these materials remains an open question. Some propose that Japanese operatives had secretly photographed them back

in 1925, when Roerich sailed on the *Katori Maru* from Marseilles to Yokohama.[28] Such a scenario is possible but fails to explain why the Japanese would so closely surveil a random passenger they could not reasonably have seen as a threat at that early date. It is likelier that *after* Roerich's arrival in Harbin, someone in the city's White community gained access to these papers and handed them to the Japanese—or that, having become sufficiently suspicious of Roerich's motives, Japanese intelligence took whatever clandestine actions were necessary to pilfer his belongings.

However this happened, the Japanese lost whatever faith in Roerich they might still have had. Assuming him to be a Soviet spy, they sabotaged his Manchurian prospects by releasing his papers to all the media outlets under their influence. Immediately after "Let God Arise" appeared in *Russian Word*, Harbin's Fascist- and Japanese-controlled newspapers, using the artist's decade-old words to incriminate him, launched a rolling barrage of vicious exposés. Roerich was a communist, proclaimed *Our Path*, the *Harbin Times*, and *Rebirth of Asia*. He was no proper Christian, but a Freemason, a Theosophist, a Rosicrucian—in short, an enemy of Christ. His blustery talk of God's will was rank hypocrisy.[29]

This anti-Roerich firestorm burned bright the rest of the winter, as Harbin's Russians compared these revelations with rumors from Paris that they had ignored or been unaware of over the past two or three years. The resulting controversy, described

by one author as "a severe Orthodox in-
quisition," obliterated Roerich's hopes in
Manchuria.[30] Despite his protestations and
excuses, his following there shrank over-
night to a tiny, disillusioned core. Even
Vladimir proved reluctant to work with his
older brother. Plans called for Vladimir to
join Helena in India, but as the dust from
this latest disgrace settled, he opted to stay
in Harbin.

The two siblings would never see each
other again, for Nicholas's time of departure
had come. Sadly, but with his characteristic
adaptability, the artist now set his sights
on Mongolia, where he and George had
planned to travel in any case, and whose
Buddhist population he still hoped to win
to his cause. "Just because the cooperative
proved unfeasible in one place," he wrote in
December, "does not mean the same idea
cannot be successfully applied in another
place."[31] On November 24, he and George
rolled out of Harbin, bound for Peking via
Dairen and Tientsin. Accompanying them
was a ragtag quartet of White Russians, a
far cry from the glorious procession Ro-
erich had envisioned. All the same, if the
new year went as he hoped, he and George
would recover from their recent stumble and
regain full momentum.

Failure in Manchuria was not the only trou-
ble weighing Roerich down as he trudged
on to Tientsin. Bad news had been arriving
from New York, Washington, and Paris.

One sore spot involved Henry Wallace's
inability to gain traction for the Banner
of Peace beyond acceptance by the United
States and its Latin American neighbors.
When other governments inquired about
the seriousness of America's commitment to
the pact, the State Department took every
opportunity to dismiss it as a vanity project.
Notes from Italy's and Germany's embassies
were answered with statements to the effect
that Roerich was "a mere crank," indulged
because of his friendship with an associate
of the president's, "whose communications
need not be taken seriously."[32] Similar re-
plies were directed under the table to other
countries.

Also, as the date of its adoption neared,
the pact attracted unwelcome attention from
Roosevelt's political foes. The treaty's uto-
pian airiness, added to Roerich's colorful
peculiarities, made it a ripe target for anti–
New Deal mockery. A pungent example
can be found in this satirical column, which
takes the form of a dialogue between the
author and a character called "The Artist":

"But to get back to that Roerich
guy," said the Artist, "that art busi-
ness gives me the laugh. Think of it.
When Goering's air fleet goes out to
bomb Paris on a night raid against the
frontier, special instructions, I guess,
will be handed to the airmen to avoid
hitting the Louvre. 'Listen, boys,' the
Premier will say, 'blow the hell out of
the Frenchies, but watch out for that
Leonardo on the third floor!'"

"How about London?" I said.

"London?" said the Artist. "The dirigible commanders will get their orders just like the aviators—'Bomb Piccadilly, but please watch out for that Whistler water-color.' And won't little Nicholas in his screwy museum on Riverside Drive be pleased when telegrams come through from the front: 'Rome bombarded. Deaths total twenty thousand. Property damage fifty million dollars. But Fra Angelico's *Madonna and Child* uninjured.'"

"Yes," the Artist continued, snorting his contempt of the proposal, "a great little idea of Nicholas's, this art pact. While millions of men and women and children are dying, Roerich will be rubbing his hands in smug glee, because some Pope's monument or the basilica of a church is not harmed. Let them die, as long as an etching is safe in the war of the worlds!"

"No," he continued, "it isn't Roerich alone that's got me hopped up. He's only one screwy mystic buried in a screwy museum full of weird landscapes. It's the smug attitude of thousands of so-called little art do-gooders like him that does."[33]

While one can fairly call the Roerich Pact naïve, it takes slippery logic indeed to assert that protecting art during war presupposes a lack of concern for war's human victims, or to heap this sort of criticism on idealists, however hapless, rather than on the aggressors who properly deserve it. But while this piece was unusually mean-spirited, other such critiques found their way into print during these months. With the new year yet to arrive, the treaty's signing was a prize already tarnished.

Flagging interest in the pact further corroded Roerich's Paris network, whose relations with his New York circle had been worsening for months. As the realization sank in that France, Germany, and other heavyweight powers had little interest in the pact—or, like Britain, opposed it—many of the Europeans laboring on its behalf gave up on it, and on Roerich himself. Georges Chklaver remained loyal (for now), but Camille Tulpinck, who had worked for Roerich in Bruges, drifted away. Baron von Taube, appalled by the November tsunami of negative publicity and incensed that Roerich had ignored his advice not to meddle in White émigré politics, withdrew from the artist's affairs by the new year and remained out of touch until late 1935, when he testily enumerated his reasons for severing relations. Madame de Vaux-Phalipau resigned her positions with the French Roerich Association and the European Center of the Roerich Museum.[34] She explained this to Helena as a sad by-product of the French government's shifting priorities, although she added a few sharp words about Frances Grant, Nettie Horch, and the "untenability" of the French section's complete dependence on the Americans for money. In a bit of side correspondence, Madame de Vaux confided to von Taube that the Russian colony's

mounting distrust of Roerich had troubled her, and that she had come to suspect Roerich of exploiting her group for his own glorification.

The worst cancer of all was metastasizing in Manhattan, where financial worries, diminished confidence in the Roerichs' omniscience, and personal hatred created an intolerable toxicity. Though she spent most of 1934 and the first months of 1935 in India with Helena, Esther Lichtmann maintained her alliance with the Horches against her sister-in-law Sina, who received only the weakest of support from her exhausted and melancholic husband, Maurice. Frances Grant avoided isolation by partnering with Sina. Competition for influence over Henry Wallace grew fiercer than ever, while Wallace himself, increasingly skittish over the winter, infected the New York group with his nervous energy.

An ominous sign of things to come involved Louis Horch's refinancing of the Master Institute in December 1934. At the time, everyone in the circle welcomed this measure, which fended off the institute's most dissatisfied investors. Secretly, though, Horch carried out a simultaneous reincorporation of the institute and the businesses connected with it. By February 1935, control would rest wholly in his hands and those of Nettie, Esther, and other chosen favorites. Excluded were Sina, Maurice, and Frances—and all four Roerichs. Hedging his bets, Louis revealed nothing of this.

Still, he had not yet jumped ship. Indeed, for several months, he joined with Helena in an audacious effort to involve Franklin Roosevelt directly in the Roerichs' dealings. Between October 1934 and the spring of 1935, Helena used Horch to deliver a series of letters to FDR that produced no tangible results but furnish the material for a most unusual chapter in the history of US presidential correspondence.

How did this strange interaction—known to scholars for decades, but poorly understood—come about? The answer lies with Helena's growing impatience at being sidelined in the mountains while her husband and son adventured in China and underlings like Horch carried out the group's most vital practicalities. Was she not the circle's spiritual mainspring, the bride of Morya and the conduit through which he made his will known? She had also lost faith in Wallace, with his feckless dithering. Encouraged by Esther, she elected to open her own channel to the source of political power. And so her letters to FDR began.

The idea that she might be heard was not in itself preposterous. FDR supported Roerich's treaty, Eleanor Roosevelt had spoken in favor of the artist's causes, and Franklin's mother, Sara, who indulged a vague "enthusiasm for Eastern art and mysticism," had been in occasional contact with Roerich's associates since mid-1933.[35] It was the content of Helena's missives that proved so extraordinary. She sent at least seven of these to Roosevelt, and they remain housed in FDR's Hyde Park presidential library.[36] Her first, composed on October 10, 1934, announced that "at the austere hour when

the entire world stands at the threshold of reconstruction and the fate of many countries is being weighed on the Cosmic Scales, I am writing to you from the Himalayan Heights." She offered "the Highest Help," from a source that, "since time immemorial, [has] observ[ed] and direct[ed] the march of the world's events." George Washington had heeded this "Himalayan Community" to his benefit, while others, including Marie Antoinette, had ignored it at their peril. "The map of the World is already outlined," Helena informed FDR, "and it is offered to You to occupy the worthiest place in the forming New Epoch. . . . The destiny of the Country is in Your hands."

No written response to Helena's letters has ever come to light. This is hardly a surprise, considering the unlikelihood that any politician as canny as FDR would commit words to paper in answer to such communications. Yet most authors on the subject have concluded that he somehow replied, based on the tone of Helena's second through fifth letters. These clearly form part of an ongoing conversation, and unless Helena believed herself to be receiving psychic transmissions from the president, he must have been in touch one way or another. On the other hand, any physical mail would surely have surfaced by now, unless destroyed by the Roerichs, who, as the example of Wallace's "guru" letters shows, would have had every incentive to keep and, if need be, publicize anything written by Roosevelt. Moreover, many of those who suggest that FDR wrote back have done so with an unaccountable

lack of curiosity about what it would mean for the president to have let himself be drawn into such a discourse. A Roosevelt who sent anything to Helena but the most perfunctory of messages would be difficult for historians to recognize: less politically savvy than generally thought, more personally susceptible to new-age hyperbolisms, or both.[37]

As it happens, previously underexamined documents at Hyde Park and the Amherst Center for Russian Culture explain how Helena and FDR exchanged words, and how Helena came to think of herself as parleying directly with the president when there were more filters between them than she understood. In a nutshell, Louis Horch hand-delivered Helena's letters to Roosevelt; after March 1935, he was joined in this by Esther Lichtmann, freshly returned from India. FDR read Helena's words in the messengers' presence, mainly in silence, but occasionally commenting or asking questions. Louis recorded his impressions of these meetings and relayed them to Helena, and because he described FDR as accepting Helena's pronouncements more eagerly than he did in truth, she labored under an inflated sense of how well her "conversations" with the president were going.

Horch first met with Roosevelt on November 7, 1934, calling at the president's Hyde Park residence in the late afternoon.[38] With him he had Helena's letter of October 10 and a copy of her recently completed *On Eastern Crossroads*. While one might suppose that he gained access to Roosevelt

through Henry Wallace, Helena had expressly forbidden him to involve Wallace in any way with her overture to the president. (To conceal this operation from the rest of the inner circle, Horch, Esther, and Helena invented a new code name—"Stephen"—to refer to FDR.) Horch approached through Roosevelt's mother, Sara, whom he had been cultivating for the past year and a half. It was Sara who ushered Horch into FDR's library and provided tea, after which, left to themselves, the two men made small talk about the Roerich Pact and the Democratic Party's success in the previous day's midterm elections. "I worried intensely," Horch wrote, "because I knew my time was so limited," and "knowing of [the president's] weakness of going off on subjects, I had to take the bold stroke of bringing him back to the subject." Interrupting as Roosevelt droned on about a Brooklyn newspaper editorial, Horch whipped out Helena's letter, informing him that it came from "a most remarkable woman of Fiery Personality" who could link him with "a Community of Great Sages in the Himalayas" who had helped world leaders over the centuries and were now "stretching their hands out to help" the White House. Reading the letter through, Roosevelt called it "tremendously interesting"—as well he might!—and confirmed his willingness to hear more from Helena. Horch could reach him through his private secretary, but if he insisted on delivering letters in person, he should be prepared for delays. Horch urged the president to conceal his visit from Henry Wallace, then

took his leave. In his summary to Helena, Horch assured her that "he accepts the help offered. . . . I felt sure that he understood that you are the closest link to the Great Source."

Helena thus felt free to dispense advice on topics ranging from high finance and foreign policy to Asian folk medicine (she had Horch give Roosevelt a vial of the same deer musk she took for therapeutic purposes) and the spiritual destiny of nations. In November, she told FDR how happy she was "that Your great heart has so beautifully accepted the Message and Your light-bearing mind was free from prejudice, this horrible contagion which extinguishes in us the divine and creative fire of faith . . . Your open mind will help me to unfold before You the entire Plan of the New Construction, in which You and Your Country are destined to play such a great part."[39] This "new construction" required the strategic marginalization of England ("the power beyond the ocean"), the promotion of White Russian causes in Siberia, and the annexation of South America by the United States ("one need not hesitate because of the existing Pan-American Union, for in its present state it represents a skeleton without a soul").[40] "Upon the mighty foundation of the courage of Your fiery heart," she wrote in December, "shall be built the Greatest of Epochs."[41] In return, Horch sprinkled his narratives to Helena with encouraging responses supposedly made by Roosevelt—"I am expecting [this communication], I am not surprised and I know of it," or "Yes,

after all Asia is the oldest source," or even "Truly the contents are so in accord with my thoughts and ideas that I could almost state I wrote this myself."[42]

Simply as documents, there is no doubting the authenticity of the notes Horch took for himself or the reports he sent to Helena: the log of visitors kept at Hyde Park shows that he met with FDR on the dates indicated, and the prose style is consistent with other examples of his writing. At issue, though, is the accuracy with which he characterized FDR's reactions, and two things appear to have clouded his perception. First, he felt a feverish desire to please Helena at all costs. Second, Horch, like many others, found Roosevelt exceptionally hard to read. In December, he admitted to Helena that the president's "apparent calmness and smile give no true indication of his inner reaction."[43] To Esther, he unburdened himself more openly, confessing his inability to figure out what Roosevelt really thought of Helena's letters: "I repeat, he smiles at everything and it is not too easy to penetrate beyond this charming smile!!! His real feelings the L[ord] knows.—I hope someday to receive more than 8 or 10 minutes, the time goes quicker than a Moving Picture and it [is] necessary to bring in so much in such a short time."[44] Given this, it seems best to regard all but the most anodyne of the remarks attributed by Horch to Roosevelt as exaggerations or inventions inserted to keep Helena happy.

It remains to ask what Roosevelt made of Helena's advice and why he continued to meet with Horch. FDR's penchant for informal consultations with clandestine envoys is well documented, as is his interest in Tibetan exotica, and there is nothing to say he did not find the whole business amusing. His chief motivation, though, was almost certainly to keep tabs on Henry Wallace, and as quietly as possible. It was one thing to back Wallace's maverick ways against the Washington establishment, as he had done with the Roerich Pact. But if one of his cabinet members was up to unauthorized mischief in a volatile part of the world, it behooved him to find out more about it, hopefully without attracting attention. (And he surely must have wished to know why Wallace's confederates were sneaking to him behind the secretary's back.) However charmed by him Louis and Esther were, Roosevelt seems to have treated his sessions with them like intelligence briefings, and to his edification, not theirs.

Nor to Helena's. Although there is something tragically grand about the hubris that convinced her she could so easily influence the great and powerful, her outreach to Roosevelt was born of desperation and led nowhere. It elevated Louis's and Esther's sense of autonomy and self-importance, leading within months to their open rebellion. It placed Helena and Nicholas at cross-purposes in their choice of political patrons, and, predictably enough, it roused suspicions among everyone whose support the couple needed. It was a stratagem doomed from the outset, and soon thrown into disarray.

In November and December 1934, with Helena's epistolary gambit just beginning, Nicholas and George moved south from Harbin to the port of Dairen (Dalian), then across the Bohai Sea to Tientsin (Tianjin). Here, where the Fifteenth US Infantry Regiment protected the city's American concession, they passed much of December.

Flourishing the carte blanche Wallace had given him after firing MacMillan and Stephens, Roerich called upon the American troops in Tientsin, and also the US Consulate there, making many demands. He submitted requests for back pay, which seemed reasonable enough, but some of his expense reports included items that struck the consulate as petty or only tangentially related to his expedition work—including a housecoat and a rolling pin. Roerich wanted to ship to America the specimens he and George had collected near Hailar, but the consulate suggested that he use the better-equipped embassy in Peking. Most controversially, Nicholas and George asked the Fifteenth Infantry to arm their expedition at government expense. The unit's commander hesitated, partly for financial reasons, but mostly because he thought it odd to supply weapons to an outfit that, while nominally American, included not a single US citizen. Although this matter was not cleared up until after Roerich had left Tientsin for Peking, Henry Wallace intervened to ensure that the artist's requisitions were approved. This included a personal plea to

the secretary of war himself, who ordered the infantry to release six rifles, four pistols, and ammunition, for a total cost of $340.55, to the Roerichs.[45]

In Tientsin and Peking, which the group reached in January, Roerich spent as much time on publicity and politics as on practical preparations. He gave interviews to the *North China Star* and the *Peiping Chronicle*, and delivered so many speeches that he wore his throat raw.[46] But to the confusion of the American officials whose help he sought, he talked mainly about the Banner of Peace, not the expedition's scientific work, and if he did speak of botany, he went on about his plants' supposed curative properties, not their capacity to resist drought. (George, to his credit, tried to steer these conversations back to the expedition's official objectives). Even when Roerich attended to his appointed tasks, the results went askew. His attempts to mail plant samples back to the States caused consternation on both sides of the Pacific. In Washington, the specimens sent back thus far had been judged unsuitable by Department of Agriculture scientists ("practically nothing has come out of this material which is worth anything"), while in China, US officials balked at transporting herbariums and seed packets via diplomatic pouch.[47] Also, when it came to relieving drought conditions, Roerich appeared to care more about Asia than America, and the one substantive comment he made on the topic was about the Gobi, not the Dust Bowl. This came in the form of a 1935 treatise called "The Desert Shall

Bloom Again," which restated theories about the Gobi that had excited Roerich in the mid-1920s: namely, that it had been unimaginably lush in the distant past and, if properly tended, could be restored to its former fruitfulness.[48] FDR, who received an early draft of the essay from Wallace, reportedly felt that it deserved to be published in a major US outlet. He asked Wallace to make sure he and Roerich had a chance to discuss it in person once the artist returned.[49]

Roerich tarried in Peking from January 1935 through the first half of March. There, he sought to mend fences with ROVS generals and other White Russians scandalized by the recent revelations about him, but nothing could be salvaged from the wreckage of his Harbin plans. More congenial was the time he and George spent with fellow Asianists and explorers. His comrade Sven Hedin was in Peking, and though their friendship would cool before long, due to the Swede's growing affinity for Nazi politics, they had much to talk about during these weeks. Roerich met with Alexander von Staël-Holstein, a linguist who had once taught Sanskrit at Saint Petersburg University and now directed the Sino-Indian Institute at Peking's Yenching University, and he acquainted himself with the American China expert Owen Lattimore, whom he would soon meet again in the field. Also during these weeks, Roerich may have spoken with surprising frankness about his religiopolitical goals with a member of the Soviet bureaucracy: the Sinologist Boris Pankratov, then an interpreter at the USSR's

embassy in Peking. As described in chapter 11, Pankratov, who trained many of Russia's Asian-studies specialists, enjoyed telling students how he had met Roerich in Peking and heard from him how he hoped to win acceptance in Tibet as the King of Shambhala. The difficulty with Pankratov's story is that he spoke of it as having taken place in 1928, a year Roerich is not thought to have been in Peking. The most likely explanation is a lapse of memory on Pankratov's part; either he misremembered the person he met in 1928—perhaps Roerich's brother Vladimir or one of the artist's companions, such as Colonel Kordashevsky—or he mistook the encounter's date, which could well have been 1935 (although this fails to explain why Roerich, anti-Soviet at the time, would confide so much to a known employee of the Stalinist regime). In all his encounters, Roerich would have been anxious to learn more about the political lay of the land in and around Mongolia. Any news of the Panchen Lama would have been a special priority.

In mid-March, Nicholas and George left Peking and headed to the hinterlands once again. Accompanying them was a contingent of Buryat and Mongol porters and guards, as well as Colonel Gribanovsky, who had traveled with the Roerichs to Hailar the previous summer, and three other White Russians. According to a report filed by Walter Adams, the US consul general in Harbin, these were Alexander Moiseyev, a hunter and member of the Military-Monarchist Association (Adams suspected him

of being a heroin addict); Nikolai Grammatchikov, a mechanical engineer and, like Gribanovsky, a member of ROVS; and the chauffeur, Mikhail Chuvstvin, described by Adams as "modest, reliable, and sober."[50] Gribanovsky organized supply and transport, while Moiseyev, who had guided museum expeditions in the past, was listed as a botanical research assistant. Grammatchikov and Chuvstvin served as camp handymen. The Roerichs also hired two Chinese botanists—Y. L. Keng of Nanking's National University, and his assistant, Walter Yang—but illness and family concerns delayed both men, and neither caught up with the caravan until July.

The Roerichs' squadron first dipped to the southeast, to pick up the weapons it had requested from the Fifteenth Infantry in Tientsin. It then reversed course, bearing northwest past Peking to Kalgan (present-day Zhangjiakou), an outpost in what was then part of Chahar Province. Here, where the Great Wall shelters the approaches to Peking, a major gateway—the meaning of the city's name, from the Mongolian *haalgan*—opens up to the western wilderness. Roerich and his companions reached this portal on March 21 and passed through on the twenty-fourth. Their path to the Mongolian frontier, and whatever awaited them there, lay clear.

As Roerich set out, arrangements were being made in Washington for the signing of his treaty, or, to use its offical title, the Inter-American Convention for the Protection of Artistic and Scientific Institutions and Historic Monuments. The ceremony took place on Pan-American Day, which fell on April 15. President Roosevelt attended, along with Wallace and representatives from the twenty-one Latin American countries that had agreed to adopt the treaty. Sina and Esther Lichtmann were present as guests, as were Louis and Nettie Horch. Participants gathered in the cabinet room at 11:45. At noon, a radio announcer, broadcasting live, explained the treaty's purpose, and, over the next half hour, FDR, Wallace, Louis Horch, and a few of the Latin Americans spoke on the air. Roosevelt, observing that Easter was less than a week away, proclaimed, "This treaty possesses a spiritual significance deeper than the text of the instrument itself."[51] Wallace predicted that the treaty would "serve as the germinal essence for what eventually will be a New Deal among the nations. And in so saying, I am not talking about a New Deal characterized by emergency agencies but about the spiritual New Deal which places that which is fine in humanity above that which is low and sordid and mean and hateful and grabbing."[52] The next day, Wallace wrote Bernhard Hansen, vice president of the Nobel Peace Prize Committee, to say, "It is my opinion that Professor Roerich would be a most worthy candidate." This was in support of Roerich's third and fourth nominations for the award, one submitted by Sol Bloom, the other by Henry Pratt Fairchild

of New York University.[53] Roerich's pact won Senate ratification on June 10, 1935.

But all this amounted to less than it seemed. For one thing, the pact remained without support from the State Department. Secretary Hull might bear responsibility for it, but he did so unwillingly, and a piquant example of the wider contempt the department felt for the treaty can be found in the notes exchanged by the acting chief of State's Division of Protocol, Richard Southgate, and one of his underlings, J. Holmes, as they finalized details for the signing. In his memo to Holmes, Southgate sneers at the idea behind the pact, then throws his hands up at what he considers the shabbiness of the event itself. (His patrician snobbery, so pervasive among State's higher echelons during these years, makes it impossible not to feel a touch of sympathy for Roerich.) The attendees, Southgate complained, would not be wearing formal dress, but "only" chancery coats and striped trousers, leading him to comment, only half in jest, "Personally, I have some doubt as to whether a treaty signed by gentlemen who did not arrive in silk hats can be valid internationally." Holmes kept up the disparaging badinage. "This sartorial degredation [sic] is devastating," he replied. "People who would appear like that would be guilty of the awful crime of wearing brown boots on a Sabbath. Where is our ancient Faith?"[54] Foreign governments were not so disdainful, but neither did they accord the pact much respect. Pact-related correspondence between US embassies and their host countries in the summer and fall of 1935 shows that most European and Asian states either disapproved of the treaty or applauded the ideals behind it, but did not believe they could be enforced.[55] Wider acceptance would not be forthcoming.

Unaware of this, Roerich himself marked the date of the signing in his essay "The Banner," written while encamped at Tsagan Kure, on the fringe of the Gobi. Roerich spoke of the pact as a signal victory in the cosmic struggle that he and Helena believed would determine the fate of the world by 1936. "Everybody knows that the Light and Darkness of which we speak are by no means abstractions," he insisted.

They are evident to every eye. Here on Earth we see the servants of Light in labor and struggle. And also here we perceive the evil servants of darkness, filled with hatred of all that exists . . . one should always rejoice at each flash of Light, which like lightning clears the thickening clouds. . . .

Verily, today, the fifteenth of April, will and must be a memorable day. One more beacon will come into being, which will bring friends closer in faraway countries, beyond the oceans, beyond the mountains, scattered through all the byways of Earth. . . . Let the Banner wave over the hearths of Light, over sanctuaries and strongholds of beauty. Let it wave over all deserts, over lonely recesses, so that from this sacred seed flowers may bloom in the desert.

The Banner is raised. In the spirit and in the heart it will not be lowered. By the luminous fire of the heart the Banner of Culture will flourish. So be it! Light conquers darkness![56]

Such expostulations were fine and well, but back in America, in ways the Roerichs were too far removed to prevent, the inner circle was nearing its terminal crisis.

Ironically, Helena expected great improvement that spring: Esther Lichtmann, returning to New York from India and deputized to speak on Helena's behalf, would surely restore discipline to the circle, and as far as Helena knew from Horch, her communications with FDR seemed to be winning the president over. Indeed, while it would soon be Louis's defection that tumbled the edifice to the ground, he remained for now the indispensable keystone. Having met with Roosevelt in November and December, Horch saw him again on January 31, and, accompanied by Esther, on March 8 and March 15. ("You can trust her just as much as my first Messenger," Helena said of Esther in her February 2 letter to FDR. "[She] will return to the Himalayas [so] your questions and words can be transmitted to me in full safety."[57]) In his reports to Helena, Horch continued to depict Roosevelt as enthusiastic and cooperative—"I take it as a command, and of course I want to serve," he quoted the president as saying on January 31—but when he was honest with himself, he knew he had gotten no better at penetrating Roosevelt's mask of bland affability.[58]

One thing he did discern was how bemused FDR was by Helena's insistence that he keep her letters secret not just from Henry Wallace, but also from Frances Grant and Sina Lichtmann.[59] Such compartmentalization took the president aback, and it was a painful twist that the followers locked out of these exchanges were those who proved most loyal in the trials to come.

These began in late March, when Louis's and Esther's meetings with FDR came to a long halt. This had less to do with the president than with a ruinous clash between Helena and Esther over questions of prophetic authority. Helena had vested much power in Esther, confirming her as acolyte in chief, the one person who, next to herself, possessed the clearest understanding of the truths revealed by Morya and Koot Hoomi. Essentially, Esther had become to Helena what George was to Nicholas—a combination of eldest offspring and disciple-lieutenant—and it was precisely this intimacy that made it so hard for Helena to bear what Esther did next. In March, Esther took it upon herself to offer Roosevelt advice not authorized by Helena, compounding the sin by presenting it as having come from the Masters through her, not her mistress. Her message, about the impact of the 1934 Silver Purchase Act on the Chinese economy, simply dressed up in occult fustian a policy suggestion from Horch, and the topic itself had no bearing on the Roerichs' concerns. Helena, however, viewed Esther's action as inconceivably presumptuous.

Helena tried to bring Esther to heel, but all she accomplished was to touch off a Luciferian revolt. Always strong-willed, Esther had grown confident enough in her mediumistic prowess to see no reason why she herself should not serve as the primary conduit for Morya's wisdom. And in this particular war of heaven, victory would pass to the rebel angels. Henry Wallace's summer defection would more visibly affect the inner circle, but it was this oedipal rupture in the spring, between Helena and Esther, that precipitated the group's destruction. Louis and Nettie Horch may have become distrustful of the Roerichs and weary of supporting them financially, but they had remained obedient thus far because they still cherished the link to divine mystery that they believed only Helena could provide. What need for the Roerichs, though, if the Horches came to view Esther as Helena's equal, if not her superior, as a transmitter of the Masters' precepts?

Not till the disasters of June and July did the trio follow this thought to its logical conclusion. For a season yet, their fraying loyalties remained intact. But if any chance still existed in the spring of averting the break to come, Helena squandered it by indulging in this bootless contest of wills with her favorite pupil. The Helena–Esther showdown also sheds crucial light on the Horches' shift in thinking at this time. At least in Anglophone treatments of the subject, the collapse of Roerich's support in America tends to be explained as an awakening on the Horches' part, much like the

"deprogramming" of cult members who come to understand the fraudulence of their leader's mystical pretensions. The Horches themselves encouraged this interpretation of events. In reality, though, they were not casting aside an occultist mindset in favor of a secular one. They were swapping one guru for another.

Whatever the case, Louis and Esther halted their visits to Roosevelt until September, and Helena would not get another letter to him until December, by which point everything had changed. Meanwhile, for the rest of the spring, a deceptive calm settled over the Roerichs' affairs, postponing the final explosion. Wallace and the Horches were busy through late April with the final passage of the Banner of Peace. Soon after the signing, Esther and Louis were off to Europe to assist with Roerich's nominations for the Nobel Peace Prize. The complexity of their movements, combined with delays in communication, slowed down the pace at which Helena and Esther learned of each other's actions and attitudes. Roerich himself was in the back country once again, disconnected from the strife building within his own circle and the political consequences of his own actions. Not, however, for much longer.

As Nicholas and George steered northwest toward the Gobi in March and April, they had no way of knowing that they were on their final adventure. Half a year later, they

would be back in Peking, unemployed and preparing to return to India.

In all respects, this last ride proved profitless. Although rugged and politically disordered, Inner Mongolia was hardly a landscape of new discovery. Nicholas and George continued their botanical work, but achieved results no more scientifically valuable than those from before. When time permitted, they indulged their archaeological and ethnographic interests, but this yielded little more than the vague and sweeping generalizations that Nicholas had always been fond of making about Eurasian cultures. The only tangible success was artistic: along the way, Roerich produced a number of paintings, some featuring local inhabitants, but most capturing the unnerving beauty of the arid vistas through which he traveled. Here, he worked with the same economy of effort he had displayed in Central Asia in 1925–1928. Nikolai Grammatchikov bore witness to how efficiently Roerich painted while on the road:

> I had imagined that such a great painter would need an entire arsenal of artistic paraphernalia. Quite the contrary. We would be riding in the car . . . [and] along the path, N[ikolai] K[onstantinovich] would ask the driver to stop. He would get out of the car, and so would I. N. K. would quickly look the area over. He would take from his pocket a little piece of cardboard and a small stub of pencil. All he needed was a few minutes of work . . . I was amazed to

see how, from just a few lines sketched with a pencil, the contours of a whole mountain would emerge. And from this he would later create his canvas.[60]

This, however, was secondary to the Roerichs' real goal: to pull the Great Plan out of the tailspin caused by the events of November. Could Roerich, even without Japanese and White Russian support, still create his pan-Buddhist realm by preaching the gospel of Shambhala? Perhaps, he thought, if only he could locate the Panchen Lama, or at least his emissaries, and win him over. And after the Harbin debacle, it became all the more necessary to exploit US connections. Helena might have given up on Henry Wallace, but Nicholas pressed him in early 1935 to persuade FDR to revise his Asia policy in favor of Mongolia: "Suggest to the Wavering One [Roosevelt]," he ordered via Frances Grant, "that a strong Kansas [Mongolia] might check the Rulers [the Japanese] and make for a balanced situation. Paint the Kansans [Mongolians] as very picturesque and worth preserving in their own right."[61] From there, he hoped—however unrealistically—that FDR could be coaxed into allying with whatever new country he himself might create on Mongolian soil. (It was in this anticipatory spirit that Roerich presented Roosevelt with "The Desert Shall Bloom Again," his essay about bringing the Gobi back to life.)

The Roerichs' movements between April and August remain opaque. According to the map traditionally used to track its movements, the expedition, having

caravaned from Kalgan into the Inner Mongolian provinces of Chahar and Suiyuan, took several paths and made various side trips that, taken together, form an irregular near-loop. This squares with Roerich's own diaries, which describe the expedition as operating out of three major camps. Between the end of March and the end of June, it worked out of Tsagan Kure, scouting the Gobi's southeastern fringe. It then relocated to the east, to the Naran Obo salt deposits, remaining there through mid-July. In late July and August, the contingent doubled back to the west, to Timur Hada, a mountain near the Alashan plateau. It is possible, though, that the Roerichs wandered *off* this map before circumstances forced them back to Peking in September. They likely entered Outer Mongolia at least once, although authors disagree as to whether they forayed briefly across the border or went farther in and for a longer time.[62]

Wherever they went, the Roerichs engaged in reconnaissance and diplomacy. No commentator, having examined the sixty-page log George kept during these months, has failed to note how much it reads like an intelligence officer's report. It meticulously records topographical features that might aid or impede vehicular progress, such as river fords and hill passes, and it tracks the movement of troops in the region, whether Japanese, Chinese, or warlord.[63] George may have simply been practicing the skills he had picked up from his military science lectures in Paris during the 1920s, but one wonders whether he intended this as logistical preparation for the kind of large-scale maneuver his parents' ambitions might require. As for the elder Roerich, he kept alert for any news of the ever-elusive Panchen Lama, and for any chance to confer with clergy affiliated with him.

It was this imperative that made Tsagan Kure, where the expedition tarried longest, so central to Roerich's plans. Close to here, at the lamasery of Peilingmiao, a community loyal to the Panchen had formed a staff headquarters of sorts. Other places the expedition passed through or near on its way to and from Tsagan Kure included Datong, where Nicholas and George viewed the Buddhist paintings and carvings hidden in the Yungang grottoes; Kweisui (Hohhot), the capital of Suiyuan Province; and Baotou, a railway hub north of the Ordos Desert.

Peilingmiao was not unaccustomed to foreign visitors. A Swedish mission operated nearby, under "Duke" Larson, a Swedish American expatriate, and the Citroën Croisière Jaune Expedition had passed through in 1932. Roerich came here to meet a local prince named Teh Wang (in Mongolian, Demtjigdonrov). A regional power broker courted by the Japanese and Chinese alike, Teh Wang had his own ambitions to form a pan-Mongolian state, and Roerich hoped to tie his effort to the prince's. He also consulted with Yun-vang, another Mongolian prince, and the Tiluwa Khutuktu, a mid-level hierarch in the Tibetan-Mongol theocracy.

Roerich's diaries depict these conversations as generating goodwill on all sides.

For accuracy, though, these are no more trustworthy than *Altai-Himalaya* is with respect to his 1925–1928 journey, and in the case of these Inner Mongolian talks, we have a rare outsider's perspective against which to check his recollections. Owen Lattimore, the *Pacific Affairs* editor whom Roerich had come to know in Peking that spring, was on hand to observe the Tiluwa encounter, even assisting with translation, and gathered impressions of Roerich from Teh Wang's retainers. Best remembered as one of FDR's advisers to Chiang Kai-shek during World War II, and even more so as one of the foreign-policy experts pilloried during the McCarthy era for having "lost" China to communism in 1949, Lattimore at this time was touring the Mongolian frontier for his own research purposes—though he also served informally as an extra pair of eyes for the State Department in these remote precincts. He was present on April 6 for Roerich's audience with the Tiluwa Khutuktu; a few days later, he received word about the artist's first meetings with Teh Wang from Pao Yueh-ch'ing, one of the prince's courtiers.

Lattimore filed reports on Roerich with Nelson Johnson, the US minister in Peking.[64] In contrast to Roerich's rosy accounts, Lattimore's summaries paint a picture of comic ineptitude, seeming to confirm more broadly the limitations of Roerich's appeal to Asian leaders and the awkwardness with which he wooed them. When he came before the Khutuktu, the artist tried to impress him with exaggerated talk of the Banner of Peace—"a flag which Professor Roerich stated was recognized by all countries and if placed over a house in time of war would protect the house and those within it from attack or interference by soldiery"—but the Khutuktu proved more curious about the expedition's botanical mission, finding it difficult to believe that anyone would search so hard for something so plentiful as grass. With a chuckle, the Khutuktu informed Lattimore and the Roerichs that "if it was grass seed the Department of Agriculture desired, he would like to have the commission" for something so "easy to obtain."

If Roerich amused the Khutuktu, he made a bad first impression on Teh Wang, whom he met at the end of March. Roerich began by presenting the prince with the Order of the Banner of Peace and an award from the Roerich Museum. According to Pao Yueh-ch'ing, he then broached the topic of American aid to China's Mongol population—"explaining . . . that America would assist them in this time of trouble"—but garbled his message when pressed for details. Teh Wang desired American help in any form, but had thus far been told only that "the United States was not in a position to give assistance" and that "the Mongols must find within themselves the opportunity for improving their situation and their manner of life." Did Roerich's arrival portend a change in official United States policy? wondered Teh Wang. Backpedaling, the artist "explained that he did not mean that the United States Government would

come to the assistance of the Mongols," but that "wealthy Americans"—meaning Horch and the New York circle—"would be glad to assist the Mongols in building up a thriving business, in this way bringing about a closer relationship between the people of America and the people of Mongolia." Such weak-kneed verbiage hardly enthused Teh Wang, and he found the artist's conduct less than endearing. Upon reaching the prince's camp, Roerich imperiously demanded accommodation for himself and his men, but when provided with the same yurts used by the Mongols themselves, he declared them unsatisfactory and rode off to bunk with the Swedish missionaries down the road. As Pao put it to Lattimore, Teh Wang had "wished to give Professor Roerich every assistance in the matter of grass seed," but the artist "was certainly very overbearing." He also "presented quite a fierce appearance riding about with such an armed party accompanying him."

Lattimore had no opportunity to observe the Roerichs again, so perhaps they made up for their unpromising start and convinced Teh Wang to look more favorably upon them.[65] From late April to June, they ranged widely—out from Tsagan Kure, into the Gobi, and around Naran Obo—to promote Roerich's messianic brand of pan-Mongolism. (This included the distribution of a self-published "biography," *A Short Account of the Great Teacher Roerich*, whose translation into Mongolian had been prepared by Roerich's old comrade, Tsyben Jamtsarano.) But at its best, Teh Wang's disposition was courteous, not actively cooperative, and if

Roerich found ears willing to listen to his message, how attentive were they? What, after all, did the artist have to offer at this point, beyond airy assurances of American support and a benign but impotent profession of sympathy for Buddhism? Roerich could gather his plant samples, view archaeological sites, and paint all the paintings he liked, but his core mission had collapsed the minute it began. And even had it been viable, it would soon be rendered moot. As June came to an end and the expedition moved on from Tsagan Kure to Naran Obo, all the reckonings piling up against the Roerichs' credit—both personal and political—were about to come due.

Not the least of Roerich's many follies was his persistent delusion that he could outrun his past. Simply shifting his point of focus from Manchuria to Mongolia could not save him from being overtaken by the turmoil that had driven him out of Harbin. Quietly at first, but more audibly by the late spring of 1935, Japanese and White Russian suspicions that Roerich was a Soviet agent made their way into newspapers throughout China and into public discussion more widely. The Soviets were convinced Roerich was spying on Japan's behalf; they would soon complain about him formally to Washington. China's Nationalist authorities believed him to be an instrument of US policy, although to what end they could not guess. And what were Americans to think of him?

The true end for Roerich came when newspapers in America began to voice this question openly. Real damage was first done on June 24, by the *Chicago Tribune* and the *New York Times*. Under the headline "Japanese Expel Explorers Sent by Sec[retary] Wallace," the *Tribune* broadcast the harmful allegations that had dogged Roerich in Asia for months.[66] The *Times* spoke of the "embarrassment" left in the artist's wake in Manchuria and China.[67] Neither explicitly accused Roerich of wrongdoing, but each dredged up details he would rather have kept out of the public eye: his squabble with MacMillan and Stephens, the distress he had caused American officials in Asia, and the aggressive posturing of what was repeatedly referred to as a squad of "armed White Russian Cossacks." Also, by highlighting the suspicions now engulfing the expedition, such coverage made it all the harder to pretend that Roerich's Asiatic sojourn was an innocent scholarly venture. The impending fallout would eventually contaminate everyone involved, but most alarmed now was Henry Wallace, unable to think of anything but how fatal Roerich's blunderous march through China could be to his career.

To add to the artist's bad luck, Wallace switched to damage-control mode just as the Horches, along with Esther Lichtmann, chose to sever the few threads still tying them to Nicholas and Helena. Before the publication of the *Tribune* and *Times* pieces, Louis and Esther had been in Oslo, tending to Roerich's recent nominations for the Nobel Peace Prize. Returning to New York, they faced not just the emerging press scandal, but a blistering letter from Madame Roerich. Received on June 24, this was Helena's delayed response to discovering how, earlier in the spring, Louis and Esther had delivered unauthorized messages to FDR. Admonishing Louis, Nettie, and Esther as a renegade "Trio," Helena accused them of "disregarding the Hierarchy"—that is, presuming themselves capable of directly contacting Morya and comprehending his will without Helena's guidance.[68] This high-handed rebuke proved too much for Esther, who now declared herself the only true channel through which the Hidden Masters would continue to speak. As she later put it, "[Helena's] love for Self-Power and Self-Glorification lost [her] the Contact. . . . We have this Contact here now in New York."[69]

Events unfolded rapidly, starting with Horch's detachment of Henry Wallace from the Roerich camp. Sometime in the last days of June, Horch rendezvoused with Wallace at the Newark airport, where the secretary was laid over en route to Connecticut, and in the words of Wallace's biographers John Culver and John Hyde, "whatever was said during those two hours changed everything."[70] Regardless of when this climactic conversation took place, its substance can be deduced from the actions that followed. Horch no doubt revealed to Wallace how Helena had ordered him to go behind Wallace's back by meeting privately with FDR, not to mention the unkind

things the Roerichs had said about Wallace as their frustration with him grew. Most of all, Horch convinced Wallace that Esther, not Helena, was now the one true source of revelations from "Our Lord." In an instant, Wallace joined the Horches as they turned against the Roerichs.

The Horch–Wallace counterstrike began on July 3. That day, in his official capacity as agriculture secretary, Wallace sent out two cables. One went to Nicholas and George, via Kalgan, ordering them to move immediately southward, away from the Mongolian border. Then, in an obvious subterfuge meant to conceal the closeness of his involvement with Roerich, Wallace addressed the second to Horch: "I do not know whether there is any foundation whatsoever for the insinuations of political activity on the part of Professor Roerich in Mongolia. I am exceedingly anxious, however, that he be engaged, both actually and apparently, in doing exactly what he is supposed to be doing as an employee of the United States Department of Agriculture engaged in searching for seeds valuable to the United States."[71] This profession of ignorance went beyond disingenuous: as "Galahad" and "Logvan," Wallace and Horch had labored for months to realize the artist's plans for Mongolia. The July 3 messages represent nothing more than frantic attempts to insert into the public record pieces of "proof" that might help Wallace to distance himself from Roerich's connivances.

In Asia, things unraveled for Roerich over the rest of July and into August. Wallace's command to head south was followed on July 9 by an equally stern note from Earl Bressman, the expedition's Department of Agriculture handler, calling upon Nicholas and George to wrap up operations by the fall and leave China by the end of the year.[72] The press barrage continued, with a wider variety of papers, both in Asia and the States, printing tales of anti-Japanese intrigue, Cossack enforcers, and mad dashes to recruit tribal leaders for some sinister purpose. The *China Weekly Review*, for example, wrote that Roerich had "incurred the enmity of Prince Teh," forcing him and his "guard of White Russian Cossacks" to "retreat" to Peilingmiao.[73]

Still ignorant of how Wallace and Horch had allied against him, Roerich tried throughout July to counter this negative publicity and restore the secretary to his former state of pliability. To the New York press, Maurice and Sina denied that the expedition had any Cossacks on staff and pointed out that Roerich himself, far from being an alien element, had a long history of public service and artistic achievement in America and was in the process of taking out naturalization papers. In the field, the Roerichs temporized by moving their encampment west to Timur Hada. Nicholas cabled Wallace directly, reassuring him that any unsavory newspaper items had arisen from a "whispering campaign," based on "gross insinuations" that could be easily rebutted, and not from any failure of the "Kansas" plan.[74] George addressed Wallace's underling Bressman, adopting a

tone of forced joviality and suggesting that the articles' more colorful details were the product of overactive journalistic imaginations: "Clippings of the 'planted story' which appeared in the press have caused considerable merriment locally, and the local authorities were greatly amused to read about Cossack detachments in the service of the Expedition! It seems that according to some newspaper men, every bearded individual must be a Cossack!" George hastened to assure Bressman that "notwithstanding newspaper reports and various rumours the Inner Mongolian region is so far quiet and scientific work is proceeding successfully."[75]

Wallace, of course, was having none of this. The wrath he felt for the Roerichs waxed through the summer, as did his sense of alarm at the political danger they posed to him. He refused to accept private letters from the family and closed his door to those representing them in America. Maurice, who tried to meet Wallace in Washington, described the situation in a July note to Sina: "Forgive me for not writing sooner, but if you only knew how tense things have been here. Yesterday and today I came close to seeing 'Galahad,' but he chased me away. . . . It is a horrible thing for someone like him to have become our enemy."[76] Frances Grant likewise strove to reestablish "Galahad's" bond with Helena, but to no avail. As she recalled years later in a letter to Sviatoslav, Frances received in July 1935 a request from Helena "asking me, in great confidence, to see Wallace and tell him that only direct messages from her were authentic." Wallace,

however, rebuffed her as forcefully as he had Maurice. "I immediately tried to carry out [your mother's] request," Frances told Sviatoslav. But "by then it was futile. Wallace refused to accept the letter, telling me 'I know you have failed in your mission. I have better messages than yours,' etc. I never saw him or could see him again."[77]

The downhill slide continued, and as July gave way to August, the Horches revealed to the Roerichs the full extent of their anger. On July 30, Louis wrote to Helena, in answer to the scolding letter he and Esther had received from her in June. "During the 14 years of our devoted service," he began,

we have encountered many disillusionments, disappointments, and severe blows inflicted upon us by yourself, Prof. Roerich, and our coworkers, but that which you have written in your letter of June 24th, 1935, has inflicted the severest. . . . In this letter you have definitely denied the Commands and Indications Given to us by the L[ord]. In this way you have attempted to shatter these foundations and have trampled the most sacred to us. . . . Did you ever realize how painful and hard it was to work for 14 years in a milieu of hatred, undermining, jealousy and injustice? However[,] despite these conditions we not only reverenced you but served you completely. . . . With great readiness I purchased the paintings and made the Museum and Building possible. . . . For many years I have generously provided

you with funds, thus removing the financial worries from you and your family. I have provided the financial means for you to undertake the five-year Expedition, which gave great prestige to your family. We have generously provided funds for all your plans and ventures unconditioned and on faith. . . . If you wish to sincerely search for the real failures which you have referred to, then in all justice you should also evaluate the actions of yourself and Prof. Roerich for the last 13 years. Under your exclusive direction and leadership the following undertakings proved to be failures: Pancosmos Corporation, Beluha and *Ur* corporations, [and] Alatas. . . . The Roerich Museum Press has been reduced to almost naught. And the Master Building has been greatly reduced in income and the prestige fallen to mediocrity. The cost of the Building has been greatly increased by the pompous demands and the constant interferences of coworkers who demanded despite my repeated warnings and protests.[78]

Louis directed his bitterness at Nicholas as well, writing on August 7 to tell him, "Things have reached the limit here. I refuse emphatically to accept blame for [the] failures of others. This is all due to the situation created by Mad[ame] Roerich and yourself in favoring in all actions your two sons and some of the Coworkers here, who for thirteen years have repaid me for all my untiring efforts and devoted Service with

Hostility and undermining. . . . I definitely herewith advise you, that I shall no longer tolerate this great Injustice."[79] This rejection was complete by September. Conveying that sad fact to Helena, Frances Grant said of the Horches and Esther that "they think they can form their own channel. They repeated constantly that they no longer needed or wanted your guidance." Nettie is said to have exclaimed with relief, "Thank God, we now know how to interpret the Teachings on our own."[80]

Recriminations were one thing; concrete actions were another. The Horches, as described below, set out to exact revenge on the Roerichs and recover as much money from them as possible. For Wallace, the immediate concern was to get Nicholas and George out of China before they could cause him more harm. The secretary's level of anxiety rose in August, when he received a report from R. Walton Moore, the military attaché stationed at the US Embassy in Moscow. According to Moore, the Soviet government feared that Roerich's party included onetime followers of the tsarist general Grigori Semyonov, notorious for his brutality, and was "now making its way toward the Soviet Union ostensibly as a scientific expedition but actually to rally former White elements and discontented Mongols."[81] A formal complaint about this matter could only imperil Wallace further, so he overrode all the delaying tactics Nicholas and George were using to prolong their stay. Both Wallace and Frederick Richey, Ryerson's replacement at the Bureau of Plant

Industry, directed the Roerichs to proceed right away to Peking and arrange to leave China by no later than October 15.[82] Reluctantly, father and son journeyed back to the capital, which they reached on September 9, and disbanded their Russian entourage.

Nor did the Roerichs' troubles end there. Once in Peking, Nicholas and George found the embassy less than eager to ship their seeds to America. The Department of Agriculture had not been impressed with the specimens sent by the Roerichs earlier that year, and the State Department dryly remarked that it was "not in the seed-transport business." In the end, the Department of Agriculture agreed to pay for a small selection of seeds to be shipped in ordinary crates, with the rest simply to be listed in George's final report. The Roerichs were forbidden to claim any remaining expenses beyond the salaries already owed them and the cost of their passage to India. Worse yet, the Treasury Department warned that they could expect a bill of at least $3,604, and perhaps more, for earlier expenses claimed improperly. The War Department asked for an additional $340.55 for the weapons the Roerichs had carried away from the US garrison in Tientsin. An expedition report was still required, Richey reminded George, helpfully pointing out that the deadline for submission was February 1, 1936.

One more injunction was handed down as the Roerichs prepared their voyage to India. Several times, and with the heaviest possible emphasis, Wallace made it clear that Nicholas and George were to remain silent about the expedition, including any details about political troubles or personnel issues. "Dep't regulations prohibit publication without previous approval of any information or comments growing out of expedition financed by Dep't," he pronounced in a cable to George, adding in a letter to Nicholas that "there must be no publicity whatever about the recent expedition. There must be no quoting of correspondence or other violation of department publicity regulations."[83] With Wallace's words ringing in their ears, Nicholas and George set sail in late September. By October, they were back in Naggar—once more in the bosom of their family, but with their Great Plan once again unfulfilled. Master Morya may have proposed, but it was Uncle Sam in the end who disposed.

Awaiting Roerich were twelve quiet years in the Kulu Valley, each marked more than the one before by a sense of isolation and lost opportunity. (One key consolation: Sviatoslav, despite his recent closeness to the Horches, quit New York to rejoin his parents and brother in India.) In 1935 and 1936, though, the family was not yet resigned to such a fate. The Roerichs fought to save what they could of their standing, their assets in America, and their international network. These struggles they lost, but even as they went down to defeat, they inflicted lasting wounds on their opponents. Wallace in particular would be hobbled for

years by the resulting scars—even after Roerich himself had breathed his last.

Having packed Roerich off to India, Wallace worked to contain any damage the artist might still cause him. Roosevelt never punished Wallace officially; he could hardly do so without embarrassing himself, though it is fascinating to think of the private castigation he must have handed down. This left Wallace free to scrub the official record until it supported his version of events. For the State Department's benefit, he compiled a large sheaf of paperwork related to Roerich's expedition, with a cover letter that featured the same evasive explanations he would rely on for years: "When I discovered that the seed collecting was going on in a territory where a misunderstanding was easy and discovered further that certain types of indiscretion might cause serious difficulty, I took action gradually to move the expedition into safer and safer territory. At the same time, however, I endeavored to maintain the expedition sufficiently long in drought resistant territory to obtain the grass seeds in which we were interested."[84] (When William Phillips, the undersecretary of state who received this communication, asked his superior how to respond, he was advised to tell Wallace that, while the documents he had sent were interesting, it would be better for him to proceed via proper channels the next time he felt tempted to engage in ventures of this type.) Wallace went further with his self-exculpation, contacting diplomats from some fifty countries, including the USSR, to inform them of the "decided reservations" he now had about the Roerichs, and informing the governor of New York, Herbert Lehman, that despite his original liking for Roerich, he had "reached the conclusion" that the artist's supporters "were worshipping Professor Roerich as a superman and were determined to stop at nothing in helping him to work out some extraordinary phantasy of Asiatic power."[85] Left unsaid, of course, was anything about Wallace's own participation in this "phantasy."

Wallace also rushed to remove any trace of Roerich from the treaty that had just been signed in his name. He arranged the withdrawal of Roerich's recent Nobel nominations, then lobbied the State Department to delete the phrase "Roerich Pact" from the treaty's text. "Roerich has become involved in Soviet politics," Wallace told State in January 1936, "and in one or two other ways has caused questions to arise as to the wisdom of giving him any kind of public recognition. . . . It [is] highly important that Roerich's name should not be used in connection with the treaty if it is possible to avoid it."[86] Because "Treaty Series 899" was still in page-proof form, Wallace's request was easily accommodated. Beyond this, Wallace used his clout to prompt an Internal Revenue Service audit of Roerich's finances. Over the next several years, the IRS determined not only that Roerich owed back taxes from 1926 and 1927, when he had been out of the country and failed to file any returns, but also that he had commited tax fraud in 1934 by failing to report income while earning a

salary from the US federal government. His total debt, the IRS computed, came to more than $49,000.[87]

The Roerichs disputed these findings and maintained (with some justification) that Louis Horch, who had held power of attorney over Roerich's affairs while he was out of the country, was to blame for any irregularities. But while they dragged their appeal out to 1938 and beyond, the final verdict would go against them. In parallel with the IRS inquiry, the State Department carried out an investigation of the Roerich enterprises in early 1936, using the same agents, R. C. Bannerman and Hall Kinsey, who had looked into the group's activities in 1925 and 1930. Kinsey reported that Wallace and the Horches had severed their connection with Roerich, having "finally come to the conclusion that [he] is and has long been a sham and more or less of a scoundrel, who has masqueraded under the cloak of his alleged art and culture for purposes of personal financial aggrandizement." But unpleasant as the episode may have been— Horch claimed to have been "stripped of his entire fortune through participation in this unfortunate venture"—Kinsey came away satisfied that it constituted no threat to national security and no longer warranted the department's attention.[88]

The IRS investigation was merely one shot in the legal cannonade directed against the Roerichs over the next several years.[89] Horch brought suit against them for $200,000, as compensation for unpaid loans, and laid claim to the Master Building

and everything in it. This included all the artwork and collectibles the Roerichs had housed there; these, the Horches reckoned, belonged to them by virtue of the agreements signed by the artist in the 1920s. Wielding the powers granted them by the Master Institute's reincorporation in early 1935, the Horches excluded all Roerich loyalists from the institute's operations. Phone calls, telegrams, and letters were redirected through Nettie's office on the fourth floor, and according to Frances Grant, she and others, including Sina, Ingeborg Fritzsche, and Katherine Campbell, were told that they were employees, not peers, and threatened with arrest for trespass if they ventured where they did not belong.[90] Frances, Sina, and Maurice countered with an injunction, hoping to block this takeover. Wallace used his influence to Horch's advantage, causing the Roerichs' lawyers, Herbert Plaut and Harold Davis, to complain to the press that the secretary was "bringing his official position into a personal row."[91] (FDR himself may have helped Wallace tip these scales, if Louis and Esther understood him correctly after meeting with him in January 1936: "We asked him if we can keep him advised about litigation and he said 'Yes.' It was a splendid visit. We rejoiced at his desire to help us in our present plight."[92])

Powerless in Naggar to affect these proceedings, the Roerichs fumed from afar. Unwelcome articles in the *Washington Daily News* ("Spy Rumors End Roerich Expedition"), *Newsweek* ("Mystery Tale that Officials Will Not Solve"), and other periodicals

persuaded Roerich to bring suits against United Press and the Sun Publishing Group for a total of $2,000,000, based on the claim that he had been "greatly injured in his credit and reputation and that the said publications have exposed him to public hatred, shame, obloquy, odium, contempt, ridicule, aversion, ostracism, degradation and disgrace."[93] According to the *New York Sun*, he considered suing Wallace himself "because of 'innuendos' . . . sponsored by 'certain officials' of the United States Department of Agriculture."[94]

In their letters and diaries, the Roerichs marveled at Wallace's treachery and that of Horch, whom they now referred to as "Alberich" instead of "Logvan," after the avaricious dwarf from Wagner's *Ring* cycle.[95] "He is leading the government astray," Roerich wrote of Horch. "In his dark soul, he knows perfectly well that he is lying and faking; he is a real American gangster."[96] Still believing she could somehow sway Roosevelt's opinion in her favor, Helena sent two more letters to FDR in December 1935 and January 1936, warning him that Esther and Louis, "having succumbed to covetousness and ambition," had "broken the sacred trust . . . pretending that [their messages] came from the Original Source through me. This Source warned me [and] when these persons saw my indignation, they, moved by fear and revenge, turned to open treason." She begged the president to turn the power of his "flaming heart" against the betrayers and end their "odious campaign to discredit our name."[97] These pleas met with silence, and Helena

would have been doubly dismayed to know that Louis and Esther continued to enjoy occasional access to Roosevelt, both by mail and in person.

For the Roerichs' New York supporters, these months proved equally torturous. As the stress of the lawsuits mounted, everyone suffered—Katherine Campbell, Ingeborg Fritzsche, Dudley Fosdik, and other loyalists—but the real psychological brunt was borne by Sina, Maurice, and Frances. Clear signs of the turmoil can be found in their messages to and from the Roerichs. In December 1935, Nicholas sent a three-page letter to "My Dear Sina, Frances, and Maurice," expressing shock at all the betrayals recently suffered:

> Mr. Horch, like a fratricide, has taken action against his comrades of many years. . . . There is no vocabulary which can define this dangerous action. . . . How many dark cunning schemes have been utilized in order that the viper of evil should creep across all thresholds and leave its slanderous poison everywhere? They used our absence for their purposes; God knows what malfeasance was performed, in order to obscure the truth and bring the greatest damage to all. [Not only] is this a matter of destroying a cultural institution—such a satanic act—but, perhaps worse, such a conspiracy drives young hearts to believe that gold alone rules the world. "Satan leads the dance." Surely this cannot be![98]

Days afterward, George wrote Frances about the "unprecedented treachery" that Horch, whom he likened to an "oriental Nawob," had shown them.[99] Frances observed in her reply that "if the Trio [Louis, Nettie, and Esther] had shown before one tenth the industry for our constructive labors, which they are now showing for destruction, great progress could have been made."[100] Frances grew more vituperative as the months wore on, complaining to George that "Levi [Horch] and his cohorts . . . synthesize the satanic force that you describe. They are rotten with evil. Their appearance, their mentality (if any), their speech, everything bespeaks something decayed and foul."[101] Returning to her longtime fixation with Esther's hair, which she and Sina believed to be artificially colored, she wrote, "As for the blonde, I do not know that I have ever read or heard of anyone who was, to such an extent, the composite of malevolence. I honestly would not be surprised to learn that, instead of spending her mornings over the *peroxide and ammonia* as she does, it is over some witch's brew made of cat's tongue, lizards' tails, the hair of a dead cat, etc."[102] Sina's diaries reveal her to have been equally oppressed in spirit, a fact that, along with her growing attraction to Dudley Fosdick, explains the final disintegration of her marriage to Maurice.

Roerich attempted to rally his followers. "Justice and law are not dead letters," he assured them in December 1935. "Upon you there is being poured out a fratricidal savagery. . . . Thousands of people are aware

of this. Is it possible that anyone can find excuse for this malicious and shameful attack? There must be many warriors of culture who will say 'Get thee hence, Satan!' and the land which first pronounces this enlightened command will be first in the construction of the New Era." Roerich reminded them of the cosmic import that the year 1936 held for them all, and closed with this benediction: "May the Lord send you strength to withstand all these unprecedented, vile conspiracies. Victory is predestined! Victory will be with truth!"[103] For a time, this tonic had the desired revitalizing effect; in a 1936 letter to George, Frances affirmed, "Yes, we feel that this is a Great Year, and no treachery will defeat its victorious implications. Despite the daily manifestations of venom, in a score of ways, we feel not the slightest doubt as to the ultimate result. . . . It will be a joy to work together again freed from the brutality of the Trio. I am sure the time for this much-desired consummation is not very far away."[104]

Nothing depresses morale, however, like sustained failure. By 1938, Herbert Plaut had lost Roerich's tax case in federal court. The firm of Hall, Cunningham, Jackson and Haywood handled the appeal, which was taken up in September 1940 but quickly went against the artist. This left the Roerichs with a tax bill of nearly $50,000, effectively barring them from ever returning to the United States. Nor could Horch be stopped from taking over the Master Building and the assets within. Here, too, Plaut faltered, at least in the eyes of Frances

Grant, who described him as "weak" and "so nervous that he would forget the major points of his defense."[105] Before George Frankenthaler, the adjudicator appointed by the New York Supreme Court, Horch paraded reams of documents to support his contention that the Master Building's construction, and all activities associated with it, had been funded overwhelmingly by him, and that legal and corporate control of the enterprise had always been his. To establish ownership of the art and artifacts housed in the museum, he presented the old agreements signed by Roerich in the 1920s. Sina and Frances maintained—no doubt sincerely, but without proof—that Horch had altered, if not faked, many of these papers, and they felt cheated by the system's bias against them. "It was obvious from the start," Frances wrote, that "Frankenthaler tried to intimidate Mr. Plaut and ignore largely any testimony of the trustees and witnesses produced by Mr. Plaut. [All of us] were witnesses to the unbelievable acts of injustice evinced by Frankenthaler."[106] At this juncture, Frances tried to introduce Wallace's letters to Roerich as evidence, but though these would have embarrassed both the secretary and Horch, Plaut saw them as irrelevant to the case.[107] (This did not prevent the letters from resurfacing eventually, as related below.)

Not surprisingly, Frankenthaler found in Horch's favor, after which the case went to appellate court, where it was settled in the spring of 1938. Horch triumphed at this level as well, with six judges ruling for him, and only one against. Among the pro-Horch judges was one of FDR's chief advisers, Samuel Irving Rosenman, who, in 1943, became the first person to hold the position of White House counsel. Rosenman initially asked to be taken off the case, on the grounds that he had been present to celebrate the Roerich Museum's opening in 1929, but this was not deemed sufficient to compromise his objectivity, so he stayed on. The court's split decision entitled Plaut to appeal the judgment, but, beaten and deflated, he opted not to do so. Adding to Roerich's legal woes, his libel suits fell by the wayside. Though not formally dismissed until 1941, these were dead in the water by 1938, chiefly because Roerich himself was not present to give testimony.[108] Even the smallest fights turned out badly. In 1936, Sina and Frances attempted to compel Nettie and Esther to return the manuscripts, books, and letters they had received from Helena over the years. Nettie riposted by claiming that any such materials had been given to her and Esther as gifts and were theirs to keep, regardless of Helena's current wishes. Plaut persuaded a sheriff to accompany him to the Horches' home to present Sina's and Frances's request, but retrieved nothing on that occasion or afterward.[109]

After 1936, defeat and disappointment scattered what remained of the Roerichs' faithful. Maurice, emotionally broken by the legal disputes and the transfer of his wife's affections to Dudley Fosdick, agreed to Sina's request for a divorce and left New York. Remarried, he moved to Santa Fe because of

health concerns brought on by asthma, and there he opened the Arsuna Gallery with Clyde Gartner and Doris Kerber. He died in 1948 and, by all accounts, was never again in touch with his sister Esther. Frances parted ways in 1937, due mostly to friction with Sina, who led the reconstitution of New York's Roerich community. ("Did *not* ask me to join," Frances noted in July, after a tense conversation about Sina's plans.) Still, she never lost her regard for the Roerichs' teachings and stayed in touch over the years with George, Sviatoslav, and Maurice. Involved for a time with the Vedanta Center in Boston and the Buddhist Society of America, Frances dedicated herself to a long career of activism connected to Latin America. As a member of the Pan-American Women's Association and the Inter-American Association for Democracy and Freedom, she promoted peace and women's rights throughout the region. She passed away in New York in 1993.

Sina remained steadfast to the end, gathering around her a new group that, while diminished in numbers and wealth, managed to preserve a Roerichite presence in America to the present day. At her side were Katherine Campbell, Ingeborg Fritzsche, and her new husband Dudley, whom she married in 1939. After clearing its debts, the Fosdick–Campbell group opened a new Roerich Academy of the Arts on 73rd Street in 1937, relocating to West 57th Street in 1939. Lean times followed in the 1940s and 1950s, and Dudley died in 1954. Nonetheless, Sina, Katherine, and Ingeborg slowly rebuilt

a substantial collection of Roerich's works. In 1949, two years after Roerich's death, they moved into a five-story brownstone on West 107th Street, near Riverside Drive— only four blocks around the corner from the original Master Building—and, in 1958, chartered it as the Nicholas Roerich Museum (NRM). Shepherded into the 1980s and 1990s by Sina and her cohort, the NRM still operates today. Perhaps, had Nicholas and Helena been able to envision the way their memory would be perpetuated in America so many years later, they would have found their mid-1930s travails a little easier to bear.

Neither Nicholas nor Helena ever set foot in the United States again, and in that sense their American story ends here. But even in absentia, they left a considerable mark on the country's history. Before shifting focus to the lives they led in India, it is worth detailing how their long American coda played out.

For over a decade, Wallace and the Horches appeared to have escaped the Roerich vortex. Though they never clawed back any money from the Roerichs, Louis and Nettie had seen them permanently expelled, and more than a thousand pieces of Nicholas's art were theirs to dispose of as they pleased. The Horches also controlled the Master Building, where they resumed normal operations in 1938. As before, most floors were given over to hotel rooms and apartments, but the lowest were transformed

into a new Riverside Museum, which opened that June. Art journalists approved this renunciation of the Roerich brand, and *Art Digest*, in a piece titled "Exit: Greatest One Man Show on Earth," sarcastically pronounced the Riverside's conversion "the concluding chapter" of the artist's "Amazing Adventures in America."[110] An indignant Roerich seethed at the readiness of once-friendly reporters to write him out of "his" museum's story. Seizing upon a positive review of the Riverside by the columnist Emily Genauer, he carped, "We have just received clippings containing articles of all sorts of bribed (bought) writers (scribblers) praising the opening of the Museum. . . . We have not been at all astonished at the articles of Genauer and other Judases, who were apparently bought by thirty shekels."[111] The Riverside remained open until 1971, although it struggled in its final years.

In addition to work with the New York Department of Trade, Louis Horch took up employment with the federal government, receiving posts from Henry Wallace in the Departments of Agriculture and Commerce. He, Nellie, and Esther remained close to Wallace through the early 1940s and strove for a time to prolong their connection with FDR. Louis and Esther met with Roosevelt at least six times between September 1935 and March 1936, chatting pleasantly about current events.[112] Roosevelt always seemed "*most* warm and *very* friendly," but the pair found it no easier to gauge his true feelings than Louis had in 1934–1935. Tellingly, it was when conversation turned to the Roerichs

that FDR grew most attentive, pressing Esther and Louis to say whether they had heard from them, or what the couple might be up to. Louis and Esther hoped to make Roosevelt more receptive to the otherworldly counsel of the "Forces of Light," but the president likely saw these talks as the most expedient way to determine how dangerous this inconvenient association of Wallace's might prove, especially with the 1936 election approaching. Indeed, after the spring, having satisfied himself that all threats from this direction were neutralized, Roosevelt lost interest. Esther's last known attempt to communicate with FDR, a lament that "we [have long been] deprived of the greatest privilege and joy of seeing You," came in April 1942.[113] Informing the president that "You live in our hearts and thoughts," Esther asked permission to send him a basketful of strawberries—"fit for a king!"—cultivated in the Adirondacks. (History remains silent on how tempting FDR found this mouthwatering offer.)

Wallace, for his part, allowed himself to think he had neatly disposed of Roerich, especially once the 1936 election came and went without scandal. "That's over now," he noted with relief in his diary, "and I think perhaps it may have been a good lesson for me."[114] Wallace went on in July 1940 to earn the vice presidential nomination at that year's Democratic National Convention, but it was then that he and Roosevelt learned how serious a hazard Roerich still posed. Seeking to punish Wallace for his turncoat ways, Frances Grant had sold his

1933–1935 "guru" letters—political poison for the Democrats—to the newspaper publisher Paul Block. Before long, copies found their way to the Republican Party, a fact that Harry Hopkins, FDR's secretary of commerce and all-around fixer, was horrified to learn in August 1940, shortly after Wallace's VP nomination.[115]

In September, Hopkins, having obtained photostats of the letters, took them and the bad news to Sam Rosenman, the president's speechwriter (and one of the judges who had denied Roerich's appeals against Horch and the IRS). "These can be dynamite if the Republicans can establish that Henry wrote them," Hopkins exclaimed. "They can make us all a laughing stock." Rosenman knew enough about Roerich not to need persuading on this count, and when he viewed the photostats, he noted wryly that they "certainly would have surprised the ordinary American voter." Hopkins and Rosenman contacted Wallace's executive assistant, Paul Appleby, who, like most of the secretary's staff, had reviled Frances Grant and had never ceased to fear that the Roerich connection would come back to haunt his boss. Appleby asked Wallace whether there might be any substance to all the talk of "those screwy letters," and the newly minted nominee could only reply, "I guess that's right, Paul."

What followed was a hasty research session, as Hopkins and Rosenman scoured the Democratic Party's bylaws, only to find that "there was no legal way at this late date for the Vice President to withdraw his candidacy, even if he wanted." Hopkins was "more dejected than ever," and then came a gloomy breakfast with FDR. As the president listened to Hopkins and Rosenman, "his face clouded over," and he shouted, "My God! What's the matter with Wallace?"[116] Rosenman observed that "it was a terrible blow . . . to this man who had so much of the world's troubles on his shoulders already—and who was going to get so much more as time went on."

Despite his outburst, Roosevelt dismissed any notion of dropping Wallace from the ticket. Even if the rules could be bent to allow it, the awkwardness of doing so would cause as much political damage as the letters' disclosure. Roosevelt assigned Hopkins to figure out what the Republicans intended to do—and how to stymie their plans. Wallace was monitored at all times and coached on how to respond if reporters queried him about the letters. Republican-friendly newspapers were informally made aware that they would face crushing libel suits if they published anything negative about Wallace without ironclad proof. Best of all, FDR's opponent, Wendell Willkie, had a chink in his own armor, involved as he was in an extramarital affair with Irita van Doren of the *New York Herald Tribune*. If need be, the Democrats could match scandal with scandal. As FDR told his aide Lowell Mellett, "we can't have any of our principal speakers refer to it, but people down the line can get it out."[117]

In the end, neither side pulled the trigger. As Rosenman and Hopkins later

learned, "there was considerable dissension" among Republicans "as to whether the letters should be used," even before the Democrats hinted at the dirt they had on Willkie. Out of principle or self-preservation, Willkie and the Republican Party chairman, Joseph Martin, decided that a mutual smear campaign was in no one's interest. ("Willkie never referred to the letters," remembers Rosenman, "and I am sure that he did not want them referred to.") Only once in 1940 was Wallace confronted about the letters, by the *Pittsburgh Post-Gazette*. Ready for this line of questioning, Wallace feigned indignation that anyone could take seriously allegations that stemmed from "a tax evader who dare not re-enter this land." Discouraged by both parties from pursuing the story, the press let the matter drop. Roosevelt went on to beat Willkie in November. Wallace, seemingly in the clear, took his place as FDR's vice president, serving in that post through 1944.

Tales of Roerich's impact on American politics typically rush through the story of 1940 on their way to the high drama of 1948, when Wallace himself ran for president, only to have his letters exposed before the electorate. But some tantalizing questions hang more on the hidden outcomes of 1940 than on the humiliations of 1948. If Wallace's letters had been aired in 1940, might that have been enough to unseat Roosevelt and put Wendell Willkie in the White House? Or, had Roosevelt won regardless, would the scandal have weakened him in dealing with a strongly isolationist and not always

cooperative Congress? The counterfactuals are fascinating to ponder.

Conversely, what if Wallace's letters had not troubled the political waters of 1940? Might Roosevelt have kept him on as vice president in 1944 instead of moving him to the Department of Commerce in favor of Harry Truman? It is not certain he would have. In *Working with Roosevelt*, Samuel Rosenman attributes Wallace's demotion to his "lack of tact" and the embarrassment his "many interdepartmental disputes" caused FDR in 1941–1943.[118] Coalition-building mattered as well. Picking Wallace as his 1940 running mate is generally seen as FDR's concession to progressive Democrats at a time when national security concerns were moving him to the right. In 1944, it was the party's conservative wing, united in hatred for Wallace, that needed mollifying, and even moderates found Wallace's vocal admiration for the USSR hard to stomach.[119] But while such calculations might have caused even a scandal-free Wallace to be discarded for Truman, the near-calamity of 1940 must also have influenced FDR's decision. Wallace later insisted that the letters had nothing to do with the reassignment of roles that year—"I'm told they tried to peddle them in 1944 and everybody just laughed at them"—but historians note that "cocktail party gossip long held that the letters figured in Wallace's fall," even though "the rumors remained sub rosa."[120]

Either way, consider what might have been had Wallace remained vice president and taken Roosevelt's place upon the

president's death in April 1945. How would Wallace have presided over the final months of World War II and the deliberations over whether to use the atomic bomb? Postwar diplomacy would have been handled in a vastly different way under Wallace, with his fervid Russophilia, than under the hard-charging Man from Missouri. The decade would have passed without any trace of the Marshall Plan, the Berlin Airlift, or the formation of NATO—or the Cold War itself, as least as we know it. Another fork in the road, loaded with history-altering potential, involves cabinet appointments that a President Wallace might have made in 1945. It is generally thought that Wallace, had he been in the Oval Office, would have nominated Laurence Duggan to serve as secretary of state and Harry Dexter White to head the Treasury Department. This would have constituted a security breach of nightmare proportions—for both have since been confirmed as Soviet spies.[121] It is no endorsement of McCarthyite paranoia to acknowledge Wallace's naïveté concerning the USSR or the magnitude of the harm his Stalin-friendly myopia could have caused. To the extent Roerich prevented Wallace's vice presidential nomination in 1944, he can be said to have performed his greatest service to the United States, and to have struck his strongest blow against Soviet intelligence, all inadvertently.

As a public matter, though, 1944 paled by comparison to 1947 and 1948, when Wallace, fired as commerce secretary by Truman in 1946, opted to campaign for president as the Progressive Party's candidate. Even with a platform too "pink" for the mainstream—they welcomed communists and supported a radical peace platform—the Progressives aimed to pick off utopians and leftists disenchanted by Cold War hawkishness and Truman's centrism. Whatever the party's prospects, Wallace was encouraged by the fact that Roerich, his chief potential liability, had slipped into obscurity halfway around the world. But if he thought the threat posed by his old letters had expired, like a political statute of limitations, he was mistaken. The Republican Party still held copies, and these, by 1946, had fallen into the hands of the Scripps-Howard journalist Westbrook Pegler. In the spring of 1947, Pegler started to hound the Progressive candidate about the contents therein.

With his "Fair Enough" column published in more than a hundred newspapers and read by over eight million readers, Pegler was a dedicated anti–New Dealer and one of the fiercest Red-baiters of the 1940s and 1950s. One critic describes him as a "leading popularizer" of "antidemocratic crusades," allied in the end with "a twitchy sect of neo-Nazis and professional racists."[122] Still admired by many on the right—William F. Buckley was a longtime fan, and Sarah Palin quoted from him upon accepting the 2008 Republican vice presidential nomination—Pegler in his time supported the World War II internment of Japanese Americans, harassed the deaf-blind educator Helen Keller, and pronounced it "the bounden duty of all intelligent Americans

to proclaim and practice bigotry." He compared Jews to geese that "gulp down everything before them and foul everything in their wake."[123] But as dark a stain as he left on American public life, when it came to linking Wallace with Roerich, his facts were straight and his instincts unerring.

Although other journalists now had access to the Wallace–Roerich correspondence, Pegler was the only one brash enough to refer to it openly. In May 1947, he asked, "Is Henry Wallace a Student of Yoga?" and began reproducing excerpts from the letters. He spent the summer reminding readers of Roerich's eccentricity, mocking him as "the old guy with the two-legged beard and the squint eyes who looks like Chu Chin Chow and is regarded as a master intellect."[124] In June, Pegler tracked down Louis Horch for an interview that appeared on the eighteenth, in the *New York American*.[125] Horch tried to focus on Roerich, portraying himself as a man of good sense who had allowed generosity to get the better of him. Pegler, however, soaked him in the same acid bath he had prepared for Roerich and Wallace. "The first time I interviewed Horch," Pegler began, "he said he soon got wise to Roerich and started to get back some of the money he had put into the big lamasery on Riverside Drive." He pretended to sympathize as Horch went on about how "old Roerich started off impossible and became more and more so. And Horch got sick and tired of the old boy's paintings of mountains and Himalayan hop-joints." After a few minutes of companionable Roerich-bashing, Pegler

slyly asked about the artist's yogic teachings. Surely, he wondered, Horch had never fallen for any of this "monkey business"? "Horch laughed," Pegler tells us. "Nope, he never went for the philosophical or spiritual nonsense. He was a practical businessman. Foreign exchange. Foreign credit. Money. Very commonsense fellow." Pegler then sprang Wallace's letters on him, reading passages that described Horch, with his odd-sounding code name of "Logvan," as a dutiful novitiate. At this, Horch "cringed so hard you could hear him." Gut-shot, he stammered out a reminder that he had fired Roerich in the end, but Pegler's contemptuous wrap-up left no one in doubt as to what a dunce he thought him.

Wallace did not crumple as easily, but the Pegler treatment added a laughingstock air to a campaign already struggling against a reputation for dewy-eyed idealism. In a tirade published on August 27, Pegler blasted not just Wallace, but other New Deal politicos who had befriended Roerich in the 1920s and 1930s, including Congressman Sol Bloom, Senator Robert Wagner, and the Democratic press agent Charles Michelson (brother of the University of Chicago scientist Albert Michelson, once a Roerich Society board member).[126] Rooseveltian cronies, warned Pegler, were covering up Wallace's indiscretions. "For two months," he wrote, "I have been calling at your office to ask whether you ever were a disciple or pupil of Nicholas Roerich, the leader of a mystical Oriental cult." He accused Sol Bloom of lying to him, boasted of having reduced Louis

Horch to jelly, and ended with a challenge to the candidate himself: "Answer the questions, Wallace. If you don't, I will."

Pegler pursued his quarry with Javert-like tenacity. Peppering his columns with quotes from the "Guru" letters, he pressed Wallace to level with the public about his relationship with Roerich. In early 1948, he and several Republicans tried to convince Frances Grant to speak openly about Wallace's folly. (King Features apparently added the incentive of a sizable cash payment.) Happy as she was to see Wallace and Horch twist in the wind—"This was a pivotal year!" she noted—Grant feared that involvement with Pegler's inquisition might get her fired from her current job, so she held back.[127] By March, Pegler was drawing persistent attention to the affair. On the ninth, he launched this fusillade: "The voters of this country are entitled to know whether or not those letters were written to a Russian whose followers regarded him as Almighty God and to members of this Russian's Oriental political and pseudo-religious cult by a man now running for President of the United States with a following composed mostly of Communist traitors. . . . The man who wrote those letters was, by American popular standards, as dizzy as a dervish. These letters are revolting in their idiotic, juvenile prattle of esoteric jargon."[128] Two weeks later, *Newsweek* shone its own light on the subject, running a major feature titled "Guru Letters: Wallace Meets the Roerich Culturalists."[129]

All this while, and till midsummer, Wallace headed off every inquiry about Roerich by standing on his dignity. It would cheapen the campaign, he argued, to respond to extravagant allegations put forward by a partisan hack. For a time, this deflection seemed to work: no one, not even his supporters, associated Pegler with journalistic objectivity, and in liberal circles, he was held to be "a mental hoodlum."[130] In July, however, as the Progressives prepared their formal nomination of Wallace and his running mate, Glen Taylor of Idaho, a number of writers joined Pegler in wanting to know more about Roerich. Open season on the "Guru" letters was about to be declared in Philadelphia, at the Progressive Party's national convention.

The first shots were fired at a July 24 press conference, given upon Wallace's acceptance of his party's nomination. More than four hundred reporters gathered in the hall, including Pegler, eager to come to grips with his prey. Also present were Alistair Cooke, Britain's premier observer of US politics, covering the election for the *Manchester Guardian*, and one of America's literary lions: the satirist H. L. Mencken, still feared, despite his advanced age, for his pitiless dissections of hypocrisy and political pretense. Cooke's reportage conveys a sense of the high drama that ensued.[131] After Wallace gave his prepared remarks, a journalist rose to ask whether the candidate would care to speak to the interesting questions Mr. Pegler had been raising over the past months. Falling back on his standard script, Wallace replied, "I never comment on Westbrook Pegler." This, however, no longer

satisfied the media beast, and several more reporters asked about the letters. All were denounced by Wallace as "stooges," merely following Pegler's lead, and when Pegler himself confronted Wallace, the candidate stubbornly repeated, "I will never engage in any discussion with Westbrook Pegler."

At this uncomfortable juncture, Mencken silenced the room by rising to his feet and, in a quiet voice, asking, "Would you consider *me* a Pegler stooge?" Abashed, Wallace replied, "No, Mr. Mencken. I would never consider you anybody's stooge." Mencken then addressed the following lines to him: "Well, then. It's a simple question. We've all written love letters in our youth that would bring a blush later. There's no shame in it. This is a question that all of us would like to have answered, so we can move on to weightier things." Wallace stiffly asserted that the matter was "not important" and finished with a limp promise to "handle it in my own time." In the space of a second, Mencken had elevated Pegler's scandalmongering to the level of reputable journalism, guaranteeing that the "Guru" hubbub would not die down till after the election. Mencken later opined that Wallace had handled the question like an "imbecile": the candidate "might have got rid of it once and for all by simply answering yes or no, for no one really cares what foolishness he fell for ten or twelve years ago." This seems unlikely. The press would hardly have let go of such a juicy story, and Mencken himself delighted in labeling Wallace the "Swami" over the next months. Either way, between July and November, Wallace faced an unending sequence of editorial barbs like this one, from the *Chicago Daily News*: "If only Wallace, the Master Guru, becomes President, we shall get in tune with the Infinite, vibrate in the correct phase, outstare the Evil Eye, reform the witches, overcome all malicious spells, and ascend the high road to health and happiness."[132]

What practical impact did the "Guru" letters have on 1948? They did not keep Wallace from becoming president; the secretary never had a plausible path to the White House. The real question boils down to how much of a spoiler an unblemished Wallace might have proved among voters on the left, who faced a choice between Wallace's Progressives, Truman's mainstream Democrats, and a breakaway bloc of southern "Dixiecrats" led by Strom Thurmond.[133] In early 1948, before the "Guru" letters became a major story, polls indicated that Wallace could expect to receive approximately 4 million votes in November, or about 7 percent of the projected total. But when the election took place, Wallace came away with only 1.15 million. In a race forever famous for Truman's razor-thin, eleventh-hour victory over the Republican Thomas Dewey, how much difference did these nearly 3 million lost votes make? And how much of this shortfall can be attributed to the Roerich effect?

It is hard to measure the latter's influence, especially relative to other factors that worked against Wallace in the fall of 1948. Among these was the well-documented tendency of third-party campaigns to fade

as Election Day approaches. Nor did it help that the Berlin Blockade, the Cold War's most stirring showdown to date, threw Wallace's perceived softness on communism into relief at exactly the worst time. Some point to Wallace's unwavering commitment to civil rights, which cost him dearly in southern states. (Voters rejecting Wallace on this basis, though, were never his constituency to begin with, and account for few if any of those who expressed support for him early in the year.) As a consequence, most commentators remained content for decades to explain the Progressives' slippage in the polls without reference to Roerich. In recent years, it has become clearer how the "Guru" scandal might have contributed to this collapse.

Whatever its causes, the dropoff may have had a part in swinging the election to Truman. Wallace's 1.15 million votes earned him not a single electoral vote, in contrast to Thurmond, who, with roughly the same total, captured four states and one of Tennessee's electoral votes. But even with this poor showing, Wallace played spoiler against Truman in New York, New Jersey, Michigan, and Pennsylvania, all of which Dewey took by slim margins. What if Wallace had come away with a result closer to the 4 million that pollsters had been predicting for him in early 1948? The next thing to ask is how many states went for Truman in November, but narrowly enough that one can envision them flipping to Dewey had Wallace finished more strongly. A better performance by Wallace could have foiled

Truman in three places: California (alloted 25 electoral votes at the time), Ohio (also worth 25), and Illinois (which had 28). Truman squeaked by in these states by approximately 17,000 votes in California, 7,000 in Ohio, and 33,000 in Illinois. In 1948, the nationwide total of electoral votes was 531, with 266 needed to win a majority. Thurmond earned 39, Dewey gained 189, and Truman won with 303. But if a Wallace unencumbered by scandal had lured just 57,000 voters away from Truman in California, Ohio, and Illinois, Truman's tally would have shrunk to 225, leaving Dewey with 267—exactly enough to place him in the White House.

Did Harry Truman thus become president because of Nicholas Roerich? It should not, perhaps, be put so baldly. Even the best counterfactual propositions are speculative, and multiple causes brought about the Progressives' decline in the polls. We can never know for certain how many votes Wallace would have received, and from where they would have come, had there been no outcry over the "Guru" letters. On the other hand, it cannot be denied that the outcry, once raised, benefited Truman to at least some degree—and given the narrow margins of 1948, that degree did not have to be large to materially affect the outcome. (Viewed in that light, what an irony to see Pegler, who abhorred Truman almost as much as he did Wallace, hoist so high with his own petard.) In numerous ways, Roerich's life story forms an important if undersung part of American history. Nowhere does this seem truer than

in the way that this, his figurative farewell, played out.

Whatever influence Roerich can be said to have had over the 1948 election, Wallace bore the marks of the controversy for years afterward. His lingering resentment shows in the reminiscences he provided in 1953 for the Columbia University Oral History Project. "I can't think of Nicholas Roerich and certain of his fanatical followers," he began, "without a strong feeling of disgust."[134] The artist, his son, and his cabal in New York had engaged in "utterly disgraceful actions," taking advantage of FDR's goodwill and deceiving him time and again. Wallace put forward a highly misleading narrative to explain how he had come to know Roerich—blaming Roosevelt's Tibetophile mother, Sara, rather than his own ties with Frances Grant—and he shamelessly downplayed the

"Guru" letters' significance. Not only had he "never sent" these "unsigned, undated, [and] high-flown" missives to Roerich, he insisted as well that "none of the material seemed to cause the slightest concern" to Roosevelt, who—in this telling—found the letters "laughable." All provable falsehoods, all nourished by a bitterness that Wallace carried with him until his own death in 1965.

They were also directed at a dead man: gone for six years when Wallace delivered them and not even alive when Wallace suffered his electoral ruin. In essence, the last part of this chapter has featured not Roerich himself, but rather his ghost, locked in a long, posthumous wrestling match with his quondam disciple. One should not forget, though, that Roerich led a long post-American life in India, full of renewed hopes, deep disillusionments, and—once again—ideological realignments. The next chapter will restore him to the foreground.

CHAPTER 15

Readjustment and Resignation, 1936–1939

When a man is abandoned by the sun of his homeland,
Who will illuminate the path of his return?

—Ivo Andrić, *The Days of the Consuls*

In 1939, as the cool of autumn descended upon the Kulu Valley, Roerich pondered his approaching sixty-fifth birthday. Perhaps thinking of his father, who had aged into bitterness, with so many aspirations unmet, the artist took stock of how his life had unfolded. "Many of my dreams have been fulfilled," he wrote. "I wanted to immerse myself in the Indian experience. And my life has been connected to India for sixteen years now. I wanted to know Tibet. And we have traveled the breadth of it. I wanted to live in a yurt—and I have lived in a yurt. I dreamed of protecting the cultural treasures of the peoples of the world, and the Banner of the Guardian has gone forth into the world."[1] From such passages, it would seem that mountain solitude had brought Nicholas and Helena to a state of contentedness, curing them of their political yearnings and their apocalyptic obsessions.

To believe this, however, would be wrong. The last twelve years of Roerich's life present a paradox. Outwardly, he and his family gave every appearance of settling happily into their highland enclave. They sincerely valued India, both as a home and as the source of their most cherished spiritual teachings. They took as much part in India's cultural and political life as circumstances permitted, and India has embraced them in return for over half a century as honorary citizens. In 1979, the Indira Gandhi government went so far as to name Roerich one of only nine individuals, and the only nonnative, whose creative works officially rank as "national art treasures"—central enough to the country's heritage that they cannot be sold or exported without special permission.[2]

That said, with the exception of Sviatoslav, the Roerichs never truly reconciled

to permanent residency in India. Neither did they shed their millenarian yearnings. Nicholas and Helena continued to wait with desperation for a miraculous day of cosmic change, whatever form it might take. As the years slipped by, they were enveloped by a deep sense of isolation. Naggar is a remote place even today, and it seemed the back of beyond in the 1930s and 1940s. Waves of homesickness left the couple aching to return once more to Russia.

This led Roerich to perform his last political pivot: despite the hostility with which he was perceived by the Stalinist regime, he lived the rest of his life as a Soviet patriot, striving but failing to return to the place of his birth. During their years in India, he and Helena wore masks of tranquility, convincing onlookers that they had accepted their lot. This show of serenity concealed the fact that, for the Roerichs, Naggar was, and would always be, a new place of exile.

Many tasks awaited Roerich as he and George returned to Naggar in October 1935. Among these was the reknitting of family ties. After such a long separation, it took effort to learn how to live as a household again, and without the women of the inner circle residing at Urusvati for months on end, as they had so recently done, the bungalow felt strangely empty. Apart from native servants, the Roerichs' ménage now consisted of Nicholas, Helena, and George; the Bogdanova sisters, Lyudmila and Raya;

and Vladimir Shibaev, Nicholas's secretary. George's relationship with Lyudmila became romantic, amounting over time to a common-law marriage. Sviatoslav arrived from the States to live with his brother and parents, and, in 1936, a new in-house physician—Anton Yalovenko, whom the family had met in Kashgar during the 1920s—took over from Konstantin Lozina.

The Roerichs settled into a cozy domestic routine.[3] Everyone rose early for breakfast, after which each member of the family worked in a favorite part of the house. In a small study, George produced learned papers on Gesar Khan and fine-tuned his Tibetan grammar. Sviatoslav had studio space for his own painting. Helena withdrew to her chambers on the top floor to meditate and write. Although Lyudmila and Raya saw to her medical and housekeeping needs, she now had to do without the editorial assistance once provided by Frances, Sina, and Esther. As for Nicholas, Shibaev tells us that he

came downstairs after breakfast to his studio or the adjacent little room that served as my office. I waited for him there, knowing that he would have prepared not only a new article, but usually several letters as well. He dictated the article to me and I typed it as he spoke. Once it was typed I read it to him with short pauses; he listened attentively and sometimes added or corrected something, after which I continued reading. But the dictation system had

been worked out so well that in most cases the article or letter was ready to be signed and sent on the first try. . . . In general, Nikolai Konstantinovich rarely changed a dictated text, just as he rarely went over his paintings while working on them. This was the result of a very precise, logical mind. Like a chess grandmaster, Roerich always saw many moves ahead. . . .

Roerich worked very assiduously and methodically. He was in no way a pedant, but considered a precisely regulated work rhythm obligatory for himself as well as for all of his coworkers. Time was apportioned so rationally that not a minute was lost in vain. . . . Over the many years we spent together, I never saw Roerich idle, inactive, scattered, or fussy.[4]

At midday, the family would gather for a short lunch, then resume work until dinner, generally followed by a pleasant stroll at dusk, with Roerich often clad in the black opera cape he still owned from his days in Paris. Occasionally, the family rolled out their handsome green Dodge for a country drive. Each evening, the household gathered on the second story in what Shibaev called "the holy of holies": a "central, windowless room, the walls decorated with many tankas and a large gilded statue of Buddha." In this "most beautiful and cherished spot," the group discussed philosophy or Helena's latest spiritual revelations. Always, issuing forth from the hand-cranked phonograph,

there was music—perhaps Rachmaninoff's Concerto No. 2 in D minor, Scriabin's "Poem of Ecstasy," or Caruso singing *Ave Maria*, and likely a selection or two from Roerich's beloved Wagner. "The repertoire," Shibaev remembers, "may not have been the most extensive, but it was varied and in excellent taste." These soirées remained "ineffably exalted" in his memory. Neither Sundays nor holidays interrupted this cycle of labor and contemplation. Only the arrival of visitors caused any variation in the daily round.

What kept the Roerichs so busy? Much of their energy went toward the lawsuits described in chapter 14. Helena's ongoing formulation of Agni Yoga yielded reams of new material—including *Aum* (1936), *Brotherhood I* (1937), and *Brotherhood II* (1937)—and she continued translating Blavatsky's *The Secret Doctrine* into Russian. George had his academic research, while Sviatoslav threw himself into art, specializing in Indian-themed portraits and landscapes. Nicholas, having lost the Horches as guaranteed buyers of his art, strengthened ties with museums, galleries, and collectors in India. Such efforts took time, but, combined with donations from followers and assistance from friends, helped to keep the family financially afloat.

After the embarrassments of 1935, Nicholas and Helena worked to repair their tattered network of supporters. Some of these attempts came to nothing. Baron von Taube angrily detached himself in a pair of letters sent that October and November.[5] He reproached Roerich for ignoring his political

advice and concealing his previous dealings with the "red devil." "You have made the whole world your enemy," he wrote, and the past months' "catastrophic consequences" were entirely his fault. In early 1936, Roerich strove to change Taube's mind, blaming his misfortunes on others. All the criticism in the press, all the "mysterious" tales of his alleged activities, he insisted, were the products of slander. He urged Taube to disregard anything said about him by Esther Lichtmann ("a most evil traitress") and Louis Horch ("a Shylock and a Judas . . . with crass Wall Street instincts").[6] Taube acknowledged receipt of Roerich's letters, but did not engage with the artist's self-justifications. The Roerichs received similar responses from other onetime allies, among them Madame de Vaux-Phalipau of the Paris Friends of the Roerich Museum. Georges Chklaver also cooled on the Roerichs, though he remained sporadically in touch.

From Theosophists and other esotericists, the Roerichs sought continued relevance and, wherever possible, financial aid. Communications with the Harbin cadre fell off after 1935, and were maintained principally via Alfred Heidok, rather than Roerich's brother Vladimir. In New York, the circle of loyalists was much smaller and greatly altered. On a positive note, the family reestablished ties with the Latvian Roerich Society, which had been shaken by the 1934 death of its leader, Felix Lukin. The poet Rihards Rudzītis took this group over in 1936 and expanded it. Roerich communities flourished in all three Baltic states until

the Soviet takeover of 1940, and the artist attracted sizable followings in Bulgaria and Yugoslavia.

To these groups, and to others in their mystical orbit, the Roerichs continued preaching the inevitability of apocalypse in 1936—though they scaled back their claims about how dramatic such an event might be. "The rule of the Lord of Shambhala does not imply that He Himself will appear and take part in the great battle," Helena informed a Parisian Agni Yogist. Only "the more ignorant Buddhists" expected this. "The battle is mainly taking place in the Subtle Spheres," and for Shambhala's king to appear in his "Fiery Body" would be "destructive to many people and many things, because His Aura consists of energies of unusual strength."[7] The true turning point, Helena wrote in *Brotherhood II*, would come in 1977—far enough in the future that she would be spared any personal embarrassment if this new foretelling did not come to pass. This circumspection stemmed from sincere belief, but also from the lessons learned by the Roerichs from their predictive failures of before.

Roerich's paintings from this time reveal an agitated state of mind. In *Armageddon*, completed in 1935–1936, he returns to a favorite motif, that of the walled city under siege (see Illustration 36). Emitting a lambent glow, the citadel stands on high ground, amid billows of smoke. Visible at its base

are refugees in flight. At the same time, he painted *Chintamini*, in which a gray horse carries the sacred "thought-gem" from the mountain heights to the mundane world below, hinting at vast transformations to come. In *On the Peaks*, a bearded hermit meditates amid the peaks; in *From Beyond*, a female spirit guides a pilgrim across a mountain bridge. These two canvases, from 1936, depict the masculine and feminine archetypes the Roerichs still believed that they themselves embodied. *The Hunt* (1936), in which two horsemen, silhouetted against mountains of blue and purple, chase after a pair of deer, serves as a parable of enlightenment, returning to a motif Roerich had used in his "Flowers of Morya" poems.

Armageddon and canvases like it reflect two things: the tenacity of the Roerichs' apocalyptic convictions and the couple's distress as international affairs worsened. If Nicholas and Helena wanted evidence that an epochal world crisis was in the offing, they had only to look around them. With Japan no longer useful to him, Roerich allowed himself to see how predatory its policy was in Manchuria and north China, and when Japan resumed war there in 1937, he, like other onlookers, would be sickened by the murderous December rampage that came to be known as the Rape of Nanking. In Europe, the right-wing dictatorships that Roerich had recently thought of as ideological counterweights to Stalinism's evils were revealing their own aggressive tendencies. Italy's conquest of Abyssinia featured the terror-bombing of civilians and the use

of poison gas. The German rearmament of 1935, in open defiance of the Treaty of Versailles, led in 1936 to Nazi reoccupation of the Rhineland and Hitler's decision to join Mussolini in aiding Francisco Franco's pro-fascist rebellion in Spain. And while the full extent of its horrors would not manifest for another half decade, the virulence of Nazi antisemitism was more than apparent by 1936 and 1937.

Each new episode of violence filled the Roerichs with alarm. The Banner of Peace had been motivated by self-serving impulses along with altruistic ones, and Nicholas and Helena had been willing to justify a holy war of their own to bring Shambhala into being. Still, they abhorred bloodshed, and the darkening political scene caused them despair. As Roerich later mused, "already by 1936, the world had entered a state of war . . . Ethiopia, Austria, Spain, China, Czechoslovakia, Memel, Albania—these are but individual components of a gigantic battlefield, where hot blood has already been spilled upon the earth."[8]

This heightening of tensions caused the Roerichs once again to reevaluate their political position. In this, they were not alone, for virtually all Russian émigrés wrestled with such dilemmas in the later 1930s. If one opposed Stalin, should one tolerate, or even encourage, the ascendancy of Hitler? Or did Nazism represent such an unparalleled menace that one should accept the Soviet regime as a lesser evil? At the time, nothing about these calculations seemed straightforward, especially because the Nazis' wartime

genocides still lay in the future, while Stalin's worst abuses—the famine of 1932–1933 and the mass arrests of 1936–1938—were recent and ongoing. It was painful for expatriate Russians to reduce complex preferences to a binary formula of pro-Soviet/pro-fascist, but the decade increasingly demanded such stark choices. As early as 1937, Nicholas and Helena were moving toward the final turn in their long, zigzag political path: a repudiation of White conservatism in favor of Soviet patriotism.

Roerich's outward gaze took in more than geopolitics. He had reached the stage of life when any artist's concern about his or her place in history becomes paramount. While he had always guarded his reputation with diligence, crossing into his sixties caused him to reflect even more intently on how posterity might view him.

Helping to prompt this backward glance was the death in June 1936 of Maxim Gorky. Having recently returned to Moscow after years of self-imposed exile, the terminally ill author still commanded respect from all parts of Russia's cultural community, both in the USSR and abroad. No one of Roerich's generation could hear of Gorky's demise without being reminded of their Silver Age youth, their creative primes, and the head-spinning tumult of world war and revolution. For those who had counted Gorky among their friends, as Roerich once had, it was a particularly grief-filled moment.

Moreover, many of Roerich's peers were similarly engaged in retrospection during the later 1930s. Whether in autobiographies or in interviews to journalists and scholars, dozens of his onetime colleagues were setting their memories down in print. Much of the history Roerich had been part of was crystallizing into a fixed narrative, in which heroes and standouts dominated the foreground, while others were relegated to the margins. How would he fit—or be made to fit—into this story as it took solid shape?

Certain signs encouraged him. A favorable biography, by the art historians Vsevolod Ivanov and Erikh Gollerbakh, was to be published in Riga in 1939. In France, Roerich's paintings continued to attract attention, according to Vladimir Zeeler, the secretary of the Paris-based Union of Russian Writers and Journalists. Friendly with such leading lights as Vladimir Nabokov, Fyodor Chaliapin, and Boris Pasternak, Zeeler came to know Roerich through Georges Chklaver and, having long admired his *Flowers of Morya* poems, corresponded with him during the 1930s.[9] Always ready to boost Russian artists over their Western rivals—"Cocteau, Derain, and even Picasso," he insisted, "pale by comparsion before Bakst and Benois"— Zeeler reported to Roerich on gallery openings and museum exhibits in Paris, assuring him that his work was well represented. Roerich also remained highly thought of in Prague. There, in 1936, he gained an ally and confidant in Valentin Bulgakov. Secretary to Leo Tolstoy before the author's death in 1910, Bulgakov headed the Tolstoy Museum in

Moscow before his expulsion in 1923 by Soviet authorities. In 1934, he opened a Russian Cultural-Historical Museum in the Zbraslav Castle, on the southern outskirts of Prague, and to this, Roerich donated approximately fifty paintings in 1937. Bulgakov pledged to keep this collection on prominent display, and except when interrupted by World War II, the two exchanged letters for the rest of Roerich's life.[10] In 1938, Roerich found gratification from another source, when the English Theosophist Barnett Conlan completed a flattering biography titled *Nicholas Roerich: A Master of the Mountains*. Conlan corresponded with the artist for years and praised his work to the European public at every opportunity, as in "Nicholas Roerich and Art's Legendary Future," an essay he placed in *The Studio* in 1939.[11]

In the main, though, these developments proved not to Roerich's liking. As personal accounts of Russia's artistic life emerged in greater profusion, the tales told by the biggest names tended to ignore him or show him in an unfavorable light. Even the Conlan biography that pleased him so much contained a bitter pill: as related in chapter 6, it was from this book that Roerich learned how Igor Stravinsky had, for years, been claiming credit for the creative concept behind *The Rite of Spring*. This unwelcome intelligence prompted him to fire off an angry rebuttal to Conlan—his "Birth of Legends" essay—and stoked in his heart an enduring resentment.

Worse was yet to come as others told their stories. In the USSR, Anna Ostroumova-Lebedeva released *Autobiographical Notes*, recounting her days with the World of Art Society. Although she admitted Roerich's capable chairmanship of the group, she spoke frankly about the personal dislike she and other *miriskusniki* had felt for him.[12] Arkady Rylov, another *miriskusnik* who had remained in Soviet Russia, recorded his own memories of Roerich before dying in 1939. Rylov had known Roerich better and longer than Ostroumova-Lebedeva; not only had the two trained together under Arkhip Kuinji, Roerich had employed Rylov as an instructor at the IOPKh School. Rylov did not deny Roerich's gifts, referring to his paintings as "remarkably beautiful," and to the artist himself as "talented and learned." But he assessed Roerich's character harshly. "One has to be amazed at how Roerich found so much strength and energy," Rylov says, before providing an answer of his own: Roerich had been motivated by an unholy trinity of "careerism, glory, and money." In 1917, these "ignoble interests" tempted him to abandon not just the IOPKh School, a sacred trust in itself, but his homeland. He "crossed the ocean," as Rylov put it, "to chase after dollars."[13]

Roerich, of course, had never forgotten the animosities of his World of Art days. But he had sublimated these memories, convincing himself over time that mutual respect and a shared love of Russian culture had come to outweigh the bickering of the past. To see old unpleasantness discussed in black and white was dispiriting, and Rylov's criticisms hurt all the more because Roerich

had assumed for decades that genuine affection existed between them. "Here I always thought Arkasha was such a good fellow!" he exclaimed. "A fair man, untouched by envy."

The memoir that wounded Roerich the most during these years was Igor Grabar's *My Life* (1937). Before the revolution, Roerich had considered Grabar a boon companion. It was mortifying, then, to see Grabar portray him as "a complete riddle" and a self-interested eccentric. While *My Life* paid tribute to Roerich's organizational skills and creative gifts, it presented numerous unflattering details: unsympathetic remarks about him by fellow *miriskusniki* (including the dismissal of him as "a typical careerist" by Valentin Serov, whom Roerich idolized), the gauche melodrama of his and Helena's Petersburg séances, the artist's seeming exaggeration of his successes in America, and the amusement Grabar and Anatoly Lunacharsky had derived from Roerich's attempt to fuse Buddhism and Marxism in the 1920s.[14] Roerich obtained a copy of *My Life* in summer 1938, and the fury of his reaction can be gauged from his letters to Valentin Bulgakov. "I did Grabar any number of favors," he complained, and in repayment, "he has made up all kinds of nonsense about me." When Bulgakov tried to pacify Roerich by mentioning the compliments Grabar had paid him, Roerich shot back, "You're too easy on him!" He cheered himself by remembering the rude pun—"Herod Grabber"—made on Grabar's name by enemies who wished to brand him as greedy and unscrupulous.[15]

One factor Roerich failed to weigh properly was the chilling effect of Stalin's terror on public self-expression in the USSR. Autobiographers took real risks if they conveyed sympathy for those who fell afoul of the regime, and while Roerich followed news from the Soviet Union as best he could, he had only a dim comprehension of how negatively he was perceived there, or how many people had been persecuted for previous associations with him. It was only natural for artists like Grabar to protect themselves by criticizing Roerich and downplaying any past amity. Hence Grabar's remark—so upsetting to Roerich—that "even when we began addressing each other familiarly, we were never truly close." The only surprise is that such judgments, delivered as Stalin's excesses neared their zenith, were not even more scathing. Roerich may have gained perspective on this over time; with Grabar, at least, he was able to heal the breach. During World War II, the two resumed a correspondence that lasted the rest of Roerich's days.

Not so with another voice that spoke against Roerich at this time. In 1939, Roerich clashed with his longtime rival, Alexandre Benois. There was no hint of this early in the year, when the two exchanged amicable greetings on the tenth anniversary of Sergei Diaghilev's death. To mark the occasion, Diaghilev's protégé, the dancer Serge Lifar, organized a Paris exhibit featuring artists associated with the Ballets Russes. Roerich was not included—an omission that even Benois pronounced

unfortunate—but whatever his true feelings, he chose not to dwell on the slight and sent a note of congratulations to Lifar, as well as a letter to Benois.[16] In the latter, he spoke of how the march of years had depleted their once-vibrant cohort: "It is astonishing to consider how many remarkable artists from this group have departed." He listed Bakst, Golovin, and others from the World of Art and the Blue Rose. "All have quit this vale of tears," he mourned. "And all before their time. How good it was, then, that Lifar honored Diaghilev with this exhibition."[17]

This moment of grace was not to last. Later in the year, Ivanov and Gollerbakh completed their biography of Roerich, a study the artist himself believed "underscores the Russian-ness of my work," as he told Valentin Bulgakov.[18] From Benois, however, the book elicited an impassioned response that, while not entirely unsympathetic, took Roerich to task for the artistic and political choices he had made over the past twenty years. It was as though the authors' hagiographic treatment of their subject uncorked the bottled-up frustrations Benois still harbored against Roerich. He reviewed the book for the émigré paper *Poslednie novosti*, and while he accepted that some of Roerich's artistic output from the 1920s and 1930s had merit, he declared it inferior to the artist's prerevolutionary work.[19] This drop-off in quality, he argued, was the product of an all-consuming "messianism," which not only channeled Roerich's energies into too many nonessential causes, but distorted his artistic vision. "I

place no faith," Benois said, "in his conferences, pacts, leagues, speeches, jubilees, and apotheoses." The Banner of Peace movement, the expeditions to Asia, the political machinations—all these distracted Roerich from his purpose. Nor did Benois care for the paintings inspired by such activities, be they portraits of gods and gurus, parables of the apocalypse, or mountain vistas. Such works gave off a surface impression of beauty, but were not, in Benois's view, "organic" or "self-contained." "Oh, if only instead of those thousands of paintings," he lamented, "we had a 'normal' quantity of them!" Moreover, "if only each painting were in some way exhaustive, if we were able to 'enter' it and 'live' there for a while—how differently Roerich's mission would have turned out! Perhaps it would have been more limited in a geographic, planetary sense, perhaps it would have been less striking in its 'universality.' But it would have been more genuine, and then apologists would not have had to present it as some kind of miracle about which they were obliged to speak in the language of the holy books. It would have spoken for itself."[20]

Benois, no doubt, believed he had spoken evenhandedly, but Roerich saw every word as a mortal insult. Vanished in a stroke was the hazy companionability from earlier that year; flooding into his memory was every barb and insinuation Benois had dealt him in the past. "See now," he told Valentin Bulgakov in July, "how Benois, having received only kind words from me, has revealed his base, traitorous nature!"[21] Many

times afterward, Roerich spoke of Benois as a petty scoundrel. "I understand why Benois is called two-faced, a Tartuffe," he fumed in 1942. "Not once have I shown him hostility, but from him I have received ill treatment many times. Well, *basta*! Enough! For me he no longer exists."[22]

Not so easily, though, could Roerich will Benois's criticisms out of existence, and neither would the other negative appraisals disappear. Roerich has always had partisans, but they have generally been outshone by detractors, both in quantity and fame. It was as he learned what his colleagues had to say about him that he came to realize what a struggle it would be to secure the place he felt he deserved in the chronicle of Russian art. In letters and diaries from this time forward, Roerich repeatedly voiced his anxiety that, once he was gone, he would not be remembered as he wished. In that sense, Benois scored a final victory over his adversary.

Whatever Benois thought of Roerich's later art, opinions about it have been sharply divided since the 1920s, when his style and subject matter began to shift. His doubling down on mysticism and mythology thrilled many and continues to do so. Others have found it not to their taste.

It is art historians in the West who have most consistently dismissed Roerich's later works. Unmoved by nationalistic attachment and, as a rule, indifferent to or skeptical of mystically themed material, non-Russian scholars tend to view these paintings as showy curiosities. They score Roerich poorly for other reasons as well: his postrevolutionary oeuvre defies easy classification and fits uncomfortably into the standard narrative of twentieth-century art, which gives short shrift to artists less actively involved in the transition from Impressionism to the avant-garde. Even at his most innovative, the younger Roerich had never swum in the fastest cultural currents, and by his older years, his outlook had turned resolutely antimodern. "Surrealism and the majority of such 'isms' do not constitute paths to the future," he scoffed in his essay "On Realism," which pines for the more genteel days of James McNeill Whistler and his beloved Puvis de Chavannes. "They lead instead to a dead end."[23] Similarly, Roerich suffers from the aversion many art historians feel for visual styles that seem overly reliant on illustrative flash—artistic novelty acts, so to speak, not to be taken seriously.

Novelty acts, however, enjoy a special appeal of their own, as demonstrated by the staying power of certain artists—M. C. Escher and Maxfield Parrish, for example, or Roerich's colleague Alphonse Mucha—who are sometimes slotted into this category. Whatever scholars may think of it, Roerich's signature style has made him a perennial crowd-pleaser among museum-goers and general audiences, and biting academic verdicts have done little to diminish the post-Soviet craze that has caused his paintings to sell in large numbers and at

exorbitant prices. This sort of admiration transcends national boundaries; a simple Google search shows how thousands worldwide use Roerich images as illustrations for blog posts, albums, and book covers, or as visual accompaniments to YouTube videos and websites devoted to yoga, mountaineering, world mythologies, and eco-activism. Many fans are content simply to include Roerich's canvases on "Best Art Ever" or "My Favorite Paintings" compilations. Naturally, such enthusiasm is most prevalent in Russia, where appreciation of his art spans the scholarly/popular divide more easily than in the West. Canvases scorned by Western academics as eye candy or supernaturalist twaddle are apt to be seen by Russians as legitimate expressions of the ever famous—and always undefinable—"Russian soul."

However they fared in the future, Roerich's paintings from the later 1930s followed patterns that were by now familiar. He recalled scenes—windswept deserts, forlorn shrines and stupas, yurts under the open sky—from his Central Asian travels. He revisited favorite subjects, depicting the virtuous Saint Sergius or the intercessional power of the Queen of Heaven, as in a new version of *Madonna Laboris* (1936). He continued to identify the shepherd Lel, from the Snow Maiden tale, as a mythic counterpart to the demigod Krishna, and to use Gothic medievalism to symbolize spiritual purity, as in the Maeterlinck-inspired *Shadows of the Past* (1937), where couples promenade beneath a diamond-shaped window of stained glass.

Roerich also conceived a variety of numinous landscapes, in which the fusion of natural setting and human presence presages moments of spiritual awakening or cosmic renewal. Christ appears in *The Path* (1936), *Miracle* (1937), and *Issa and the Giant's Head* (1939), where he ruminates on the sight of a huge skull. In *She Who Keeps the World* (1937), a holy woman, cloaked and crowned, stands in a mountain wilderness under a single star. Asiatic imagery predominates in *Charaka* (1935–1936), in which an Ayurvedic monk gathers healing herbs, and *The Book of Life*, where a lama, icy-blue peaks behind him and deer resting on the slopes below, reads a sacred text. In *Voice of Mongolia* (1937), a messenger on horseback relays tidings to a traveler on foot, as the sun behind them blazes over the steppe. Whatever geographical form they took, whatever tradition they drew upon, such canvases reflected Nicholas's and Helena's continued yearning for Shambhala, their hope that the dark torments of the age of iron, or Kali Yuga, would soon end, restoring the dharma to a state of purity.

Then there were the mountainscapes, which flowed by the dozen from Roerich's brush (see Illustrations 34 and 35). Some depicted actual sites, whether painted from life or from memory and old sketches. These included the Sasser Pass in Ladakh, China's Nanshan range, Kanchenjunga, and Everest itself—or Chomolungma, its Tibetan name, which Roerich used more often than not. The mountains surrounding the Kulu Valley were a favorite subject. Other scenes exist

partly in Roerich's imagination, such as *Call of the Skies* (1935–1936), where spears of lightning split the night sky over a row of dark peaks, or the haunting *Silver Kingdom* (1938), a blue-and-white panorama in which a jagged summit stands inaccessible, separated from the viewer by a veil of mist. Some of Roerich's mountains remain nameless, identified by a geological feature or as generically "Himalayan." They come in all hues, sizes, and shapes, and in every combination of shadow and light. Roerich experimented more boldly with his palette and sometimes attempted painting on cardboard instead of canvas, trying to capture the texture of rock.

Often, Roerich's critics write these scenes off as tedious and repetitive, but such assessments ignore how breathtaking many of them are. And to his supporters, the sameness is precisely the point: if mountains are symbols of transcendence, each effort to capture their essence becomes an act of meditative discipline, no less imbued with sacred meaning than the endlessly varied icons and mandalas that bear images of Christ or the Buddha Shakyamuni. Even those who do not see these works as *literally* sublime can find themselves powerfully stirred by them, including some of our era's most noteworthy adventurers and travelers. One who particularly cherished Roerich's mountains was the Russian alpinist Anatoly Boukreev, among the finest climbers of his generation and a central figure in the rescue efforts that followed the Mount Everest disaster of 1996. Before his own death on the slopes of Annapurna in 1997, Boukreev lavishly praised Roerich for his ability to "sing of Himalayan beauty," and his posthumously published memoir, *Above the Clouds*, is sprinkled throughout with quotations from Roerich's *Shambhala*.[24] Affected differently, but no less poignantly, is Barry Lopez, the author of *Arctic Dreams* and one of America's most respected travel writers. In his 2019 retrospective, *Horizon*, Lopez recalls a visit to the Nicholas Roerich Museum in Manhattan and describes his first experience of seeing the artist's Asian landscapes as a "rivet[ing] vision."[25] The relative value of such testimonials versus academic criticism in measuring the aesthetic worth of these scenes is left for the reader to determine.

In the summer of 1937, the Roerichs resumed an epistolary relationship that had seemed lost after the collapse of their US interests. That July, they wrote their one-time patron, the philanthropist and diplomat Charles Crane. They cannot have held out much hope for an answer of substance: Crane's enthusiasm for them had waned in 1934, and the scandals of 1935 had reduced his communications to a bare trickle. And yet, even in retirement and dividing his time between Woods Hole in Massachusetts and California's Coachella Valley, he sent a cheery reply in September. "You are certainly living in an inspiring part of the world," he told the Roerichs, "and I hope the climate suits you. Of course we miss you

here but I am grateful for your letters giving me news of your important activities which indicate that your exile has not diminished them in any way." Having been sent some photos of Sviatoslav's paintings, Crane pronounced them "remarkable achievements."[26]

Warm feelings aside, the most notable thing about Crane's letter and the ones that followed was the 180-degree political turn he and the Roerichs experienced simultaneously. Crane had recently visited Moscow, and it was hearing of this from informants in Prague that had caused Roerich to reach out to him. "You will understand our eagerness," he told Crane, "to hear your impressions of such an interesting trip. Every detail, in your judgment and description, would be for us more valuable than pages of newpapers."[27] Crane replied that he had been impressed by the state of affairs in the USSR, and particularly pleased that, with Stalin firmly in the saddle, Russian culture seemed to be on the rebound after years of Leninist internationalism. "The period which the Bolsheviki went through, condemning everything that was essentially Russian has entirely passed away," he told the Roerichs. "There is no trace of that bitter anti-Russian feeling. The new movement has so much vigor that I am sure it cannot be stopped or turned back, and the Russian people will come into their own again."[28] This matched exactly the press statements Crane released in June 1937—enthusing about the centennial celebrations of the poet Alexander Pushkin and the record-breaking flights made by Soviet pilots over the North Pole to America—and a November memo he sent to FDR, reporting that the Russian "genius," so long suppressed, was undergoing a much-needed revival.[29]

A curious characterization, one might think, from such a fervent anticommunist. But Crane had traveled a long way politically since the early 1930s, when he had advised Roosevelt to align with Nazi Germany as a hedge against the USSR. By 1935 and 1936, measures such as the Nuremberg Laws, which stripped German Jews of their civil rights, and aggressive foreign-policy moves like the Rhineland occupation had caused the scales to fall from Crane's eyes concerning Hitler. Friends in his beloved Czechoslovakia were coming to view the Soviets as protectors against looming Nazi encroachment. Also, like many outsiders, Crane was taken in by Stalin's utopia-spinning propaganda machine, with its socialist-realist façade of technological prowess, heroic achievement, and Russocentric patriotism.

Crane's opinion mattered to the Roerichs because his shift in thinking mirrored theirs. As with the couple's earlier fluctuations, a mix of pragmatism and sincerity was at work. Roerich, expelled from America and persona non grata among most White Russians, had seen his most bountiful sources of support run dry. He and his family lived in quarters already paid for, but household upkeep took money. They could never feel secure in their occupancy of Hall Estate with the Horches seeking to recover assets from them, and their right to reside in India depended on the continued sufferance

of the unsympathetic British. As for his name recognition, this was fading throughout Europe and America, a decline not yet offset by his slowly accumulating successes in India. Practical reasons abounded for the Roerichs to reconcile again with Soviet rule.

Yet their decision was governed as much by sentiment and homesickness. The media wizardry which persuaded Charles Crane that Russia was thriving under Stalin wove the same spell over Nicholas and Helena. Another Russia-watcher of their acquaintance, Bernard Pares of the University of London, had come away from a recent visit with favorable impressions of "youth and patriotism."[30] Prominent émigrés were returning to Russia or considering the idea. Gorky had led the way by repatriating in the early 1930s. In 1936, the composer Sergei Prokofiev staged his own homecoming to great fanfare, and Roerich's longtime friend, Ivan Bilibin, left Paris that year for Leningrad and obtained a post at the Academy of Arts. Family ties tugged at the Roerichs as well. Nicholas had fallen out of touch with his sister Lydia, and his brother Vladimir remained silent in Harbin. But he worried incessantly about his brother Boris, who had relocated to Moscow in 1932, after his brief incarceration by the secret police. Also in the Roerichs' thoughts were Helena's relatives, the Mitusovs, who had stayed true to them over so many years. The emotional allure of reunion cannot be quantified or discounted.

By 1937 and 1938, then, the Roerichs had fully reoriented their politics along pro-Soviet lines and were openly voicing their desire to return to Russia. He debated this question with the *miriskusnik* Boris Grigorev, who was happily settled in France. The mere idea of repatriation infuriated Grigorev, but Roerich hoped (vainly) to change his mind. "He thunders on," Roerich wrote, "saying he will never go back to the Motherland, but I do not believe him. Not only will he return, he will perceive the Russian people in a new light."[31] Roerich spoke just as forthrightly to Valentin Bulgakov, complaining that "so many Russians have turned themselves into foreigners" and sniping at Sergei Sudeikin for listing himself as "an American artist" in his latest catalog (conveniently forgetting the pro-American statements he himself had made when it suited his interest).[32] In February 1939, he told Bulgakov, "I do not wish to waste my final years. I wish to make use of them in Russia, with all the fervor I can summon . . . to make the Motherland flourish."[33]

Bulgakov, living in a Prague still shaken by the Sudeten crisis of 1938 and the Anglo-French appeasement that amputated Czechoslovakia afterward, shared Roerich's sympathies. Indeed, the Roerichs' Sovietophilia was intensified by geopolitical urgency. In 1937 and 1938, their attention had been fixed on the death agonies of the Soviet-supported Republic in Spain's civil war, the absorption of Austria into Hitler's Reich, the two-week battle of Lake Khasan—which pitted Soviet troops against the Japanese on the Russo-Manchurian border—and the Munich Agreement that handed the

Sudetenland to Germany. For any Russian fearful of fascism, it was only natural to feel a stronger sense of attachment to the USSR.

But what of Soviet domestic affairs? Here, the Roerichs were less clear-eyed. In 1936, Stalin plunged his country into a new round of terror, lasting nearly three years and claiming the freedom and lives of millions. The resulting show trials and mass arrests were publicized internationally, but the Roerichs failed to grasp their true enormity—or their own likely fate had they been in Russia at the time. Certain artists could expect a warm welcome from Stalin's regime, which trumpeted the return of prodigal celebrities as validations of the Soviet system, and reports in 1937 that Leningrad's State Russian Museum had included some of his work in its World of Art galleries gave Roerich hope that he might be received with honor if he chose to return.[34] He was further misled by Charles Crane's talk of how older cultural traditions appeared to be prospering under Stalin. "He and his government do not hate the Russian people as the Bolsheviki did," Crane assured him. "The government seems to understand and value their genius."[35]

Nicholas and Helena, however, were not just unwanted, they would have likely been signing their own death warrants had they returned. Most of Roerich's art remained out of favor in the USSR, seen as stylistically outmoded and too religious. He himself was held to be ideologically suspicious, if not politically dangerous. Despite his brother Boris's brief arrest in 1931–1932,

Roerich seems to have remained ignorant of the long roll of individuals who met unfortunate ends at least partly due to ties with him. As noted in chapter 11, Agvan Dorjiev and Tsyben Jamtsarano, Roerich's fellow syncretizers of Buddhism and communism, died in custody in 1938 and 1942, respectively. Occult-minded members of the secret police, notably Alexander Barchenko and Gleb Bokii, were accused of—and executed for—plotting with the artist. Konstantin Riabinin and Pavel Portniagin, who traveled with the Roerichs to Tibet, spent years exiled in Stalin's camps. Others from Roerich's past suffered. The archaeologist Nikolai Makarenko, who taught under Roerich at the IOPKh School, was shot after his 1937 arrest. The same fate met the icon restorer Alexander Anisimov, who served on Roerich's pre-Petrine commission in the 1910s. Several of the cosmic utopians who formed the Roerich-inspired Amaravella cooperative came in for anxious moments during the late 1930s, although these consisted mainly of interrogations and brief periods of arrest, not loss of life. Association with Roerich might not be the chief reason one fell afoul of the organs of justice, but no one's lot was improved by having worked with him or praised him too loudly.

How much more harshly, then, would Roerich have been treated had he been present for the purges? Still, he and Helena blinded themselves to any notion that Stalinist policy might pose a threat to them, or that the terror, were they exposed to it, would grind them into prison dust.

Displaying an obtuseness that the historian Alexandre Andreyev describes as "incredible," the Roerichs viewed the purges as a natural unfolding of cosmic justice.[36] "Let us not imagine that Russia is in a state of terror," Helena recorded in her journals. "Death hovers over those who have brought death to others. That is how the Higher Consciousness works."[37] "Without knowing it," she continued, "Stalin furthers the construction of Russia. He is acting as a huge broom, trying to sweep away all filth, so let him go about his work."[38] The terror was simply "a cleansing of harmful people."[39]

Heedless of the reality that the Kremlin would have classed him among those "harmful people," Roerich continued to sing the USSR's praises. Canvases representing heroic figures from Russian folklore—Sviatogor the warrior-giant, the mighty plowman Mikula Selianinovich, and Mikula's shieldmaiden daughter Nastasya Mikulichna, all painted in 1938—were intended as panegyrics to the Soviet nation. And yet the Roerichs' greatest fortune was that they never attained the repatriation they so desired. Their wish would have been their undoing.

The first eight months of 1939 were replete with anxiety for millions throughout the globe. Springtime brought with it the German occupation of rump Czechoslovakia and the Lithuanian port of Memel, as well as Italy's conquest of Albania. Over the summer, the world hurtled toward cataclysm. The Rome–Tokyo–Berlin Axis took firmer shape. The Soviet Army battled Japanese forces once again, this time at Khalkhin Gol, or Nomonhan, an action involving more than 100,000 troops. Hitler threatened Poland over the Danzig corridor that separated East Prussia from Germany proper.

This sweep of events disturbed the Roerichs, but 1939 proved pivotal for personal reasons as well. A number of deaths deflated Roerich's mood. Two more artists from his World of Art days passed away: Vladimir Shchuko, who had taught with him in Petersburg, and Boris Grigorev, with whom he had lately been arguing the question of repatriation. More grief came with the death of Charles Crane, whose sunny missives were missed by Nicholas and Helena. Other relationships were ended by political polarization. Most notable was Roerich's falling-out with the orientalist Sven Hedin. The grizzled Swede's pro-Nazi drift, which included standing by Hitler's side at the Berlin Olympics of 1936, had become intolerable to the artist by decade's end.[40]

Also gone glimmering was any illusion Roerich might still have had about inserting himself into the Shambhala myth. This aspiration had rested largely on whether the artist could pass himself off to Buddhist clerics as the most recent incarnation of the Dalai Lama, and at least in his eyes, this prospect had gained new viability with the death of the Thirteenth Dalai Lama in December 1933. As long as the Dalai's throne

remained vacant, Roerich could continue believing that it belonged to him. However, in the summer of 1939, Lhamo Thondup, a young boy from Tibet's Amdo region, was revealed to the world as the Fourteenth Dalai Lama, having been secretly identified as such by the Panchen Lama two years before. Adopting the religious name Tenzin Gyatso, the tiny theocrat entered Lhasa that October, and while he has since emerged as one of the planet's most-admired symbols of political resistance and spiritual wisdom, he represented to Roerich another entry in his growing catalog of disappointments. Even the idea of Shambhala had been tarnished, Roerich felt, by its commercialization in the form of "Shangri-La," as James Hilton renamed it in his novel *Lost Horizon*. Although more than half a decade old, Hilton's book had lately been on Roerich's mind, as news of the 1937 film version, directed by Frank Capra, reached him belatedly in the Himalayas.[41] Roerich says little of the movie and may not have seen it, but his feelings about it would have been mixed at best: any Hollywood take on a concept so near to his heart would have been too tawdry for his taste, and he and Helena would have been pierced with envy that someone else was now Shambhala's chief popularizer.

Other unwelcome changes came to the household in 1939. To everyone's surprise, Vladimir Shibaev left the family after two decades in Roerich's service. Resentment had been building within him since 1937. He grumbled about being underpaid and

"misused," and felt that Helena had lured him into wasting the best years of his life.[42] Following Morya had not provided him with fulfillment or prosperity, and two continents separated him from the love of his life, a woman who resided in England and, as a devout Christian, disapproved of the Roerichs' mysticism. The embittered Shibaev quit Naggar for Delhi, where he taught Russian and began a new romance with another Englishwoman. Taking her as his bride, he left India for Britain and taught Russian at the University of Cardiff until the 1970s. He came to regret the angriness of his departure and resumed his correspondence with the Roerichs in later years, but the loss of his labor and companionship hit the family hard.

Shibaev's departure paled by comparison to the dire medical news the family received about Nicholas that year. For some time, he and Helena had been feeling their age, a tale told clearly by photographs and the portraits of them painted by Sviatoslav (see Illustration 37). While much of her former beauty remained, age and inactivity had stoutened Helena and thickened her features. Her health had been precarious (or so the family maintained) since her time in Tibet. As for Nicholas, the staging of his poses partly distracts from the whitening of his beard and the wizening of his countenance. He often presented himself in action—firing an arrow, riding on horseback, working at the easel—and this was not all show: he had kept himself trim and fit, and continued to roam the region's peaks and passes

whenever he could. All the same, he could not disguise how heavily his sixties were bearing down on him. And this was before Dr. Yalovenko, the family physician, diagnosed him as suffering from heart disease. This would not be the ailment that killed him, but it was a grim sentence under which to live out the next eight years, and it forced all manner of restrictions upon him: what he could eat and drink, how vigorously he could take exercise, how far and how often he could travel. Being thus tethered added to the sense of isolation that came with living in Kulu's lovely but lonely valley, and his growing frailty kept him constantly aware of his fleeting mortality.

Small wonder, then, that gloom pervaded Roerich's canvases as the fall of 1939 approached. These convey a fear of war as well. In *The Chapel*, a guardsman, rushing in response to the sounds of a night battle, finds his way barred by a female apparition, robed in white and attempting to forestall the violence caused by human ignorance. *Tower of Fear* shows grief-stricken figures at prayer in a vaulted chamber. In *Sorrow*, a similar melancholy bows the heads of boatsmen gliding across a blue-misted lake. All three recall the "prophetic" scenes painted by Roerich before and during World War I.

In this case as well, the artist's alarm was justified. Disclosure of the Nazi–Soviet Pact in August stunned the world and all but guaranteed a German invasion of Poland. While the agreement appeared to keep Russia safe for the moment, the September 1 outbreak of war in Europe appalled Roerich. Had he lived so long and hoped so hard, only to see humanity regress so far, plunging into the same peril it had barely survived a generation earlier? As he tells us in the diary fragment "Again, War," Roerich could not help but think of World War I the instant he learned of the Nazi assault on Poland. On that summer day twenty-five years before, he had been working in Princess Tenisheva's Church of the Holy Spirit in Talashkino, and the princess's friend, Yekaterina Sviatopolk-Chetvertinskaya, had rushed to the sanctuary to deliver the fateful tidings of the kaiser's and tsar's declarations of war. "I faced August 1914 while in a church," Roerich writes. "I now face September 1939 with the Himalayas before me. If one was a church, so is the other. There and then, we refused to believe that all humanity is mad. Here and now, our hearts will not despair, even as another earthly horror begins. Once again, the idea of art will remind us that wanton destruction cannot be tolerated. And once again we will hope that humankind comes to understand where its true treasures are laid up, and what meaning its perfectibility holds for the future."[43] These were brave words, and Roerich did his best to live up to them. But they would prove a flimsy shield in time. The despondency and deprivation of war spread outward, soon touching the Roerichs and all they held dear.

CHAPTER 16

Into the Twilight, 1939–1947

I walk along the fortress ramparts,
In the anguish of the spring evening.
And the evening lengthens the shadows.

—Marina Tsvetaeva, "Above Feodosia"

According to the tale of Gesar Khan, the Himalayan saga so highly valued by Roerich and his son George, the eponymous hero-king is fated to reappear when

Our earth is wounded,
Her oceans and lakes are sick,
Her rivers are like running sores,
The air is filled with subtle poisons,
And the oily smoke of countless hellish
 fires blackens the sun.[1]

Roerich's interest in the Gesar epic spanned decades, but rose to new heights during World War II. He wrote of it as an Asiatic counterpart to the Teutonic *Nibelungenlied* and based several canvases on it: *Signs of Gesar* (1940), in which figures representing hunters and beasts are carved into the side of a hill; *Gesar Khan* (1941),

depicting an archer, blood-red clouds behind him, as he looses an arrow across a barren plain (see Illustration 39); and *Sword of Gesar* (1943). Reminded, perhaps, of the composer Scriabin's dying effort to complete the flamboyantly ambitious and cosmically themed oratorio *Mysterium*, Roerich dreamed of creating an opera about Gesar—Wagnerian in scope, but culminating in redemptive victory, rather than the world-destroying *Götterdämmerung*, or twilight of the gods.[2]

Roerich brought no such opera into being, but to his mind it would have been a fitting accompaniment to the apocalyptic grandeur embodied by World War II. Over its six-year duration, the war elicited from Roerich a paradoxical psychological reaction. A man of peace, he abhorred the earth-shattering violence, and when the conflict expanded to Russia, he feared the existential menace to his homeland.

But on another level, the struggle, fought with Homeric intensity and on a planetary scale, sparked within him a renewed sense of purpose. With mechanized barbarism threatening every corner of the earth, the moral stakes at hand and the proper course of action seemed clear to him for the first time since his return to India. The quest for victory quickened his passions as few other things could have done.

On balance, though, despair predominated. Nicholas and Helena enjoyed a scattering of happy personal moments, but they spent the war years in near-constant isolation and remained powerless to halt the decline in their health. When news reached them from outside, it spoke all too often of the death or disappearance of friends and loved ones. Having dreamed so long of steering the course of world events, they felt crushed by a sense of impotence in the face of global chaos. The tides of history carried them along, showing no greater favor to them than to anyone else. "Armageddon thunders on, and its psychic impact is enormous," wrote Roerich in January 1941. "The Dance of Death plays out not just on the fields of battle, but in every dimension of earthly life."[3]

Even war's end brought little surcease. Relief at the advent of peace was countervailed by emotional exhaustion and the pain of bereavement. Fascism might lay in ruins, but new dangers had been brought into being by the Cold War and the dark alchemy of atomic arms-making. Desperate to return to Russia, Roerich was repeatedly rebuffed by the Soviet authorities. The joy he experienced in 1947, when India won its freedom, soured as the trauma of Hindu–Muslim partition tore the newborn country apart. Worst of all, his body began its final self-betrayal, allowing heart disease and cancer to work their fatal ravages till there was no destruction left to accomplish.

Until the summer of 1941, the Roerichs' dismay about World War II was mainly abstract. British India went to war against Nazi Germany in September 1939, and while Japan held back from the conflict, its predatory interest in South Asia was obvious and unnerving. Still, the fighting remained distant, and Russia kept neutral for now.

Not that these months gave Roerich peace of mind. His legal wrangles in America limped to their sad end as high courts struck down his appeals against the Horches and the IRS. He resented the limitations imposed on him by his newly diagnosed heart disease. And the war, far away though it might be, was going poorly. Axis mastery over continental Europe seemed assured by late 1940. In Asia, the defeat of France and the Netherlands left colonies such as Indochina and the Dutch East Indies vulnerable to Japanese aggression. In September 1940, Roerich marked the war's anniversary by comparing it to the end times. "What a fateful year has passed!" he exclaimed. "Armageddon has befallen us!"[4] Prospects for 1941 looked no better.

Adding to Roerich's distress was the conflict's growing impact on India. Home-front privations became noticeable in 1940 and bothersome in 1941; they would reach crisis level by 1942. The war also exacerbated tensions between the British Raj and its Indian subjects. These emerged in 1939, when India's Viceroy, Lord Linlithgow, declared war against Germany without consulting the Indian National Congress or Muhammad Ali Jinnah's Muslim League. Both were willing to comply with British wartime policy, but not unconditionally. Jinnah, by now diverging from Congress's ideal of a united India, hoped to win London's support for a separate Islamic homeland. As for Congress, most of its leaders—notably excepting Subhas Chandra Bose, who broke away to collaborate with the Japanese—execrated the Axis and agreed with Jawaharlal Nehru that "our sympathies must inevitably be on the side of democracy."[5] Still, recalling the shabby treatment India had received after World War I, Congress had no wish to contribute to another British war effort without firm assurance that Indian sacrifices would be rewarded. In October 1939, Nehru pledged Linlithgow his party's full cooperation, but only if Britain guaranteed India outright independence after the war, instead of half measures like home rule. Linlithgow rejected this request out of hand, and in a report to Gandhi, Nehru wearily observed that "the same old game is played again. The background is the same, the various epithets are the same and the actors are the same and the results must be the same."[6]

Distrust worsened in 1940. That March, the Muslim League issued the Lahore Resolution, outlining its desire to form "autonomous" states where "Muslims are numerically in a majority." This divided the league's interests from Congress's and marked a pivotal step toward postindependence partition. Over the summer, Congress locked horns again with Linlithgow, who, on behalf of Winston Churchill, the new prime minister, offered a promise of dominion status for India as soon as circumstances permitted. This vaguely phrased offer fell short of what Congress had already demanded, causing the group to launch a campaign of civil disobedience in the fall. The British struck back in October, arresting hundreds, including Nehru, who remained in custody until December 1941.

Even tucked away in the Kulu Valley, the Roerichs shared in this general stress. Material want did not yet trouble them as it later would, but one pinch they felt early on was the rationing of gasoline. This added to their already pronounced feeling of isolation, especially with twelve miles separating Hall Estate from the nearest post office. A letter from 1940, to the biographer Barnett Conlan, shows how peevish this sense of confinement could make Roerich. "You live calmly in Paris," he chided Conlan in response to a query about *The Rite of Spring*, "and imagine, of course, that everything here is in good order." Describing angrily the letters and records that had vanished or been made inaccessible to him, he returned to Conlan's original question. "You ask

if I have with me the libretto to *The Rite of Spring*. Of course I do not, just as I no longer have many other things. Where have they disappeared to? Well, do we not live on the edge of Tibet, in these days of Armageddon?"[7]

The family resented British high-handedness, whether toward ordinary Indians or persecuted figures such as Nehru and Gandhi. And as the war spread to new fronts in Europe and Asia, their anxiety was compounded by fear for friends and loved ones living in combat zones or under Axis occupation. From Shanghai to Bruges, from Prague to Paris, dozens of the Roerichs' relatives and colleagues seemed to disappear without a trace. Conlan (interned after the Nazi takeover of France), Valentin Bulgakov (swept up by the Gestapo in June 1941), Alfred Heidok, Rihards Rudzītis, and so many others—were they dead? Under arrest? Or simply cut off as the war disrupted normal communications? Years of apprehension lay ahead, as the family pondered the fates of those gone missing.

Minor compensations banished some of the gloom. Early in the war, Roerich reestablished contact with several people he had fallen out of touch with. Alexei Remizov, for example, still exiled in Paris, swapped letters with Roerich about *russkost*, or "Russian-ness," in the months before France's fall.[8] A more surprising reconnection was with Igor Grabar, whose autobiographal revelations had infuriated Roerich in 1937. The turnaround came in 1939, when Roerich confessed to Valentin Bulgakov that,

whatever hurt Grabar might have caused him, he could not bring himself to stay angry: "It is, after all, water under the bridge. . . . No wound should be considered unhealable."[9] Bulgakov attributed this to the mellowing effects of Eastern philosophy, and he acted as intermediary, informing Grabar of Roerich's change of heart. Grabar reached out, and the two were never again out of touch. "The peace policy bore fruit," Bulgakov later noted with satisfaction.

Roerich also inserted himself into India's political and artistic life. He openly supported independence, and though his health left him unable to play agitator or march in the streets, his sympathy was appreciated by those who did. He wrote tracts and essays, painted new paintings, and showed his work widely. He reacted to this second world war with the same idealistic energy he had shown during the first, reminding all who would listen that "we must not cease to defend art. Art and Science are indispensable always, but in our days of Armageddon it falls to us to guard them with every ounce of our strength. . . . Without Art, the soul of the nation perishes."[10]

Helping Roerich here were the bona fides he had established with Rabindranath Tagore and others among India's intellectual elite; he was aided further by George's and Sviatoslav's growing list of contacts. In 1940 alone, shows in Bombay, Calcutta, Hyderabad, Lahore, Mysore, Allahabad, Travancore, Benares, and Madras featured his art.[11] His writings appeared in papers and journals ranging from *Maha Bodhi* and

the *Theosophist* to the *Hindustan Review*, *Young Ceylon*, the *Malabar Herald*, and *Free India*.[12] An Indian Roerich Society came into existence, with its secretary, K. P. P. Tampi, penning a worshipful biography of the artist, titled *Gurudev*, or "divine teacher." His personal ties with the Tagore clan grew tighter, as Sviatoslav began courting the poet's grandniece, the actor Devika Rani. The star of *Karma* (1933), the first Hindi-language sound film, Rani played an instrumental role in developing India's movie industry, founding the influential Bombay Talkies with her husband, the director Himanshu Rai. After Rai's death in 1940, Rani gave up acting to run Bombay Talkies and soon thereafter found herself charmed by Sviatoslav. The two eventually married, and while Tagore himself did not live to celebrate their union—he passed away in August 1941—the joining of the families filled Roerich with joy.

Roerich's paintings from 1940 and early 1941 reflect the preoccupations of the day. He idealized India in *Treasure of the Snows* (1940), which depicted Kanchenjunga, his favorite mountain; *Brahmaputra* (1940), in which the river winds like a silver ribbon through dark hills; and *Nanda Devi* (1941), an ethereal portrait of India's second-highest peak. To sublimate his anxieties about Russia—still at peace, but for how long?—he allegorized his homeland's saints and heroes. Alertness was the theme of canvases like *Alexander Nevsky* and *Message to Fyodor Tiron*, both from 1940. Seven centuries before, the real-life Nevsky had repelled Teutonic crusaders with an epic victory on the ice-covered surface of Lake Peipus. As movie buffs know from Sergei Eisenstein's monumental film version of this story, Nevsky's triumph was a ready-made symbol of Slavic defiance in the face of German menace. Fyodor Tiron is the Russianized form of Theodore Tyron, a Roman soldier canonized as a saint in the Orthodox Church; here, he guards a frontier castle in midwinter. Also in 1940, Roerich returned to a favorite subject: Sergius of Radonezh, Russia's patron saint and great protector.

If works like these advocated vigilance, others conveyed Roerich's sense of foreboding, much like his "prophetic" paintings from World War I. *The Thrice-Tenth Kingdom* (1940) takes its title from old Russia's *skazki*, or "wonder tales." Traditionally, this land of enchantment is home to the object of the hero's quest, or to foes like the witch Baba Yaga. Roerich equates it with Shambhala, presenting it as a mountain refuge, where the virtuous, sheltered by silver-blue peaks, pray in darkness for better times to come. *She Who Waits* and *The Hermit*, a pair of canvases from 1941, function as metaphorical self-portraits. In the former, a shamaness stands by the shore of a lake; the latter depicts a male guru, meditating in a mountain valley. Both speak to the Roerichs' remaining glimmer of faith that, as embodiments of Maitreya and the Mother of the World, they had some part yet to play in the universe's grand scheme. As for the war itself, Roerich's uncertainty about its outcome found expression in early

1941, when he completed a second version of *Armageddon*, just as disquieting as the 1935–1936 original.

In the second half of 1941, two hammer blows brought wartime reality closer to home for the Roerichs. On June 22, Adolf Hitler launched Operation Barbarossa against the USSR. By the fall, three mammoth blitzkriegs had penetrated far to the east. One gave the Germans possession of Kiev; a second carried them along the Smolensk road to the gates of Moscow. The third force surrounded Leningrad—Nicholas and Helena's home city—and besieged it for the next two and a half years. Only as winter set in did the Red Army blunt the Germans' momentum. This left the enemy stalled outside Moscow, but also standing in strength, deep in Soviet territory, along a front stretching a thousand miles north to south.

Then, in December, Japan suddenly expanded the range and lethality of its war in Asia. After bombing Pearl Harbor, Japanese forces swept to victory in Hong Kong, Thailand, Singapore, the Dutch East Indies, and the Philippines. Threatening India most directly was Japan's invasion of Burma. By March 1942, the Japanese had taken Rangoon and severed the Burma Road, the supply route linking China with India. British and native defenders retreated to the Burmese–Indian border, and only the monsoon rains of May kept the Japanese from pushing into India itself. Adding to this danger was the emergence of a pro-Japanese Indian National Army, a fifth column commanded by the Congress renegade Subhas Chandra Bose. Bose had fled from India to Germany in 1940 and now, with Axis assistance, returned as a would-be quisling. From the spring of 1942 onward, India was in a perpetual state of emergency.

These new offensives provoked strong reactions from the Roerichs. Russia's plight fired their patriotism, and in an initial flush of excitement, they envisioned the gargantuan clash of arms there as the epochal struggle that would shape the coming new age. The Soviet theater, Roerich wrote, was equal in grandeur to Kurukshetra, the north Indian plain where the fabled war between the Kauravas and Pandavas is said to have been decided, forming the subject of the *Mahabharata*.[13] Roerich exulted at the thought that Russia's involvement would make the difference between victory and defeat. "The outcome depends entirely on the Russian people," he wrote. "About this there can be no debate. And you must forgive me if I delight in Russia's accomplishments. They stand out so brilliantly, they invigorate all who witness them, and I rejoice that it is specifically our people to whom this destiny [of saving the world] has fallen."[14]

Biographical convention holds that George and Sviatoslav petitioned Soviet officials for permission to enlist in the Red Army, but to no avail. As for the elder Roerich, he sought to boost Soviet morale and rally international sympathy for Russia with

rousing essays and new canvases. "Amid thunder and lightning," he wrote in 1941, "the Russian people are forging their own glory. Amid thunder and lighting, heroes will be born."[15] He continued to paint saints and heroes from Russia's past, invoking their protective might and virtue. Subjects included *Yaroslav the Wise* (1941 or 1942), the resolute warrior-prince of Kievan Rus; *Vasilisa the Beautiful* (1941), the beloved fairy-tale heroine; the martyrs *Boris and Gleb* (1942); the herculean warrior-giant *Sviatogor* (1942); and the armor-clad, Amazonian *Nastasia Mikulichna* (1942–1943). In *Prince Igor's Host* (1942), Roerich returned to a theme dear to him for decades, though he doubtless hoped for the Red Army to come to a better end than the doomed force in the old tale.

Recalling his aptitude as a wartime fundraiser from a quarter century before, Roerich put his paintings to practical use. In 1941, he and Sviatoslav sold over two dozen works at exhibitions in Lahore and Indore, with all proceeds going to Russian war relief. *Alexander Nevsky* went for 2,500 rupees, and the Maharajah of Indore donated an additional 50,000 rupees to the Russian Red Cross. Working toward a clear goal reenergized the aging artist, and he permitted himself a brief period of exhilaration at the end of 1941: in December, the Red Army, buttressed by troops redeployed from the Siberian frontier, struck hard against the German forces approaching Moscow. This counteroffensive lasted into January 1942 and pushed enemy units many miles westward, shocking the overconfident invaders.

Roerich celebrated these triumphs in the essays "Mighty Russia" and "A People's Victory."[16]

Such optimism, however, quickly dimmed. When fighting resumed in the spring of 1942, the Germans sliced through Soviet defenses, especially in the south, where their progress brought them to Stalingrad by the end of August. On all sectors of the front, there was much to mourn. Leningrad, encircled the previous autumn, remained in the cruel grip of the Nazi blockade, which by its end would claim approximately 1.5 million Soviet lives. So much of Roerich's identity, past and present, was interwoven with the city's fate, and he and Helena hungrily collected every scrap of news they could get of its ordeal. He spent countless hours pondering which of Russia's treasures the Germans might have damaged or destroyed. How many of the churches and castles he had painted so lovingly in Novgorod and Pskov now lay in ruins? What of Princess Tenisheva's Talashkino estate, which stood squarely in the German line of advance? He recoiled in horror to hear that German forces had vandalized such cultural shrines as Tchaikovsky's home, the Rimsky-Korsakov Museum, and Tolstoy's grave at Yasnaya Polyana. "What savagery!" Roerich spat in disgust. "Thus do we see what the great-grandsons of Schiller and Goethe have come to!"[17] As for family and friends still in Russia—the Mitusovs and Nicholas's sister Lydia in Leningrad, or Boris in Moscow, from whom there had been no news for months—Nicholas and

Helena barely dared to contemplate their fates.

The outlook for Asia looked little better. Roerich's misgivings about 1942 can be seen in paintings like *The Last Angel*, a reworking of his 1912 original, and essays such as "The Rebuilding of the World," in which he interprets the trends of the day as the stuff of prophecy. "Only yesterday, we read the divinations of Guru Govinda with disbelief," he writes. "Today we marvel at their fulfillment. Yesterday, we laughed at Nostradamus; today, his visions are cited in the most serious journals. The world lies in Babel-like confusion, with the threat of technocracy on one side and the wisdom of the *Bhagavad Gita* on the other." He then exhorts his readers to "take comfort in the knowledge that the rebuilding of the world approaches, and that the Russian people, indefatigable as ever, will succeed beyond success."[18] Given the sad state of the Allied war effort, Roerich likely intended these reassurances as much for himself as for his audience.

Despite his oscillations between hope and despair, it was in 1942 that Roerich came alive as a wartime activist. This included a more visible association with Congress's drive for self-rule. Still aiming for full independence as a price for wartime cooperation, Congress continued its balancing act of defying the British without plunging into actual betrayal. Neither Congress nor the Muslim League would actively aid Britain's foes, the way Subhas Chandra Bose and the Axis-backed Indian National Army chose

to do, but the question before both groups was how to respond to the relative leniency of British policy between December 1941 and the summer of 1942. Nehru and the other Congress notables jailed in October 1940 were suddenly released, and with the Japanese bearing down in early 1942, Winston Churchill delegated Stafford Cripps, the most prominent Labour member of his war cabinet, to negotiate once again with India's leading nationalists. Jinnah and the Muslim League held to the two-nation goal enshrined in the Lahore Resolution. Nehru felt tempted to compromise, even though Cripps had little more to offer than the same amorphous assurances about self-government from before, but others in Congress—including Gandhi himself and Sardar Vallabhbhai Patel, the future commander in chief of India's armed forces—proved more intransigent. In August, Gandhi persuaded Congress to begin its "Quit India" campaign, a nationwide program of civil disobedience meant to undermine the Raj's authority and compel it to depart the subcontinent. Viceroy Linlithgow, unwilling to tolerate such disruption, cracked down, quashing riots and strikes throughout the autumn and arresting over sixty thousand, including Gandhi, Nehru, and every high-ranking member of Congress within reach. Age and failing health won early release for Gandhi, in May 1944, but not till June 1945 would Nehru and his fellow detainees taste freedom again.

It was during the interlude preceding "Quit India" that Roerich experienced his

most memorable moment as a Congress ally: for a week in May 1942, he and Helena hosted Nehru and his daughter—the future Indira Gandhi, then twenty-four years old—at their home in Naggar (see Illustration 38). Nehru already had warm feelings for Roerich. Tagore had endorsed him, and Nehru himself knew Roerich's work and rated it highly. Nehru's autobiography, *Toward Freedom*, recounts the mental exercises he put himself through to maintain psychological equilibrium while in prison. Most famous was his feat of compiling an analytical outline of global history—originally in the form of letters to his daughter, later published as *Glimpses of the World*—entirely from memory. Another, meant to stave off claustrophobia, was to read narratives of exploration, and of these tale-spinners, Roerich became one of Nehru's favorites. "In prison, one hungers for wide spaces and seas and mountains," Nehru later recalled. "Travel books were always welcome," whether by "old travelers [such as] Hiuen Tsang, Marco Polo, Ibn Battuta, and others, or moderns like Sven Hedin or Roerich, finding strange adventures in Tibet."[19] Face-to-face, Roerich did not disappoint, and Nehru treasured the time spent in his company.[20] The two spoke about philosophy, art, and India's future. Both favored unity, with no separate nation for Muslims, and they made plans for the Indo-Russian Cultural Association (IRCA), a new organization that Roerich and the Maharajah of Indore were in the process of establishing. Sviatoslav completed studies for portraits of Nehru and Indira,

and Nehru remained in touch with the family for years, expressing public admiration for Roerich on many occasions.

The blessed tranquility of this visit made it all the more galling when, two and a half months later, the "Quit India" controversy landed Nehru in prison again. Roerich's papers from August show his outrage at Britain's suppressive actions. When the authorities violently put down protests in Delhi, Bombay, and Calcutta that month, Roerich cried out, "as India turns this new page in its history, everything is so terrible, words cannot describe it."[21] He deplored the arrests of Gandhi, Nehru, Gandhi's secretary Mahadev Desai—who perished of cardiac arrest when taken into custody—and Nehru's sister Lakshmi Pandit. His anti-British indignation flared as the war went on.

Roerich's second project in 1942 involved mustering US support for Russia's war effort. This was already a bandwagon cause, with Lend-Lease largesse flowing to the USSR and a variety of groups staging rallies and fundraisers for America's newest cobelligerent. Some of these were explicitly or covertly communist (if not Soviet-controlled), while others acted out of common cause against Germany. Hovering in between was the entity that Roerich nominally headed. In conjunction with the Indo-Russian Cultural Association he had founded with the Maharajah of Indore, Roerich helped to assemble an American-Russian Cultural Association (ARCA). ARCA's day-to-day work fell to the remnants of

Roerich's New York circle and other friendly associates there. Joseph Weed headed ARCA, with Magdalena Lehrer as his chief secretary; Roerich served as honorary chair.

IRCA and ARCA cooperated with Soviet diplomats in India and America. IRCA published a newpaper titled *News of the Soviet Union* and made plans (never realized) to build a museum of Russian art in Delhi. ARCA linked itself to an institution with a long history of propagandizing for Moscow: the All-Union Society for Cultural Relations with Foreign Countries (VOKS), whose purpose since 1925 had been to foster friendly ties between Soviet cultural elites and their counterparts abroad. VOKS won much sympathy during the 1930s and 1940s among left-leaning Western intellectuals, but is also known to have fronted Soviet intelligence operations. There is no doubting the sincerity of Roerich's wish to help his homeland, but cooperating with VOKS also gave him the chance to ingratiate himself with Soviet officials, advancing his own goal of someday returning to the USSR.

Whatever Roerich's motivations, ARCA raised considerable sums for the Red Army and valorized Russia's wartime struggle in the eyes of the American public. Its success depended on numerous artists, musicians, and authors; some of these had ties with Roerich, while others knew little of him but were happy to put their name recognition to good use. Included here were superstars such as Charlie Chaplin, Ernest Hemingway, and Upton Sinclair. The painter Rockwell Kent, who had taught at the Master Institute, played an active role in ARCA, as did the Russian American conductor Serge Koussevitzky, then in the midst of his tenure with the Boston Symphony Orchestra, and the Ballets Russes choreographer Léonide Massine, who joined ARCA's board of directors.

ARCA did not accomplish all Roerich desired it to. He was too far away to regain more than a tiny bit of his former American fame, and whatever good ARCA did, Moscow was not persuaded by it to let Roerich come home after the war. Still, the fundraising gave him a much-needed sense of relevance, and partnering with ARCA and VOKS allowed him to promote his own work. Both organizations, along with the USSR's State Publishing House (Gosizdat), published his essays and sold reproductions of his paintings, old and new. At the least, such work gave Roerich focus and direction that he would otherwise have lacked at this trying time.

If Roerich gained mental surcease from his art and his activism, it was sorely needed in late 1942 and early 1943. Soviet collapse seemed all but certain during these months, and while India did not face immediate ruin, material conditions declined horribly.

In the summer of 1942, German troops continued their strangulation of Leningrad and, in the south, bulldozed to the Don and Volga Rivers, reaching the gates of Stalingrad at the end of August. There, in

September and October, the German Sixth Army came within a thousand yards of pushing Soviet forces across the Volga, a feat that would have all but guaranteed Hitler's victory in the east. The Red Army's stand to hold the enemy back gave rise to months of grueling combat, killing nearly two million on both sides and leaving the entire war's outcome in doubt for weeks on end.

To the Roerichs, the clash at Stalingrad signaled the apocalypse at hand. Also, the war's personal stakes felt higher than before. The fate of loved ones in Leningrad remained a mystery, and Nicholas tormented himself with worry about his brother Boris. A touch of relief came in September, when a letter from Boris reached Naggar. "What joy!" Roerich noted in his diary, but the letter was dated June 18, and knowing that his brother was in poor health, he grew anxious again.[22] Another letter, written in December 1942, came in March 1943, but silence fell after that, causing Roerich to ask again and again, "What is happening with Boris?" He had no way to know that this December letter was the last communication he would have with any of his siblings.

Roerich found it a challenge to sort through his feelings in 1943. On the broad scale, there was cause for hope. The previous November, fighting on the Eastern Front had turned decisively in the USSR's favor, as the Red Army unleashed Operation Uranus, a counterattack that encircled Axis forces in and around Stalingrad. Over the winter, the Soviets tightened the noose, and all the Germans trapped within had died or surrendered by February. Nicholas dedicated the essay "Glory!" to the Stalingrad triumph, and the family took cheer from the string of Allied wins that followed: the defeat of Rommel in North Africa, the Amercians' grinding slugfest against Japan at Guadalcanal, and the summer invasions of Sicily and southern Italy, which toppled Mussolini's Fascist regime. ("Italy!" Roerich shouted upon hearing this news. "The Axis has been broken!"[23])

News from Leningrad, still under siege, was less uniformly good. The city was safer than in 1941–1942, with the front now stabilized, methods of supply established, and most nonessential civilians evacuated. Roerich took pride in his hometown's unyielding stand, ceaselessly praising Andrei Zhdanov, the Communist Party secretary in charge of Leningrad's defenses, and taking inspiration from Dmitri Shostakovich, whose Seventh Symphony, dedicated to the city's wartime suffering, had won international renown since its Moscow premiere in March 1942. Leningrad's first performance of the Seventh, given in August 1942 by the starvation-depleted Leningrad Radio Orchestra and broadcast throughout the city after the silencing of German artillery by a deliberately timed Soviet cannonade, remains a stirring instance of odds-defying courage. Of the symphony, Roerich wrote in 1943, "It is astounding how, in a country pierced to the very heart by its enemy, where one has to defend one's life hourly, and where hunger and cold dominate everyday existence, art has been placed above all

else!"²⁴ On the other hand, neither he nor Helena could think of Leningrad without pondering the still-unknown whereabouts of their loved ones.

If any event from the year crystallized Roerich's confidence in Soviet victory, it was the Battle of Kursk, which raged on the Russian steppe from July 5 through July 13. Hoping to avenge his losses at Stalingrad, Hitler sent 780,000 troops and almost 3,000 tanks to pinch off the Kursk salient, a bulge in the front lines some 300 miles south of Moscow. These forces stumbled into a cunningly prepared, mine-strewn killing zone where 1.9 million Red Army troops, supported by more than 5,000 tanks, awaited. In what is popularly considered the largest tank battle in history, the Soviets stopped the German advance and crippled the Wehrmacht's capacity for large-scale offensive action in the east. The Soviets then shouldered their way westward through Ukraine, liberating Kiev as a Christmas gift to Stalin. In December, Roerich bragged contentedly that "Russian might has shielded and saved Roosevelt and Churchill."²⁵

To this feat of arms, Roerich attached the highest order of cosmic significance. Nineteen forty-three, he and Helena declared, marked the year of transition between Kali Yuga, the epoch of degradation, and Satya Yuga, the blessed age that renews the universal cycle. They pegged the exact moment of transformation to August 1, in honor of Kursk. "Today the sun has set, and the age of Kali Yuga has ended," Roerich affirmed. Rigden Djapo, the Avatar of Light

and King of Shambhala, would enter the fight in a matter of days. "The word 'Shambhala' can be heard on everyone's lips! Just think how many people lived in anticipation of 1943!"²⁶ Thus had the new age dawned, and the task of leading humanity into this bright future now belonged to Russia. The painterly apotheosis of this vision can be found in *Terra Slavonica* (1943), a large canvas in which an old tsar looks out from the bell tower of a kremlin standing on a lakeside promontory. The land is green and lush, with mist-blanketed mountains in the distance. This is Russia at its most idyllic, the foundation upon which Roerich hoped the destiny of the USSR—and the world as a whole—would be built.

At closer range, circumstances made it hard to sustain this rosy view. Even with Congress decapitated by the arrest of its leaders, resistance to British rule continued, and the consequent reprisals further stoked Roerich's anti-British animus. Of Churchill's snide dismissal of Gandhi as a "naked fakir," he wrote, "What inhumanity! How contemptible!"²⁷ He likewise abominated Britain's mishandling of the Great Bengal Famine, which killed perhaps three million people. Touched off by the flood of refugees and the disruption of food supplies resulting from Japan's invasion of Burma, the famine was made even deadlier by the Churchill government's draconian refusal to divert any resources from the war effort. In October 1943, the viceroy, Archibald Wavell, organized relief efforts in defiance of Churchill's policy, but deaths continued into 1944.

Famine did not touch the Roerichs directly, but a wider range of deprivations now did. Mail from even relatively safe places reached Naggar more than three months late, if at all. Electric power blacked out routinely, sometimes for days on end, and kerosene was in short supply. With no gas to be had, the family car stood idle, and winter cold became a true hardship. The household made do with candlelight in the evenings. Batteries for the radio, the family's only link to the outside world, were increasingly difficult to obtain. The family also ran low on art supplies and paper, a shortage that impeded Nicholas's artwork and Helena's efforts to finish her later "Agni Yoga" volumes. It was always cause for jubilation when friends and well-wishers got packages through to Naggar containing paints, ink, canvases, and paper. Particularly generous in this respect were the Muromtsevs, Helena's cousins in New York.

Another malaise, more intangible, seeped into the household. The most gut-churning fears—that fascism would triumph, or that Russsia would fall—had passed, but the Roerichs found it hard to shake off a duller sense of futility. The grand sweep of World War II was enough to make anyone feel minuscule. But for Nicholas and Helena, who had seen themselves for two decades as agents of destiny, this sense of in-consequentiality was even more disheartening. Unable to alter the war's course by one iota, the couple could only wait and watch, marginal and increasingly penurious, as the conflict dragged on.

⁘

For the Roerichs, the war's last years ticked by slowly, full of fretful tedium. Combat news, at least, was positive. In January 1944, Leningrad freed itself from the torment of its twenty-eight-month siege. Over the spring and early summer, British India repulsed the Japanese forces that had gathered at Imphal to invade from the northeast. The twin triumphs in Europe that summer of the Normandy landings and Operation Bagration, as the USSR nicknamed its westward-thrusting Belorussian Strategic Offensive, assured the eventual defeat of Germany. A satisfied Roerich wrote in August, "Russia's victories take one's breath away! Each day the Red Army captures hundreds of objectives— what inexhaustible energy!"[28]

But all this took time, and, disappointingly, the successes of 1944 would not end the war by Christmas, as many had hoped. Age proved another source of urgency: Nicholas turned seventy in October 1944, and Helena was sixty-five. Between his heart troubles and her long-term debilitations, neither could be sure how many years remained to them. Most often, Roerich contemplated this fact with equanimity or distracted himself with his work. Still, he yearned to see his homeland victorious, he yearned to return to Russia, and he yearned to know for certain that some aspect of his legacy—artistic, philosophical, or human-itarian—would live on. In his lowest moments, Roerich feared he would pass from life without accomplishing any of this.

There were other spasms of discontent. The domestic discomforts of the war's middle years grew more burdensome in 1944 and 1945: the scant rations, the lack of fuel and electricity, the irregular delivery of papers and the mail. Roerich tried to put a brave face on things, emphasizing the peaceful solitude that reigned over Kulu: "The sunrises and sunsets are always a comfort to us. And the stars, always the stars! Thus far, our eyrie remains one of the most serene places on earth."[29] More frequently, though, he compared existence in Naggar to life on an island or in a monastery, confessing that "with every day, our isolation grows."

Further darkening the family's mood was the knowledge that the faster the war ended, the sooner they would have to confront the loss of loved ones. Every joyful tiding from the front carried a reminder of the butcher's bill that impended, and while no one wished to see that bill come due, it was maddening to have months go by with no idea who had survived and who had not. As Roerich lamented in the spring of 1944, "the delivery of mail has ceased almost completely. As a result, we do not know where many of our friends are. It is awful to think how many may not have lived through this terrible Armageddon."[30]

Most agonizing was the long dearth of news regarding Boris, whose last letter had arrived in March 1943. A year and a half passed without a single word from or about him. Was he still in the capital, or had he and his wife Tatyana been evacuated to the east? Had illness overtaken him, or had he once again been arrested? Between the spring of 1943 and the fall of 1944, Roerich speculated constantly about Boris's fate: "His silence is incomprehensible," "We are at our wits' end as to why his letters have ceased so abruptly," and, plaintively, "Where has he gotten to?"[31] Finally, in October, another update arrived—but it was from August 31, a month and a half old, and it brought bad news: Boris had been hospitalized, although the reason was not well explained.[32] Two weeks later, Roerich learned from the ballerina Valentina Dutko, a mutual acquaintance, that Boris had recovered enough to be sent home.[33] This welcome bulletin, however, was followed by another four-and-a-half-month information gap, leaving Roerich as confused and dismayed as before.

Other disgruntlements rankled: some consequential, others less so. Against the British, Roerich rehashed old grievances and took up new ones. Gandhi was released in May 1944 due to poor health, but the artist remained in high dudgeon over the Raj's continued abuse of Congress. He also picked a petty fight with the British over a renewed but wildly impractical desire to return to Tibet. Whether this sprang from nostalgia or some last-ditch hope of fulfilling the Great Plan, Roerich was deluding himself if he thought he was physically capable of making such a trip or that the Raj would consider letting him attempt it. Told that he would not be allowed to reenter India if he insisted on leaving for the north, he felt unfairly singled out and fell into a prolonged sulk.

The British, he griped, were happy to wave through anyone else who wished to visit Tibet, including the hated Germans: "Only Russians are forbidden. When George and I ask, the British turn their long noses up at us."[34] It was true that several explorers traveled to Tibet between the late 1930s and mid-1940s, including Wilhelm Filchner, whom Roerich particularly disliked; the zoologist Ernst Schäfer, leader of the 1938–1939 SS-Tibet Expedition sponsored by Heinrich Himmler; Austria's Heinrich Harrer, of *Seven Years in Tibet* fame; and the American naturalist Brooke Dolan, who, with Ilya Tolstoy (the novelist's grandson), met the Dalai Lama in 1942–1943. But this hardly constituted an open revolving door. Schäfer had left Asia before the war started, Harrer's purpose in trekking to Lhasa was to escape British detention, and Dolan and Tolstoy, carrying out a covert mission for the Office of Strategic Services—the CIA's forerunner—proceeded in secret. And had he known it, Roerich could have taken spiteful comfort in the fact that Filchner, working in Nepal when the war began, ended up in a British internment camp, ill with malaria and kidney stones. Instead, Roerich carped for months about the Raj's injustice: "They say, of course, that I am a big Soviet spy. And Helena is the most dangerous woman in Asia!"[35] Such petulance brought him no closer to Tibet.

More abstractly, Roerich was haunted by doubts about what the war's end, no matter how victorious, might bequeath to the world. He now warned that a new struggle, which he termed the "Armageddon of Culture," would pit enlightenment against barbarism. "The current phase of Armageddon is nearing its conclusion," he told his American followers. "But a more difficult phase lies ahead: the cleansing transformation of life itself, presently tainted by hatred and ignorance."[36] Such thinking prompted Roerich to declare 1944 the "black year" of Lonak, foretold in Tibetan and Bhutanese folklore.[37]

Even so, the Roerichs could not help greeting the spring of 1945 with lighter hearts. The season of rebirth was always welcome. Mail service had begun to recover. With growing pride, the household followed the war's endgame in Europe, as the Allies steamrolled toward Berlin from east and west, forcing Hitler's suicide in April and Germany's surrender in May. During Easter week, Nicholas reminisced about the Trinity-Saint Sergius Monastery, the spiritual heart of the Russian Orthodox Church, mixing in his mind joyful anticipation of the USSR's martial triumph with past impressions of old Slavdom's sacral virtues. "As the Paschal celebration approaches," he exulted, "we can speak at once of springtime, victories, and the Glory of Russia."[38] His good cheer was amplified by confidence that he would soon be returning to Russia, aided by his wartime fundraising with VOKS and ARCA, as well as the relationships he had cultivated with India-based correspondents for TASS (Telegraph Agency of the Soviet Union). Letters from Igor Grabar in Moscow encouraged him further. Whether

Grabar spoke seriously or out of politeness when he wrote that "those of us still alive who were privileged to be your friend have kept close watch on your successes abroad and have faith that you will someday return to us," Roerich latched on to his words as a sure sign that his return to Russia was eagerly awaited.[39]

The spring did not pass without sadness. The hardest blow came in March, when definitive news about Boris arrived from Moscow. "The enigma has been cleared up," Roerich noted, "but the answer is sorrowful. On March 9, we received a telegram from Tatyana: Boris is in the hospital, gravely ill. We are trying to telephone, but there is no doubt the situation is critical."[40] A month later, Roerich learned that Boris was "dangerously ill with a disease of the brain," and while Tatyana still hoped he might recover, the illness overtook him in early May. On the seventeenth, Roerich addressed this letter of consolation to his widowed sister-in-law:

> Dear Tatyana Grigorevna! It is sad news you have delivered to us. We mourn Boris as a kind and beloved man and as an outstanding architect. Only recently, Borya and I dreamed of working together once more, but fate has decided otherwise. I know you understand how badly we want to know everything concerning Borya, his work, his final illness. Helena, George, and Sviatoslav have always loved Borya as much as I, and they also await any information you

can provide. We send you our best and most heartfelt wishes and look forward to hearing from you again. We are most sincerely with you in spirit.[41]

Virtually every tie to Roerich's childhood and upbringing had now been severed, with both parents and two siblings dead, and his remaining brother stubbornly incommunicado. But dismaying as it was to lose Boris, knowing what had become of him allowed honest grief to replace the uncertainty that had torn at Roerich for two and a half years. Another passing caught his eye at this time: the death of Franklin Roosevelt on April 12. Roerich acknowledged the moment, not with sadness, but neither with the resentment one might have expected. "Roosevelt has departed," he wrote solemnly. "Truman's speech [upon taking office] was quite good; he seems to be an honest man."[42]

The summer months somewhat restored the family's spirits. Germany's surrender came in May, and reconstruction in the USSR began soon after. In India, Nehru and other political prisoners were released from jail. By September, the British had agreed to hold elections at the end of the year to national and provincial legislatures that, in turn, would select the bodies responsible for writing a constitution and negotiating the terms of Indian independence. Much contention lay ahead before that goal's realization, but for the moment, Roerich shared in the general excitement.

Another moment of solace came in August, as Sviatoslav married Devika Rani after

nearly five years of courtship. With George already attached to Lyudmila Bogdanova, Nicholas and Helena had managed to see both sons settled into stable relationships. The wedding caused the two to reflect on their own nuptial happiness. In November 1941, they had marked their fortieth anniversary, a moment celebrated by Nicholas in this passage: "Forty years is quite a long time. On such a long voyage, meeting many storms and dangers from without, together we overcame all obstacles. And obstacles turned into possibilities. I dedicated my books to 'Helena, my wife, friend, fellow traveler, inspirer!' Each of these concepts was tested in the fire of life . . . we worked, we studied, we broadened our consciousness. Together we created, and not without reason is it said that the work should bear two names—a masculine and a feminine."[43] These sentiments washed over the couple again, as they watched their youngest pledge his troth to Devika. It gratified Roerich to see his family formally united with Tagore's, a satisfaction marred only by the absence of Tagore himself, who had died four years before.

Roerich finished a number of paintings at this time, aided by the greater availability of art supplies. Among these were Asian-themed works, including scenes of the Brahmaputra, flowing south from Tibet into India, and *Beda the Preacher* (1945), in which a blind holy man speaks to the stones surrounding a lake at sunset, eliciting a chorus of "amens" from the earth itself. Pride of place, however, belonged to a twin commission from far away. In 1944, Léonide

Massine, brought into contact with Roerich by his relief work with ARCA, mentioned his desire to stage a series of Ballets Russes classics once the war was over. That August, Roerich sent Massine a bundle of sketches for *Prince Igor* and *The Rite of Spring*. Massine praised them and asked if the artist would work them up into formal studies: "My heartfelt thanks to you for sending me [these]. It was a festive occasion when I received them. . . . I am convinced that the revival of [*Igor*] in such a beautiful interpretation will give much joy to all who know and value the true Russian ballet. Now, I have a strong desire to revive 'Le Sacre du Printemps' as well. My first thought was to use the material that was made in 1929 for the League of Composers, but to my regret, it no longer exists. May I ask you to make new sketches?"[44] Roerich did so with zeal, completing the task in 1945. In terms of subject, palette, and composition, he reprised his Ballets Russes designs from 1909–1913. From his earlier *style*, though, he departed significantly. His originals had been characterized by a roughness of line and an earthy feel; the 1944–1945 variants are stylized and sharply angular. Also, faces in the newer designs are clearly meant to appear more Asiatic than their older counterparts. The studies found their way to Massine as intended, but Roerich did not live long enough to see them used. They enjoyed a distinguished performance history, inspiring the decor and costumes for productions at London's Covent Garden, La Scala in Milan, and the Royal Swedish Ballet between 1948 and 1965.

As for the Roerichs in 1945, the war's last moments seemed to arrive suddenly, much like the end of monsoon season. The USSR invaded Japanese-held Manchuria in August. US forces had advanced across the Pacific to the country's home waters. All that remained was to unleash the new and terrifying thunder of atomic weaponry against Hiroshima and Nagasaki, on August 6 and August 9. With Japan's formal surrender on the deck of the USS *Missouri* on September 2, the deadliest armed conflict in human history was over. Like the rest of the weary world, the Roerichs were ready to put the long years of war behind them. But what would they make of the peacetime that now stretched before them?

Decades afterward, the Nobel Prize–winning physicist and activist Andrei Sakharov remembered the idealistic bliss with which he and his fellow students greeted the end of World War II. "We all believed," he says in his *Memoirs*, "that the postwar world would be decent and humane. How could it be otherwise?"[45] A similar optimism briefly governed Roerich's outlook, bolstered by his faith that "the coming century will be a Russian Century. And all those who contribute to the unfolding of this age will be blessed."[46] He expected, of course, to be one of those so blessed, returned to his homeland and helping to shape the bright era to come. Reality took little time to set in.

This sobering-up began as the family discovered the fates and whereabouts of those they cared about. Not only was Roerich's brother Boris lost, but Stepan Mitusov, Helena's favorite cousin, had died in 1942, during the Leningrad blockade. The same fate befell Roerich's friend Ivan Bilibin and, in 1943, his sister Lydia (though he seems not to have learned about this before his own death). Yekaterina Sviatopolk-Chetvertinskaya, the longtime companion of Roerich's patroness, Princess Tenisheva, had died in German-occupied France. The orientalist Viktor Golubev, who interested Roerich in Asian art before the revolution, had been teaching at the French Institute of the Far East in Hanoi and passed away under Japanese rule there. Other names, less famous but no less dear to the Roerichs, found their place on this necrology in the months to come.

There were a few happy surprises. Roerich's follower Alfred Heidok survived the ravages of war on the Chinese mainland and was back in touch by the end of 1945. The English Theosophist Barnett Conlan, having endured Nazi imprisonment in France, likewise resumed communications. Another friend emerging from German captivity was Valentin Bulgakov, the curator of Prague's Russian Cultural-Historical Museum. The Gestapo had snapped up Bulgakov in the summer of 1941, and Roerich had feared the worst. When Bulgakov's first postwar letter arrived in the summer of 1946, it brought great joy.

As colleagues and supporters resurfaced, Nicholas and Helena sought to rebuild

their old network. Some of these efforts led to little. For example, what of Georges Chklaver? Was he safe in Paris? (Yes, to the Roerichs' relief.) Could he be reenlisted to fight on the family's behalf? (No, to their frustration.[47]) Months went by without word from adherents in Bruges, Zagreb, and Belgrade, leaving Roerich to wonder whether they had been killed or displaced, or had simply abandoned him. He feared most for his Baltic followers, especially in Latvia, and found himself asking as late as 1946 and 1947, "Where are our Riga friends? What of Lukin and Rudzitis?"[48] Eventually, Nicholas and Helena reestablished some of their European ties. Outlawed by the USSR, Roerich's Latvian circle survived underground, preserving a sizable cache of his paintings and archival materials. Occultist admirers such as Alexander Aseyev and Boris de Zirkoff communicated regularly, and Helena remained in contact with the Theosophical Society in Adyar and Geneva. But little immediate benefit came from this.

Roerich's US following became less cohesive. Helena's cousins, the Muromtsevs, remained a source of comfort and care packages, but the New York circle had been reduced to a tiny core consisting of Sina, Dudley Fosdick, Katherine Campbell, and Ingeborg Fritzsche. Frances Grant was on the outs with this group and soon detached herself altogether. Maurice Lichtmann wrote now and again from Santa Fe, but kept aloof beyond that. As for the outer layers of America's Roerich-friendly community, most had fallen away or gone lukewarm.

Upton Sinclair might still call himself "impressed" by Roerich, and Rockwell Kent might remain "a good friend," but neither could be considered a committed "worker," and Roerich conceded that it was best to "leave such people in peace."[49]

Another dream—the hope of returning to Russia—flickered out after 1945. We know with hindsight how misguided this aspiration was, but it would not have seemed illogical in the moment; Roerich would have been far from the only émigré to repatriate as the USSR celebrated its wartime victory. The example that intrigued him most was the homecoming of the sculptor Sergei Konenkov, in the summer of 1945. The so-called Russian Rodin, who had resided in New York with his wife Margarita since 1923, sailed back on a ship dispatched to America on Stalin's direct orders and was promptly alloted a luxurious studio in central Moscow. Why, Roerich wondered, should similar honors not await him?[50] (He had no idea that Moscow's eagerness to bring Konenkov home stemmed less from regard for his art and more from curiosity about his wife's friendship with the atomic physicist J. Robert Oppenheimer and her probable romance with Albert Einstein. Whether or not Margarita actually spied for the USSR—an ongoing debate—the Kremlin wished to know more about these relationships.) His wartime fundraising with VOKS and ARCA, he felt, had established his patriotic reliability, and he counted on the good opinion that Soviet journalists in Asia seemed to have of him. The TASS

station head in Delhi was cordial, and according to Alfred Heidok, the TASS director in Shanghai had said of him, "Roerich is a force, and it is fortunate that such a force ended up in the anti-fascist camp."[51] Roerich took it as another positive sign that the New York–based Amtorg Corporation, the Soviet organization that oversaw trade with the United States (in addition to fronting intelligence activity and back-channel diplomacy), was seeking to buy a quantity of his paintings. In December 1945, the Amtorg representative Alexander Gusev asked Roerich if he would consent to such a purchase (even though he had no legal say in the matter, with the pieces in question owned by American collectors). Roerich replied with gusto. "I am deeply touched," he told Gusev. "I consider my ties to the Motherland never to have been broken, and I have always dreamed of bringing the fruits of my labor back to Russia. . . . I consider all these paintings part of Russia's cultural inheritance."[52]

Most of all, Roerich pinned his hopes on comments made by friends in Russia such as Igor Grabar. In 1944, Grabar had broached the idea of homecoming, and in May 1946, he told Roerich again, "Your return to Russia is widely discussed among us. You are needed here, badly needed."[53] He then went on with such brio about Konenkov's lavish reception in Moscow that Roerich, with a pang of envy, could not resist reading deeper significance into these remarks. "There must be a reason," he insisted, "that Grabar described this episode in such detail."[54] Was Grabar simply

gossiping? Offering courteous platitudes? Or, as Roerich hoped, delivering some kind of assurance that he, too, would soon be journeying home?[55]

Whatever Grabar intended, reality asserted itself in the second half of 1946. Even had the USSR wished to readmit the Roerichs, it maintained no facility in British India capable of relocating them efficiently, especially with their massive collection of paintings and manuscripts. Nor would going back have worked to Roerich's benefit. He could compose all the paeans he liked to Stalin and to Andrei Zhdanov, the regime's cultural watchdog, but less than a decade earlier, the purges of the 1930s had rendered him persona non grata in the USSR. Moreover, Stalin's postwar policy included a suffocating reimposition of control over Soviet culture. This crackdown, the so-called *Zhdanovshchina*, subjected numerous artists and writers to public abuse and arbitrary discipline from 1946 to 1948. Among its best-known victims were the humorist Mikhail Zoshchenko, the poet Anna Akhmatova, and Dmitri Shostakovich, whose Leningrad Symphony had made him the government's darling just a short time before. Roerich knew nothing of this, and if he had, he would have thanked every lucky star he believed in that his homecoming wish had not come true.

Not that this occurred to him in the summer of 1946, which saw him seething with bewilderment. Why, he wanted to know, was the USSR taking so long to open its embassy in India? Maybe, he theorized,

the British or the Americans were secretly undermining his attempts to go home. He vented his distress to anyone who would listen, but bearing the brunt of his temper were Valentina Dutko, Valentin Bulgakov (now back in Russia, restoring Yasnaya Polyana's war-torn Tolstoy House-Museum), and Grabar, who had raised his hopes in the first place. To the last, he addressed this anxious missive in August:

> If, as you say, my return is widely discussed, and if I have always proven ready to lend my strength to the Motherland, then why have things stalled? Put the Committee for Artistic Affairs onto it, or one of the other committees you head—or some government agency. It should be more obvious to you than to anyone that I am not pressing this matter for my own benefit. We must not delay this opportunity for me to work for the common good.
>
> Of course, mine will not be a small caravan. Hundreds of paintings, large and small, many books, Tibetan curios, my archive—we cannot leave all of this to be devoured by the ants and other vermin. But we have heard that the government is able to meet halfway in such cases. After all, steamers are already sailing from here to Odessa and other [Soviet] ports. . . .
>
> You are correct—why should I remain in the Himalayas to proclaim Russia's glories, when I could be with you in our beloved Motherland, labor-

> ing together in friendship. Both of us have faithfully served Russian Culture, and we have always known to what heights the Russian People can rise. We have both done much work in Russia's name, and to assist in its present uplift will be for us a great joy.
>
> In closing, I await your reply and am confident that you will not delay, for there is no time for us to waste.[56]

Roerich was concerned enough that Grabar receive this letter that he sent a follow-up telegram to ensure it had arrived.[57]

Roerich did not stop there. He exploited every connection he thought might prove useful and directly petitioned Vyacheslav Molotov, Stalin's foreign minister.[58] In personal and official letters, he professed allegiance to Soviet Russia and Stalin, and, wherever possible, appealed to old ties and sentiment. "On my windowsill sits an open compass," he told one friend, comparing the northward-pointing arrow to the patriotic impulse pulling him, as if by magnetism, toward his homeland.[59] To another correspondent: "The letters we receive from Russia call to us, 'Come!' We answer in return, 'Ring the bell to summon us!' By this I mean we are, and always have been, ready to return. No one who knows us can say we have lost our connection to the Motherland. That connection we have always kept alive."[60] In the end, these words went unheeded. Whether Soviet authorities actively opposed his return or, if willing to *allow* him back, were unwilling to *bring*

him back if it required effort, the result was the same. Once again, Roerich had become Izgoi, or the "outcast," as he had brashly dubbed himself so many years before.

Current events in India presented other causes for discouragement. Roerich was pleased to see the country take its final steps toward independence, but the path grew steeper and more painful the more it neared the endpoint.

His disappointments were both local and national. With independence in the offing, Roerich was finally in a position to benefit from having been one of Congress's fellow travelers. In *Maha Bodhi*, the historian Kalidas Nag called him "Russia's chief ambassador of beauty," and the Association of Indian Culture entreated him to chair the Fine Arts Section of the 1946 All-Indian Conference on the Unity of Culture.[61] "You, and only you," the hosts told him, "are properly able to lead this session." The Roerich biography *Gurudev* gained in popularity, and philosopher Sanjeev Dev lectured on themes such as "Roerich, the Conqueror of Darkness" and "Roerich—The Transfigurer of Cosmic Chaos." Invitations streamed in, asking Roerich to serve on the boards of museums and art schools, to organize and judge exhibitions, to show his own art, and to speak publicly. Once, Roerich would have welcomed each of these opportunities. Illness compelled him to refuse nearly all of them.

More disturbing were the countrywide birth pangs of independence. In December 1945 and January 1946, Congress won a clear majority in elections to India's national and provincial legislatures, but the solid minority earned by the Muslim League encouraged its leaders to continue pursuing maximum autonomy. Tensions heightened immediately in February, as twenty thousand sailors and various military and police units, urged on by the Indian Communist Party and impatient for the British to leave, staged the brief but alarming Royal Indian Navy Mutiny.

India moved closer to the precipice in the spring and summer of 1946, as the Clement Attlee government dispatched a Cabinet Mission to assist the viceroy, Lord Wavell, in forming a constituent assembly and hammering out the final terms of independence. Both London, still hoping to retain India as a military ally, and Congress favored a single state with a strong central government, while the Muslim League sought greater authority for the provinces. Additional questions complicated these talks, including the status of Sikhs, Parsees, and other minorities, and the incorporation of princely states not previously under the Raj's direct rule.

Arriving in March, the mission consulted with all interested parties, then issued its Plan of May 16, offering dominion status, similar to Canada's and Australia's, under the British crown. Soundly rejected by Congress and the Muslim League, this gave way to a revised Plan of June 16, which proposed a Muslim state within an Indian national framework.

This foundered as well. As for the constituent assembly, the appointment of its nearly four hundred members went forward in late summer. Congress's overwhelming majority embittered Jinnah and the league, and the viceroy's efforts to form a fourteen-person interim executive council were stalemated by ill will. Both Nehru and Jinnah received invitations, but the former insisted on being named to the highest office (vice president under the viceroy), while the latter, in July, damned the whole process as unfair.

This impasse broke catastrophically in mid-August. On Nehru's initiative and that of his deputy Vallabhbhai Patel, the executive council began establishing Congress-run provincial governments in Hindu-majority areas, an important step in the transfer of power as envisioned by Wavell. In reaction, Jinnah withdrew all support for the interim government and demanded a separate constituent assembly. To show his resolve, Jinnah called upon his voters to flood the streets with pro-Pakistan protests. These demonstrations, and the Hindu and Sikh responses to them, quickly turned violent, especially in Bengal and the Punjab, but also in Bombay, Delhi, and other urban centers. The worst of the bloodshed began on Direct Action Day, a general strike carried out by the Muslim League on August 16 and leading to a lengthy slaughter still remembered by such grim nicknames as the "Week of the Long Knives" and the "Great Calcutta Killings." Within a week, the fighting had caused some five thousand to ten thousand deaths nationwide and left thousands homeless. Even after this horrific climax, mob violence would not cease until well after independence. Moreover, the killings of 1946 ensured that whatever state emerged from the independence process would be far from united.

Roerich was not unacquainted with sectarian clashes in India. The maelstrom of 1946, however, left him aghast on principle and, given Naggar's proximity to the bitterly contested Punjab, frightened for himself and his family. Recalling his apocalyptic warnings from the year before, Roerich wrote in 1946 that "the Armageddon of Culture menaces the whole earth. And this flourishing of hatred is the worst sign of it."[62] Given his pro-Congress leanings, Roerich blamed most of this on Muslims, but Hindus did not escape his criticism. He simultaneously railed against and grieved for all sides as political passions morphed into madness. "Savage assaults continue against guiltless bystanders in Calcutta, Bombay, Dhaka, Ahmedabad, and other cities," he observed in October. "It is dangerous for people to leave their homes. Who are the killers? Who are the victims? All we know for certain are the raw, merciless numbers that add to the bleakness of each day's death toll. But who has masterminded this? Who has inspired it? Thanks to this 'time of knives,' a bloody fog hangs over us all. This is no revolution, but murder. Someone has armed these *goondas* [thugs] with knives and daggers and sent them out by the thousands to carry out these beastly errands. How much longer will it go on?"[63]

By autumn, the worst of this disorder had been contained. In October, Wavell and Nehru coaxed Jinnah into joining the interim government. Muslim League members claimed several portfolios, including finance and commerce, and the coalition survived into early 1947. By then, however, its dysfunction had become apparent: Congress and League ministers rarely met, busying themselves instead with sabotaging each other's programs. In February, the Attlee government, judging this "state of uncertainty" to be "fraught with danger," sent Lord Mountbatten to replace Wavell as viceroy, with orders to accomplish the transfer of power by no later than June 1948.[64] Mountbatten attempted in the spring to salvage plans for a unified India, but Jinnah rebuffed him in a pivotal meeting on April 5, making Hindu–Muslim partition inevitable. A new round of riots convinced Roerich that a "tornado" of fear and hatred was about to engulf the subcontinent.[65]

Bowing to this reality, Mountbatten accelerated his timetable, largely to pressure Congress into acknowledging partition's unavoidability. His Indian Independence Act, announced in June 1947, divided British India into separate Indian and Pakistani nations, both to go free that August, even though the boundaries between them had yet to be drawn up. Nehru and Congress gave in reluctantly, with Gandhi—who claimed both states as "my country" and declared, "I am not going to take out a passport for going to Pakistan"—remaining the least reconciled.[66]

To Roerich, the divorce seemed equally unthinkable. In a June letter to Grabar, he spoke of the "vivisection of India," a metaphor he used often over the next months.[67] Once again, panic seized the population, especially the millions who stood to be caught on the wrong side of the yet-to-be-determined borders. Of the coming displacement, Roerich remarked: "Thus is India consigned to her bitter fate. What a misfortune that such a large portion of Muslims, who at bottom wish to honor the Koran, have forgotten the worthiest of their religion's precepts. It is the capitalists and nabobs among them who have incited the unenlightened masses to violence. So many innocents have been killed or tormented. What cruelty! What beastliness!"[68] Only a while before, Roerich had regarded Indian independence as the worthiest goal imaginable. Now, with its consummation approaching, he could only look on with dread.

However unpredictable India's future seemed, Roerich's, alas, was all too assured. He was now dying.

The decline in his health had continued through 1947. In addition to the heart disease that had troubled him since 1939, he was revealed in the summer to be suffering from cancer, which appears to have spread from his prostate by the time it was diagnosed.[69] Surgeries to remove the cancer were attempted in July, but all curative efforts failed, leaving Roerich largely confined to bedrest and living on borrowed time.

The family, then, spent the summer and early fall consumed by anxiety over Nicholas's illness and the threats posed by partition. Matters were not improved by Helena's poor condition: fever, migraines, and toothache pained her ceaselessly. This the Roerichs blamed on malevolent psychic energies stirred up by the crises of the day. As Nicholas wrote, "all the cosmic perturbations of late are taking a toll on [Helena's] body."[70]

Living as they did on one of the fault lines of partition, the Roerichs had reason to fear the countdown to independence. It was with less than a week before deadline that the border commission finished dividing India's territory from Pakistan's, and not till two days *after* independence was the final version of this map made public. Everyone, however, knew roughly where the pen's strokes would fall: to create Pakistan in the west, the Punjab would have to be split, and carving out present-day Bangladesh (then East Pakistan) required the same for Bengal. Independence went into effect the night of August 14–15, 1947, with Pakistan going free at 11:57 p.m. on the fourteenth, and India five minutes later, at 12:02 a.m. on the fifteenth. "At the midnight hour," Nehru declaimed, "when the world sleeps, India will wake to life and freedom."[71]

Such high rhetoric, though, said nothing of the pandemonium that followed. In the chaotic upheaval identified by the scholar Sunil Khilnani as "the largest transfer of population in human history," some fifteen million people left their homes so they could be on the "right" side of the new frontiers.[72] A million or more of these refugees are estimated to have died, some because of massacres and banditry, others from hunger, exposure, and epidemic. None of these scourges touched the Roerichs, but their effects were felt nearby, and the family had no way to know if they would come through unharmed.

These weeks of trauma coincided with the worst of Nicholas's suffering, which peaked from July to early October. During the sweltering heat of summer, he lay bedridden and in pain, and all news, whether from abroad or closer to home, caused him to grieve. Along with India's agonies, he lamented the existence of atomic bombs, a blight he feared humanity would never be rid of, and the entrenchment of superpower battle lines. Not only did the Cold War threaten peace, Roerich blamed it for the "epidemic of Russophobia" he saw everywhere—from Winston Churchill's "iron curtain" speech and the Truman Doctrine to smaller moments, such as the Kansas City Art Museum's decision to remove Russian paintings from its galleries.[73] (This puts an ironic spin on his decision to let his followers release Henry Wallace's "Dear Guru" letters to Westbrook Pegler—a true Russophobe if ever there was one—and he lived long enough to regret having trusted this "Rasputin of the yellow press."[74]) Roerich also continued to sound his theme of the Armageddon of Culture, which he blamed for "every kind of anti-negro hatred, antisemitism, and anti-humanism" across the

globe.[75] It was "more terrible than the Armageddon of War," he told Alfred Heidok, and to Maurice Lichtmann, he cried, "It is horrifying! And it has only just begun!"[76]

October and November brought a measure of relief. The weather cooled, leaving Roerich able to leave his sickbed for longer periods of time, and even to paint. This was no season of grace—he remained too melancholy for that—but he grew more accepting of his fate. Perhaps he took consolation from the words of the *Bhagavad Gita*, spoken by the demigod Krishna, whom he had painted so many times: "Death is certain for the born. Rebirth is certain for the dead. You should not grieve for what is unavoidable."[77]

Roerich's last paintings exude a serene, valedictory quality. Two canvases from 1947 stand out in particular. *Lights on the Ganges*, a nighttime tableau dominated by deep blues and purples, shows a woman on the riverbank, setting candles in the water to drift with the current. The scene calls to mind the Ganga Aarti ritual associated with the holy city of Benares; the candles, nested in bowls crafted from blossoms, carry the prayers of the faithful. As so often in Roerich's work, the river motif connotes spiritual progress, and the artist's funereal musings are more than evident. Dealing just as overtly with themes of passage is *The Master's Command* (see Illustration 40). Along the center line of this mountain vista, a river cuts through a blue-shadowed valley. Over the distant peaks shines a golden sunset, representing the transcendent realm sought by every virtuous soul. In the lower left, an adept,

meditating on a high overlook, bows his head to the lowering sun. Approaching from above is a white bird, an emissary from the eponymous Master, summoning the adept to a higher plane of existence. Heartbreakingly contemplative, this work stands as Roerich's farewell, in the medium he loved best, to this earthly life.

Roerich said other goodbyes in October and November. Final letters went out to his most valued correspondents. On October 9, he wrote Grabar for the last time, thanking him for the friendship they had rekindled over the past years.[78] The following day, he turned to Bulgakov, reporting on the "ocean of sorrow" India had become, but holding out hope that Russia would save humanity by building the culture of the future.[79] He wrote Heidok and his Shanghai circle on October 18, and, on November 17, he praised Sina for her years of unstinting loyalty.[80] Tragically, there would be no last exchange with his brother Vladimir, although Nicholas conveyed a farewell to him in his letter to Heidok. Only in May 1951 would Helena come to learn of Vladimir's death in China, from her follower Pavel Chistyakov, who tended to Vladimir during his last illness.[81]

Only days before midwinter, Roerich's bodily struggles ended: on December 13, he quit this earthly life. Family and friends laid him to rest two days later in a simple ceremony. His body was cremated on the grounds of the Naggar estate, and his ashes—some of which have since been unearthed and transported to Moscow—were buried at a vantage point overlooking the

mountains. Marking the location is a commemorative stone, carved as follows: "The body of Maharishi Nicholas Roerich, great friend of India, was cremated on this spot on 30 Mahar in the year 2004 of the Vitram era, corresponding to 15 December 1947. OM RAM."[82]

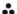

Prophets, we are told by the Book of Matthew, are not without honor, save in their own country. Whether or not the designation fits Roerich, the dilemma befell him. In the USSR, reaction to his death was muted at best. Over a decade would elapse before his reputation there began to recover from its Stalin-era nadir.

In America, where he had soared to such fame, then fallen so far, a few mourned Roerich sincerely. A woeful Sina longed for the day when she would be "reunited with him in the eternal current of the river of life."[83] Others were equally interested in Roerich's death, but for different reasons: Louis Horch, still hoping to recoup his money, asked the State Department to obtain a copy of the artist's death certificate and any "information pertaining to the administration of his estate in India."[84] (Sviatoslav fended off these inquiries with a blunt message to the US Embassy in Delhi that the elder Roerich was not an American citizen and "had no estate in India at the time of his passing.")

When America took note of Roerich's death, it responded mainly with snideness or bemusement. Even obituaries that saluted his accomplishments assessed him equivocally. The *New York Times* published a full column, complete with photo, under the headline "N. K. Roerich Dies; Artist, Explorer."[85] It omitted talk of the "Dear Guru" letters and glossed over his Manchurian troubles in a single sentence, but reminded readers of the extravagant claims he had made about Christ and the Himalayas during his 1925–1928 travels. If the *Times* was more restrained than respectful, it at least kept its tone demure. By contrast, *Art Magazine*'s "Fabulous Roerich" detailed his scandals and referred to him as a "searcher after strange gods" who looked like "a combination of Lenin and the Dalai Lama."[86] *Time* magazine dwelled on Roerich's eccentricities in "Silver Valley," published in late December.[87] Recalling him as "an egg-bald Russian with a twin-pronged beard," *Time* took delight in listing his pratfalls:

Devoted followers thought he was a genius who could unify humanity through art. Loudmouthed Westbrook Pegler thought he was a quack who wanted to become "head" of Siberia. Quack or genius, Roerich led a busy life that brushed against Eternal Krishna the Regenerator—and the ferrets of the U.S. Bureau of Internal Revenue; against dreamy Henry Wallace—and the 363 local gods of the Punjab's Kulu Valley. . . .

In Manchukuo the Japanese thought he was a Russian agent. The

Russians thought he was a Japanese spy. The Chinese thought he was a U.S. spy. The British had denied him a visa into troubled India in 1930, on the grounds that he was a Russian sympathizer.

Roerich may have "spent a lifetime seeking peace," *Time* observed, but until the last moment of his "troubled life," he had "disturb[ed] everything he touched." Such seemed likely to be the last American word on him.

Only in India did Roerich seem positioned to enjoy lasting repute. Here, he continued to be valued widely, and his sons, especially Sviatoslav, did much to cement their father's place in India's cultural history. Admiration for Roerich extended to the uppermost levels of India's leadership. In his capacity as the new country's prime minister, Nehru, who had visited the artist in Naggar only months before, in the spring, honored him with the following eulogy:

> When I think of Nicholas Roerich, I am astounded at the scope and abundance of his activities and creative genius. A great artist, a great scholar and writer, archaeologist and explorer, he touched and lighted up so many aspects of human endeavour. The very quantity is stupendous—thousands of paintings and each one of them a great work of art. When you look at these paintings, so many of them of the Himalayas, you seem to catch the spirit of those great mountains which have towered over the Indian Plain and been our sentinels for

ages past. They remind us of so much in our history, our thought, our cultural and spiritual heritage—so much not merely of the India of the past, but of something that is permanent and eternal about India, that we cannot help feeling a great sense of indebtedness to Nicholas Roerich, who has enshrined that spirit in these magnificent canvases.[88]

Nor has India's regard for Roerich diminished since.

Had Roerich's story ended, full stop, with the way things stood in 1947 and 1948, it would have been one of a legacy truly displaced, of an artist better appreciated in a land half a world from the place of his birth than in his own country. Lucky for him, then, that revisions were in store: the restoration of his fame, both at home and globally, would follow in due course. That fame did not always take form in ways he would have anticipated or desired, but so it stands with all creative figures. No artist or thinker can predict with surety what impact his or her works or ideas will have, how long his or her influence will last, or how far and in what ways that influence will spread. Roerich knew this truth as well as anyone, and pondered it in one of his final essays, "The Builder": "Can the sower know for certain how the seeds he has sown will grow? The sower may suppose, but it is not given for him to know. The builders of wondrous temples and fortresses never knew whether they would be destined to complete their work. All the same, they laid their

foundations with firmness and confidence, building skyward so long as strength and opportunity remained to them."[89]

Thus Roerich conducted himself while he was able. If we liken him to the sower he speaks of, and his life story to the garden grown by his efforts, we see an array of specimens stunning in their variety and vibrancy. Many impress with their beauty and exoticism. Others, like rogue cultivars, baffle or confuse, and a few noxious weeds are scattered throughout. For a certainty, we will find nothing monochromatic. Neither has Roerich's garden ceased to grow, nor has it done so in straightforward ways. Perhaps even he would be surprised to know the strange and compelling shapes it has taken since his death.

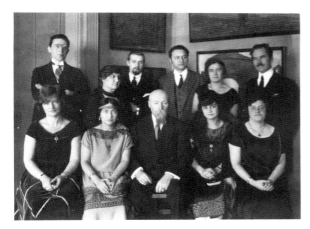

Illustration 26. Roerich with his New York "inner circle" in December 1924. L to R (standing): Louis Horch, Sophie Shafran, Sviatoslav Roerich, Maurice Lichtmann, Tatyana Grebenshchikova, Georgii Grebenshchikov; L to R (sitting): Esther Lichtmann, Sina Lichtmann, Nicholas Roerich, Nettie Horch, Frances Grant. NRM Archive, New York, ref. no. 400714.

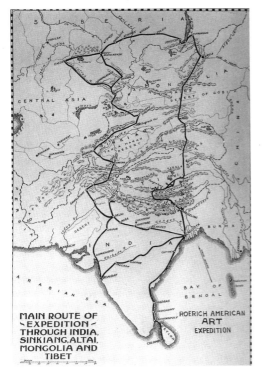

Illustration 28. Sketch for the Master Building, 310 Riverside Drive, New York. Financed by Louis and Nettie Horch to house the Roerich Museum and Master Institute, designed and built by the celebrated architect Harvey Wiley Corbett. Opened in 1929, the actual structure did not feature the stupa-like spire that Roerich wanted to include. NRM Archive, New York.

Illustration 27. Searching for Shambhala. The official map for the mid-1920s "Roerich American Art Expedition." (Note how the "main route" gives no hint of the group's secret and highly irregular detour to Moscow.) NRM Archive, New York.

Illustration 29. *Madonna
Oriflamma* (1932). A broadly
Eurasian rendering of
Roerich's archetypal goddess.
Like the other madonnas
Roerich painted at this
time, the Oriflamma is
symbolically linked with
his Banner of Peace treaty
campaign, whose orb-and-
ring emblem adorns the
cloth in her hands. Nicholas
Roerich Museum, New York,
tempera on canvas, 173.5 ×
99.4 cm.

Illustration 30. *Sophia—Wisdom of the Almighty* (1932). The most dynamic incarnation of female divinity painted by Roerich. As she traces her fiery arc across the sky, Sophia unfurls the Banner of Peace to protect the city below. Nicholas Roerich Museum, New York, tempera on canvas, 107.3 × 153 cm.

Illustration 31. *Saint Sergius of Radonezh* (1932). One of Russia's most beloved patron saints, painted repeatedly by Roerich over many years. In this instance, the artist, seeking support from White military officers, appeals to their religious sensibilities (and links himself with Sergius's virtues by giving the saint an appearance similar to his own). Note also the Eye of Providence—a symbol popularly associated with Masonry and featured on the US one-dollar bill (whose design Roerich may have influenced)— floating in the sky. State Tretyakov Gallery, Moscow, tempera on canvas, 153.3 × 107.2 cm.

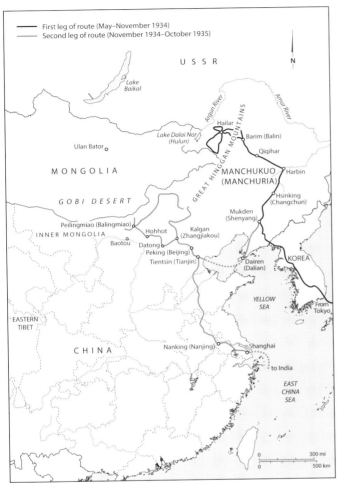

Illustration 32. A map of Roerich's 1934–1935 expedition to Asia. Ostensibly in the region to collect drought-resistant grasses on behalf of the US secretary of agriculture, Henry Wallace, Roerich and his son George pursued their own political agenda there. Their maladroit handling of affairs embarrassed Wallace and wrecked for good the family's Great Plan. Arriving in Manchuria from Japan, Nicholas and George progressed north to Harbin, then looped westward toward the Mongolian border. Later, they traveled northwest from Beijing to the edge of the Gobi Desert. Map prepared by Bill Nelson Cartography.

Illustration 33. Official photo of Henry A. Wallace, who served the FDR administration as secretary of agriculture, vice president, and secretary of commerce. A devotee of the Roerichs' spiritual teachings, he sponsored the artist's 1934–1935 expedition to Asia, only to turn on him when the resulting scandals threatened his career. His own presidential run, in 1948, was fatally handicapped by his past association with Roerich. Agricultural Research Service, US Department of Agriculture.

Illustration 34. *Remember* (1924). A poignant scene of leavetaking, set against a backdrop of the breathtaking mountains Roerich is so famous for painting. Part of the "His Country" series. Nicholas Roerich Museum, New York, tempera on canvas, 87.5 × 117.5 cm.

Illustration 35. *Mount of Five Treasures* (Two Worlds) (1933). One of the dozens of mountainscapes produced by Roerich between the 1920s and the 1940s. For Roerich, each attempt at capturing a mountain's essence was akin to a spiritual exercise. As suggested by the title, the cloudline separates celestial perfection, represented by the peaks, from the terrestrial realm below—a metaphor often employed by Roerich. Part of the "Holy Mountains" series. Nicholas Roerich Museum, New York, tempera on canvas, 46.8 × 78.8 cm.

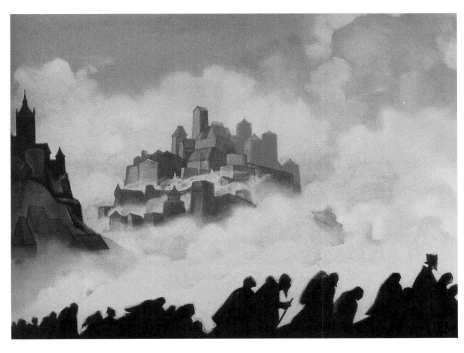

Illustration 36. *Armageddon* (1935–1936). The Roerichs foretold the coming of Apocalypse in 1936. While they eagerly awaited the upcoming turn in the cosmic cycle, they feared the violence and trauma that would precede the transition. The worsening state of international affairs during the 1930s disquieted Roerich, and fear of an impending global conflict caused him to depict the battle of Armageddon numerous times throughout the decade. State Museum of Oriental Art, Moscow, tempera on canvas, 92 × 122 cm.

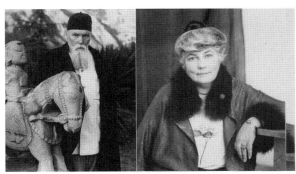

Illustration 37 (*above*). Nicholas and Helena in Naggar, ca. 1936–1937. Nicholas stands next to a statue of Guga Chohan, a folk deity of northern India. Sviatoslav used these photos to paint portraits of his parents in 1937. NRM Archive, New York, ref. nos. 401776 and 400112.

Illustration 38 (*right*). Jawaharlal Nehru and his daughter Indira Gandhi visit the Roerichs in Naggar (1942). L to R: Nehru, Sviatoslav Roerich, Indira Gandhi, Helena Roerich (under umbrella), Nicholas Roerich, unidentified, Mohammad Yunus Khan. NRM Archive, New York, ref. no. 401802.

Illustration 39. *Gesar Khan* (1941). The beloved warrior-king of Tibetan myth. A figure painted repeatedly by Roerich and researched academically by his son George. Last held by International Center of the Roerichs, Moscow, tempera on canvas, 91 × 152.5 cm.

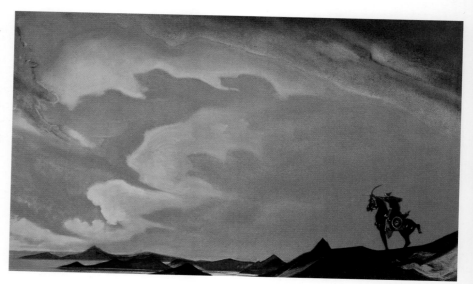

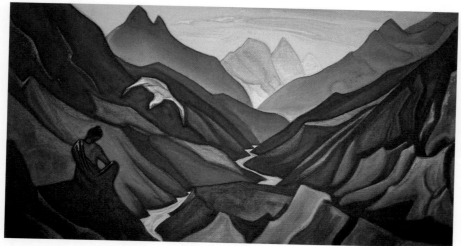

Illustration 40. *The Master's Command* (1947). One of the last paintings Roerich produced before his death. Its theme of valediction is evident. State Museum of Oriental Art, Moscow, tempera on canvas, 84.5 × 153 cm.

EPILOGUE

Contested Legacies

There must have been an idea more powerful than all the calamities and sorrows of this world, famine or torture, leprosy or plague—an idea which entered into the heart, directed and enlarged the springs of life, and made even that hell supportable to humanity! Show me a force like that, in our century of vice and railways! . . . Show me a single idea that unites men nowadays with half the strength as in centuries past.

—Fyodor Dostoevsky, *The Idiot*

Which Roerich most deserves to live on in memory? The peace-loving, spiritual idealist who spoke of the unity of man? Or the scandal-ridden schemer, consumed by baroque eccentricities and grandiose ambitions?

No likeness of Roerich can be considered true that does not encompass both. He remains in retrospect as protean as he was in life. Indeed, it is precisely this many-sidedness that accounts for the burgeoning of his fame over the past decades, especially in post-Soviet Russia. Whether one considers his worldview inconsistent or inclusive, it derives enormous appeal from the fact that anything one likes can be read into its philosophically inchoate sprawl. There is something in Roerich for nearly everyone—provided one squints hard enough to filter out those things about him one would rather not know.

For years, then, a bruising contest has raged, in Russia and elsewhere, and in the scholarly and public spheres, over the question that opens this chapter. Which of the various Roerichs on display—in museums or on Internet fan sites, in the artist's own writings or in official records in half a dozen countries—is most real? None of them can be ignored, but the impulse to view the artist solely through one's preferred lens remains nigh irresistible for many. Add to this a physical legacy—manuscripts, publishing rights, a valuable body of paintings—much of it up for grabs in a multitude of legal and institutional battles, and there is no reason to expect that the disputes over who Roerich is and how he should be remembered will end anytime soon.

Roerich may have been laid to rest in Naggar, but his family did not tarry there long. Few places in India could be considered secure in the new year of 1948, as witnessed by the January 30 assassination of Gandhi himself, but the Punjab frontier was especially dangerous. That month, Helena descended from the mountain heights for the first time in years. She and George, accompanied by Lyudmila and Raya Bogdanova, made their way to Delhi, and then to Khandala, on the outskirts of Bombay, hoping from there to sail to Russia. As Helena told Yevgeny Pavlovsky, a family friend in Leningrad, "we are making plans to return home, with the paintings."[1]

The Soviet authorities, however, proved no more willing than before to allow the Roerichs' repatriation. With the Bogdanovas, George and Helena relocated to Kalimpong, a West Bengal hill station east of Darjeeling. Kalimpong provided a highland environment agreeable to Helena, who still professed to feel more comfortable at higher altitudes, and George continued his linguistic and folkloric research at the Indo-Tibetan Institute of West Bengal. Sviatoslav parted ways with his birth family, taking up residence in Bangalore with his wife, Devika.

Helena continued to promulgate her and her husband's teachings. In Kalimpong, she founded a new Roerich Museum, stocked with the paintings she and George had managed to bring with them. She corresponded with her faithful and added to the Agni Yogist canon. As for her

prophecies, humbler circumstances forced her to moderate their scope and terms: the new age was no longer imminent, but had already arrived. World War II had marked the apocalypse, and Satan, vanquished, had departed the material plane. As of October 17, 1949, the misery-laden centuries of Kali Yuga had given way to the bright epoch of Satya Yuga.[2]

Not that this new era provided complete satisfaction. Helena still yearned to return to Russia, although she had ceased to idealize the Soviet system. "Communism, at least in its present form," she told one disciple, "has outlived itself and is hopelessly worn out."[3] This, however, in no way diminished her desire to go home, and it proved a crushing disappointment when the USSR's foreign ministry refused in 1949 to reconfirm the Soviet citizenship she claimed to have taken out with Nicholas and George during their clandestine journey to Moscow in 1926. In December 1950, Helena appealed to the foreign minister himself, Andrei Vyshinsky: "I ask you not to deny me and my two young ones permission to return to the Motherland. Despite my advanced age, do not deny me the chance to make myself available to our Motherland—and the New Country—for cooperative labor in the hard days to come."[4] This entreaty went unanswered, as did all her others. Eventually, her measure of years ran its course, and she died in Kalimpong on October 5, 1955. Like Nicholas, she was cremated, and her ashes, like his, were interred in a tranquil hillside setting. A white stupa, bearing the legend

"Helena Roerich, the wife of Nicholas Roerich, thinker and writer, old friend of India," stands over her resting place.

Had Helena's health held out just a while longer, she might have realized her dream of homecoming. Only two years after her death, George returned to Russia, accompanied by both Bogdanova sisters. By all indications, this came about thanks to the intervention of Soviet leader Nikita Khrushchev. George, as the story goes, arranged with some highly placed Indian friends to be present at a reception held in Khrushchev's honor when he visited India in November 1955. The general secretary listened sympathetically to George's request and cleared a homeward path for him. (The option to return was also extended to Sviatoslav, with whom Khrushchev stayed in touch during the 1960s, but marriage and a flourishing career had integrated the younger Roerich more thoroughly into Indian life.) In 1957, after months of packing and paperwork, George, Lyudmila, and Raya bade farewell to Bengal and traveled to Moscow, with more than four hundred of Nicholas's paintings in tow. Khrushchev's son Sergei attests that his father had "particularly warm feelings" for the Roerichs, but Cold War gamesmanship had as much to do with his decision.[5] India figured prominently in the USSR's strategic calculus, and what better way to foster Indo-Soviet friendship than to cultivate a Russian family on such good terms with India's prime minister?

Whatever Khrushchev's intentions, George went back to Russia in honor. He took up a leadership position at Moscow's Institute of Oriental Studies and assisted in refurbishing the Buddhist temple in Leningrad that his father had helped design during the tsarist era. His tenure at the institute proved brief, but he left a weighty imprint, both by virtue of the manuscripts and items he added to its collections and the academic influence he exerted on students there, including the famed orientalist Alexander Piatigorsky, who taught in London after fleeing the USSR in 1974. George's expertise, his adventuresome travels, and his family's exotic glamour ensured his popularity as a teacher and mentor. For all the battles he had waged with himself and his parents over how to reconcile scholarly empiricism with the more ethereal of the family's beliefs, George retained, according to his students and colleagues, a lingering faith in the unseen world and Maitreya's eventual return to the physical plane.[6] He remained an active researcher until his death, the result of a heart attack on May 21, 1960. Like his parents, George was cremated, and his ashes were placed in one of Moscow's most distinguished burial grounds: Novodevichy Cemetery, where luminaries from all walks of life are laid to rest. At least one member of the family now slept enshrouded by native soil.

George's return to Russia facilitated a more complete rehabilitation of his father there. It was largely on his initiative (and using the paintings he had brought from India) that, in

1958, the Union of Soviet Artists and Moscow's Tretyakov Gallery organized a major exhibition in Roerich's honor. Cautiously sympathetic reviews appeared in journals such as *Iskusstvo* and *October*, and approximately ninety thousand visitors attended in April and May, queuing for up to six hours to see the show. "These fantastic works should be permanently exhibited," wrote one commenter in the guest book, while another noted bluntly that, when viewed next to Roerich's canvases, "it becomes crystal clear that our contemporary fine art is totally immersed in shit."[7] The 1958 show moved on to Leningrad, Kiev, Tbilisi, and Riga, and a second Moscow exhibit followed in 1959. Soviet museums began displaying Roerich's art more prominently, aided by George's bequest of 418 of his father's works to the government. (George hoped to persuade the authorities to open a museum in his father's honor, but this aspiration went unfulfilled until after the USSR's demise.)

Positive connotations attached to Roerich's name in other spheres of Soviet life. The USSR now trumpeted his Banner of Peace efforts from the 1920s and 1930s, thanks to the fact that the Hague Convention on the Protection of Cultural Property in the Event of Armed Conflict—signed in May 1954 and in force by August 1956—had been written largely on the basis of the 1935 Washington Pact, the official version of Roerich's treaty.[8] By the early 1960s, the artist had been mainstreamed enough that when Yuri Gagarin, the first person to behold our planet from outer space, likened the sight

to one of Roerich's paintings, the allusion was lost on no one. (Other cosmonauts, among them Vitaly Sevastianov and Valentina Tereshkova, the first woman in space, were equally fond of Roerich analogies as they described their orbital odysseys.[9]) By this point, Roerich had settled comfortably into the art-history niche he would occupy for the rest of the Soviet era: accessible and visually striking, free from the decadent languor associated with Russia's Silver Age, and inspirationally transcendent in a manner vague enough not to clash with official atheistic dogma. It was this Roerich the regime celebrated in 1974, the one hundredth anniversary of the artist's birth, with postage stamps, new biographies, commemorative editions of his writings, and a new round of exhibitions. The Isvara estate, so important to Roerich's childhood, but lying in disrepair after World War II, was, starting in the early 1970s, restored to its former beauty by the Leningrad Regional Executive Committee. It has since transformed itself into an attractive museum.

All this took place in public view and with the state's full sanction. At the same time, a less obvious Roerich revival gained traction: not exactly underground, but surreptitiously, as several groups in the USSR preserved and even cautiously promoted the more esoteric aspects of the artist's legacy. Typically this was done by adherents who had known Nicholas and Helena personally or corresponded with them in their later years, or had become acquainted with George upon his return to Russia. Riga's

once-thriving Roerich Society, hounded into inactivity by Stalin's occupation of Latvia, rebounded in the 1960s. Also significant was the Estonian Roerich Society, whose head, Pavel Belikov, communicated with the family and emerged in the 1960s and 1970s as one of Roerich's leading biographers. In 1959, a Siberian Roerich Society sprang up in Novosibirsk and the nearby hub of reseach institutes known as Akademgorodok, thanks to Natalia Spirina and Boris Abramov, a pair of émigrés returning from Harbin. The Altai region, so central to Agni Yogist cosmology, attracted Roerichites as well. In the Soviet-bloc nation of Bulgaria, Lyudmila Zhivkova, the daughter of the country's communist strongman, not only boosted Roerich publicly in her capacity as minister of culture, but privately embraced his spiritual doctrines—a fact conspiracy theorists believe played a role in her death in 1981.[10]

Most such groups operated openly and legally, and the degree to which they pursued actual mysticism varied. Some were content to study parapsychological phenomena—entirely legitimate at a time when Soviet scientists were researching ESP and the Kirlian photography of aura-like bioelectric fields—or to meditate on human consciousness and philosophical abstractions. Others, committed to environmental protection, found in Roerich's love of nature a credo capable of lifting their own earth-friendliness to a loftier plane. Everyone understood that official acceptance of Roerich came with limits and that it was risky to acknowledge anything theosophical or quasi-religious

about his past. On occasion, this line was crossed, as in Akademgorodok, where, in 1979, a number of Academy of Sciences researchers in the Institute of History, Philology, and Philosophy proposed the creation of a "cultural-scientific center" to propagate the Roerichs' spiritual ideals.[11] This triggered a crackdown in which the institute's deputy director blasted the Roerichites for their "unrealistic Blavatskianism." The Akademgorodok renegades were brought to heel without further trouble, but the incident shows how restricted Soviet appreciation of Roerich could be, at least until the later 1980s.

The reflorescence of Roerich's fame proceeded outside Russia as well, though not at the same pace. India made much of him in 1974, the centennial of his birth. Indira Gandhi, the prime minister, fondly recalled her memories of visiting the Roerichs with Nehru. "My father and I were privileged to know Nicholas Roerich," she declared in a testimonial that October: "He was one of the most impressive people I have met. . . . He lived in the Himalayas for years and seems to have captured the spirit of the mountains, portraying their ever-changing moods and colours. Nicholas Roerich's work has inspired many new trends among our own painters. The centenary celebrations provide an occasion for us to pay tribute to this great artist and philosopher who made India his home."[12] The Indian government

issued a one-rupee stamp in Roerich's honor, and the scholar S. N. Verma completed a lavish commemorative biography. Before the decade was out, Roerich received his official designation as a "National Treasures Artist," which made him one of only nine artists—and the only one not native to India—whose works cannot be exported without special government permission.

It took longer for Roerich's reputation to reawaken in America. In New York, Sina Lichtmann (now Sina Fosdick) kept the beacon lit, along with her husband Dudley, Katherine Campbell, and Ingeborg Fritzsche. The new Nicholas Roerich Museum (NRM) founded by them in 1958 survives to this day on 107th Street and Riverside. Sina served as its director until her death in 1983, followed by Daniel Entin and, after 2016, Gvido Trepsa. During the Fosdik–Entin years, crucial support came from the British-American producer Edgar Lansbury, brother of the actress Angela Lansbury and best known for launching the Off Broadway and movie versions of *Godspell* in the 1970s. From the 1950s through the 1980s, the museum displayed over 150 of Roerich's paintings, along with artifacts and memorabilia, keeping the artist's name in public view. The image of Roerich put forward by the NRM mirrored the one promoted by the USSR; both presented him as a wise visionary with a gift for painting the sublime and a boundless desire for peace and harmony. To transform Moscow's Roerich into New York's, one needed only to subtract the Soviet patriotism and add a dollop

of new age wonder. In a 1986 profile, the journal *ARTNews* depicted the museum as "maintaining a worshipful atmosphere to perpetuate [Roerich's] message almost forty years after his death."[13] Among Roerichite institutions worldwide, the NRM, both then and since, has been the most consistent in cleaving to the beneficent and inclusive side of the family's teachings.

Much of Roerich's appeal in the West was felt among practitioners of alternative faiths. Helena retained her place in the Blavatskian firmament, and Agni Yoga melded comfortably with most new age doctrines, making the Roerichs objects of respect among Theosophists, astrologers, Tibetophiles, and students of yoga and Zen. They have been adopted by latter-day gurus invested in the "ascended masters" concept—in which religious leaders from all eras and cultures guide humanity's spiritual footsteps—and the "lost years of Jesus" tradition, which, as earlier chapters have shown, maintains that Christ, as a young man, traveled to the Himalayas and gained "eastern wisdom" there. One example is the work of Elizabeth Clare Prophet, the leader of the Church Universal and Triumphant (CUT) and cofounder with her husband Mark of the CUT-affiliated Summit University in Montana. Prophet cites Roerich's search in Ladakh for "Issa" in her *Lost Teachings of Jesus* and other writings, and named him an ascended master before her own death in 2009.[14] Continuing this trend has been Tricia McCannon (no relation to the present author), a self-described "mysteries expert"

who claims in *Jesus: The Explosive Story of the Lost Years* to have revealed Jesus as "the Master Initiate waited on for centuries" by the Great White Brotherhood.[15]

Along more conventional lines, awareness of Roerich heightened in the West, both among academics and the public. Museums beyond the NRM began showing Roerich's art, and more of his paintings entered circulation after 1971, when the Horches' Riverside Museum shut down and sold or lent out much of its collection. In 1974, the prestigious Cordier and Ekstrom Gallery in Manhattan marked Roerich's centenary by hosting a lavish exhibition of his theatrical designs. More positive press came that year when Katherine Campbell of the Nicholas Roerich Museum, in a gesture well suited to the détente era, returned to the USSR some forty paintings by Roerich, most belonging to the "Architectural Studies" lost to him after the 1904 Louisiana Purchase Exposition. These ended up in the State Museum of Oriental Art, which has since enjoyed a cordial relationship with the NRM.

In the 1980s, Roerich's artistic bona fides were further bolstered by a fresh evaluation of *The Rite of Spring* that refocused attention on his and Vaslav Nijinsky's influence on the ballet's creation and premiere. The centerpiece here was the 1987 revival of *The Rite* by New York's Joffrey Ballet, based on a meticulous re-creation of the original designs and choreography by Millicent Hodson and Kenneth Archer. The *New York Times* reviewer Anna Kisselgoff hailed the Joffrey production as a "pantheistic hymn" to the "union of man and nature" and praised it for spotlighting Roerich's "guiding role" in *The Rite*'s conception."[16] Not everyone agreed—the critic Joan Acocella described the Joffrey *Rite* as "shaggy" and "pseudo-folkloric"—but even negative assessments had the effect of writing Roerich back into Western narratives of Russian cultural history.[17]

Not always flatteringly, though. Among Western scholars and journalists, there was as much pushback as applause, especially against uncritical idealizations like those found in such works as Jacqueline Decter's stunningly illustrated but near-hagiographic *Nicholas Roerich* (later retitled *Messenger of Beauty*), from 1989. More skeptical researchers admitted Roerich's importance, but pointed out that he had played a less central role in the World of Art than his carefully tailored résumé suggested—John Bowlt's take on him in *The Silver Age*—or dredged up the more scurrilous details about his time in America, as Robert Williams did in *Russian Art and American Money*. A simultaneous wave of writing on Henry Wallace foregrounded Roerich's Svengali-like role in US history. Music and ballet historians acknowledged more routinely, if sometimes grudgingly, Roerich's contributions to *The Rite of Spring*, but the majority proved reluctant to buck the pro-Stravinsky orthodoxy in the unending debate about who first had the idea for it.

In 1988, a spirited exchange in the *New York Times* gave a clear sense of how conflicted America's view of Roerich had become.

That January, the journalist Karl Meyer, in an editorial titled "The Two Roerichs Are One," pointed out that Roerich's record was far from stainless and warned against glorifying him more than the facts warranted.[18] Meyer's frank discussion of Roerich's "mystic" pronouncements and his "oracular" sway over Henry Wallace attracted predictable anger from admirers. "Nicholas Roerich was far ahead of his time," insisted the self-help specialist Nanette Hucknall, who took issue with Meyer's letter in a February follow-up to the *Times*: "He thought about the planet as a whole and worked for the betterment of all people. Maybe for that type of thinking, back in the 1930's, in the United States, some individuals did not understand him, and therefore condemned him as a mystic. I'm sorry to read that in the 1980's he is so little understood by the media."[19] Such splits in opinion shape US perceptions of Roerich to this day.

Meanwhile, new developments in the USSR propelled Roerich to full celebrity status. In the mid-1980s, Mikhail Gorbachev's policy of glasnost, or "openness," created a friendlier climate for long-proscribed forms of spirituality, ranging from Orthodox Christianity to astrology and yoga. In ways unthinkable just a short time before, even the most explicitly mystical aspects of Roerichism could be safely espoused.

More than that, Gorbachev himself and his wife Raisa held Roerich in the highest regard. "In the Roerich family," Gorbachev proclaimed, "we have outstanding representatives of our country and people. They represent our civilization. They are one of its cultural pillars."[20] At a time when Marxist-Leninist symbology had lost much of its appeal, the Gorbachevs hoped the "Roerich idea" might reenergize the inner lives of Soviet citizens—serving as "a kind of spiritual communism"—and Raisa seems to have been attracted to the metaphysical side of Roerichite thought.[21] She began a close friendship with Sviatoslav Roerich and Devika Rani in spring 1987. To know Sviatoslav was "a blessing," she wrote. "We spoke of wisdom, beauty, virtue, and, of course, fate."[22]

This closeness inspired Gorbachev to put Roerich's legacy on a firmer footing. In 1989, after consulting with Dmitri Likhachev, his adviser on cultural affairs, Gorbachev signed into being the Soviet Roerich Foundation. The foundation's tasks were to foster awareness of the family's accomplishments and to gather and display as many of its artworks and belongings as possible. At Sviatoslav's request, it operated with "considerable independence," rather than under the Soviet Ministry of Culture or the State Museum of Oriental Art, as some in the government suggested.[23] The foundation received sumptuous new quarters in Moscow: the Lopukhin Estate, a neoclassical mansion on Malyi Znamensky Lane, a short stroll from the Kremlin. In 1990, Gorbachev facilitated the transport of more than two hundred Roerich paintings,

along with jewelry, manuscripts, and other items, from India to Moscow. Although this airlift pushed the limits of, and arguably violated, the antiquities act that had decreed Roerich one of India's National Treasures Artists, Sviatoslav openly supported it and was gratified to see the objects housed in the Lopukhin. Portions of Nicholas's and Helena's ashes were recovered from their resting places in India and likewise brought to Moscow.

Thus began the ascendancy of the institution that, for over a quarter century, dominated Roerich's revival in Russia and defined how he was perceived there. This was the International Center of the Roerichs (MTsR), which sprang up alongside the Soviet Roerich Foundation in 1991, then supplanted it upon the USSR's collapse. Linking both bodies was the Indologist Lyudmila Shaposhnikova, who had come to know Sviatoslav in the 1960s. During the 1970s and 1980s, Shaposhnikova headed the Communist Party apparatus at Moscow State University, enforcing ideological conformity, but she also forged ties with some of the Roerichite circles described above. At her disposal were useful friendships from her student days, as former classmates rose to prominence in politics and the diplomatic services. These included Yevgeny Primakov, an Arabist who directed the USSR's Institute of Oriental Studies and would serve Boris Yeltsin as foreign minister and prime minister in the 1990s; Alexander Kadakin, a future ambassador to Nepal and India; and Yuli Vorontsov, Gorbachev's deputy foreign minister and the Soviet ambassador to the United Nations in 1990–1991.

Shaposhnikova was thus ideally positioned in early 1991, when Roerich societies from across the USSR convened in Moscow by invitation of the Soviet Roerich Foundation. Also present were foreign guests, among them Daniel Entin of New York's NRM and representatives of the Indian Roerich Trust. The key proposal to emerge from this gathering—designating the MTsR as a helpmate to run the foundation's new Roerich museum—seemed unobjectionable and was readily agreed to. Yuli Vorontsov became the center's president, giving it a certain clout with UNESCO, but his post was largely honorary compared with that of Shaposhnikova, who, as vice president and director, emerged as the MTsR's true guiding force.

The months-long incorporation of the MTsR coincided with the USSR's final breakdown; by December 1991, when the center registered itself with the Ministry of Justice, the Soviet state itself was only days away from its formal disbandment. Left unresolved was the question of what should become of the Soviet Roerich Foundation if the term "Soviet" ceased to be of significance. Without hesitation, Shaposhnikova and Vorontsov declared the MTsR to be the foundation's natural successor and the rightful custodian of its assets, including paintings, artifacts, copyrights, and the Lopukhin Estate itself. The State Museum of Oriental Art strenuously objected to these assertions, and no Russian government since

1991 has ever recognized their logic or legality—a key stumbling block in the MTsR's many lawsuits and disputes during the 1990s and 2000s.

On a de facto basis, though, the MTsR made its claims stick for more than twenty-five years. Aided by Sviatoslav's endorsement until his death in 1993 and leveraging powerful connections among post-Soviet Russia's political and financial elite, Shaposhnikova and her fellows retained possession of the Lopukhin Estate and held up the center as the nation's premier arbiter of all things Roerich: the caretaker of his art, the shaper of popular and academic discourse on the family, the interpreter of his and Helena's teachings.[24] The MTsR aimed to identify itself so strongly with the Roerichs that, in the public mind, it and the family would become synonymous. It never realized this goal, but, for a time, came exceedingly close to doing so.

It was not just the MTsR's fortunes that rose during these years. Some five hundred Roerich societies existed in Russia during the 1990s and 2000s: some small or short-lived, but all lifted upward by the artist's skyrocketing popularity.[25]

Public enthusiasm for Roerich during these years cannot be doubted. His eye-catching painterly style accounted for much of this, as attested to in online reviews, tourist guidebooks, and other such sources. I myself, in venues like the Tretyakov Gallery and the State Russian Museum, have witnessed visitors—particularly schoolchildren on field trips, made glassy-eyed with boredom by droning museum guides—spark with excitement upon entering a hall containing Roerich's art, exclaiming *klass!* and *zdorovo!* ("cool!" "excellent!") as they rush to examine his paintings. Art historians *in* Russia, less ambivalent about Roerich than their Western colleagues, have catered to this taste with a plethora of publications about him, and collectors have acquired his work with growing avidity. Prominent Russians have been vocal about their affection for him. Since the days of Yuri Gagarin, Roerich has remained a favorite among members of Russia's space program. As noted earlier, the mountaineer Anatoly Boukreev frequently spoke of his admiration for Roerich. Other self-described fans have included the public intellectual Dmitri Likhachev, the acclaimed cellist Mstislav Rostropovich, the chess grandmaster Anatoly Karpov, and the Oscar-winning director Nikita Mikhalkov. Lyudmila Putina, before her 2013 divorce from President Vladimir Putin, used her status as Russia's first lady to favor Roerich, and even Putin endorsed him for a time, calling him a symbol of "the spirit of closeness that binds all people."[26]

Roerich's ascent also found expression in the post-Soviet rush to name things after him and to memorialize landmarks associated with him. In 1993, planetoid #4426, discovered by Soviet astronomers in 1969, was renamed in Roerich's honor. (In keeping with this cosmic theme, the MTsR

arranged for a Banner of Peace flag to be flown by the space shuttle *Columbia* to Russia's *Mir* space station, where it was proudly displayed.) Four glaciers in the Tien Shan range bear Nicholas's, Helena's, George's, and Sviatoslav's names, as do a cluster of peaks in the Altai. The container ship *Rerikh* gained a brief spot of fame in 2001 by helping to rescue the passengers of a US cargo plane that crashed into the Sea of Okhotsk. In Moscow and Saint Petersburg, the commemorative infrastructure dedicated to Roerich expanded considerably.

More than art lay behind the Roerich boom. As Gorbachev had hoped in the 1980s, though in ways he could not have anticipated, the "Roerich idea" caught on among post-Soviet Russians from all parts of the country and of every imaginable persuasion. As one team of experts on religion in Russia notes, Roerichite views "can be shaped to any school of thought," and this inconsistency has proved an asset, not a detriment.[27] Infinitely customizable, Agni Yoga can appeal to the left or the right, and has been conjoined with scores of spiritual practices, from atheism to neo-shamanism, and even with monotheistic faiths such as Christianity (although the Russian Orthodox Church, as described below, objects to such syncretism). It resonates equally well with messianists who expect the future to unfold apocalyptically and with transcendentalists who believe it will do so in gradual, noospheric fashion. Whatever specific outlook it fused with, Roerichism seemed to offer a compelling new vision of Russia's

place in the world and what it meant to *be* Russian.

Roerich's influence has occasionally operated at high levels of punditry and policymaking. Russian jurists point to the Roerich Pact as a noteworthy contribution to international law.[28] Among foreign-policy thinkers, Roerich has been cited by political scientists looking for models of "multipolarity" and "global pluralism" to counter triumphalist or confrontational theories from the West, such as Francis Fukuyama's "end of history" or Samuel Huntington's "clash of civilizations." Here, he is mentioned alongside other "universalists," such as Pitirim Sorokin, Sun Yat-sen, and Pierre Teilhard de Chardin.[29]

As for the Russian public, its receptivity to Roerichism has ranged from fandom and casual dabbling to dogmatic adherence. In addition to those belonging to actual Roerich groups, unspecified thousands pursue Roerich-related interests to a measurable degree, and one scholarly estimate of how many Russians find Roerichite ideas in any way appealing runs to "the millions."[30] The family's more dedicated votaries have attracted attention with their unconventional behavior. In the 1990s, Roerichite expectations that a great flood would soon engulf Eurasia sparked a set of pilgrimages to the Altai, where the faithful hoped to survive into the next cosmic era. Not only did the awaited deluge fail to occur, but the pilgrims argued about their fundamental purpose. Would Roerich's "radiant city" of Zvenigorod miraculously appear if they trusted

to fate? Or were they meant to erect it themselves before the rains poured down?[31] The head of the Church of Maitreya in Cheliabinsk asserted her status as Helena Roerich's representative on earth, and the leader of the Roerichite Bazhov Center in the Urals claimed to be the reincarnation of Confucius. Other such instances abounded.

Most significant, though, is the vaguely admiring attitude of the aforementioned "millions": ordinary Russians, whose warm feelings for Roerich indicate how firmly the artist's supporters have embedded him in the country's cultural consciousness. Roerich's post-Soviet partisans have successfully equated him with a hazily positive view of Russia as a morally pure realm, connected organically to Asia and the Christian world alike by virtue of geography, and spiritually richer than the close-minded, narrowly empirical materialists of the West—all without sacrificing his usefulness as a symbol of universal peace and multicultural tolerance. This image, a product of Roerichism's exceptional elasticity, became the principal basis for the artist's popularity during the Yeltsin decade, and it has remained such during the Putin era.

That said, the Roerich renaissance involved scandal as well as stardom. Some of this was innocuous, little more than bemused eye-rolling at the family's mysticism. The Moscow Info website, for example, while praising Roerich's paintings at the Museum of Oriental Art, mentions as well his "fascinatingly crazy" worldview.[32] The slang term *rerikhnutsia*, coined from Roerich's name and punning on the verb *rekhnutsia*—"to go off one's rocker"—made its snide debut in the 1990s and still crops up in the present century.[33]

More substantively, nothing could contain the scholarly and journalistic revelations that spilled forth as interest in the Roerichs waxed and more documents about the family's affairs came to light. Sensationalist exposés such as Oleg Shishkin's *Struggle for the Himalayas*, from 1999, raised important questions about the Roerichs' actions, but undid much of their usefulness by indulging in melodramatic speculation.[34] Far more credible have been researchers from the academic sphere, with two historians in particular—Alexandre Andreyev and Vladimir Rosov—meriting special attention. Both men's publications tackle head-on the thorniest issues regarding the Roerichs' mystical beliefs and political dealings; they stand as models of rigorous sourcemanship and have been cited throughout this book. Any frank treatment of Roerich, no matter how judicious, has tended to come under fire from Roerich-friendly institutions, and even from academic peers who prefer comfortingly sanitized portrayals of the artist. Nothing, however, has so far matched the fury that greeted the publication of Rosov's two-volume biography of Roerich, *Herald of Zvenigorod*, and the dissertation he prepared simultaneously for his higher doctoral degree, which underwent a two-stage defense

in October 2005 and March 2007. Seeking to discredit this research, Roerich partisans, especially from the MTsR, unleashed a months-long torrent of denunciation, complete with thuggish accusations in the national press of "deficient scholarship" and "outright slander." Backed by thirty academicians and other historians, Rosov brought this process to a successful end in 2007, but the uproar showed how far the MTsR and its allies were willing to go to protect "proper" understandings of Roerich.[35]

Effective as a way to torment foes, such shrillness, on balance, served the Roerich cause poorly. Over time, petulant displays of righteous indignation wore on the public's nerves and contrasted unfavorably with the sober marshaling of documentable facts. Moreover, such defensiveness drew attention to the cultlike attributes of Roerich's most fervent idealizers, especially the MTsR. While the center strove for years to present itself as a respectable single-artist museum on the order of Fallingwater or the Musée Rodin, it gave off as well the palpable feel of a mother church—gratifying, perhaps, to the faithful, but off-putting to others. The longer Shaposhnikova led the MTsR, the more she spoke of the Roerichs in unabashedly supernatural terms, assigning them a place in the centuries-spanning chain of "ascended masters" and promoting Agni Yoga as an instrument of salvation for Russia and the world.

The very layout of the MTsR's museum resembled that of a place of worship. Passing through a courtyard dominated by statues of Nicholas and Helena, visitors entered a series of galleries that alternated in purpose, with some telling the Roerichs' story as any museum might and others offering a perspective most charitably described as semireligious. Details varied over the center's years of operation, but while a few rooms displayed art and photographs conventionally enough, the rest promoted the Roerichs as celebrities or blatantly proselytized on Agni Yoga's behalf. In the Hall of Living Ethics, portraits of Morya and Koot Hoomi gazed down upon a row of busts depicting assorted "ascended masters," and simply to enter the galleries, one passed through a dim vestibule lit by a huge artificial crystal—a representation of Chintamini, the sacred stone—illuminated from within by an electric lamp and, at least to a Western viewer, recalling a lost prop from the set of *Star Trek*, circa 1966. For the uninitiated, an excursion to the MTsR felt like nothing so much as stepping into the Smithsonian, only to find it unexpectedly annexed by a Scientology information center.

Other signs of uncanniness became evident. The MTsR's financial underpinnings depended disproportionately on one body: Master-Bank, headed by the Ukrainian-born oligarch Boris Bulochnik. This was not just philanthropical outreach; Roerichism was the core mission of Master-Bank, which adopted the Banner of Peace as its principal logo, plastered on ATMs and billboards throughout the country, and whose very name connoted Roerich and Morya himself. Master-Bank made possible the

spending spree by which the MTsR renovated its museum and purchased so many of Roerich's paintings from abroad, and Master-Bank money funded the publication of a whole library of books about the Roerichs, all bearing the center's imprimatur. Cash-strapped cultural institutions in post-Soviet Russia have often had to embrace dubious means of raising money, but to many, the MTsR/Master-Bank relationship seemed shady even by the standards of a shady time.

Neither did the MTsR bring credit to itself—or to Roerich's name—with the dozens of quarrels it pursued during the 1990s and 2000s. In addition to baiting scholars and commentators of whom it disapproved, the center fought institutional rivals over points of interpretation and the ownership of tangible assets. Its chief opponents included the Museum of Oriental Art (whose collection of Roerich works it coveted), the Moscow-based Sfera Press (over the right to publish Helena's diaries), and the Nicholas Roerich Museum in New York (whose support of Sfera and the Museum of Oriental Art led Shaposhnikova to denounce Daniel Entin as "a traitor worse than Louis Horch").[36] The MTsR ultimately lost these disputes, and such tawdry shows of acquisitiveness, which squared poorly with the center's rhetoric about cosmic harmony, bruised its reputation. Further inflaming tensions were Shaposhnikova's ceaseless campaigns to impose homogeneity of belief among Roerichite clubs and circles. For every group she brought under her control, she alienated another with her domineering

ways. Moreover, the more forcefully she elevated herself, the more sharply she veered away from Agni Yoga's ecumenical inclusivity, preaching instead a more Slavophilic and exclusionary creed that struck many as extremist.

If anything has truly threatened Roerich's standing in post-Soviet Russia, it is the sustained and savage criticism of him by the Russian Orthodox Church. This conflict has deep roots, dating to the church's anathematization of Roerichism in the 1930s, and it began again in 1994, when the church denounced the Roerich movement as a "totalitarian, anti-Christian sect." In 1996, church officials reconfirmed that Roerichite doctrine was "not only incompatible with Christianity, but directly inimical to it."[37] The Moscow deacon Andrei Kuraev pushed this charge further in his essay "Satanism for the Intelligentsia," which accused Roerich of being "an NKVD [secret police] spy, a crypto-Nazi, and a bad painter."[38] The more intemperate of Roerich's supporters counterattacked with equal heat. Ksenya Myalo, in a diatribe called "Christ in the Himalayas," holds Roerich up as "more Russian and more Orthodox than the Church itself," then goes on to list Russia's "real" enemies, in whose ranks she numbers "Tolkien, G. K. Chesterton, the 'Judaic' media, the Catholic Church, global capital, NATO, and the Internet."[39]

As the critic Rachel Polonsky observed in 2002—while noting how close the Lopukhin Estate stood to Moscow's mammoth Cathedral of Christ the Savior,

the most visible symbol of Orthodoxy's post-Soviet resurgence—the "crackling row" between the Orthodox Church and the MTsR obscured the ironic fact that, on the plane of ideas, the two had more in common than they cared to admit. Despite their mutual loathing, their outlooks shared a messianic Russophilia and an aggrieved sense that "the West had defiled Russia's sacred space and led her away from salvation."[40] Any such similarity, though, has done nothing to repair relations, and while there are any number of ways to reconcile admiration for Roerich with one's personal Christianity, church disapproval remains a sore point with the artist's devotees. Not fatal to his general popularity, but a liability nonetheless.

Recent years have brought continued turbulence to Roerich's cultural afterlife. This has less to do with the artist's own renown, which remains secure, and more with institutional Roerichism, which hit several bumpy patches in the 2010s and 2020s.

In 2012–2013, for example, charges of influence peddling and mismanagement bedeviled India's Roerich Memorial Trust, which manages the Roerich museum in Naggar, causing one editorial to remark that the Kulu Valley risked becoming not the "abode of the gods," but the "abode of the land mafia."[41] The Nicholas Roerich Museum in New York experienced a sad moment in 2017 with the death of Daniel Entin, although the directorship had passed smoothly into younger hands the year before.[42] It was the MTsR, however, that suffered the most crippling blows. In 2013, the center's chief source of financial support, Master-Bank, went suddenly bankrupt. Making things worse, Master-Bank's head, Boris Bulochnik, fled the country to escape charges of corruption and money laundering.[43] (He has since been placed under arrest in absentia.) This left the MTsR not just poorer, but immured in scandal. Onlookers were left to wonder whether the center had been defrauded by the bank's malfeasance—or complicit in it. Lyudmila Shaposhnikova's long reign over the MTsR came to its close, diminished by the ordeals of the early 2010s and ended by her death in 2015.

This formed the prelude for the most thunderous reversal of all. In 2016, the Russian Ministry of Culture declared the MTsR's curatorship of the Lopukhin Estate museum invalid, assigning the collection there instead to the Museum of Oriental Art. The government then enforced this decree in a moment of high drama: in March 2017, officials from the Interior Ministry, backed by heavily armed police, swooped into the Lopukhin Estate, confiscating the artworks and assets contained therein. By April, all MTsR personnel had been expelled from the premises.[44] The reasons for the center's crash and the details of its long denouement are beyond the scope of this chapter. Suffice it to say that the MTsR has presented itself since 2017 as the innocent victim of predatory rivals and authoritarian malice.[45]

Many institutions indeed have been bullied by Putin's regime over questions of free expression and political principle, but how far the center can be counted among them is debatable. By every indication, the MTsR lost a series of straightforward power games, not a valiant crusade for some righteous ideal. (One factor that perhaps contributed to its defeat is the steady strengthening of Putin's political alliance with the Orthodox Church over the past decade. If the price for church support was the humbling of a hated rival, it is easy to imagine Putin withdrawing without hesitation the state protections the MTsR once enjoyed.)

Whatever brought the MTsR low, its visible quirks and crankiness, not to mention its record of intimidating weaker rivals during its own heyday, have kept it from garnering the measure of public sympathy it craves, and its legal efforts to undo the actions of 2017 have so far sputtered out completely. In the meantime, the Museum of Oriental Art began the process of absorbing the MTsR's former assets. By 2019, the museum's amalgamated Roerich collection, curated by Vladimir Rosov, had been reorganized into several parts. In its quarters on Moscow's Nikitsky Boulevard, the museum continues to house approximately thirty Roerich paintings in a hall that has been dedicated to the artist since the 1970s. It has taken charge of the Lopukhin Estate and runs it as an affiliated facility, with many renovations underway. It has also created an enormous permanent exhibit, titled "Preserving Culture" and comprising more

than six hundred of Roerich's and Sviatoslav's paintings, and installed it in Pavilion 13 of Moscow's famed VDNKh exposition grounds.

Whither Roerich—and Roerich studies—in the aftermath of these changes? Where the Roerich movement is concerned, it is now more accurate to speak of "movements," and in an era driven by the Internet and social media, diversity and individualized syncretism appear to be the future, both for Roerichism as a belief system and Roerich fandom more broadly. The general public is freer than ever before to perceive Roerich however it pleases.

As for Roerich scholarship and museology, the best possible outcome would be normalization. Patriotically prideful views of Roerich will not disappear in Russia, and at the time of this writing, the Putin regime is engaged in a dismaying reimposition of constraints on academic discourse and free expression. Vast differences still divide historians, whether Russian or non-Russian, on fundamental questions about Roerich and his family. Still, many of the forces that most stubbornly obstructed open inquiry into their deeds and beliefs have fallen, a fact one can hope will encourage research that hews more closely to standard biographical conventions. Reassessment of Roerich along these lines is ongoing and will remain a work in progress for some time. Given Roerich's peregrinations, it will by necessity be a multinational project. Given his idiosyncrasies, to say nothing of the many things he strove to hide from view,

it may never be complete. But it cannot do other than improve our understanding of what remains a most mysterious topic.

Such has been the aim of this book—of which, it must be confessed, Roerich himself would emphatically disapprove. Not just for what it exposes, or for its lack of faith in what he and Helena taught, although both would rankle him. In his later years, Roerich became irreversibly convinced that only by a fellow Russian could his story be told. So he said in a 1938 letter to the journalist Vladimir Zeeler. Speaking of commentaries written about him by Western scholars and reporters, Roerich told Zeeler, "Of course, no foreign author can fully comprehend the *russkost'* [Russian-ness] of my work. Even to ask such a thing is impossible; it is a task for Russian authors only."[46]

To be sure, there are dimensions of Roerich's art and outlook best grasped or appreciated by his compatriots. Yet his is such an international tale, and his professed philosophy one that speaks so eloquently of communicating across borders, that his remark to Zeeler can hardly be the last or best word on the subject. The refining and refashioning of Roerich's story in the years to come should be done by as many hands as possible, and from as many places. My hope is that this book stands as a useful contribution to that larger endeavor.

Notes

Abbreviations for Archives and Frequently Cited Sources

AAA	American Archive of Art	NARA	National Archives and Records Administration of the United States
ACRC	Amherst Center for Russian Culture		
AG/PB	Rerikh, *Altai-Gimalai/Puti blagosloveniia*	NKR	Belikov and Kniazeva, *N. K. Rerikh*
AH	Roerich, *Altai-Himalaya*	NKR: zit	Kuz'mina, ed., *N. K. Rerikh: zhizn' i tvorchestvo*
AUDU AV ČR	Archive of the Institute of Art History of the Academy of Sciences of the Czech Republic	NR	Poliakova, *Nikolai Rerikh*
		NRM	Nicholas Roerich Museum
AVP RF	Foreign Policy Archive of the Russian Federation	NRVZ	Rosov, *Nikolai Rerikh: Vestnik Zvenigoroda*
BAR	Bakhmeteff Archive	OR GTG	Manuscript Department, State Tretyakov Gallery
BzG	Shishkin, *Bitva za Gimalai*		
ELD	Esther Lichtmann diaries	PRS	*Peterburgskii Rerikhovskii sbornik*
FBI/Roerich	Federal Bureau of Investigation, Archive of (Roerich, Nicholas K.)	RGALI	Russian State Archive of Literature and Art
FNA	Finnish National Archives	RGVA	Russian State Military Archive
FRGP	Frances Ruth Grant Papers	RT	Riabinin, *Razvenchannyi Tibet*
GARF	State Archive of the Russian Federation	RvPP	Korotkina, *Rerikh v Peterburge-Petrograde*
HoA	Roerich, *Heart of Asia*	SatRT	Taruskin, *Stravinsky and the Russian Traditions*
HRD	Helena Roerich diaries		
IiKhP	*Iskusstvo i khudozhestvennaia promyshlennost'*	SDiRI	Zil'bershtein and Samkov, eds., *Sergei Diagilev i russkoe iskusstvo*
IOLR	India Office Library and Records	SoS	Rerikh, *Sobranie sochinenii*
IzLN	Rerikh, *Iz literaturnogo naslediia*	ST	Portniagin, "Sovremennyi Tibet"
LD	Rerikh, *Listy dnevnika*	TDI	Iakovleva, *Teatral'no-dekoratsionnoe iskusstvo N. K. Rerikha*
MoB	Decter, *Messenger of Beauty*		
MoTM	Andreyev, *The Myth of the Masters Revived*	TiS	Kordashevskii, *Tibetskie stranstviia polkovnika Kordashevskogo*
MTsR	International Center of the Roerichs		
		TtIA	Roerich, George, *Trails to Inmost Asia*
MU	Fosdik, *Moi uchitelia*		

Introduction: The Artist Who Would Be King?

1. Igor' E. Grabar', *Moia zhizn'* (Moscow: Iskusstvo, 1937), 170–71.

2. Yuri Gagarin, *Road to the Stars* (Honolulu: University Press of the Pacific, 2002), 155; foreword to N. K. Rerikh, *Zazhigaitse serdtsa* (Moscow: Molodaia gvardiia, 1978), 22.

3. Text displayed at the Roerich Gallery, Naggar, India.

4. See www.unesco.org/new/fileadmin/ MULTIMEDIA/HQ/CLT/pdf/1954_Convention_ EN_2020.pdf.

5. In 2013, *Madonna Laboris* (1931) sold for £7.9 million, the highest price earned to that date by a single canvas in an auction devoted exclusively to Russian paintings (*Calvert Journal* [June 14, 2013]). In 2006, Roerich's *Lao-tze* (1924) went for $2.2 million at Sotheby's New York, making it the top earner in a 589-lot sale of Russian art that brought in $54 million (*Russian Life* 49 [July–August 2006]: 11).

6. Igor Stravinsky and Robert Craft, *Conversations with Igor Stravinsky* (London: Faber and Faber, 1959), 105.

7. Carl Jung, *Modern Man in Search of a Soul* (New York: Harcourt, 1962).

8. Maria Carlson, "Fashionable Occultism," *Journal of the International Institute* 7 (Summer 2001): 1–2. See also Maria Carlson, *"No Religion Higher Than Truth": A History of the Theosophical Movement in Russia, 1875–1922* (Princeton, NJ: Princeton University Press, 1993); Bernice G. Rosenthal, ed., *The Occult in Russian and Soviet Culture* (Ithaca, NY: Cornell University Press, 1997); and Birgit Menzel, Michael Hagemeister, and Bernice G. Rosenthal, eds., *The New Age of Russia: Occult and Esoteric Dimensions* (Munich: Kubon & Sagner, 2012).

9. N. K. Rerikh, *Listy dnevnika (1936–1941)*, vol. 2 (Moscow: MTsR, 2000), 385–86.

10. First quote from the 1944 edition of the *Bol'shaia Sovetskaia Entsiklopediia*. The conspiracy charge is mentioned in the memoirs of the dissident Lev Razgon, *True Stories* (Dana Point, CA: Ardis, 1997), 279.

11. Notable authors on Roerich's art in English include John Bowlt, Robert Williams, Kenneth Archer, Millicent Hodson, and Richard Taruskin. Among Russians are P. F. Belikov and V. P. Kniazeva, *N. K. Rerikh* (Moscow: Molodaia gvardiia, 1996 [orig. 1972]) [hereafter NKR]; E. I. Poliakova, *Nikolai Rerikh* (Moscow: Iskusstvo, 1973) [hereafter NR]; L. V. Korotkina, *Rerikh v Peterburge-Petrograde* (Leningrad: Lenizdat, 1985) [hereafter RvPP]; M. T. Kuz'mina, ed., *N. K. Rerikh: zhizn' i tvorchestvo* (Moscow: Izobrazitel'noe iskusstvo, 1978) [hereafter NKR: zit]; E. P. Iakovleva, *Teatral'no-dekoratsionnoe iskusstvo N. K. Rerikha* (Samara: Agni, 1996) [hereafter TDI]; and E. G. Soini, *Severnyi lik Nikolaia Rerikha* (Samara: Agni, 2001). Robert Williams and Robert Rupen delved into Roerich's expeditions and politicking in the 1970s, and several fine works—notably by Alexandre Andreyev, Vladimir Rosov, Karl Meyer and Shareen Brysac, Markus Osterrieder, Dany Savelli, Anita Stasulane, Darya Kucherova, Andrei Znamenski, Ernst von Waldenfels, and Maksim Dubaev—have continued this line of inquiry.

12. The key example being the gorgeously produced but uncritical *Messenger of Beauty* (Rochester, VT: Park Street Press, 1997), by Jacqueline Decter, first released in 1989 as *Nicholas Roerich: The Life and Art of a Russian Master* [hereafter MoB]. Even more adulatory are Ruth Drayer, *Nicholas and Helena Roerich* (Wheaton, IL: Quest Books, 2005); Garabad Paelian, *Nicholas Roerich* (Sedona, AZ: Aquarian Educational Group, 1996); and Colleen Messena, *Warrior of Light: The Life of Nicholas Roerich* (Malibu, CA: Summit University Press, 2002). Similarly, Soviet-era biographies are more useful as discussions of Roerich's art than as actual chronicles of his life.

13. A valuable body of diaries, kept by the Roerichs' followers, includes Z[inaida] G. Fosdik, *Moi uchitelia: po stranitsam dnevnika 1922–1934* (Moscow: Sfera, 1998) [hereafter MU], by Sina Lichtmann, the Roerichs' most zealous disciple in America ("Sina" was her Americanized nickname,

and "Fosdik" is the Russian version of "Fosdick," her second husband's surname). Also revealing are the Frances Ruth Grant papers [hereafter FRGP], housed at Rutgers University; K. N. Riabinin, *Razvenchannyi Tibet* (Magnitogorsk: Amrita-Ural, 1996) [hereafter RT]; N. K. Kordashevskii, *Tibetskie stranstviia polkovnika Kordashevskogo (s ekspeditsiei N. K. Rerikha po Tsentral'noi Azii)* (Saint Petersburg: Dmitrii Bulanin, 1999) [hereafter TiS]; and P. K. Portniagin, "Sovremennyi Tibet: Missiia Nikolaia Rerikha; Ekspeditsionnyi dnevnik," *Ariavarta* 2 (1998): 11–106 [hereafter ST]. The Esther Lichtmann diaries [hereafter ELD] are held by the artist Oriole Farb Feshbach, the youngest child of Louis and Nettie Horch. Helena Roerich kept a journal of her own, recording daily events and transcribing séances. Original copies [hereafter HRD, volume, and page number or date] are housed at the Amherst Center for Russian Culture (ACRC). Many unofficial copies are available in Russia and online. The Nicholas Roerich Museum in New York has made its online archive of letters and photographs available at www.roerich.org [NRM, followed by file number].

14. N. K. Rerikh, *Listy dnevnika (1942–1947)*, vol. 3 (Moscow: MTsR, 2002), 343–44.

15. *The Times Atlas of World Exploration* (New York: HarperCollins, 1991), 222. See also Ian Chilvers, *Oxford Dictionary of 20th-Century Art* (Oxford: Oxford University Press, 1999), 524–25; and *The Thames and Hudson Dictionary of Art and Artists* (London: Thames and Hudson, 1994), 311.

16. Irina Corten, *Nicholas Roerich: An Annotated Bibliography* (New York: Nicholas Roerich Museum, 1986), 24–25, on Robert Williams's *Russian Art and American Money: 1900–1940* (Cambridge, MA: Harvard University Press, 1980), which she also calls "highly tendentious."

17. See the "Zashchita imeni i nasledia Rerikhov" section of the MTsR website (icr.su, formerly roerich-museum.ru), and the three-volume *Zashchitim imia i nasledie Rerikhov* (Moscow: MTsR, 2001–2005). Among others, Darya Kucherova, "Art and Spirituality in the Making of the Roerich Myth"

(PhD diss., Central European University, 2006), 309–10; and Rachel Polonsky, "Letter from Peryn," *Times Literary Supplement* (June 7, 2002), comment on the center's reflexive protectionism. (Disclaimer: the defunct version of the MTsR website condemned my own work as overly materialistic and insufficiently respectful.)

18. Kenneth Archer, reviewing Decter's *Nicholas Roerich*, in *Art History* 13 (September 1990): 419–23.

19. Robert Craft, *Stravinsky: Glimpses of a Life* (New York: St. Martin's Press, 1993), 247n1.

20. The espionage line is pursued most vigorously by O. P. Shishkin, *Bitva za Gimalai: NKVD; magiia i shpionazh* (Moscow: OLMA-Press, 1999) [hereafter BzG] and Anton Pervushin, *Okkul'tnye tainy NKVD i SS* (Leningrad: Neva, 1999). On the Orthodox Church's anti-Roerich stance, see Polonsky, "Letter."

21. Helena Roerich, *On Eastern Crossroads* (Delhi: Prakashan Sansthan, 1995), 78, 94, 104.

22. Cited in Ruth Drayer, *Wayfarers: The Spiritual Journeys of Nicholas and Helena Roerich* (La Mesilla, NM: Jewels of Light, 2003), 265–66.

23. Soviet-era volumes include N. K. Rerikh, *Iz literaturnogo nasledia* (Moscow: Izobrazitel'noe iskusstvo, 1974) [hereafter IzLN]; N. K. Rerikh, *Izbrannoe* (Moscow: Sovetskaia Rossiia, 1979); and V. E. Larichev and N. Velizhanina, eds., *Rerikhovskie chteniia* (Novosibirsk, 1976–1980). A key post-Soviet collection is Rerikh, *Listy dnevnika* (Moscow: MTsR, 2002), covering 1931–1935, 1936–1941, and 1942–1947 [hereafter LD, followed by volume and page number]. See also Rerikh, *Sobranie sochinenii* (Moscow: Sytin, 1914) [hereafter SoS]; Nicholas Roerich, *Altai-Himalaya* (New York: F. A. Stokes, 1929) [hereafter AH]; and Nicholas Roerich, *Heart of Asia* (Rochester, VT: Inner Traditions, 1990 [orig. 1929]) [hereafter HoA]. *Altai-Himalaya*'s Russian original, *Altai-Gimalai*, is reproduced in N. K. Rerikh, *Puti blagosloveniia* (Moscow: Eksmo, 2007) and cited hereafter as AG/PB.

24. Graham Greene, *The Quiet American* (London: Heinemann, 1955), 103, 110. In the

book, Tây Ninh appears as "Tanyin." Caodai was established in late 1925; see www.caodai.org.

25. Cited by Arthur Cotterell, *A Dictionary of World Mythology* (New York: Perigee, 1979), 88.

26. Alexandre Andreyev, "Dreams of a Pan-Mongolian State," paper presented at the Second Conference "Buddhism and Nordland," Tallinn University, September 25–27, 2008; Markus Osterrieder, "From Synarchy to Shambhala: The Role of Political Occultism and Social Messianism in the Activities of Nicholas Roerich," in Menzel, Rosenthal, and Hagemeister, *New Age of Russia*, 103. See also Kucherova, "Art and Spirituality," 53, who insists that Roerich was not a "mentally unstable swindler," but "a legitimate heir to several cultural tendencies of [the] Russian *fin-de-siècle* [*sic*]"; and Andrei Znamenski, *Red Shambhala: Magic, Prophecy, and Geopolitics in the Heart of Asia* (Wheaton, IL: Quest Books, 2011).

27. Alexandre Andreyev, *The Myth of the Masters Revived: The Occult Lives of Nikolai and Elena Roerich* (London: Brill, 2014) [hereafter MotM], 423, 446–48, on the question of epilepsy.

28. Andreev, MotM, 23 ("neurotic"). Storr quoted in Jon Krakauer, *Under the Banner of Heaven* (New York: Anchor Books, 2004), 291, 306–9. See also Lawrence Wright, *Going Clear: Scientology, Hollywood, and the Prison of Belief* (New York: Vintage, 2013), 62, who cites the University of British Columbia psychiatrist Stephen Wiseman's theory that Scientology's founder, L. Ron Hubbard, exhibited signs of "malignant narcissism." According to the *Diagnostic and Statistical Manual of Mental Disorders* (DSM-IV), narcissistic personality disorder strikes approximately 1 percent of the US population. Over time, the Roerichs may also have suffered shared psychotic disorder, traditionally referred to as folie à deux.

29. Grabar', *Moia zhizn'*, 170–71.

Chapter 1: Childhood and Youth, 1874–1893

1. The proper way to say "Roerich" remains confusing, due to the "e" in Рерих (Rerikh), as the name appears in Russian. A vowel normally voiced as "ye," "e" yields the "REHR-ik" most commonly—though not exclusively—heard among Russians today. Darya Kucherova, "Art and Spirituality in the Making of the Roerich Myth" (PhD diss., Central European University, 2006), viii, notes the difficulty of knowing if this pronunciation prevailed in Roerich's time, but his parents are thought to have used it, as did legal documents pertaining to the family. Still, a minority prefers "RYOR-ik," based on the possibility that the "e" is actually "ë," voiced as "yo." Written Russian typically omits the diaeresis mark even when "yo" is called for—native speakers are expected to know by memory how to sound any given "e"—so in the case of unusual words, the absence of a diaeresis does not by itself settle the question. Complicating matters further, Roerich himself occasionally dotted his signature with a diaeresis, though not on legal or formal documents. Linked to Roerich's Russian-language Wikipedia page is a lengthy subessay dedicated to these perplexities, titled "On the Surname's Second Letter" (ru.wikipedia.org/wiki/Рерих_(фамилия)#О_второй_букве_фамилии). Like the majority of Roerich scholars, both Russian and non-Russian, I incline toward "REHR-ik."

2. Ivars Silars, "Predki Nikolaia Rerikha," *Rerikhi: mify i fakty*, ed. A. I. Andreev and Dany Savelli (Saint Petersburg: Nestor-Istoriia, 2011), 18–29.

3. The standard account of Roerich's early life comes mainly from his own reminiscences, as in Rerikh, IzLN, and the three volumes of LD. See also Korotkina, RvPP. His mother's birth year is sometimes given as 1845.

4. Rerikh, LD, 3:461.

5. Roerich's grandfather owned a set of Masonic badges that the children were allowed to look at but not touch, and Roerich continued to wonder about their fate after the revolution. Manuscript Department of the State Tretyakov Gallery (OR GTG), f. 44, op. 1, ed. khr. 46, l. 1. Fyodor belonged to a Masonic lodge in Riga (Andreev and Savelli,

Rerikhi, 63), and it is commonly assumed that Konstantin was also a Mason. Whether Nicholas or his brothers became Masons remains uncertain.

6. Memories recorded in Nicholas Roerich, *Realm of Light* (New York: Roerich Museum Press, 1931), 174–76; Rerikh, IzLN, 78–80, 99–101; and Rerikh, LD, 2:73–75, 98–99, 266–67.

7. Rerikh, IzLN, 79.

8. OR GTG, f. 44, op. 1, ed. khr. 1857, l. 1.

9. Dozens of times in his journals, Roerich recalled Tissandier's book as he compared himself to Copernicus, Galileo, and others threatened with "the stake, tortures, and the scaffold" (Roerich, *Realm of Light*, 88).

10. David Burliuk, "Tvorchestvo Rerikha" (1924 essay). OR GTG, f. 44, op. 1, ed. khr. 646, ll. 1–10.

11. Poliakova, NR, 9–11; Belikov and Kniazeva, NKR, 10–13; and Nikita Blagovo, *Sem'ia Rerikhov v gimnazii K. I. Maia* (Saint Petersburg: Nauka, 2006).

12. Kenneth Archer, "The Theatrical Designs of Nicholas Roerich: Problems of Identification" (MA thesis, Antioch University, 1985), 72; Nicholas Roerich, *Fiery Stronghold* (Boston: Stratford, 1933), 396–402; Rerikh, IzLN, 81–82, 144–45; and Iakovleva, TDI, 7–9.

13. Rosamund Bartlett, *Wagner and Russia* (Cambridge: Cambridge University Press, 1995), 46–49, 67–68.

14. John E. Bowlt, *The Silver Age: Russian Art of the Early Twentieth Century and the "World of Art" Group* (Newtonville, MA: Oriental Research Partners, 1979), 49; Janet Kennedy, *The "Mir iskusstva" Group and Russian Art* (New York: Garland, 1977), 14–15; and Camilla Gray and Marian Burleigh-Motley, *The Russian Experiment in Art, 1863–1922* (London: Thames and Hudson, 1986), 43–44. Sviatoslav Roerich recalls that his father "kept away" from the group at school "because he did not share their ultra-European views" (Archer, "Theatrical Designs," 45–46). In the 1930s, Roerich told Mikhail Taube that he had had little to do with the circle, whose members "were, after all, six classes ahead of me." Bakhmeteff Archive of Russian

Culture [hereafter BAR], MsColl/Taube, M. A, box 1.

15. Andreyev, MotM, 4, citing the 1993 edition of A. N. Benua, *Moi vospominaniia*, 485.

16. *Peterburgskii Rerikhovskii sbornik* [hereafter PRS], 5 vols. (Saint Petersburg: Bukovskoe, 1998–2002), 2/3:23–27, 110–11.

17. Rerikh, IzLN, 84.

18. Poliakova, NR, 20–22; and letters from Mikeshin to Roerich, OR GTG, f. 44, op. 1, ed. khr. 997–1007.

19. Poliakova, NR, 4.

20. Rerikh, IzLN, 82–83, 87, 242.

21. OR GTG, f. 44, op. 1, ed. khr. 5, l. 1.

Chapter 2: Academy Days, 1893–1897

1. Korotkina, RvPP, 22, relying on Roerich's student diaries (OR GTG, f. 44, op. 1, ed. khr. 11, l. 57; ed. khr. 14, ll. 7–8).

2. Belikov and Kniazeva, NKR, 15.

3. Darya Kucherova, "Art and Spirituality in the Making of the Roerich Myth" (PhD diss., Central European University, 2006), 25, citing Roerich's diary in OR GTG, f. 44.

4. OR GTG, f. 44, op. 1, entry from October 20, 1894.

5. Poliakova, NR, 25, as translated by Decter, MoB, 14.

6. Related in Roerich's diaries, and by A. A. Bondarenko and V. L. Mel'nikov, "N. K. Rerikh—student iuridicheskogo fakul'teta," Saint Petersburg State Museum-Institute of the Roerich Family (www.roerich.spb.ru).

7. OR GTG, f, 44, op. 1, ed. khr. 10, l. 3. Roerich used the term "kikimora," a malevolent figure from Slavic myth. Latkin similarly tormented the author Alexander Blok, giving him the equivalent of a C.

8. Rerikh, LD, 2:63–64; PRS, 2/3:37–97, 177–80, 747–48.

9. Irina Tatarinova, "'The Pedagogic Power of the Master': The Studio System at the Imperial Academy of Fine Arts in St. Petersburg," *Slavonic and East European Review* 83 (July 2005): 470–89.

10. Robert C. Williams, *Artists in Revolution: Portraits of the Russian Avant-Garde, 1905–1925* (Bloomington: Indiana University Press, 1977), 10–15; and Elizabeth Kridl Valkenier, *Russian Realist Art: The Peredvizhniki and Their Tradition* (Ann Arbor, MI: Ardis, 1977), 10–17.

11. Other instructors included the sculptors Nikolai Lavaretsky and Hugo Zaleman, the engraver Ivan Pozhalostin, Bogdan Villevalde, Nikolai Bruni, Ivan Podozerov, and the critic and painter Konstantin Makovsky. Rerikh, IzLN, 88–92; Rerikh, LD, 2:101–3, 3:65–66.

12. OR GTG, f. 44, op. 1, ed. khr. 14, l. 3; Belikov and Kniazeva, NKR, 18; and Korotkina, RvPP, 24–25.

13. Belikov and Kniazeva, NKR, 18.

14. Rerikh, LD, 3:65–66.

15. Nikolai Chernyshevsky, *Selected Philosophical Essays* (Moscow: Foreign Languages, 1953), 379.

16. Mstislav V. Dobuzhinskii, *Vospominaniia* (Moscow: Nauka, 1987), 130, 134.

17. Igor' E. Grabar', *Moia zhizn'* (Moscow: Iskusstvo, 1937), 170–71.

18. Korotkina, RvPP, 21–22, translation modified in part from Decter, MoB, 14.

19. Kucherova, "Art and Spirituality," 13.

20. Andreyev, MotM, 6–7.

21. Korotkina, RvPP, 23–26; and Rerikh, LD, 2:106, 329–30.

22. Bondarenko and Mel'nikov, "N. K. Rerikh—student iuridicheskogo fakul'teta."

23. On Skalon and Antokolsky, see OR GTG, f. 44, op. 1, ed. khr. 6–9, 1294–1308; OR GTG, f. 44, op. 1, ed. khr. 567–76; and PRS, 2/3:151–60, 171.

24. Bondarenko and Mel'nikov, "N. K. Rerikh—student iuridicheskogo fakul'teta."

25. Kucherova, "Art and Spirituality," 41, citing diary entries from 1899.

26. Roerich's diary from March 1895, OR GTG, f. 44, op. 1, ed. khr. 9, l. 5.

27. OR GTG, f. 44, op. 1, ed. khr. 11, l. 3.

28. OR GTG, f. 44, op. 1, ed. khr. 11, l. 3.

29. Repin cited by Poliakova, NR, 29. On Kuinji, see V. S. Manin, *Kuindzhi* (Leningrad: Khudozhnik RSFSR, 1990); V. S. Manin, *Arkhip Ivanovich Kuindzhi i ego shkola* (Leningrad: Khudozhnik RSFSR, 1987); and O. P. Voronova, *Kuindzhi v Peterburge* (Leningrad: Lenizdat, 1986).

30. Kucherova, "Art and Spirituality," 18.

31. Nicholas Roerich, *Himavat: Diary Leaves* (Allahabad: Kitabistan, 1947), 101–10.

32. Poliakova, NR, 31.

33. Belikov and Kniazeva, NKR, 23–27.

34. Rerikh, IzLN, 181–83.

35. Roerich, *Himavat*, 265.

36. Arkadii A. Rylov, *Vospominaniia* (Leningrad: Iskusstvo, 1940), 38.

37. Roerich, *Himavat*, 101.

38. Richard Taruskin, *Musorgsky* (Princeton, NJ: Princeton University Press, 1993), 8.

39. September 4, 1895, entry, cited in Kucherova, "Art and Spirituality," 14.

40. V. V. Stasov, "Proiskhozhdenie russkykh bylin," *Vestnik Evropy* 1–4 (1868). See also Marlène Laruelle, *Mythe aryen et rêve impérial dans la Russie du XIXe siècle* (Paris: CNRS, 2005), 114–15; Orlando Figes, *Natasha's Dance: A Cultural History of Russia* (London: Allen Lane, 2002), 393–96; Alison Hilton, *Russian Folk Art* (Bloomington: Indiana University Press, 1995), 223, 320; James Bailey and Tatyana Ivanova, eds., *An Anthology of Russian Folk Epics* (Armonk, NY: M. E. Sharpe, 1998), xxx–xlv; and David Schimmelpenninck van der Oye, *Russian Orientalism: Asia in the Russian Mind from Peter the Great to the Emigration* (New Haven, CT: Yale University Press, 2010), 231–32.

41. Znamenski, *Red Shambhala*, 168–70, summarizing G. I. Potanin, *Vostochnye motivy v srednevekovom evropeiskom epose* (Moscow: Kushnerev, 1899). Roerich also likely read N. M. Przheval'skii, *Mongoliia i strana Tangutov* (Saint Petersburg: Imperial Russian Geographical Society, 1875).

42. Rerikh, LD, 3:208, 250. Such recollections minimize Solovyov's ambivalence about Asia, reflected in works like "Enemy from the East," but

the trio spoke most about South and Central Asia, which perturbed Solovyov less than East Asia. On this distinction, see Susanna Soojung Lim, "Between Spiritual Self and Other: Vladimir Solov'ev and the Question of East Asia," *Slavic Review* 67 (Summer 2008): 321–41. On Solovyov, see Samuel Cioran, *Vladimir Solov'ev and the Knighthood of the Divine Sophia* (Waterloo, ON: Wilfred Laurier University Press, 1977).

43. OR GTG, f. 44, op. 1, ed. khr. 34, l. 1; and L. S. Zhuravleva, *Talashkino* (Moscow: Izobrazitel'noe iskusstvo, 1989), 140.

44. OR GTG, f. 44, op. 1, ed. khr. 11, l. 4.

45. Cited in Kucherova, "Art and Spirituality," 33.

46. Korotkina, RvPP, 26–27. Quotation from Philip Pomper, *The Russian Revolutionary Intelligentsia* (Arlington Heights, IL: Harlan Davidson, 1970), 42.

47. Sergei Ernst, *N. K. Rerikh* (Petrograd: Sv. Evgenii, 1918), 44–45.

48. In-depth treatment is beyond this study's scope, but while the Varangian-Normanist thesis has been debated since its inception, it remains popular among general audiences, and many historians, whatever their feelings about the *Chronicle*'s literal truth, accept elements of it. See George Vernadsky, *Kievan Russia* (New Haven, CT: Yale University Press, 1948), 18–22; Serge A. Zenkovsky, ed., *Medieval Russia's Epics, Chronicles, and Tales* (New York: E. P. Dutton, 1974), 11–13, 43–51; Simon Franklin and Jonathan Shephard, *The Emergence of Rus* (London: Longman, 1998), xvii–xviii, 50–70; and P. A. Barford, *The Early Slavs: Culture and Society in Early Medieval Eastern Europe* (Ithaca, NY: Cornell University Press, 2001), 99–103, 232–48.

49. Poliakova, NR, 46–49. This list changed over the months, as Roerich exchanged ideas with Stasov.

50. OR GTG, f. 44, op. 1, ed. khr. 1319, l. 1; ed. khr. 1320, ll. 1–2.

51. Poliakova, NR, 31–32, 55; Aleksandr Gidoni, "Tvorcheskii put' Rerikha," *Apollon* 4–5 (April–May 1915): 5; Voronova, *Kuindzhi v Peterburge*, 170–84;

Manin, *Arkhip Ivanovich Kuindzhi i ego shkola*, 31; and Manin, *Kuindzhi*, 46, 69.

52. This quote (and the one that follows) from Rerikh, IzLN, 86; and Voronova, *Kuindzhi v Peterburge*, 178.

53. Korotkina, RvPP, 50 (Diaghilev); Kucherova, "Art and Spirituality," 25 (Repin); Grabar', *Moia zhizn'*, 172 (Vereshchagin); and Russian State Archive of Literature and Art (RGALI), f. 2408, op. 1, d. 42, l. 4 (Ernst).

54. Grabar', *Moia zhizn'*, 172; and Belikov and Kniazeva, NKR, 29–30.

55. The traditional version of this story, with quotations, is in Roerich, *Himavat*, 91–101; Rerikh, IzLN, 107–9; and Decter, MoB, 19. Valentin Bulgakov, Tolstoy's secretary, accepted Roerich's tale at face value when they corresponded about it (V. F. Bulgakov, *Vstrechi s khudozhnikami* [Leningrad: Khudozhnik RSFSR, 1969], 256–58, 285). One inaccuracy is apparent: Roerich describes Stasov criticizing Rimsky-Korsakov's *Tale of the Invisible City of Kitezh*, but this opera was not completed until 1905.

56. Fosdik, MU, 76–77. Earlier that year, in "What Is Art?" Tolstoy had written disapprovingly of Wagner, and if he criticized the composer during Stasov's visit, Roerich might have taken umbrage, but it hardly follows that he would have reacted so heatedly.

Chapter 3: Journeyman Years, 1897–1902

1. Cited in Darya Kucherova, "Art and Spirituality in the Making of the Roerich Myth" (PhD diss., Central European University, 2006), 17.

2. Fosdik, MU, 95–96 ("beast"); and A. A. Bondarenko and V. L. Mel'nikov, "N. K. Rerikh—student iuridicheskogo fakul'teta," Saint Petersburg State Museum-Institute of the Roerich Family (www.roerich.spb.ru) (Platonov).

3. In Russian, *Iskusstvo i khudozhestvennaia promyshlennost'* [hereafter IiKhP]. See Elena A. Borisova and Grigory Sternin, *Russian Art Nouveau* (New York: Rizzoli, 1998), 27–33; and Janet Kennedy,

"Turn-of-the-Century Art Journals," in *Defining Russian Graphic Arts: From Diaghilev to Stalin, 1898–1934*, ed. Alla Rosenfeld (New Brunswick, NJ: Rutgers University Press, 1999), 63–78.

4. Rerikh, LD, 2:111–12; 3:445–46.

5. N. K. Rerikh, "Zapisnye listki," *Zolotoe runo* 2 (1906): 95–96; and N. K. Rerikh, "Spas Nereditskii," SoS, 91–92.

6. E. A. Riabinin, "N. K. Rerikh i IAK," PRS, 2/3:15–34.

7. The phrase used by C. H. Whittaker, "The Impact of the Oriental Renaissance in Russia," *Jahrbücher für Geschichte Osteuropas* 26, no. 4 (1978): 511, summarizing views among Russian archaeologists of the 1800s.

8. N. K. Rerikh, "Po puti iz Variag v Greki," IiKhP (June–July 1899): 719–30; Rerikh, SoS, 41–58, includes a revised version from 1900.

9. N. K. Rerikh, "Grimr-Viking," SoS, 276–80.

10. PRS, 2/3:15–109; and Mstislav V. Dobuzhinskii, *Vospominaniia* (Moscow: Nauka, 1987), 187, 409.

11. N. K. Rerikh, "Nekotorye drevnosti Shelonskoi piatiny i Bezhetskogo kontsa," *Zapiski IRAO* 11, no. 1–2 (1899): 349–77; N. K. Rerikh, "Ekskursiia Arkheologicheskogo Instituta 1899 g. v sviazi s voprosom o finskikh pogrebeniiakh Sankt-Peterburgskoi gubernii," *Vestnik arkheologii i istorii* 13 (1900): 102–14; and N. K. Rerikh, "K drevnostiam Valdaiskim i Vodskom," *Izvestiia IAK* 1 (1901): 60–68; and similar essays.

12. PRS, 2/3:275, 628–29, 747–48.

13. N. K. Rerikh, "Na kurgane," SoS, 1–26.

14. "Iskusstvo i arkheologiia," IiKhP (December 1898): 185–94, and IiKhP (January–February 1899): 251–66. The lecture was originally titled "Khudozhestvennaia tekhnika v primenenii k arkheologii."

15. John Ruskin, *The Poetry of Architecture* (London: Routledge, 1907), 1.

16. Fosdik, MU, 44–45, 59–71, 92–95, 325–26; Harold Balyoz, *Three Remarkable Women* (Flagstaff, AZ: Altai, 1986), 37–38; and ELD, 2 (June 20, 1929), 3 (September 9, 1929), 6 (June 25, 1930).

17. Kucherova, "Art and Spirituality," 100.

18. Fosdik, MU, 325–26.

19. Korotkina, RvPP, 90–91.

20. Poliakova, NR, 62.

21. Fosdik, MU, 58.

22. Andreyev, MotM, 423, 446–48.

23. ELD, 2 (July 31, 1929), 6 (June 25, 1930); Fosdik, MU, 62–69; and Balyoz, *Three Remarkable Women*, 38.

24. Fosdik, MU, 66.

25. Carl Sagan, *The Demon-Haunted World: Science as a Candle in the Dark* (New York: Random House, 1996), 104–10, 153–55, 165, discusses physical and psychological factors that can cause visions without being the product of dishonesty or mental disturbance. See also David J. Hess, *Science in the New Age: The Paranormal, Its Defenders and Debunkers and American Culture* (Madison: University of Wisconsin Press, 1993); and George Abell and Barry Singer, eds., *Science and the Paranormal: Probing the Existence of the Supernatural* (New York: Scribner's, 1981).

26. Fosdik, MU, 114, 188, 320–21; Znamenski, *Red Shambhala*, 158; and Andreyev, MotM, 423, 446–48. The doctor, Anton Yalovenko, taking Helena's word that her mother had attempted to abort her, also wondered about the impact of perinatal damage on her neurological system.

27. Andreyev, MotM, 50–52.

28. N. K. Rerikh, "Detskaia skazka" (1893), SoS, 271–75.

29. M. V. Nesterov, *Davnie dni* (Moscow: Iskusstvo, 1959), 123 ("stepchildren").

30. John E. Bowlt, "Two Russian Maecenases: Savva Mamontov and Princess Tenisheva," *Apollo* 98 (December 1973): 444–53; Michael Ginsburg, "Art Collectors of Old Russia," *Apollo* 98 (December 1973): 470–85; and Elenora Paston, *Abramtsevo: iskusstvo i zhizn'* (Moscow: Iskusstvo, 2003).

31. Roerich is sometimes mistakenly identified as having worked at Abramtsevo (e.g., Beverly Kean, *All the Empty Palaces* [New York: Universe, 1983], 57; and Camilla Gray and Marian Burleigh-Motley,

The Russian Experiment in Art, 1863–1922 [London: Thames and Hudson, 1986], 22–24). Soviet-era studies of Roerich say nothing of time spent there, nor does Paston's definitive *Abramtsevo*.

32. Igor' E. Grabar', *Moia zhizn'* (Moscow: Iskusstvo, 1937), 125.

33. On the World of Art, I have been guided especially by John E. Bowlt, *The Silver Age: Russian Art of the Early Twentieth Century and the "World of Art" Group* (Newtonville, MA: Oriental Research Partners, 1979); Janet Kennedy, *The "Mir iskusstva" Group and Russian Art* (New York: Garland, 1977); Borisova and Sternin, *Russian Art Nouveau*; David Elliott, *New Worlds: Russian Art and Society, 1900–1937* (New York: Rizzoli, 1986); Richard Buckle, *Diaghilev* (New York: Atheneum, 1979); Lynn Garafola, *Diaghilev's Ballets Russes* (New York: Oxford University Press, 1989); and I. S. Zil'bershtein and V. A. Samkov, eds., *Sergei Diagilev i russkoe iskusstvo*, 2 vols. (Moscow: Izobrazitel'noe iskusstvo, 1982) [hereafter SDiRI].

34. Eugene Klimoff, "Alexandre Benois and His Role in Russian Art," *Apollo* 98 (December 1973): 460–69; Bowlt, *Silver Age*, 172–98; Alexandre Benois, *Memoirs*, 2 vols. (London: Chatto and Windus, 1960–1964); and Alexandre Benois, *Reminiscences of the Russian Ballet* (London: Putnam, 1941).

35. Cited in Bowlt, *Silver Age*, 74.

36. The comment, from 1898, is cited in Bowlt, *Silver Age*, 74–75.

37. Grabar', *Moia zhizn'*, 125–26.

38. "Complex Questions," in Bernice Glatzer Rosenthal and Martha Bohachevsky-Chomiak, eds., *A Revolution of the Spirit: Crisis of Value in Russia, 1890–1918* (Newtonville, MA: Oriental Research Partners, 1982), 90–91; and Kennedy, *"Mir iskusstva" Group*, 38–48, gives Repin's response.

39. Simon Karlinsky, "A Cultural Educator of Genius," in *The Art of Enchantment*, ed. Nancy Van Norman Baer (San Francisco: Fine Arts Museum of San Francisco, 1988), 18–20.

40. V. V. Stasov to N. K. Rerikh, July 5, 1898 (June 23, OS). OR GTG, f. 44, op. 1, ed. khr. 1321, ll. 1–2. Emphasis in the original.

41. See comments in IiKhP (December 1898): 237; IiKhP (March 1899): 251; and Rerikh, LD, 3:411–12.

42. Both quotes from OR GTG, f. 44, op. 1, ed. khr. 13, as translated by Kucherova, "Art and Spirituality," 40–41, with slight alteration (see also 130, 315). Braz was a painter and collector. As noted in chapter 2, Gintsburg visited Tolstoy with Roerich and Stasov in 1897.

43. Kucherova, "Art and Spirituality," 130, hypothesizes that Roerich was encouraged to indulge in such crudity by his mentors at the time, particularly the intemperate Stasov.

44. Cited in Andreyev, MotM, 37–38.

45. Cited in Andreyev, MotM, 37–38.

46. Poliakova, NR, 49–51; Rerikh, IzLN, 17; and M. M. Dal'kevich, "Vystavka peterburgskogo obshchestva khudozhnikov i vesenniaia vystavka v Akademii khudozhestv," IiKhP (April 1899): 595–96. Kuinji and Repin disliked *Elders*, but for its composition, not its style or approach.

47. Nicholas Roerich, *Himavat: Diary Leaves* (Allahabad: Kitabistan, 1947), 103.

48. Poliakova, NR, 53–55.

49. V. V. Stasov to N. K. Rerikh, May 18, 1899 (May 5, OS). OR GTG, f. 44, op. 1, ed. khr. 1322, ll. 1–2. Emphasis in the original.

50. *Mir iskusstva* 1, nos. 1–12 (1900): 117; and Zil'bershtein and Samkov, SDiRI, 2:49, 370 (the invitation).

51. Korotkina, RvPP, 88–89, as translated by Decter, MoB, 23.

52. See Stephen Escritt, *Art Nouveau* (London: Phaidon, 2000), 11–25, 59–60, 126–27, 191–200; and Wendy Salmond, "Moscow Modern," in *Art Nouveau, 1890–1914*, ed. Paul Greenhalgh (London: Victoria and Albert, 2000), 388–97.

53. Zil'bershtein and Samkov, SDiRI, 1:119–20.

54. N. K. Rerikh to E. I. Shaposhnikova, July 1900, in Zil'bershtein and Samkov, SDiRI, 1:119–20.

55. Silen [A. Nurok], "O nagradakh," *Mir iskusstva* 17–18 (1900): 115–16.

56. Aleksandr Benua, "Pis'ma so Vsemirnoi vystavki," *Mir iskusstva* 19–20 (1900): 158.

57. N. K. Rerikh to E. I. Shaposhnikova, late summer 1900, in Zil'bershtein and Samkov, SDiRI, 1:335.

58. N. K. Rerikh to V. V. Stasov, November 2, 1900, in Zil'bershtein and Samkov, SDiRI, 1:119–20. Roerich uses the Italian phrase in the original.

59. *Rossiia* 578 (December 2, 1900), in Zil'bershtein and Samkov, SDiRI, 1:123, 334–36.

60. Rerikh, IzLN, 83, as translated by Decter, MoB, 26.

61. Poliakova, NR, 55.

62. PRS, 2/3:181–85.

63. N. K. Rerikh to E. I. Shaposhnikova, August 25–26 (OS), 1900. OR GTG f. 44, op. 1, ed. khr. 162, l. 1.

64. Rerikh, IzLN, 83.

65. See his letter to Helena on August 25–26 (OS), 1900. OR GTG f. 44, op. 1, ed. khr. 162, ll. 1–2.

66. Reported to Helena in Roerich's letter of August 25–26 (OS), 1900. OR GTG f. 44, op. 1, ed. khr. 162, ll. 1–2.

67. V. V. Stasov to N. K. Rerikh, May 18, 1899 (May 5, OS). OR GTG, f. 44, op. 1, ed. khr. 1322, ll. 1–2.

68. N. K. Rerikh to B. K. Rerikh, October 7, 1900. OR GTG, f. 44, op. 1, ed. khr. 127, ll. 1–2.

69. N. K. Rerikh to A. Polovtsov, November 17, 1900, cited in Korotkina, RvPP, 13.

70. N. K. Rerikh to A. Polovtsov, February 24, 1901, cited in Korotkina, RvPP, 13.

71. Cited in Poliakova, NR, 56.

72. N. K. Rerikh to A. Polovtsov, November 17, 1900, cited in Korotkina, RvPP, 13.

73. Rerikh, IzLN, 301, as translated by Decter, MoB, 26–27.

74. Maksim Dubaev, *Nikolai Rerikh* (Moscow: Molodaia gvardiia, 2003), 145; Aleksandr I. Andreev, "Okkul'tizm i mistika v zhizni i tvorchestve N. K. i E. I. Rerikh," in Andreev and Savelli, *Rerikhi: mify i fakty*, 59–60; and Kucherova, "Art and Spirituality," 132. The original source is OR GTG, f. 44, op. 1, ed. khr. 204.

75. Andreyev, MotM, 45.

76. Cited in Poliakova, NR, 62.

77. Cited in Poliakova, NR, 62.

78. R. Izgoi [Rerikh], "Nashi khudozhestvennye dela," IiKhP (March 1899): 489.

79. N. K. Rerikh, "Marées et Böcklin," *Zolotoe runo* 6 (1906): 78–80; and Kenneth Archer, *Nicholas Roerich: East and West* (Bournemouth: Parkstone, 1999), 125, 141.

80. Rerikh, LD, 3:266; and Poliakova, NR, 127. Golubev knew Rodin well enough for this story to be plausible: Rodin carved a bust of his wife Natasha in 1906, and Golubev encouraged Rodin's interest in Asian art.

81. Cited in Poliakova, NR, 57, as translated by Decter, MoB, 26. In essays and letters, Roerich often speaks figuratively of Puvis as one of his teachers; some authors have misinterpreted this as meaning that he literally studied with Puvis—an impossibility, given that the older artist died in 1899.

82. V. N. Ivanov, *Ogni v tumane: Rerikh—Khudozhnik-myslitel'* (Moscow: Sovetskii pisatel', 1991), 323.

83. Poliakova, NR, 60.

84. *Zamorskie gosti*, the Russian title, is translated several ways: those given in the text are the most usual. The modern cognate "guest" for *gost'* is misleading; in old Russia, the term had commercial connotations, and the title could easily be *Merchants from Overseas*, since trade with Byzantium was the Vikings' goal. Several prototypes—including *Red Sails* (1900–1901, also called *Prince Vladimir's Raid on Cherson*) and *Boats* (1901)—preceded *Zamorskie gosti*.

85. OR GTG, f. 44, op. 1, ed. khr. 492; and f. 48, op. 1, ed. khr. 493.

86. Poliakova, NR, 64.

87. Poliakova, NR, 65–66.

88. A. Nurok, "Zametki," *Mir iskusstva* 2 (1902): 39.

89. *Mir iskusstva* 5–6 (1902): 309–15.

90. PRS, 2/3:188–89, 193–95.

91. Korotkina, RvPP, 81–82, as translated by Decter, MoB, 24–25. The printed text of *Confessions* was in English; Roerich's answers were handwritten in Russian.

Chapter 4: The Architecture of Heaven, 1903–1906

1. Rerikh, IzLN, 169–70.

2. Comment from 1921, cited in Heinz Hiebler, *Hugo von Hofmannsthal und die Medienkultur der Moderne* (Würzberg: Königshausen & Neumann, 2003), 189.

3. Belikov and Kniazeva, NKR, 49.

4. RGALI, f. 2408, op. 1, d. 35, l. 44 (Rozanov); and Poliakova, NR, 68–69 (Surikov).

5. K. I. Chukovskii, *Dnevnik, 1930–1969* (Moscow: Sovremennyi pisatel', 1994), 463–64.

6. OR GTG, f. 10, op. 1, ed. khr. 1543; f. 48, op. 1, ed. khr. 188, 217; and Aleksandr Gidoni, "Tvorcheskii put' Rerikha," *Apollon* 4–5 (April–May 1915): 12. Emphasis in the original.

7. Mstislav V. Dobuzhinskii, *Vospominaniia* (Moscow: Nauka, 1987), 194, 205–7; Igor' E. Grabar', *Moia zhizn'* (Moscow: Iskusstvo, 1937), 169; and V. N. Levitskii, *Rerikh* (Prague, 1916), 32 (on Benois).

8. Both quotations from Grabar', *Moia zhizn'*, 169–71.

9. Dobuzhinskii, *Vospominaniia*, 205–7.

10. Poliakova, NR, 68–69.

11. V. V. Stasov, "Dve dekadentskie vystavki," *Birzhevaia gazeta* 112 (April 25, 1903): 293.

12. V. V. Stasov to N. K. Rerikh, September 18 (OS), 1904. OR GTG, f. 44, op. 1, ed. khr. 1326, l. 1. Emphasis in the original.

13. N. K. Rerikh to M. K. Tenisheva, March 12 (OS), 1905. RGALI, f. 2408, op. 2, d. 6, ll. 23–24.

14. M. V. Nesterov to A. M. Vasnetsov, March 3 (OS), 1902 (OR GTG, f. 11, op. 1, ed. khr. 724, ll. 1–2); and N. K. Rerikh to A. M. Vasnetsov, October 7 (OS), 1903 (OR GTG, f. 11, op. 1, ed. khr. 751, l. 1).

15. S. K. Makovskii, "Sviatyni nashei stariny," *Zhurnal dlia vsekh* 6 (1904): 350; S. K. Makovskii, "Khronika," *Iskusstvo* 4 (1905): 69; and Wendy Salmond, *Arts and Crafts in Late Imperial Russia: Reviving the Kustar Art Industries, 1870–1917* (Cambridge: Cambridge University Press, 1996), 132, 237.

16. Dobuzhinskii, *Vospominaniia*, 194; and Elena A. Borisova and Grigory Sternin, *Russian Art Nouveau* (New York: Rizzoli, 1998), 232–38.

17. N. K. Rerikh, "Po starine," SoS, 64. Written in 1903 and published in *Zodchii* (June 27, 1904): 299–301; (July 11, 1904): 319–22; and (July 25, 1904): 343–46.

18. "Etiudy russkoi stariny," *Peterburgskii listok* (December 31, 1903); and Rerikh, LD, 1:228–31, 3:180–81. In 1903, Roerich visited Narva, Rugodiv, Vyborg, Grodno, Vilnius, Kaunas, Trakai, Mitava, Riga, Velana, Koren, Chernigov, Kiev, Pechory, Pskov, Smolensk, Rostov Velikii, Izborsk, Yuriev-Polsky, Moscow, Yaroslavl, Kostroma, Vladimir, Suzdal, Nizhnii Novgorod, and Kazan. In 1904, he reached Tver, Uglich, Kaliazin, Valdai, and Zvenigorod, and returned to Smolensk.

19. Cited in NKR: ZiT, 66, as translated by Decter, MoB, 38.

20. On Roerich and the Louisiana Purchase Exhibition, see S. K. Makovskii, "N. Rerikh," *Zolotoe runo* 4 (1907): 4–7; Rerikh, LD, 3:224–25; Robert C. Williams, *Russian Art and American Money: 1900–1910* (Cambridge, MA: Harvard University Press, 1980), 42–82; and Robert C. Williams, *Russia Imagined* (New York: Peter Lang, 1997), 187–213.

21. ELD #1 (May 8, 1929).

22. Adam Hochschild, *King Leopold's Ghost: A Story of Greed, Terror, and Heroism in Colonial Africa* (Boston: Mariner, 1999), 245–50, 257, 283–84. Kowalsky's rank of colonel was fictitious.

23. Cited in Williams, *Russia Imagined*, 187.

24. L. S. Zhuravleva, "N. K. Rerikh v Talashkine," in NKR: ZiT, 110–17; John E. Bowlt, "Nikolai Rerikh at Talashkino," *Experiment* 7 (Winter 2001): 103–21; M. K. Tenisheva, *Vpechatleniia moei zhizni* (Leningrad: Iskusstvo, 1991), 225–27; Evgeniia Kirichenko, *Russian Design and the Fine Arts, 1750–1917* (New York: Abrams, 1991), 170–78; and Salmond, *Arts and Crafts*, 133–34.

25. Cited in John E. Bowlt, *The Silver Age: Russian Art of the Early Twentieth Century and the "World of Art" Group* (Newtonville, MA: Oriental Research Partners, 1979), 41.

26. V. V. Stasov to N. K. Rerikh, January 22 (OS), 1901. OR GTG, f. 44, op. 1, ed. khr. 1325, ll. 1–2.

27. Tenisheva, *Vpechatleniia*, 226–27.

28. N. K. Rerikh to E. I. Rerikh, July 1903. OR GTG, f. 44, op. 1, ed. khr. 390, l. 1.

29. Tenisheva, *Vpechatleniia*, 225–26, 251.

30. Tenisheva, *Vpechatleniia*, 250–51.

31. N. K. Rerikh to M. K. Tenisheva, September 30 (OS), 1903. RGALI, f. 2408, op. 2, d. 4, l. 3.

32. Tenisheva, *Vpechatleniia*, 225–26.

33. A. A. Rostislavov, "Individualizm Rerikha," *Zolotoe runo* 4 (1907): 8–10. John E. Bowlt, *Moscow and St. Petersburg, 1900–1920* (New York: Vendome, 2008), 265–66, calls Roerich Talashkino's "sometime curator."

34. Andrei Bely, *Petersburg* (New York: Grove, 1987), 72.

35. Tenisheva, *Vpechatleniia*, 280; Richard Buckle, *Diaghilev* (New York: Atheneum, 1979), 54, 546–47; and Dobuzhinskii, *Vospominaniia*, 219–20.

36. A. N. Benua to V. A. Serov, November 30 (OS), 1904, in Zil'bershtein and Samkov, SDiRI, 2:174–75, 467.

37. Bowlt, *Silver Age*, 110–16.

38. Cited in and translated by Anne Nesbit, "Savage Thinking," in *Metamorphosis in Russian Modernism*, ed. Peter Barta (New York: Central European University Press, 2000), 161.

39. Poliakova, NR, 94–95; and Korotkina, RvPP, 19, 43.

40. N. K. Rerikh to M. K. Tenisheva, January 14 (OS), 1905. RGALI, f. 2408, op. 2, d. 6, l. 5, as translated by Darya Kucherova, "Art and Spirituality in the Making of the Roerich Myth" (PhD diss., Central European University, 2006), 57.

41. N. K. Rerikh to M. K. Tenisheva, January 14 (OS), 1905. RGALI, f. 2408, op. 2, d. 6, l. 5. My translation.

42. N. K. Rerikh to M. K. Tenisheva, January 14 (OS), 1905.

43. Nicholas Roerich, *Fiery Stronghold* (Boston: Stratford, 1933), 423–42; and M. M. Boguslavskii, "Pakt Rerikha i zashchita kul'turnykh tsennostei," *Sovetskoe gosudarstvo i pravo* 10 (1974): 111–15.

44. PRS, 2/3:208–9, 227, 465, 747–48.

45. See N. K. Rerikh to M. K. Tenisheva, January 14 (OS), 1905, and N. K. Rerikh to M. K. Tenisheva, March 12 (OS), 1905. RGALI, f. 2408, op. 2, d. 6, ll. 5, 23.

46. A. M. Remizov, *Kukkha: Rozanovy pis'ma* (Berlin, 1923), 25.

47. Christmas Humphreys, *Both Sides of the Circle* (London: George Allen and Unwin, 1978), 54.

48. N. K. Rerikh, "Obedneli my," SoS, 103–15. The lament comes from Plutarch's *Of Isis and Osiris*, although Roerich may also have known Elizabeth Barrett Browning's poem "The Dead Pan." See also N. K. Rerikh, "Tikhie pogromy," SoS, 168–76; "Golgofa iskusstva," SoS, 100–102; "Spas Nereditskii," SoS, 91–92; "Strannyi muzei," *Zolotoe runo* 2 (1906); and "Vostanovleniia," *Zolotoe runo* 7–8–9 (1906).

49. N. K. Rerikh, "Vozhd'," SoS, 281–86; "Devassari Abuntu," *Vesy* 8 (August 1905); and "Italianskaia legenda," *Zolotoe runo* 7–8–9 (1906), published as "Velikii kliuchar'," SoS, 294–95.

50. V. S. Solov'ev, *Sobranie sochinenii* (Brussels, 1966), 6:90; Bernice Rosenthal, *New Myth, New World: From Nietzsche to Stalinism* (University Park: Pennsylvania State University Press, 2002), 30–50.

51. S. K. Makovskii, "Golubaia roza," *Zolotoe runo* 5 (1907): 25–28.

52. Igor' E. Grabar', *Pis'ma, 1891–1917* (Moscow: Nauka, 1974), 154–57, 191–94, 196–98, 370–72, 392–93.

53. Igor Stravinsky and Robert Craft, *Conversations with Igor Stravinsky* (London: Faber and Faber, 1959), 105.

54. Moscow's Scriabin House-Museum displays a number of Roerich paintings, and Theosophists take it for granted that the two were close (I. M. Oderberg, "H. P. Blavatsky's Cultural Impact," www.theosophy-nw.org/theosnw/theos/th-imo.htm). But Faubion Bowers, *The New Scriabin* (New York: St. Martin's, 1973), Boris de Schloezer, *Scriabin: Artist and Mystic* (Berkeley: University of California Press, 1987), and E. Krzhimovskaia, "Skriabin i Rerikh," *Muzykal'naia zhizn'* (August 1983): 15–16, give no indication that they met.

55. Rerikh, IzLN, 105–6, 309–12. See also S. P. Iaremich, *M. A. Vrubel'* (Moscow: Knebel', 1911), 168; and N. S. Sergeeva, *Rerikh i Vrubel'* (Moscow: MTsR, 2002), 12–13.

56. N. K. Rerikh, "Vystavka," cited in Kucherova, "Art and Spirituality," 104, 320.

57. Nicholas Roerich, *Invincible* (New York: Roerich Museum Press, 1974), 334–44. The Mánes Society introduced foreign artists of note, among them Matisse and Picasso, to the Czech public. It still operates a gallery today.

58. Buckle, *Diaghilev*, 91–93; and Salmond, *Arts and Crafts*, 141–42.

59. N. K. Rerikh to I. E. Grabar', January 9 (OS), 1907. Zil'bershtein and Samkov, SDiRI, 2:178–79.

60. RGALI, f. 2408, op. 2, d. 6, ll. 34–43; d. 7, ll. 5–23.

61. *Birzhevye vedomosti* (October 17, 1906); *Slovo* (December 19, 1906); *Paris-Moscou, 1900–1930* (Paris: Centre Pompidou/Gallimard, 1991), 30–32; and *Le Symbolisme Russe* (Bordeaux: Musée des Beaux-Arts de Bordeaux, 2000).

62. S. A. Shcherbatov to N. K. Rerikh, October 7 (September 25, OS), 1906. Zil'bershtein and Samkov, SDiRI, 1:406–8; 2:177–79.

63. M. K. Tenisheva to N. K. Rerikh, October 24 (October 11, OS), 1906. Zil'bershtein and Samkov, SDiRI, 2:177–78.

64. M. K. Tenisheva to N. K. Rerikh, November 8 (October 28, OS), 1906. Zil'bershtein and Samkov, SDiRI, 1:406–8.

65. L. S. Bakst to L. P. Bakst, November 26 (November 13, OS), 1906. Zil'bershtein and Samkov, SDiRI, 2:178–79.

66. Makovskii, "N. K. Rerikh," 3–7. The error influenced scholarship long after the event. Richard Buckle (*Diaghilev*, 91–93), uses Benois's exact words to describe Nesterov and Roerich.

67. N. K. Rerikh to I. E. Grabar', January 9 (OS), 1907. Zil'bershtein and Samkov, SDiRI, 2:178–79.

68. Rerikh, IzLN, 90–91; and Rerikh, LD, 2:157–61. See also Rerikh, LD, 1:55–58, 2:111–12.

69. Grabar', *Moia zhizn'*, 183; on Wrangel, G. D. Zlochevskii, *Nasledie Serebrianogo veka* (Moscow: Institut naslediia, 2006), 116–17, 164–67.

70. Fosdik, MU, 129–30.

71. Fosdik, MU, 86–87.

72. Fosdik, MU, 59–60.

73. Fosdik, MU, 70.

74. Fosdik, MU, 59, 122.

75. N. K. Rerikh to E. I. Rerikh, July 26, 1908. OR GTG, f. 44, op. 1, ed. khr. 240, l. 1.

76. N. K. Rerikh to E. I. Rerikh, July 13 (OS), 1910. OR GTG, f. 44, op. 1, ed. khr. 341, l. 1.

77. Fosdik, MU, 190, as translated by Kucherova, "Art and Spirituality," 274–75.

78. Fosdik, MU, 64, 70, 90, 94–95, 190. Esther Lichtmann's diaries (ELD) tell some of the same stories.

79. Fosdik, MU, 376–77.

80. Fosdik, MU, 376–77. Joy Dixon, *Divine Feminine: Theosophy and Feminism in England* (Baltimore: Johns Hopkins University Press, 2001); Molly McGarry, *Ghosts of Futures Past: Spiritualism and the Cultural Politics of Nineteenth-Century America* (Berkeley: University of California Press, 2008); and Maria Carlson, *"No Religion Higher Than Truth": A History of the Theosophical Movement in Russia, 1875–1922* (Princeton, NJ: Princeton University Press, 1993), have highlighted connections between fin-de-siècle feminism and Theosophy's popularity. Kucherova, "Art and Spirituality," 267–86, applies this line of reasoning to Helena.

81. Fosdik, MU, 60.

82. Rerikh, LD, 1:440–42; PRS, 2/3: 212–13.

83. Poliakova, NR, 115.

84. N. K. Rerikh to E. I. Rerikh, June 11, 1906, asks her to meet him in Florence. OR GTG, f. 44, op. 1, ed. khr. 295, l. 1.

85. That Roerich knew Hodler is evident from Rerikh, LD, 3:266, 412. Speculation about Hodler's influence is my own, based on visual comparison with Hodler landscapes like *Rising Mist and the Wetterhorn* (1908), *Breithorn* (1911), and *The Jungfrau* (1912). See *Ferdinand Hodler: Le Paysage* (Paris: Somogy, 2003).

86. Rerikh, SoS, 123–35.

87. Rerikh, IzLN, 93.

88. George Landow, "Pre-Raphaelites," Victorian Web (www.victorianweb.org/painting/prb/index.html).

89. M. Meterlink, *Sochineniia*, 3 vols. (Saint Petersburg: Pirozhkov, 1906–1907). Roerich's illustrations appeared in *Vesy* 7 (July 1905).

90. On the *latyr'* (sometimes spelled *alatyr'*), see James Bailey and Tatyana Ivanova, eds., *An Anthology of Russian Folk Epics* (Armonk, NY: M. E. Sharpe, 1998), 37–38, 398. Michael Willis, *Tibet: Life, Myth, and Art* (New York: Duncan Baird, 1999), 81, discusses *chinta-mini*, and Andreyev, MotM, 28, suggests that Roerich was familiar with this myth as early as 1893.

91. Iakovleva, TDI, 9–10.

92. The columnist "Skorpion" discussed the Devassari–Ajanta link in *Vesy* 8 (1906). See also PRS, 2/3:409–10, 424; Iakovleva, TDI, 9–10; and F. X. Salda, "N. K. Roerick," *Volné smery* 3 (1906).

93. On Kandinsky's archaeological interests, see Peg Weiss, *Kandinsky and Old Russia* (New Haven, CT: Yale University Press, 1995); and Alison Hilton, "Northern Visions," in *The Art of the Russian North*, ed. Anne Odom, Abbott Gleason, William C. Brumfield, and Alison Hilton (Washington, DC: Hillwood Museum and Gardens, 2001), 66–68. Visual similarities between *Slavs* and *Song* are self-evident, and several authors, including Noemi Smolik, "Kandinsky: Resurrection and Cultural Renewal," in *Kandinsky* (London: Tate, 2006), 140–46; Rose-Carol Washton Long, *Kandinsky* (Oxford: Clarendon Press, 1980), 85; and Diana Dalbotten, "Ancient Souls and Modern Art: Nicholas Roerich and the Silver Age of Russian Art" (PhD diss., University of Minnesota, 2000), describe Roerich's influence on Kandinsky's historical paintings.

94. Most assume that Roerich is depicting George the Dragon-Slayer, one of Russia's favorite saints, in unusual fashion, but in none of the stories told about George does he rescue a woman related to his enemy. L. V. Korotkina, *Nikolai Rerikh* (Saint Petersburg: Khudozhnik Rossii, 1996), 38, postulates that Roerich had in mind a legend retold by Alexander Afanasev, in which the Slavic thunder god Perun battles an evil serpent to save a maiden. But even here, the maiden is not kin to the dragon. The association of women (symbols of Eve) with serpents (symbols of Satan) was commonplace in fin-de-siècle European art, and Orthodox iconography often portrayed the devil as a serpent with the breasts of a woman; Roerich may have been thinking of either or both. See Bram Dijkstra, *Idols of Perversity: Fantasies of Feminine Evil in Fin-de-Siècle Culture* (New York: Oxford University Press, 1986), 305–14; Eve Levin, *Sex and Society in the World of the Orthodox Slavs* (Ithaca, NY: Cornell University Press, 1989), 45–52; and Linda Ivanits, *Russian Folk Belief* (Armonk, NY: M. E. Sharpe, 1989), 43–44. Herodotus, whose *Histories* Roerich read attentively, describes Hylaea, the supposed homeland of the Scyths, as the dwelling place of a viper-maiden; the canvas may also be an anachronistic retelling of the golden fleece myth, in which Medea uses her magic to help Jason defeat the dragon serving her father.

95. Richard Taruskin, *Stravinsky and the Russian Traditions: A Biography of the Works through Mavra*, 2 vols. (Berkeley: University of California Press, 1996), 880–81 [hereafter SatRT].

96. George Orwell, "W. B. Yeats," *The Penguin Essays of George Orwell* (London: Penguin, 1994), 233–38.

97. Carlson, *"No Religion,"* 3–8.

98. Georges Florovsky, *Ways of Russian Theology*, 2 vols. (Vadiz, 1989), 2:233–34.

99. Don Rawson, "Mendeleev and the Scientific Claims of Spiritualism," *Proceedings of the American Philosophical Society* 122, no. 1 (1978): 1–8; and Michael Gordin, "Loose and Baggy Spirits: Reading Dostoevskii and Mendeleev," *Slavic Review* 60 (Winter 2001): 756–80.

100. Cited in Klaus Klostermeier, *Hinduism* (Oxford: Oneworld, 2000), 270–71. Ramakrishna's and Vivekananda's revision of Vedanta was part of the "Hindu renaissance" sparked in the 1800s

by reaction to Christian missionizing. Political agendas also drove these efforts: Westerners drawn to Hinduism, Buddhism, and synthetic cousins like Vedanta and Theosophy were easily converted to the cause of home rule or independence for India.

101. Paradoxically, Biocosmism enjoyed a following among Soviet engineers and scientists, including Konstantin Tsiolkovsky, the father of Soviet rocketry, and the atomic physicist Vladimir Vernadsky. See Michael Hagemeister, "Konstantin Tsiolkovskii and the Occult Roots of Soviet Space Travel," in *The New Age of Russia: Occult and Esoteric Dimensions*, ed. Birgit Menzel, Bernice G. Rosenthal, and Michael Hagemeister, 135–50 (Munich: Kubon & Sagner, 2012); George Young, *The Russian Cosmists: The Esoteric Futurism of Nikolai Fedorov and His Followers* (New York: Oxford University Press, 2012); and James Andrews, *Red Cosmos: K. E. Tsiolkovskii, Grandfather of Soviet Rocketry* (College Station: Texas A&M University Press, 2009).

102. This narrative is based particularly on Carlson, *"No Religion"*; James Webb, *The Occult Underground* (La Salle, IL: Open Court, 1974); James Webb, *The Occult Establishment* (La Salle, IL: Open Court, 1976); Sylvia Cranston, *HPB: The Extraordinary Life and Influence of Helena Blavatsky, Founder of the Theosophical Movement* (New York: Tarcher/Putnam, 1993); and Stephen Prothero, *The White Buddhist: The Asian Odyssey of Henry Steel Olcott* (Bloomington: Indiana University Press, 1996).

103. Annie Besant, *The Ancient Wisdom* (Adyar: Theosophical Publishing House, 1897), 4–5.

104. Besant, *Ancient Wisdom*, 4–5.

105. Carlson, *"No Religion,"* 229. In *Le Théosophisme: Histoire d'une pseudo-religion* (Paris, 1965), 48, 97, the metaphysician René Guénon considered Morya and Koot Hoomi "pure and simple" inventions, but wondered whether *dzyan* was a corruption of the Sanskrit *jnana* ("consciousness").

106. State Archive of the Russian Federation (GARF), f. 109, op. 1, d. 3, l. 22, cited in Maria Carlson, "To Spy or Not to Spy: The 'Letter' of

Mme. Blavatsky to the Third Section," *Theosophical History* 5 (1995): 225–31.

107. Hence the lie the Roerichs peddled in emigration about not having heard of Theosophy until 1920, when they joined the TS's English-Welsh chapter (Fosdik, MU, 59, 708–10). Cranston, *HPB*, 551, refers to the Roerichs as having been Theosophists in Russia, but not necessarily RTS members; as Daniel Entin of the NRM told her, "I have no proof that they were members in Russia, but they very well may have been. But there's no doubt that they moved in [those] circles." Andreyev, MotM, 48–49, asserts firmly that the Roerichs did *not* join the RTS.

108. "Promiscuous" quote from J. C. Ransom, "Yeats and His Symbols," in *The Permanence of Yeats*, ed. James Hall (New York: Collier Books, 1961), 90. Carlson, *"No Religion,"* 22–25, characterizes Theosophy as "intellectually undisciplined."

109. N. K. Rerikh to E. I. Shaposhnikova, August 25–26 (OS), 1900. OR GTG, f. 44, op. 1, ed. khr. 162.

Chapter 5: The Nightingale of Olden Times, 1907–1909

1. George Balanchine and Francis Mason, *Balanchine's Complete Stories of the Great Ballets* (Garden City, NY: Doubleday, 1977), 781.

2. Igor' E. Grabar', *Moia zhizn'* (Moscow: Iskusstvo, 1937), 172.

3. A. N. Benua to E. E. Lanseré, March 24, 1906, in Janet Kennedy, *The "Mir iskusstva" Group and Russian Art* (New York: Garland, 1977), 274. Benois had in mind de Staël's comment that "the imagination of Northern men soars beyond this earth."

4. N. K. Rerikh, "Podzemnaia Rus,'" SoS, 207–19.

5. E. G. Soini, *Severnyi lik Nikolaia Rerikha* (Samara: Agni, 2001), 32, 44, 138. The suite includes *The Battle* (1906), *Song of the Viking* (1907), *Triumph of the Viking* (1908), *Varangian Motif* (1909–1910), *Varangian Sea* (1909–1910), and *The Old King* (1910).

6. *Apollon* 1 (October 1909): 64–65; and V. I.

Ivanov, "Zavety simvolizma," *Apollon* 8 (May–June 1910): 5–20.

7. V. P. Kniazeva, "Bogatyrskii friz," NKR: zit, 105–9. Bazhanov's house was built by P. F. Aleshin; after 1917, it became a government office, and while Roerich's panels were left in place, they were poorly cared for. In 1964, they were transferred to the State Russian Museum and restored.

8. Rerikh, LD, 3:411–12. S. A. Mansbach, *Modern Art in Eastern Europe* (Cambridge: Cambridge University Press, 1999), 343, categorizes Roerich and Gallen-Kallela as like-minded neo-Romantics.

9. N. K. Rerikh to A. Gallen-Kallela, June 16, 1907; and N. K. Rerikh to A. Gallen-Kallela, September 18, 1907. Written in French. Papers of the Gallen-Kallela Museum, housed in the Finnish National Archives (FNA), microfilm VAY 3549 (A. Gallen-Kallela).

10. Cited in Soini, *Severnyi lik*, 28.

11. N. K. Rerikh to B. K. Rerikh, June 25, 1907. OR GTG, f. 44, op. 1, ed. khr. 133, l. 1. The letter's envelope is dated June 25, 1908, but Soini, *Severnyi lik*, 26–27, explains this as a misprint.

12. N. K. Rerikh, "Drevneishie finskie khramy," *Starye gody* 2 (February 1908): 75–86. Lecture delivered January 24, 1908.

13. Cited in Sergei Golynets, *Ivan Bilibin* (New York: Abrams, 1982), 186.

14. Rostovtsev cited in Neal Ascherson, *Black Sea* (London: Hill and Wang, 1995), 8.

15. On the ideas underpinning Roerich's thoughts, see Marlène Laruelle, *Mythe aryen et rêve impérial dans la Russie du XIXe siècle* (Paris: CNRS, 2005); Marlène Laruelle, *Russian Eurasianism: An Ideology of Empire* (Baltimore: Johns Hopkins University Press, 2008); David Schimmelpenninck van der Oye, *Russian Orientalism: Asia in the Russian Mind from Peter the Great to the Emigration* (New Haven, CT: Yale University Press, 2010); Mark Bassin, "Asia," in *The Cambridge Companion to Modern Russian Culture* (Cambridge: Cambridge University Press, 1998); Mark Bassin, *The*

Gumilev Mystique: Biopolitics, Eurasianism, and the Construction of Community in Modern Russia (Ithaca, NY: Cornell University Press, 2016); and L. N. Gumilev, *Drevniaia Rus' i velikaia step'* (Moscow: ACT, 2001).

16. Nicholas Roerich, "Joy of Art," *Adamant* (New York: Corona Mundi, 1922), 123.

17. Roerich, "Joy of Art," 123.

18. Mircea Eliade, *Occultism, Witchcraft, and Cultural Fashions* (Chicago: University of Chicago Press, 1976), 21.

19. W. B. Yeats, "The Symbolism of Poetry," in *The Yeats Reader* (New York: Scribner, 2002), 381.

20. V. I. Ivanov, "Religiia Dionisa," *Voprosy zhizni* (June 1905): 190, translated by Marilyn Meyer Hoogen, "Igor Stravinsky, Nikolai Roerich, and the Healing Power of Paganism" (PhD diss., University of Washington, 1997), 107.

21. N. K. Rerikh, "Radost' iskusstvu," *Vestnik Evropy* 2 (April 1909): 508–33. Reprinted in Rerikh, SoS, 116–53; and Roerich, *Adamant*, 108–24 and 125–39 (as the twin essays "Joy of Art" and "The Stone Age"). The grammatically imprecise "Joy of Art" is the most common translation; I have followed Taruskin, SatRT, 851–66, in translating it as "Joy in Art" (except when referring to the *Adamant* edition).

22. S. K. Makovskii, "N. Rerikh," *Zolotoe runo* 4 (1907): 4–7.

23. M. A. Voloshin, "Arkhaizm v russkoi zhivopisi," *Apollon* 1 (October 1909): 43–53.

24. Alexander Blok, "Russia," in *Selected Poems* (Manchester: Carcanet, 2000), 37–38.

25. Grabar', *Moia zhizn'*, 173–74, as translated by Decter, MoB, 67.

26. G. D. Zlochevskii, *Nasledie Serebrianogo veka* (Moscow: Institut naslediia, 2006), 25–74, 175, 299, 356–65; and PRS, 2/3:43–54.

27. Soviet-era biographers pointedly stressed Roerich's repudiation of tsarist rank, which would have ennobled him and Helena personally, though not their heirs. He may have indeed finally accepted the *statskii sovetnik* position; at least one letter from Prince Putiatin in 1917 addresses him as "your

worship" (*vashe vysokorodie*), the exact term one would use to correspond with someone of that rank. On the other hand, this may have been in jest, and Andreyev, MotM, 36, remains convinced (based on his reading of Esther Lichtmann's conversations with Helena years later) that Roerich's initial refusal stood.

28. John E. Bowlt, *The Silver Age: Russian Art of the Early Twentieth Century and the "World of Art" Group* (Newtonville, MA: Oriental Research Partners, 1979), 82, 87, 123 ("putrefaction"); Francis Maes, *A History of Russian Music: From Kamarinskaya to Babi Yar* (Berkeley: University of California Press, 2002), 201 ("dying century"); and Peter Stupples, *Pavel Kuznetsov* (Cambridge: Cambridge University Press, 1989), 84–85.

29. M. K. Tenisheva to N. K. Rerikh, November 13 (October 31, OS), 1907, in Zil'bershtein and Samkov, SDiRI, 2:180; see also 2:179–80, 472–73; and N. K. Rerikh to E. I. Rerikh, November 22 (OS), 1907 (OR GTG, f. 44, op. 1, ed. khr. 354, l. 1).

30. N. S. Gumilev, "Vystavka novogo russkogo iskusstva v Parizhe," *Vesy* 11 (November 1911): 87–88.

31. E. Sviatopolk-Chetvertinskaia to N. K. Rerikh, December 22 (December 9, OS), 1907, in Zil'bershtein and Samkov, SDiRI, 2:180.

32. M. K. Tenisheva, *Vpechatleniia moei zhizni* (Leningrad: Iskusstvo, 1991), 424–25.

33. Zil'bershtein and Samkov, SDiRI, 2:180.

34. N. Shebuev, "Negativy," *Slovo* 320 (December 2, 1907).

35. Denis Roche, "Une Exposition d'Artistes Russes à Paris," *Art et décoration* 22 (June–December 1907); Denis Roche, "Nicolas Roerich," *Gazette des Beaux-Arts* 2 (1908); Casimir de Danilowicz, "Exposition d'art russe moderne," *L'Art décoratif* 112 (January 1908); and Gumilev, "Vystavka." Nathanaëlle Tressol, "The Reception of Russian Arts and Crafts in French Art Journals," *Experiment* 25 (2019): 361, testifies to the "high esteem" in which French critics held Roerich during this period.

36. N. K. Rerikh to B. K. Rerikh, July 2, 1908. OR GTG, f. 44, op. 1, ed. khr. 131, ll. 1–2.

37. PRS, 3/4:225–29.

38. Belikov and Kniazeva, NKR, 92–93. After his unpleasant experience with the 1900 Paris Expo, Roerich routinely turned medals down. He did so in Milan, and again in 1910, in Brussels.

39. A. N. Benua, "Rerikh na vystavke 'Salona,'" *Rech'* (January 28, 1909), as translated by Decter, MoB, 68.

40. E. I. Rerikh to N. K. Rerikh, June 21 (OS), 1909. OR GTG, f. 44, op. 1, ed. khr. 192, ll. 1–2.

41. PRS, 3/4:238–75.

42. Anna Ostroumova-Lebedeva, *Avtobiograficheskie zapiski*, 2 vols. (Leningrad: Iskusstvo, 1935–1945), 2:113–14.

43. Rerikh, LD, 3:344.

44. Belikov and Kniazeva, NKR, 53–55.

45. M. V. Nesterov to N. K. Rerikh, April 14, 1906. OR GTG, f. 44, op. 1, ed. khr. 1056, ll. 1–2.

46. *Apollon* 6 (August 1913): 51–52.

47. Poliakova, NR, 101; and OR GTG, f. 44, op. 1, ed. khr. 615–24, 792–98.

48. Fosdik, MU, 86; and Nina Selivanova, *The World of Roerich* (New York: Corona Mundi, 1923), 50–55.

49. Rerikh, LD, 2:270–72.

50. Fosdik, MU, 86–87.

51. Fosdik, MU, 86–87.

52. Belikova and Kniazeva, NKR, 58–61.

53. Rerikh, LD, 2:247–49.

54. Fosdik, MU, 86–87; and ELD, 1 (May 8, 1929).

55. "Uchenicheskaia vystavka v Obshchestve Pooshchreniia Khudozhestv," *Apollon* 6 (August 1913): 51–52.

56. E. M. Bebutova, "Vospominaniia," RGALI, f. 2714, op. 1, d. 25; and Nina Lobanov-Rostovsky, "Soviet Propaganda Porcelain," *Journal of Decorative and Propaganda Arts* 11 (Winter 1989): 126–41. Uga Skalme, a member of Latvia's most famous family of artists, studied under Bilibin and Roerich, and was satisfied with their instruction (Latvian State Museum of Art).

57. Poliakova, NR, 101.

58. Chagall's autobiography has him arriving in early 1907, but this has been established as an error. See Marc Chagall, *My Life* (New York: Orion Press, 1960), as well as Benjamin Harshav, *Marc Chagall and His Times: A Documentary Narrative* (Stanford, CA: Stanford University Press, 2004); Sidney Alexander, *Marc Chagall* (New York: G. P. Putnam's, 1978); Jean-Paul Crespelle, *Chagall* (New York: Coward-McCann, 1970); Jacob Baal-Teshuva, *Marc Chagall* (Cologne: Taschen, 2000); and Monica Bohm-Duchen, *Marc Chagall* (London: Phaidon, 1998).

59. All quotes taken from Chagall, *My Life*, 78–79, 86.

60. Harshav, *Marc Chagall and His Times*, 136. Crespelle, *Chagall*, 62, writes that Chagall "felt great affection" for Roerich, an inexplicable error.

61. In *Marc Chagall and His Times*, 135, 969, Harshav pinpoints this exchange as taking place in July 1908, with an instructor named Bobrovsky. Prudishness and mistranslation seem to have obscured what happened. French- and English-language biographies describe Bobrovsky as complaining about Chagall's attempt to draw a human knee. Euphemisms such as "garbage" and "nonsense" are often substituted for the expletive Bobrovsky apparently used. Interestingly, in a 1925 draft autobiography, Chagall reports that Bobrovsky shouted "what kind of behind is that?" Whether he was speaking of a posterior that Chagall was drawing, or, in some sort of homosexual advance, Chagall's own, Harshav is unable to determine. As for Roerich, he claimed thirty-five years later in a letter to a friend (LD, 3:99–100) that Chagall had been expelled for helping a friend cheat on an exam. This would explain Chagall's bitterness, but is almost certainly false memory or plain spite.

62. Harshav, *Marc Chagall and His Times*, 25.

63. Baal-Teshuva, *Marc Chagall*, 18–22, notes Roerich's generosity here.

64. Cited in Harshav, *Marc Chagall and His Times*, 179; see also Bohm-Duchen, *Marc Chagall*, 30–32.

65. This does not include Roerich's "Devassari Abuntu" paintings, which some scholars, such as Iakovleva, TDI, 9–10, regard as his first designs for the stage.

66. Sergei Makovskii, cited in Iakovleva, TDI, 19–23.

67. N. K. Rerikh to Iu. D. Beliaev, November 20, 1908, cited in Iakovleva, TDI, 16.

68. S. I. Mamontov to N. A. Rimskii-Korsakov, March 5 (OS), 1908, in Iakovleva, TDI, 29. As a first choice, Mamontov suggested Viktor Vasnetsov, but mentioned Roerich as a fine alternative.

69. Nikolai A. Rimsky-Korsakov, *My Musical Life* (New York: Knopf, 1947), 453–55.

70. T. V. Rimskaia-Korsakova, "Istoriia odnogo pamiatnika," PRS, 1:208–12.

71. Iakovleva, TDI, 23–24, 120–21; and Poliakova, NR, 154–56, 178.

72. Ostroumova-Lebedeva, *Avtobiograficheskie zapiski*, 2:113–14.

73. A. M. Remizov to N. K. Rerikh, November 22 (OS), 1909. OR GTG, f. 44, op. 1, ed. khr. 1190, l. 1.

74. S. K. Makovskii, "Khudozhestvennye itogi," *Apollon* 7 (April 1910): 21–33.

75. Richard Buckle, *Diaghilev* (New York: Atheneum, 1979), 176–77.

76. Bronislava Nijinska, *Early Memoirs* (New York: Holt, Rinehart and Winston, 1981), 448–49.

77. For a translation with commentary, see Serge A. Zenkovsky, ed., *Medieval Russia's Epics, Chronicles, and Tales* (New York: E. P. Dutton, 1974), 167–90.

78. Russia's Scythian movement took formal shape in 1916, but existed loosely beforehand. With Laruelle, *Russian Eurasianism*, Bassin, *Gumilev Mystique*, and Schimmelpenninck van der Oye, *Russian Orientalism*, see Taruskin, SatRT, 437–46, 854–58, 950–65; and Stefani Hoffman, "Scythianism: A Cultural Vision in Revolutionary Russia" (PhD diss., Columbia University, 1975). On the historical Scythians, see Tamara Talbot Rice, *The Scythians* (London: Thames and Hudson, 1957); Renate Rolle,

The World of the Scythians (Berkeley: University of California Press, 1989); George Vernadsky, *Ancient Russia* (New Haven, CT: Yale University Press, 1943); and Michael Rostovtzeff, *Iranians and Greeks in South Russia* (New York: Russell, 1969).

79. V. P. Nikitin, "My i vostok," *Evraziia* 1 (November 24, 1928), cited in Laruelle, *Russian Eurasianism*, 38.

80. Rerikh, SoS, 124. Unconventional as the argument may seem, it anticipates the "constructive innovation" thesis advanced by later historians of Asian art, according to which the Mongols caused "artistic influences [to flow] across Asia to an extent hardly before dreamed of." David Morgan, *The Mongols* (Oxford: Blackwell, 2007), 205.

81. Rerikh, LD, 2:121–22.

82. N. K. Rerikh to Iu. D. Beliaev, November 20, 1908, in Iakovleva, TDI, 32–33.

83. Richard Buckle, *Nijinsky* (New York: Simon and Schuster, 1971), 79–80.

84. Alexandre Benois, *Reminiscences of the Russian Ballet* (London: Putnam, 1941), 298–99; and Sanin in Zil'bershtein and Samkov, SDiRI, 2:423–24.

85. Lynn Garafola, *Diaghilev's Ballets Russes* (New York: Oxford University Press, 1989), 13.

86. Benois, *Reminiscences*, 298–99.

87. Rerikh, IzLN, 193.

88. M. Fokine to N. K. Rerikh, April 4 (OS), 1910. OR GTG f. 44, op. 1, ed. khr. 1447, l. 1.

89. Nijinska, *Early Memoirs*, 264.

90. A. A. Sanin to N. K. Rerikh, May 27 (May 14, OS), 1909. OR GTG, f. 44, op. 1, ed. khr. 1277, ll. 1–2. Benois, *Reminiscences*, 298–99, believes Anisfeld's work was adequate and that Sanin and Diaghilev overreacted.

91. Buckle, *Diaghilev*, 142–43.

92. Jules Claretie, "La Vie à Paris," *Le Temps* (May 21, 1909), in Garafola, *Diaghilev's Ballets Russes*, 32–35.

93. Tamara Karsavina, *Theatre Street* (New York: E. P. Dutton, 1931), 240; and Buckle, *Diaghilev*, 142–43.

94. Cited in Buckle, *Diaghilev*, 161.

95. A. A. Sanin to N. K. Rerikh, May 27 (May 14, OS), 1909. OR GTG, f. 44, op. 1, ed. khr. 1277, ll. 1–2.

96. *Zolotoe runo* 2–3 (1909): 119–20.

97. A. Benua, "Russkie spektakli v Parizhe," *Rech'* 171 (June 25, 1909).

98. Cited in Iakovleva, TDI, 87–88.

99. V. A. Serov to N. K. Rerikh, June 9 (OS), 1909, in Zil'bershtein and Samkov, SDiRI, 2:421. Fokine quoted in the Copenhagen newspaper *Vore Herrer* (February 2, 1920). Camilla Gray and Marian Burleigh-Motley, *The Russian Experiment in Art, 1863–1922* (London: Thames and Hudson, 1986), 56, attribute much of *Igor*'s "delirious reception" to Roerich's set.

100. Rerikh, LD, 2:246–47, on the honorarium; quotation from Benois, *Reminiscences*, 298–99.

101. Alexander Schouvaloff, *The Art of the Ballets Russes* (New Haven, CT: Yale University Press, 1997), 225–26.

102. Karsavina, *Theatre Street*, 244.

Chapter 6: The Great Sacrifice, 1910–1913

1. Igor Stravinsky, *An Autobiography* (London: Marion Boyars, 1990), 31.

2. Cited in Paul Griffiths, *Stravinsky* (New York: Schirmer Books, 1993), 5.

3. N. K. Rerikh, "Zarozhdenie legend," IzLN, 156–57 (also LD, 2:276–77); N. K. Rerikh, "Vesna," LD, 2:382–83; Nicholas Roerich, "Rhythm of Life," *Adamant* (New York: Corona Mundi, 1922), 67–71.

4. Roerich's draft outline for *A Game of Chess* is held by Moscow's Bakhrushin Museum.

5. Richard Taruskin, describing how "one could say with little exaggeration that [Stravinsky] spent the second half of his life telling lies about the first half," in "Resisting the Rite," in The Rite of Spring *at 100*, ed. Severine Neff et al. (Bloomington: Indiana University Press, 2017), 436–37.

6. Robert Craft, "Genesis of a Masterpiece," *Perspectives of New Music* 5 (1966–1967): 22–23.

7. Tamara Karsavina, *Theatre Street* (New York: E. P. Dutton, 1931), 236–38, 244–45, 260.

8. Benois, in the paper *Rech'*, cited in John E. Bowlt, *The Silver Age: Russian Art of the Early Twentieth Century and the "World of Art" Group* (Newtonville, MA: Oriental Research Partners, 1979), 122–28.

9. Rerikh, LD, 3:120.

10. Mstislav V. Dobuzhinskii, *Vospominaniia* (Moscow: Nauka, 1987), 291.

11. Anna Ostroumova-Lebedeva, *Avtobiograficheskie zapiski*, 2 vols. (Leningrad: Iskusstvo, 1935–1945), 2:129.

12. Zil'bershtein and Samkov, SDiRI, 2:426.

13. All quotes are from S. A. Shcherbatov, *Khudozhnik ushedshei Rossii* (Moscow: Soglasie, 2000), 142–43, as translated by Andreyev, MotM, 33–34.

14. On Roerich's likes and dislikes at this time, see Rerikh, LD, 2:121–22, 207–12.

15. As Roerich told Helena in a letter of June 26 (OS), 1913. OR GTG, f. 44, op. 1, ed. khr. 382.

16. See the "Mikalojus Konstantinas Čiurlionis" website, hosted in partnership with Lithuania's M. K. Čiurlionis National Art Museum (http://ciurlionis.eu/en/).

17. Rerikh, IzLN, 398–40; and Poliakova, NR, 34–40.

18. On Roerich and Blok, see A. M. Gordin and M. A. Gordin, *Aleksandr Blok i russkie khudozhniki* (Leningrad: Khudozhnik RFSFR, 1986) 78–79, 96–99, 150–51, 350; and Nicholas Roerich, *Fiery Stronghold* (Boston: Stratford, 1933), 21–27.

19. A. A. Blok, *Sobranie sochinenii* (Moscow, 1962), 8:436; Avril Pyman, *The Life of Aleksandr Blok*, 2 vols. (Oxford: Oxford University Press, 1980), 2:63; and Lucy Vogel, *Aleksandr Blok: The Journey to Italy* (Ithaca, NY: Cornell University Press, 1973), 11–13. The A. A. Blok Museum-Apartment refers to the painting as *Towns of Italy*.

20. Gordin and Gordin, *Aleksandr Blok*, 150–51.

21. Robert Craft, "100 Years On: Igor Stravinsky on *The Rite of Spring*," *Times Literary Supplement* (June 19, 2013).

22. The libretto's earliest version appears not to have survived (Stephen Walsh, *Stravinsky: A Creative Spring* [New York: Knopf, 1999], 173, 591). For related letters, see Igor Stravinsky, *The Rite of Spring: Sketches, 1911–1913* (London: Boosey and Hawkes, 1969); I. Ia. Vershinina, "Pis'ma I. Stravinskogo N. Rerikhu," *Sovetskaia muzyka* 30 (August 1966); Viktor Varunts, ed., *I. F. Stravinskii: perepiska s russkimi korrespondentami* (Moscow: Kompozitor, 1997); and Igor Stravinsky, *Stravinsky: Selected Correspondence*, ed. Robert Craft (New York: Knopf, 1983–1985).

23. On Kuinji's death, see V. S. Manin, *Kuindzhi* (Saint Petersburg: Khudozhnik Rossii, 1997), 70; O. P. Voronova, *Kuindzhi v Peterburge* (Leningrad: Lenizdat, 1986), 230; Rerikh, IzLN, 181–83; PRS, 2/3:275–80; and Fosdik, MU, 88–90.

24. N. K. Rerikh to E. I. Rerikh, July 4 (OS), 1910. OR GTG, f. 44, op. 1, ed. khr. 248, l. 1.

25. On the Novgorod dig, see PRS, 2/3:238–316.

26. PRS, 2/3:287–90.

27. Cited in Rerikh, IzLN, 181–83.

28. N. K. Rerikh to E. I. Rerikh, July 12 and 13 (OS), 1910. OR GTG, f. 44, op.1, ed. khr. 465, 341.

29. Cited in PRS, 2/3:313–14.

30. A. A. Rostislavov (a PPC member) wrote for *Starye gody* in November 1910, December 1910, and May 1911. See also Olga Bazankur, "Beseda s N. K. Rerikhom o raskopakh v Novgorode," *Sankt-Peterburgskie Vedomosti* (October 31, 1910); and N. K. Rerikh in *Zodchii* 4 (1911): 29–30, and *Zodchii* 6 (1911): 61–62.

31. N. K. Rerikh to E. I. Rerikh, August 20 (OS), 1910. OR GTG, f. 44, op. 1, ed. khr. 307, l. 1.

32. I. F. Stravinskii to N. K. Rerikh, in a letter begun in Ustilug on July 2 (June 19, OS), 1910, and completed in La Baule on July 12 (June 29, OS). OR GTG, f. 44, op. 1, ed. khr. 1339, l. 1. A modified translation is given by Taruskin, SatRT, 662–64.

33. N. K. Rerikh to E. I. Rerikh, July 9 (OS), 1910. OR GTG, f. 44, op. 1, ed. khr. 342, l. 1.

34. I. F. Stravinskii to A. N. Benua, August 24 (OS), 1910 ("Has Diaghilev patched things up with Fokine? This is a very important question, because

if the answer is yes, then *The Great Sacrifice* will be Diaghilev's. If it is no, then it will go to Telyakovsky, which is by no means as good!"). Walsh, *Stravinsky*, 147–48.

35. Walsh, *Stravinsky*, 147–48. On August 9, 1910, Stravinsky informed Roerich, "I have started work (sketches) for *The Great Sacrifice*. . . . Have you done anything for it yet?" (Stravinsky, *Rite of Spring: Sketches 1911–1913*, 29).

36. *Russkoe slovo* (July 15, 1910).

37. El', "Nashi besedy u N. K. Rerikha," *Obozrenie teatrov* (September 30, 1910): 14. Also, "Balet khudozhnika N. K. Rerikha," *Peterburgskaia gazeta* (August 18, 1910); and N. N., "Raznye izvestiia," *Russkaia muzykal'naia gazeta* 32–33 (August 8–15, 1910).

38. S. P. Diagilev to N. K. Rerikh, October 9, 1910. OR GTG, f. 44, op. 1, ed. khr. 777, ll. 1–2.

39. I. F. Stravinskii to A. N. Benua, November 3 (October 20, OS), 1910. Cited in Zil'bershtein and Samkov, SDiRI, 2:185–88.

40. Zil'bershtein and Samkov, SDiRI, 2:426.

41. Iakovleva, TDI, 45–46, 124, 262.

42. S. P. Diagilev to N. K. Rerikh, October 9, 1910. OR GTG, f. 44, op. 1, ed. khr. 777, ll. 1–2.

43. Iakovleva, TDI, 46, 128, 262. Roerich gave his *Sadko* piece to Maria Tenisheva.

44. On Fevronia, see Serge A. Zenkovsky, ed., *Medieval Russia's Epics, Chronicles, and Tales* (New York: E. P. Dutton, 1974), 290–300. On Kitezh, see Simon Morrison, *Russian Opera and the Symbolist Movement* (Berkeley: University of California Press, 2003), 116–41; Francis Maes, *A History of Russian Music* (Berkeley: University of California Press, 2002), 189–91; and Munin Nederlander, *Kitezh: The Russian Grail Legends* (London: Aquarian Press, 1991).

45. Evgeniia Kirichenko, *Russian Design and the Fine Arts, 1750–1917* (New York: Abrams, 1991), 237–41, identifies the "Church Militant" allusion.

46. Roerich quotes Stravinsky in an undated letter to A. V. Rumanov (RGALI, f. 1694, op. 1, ed. khr. 546, l. 38). See also Iakovleva, TDI,

44–45, 129, 262; Belikov and Kniazeva, NKR, 51; Richard Buckle, *Nijinsky* (New York: Simon and Schuster, 1971), 171, 191; and Kenneth Archer, "The Theatrical Designs of Nicholas Roerich: Problems of Identification" (MA thesis, Antioch University, 1985), 41–42. The Kazan Station project was announced in *Apollon* 5 (May 1913) and 6 (August 1913), though the May issue mistakenly spoke of Moscow's Kursk Station.

47. Iakovleva, TDI, 24–27, 130, 262.

48. A. A. Mgrebov, *Zhizn' v teatre* (Moscow, 1932), 2:77, 101–3. Sergei Ernst, *N. K. Rerikh* (Petrograd: Sv. Evgenii, 1918), 77, is among those responsible for perpetuating the false image of aloofness.

49. A. N. Benua, "Starinnyi teatr," *Rech'* (December 23, 1911).

50. Ostroumova-Lebedeva, *Avtobiograficheskie zapiski*, 2:37.

51. See *Apollon* 2 (February 1911): 14–24; *Apollon* 10 (December 1912): 78–79; A. A. Rostislavov, "Vystavka 'Mir iskusstva,'" *Rech'* (January 14, 1913); *Apollon* 2 (February 1913): 39–48; *Apollon* 8 (October 1913): 62; *Apollon* 9 (November 1913); and *Apollon* 1–2 (January–Feburary 1914): 138.

52. *Apollon* 1–2 (January–February 1914): 138.

53. Jelena Hahl-Koch, *Kandinsky* (New York: Rizzoli, 1993), 200, citing Kandinsky's letter to Gabriel Munter on November 16 (November 3, OS), 1912.

54. Roerich also knew Boris Zaitsev's poem on this theme. See G. I. Potanin, *Vostochnye motivy v srednevekovom evropeiskom epose* (Moscow: Kushnerev, 1899), 633–34.

55. Nicholas Roerich, *Shambhala the Resplendent* (New York: Nicholas Roerich Museum, 1978 [orig. 1930]), 130–32, associates *The Benevolent Nest* with a story about Saint Procopius. Marilyn Meyer Hoogen, "Igor Stravinsky, Nikolai Roerich, and the Healing Power of Paganism" (PhD diss., University of Washington, 1997), 90, suggests that Roerich's use of the tree-of-life symbol was inspired by a Konstantin Balmont poem, "The Slavonic Tree."

56. G. P. Fedotov, *The Russian Religious Mind* (New York: Harper and Row, 1965), 344, 355–57; Kenneth Archer, *Nicholas Roerich: East and West* (Bournemouth: Parkstone, 1999), 39–42; and E. G. Soini, *Severnyi lik Nikolaia Rerikha* (Samara: Agni, 2001), 32–34, 37.

57. Among the ethnographers who popularized this view was Nikolai Iadrintsev, in "The Bear Cult in Russia" (1891). See Fedotov, *Russian Religious Mind*, 9–10; and Jack V. Haney, *An Introduction to the Russian Folktale* (Armonk, NY: M. E. Sharpe, 1999), 65–71, 89–90.

58. A. I. Gidoni, "Tvorcheskii put' Rerikha," *Apollon* 4–5 (April–May 1915): 1–34; also "Predchustvie voiny v tvorchestve N. K. Rerikha," *Niva* 9 (March 4, 1917). The English Theosophist Barnett Conlan reinforced the notion that these paintings were "obviously prophetic" in "Nicholas Roerich and Art's Legendary Future," *The Studio* 118 (July–December 1939): 66–71.

59. Cited in Ernst, *N. K. Rerikh*, 102.

60. Nicholas Roerich, *Invincible* (New York: Roerich Museum Press, 1974), 358–65, recounts Gorky's reaction to *Purest City* at the 1915 World of Art show.

61. A. I. Andreev, *Khram Buddy v Severnoi stolitse* (Saint Petersburg: Nartang, 2004); Alexandre Andreyev, *Soviet Russia and Tibet: The Debacle of Secret Diplomacy* (Leiden: Brill, 2003), 49–68; Aleksandr I. Andreev, *Vremia Shambaly* (Saint Petersburg: Neva, 2004), 31–38; John Snelling, *Buddhism in Russia: The Story of Agvan Dorzhiev; Lhasa's Emissary to the Tsar* (Rockport, MA: Element, 1993), 136–41; Tatiana Shaumian, *Tibet: The Great Game and Tsarist Russia* (New York: Oxford University Press, 2000), 118–19; and Nicholas Roerich, *Himalayas: Abode of Light* (London: Marlowe, 1947), 110.

62. Karl E. Meyer and Shareen Blair Brysac, *Tournament of Shadows: The Great Game and the Race for Empire in Central Asia* (Washington, DC: Counterpoint, 1999), 449.

63. On this community of scholars, see Andreyev, *Soviet Russia and Tibet*, 27–28, 49–51; Maria Carlson, *"No Religion Higher Than Truth": A History of the Theosophical Movement in Russia, 1875–1922* (Princeton, NJ: Princeton University Press, 1993), 193–94; David Schimmelpenninck van der Oye, *Russian Orientalism: Asia in the Russian Mind from Peter the Great to the Emigration* (New Haven, CT: Yale University Press, 2010), 171–73, 234–35; and Marlène Laruelle, "'The White Tsar': Romantic Imperialism in Russia's Legitimizing of Conquering the Far East," *Acta Slavica Iaponica* 25 (2008): 113–34. I take the terms "neo-" and "theosopho-Buddhists" from Andreyev.

64. Snelling, *Buddhism in Russia*, passim; Meyer and Brysac, *Tournament of Shadows*, 261–90; Isabel Hilton, *In Search of the Panchen Lama* (New York: W. W. Norton, 1999), passim; and Emanuel Sarkisyanz, "Communism and Lamaist Utopianism in Central Asia," *Review of Politics* 20, no. 4 (1958): 623–33.

65. Cited in Michael Kapstein, *The Tibetans* (Oxford: Blackwell, 2006), 169.

66. Cited in Andreyev, *Soviet Russia and Tibet*, 25.

67. Andreyev, *Soviet Russia and Tibet*, 48–49; and David Schimmelpenninck van der Oye, *Toward the Rising Sun: Russian Ideologies of Empire and the Path to War with Japan* (DeKalb: Northern Illinois University Press, 206), 199–201.

68. Andreyev, *Soviet Russia and Tibet*, 49–51.

69. Roerich later identified his time with the Temple Commission as the moment he first learned of the Shambhala myth. Considering his longtime acquaintance with Potanin's and Blavatsky's writings, this seems improbable. More likely he was referring to a new level of interest in the myth's apocalyptic details. Andrei Znamenski, *Red Shambhala: Magic, Prophecy, and Geopolitics in the Heart of Asia* (Wheaton, IL: Quest Books, 2011), 1–12, provides a good summary of the myth.

70. Nicholas Roerich, *Himavat: Diary Leaves* (Allahabad: Kitabistan, 1947), 137–38.

71. On Schneider, see Anita Stasulane, *Theosophy and Culture: Nicholas Roerich* (Rome: Pontifica

università gregoriana, 2005), 23–25; on Remizov, see OR GTG, f. 44, op. 1, ed. khr. 1189, l. 1.

72. Nina Berberova, *The Italics Are Mine* (London: Vintage, 1993), 258.

73. Rerikh, LD, 3:183–85.

74. Martinism, part of the Rosicrucian tradition, gained prominence in Russia, Serbia, and Montenegro after 1880. Markus Osterrieder, "From Synarchy to Shambhala: The Role of Political Occultism and Social Messianism in the Activities of Nicholas Roerich," in *The New Age of Russia: Occult and Esoteric Dimensions*, ed. Birgit Menzel, Bernice G. Rosenthal, and Michael Hagemeister, 101–34 (Munich: Kubon & Sagner, 2012); Andreev, *Vremia Shambaly*, 94–102; and Marlène Laruelle, *Mythe aryen et rêve impérial dans la Russie du XIXe siècle* (Paris: CNRS, 2005), 130–31. Running ahead of available evidence, Shishkin, BzG, 18–26, and Anton Pervushin, *Okkul'tnye tainy NKVD i SS* (Leningrad: Neva, 1999), 70–96, use Roerich's possible Martinist ties to connect him before 1917 to Gleb Bokii and Alexander Barchenko, Tibetophiles who later worked in the Soviet secret police's Special Department for paranormal research, as well as to Khayan Khirva (Namzil-un Qayangkhirva, aka Khayan Khirab), later of the Mongolian secret police, and the Mongolian scholar-activist Tsyben Jamtsarano. Roerich met these individuals eventually, but while he may have known some or all of them before the 1920s, concrete proof of that—or of any cooperative effort among them—is lacking, a point made by Andreev, *Vremia Shambaly*, and Znamenski in *Red Shambhala*.

75. Igor' E. Grabar', *Moia zhizn'* (Moscow: Iskusstvo, 1937), 174–76 (here, Guzik is referred to as "Janek"); Maksim Dubaev, *Nikolai Rerikh* (Moscow: Molodaia gvardiia, 2003) 147–48; and Carlson, *"No Religion,"* 27.

76. Cited in James Billington, *The Icon and the Axe* (New York: Vintage, 1970), 465.

77. Belikov and Kniazeva, NKR, 75, 84, 108; Rerikh, LD, 2:133–37; and Mikhail Agursky, "An Occult Source of Socialist Realism," in *The Occult in Russian and Soviet Culture*, ed. Bernice Glatzer Rosenthal (Ithaca, NY: Cornell University Press, 1997), 247–72.

78. Alexander Etkind, *Eros of the Impossible: The History of Pschoanalysis in Russia* (Boulder, CO: Westview, 1997), 115–16.

79. N. K. Rerikh, "Zakliatiia," SoS, 321–23, also N. K. Rerikh, *Tsvety Morii* (San Francisco: Slavic Yoga Society, 1974), 11–12. The principal English version, translated by Mary Siegrist and Esther Lichtmann, is *Flame in Chalice* (New York: Roerich Museum Press, 1929–1930), which I have used as a guide for translation, albeit with modifications.

80. M. K. Tenisheva, *Vpechatleniia moei zhizni* (Leningrad: Iskusstvo, 1991), 250–51; A. Zelinskii, "Zabytyi pamiatnik russkogo iskusstva," *Iskusstvo* 3 (1962): 61–62; S. Shcherbatov, "Russkie khudozhniki," *Vozrozhdenie* 18 (1951): 117; John E. Bowlt, "Nikolai Roerich at Talashkino," *Experiment* 7 (Winter 2001): 103–21; Wendy Salmond, *Arts and Crafts in Late Imperial Russia* (Cambridge: Cambridge University Press, 1996), 143–44; and V. I. Kochanova, "Khram Sv. Dukha vo Flenove," *Muzeinyi vestnik* 6 (2012): 75–89.

81. Tenisheva, *Vpechatleniia*, 250.

82. L. S. Zhuravleva, *Talashkino* (Moscow: Izobrazitel'noe iskusstvo, 1989), 12, 250–51. In "Nikolai Roerich at Talashkino," John Bowlt emphasizes the noncanonical impression Tenisheva and Roerich were aiming for.

83. I. F. Stravinskii to N. K. Rerikh, July 15 (July 2, OS), 1911. OR GTG, f. 44, op. 1, ed. khr. 1341, l. 1.

84. Igor Stravinsky and Robert Craft, *Expositions and Developments* (London: Faber and Faber, 1962), 140–41. André Schaeffner, *Strawinsky* (Paris: Reider, 1931), 39, maintains that the incident took place on Stravinsky's return trip, and Walsh, *Stravinsky*, 174, 591n27, follows him on this.

85. Nicholas Roerich, *Realm of Light* (New York: Roerich Museum Press, 1931), 186; and Pieter van den Toorn, *Stravinsky and The Rite of Spring: The Beginnings of a Musical Language* (Berkeley: University of California Press, 1987), 22–27.

Taruskin, SatRT, 859, and Rachel Polonsky, *English Literature and the Russian Aesthetic Renaissance* (Cambridge: Cambridge University Press, 1998), 65–68, discuss how Stravinsky drew inspiration from Sergei Gorodetsky's *Yarila* [*sic*], a two-section cycle of poems devoted to the Slavic sun god. Note that Roerich knew Gorodetsky's work equally well and was personally close to the poet.

86. Titles as given by Taruskin, SatRT, 873, with modifications suggested by van den Toorn, *Stravinsky*, 24–25 (who attributes the titles to Roerich).

87. I. F. Stravinskii to N. K. Rerikh, September 26 (September 13, OS), 1911. OR GTG, f. 44, op. 1, ed. khr. 1342, l. 1, as translated by Walsh, *Stravinsky*, 591n31.

88. Taruskin, SatRT, 873.

89. Stravinsky and Craft, *Expositions and Developments*, 141; and Walsh, *Stravinsky*, 174.

90. Rerikh, IzLN, 359–63.

91. *Peterburgskaia gazeta* (September 7, 1911).

92. Svetlana Savenko, "*The Rite of Spring* in Russia," in Neff et al., Rite of Spring *at 100*, 237–45, provides this lengthy list, including alternatives such as *Vesennee zhertvoprinoshenie* ("Springtime Offering of the Sacrifice"), *Osviashchennaia vesna* ("Spring Sanctified"), and *Tainstvo vesny* ("The Mystery of Spring").

93. Vera Stravinsky and Robert Craft, *Stravinsky in Pictures and Documents* (New York: Simon and Schuster, 1978), 83–84; and Walsh, *Stravinsky*, 178.

94. I. F. Stravinskii to N. K. Rerikh, September 26 (September 13, OS), 1911, in V. Stravinsky and Craft, *Stravinsky in Pictures and Documents*, 77.

95. Iakovleva, TDI, 64–67; and Nils Åke Nilsson, *Ibsen in Russland* (Stockholm: Almqvist & Wiksell, 1958), 128–31.

96. Roerich, *Adamant*, 48–54, describes Stanislavsky. He also says that Nemirovich-Danchenko offered him the "difficult task" of choosing between *Peer Gynt* and Maeterlinck's *Princess Maleine*, but this is unconfirmed.

97. E. M. Bebutova, "Vospominaniia," RGALI, f. 2714, op. 1, ed. khr. 25; and Iakovleva, TDI, 64–67.

98. Bebutova, "Vospominaniia."

99. John Horton, *Grieg* (London: J. M. Dent, 1974), 43–45.

100. Mardzhanov and Roerich settled on terms in October–November 1911. Iakovleva, TDI, 62–63, 263.

101. Roerich, *Adamant*, 48–54.

102. F. Ia. Syrkina, "Rerikh i teatr," NKR: zit, 90–91.

103. "Rerikh o 'Per Giunte,'" *Maski* 1 (1912): 43–44; and S. S. Glagol', "'Per Giunt' na stsene Khudozhestvennogo teatra," *Maski* 1 (1912): 57.

104. S. M. Gorodetskii to N. K. Rerikh, May 3 (OS), 1913. OR GTG, f. 44, op. 1, ed. khr. 723, l. 1.

105. Roerich, *Adamant*, 49; and Roerich, IzLN, 193.

106. Reviews cited by Iakovleva, TDI, 64–67.

107. Cited in Poliakova, NR, 162. René Fülöp-Miller believed the *miriskusnik* style was not well-matched to MKhT's, and that Roerich's designs in particular "interfered with the customary business of the actors." René Fülöp-Miller, *The Russian Theatre* (New York: Benjamin Blom, 1968), 52.

108. Iakovleva, TDI, 76–80.

109. Poliakova, NR, 157–60; and Iakovleva, TDI, 58–61, 159–63, 262–63.

110. Cited in Iakovleva, TDI, 159.

111. *Birzhevye vedomosti* (September 17, 1912).

112. Iakovleva, TDI, 60–61; *Birzhevye vedomosti* (September 17, 1912); and S. Auslender, "Na general'noi repetitsii 'Snegurochki,'" *Teatr* 17 (September 15, 1912): 2.

113. *Leaves of Morya's Garden*, section II, cited in Harold Balyoz, *Three Remarkable Women* (Flagstaff, AZ: Altai, 1986), 92.

114. E. I. Rerikh, *Pis'ma s gor* (Minsk, 2000), 1:98–99; and Helena Roerich [E. I. Rerikh], *On Eastern Crossroads* (Delhi: Prakashan Sansthan, 1995), 45.

115. Roerich, *Himavat*, 286. Esoterica aside, Roerich as an archaeologist theorized, as did many researchers of his day, that worship of a great goddess was common to most Eurasian peoples

during the Stone Age. Mikhail Rostovtzeff believed this (Neal Ascherson, *Black Sea* [London: Hill and Wang, 1995]), 111–24, 210–12), and the historian G. P. Fedotov argued that "if pagan Slavs had no name for the Great Goddess, it does not mean that they did not know her" (Fedotov, *Russian Religious Mind*, 1:360–62).

116. Rerikh, SoS, 310–11.

117. Hoogen, "Igor Stravinsky," 99–102, 374–76, discusses posture and clothing. Speculation about the Upanishads is my own, based on Mircea Eliade, *Patterns in Comparative Religion* (New York: New American Library, 1974), 193–94; and Joseph Campbell, *The Masks of God, Volume 2. Oriental Mythology* (New York: Viking Compass, 1972), 336. Roerich mentions the bodhisattva of mercy in *Himavat*, 110–18, 286–89; his Lakshmi poem is in SoS, 303–6.

118. S. Shcherbatov, "Russkie khudozhniki," *Vozrozhdenie* 18 (1951): 117.

119. M. Voloshin, "Khudozhestvennye itogi zimy 1910–1911," *Russkaia mysl'* 6 (1911): 30.

120. Walsh, *Stravinsky*, 178; and I. F. Stravinskii to N. K. Rerikh, March 6, 1912. OR GTG, f. 44, op. 1, ed. khr. 1343, l. 1, translation from Stravinsky, *Rite of Spring: Sketches, 1911–1913*, 31.

121. V. Stravinsky and Craft, *Stravinsky in Pictures and Documents*, 92–93.

122. Oliver Daniel, for example, repeats the error in "*Rite of Spring*, First Staging in America," *Ballet Review* (Summer 1982): 68. After 1920, Roerich himself confused the issue, speaking often about anthropological connections between indigenous Americans and Siberians, inadvertently signaling that he had these connections in mind when designing *The Rite*.

123. Quotations from Lynn Garafola, *Diaghilev's Ballets Russes* (New York: Oxford University Press, 1989), 68. See also Modris Eksteins, *Rites of Spring: The Great War and the Birth of the Modern Age* (New York: Anchor Books, 1990); and Peter Conrad, *Modern Times, Modern Places* (New York: Knopf, 1999), 381–88.

124. Taruskin, SatRT, 893–900.

125. Maes, *History of Russian Music*, 223–29.

126. Garafola, *Diaghilev's Ballets Russes*, 427n58, speculates about Remizov and Stravinsky.

127. Maes, *History of Russian Music*, 223–29.

128. Millicent Hodson, "Nijinsky's Choreographic Method: Visual Sources from Roerich for *Le Sacre du Printemps*," *Dance Research Journal* 18 (Winter 1986–1987): 9–11. See also Garafola, *Diaghilev's Ballets Russes*, 71–73; Simon Karlinsky, "Stravinsky and Russian Preliterate Theater," *Nineteenth-Century Music* 6 (1983): 234–35; and Conrad, *Modern Times, Modern Places*, 381–88. My own first treatment of this topic—"In Search of Primeval Russia: Stylistic Evolution in the Landscapes of Nicholas Roerich, 1897–1914," *Ecumene* [now *Cultural Geographies*] 7 (July 2000): 271–97—expresses similar confusion.

129. Taruskin, SatRT, 864. Maes, *History of Russian Music*, 223–29, follows this reasoning, as do most Stravinsky scholars cited in this chapter.

130. Rachel Polonsky, "Letter from Peryn," *Times Literary Supplement* (June 7, 2002): 5.

131. Barbara Ehrenreich, *Blood Rites: Origins and History of the Passions of War* (New York: Metropolitan, 1997), 61. See also Jean Guillaume and Jean Zammit, *The Origins of War: Violence in Prehistory* (Oxford: Blackwell, 2005), 33–37, 163–64; and Patrick Tierny, *The Highest Altar: Unveiling the Mystery of Human Sacrifice* (New York: Penguin, 1989).

132. Thomas Forrest Kelly, *First Nights: Five Musical Premieres* (New Haven, CT: Yale University Press, 2001), 270, notes, "[Roerich's] assertions as to what was prehistoric and Russian were generally believed (though modern anthropologists might have serious doubts)." Those who "generally believed" in Roerich's time include E. V. Anichkov, *Iazychestvo i drevniaia Rus'* (Saint Petersburg: Stasiulevich, 1914), 238; and D. K. Zelenin, *Izbrannye trudy, 1901–1913* (Moscow: Indrik, 1994). In the 1940s, G. P. Fedotov approvingly cited Anichkov's research on orgiastic rites dedicated to Yarilo (Fedotov, *Russian Religious*

Mind, 11–15, 351–54), and, in the USSR, academic opinion remained open to the idea that the Slavs practiced human sacrifice, even if state authorities looked on the notion with disfavor. Greater skepticism became the norm from the 1950s onward, but I. Ia. Froianov considered human sacrifice to have been probable, while B. D. Grekov thought it possible. See also N. N. Veletskaia, *Iazycheskaia simvolika slavianskikh arkhaicheskikh ritualov* (Moscow: Nauka, 1978); I. V. Dubov, *Istoriko-arkheologicheskoe izuchenie Drevnei Rusi* (Leningrad: LGU, 1988); and B. A. Rybakov, whose works have enjoyed a revival in post-Soviet Russia, even if Western scholars tend not to value him highly.

133. P. A. Barford, *The Early Slavs: Culture and Society in Early Medieval Eastern Europe* (Ithaca, NY: Cornell University Press, 2001), 119–20. Simon Franklin and Jonathan Shepherd concur in *The Emergence of Rus: 750–1200* (London: Longman, 1998), 45, 158, as do nonspecialist volumes like *Forests of the Vampire* (Amsterdam: Time-Life, 1999), 25, 36, 93.

134. Tadeusz Sulimirski, *The Sarmatians* (New York: Praeger, 1970), 36–38, 106; Renate Rolle, *The World of the Scythians* (Berkeley: University of California Press, 1989), 117–19; and Ascherson, *Black Sea*, 76–79, 126–27.

135. Orlando Figes, *Natasha's Dance: A Cultural History of Russia* (London: Allen Lane, 2002), 279–81. Recall Roerich's interest in midsummer bonfire rituals, dating from his 1907 visit to Finland.

136. Taruskin, SatRT, 860–66; Garafola, *Diaghilev's Ballets Russes*, 423n58; van den Toorn, *Stravinsky*, 10; Peter Hill, *Stravinsky:* The Rite of Spring (Cambridge: Cambridge University Press, 2000), 102–4; Lawrence Morton, "Footnotes to Stravinsky Studies," *Tempo* 128 (March 1979): 10–12.

137. Taruskin, SatRT, 860–66, argues that the maiden sacrifice idea "could only have occurred to someone steeped in the traditions and clichés of the romantic musical theater," and lays heavy emphasis on the fact that Stravinsky's father, a professional singer, often played the Pilgrim Elder in *Rogneda*.

But *Rogneda* was hardly a fringe work, and Taruskin fails to acknowledge how familiar Roerich was with the same "traditions and clichés."

138. Garafola, *Diaghilev's Ballets Russes*, 68.

139. Garafola, *Diaghilev's Ballets Russes*, 68. This theme is developed further in Hoogen, "Igor Stravinsky."

140. Durkheim cited in Robert Wright, *The Evolution of God* (New York: Little, Brown, 2009), 43–44.

141. Figes, *Natasha's Dance*, 279, 279–81. Thomas Kelly agrees in *First Nights*, 269–70 ("Roerich was the originator of the scenario"), and Jeffrey Brooks expresses skepticism about Stravinsky's claims in *The Firebird and the Fox: Russian Culture under Tsars and Bolsheviks* (Cambridge: Cambridge University Press, 2019), 140. Others who favor Roerich's version of events or raise points supporting it include Bernice Rosenthal, "Wagner and Wagnerian Ideas in Russia," in *Wagnerism in European Culture and Politics*, ed. David Large (Ithaca, NY: Cornell University Press, 1984), 209; Vera Krasovskaya, *Nijinsky* (New York: Schirmer Books, 1979), 225, 234–35; and Charles Joseph, *Stravinsky and the Piano* (Ann Arbor, MI: UMI, 1983), 2. Essays by John Bowlt, Jan Assmann, and Paul and Edmund Griffiths in *Avatar of Modernity: The Rite of Spring Reconsidered*, ed. Hermann Danuser and Heidi Zimmermann (London: Boosey and Hawkes, 2013), assess Roerich's role in the ballet's creation with more nuance than found in earlier rounds of this debate.

142. From N. K. Rerikh, "Na kurgane," SoS, 1–26, as translated by Taruskin, SatRT, 867.

143. Letter to Florent Schmitt, cited in Walsh, *Stravinsky*, 175.

144. Tatiana Baranova Monighetti, "Stravinsky, Roerich, and Old Slavic Rituals in *The Rite of Spring*," in Neff et al., Rite of Spring *at 100*, 189, insists that, while "the accurate scenario of ancient Russia would not have existed" without Roerich, Stravinsky "had undoubtedly studied Old Slavic rituals on his own." True as this is, it in no way

changes the fact that Roerich's expertise vastly dwarfed Stravinsky's.

145. Hill, *Stravinsky*, 117. Stravinsky diminished Benois's role in writing *Petrushka*'s libretto, downplayed the help Boris Kochno and Jean Cocteau gave him on *Oedipus Rex*, and slighted the violinist Samuel Duskin, who worked with him on *Duo Concertant*. See Walsh, *Stravinsky*, 148–49, 153–58; Charles A. Joseph, *Stravinsky Inside Out* (New Haven, CT: Yale University Press, 2001), 7, 12, 239; and Charles A. Joseph, "Diaghilev and Stravinsky," in *The Ballets Russes and Its World*, ed. Lynn Garafola and Nancy van Norman Baer (New Haven, CT: Yale University Press, 1999), 213.

146. Richard Taruskin, "Stravinsky and Us," in *The Cambridge Companion to Stravinsky*, ed. Jonathan Cross (Cambridge: Cambridge University Press, 2003), 264.

147. Taken from Stravinsky's interview with Michel Georges-Michel, "Les deux *Sacres du printemps*," *Comœdia Illustré* (December 11, 1920). Hill, *Stravinsky*, 117, characterizes them as false, as do most others.

148. Quotation from Georges-Michel, "Les deux *Sacres du printemps*." Stravinsky maintained that only the bassoon solo that opens *The Rite* derived from folk music (Taruskin, SatRT, 881–91). Lawrence Morton, "Footnotes," addresses this misconception.

149. Both quotations from van den Toorn, *Stravinsky*, 113.

150. I. F. Stravinskii to N. F. Findeizen, December 15 (December 2, OS), 1912, in Zil'bershtein and Samkov, SDiRI, 2:480.

151. I. F. Stravinskii to Maksimilian Shteinberg, February 2 (January 21, OS), 1913, in Monighetti, "Stravinsky, Roerich, and Old Slavic Ritual," 193.

152. Igor Stravinsky, "What I Wished to Express in 'The Consecration of Spring,'" *Montjoie* (May 29, 1913). *Boston Evening Transcript* version in V. Stravinsky and Craft, *Stravinsky in Pictures and Documents*, 522–26. In years to come, Stravinsky disowned the interview, but the original text bears his signature. Hill, *Stravinsky*, 111–12; and Taruskin, SatRT, 877, affirm that the comments were his.

153. A facsimile appears in V. Stravinsky and Craft, *Stravinsky in Pictures and Documents*, 78, with a caption reading "1910. The libretto in Stravinsky's hand." The dating error belongs to the editors; it does not appear on the original. See van den Toorn, *Stravinsky*, 26–27; and Taruskin, SatRT, 878–79.

154. "Divorce" comment in Hill, *Stravinsky*, 115; and Stravinsky's words in Georges-Michel, "Les deux *Sacres du printemps*."

155. Roerich, "Rhythm of Life," *Adamant*, 67.

156. Roerich, "Sacre," *Realm of Light*, 185–91.

157. Rerikh, "Zarozhdenie legend," IzLN, 156–57. Also in *Segodnia* 134 (March 16, 1939): 1.

158. Rerikh, "Vesna," LD, 2:382–83.

159. Taruskin, SatRT, 861–64, points out the erroneous date. Also, to him, Roerich's choice of title (*The Rite of Spring*, rather than *The Great Sacrifice*) is further cause to doubt his essay's veracity. Given that the world had known the ballet as *The Rite of Spring* for more than three decades by 1939, it seems unreasonable to make an issue of this. More seriously, Hill, *Stravinsky*, 4–7, declares that "The Birth of Legends" cannot be true because it describes Diaghilev encouraging Stravinsky to approach Roerich, while, in reality, the two kept their project hidden from Diaghilev as long as possible. This would be a damning point if Diaghilev were actually mentioned in "The Birth of Legends"—but he is not. Hill's information about the essay comes secondhand, from Decter, MoB, 55, who mistakenly inserts Diaghilev into the story ("the impresario decided to team Roerich up with a young, talented composer he had discovered—Igor Stravinsky").

160. Igor Stravinsky and Robert Craft, *Conversations with Igor Stravinsky* (London: Faber and Faber, 1959), 105.

161. Arnold Haskell, with Walter Nouvel, *Diaghileff: His Artistic and Private Life* (New York: Simon and Schuster, 1935), 219. An alternative, but provably false, theory comes from Serge Lifar, *Serge Diaghilev* (New York: G. P. Putnam's, 1940), 199, who says that Diaghilev "conceived the idea of producing a primitive ballet . . . and to this end called on Roehrich [*sic*] and Stravinsky."

162. Nijinska, *Early Memoirs*, 448; Marie Rambert, *Quicksilver* (London: St. Martin's Press, 1972), 63. George Balanchine endorses Rambert's account of *The Rite*'s creation, commenting that she "has written, in a way no one else can match, the background of this ballet" (George Balanchine and Francis Mason, *Balanchine's Complete Stories of the Great Ballets* [Garden City, NY: Doubleday, 1977], 548–49).

163. Alexandre Benois, *Reminiscences of the Russian Ballet* (London: Putnam, 1941), 346–47.

164. Rerikh, "Vesna," LD, 2:382–83; and Boosey and Hawkes's 2003 *Dance* catalog, 7. In the West, both men were legally considered to have authored the libretto. In 1962, Stravinsky wrote that "authorship [of the libretto] . . . belongs to me with N. Roerich (now replaced by his son Sviatoslav)" (Igor Stravinsky to Ernst Roth of Boosey and Hawkes, March 8, 1962, in Stravinsky, *Stravinsky: Selected Correspondence*, 3:436).

165. Igor Stravinsky and Robert Craft, *Themes and Episodes* (New York: Knopf, 1967), 320. Stravinsky added changes through April 1913.

166. *Rech'* (November 22, 1912) was among the first to publish the news.

167. I. F. Stravinskii to N. K. Rerikh, December 14 (December 1, OS), 1912. OR GTG, f. 44, op. 1, d. 1344, l. 1. This was not just flattery. When Stravinsky's friend, the composer Maurice Delage, saw Roerich's studies in January, he exclaimed, "Ils sont splendides!" (V. Stravinsky and Craft, *Stravinsky in Pictures and Documents*, 93).

168. V. Stravinsky and Craft, *Stravinsky in Pictures and Documents*, 90.

169. V. Stravinsky and Craft, *Stravinsky in Pictures and Documents*, 92–93.

170. Stravinsky, *Stravinsky: Selected Correspondence*, 2: 5.

171. From the 1967 Boosey and Hawkes edition, in van den Toorn, *Stravinsky*, 24–27. Titles in brackets are common alternative translations.

172. S. P. Diaghilev to I. F. Stravinsky, March 23, 1913 (Stravinsky, *Stravinsky: Selected Correspondence*,

2:6); N. K. Rerikh to S. P. Diagilev, undated (Zil'bershtein and Samkov, SDiRI, 2:120, 430–31; with an abbreviated English version in Lifar, *Serge Diaghilev*, 200). The letter's opening and closing sections are missing; it cannot have been written before February 1913, because Roerich refers to choreographic work not done by Nijinsky until then.

173. Rerikh, IzLN, 193; and Iakovleva, TDI, 55.

174. V. Stravinsky and Craft, *Stravinsky in Pictures and Documents*, 94.

175. Wallace Brockaway and Herbert Weinstock, *Men of Music* (New York: Simon and Schuster, 1958), 599.

176. Stravinsky, *Autobiography*, 62–65; "maladroit" from Brockaway and Weinstock, *Men of Music*, 599. Nijinska, *Early Memoirs*, 122, notes that Nijinsky played several instruments, including piano and mandolin.

177. Eric Walter White, *Stravinsky: The Composer and His Works* (Berkeley: University of California Press, 1984), 214.

178. Quotation from Nijinska, *Early Memoirs*, 457–58. See also Benois, *Reminiscences*, 290, 348; S. L. Grigorev, *The Diaghilev Ballet 1909–1929* (London: Constable, 1953), 64–71; and Buckle, *Nijinsky*, 246.

179. Nijinska, *Early Memoirs*, 457–58.

180. Both quotes from Nijinska, *Early Memoirs*, 461.

181. Nijinska, *Early Memoirs*, 461.

182. Nijinska, *Early Memoirs*, 448–49.

183. Millicent Hodson, *Nijinsky's Crimes Against Grace: Reconstruction Score of the Original Choreography for* Le Sacre du Printemps (New York: Pendragon, 1996); and Millicent Hodson, "Nijinsky's Choreographic Method," 7–15, citing Prunière's 1929 essay.

184. Minna Lederman, ed., *Stravinsky in the Theatre* (New York: Pellegrini and Cudahy, 1949), 128–29.

185. Buckle, *Diaghilev*, 253.

186. Stravinsky and Craft, *Conversations*, 48.

187. White, *Stravinsky*, 214; and Hodson, *Nijinsky's Crimes Against Grace*, x.

188. Walsh, *Stravinsky*, 203.

189. Truman Bullard, "The First Performance of Igor Stravinsky's *Sacre du Printemps*" (PhD diss., University of Rochester, 1971); Kelly, *First Nights*, 284–99; Eksteins, *Rites of Spring*, 10–16; Nijinska, *Early Memoirs*, 470; Stravinsky and Craft, *Conversations*, 47–48; Garafola, *Diaghilev's Ballets Russes*, 296–99; and Buckle, *Nijinsky*, 208–9, 291–94, 302. In 2005, the BBC aired the docudrama *Riot at the Rite*, which contained numerous factual errors; see Kenneth Archer and Millicent Hodson, "Reading the Riot Act," *Ballet Magazine* (February 2006).

190. White, *Stravinsky*, 43.

191. Nijinska, *Early Memoirs*, 470.

192. White, *Stravinsky*, 43; and Stravinsky and Craft, *Conversations*, 47.

193. Nijinska, *Early Memoirs*, 470; and Stravinsky and Craft, *Conversations*, 47–48.

194. Stravinsky and Craft, *Expositions*, 143.

195. Roerich, "Rhythm of Life," *Adamant*, 67–68.

196. Cocteau told this story in the January 1921 issue of the *Dial*. See White, *Stravinsky*, 44–45.

197. Roerich, "Sacre," *Realm of Light*, 185–91.

198. Roerich, "Rhythm of Life," 68.

199. Militsa Pozharskaia, "Diaghilev and the Artists of the Saisons Russes," in *Diaghilev*, ed. Ann Kodicek (London: Barbicon, 1996), 65; and Kelly, *First Nights*, 324.

200. *La France* (June 4, 1913), in Kelly, *First Nights*, 314.

201. Fry in Eksteins, *Rites of Spring*, 51–52; H. Colles, *London Times* (July 12, 1913), in Hill, *Stravinsky*, 95–96; and Beaumont in Kelly, *First Nights*, 288.

202. Savenko, "*The Rite of Spring* in Russia," 237–38; and Pozharskaia, "Diaghilev," 65.

203. Stravinsky and Craft, *Conversations*, 106. Craft, "100 Years On," notes that the two exchanged letters as late as 1939.

204. Simon Karlinsky, "A Cultural Educator of Genius," in *The Art of Enchantment: Diaghilev's Ballets Russes, 1909–1929*, ed. Nancy Van Norman Baer (San Francisco: Fine Arts Museum of San Francisco, 1988), 21–22; and Garafola, *Diaghilev's Ballets Russes*, 76–90.

205. Cited in Daniel Albright, *Stravinsky* (New York: Gordon and Breach, 1989), 14.

Chapter 7: The Doomed City, 1913–1918

1. Isaiah Berlin, *The Proper Study of Mankind* (New York: Farrar, Straus and Giroux, 1998), 532.

2. N. K. Rerikh, "Indiiskii put'," SoS, 258–61.

3. Andreyev, MotM, 37, refers to Yekaterina's "mental disorder" late in life.

4. L. K. Rerikh to N. K. Rerikh, July 7 (OS), 1913. OR GTG, f. 44, op. 1, ed. khr. 1224, ll. 1–2. See also Rerikh, LD, 3:181; RGALI, f. 2408, op. 1, d. 35, l. 44; and OR GTG, f. 44, op. 1, ed. khr. 382, 388, 404.

5. Kenneth Archer, *Nicholas Roerich: East and West* (Bournemouth: Parkstone, 1999), 52–53.

6. Ruskin cited in Simon Schama, *Landscape and Memory* (New York: Knopf, 1995), 508.

7. *Letopisnyi i litsevoi izbornik Doma Romanovykh*, edited by M. S. Putiatin. See PRS, 2/3:643–50.

8. Rerikh, LD, 3:445.

9. *Apollon* 1–2 (January–February 1914): 132; *Apollon* 4 (April 1914): 56, 59; *Apollon* 6–7 (August–September 1914): 120–22; and *Katalog ofver Baltiska Utstallningens i Malmo* (Malmo, 1914).

10. Iakovleva, TDI, 68–76, 184–95, 205–8, 263–64.

11. K. A. Mardzhanov to N. K. Rerikh, n.d. OR GTG, f. 44, op. 1, ed. khr. 976, l. 1.

12. Regarding auras and the spiritual qualities of color, see Nicholas Roerich, *Adamant* (New York: Corona Mundi, 1922), 256–61; and Fosdik, MU, 326–27. The Roerichs also believed the colors of the rainbow corresponded to the notes of the scale.

13. Rerikh, IzLN, 192.

14. A. A. Sanin to N. K. Rerikh, late 1913. OR GTG, f. 44, op. 1, d. 1284, ll. 1–2.

15. I. F. Stravinskii to S. S. Mitusov, August 12 (July 30, OS), 1913, in Stephen Walsh, *Stravinsky: A Creative Spring* (New York: Knopf, 1999), 218.

16. Walsh, *Stravinsky*, 218.

17. I. F. Stravinskii to A. N. Benua, August 12 (July 30, OS), 1913, in Iakovleva, TDI, 46–47.

18. I. F. Stravinskii to A. N. Benua, October 3 (September 20, OS), 1913, in Richard Taruskin, *Defining Russia Musically* (Princeton, NJ: Princeton University Press, 1997), 381–82.

19. I. F. Stravinskii to A. N. Benua, March 31 (March 18, OS), 1914, in Taruskin, SatRT, 1086–87.

20. A. N. Benua to I. F. Stravinskii, September 30 (September 17, OS), 1913, in Iakovleva, TDI, 46–47.

21. Walsh, *Stravinsky*, 218.

22. Walsh, *Stravinsky*, 223–24.

23. A. N. Benua to I. F. Stravinskii, October 5 (September 22, OS), 1913. Cited in Walsh, *Stravinsky*, 220.

24. Mitusov cited by Taruskin, SatRT, 1086–87.

25. Thomas Beecham, *A Mingled Chime: An Autobiography* (New York: G. P. Putnam's, 1943), 210.

26. Iakovleva, TDI, 85–87.

27. A. A. Sanin to N. K. Rerikh, May 1914. OR GTG, f. 44, op. 1, ed. khr. 1282, l. 1.

28. Arthur Rubinstein, *My Young Years* (New York: Knopf, 1973), 387.

29. Elaine Feinstein, *Anna of All the Russias: A Life of Anna Akhmatova* (New York: Knopf, 2006), 52.

30. Rerikh, LD, 3:181.

31. Belikov and Kniazeva, NKR, 99–107; Poliakova, NR, 185–88; and PRS, 2/3:344–53, 620–713. On Russian art during World War I, see Hubertus Jahn, *Patriotic Culture in Russia during World War I* (Ithaca, NY: Cornell University Press, 1998); and Aaron Cohen, *Imagining the Unimaginable: World War, Modern Art, and the Politics of Public Culture in Russia, 1914–1917* (Lincoln: University of Nebraska Press, 2008).

32. *Apollon* 8 (October 1914): 59–61.

33. V. G. Karatygin, "Muzykal'naia drama," *Rech'* 344 (December 20, 1914): 7. See also A. Koptiaev, "Sestra Beatrisa," *Birzhevye vedomosti* (December 14, 1914): 5; and E. Stark, "Teatr Muzykal'noi dramy," *Apollon* 3 (March 1915): 62.

34. Stark, "Teatr," 62.

35. A. I. Gidoni, "Tvorcheskii put' Rerikha," *Apollon* 4–5 (April–May 1915): 1–34.

36. Fokine in E. G. Soini, *Severnyi lik Nikolaia Rerikha* (Samara: Agni, 2001), 67; and Benois in I. A. Gutt, "Rerikh i dramaturgiia Meterlinka," in NRK: zit, 96.

37. OR GTG, f. 44, op. 1, ed. khr. 80, ll. 1–4; and Iakovleva, TDI, 211, 264.

38. *Apollon* 6–7 (August–September 1915): 96; Dmitrii V. Sarab'ianov, *Russian Art: From Neoclassicism to the Avant-Garde* (New York: Abrams, 1990), 304; John E. Bowlt, *The Silver Age: Russian Art of the Early Twentieth Century and the "World of Art" Group* (Newtonville, MA: Oriental Research Partners, 1979), 127–28; and Peter Stupples, *Pavel Kuznetsov* (Cambridge: Cambridge University Press, 1989), 142–43.

39. K. S. Malevich, "Mir miasa i kosti ushel," *Anarkhiia* 83 (June 11, 1918): 4.

40. Rerikh, LD, 2:370–71, 419–20, 431, 442, 458.

41. Isaak Babel, "Guy de Maupassant," in *Red Cavalry and Other Stories* (London: Penguin, 2005), 73.

42. Gidoni, "Tvorcheskii put' Rerikha."

43. N. N. Vrangel', "Otblesk bylogo," *Russkii bibliofil* 5 (1916): 5–10.

44. Iu. Baltrushaitis, A. N. Benua [Benois], A. I. Gidoni, A. M. Remizov, and S. P. Iaremich, *Rerikh* (Petrograd: Svobodnoe iskusstvo, 1916). For commentary, see V. L. Mel'nikov, "N. K. Rerikh i izdatel'stvo 'Svobodnoe iskusstvo' (1916–1917)," PRS, 1:293–340.

45. Benua, "Put' Rerikha," cited by Poliakova, NR, 123–24 (and in part by Decter, MoB, 31). Emphasis in the original. The Freud quote, from 1930, comes from *The Freud Reader* (New York: W. W. Norton, 1995), 735.

46. As translated by Nina Selivanova, *The World of Roerich* (New York: Corona Mundi, 1923), 71.

47. See, for example, OR GTG, f. 44, op. 1, ed. khr. 598, 614, 721; A. A. Blok, *Zapisnye knizhki* (Moscow, 1965), 280; and A. A. Blok, *Perepiska:*

Annotirovannyi katalog (Moscow, 1979), 2:392. A number of these date from 1915, between the jubilee's announcement and the book's release.

48. Igor' E. Grabar', *Pis'ma, 1891–1917* (Moscow: Nauka, 1974), 263, 428–29.

49. Rerikh, LD, 2:76–80; and Rerikh, IzLN, 113–15.

50. Nina Berberova, *The Italics Are Mine* (London: Vintage, 1993), 291.

51. "Vystavki i khudozhestvennye dela," *Apollon* 3 (1915): 57.

52. N. K. Rerikh, "Slovo napustsvennoe," *Birzhevye vedomosti* (March 14, 1916); reprinted in Rerikh, IzLN, 301–8.

53. Most sources, including *Polveka dlia knigi* (Moscow: Sytin, 1916), 191, give 1914 as this work's date. PRS, 2/3:635; and Cohen, *Imagining the Unimaginable*, 81–82, speak to its popularity.

54. Alexei Remizov based his story "The Life of Procopius the Righteous" on this painting and Roerich's *Procopius the Righteous Averts the Stone Cloud from the City of Ustiug*, also from 1914 (Poliakova, NR, 178).

55. Belikov and Kniazeva, NKR, 98–99; and Archer, *Nicholas Roerich: East and West*, 57.

56. From A. M. Remizov, "Zherlitsa druzhinnaia," *Rerikh* (Petrograd: Svobodnoe iskusstvo, 1916), 87–124.

57. Cited in Nicholas Roerich, *Invincible* (New York: Roerich Museum Press, 1974), 358–65.

58. Boris Strugatsky, in the 2001 afterword to Arkady and Boris Strugatsky, *The Doomed City* (Chicago: Chicago Review Press, 2016), 457–58. The idea for the novel occurred to the brothers in 1967, and they decided on its title in 1969. They completed their first draft in 1972, but did not believe it could pass Soviet censorship and so shelved it until 1989. Boris adds that "we never worked so long and painstakingly on any of our other works, either before or after."

59. The RTO commission is mentioned in *Mir iskusstva* (Saint Petersburg: State Russian Museum, 1998), 151.

60. Roerich talked of having based *Meheski* on a Tibetan myth about a tribe descended from moon people (*Gosudarstvennyi muzei izobrazitel'nykh iskusstv Respubliki Tatarstan* [Moscow: Belyi Gorod, 2002], 45). Based strictly on visual comparison, it is possible he was influenced by Stepan Bakalovich's 1903 *Prayer to Khonsu*, which depicts Egyptian moon-worshipping priests on a temple rooftop.

61. PRS, 2/3:663–69, 677–86.

62. Rabindranath Tagore, *Song Offerings (Gitanjali)* (London: Anvil, 2000), 56.

63. On *Mysterium*, see Faubion Bowers, *The New Scriabin* (New York: St. Martin's, 1973), 96–100, 123–25; and Boris de Schloezer, *Scriabin: Artist and Mystic* (Berkeley: University of California Press, 1987), 262–71. Roerich's comment comes from N. K. Rerikh, "Skriabin," LD, 2:366–67.

64. ELD #A (October 22, 1928).

65. A. Remizov to N. K. Rerikh, December 10 (OS), 1915. OR GTG, f. 44, op. 1, ed. khr. 1192, l. 1.

66. N. K. Rerikh to A. Remizov, December 11 (OS), 1915. PRS, 1:309–13.

67. A. Remizov to N. K. Rerikh, December 11 (OS), 1915. OR GTG, f. 44, op. 1, ed. khr. 1193, l. 1.

68. N. K. Rerikh, "Pora," in *Tsvety Morii* (Berlin: Slovo, 1921). 30; and Nicholas Roerich, "The Hour," in *Flame in Chalice*, trans. Mary Siegrist and Esther Lichtmann (New York: Roerich Museum Press, 1929), 48–49.

69. N. K. Rerikh, "Zhezl," *Tsvety Morii*, 51; and Nicholas Roerich, "The Scepter," *Flame in Chalice*, 75.

70. For example, *Russkaia poeziia: XX vek: Antologiia* (Moscow: OLMA, 1999), 61–62; and N. K. Rerikh, *Pis'mena* (Moscow: Profizdat, 2006), part of a "Poetry of the 20th Century" series.

71. Sylvia Cranston, *HPB: The Extraordinary Life and Influence of Helena Blavatsky, Founder of the Theosophical Movement* (New York: Tarcher/Putnam, 1993), 194, likens Roerich's verse to Blavatsky's; the comparisons to Tagore, Nietzsche, and Gibran are my own. For other readings of the "Morya" poems, see Irina Corten, *Flowers of Morya: The Theme of*

Spiritual Pilgrimage in the Poetry of Nicholas Roerich (New York: Roerich Museum Press, 1986); and S. I. Karpova, *O sviazi poezii i prozii N. K. Rerikha s indiiskoi kul'turoi* (Leningrad, 1982).

72. Shishkin, BzG, 30–31, argues that Roerich left upon being warned about Rasputin's impending assassination (in this scenario, Felix Yusupov, the killers' ringleader, belonged to the same group of Freemasons as Roerich's confidant Konstantin Riabinin, who, learning of the plot, informed Roerich). Neither Yusupov's own memoir, *Lost Splendor* (New York: G. P. Putnam's, 1953), nor recent biographies of Yusupov mention Riabinin or Roerich. That said, rumors did circulate, including among Pavel Miliukov and other liberal Kadets, several of whom (like Miliukov) knew Roerich, so it is possible the artist knew of the disruption to come. See Bernard Pares, *The Fall of the Russian Monarchy* (London: Cape, 1939), 403.

73. On Roerich's move to Finland, see Rerikh, LD, 3:599–600; and Soini, *Severnyi lik*, 46–85.

74. *Apollon* 8 (October 1916): 55; and *Apollon* 1 (January 1917): 60.

75. S. Glagol', "Pevets nezdeshnei krasoty," *Russkaia volia* (January 16, 1917); P. Ettinger, "N. K. Rerikh," *Utro Rossii* (January 21, 1917); and P. Ettinger, "Predchuvstvie voiny v tvorchestve N. K. Rerikha," *Niva* (March 4, 1917): 129–31. For other views, see N. Radlov, "O futurizme i 'Mir iskusstva,'" *Apollon* 1 (January 1917): 1–17; V. Dmitriev, "Moskvichi," *Apollon* 1 (January 1917): 18–23; and V. P. Lapshin, *Khudozhestvennaia zhizn' Moskvy i Petrograda v 1917 godu* (Moscow: Sovetskii khudozhnik, 1983), 273, 324–25, 469–72.

76. Radlov, "O futurizme," 5.

77. Berberova, *Italics Are Mine*, 79.

78. V. A. Rosov, *Nikolai Rerikh: Vestnik Zvenigoroda* (Saint Petersburg: Aleteia, 2002), 1:38 [hereafter NRVZ].

79. On Roerich's political activities in 1917, see Poliakova, NR, 192–95; Belikov and Kniazeva, NKR, 104–7; PRS, 2/3:707–13; Sheila Fitzpatrick, *The Commissariat of Enlightenment: Soviet Organization of Education and the Arts under Lunacharsky* (Cambridge: Cambridge University Press, 1970), 77; Daniel Orlovsky, "The Provisional Government and Its Cultural Work," in *Bolshevik Culture*, ed. Abbott Gleason, Peter Kenez, and Richard Stites (Bloomington: Indiana University Press, 1985), 39–56; Charles Rougle, "The Intelligentsia Debate in Russia, 1917–1918," in *Art, Society, Revolution: 1917–1921*, ed. Nils Åke Nilsson (Stockholm: Almqvist & Wiksell, 1979), 54–103; Lapshin, *Khudozhestvennaia zhizn'*, passim; Grabar,' *Pis'ma, 1891–1917*, 449–50; K. D. Muratova, *Gor'kii v bor'be za razvitie sovetskoi literatury* (Moscow, 1958); and I. S. Zil'bershtein and A. N. Savinov, eds., *Aleksandr Benua razmyshliaet* (Moscow: Sovetskii khudozhnik, 1968), 62–70. For obvious reasons, USSR biographies play up Roerich's interaction with the Soviet more than with the government.

80. P. Surozhskii in *Novaia zhizn'* (May 17 [OS], 1917).

81. Lapshin, *Khudozhestvennaia zhizn'*, 88, 332–42. *Petrogradskaia gazeta* (March 9 [OS], 1917) discussed Benois's plans for a new ministry, listing Roerich, Diaghilev, Dobuzhinsky, Nouvel, and Yaremich as the people he most wanted to work with. Admirers have suggested that Roerich was a candidate to lead such a ministry, but he was in fact a front-runner to head a possible department of artistic education within it. See *Apollon* 2–3 (February–March 1917): 65–66 (released several months after the issue date).

82. On Lunacharsky and Krasin, see Fosdik, MU, 99, 235; on Plekhanov, see N. K. Rerikh to A. P. Ivanov, September 28 (OS), 1917, in E. G. Soini, "Perepiska N. K. Rerikha s sovremennikami," *Sever* 4 (1981): 110.

83. *Birzhevye vedomosti* (May 1, 1917); and Poliakova, NR, 198–99.

84. V. Zarubin to N. K. Rerikh, June 28 (OS), 1917. OR GTG, f. 44. op. 1, ed. khr. 795, ll. 1–2.

85. N. K. Rerikh to A. P. Ivanov, September 28 (OS), 1917, in Soini, "Perepiska," 110.

86. A. A. Rostislavov, "Iskusstvo i revoliutsiia," *Apollon* 6–7 (August–September 1917): 70–85.

87. A. Lawton, ed., *Russian Futurism through Its Manifestoes* (Ithaca, NY: Cornell University Press, 1988), 253.

88. N. K. Rerikh to A. Benua, July 17 (OS), 1917, in Soini, *Severnyi lik*, 53–54.

89. N. K. Rerikh to A. P. Ivanov, September 28 (OS), 1917, in Soini, "Perepiska," 110.

90. Fosdik, MU, 64, 70, 94–95, 190, with corroborating passages in Esther Lichtmann's diaries.

91. OR GTG, f. 44, op. 1, ed. khr. 491, in Darya Kucherova, "Art and Spirituality in the Making of the Roerich Myth" (PhD diss., Central European University, 2006), 27.

92. N. K. Rerikh to A. P. Ivanov, September 28 (OS), 1917, in Soini, "Perepiska," 110.

93. N. K. Rerikh, "Slovo naputstvennoe," *Birzhevye vedomosti* (March 14 [OS], 1916).

94. N. K. Rerikh, "Edinstvo," dated October 15, 1917, and reprinted in *Puti blagosloveniia*, 231–32, as translated by Kucherova, "Art and Spirituality," 150, with slight modifications of my own.

95. N. K. Rerikh to A. P. Ivanov, September 28 (OS), 1917, in Soini, "Perepiska," 110.

96. N. K. Rerikh to A. Benua, October 4 (OS), 1917, in Soini, *Severnyi lik*, 54–55.

97. L. V. Korotkina, *Nikolai Rerikh* (Saint Petersburg: Khudozhnik Rossii, 1996), 59.

98. N. K. Rerikh, "Miloserdie," *Sovremennaia dramaturgiia* 1 (1983): 189–92.

99. N. K. Rerikh to A. Benua, December 5 (OS), 1917, in Soini, *Severnyi lik*, 59.

100. Feinstein, *Anna of All the Russias*, 77.

101. Berberova, *Italics Are Mine*, 140–41.

102. Fosdik, MU, 99.

103. Belikov and Kniazeva, NKR, 139.

104. ELD #2 (June 29, 1929).

105. As reported by the orientalist Alexander Piatigorsky, who studied with George Roerich in the 1950s, then taught at SOAS in London after emigrating from the USSR. Correspondence with Ian Heron, April 28, 2009.

106. ELD #2 (June 29, 1929).

Chapter 8: The Exile, 1918–1920

1. Andreyev, MotM, 61.

2. N. K. Rerikh, "Ostavil," in *Tsvety Morii* (Berlin: Slovo, 1921), 34.

3. N. K. Rerikh, *Izbrannoe* (Moscow: Sovetskaia Rossiia, 1979), 55–71.

4. E. G. Soini, *Severnyi lik Nikolaia Rerikha* (Samara: Agni, 2001), 59–60, interprets *Karelia— Eternal Expectation* differently, suggesting that it symbolizes the anticipation of death.

5. Rerikh, *Izbrannoe*, 56.

6. Rerikh, *Izbrannoe*, 57.

7. N. K. Rerikh to A. Gallen-Kallela, July 12, 1918; and N. K. Rerikh to A. Gallen-Kallela, August 20, 1918. Finnish National Archive [hereafter FNA], microfilm VAY 3549 (A. Gallen-Kallela).

8. N. K. Rerikh to A. Gallen-Kallela, August 29, 1918. FNA, microfilm VAY 3549 (A. Gallen-Kallela).

9. N. K. Rerikh, *Puti blagosloveniia* (Moscow: Eksmo, 2007) [Riga, 1924], 231–32.

10. Nicholas Roerich, *Violators of Art* (London, 1919).

11. L. N. Andreev, *S.O.S.* (Moscow, 1994) [orig. Vyborg, 1919]. See L. N. Andreev's letter of thanks to N. K. Rerikh, February 25, 1919, in Soini, *Severnyi lik*, 81.

12. Letter from N. K. Rerikh to Osobyi Komitet po delam russkikh v Finliandii, dated 1919, cited in Rosov, NRVZ, 1:116.

13. Rosov, NRVZ, 1:117.

14. Rosov, NRVZ, 1:117, 248n8. Rosov cites Ross's report, contained in the records of the British India Office.

15. Rerikh, LD, 2:62–64, 373–74; and Rerikh, AH, 333.

16. On Ungern, see Fitzroy Maclean, *To the Back of Beyond* (Boston: Little, Brown, 1975), 120–34; W. Bruce Lincoln, *Red Victory: A History of the Russian Civil War* (New York: Simon and Schuster, 1989), 255–58; L. A. Iuzefovich, *Samoderzhavets pustyni* (Moscow, 1993); James Palmer, *The Bloody White Baron: The Extraordinary Story of the Russian Nobleman Who Became the Last Khan of Mongolia*

(London: Faber and Faber, 2008); and Michael Jerryson, *Mongolian Buddhism: The Rise and Fall of the Sangha* (Chiang Mai: Silkworm Books, 2007). Willard Sunderland, in *The Baron's Cloak: A History of the Russian Empire in War* (Ithaca, NY: Cornell University Press, 2014), looks beyond traditional accounts of Ungern as merely a madman, holding him up as emblematic of the multinational and ideological complexities that bedeviled the tsarist regime in its final days.

17. Lincoln, *Red Victory*, 255.

18. Both quotes from Lincoln, *Red Victory*, 256–57.

19. Alexandre I. Andreyev, *Soviet Russia and Tibet: The Debacle of Secret Diplomacy* (Leiden: Brill, 2003), 153; and Iuzefovich, *Samoderzhavets pustyni*, 193.

20. Rosov, NRVZ, 1:4–5; and Iuzefovich, *Samoderzhavets pustyni*, 132–33.

21. Cited in Frederick H. White, *Memoirs and Madness: Leonid Andreev through the Prism of the Literary Portrait* (Montreal: McGill-Queen's University Press, 2006), 283. Andreyev was hospitalized in 1901 for "acute neurasthenia"; White convincingly speculates that he suffered from bipolar disorder.

22. L. N. Andreev to N. K. Rerikh, September 30, 1918, in Andreev, *S.O.S.*, 255; and Soini, *Severnyi lik*, 78.

23. L. N. Andreev to N. K. Rerikh, n.d., 1918, in Soini, *Severnyi lik*, 81. Emphasis in the original.

24. Cited in Soini, *Severnyi lik*, 51, 65–66.

25. The passports were issued on December 6, 1918 (November 22, 1918, by the old calendar still used by the Provisional Government). On the Swedish Theosophists, see Roerich's letters in 1939 and 1940 to Blavatsky's grandnephew, Boris Tsyrkov, in Fosdik, MU, 717–20.

26. N. K. Rerikh to S. P. Diagilev, February 12, 1919. In Zil'bershtein and Samkov, SDiRI, 2:131.

27. *Salon Strindberg* (Helsinki: Kuvataiteen Keskusarkisto, 2004), 129–30; and Soini, *Severnyi lik*, 67–76.

28. L. N. Andreev to N. K. Rerikh, March 1, 1919. Cited in Soini, *Severnyi lik*, 81.

29. L. N. Andreyev, "The Realm of Roerich," *New Republic* (December 21, 1921). Emphasis in the original. See also "Rôrichin Valtakunta," *Otava* (March 29, 1919), and "Tsarstvo Rerikha," *Russkaia zhizn'* (March 29, 1919).

30. N. K. Rerikh to L. N. Andreev, April 3, 1919. Cited in Soini, *Severnyi lik*, 77.

31. ELD #6 (September 17, 1930).

32. ELD #6 (September 17, 1930).

33. N. K. Rerikh to A. Gallen-Kallela, April 6, 1919. FNA, microfilm 3549 (A. Gallen-Kallela).

34. *Ateneum Art Museum* (Helsinki: Antalis, 2000), 160.

35. Rerikh, LD, 3:411–12.

36. Timo Martin and Douglas Sivén, *Akseli Gallen-Kallela* (Helsinki: Watti-Kustannus, 1985), 226, 238–40.

37. HRD, vol. 21 (September 1, 1924).

38. L. N. Andreev to N. K. Rerikh, March 19, 1919. Cited in Soini, *Severnyi lik*, 81.

39. L. N. Andreev to N. K. Rerikh, June 17, 1919. Cited in Soini, *Severnyi lik*, 82.

40. L. N. Andreev to N. K. Rerikh, September 4, 1919. Cited in Soini, *Severnyi lik*, 83.

41. L. N. Andreev to N. K. Rerikh, September 10, 1919. Cited in Soini, *Severnyi lik*, 83–84.

42. Fosdik, MU, 88.

43. As noted by Roerich in "Venok Diagilevu," his 1930 essay in honor of Diaghilev's death. Zil'bershtein and Samkov, SDiRI, 2:325–27, 508–9.

44. N. K. Rerikh to I. F. Stravinskii, August 16, 1919. Cited in Iakovleva, TDI, 89.

45. Iakovleva, TDI, 88.

46. Belikov and Kniazeva, NKR, 117–18.

47. N. K. Rerikh to M. K. Tenisheva, October 27, 1919. RGALI, f. 2408, op. 2, d. 8, l. 3.

48. N. K. Rerikh to I. F. Stravinskii, November 21, 1919. Cited in Iakovleva, TDI, 90.

49. N. K. Rerikh to M. K. Tenisheva, October 27, 1919. RGALI, f. 2408, op. 2, d. 8, l. 3. Roerich refers to the production as being Diaghilev's, as

opposed to Beecham's, whose it really was. On November 7, he complained to Tenisheva that "the public, of course, thinks such shows are a great success. People here know so little about Russia (at least as it was) that performances appearing wretchedly done to us seem wonderful to them" (RGALI, f. 2408, op. 2, d. 8, l. 4).

50. N. K. Rerikh to I. F. Stravinskii, November 21, 1919. Cited in Iakovleva, TDI, 90.

51. Nicholas Roerich, *Realm of Light* (New York: Roerich Museum Press, 1931), 141; and Rerikh, LD, 2:80–83, 151–52, 3:252–62.

52. Christmas Humphreys, *Zen Buddhism* (London: George Allen and Unwin, 1957), 174; and Christmas Humphreys, *Both Sides of the Circle* (London: George Allen and Unwin, 1978), 54.

53. N. K. Rerikh to M. K. Tenisheva, November 7, 1919. RGALI, f. 2408, op. 2, d. 8, ll. 4–5a.

54. V. L. Krymov, *Liudi v pautine* (Berlin, 1929), 209, cited in Markus Osterrieder, "From Synarchy to Shambhala: The Role of Political Occultism and Social Messianism in the Activities of Nicholas Roerich," in *The New Age of Russia: Occult and Esoteric Dimensions*, ed. Birgit Menzel, Bernice G. Rosenthal, and Michael Hagemeister (Munich: Kubon & Sagner, 2012), 105.

55. N. Jarintsova, "A Russian Painter: N. K. Roerich," *Studio* 79, no. 325 (April 1920): 60–69.

56. See Paul Miliukov, *Outlines of Russian Culture, Volume 3: Architecture, Painting, and Music in Russia* (Philadelphia: University of Pennsylvania Press, 1942); Roerich appears in 3:66–68, 74, 86–87, 131.

57. Rerikh, LD, 1:205–7.

58. V. A. Shibaev, "Iz vospominaniia ochevidtsa," *Derzhava Rerikha* (Moscow, 1994), 333. See also Fosdik, MU, 691–96.

59. Shishkin, BzG, 35–40, "reveals" Shibaev's supposed code name, Gorbun ("Humpback"), but does not say where he gets this information.

60. Fosdik, MU, 80; and N. K. Rerikh to M. K. Tenisheva, November 1919, RGALI, op. 2408, op. 2, d. 8, l. 6. Shishkin, BzG, 35–40, tries to identify

Shibaev as having made the "internationalist" offer; similarly, he interprets an anecdote told by Roerich about a mysterious encounter in Stockholm in 1918 as an attempt by a Narkomindel representative to persuade Roerich to rendezvous with German communists in Berlin (BzG, 31–35). In neither case does he offer corroborating evidence.

61. Rerikh, LD, 2:85–92; Nicholas Roerich, *Himavat: Diary Leaves* (Allahabad: Kitabistan, 1947), 97; Krishna Dutta and Andrew Robinson, *Rabindranath Tagore: The Myriad-Minded Man* (London: Bloomsbury, 1995), 225; Rathindranath Tagore, *On the Edge of Time* (Bombay, 1958), 131; and Bikash Chakravarty, ed., *Poets to a Poet, 1912–1940* (Calcutta: Visva-Bharati, 1948), 227.

62. Tagore, *On the Edge of Time*, 131; Das Gupta quoted in Roerich, *Himavat*, 97.

63. Rerikh, IzLN, 111.

64. Dutta and Robinson, *Rabindranath Tagore*, 225.

65. Tagore, *On the Edge of Time*, 131.

66. Roerich likely intended this as a metaphor for esoteric learning. Solomon in the Koran proclaims, "Lo! We have been taught the language of birds and have been given abundance of all things," and Elif Batuman, *The Possessed* (New York: Farrar, Straus and Giroux, 2010), 170, notes that, "among alchemists and Kabbalists, the perfect language that would unlock ultimate knowledge was known as either 'the green language' or the 'language of birds.'" Batuman adds that the Futurist poet Velimir Khlebnikov, a contemporary of Roerich's, "invent[ed] 'transrational' languages, among them 'god language' and 'bird language.'"

67. Iakovleva, TDI, 215–30, 264–65, refers to this as a 1919 production. Kenneth Archer, "The Theatrical Designs of Nicholas Roerich: Problems of Identification" (MA thesis, Antioch University, 1985), maintains it was staged in 1920. Roerich likely completed the designs in 1919.

68. *Daily Telegraph* (May 11, 1920).

69. Rerikh, LD, 3:224–25.

70. Rerikh, LD, 2:80–83, 351–52; Rosov, NRVZ,

1:68–72; Maurice Tuchman, "Hidden Meanings in Abstract Art," in *The Spiritual in Art: Abstract Painting, 1890–1985* (New York: Abbeville Press, 1999), 38; and Penelope Chetwode, *Kulu: The End of the Habitable World* (London: John Murray, 1972), 153.

71. ELD #4 (December 11, 1929).

72. David Nice, *Prokofiev* (New Haven, CT: Yale University Press, 2003), 169.

73. *Daily Telegraph* (May 11, 1920); and Jarintsova, "Russian Painter."

74. Paul Miliukov, *Russia To-Day and To-Morrow* (New York: Macmillan, 1922), 375–76.

75. *Art Institute Scrapbook* 42 (April 15, 1921–January 26, 1922), in the Archive of the Art Institute of Chicago. In October 1921, Harshe became the institute's director, replacing George Eggars.

76. Rerikh, LD, 2:263, 300–301, 304–5.

77. N. K. Rerikh, *Pis'mena* (Moscow: Profizdat, 2006), 89–90; and HRD, vol. 1 (March 24, 1920).

78. On this moment, see Fosdik, MU, 13, 700–701; Rosov, NRVZ, 1:20–21; Andreyev, MotM, xiv, 68–73; Darya Kucherova, "Art and Spirituality in the Making of the Roerich Myth" (PhD diss., Central European University, 2006),167–68; and Anita Stasulane, *Theosophy and Culture: Nicholas Roerich* (Rome: Pontifica università gregoriana, 2005), 88.

79. Andreyev, MotM, 68–73, notes inconsistencies in various retellings of Helena's story, both by Helena herself and by Lyudmila Shaposhnikova of the International Center of the Roerichs, regarding where in Hyde Park the pair supposedly appeared and what they wore. Andreyev also cites Sina Lichtmann (Fosdik, MU, 315–17) to show that, at first, Nicholas, George, and Sviatoslav did not believe Helena's Hyde Park story.

80. Reproduced in Fosdik, MU, 708–10.

81. Robert C. Williams, *Russian Art and American Money: 1900–1940* (Cambridge, MA: Harvard University Press, 1980), 115–16.

82. Fosdik, MU, 711–13; and "'Predstoit Bol'shaia Rabota v Rossii': Pis'ma N. K. Rerikha k V. A. Shibaevu (1922–1924)," *Vestnik Ariavarty* 1, no. 2 (2002): 48–49.

83. Maria Carlson, *"No Religion Higher Than Truth": A History of the Theosophical Movement in Russia, 1875–1922* (Princeton, NJ: Princeton University Press, 1993), 195; and Fosdik, MU, 118.

84. Rerikh, *Pis'mena*, 89–90.

85. Anthony Storr, *Feet of Clay: Saints, Sinners, and Madmen* (New York: Free Press, 1996), cited in Jon Krakauer, *Under the Banner of Heaven: A Story of Violent Faith* (New York: Anchor Books, 2004), 165.

86. For an introduction to shared psychotic disorder, see Brian Palmer, "Two Flew Over the Cuckoo's Nest," *Slate* (October 25, 2010). Note particularly how a pair subject to folie à deux "frequently lives in geographic, linguistic, or social isolation."

87. N. K. Rerikh, "Plamia," *Izbrannoe*, 55.

88. Rosov, NRVZ, 1:68–72.

89. Belikov and Kniazeva, NKR, 119, for example, maintain that Britain refused the Roerichs permission to travel to India. As discussed in chapter 9, Shishkin, BzG, 51–59, argues that Roerich was already in Soviet pay and went to the United States on Comintern orders. His view is seconded in Richard Spence's highly speculative "Red Star over Shambhala," *New Dawn Magazine* 109 (July–August 2008).

90. Sunil Khilnani, *The Idea of India* (London: Penguin, 1997), 7, 25.

91. Government of India papers cited by Dany Savelli, "Shambhala de-ci, de-là: syncrétisme ou appropriation de la religion de l'Autre?" *Slavica Occitania* 29 (2009): 322; also Andreyev, MotM, 74–75.

92. National Archives and Records Administration of the United States (NARA), Record Group 59 (General Records of the Department of State, Visa Division, Visa Case Files), box 811.111 (Roerich, Nicholas).

Chapter 9: The Watchtowers of America, 1920–1923

1. Nicholas Roerich, *Adamant* (New York: Corona Mundi, 1922), 76–80.

2. T. S. Eliot, *Selected Poems* (New York: Harcourt Brace Jovanovich, 1964), 125.

3. Sarah McPhee, "One Man's Museum," *ARTNews* 85 (April 1986): 14; Christian Brinton, *The Nicholas Roerich Exhibition* (New York: Redfield-Kendrick-Odell, 1920); *Outlook* (January 5, 1921); *American Art News* (December 30, 1920); *New York Herald* (December 26, 1920), ("overwork" and "original" quotes); *Detroit News* (December 26, 1920), ("sensation" quote); and "Master of Modern Arts," *Touchstone* 8 (February 1921): 325–34.

4. Both quotations from Rerikh, LD, 3:361.

5. *Art Institute Scrapbook* 42 (April 15, 1921–January 26, 1922), Archive of the Art Institute of Chicago.

6. FRGP, folder 65, Biographical Sketch.

7. Sina's diaries give her birthdate as "around 1889" (Fosdik, MU, 7). She described herself as thirty-four years old in the fall of 1928, meaning a birthdate of 1894 (Fosdik, MU, 374). Her 1926 application for a visa to the USSR gives her age as thirty-one, which would make 1895 her year of birth—possibly 1894 if the application was assembled in late 1925 (GARF, f. 8350, op. 1, d. 729, ll. 41, 106).

8. Fosdik, MU, 34–35.

9. Fosdik, MU, 38.

10. HRD, vol. 2 (January 22, 1921).

11. HRD, vol. 1 (January 1921); HRD, vol. 2 (February 26, 1921); and N. K. Rerikh, *Pis'mena* (Moscow: Profizdat, 2006), 95–96.

12. N. K. Rerikh, *Puti blagosloveniia* (Moscow: Eksmo, 2007 [Riga, 1924]), 333. Roerich used the term again in a 1921 interview with the *New York Sun* (Riabinin, RT, 280).

13. HRD, vol. 1 (March 9, 1921; March 17, 1921). The standard edition of Sina's diaries alludes to Roerich's continued interaction with Kellogg in late 1924, but confuses him with Frank Kellogg, the Nobel Peace Prize–winning secretary of state (Fosdik, MU, 210, 216, 223–36).

14. *Chicago News* (April 15, 1921); *Chicago Evening News* (April 19, 1921); and *Chicago Tribune* (n.d.; clipping in *Art Institute Scrapbook*, 5).

15. Roerich, *Adamant*, 55–61; and Rerikh, IzLN, 320–23.

16. Paul Horgan, *Encounters with Stravinsky: A Personal Record* (New York: Farrar, Straus and Giroux, 1972), 48–49.

17. *Minneapolis Morning Tribune* (May 14, 1921); *New York Journal* (May 18, 1921); and *Nebraska Press* (June 5, 1921). See *Art Institute Scrapbook*, 6, 8, 21.

18. *Art Institute Scrapbook*, 6, 8, 21.

19. Olin Downs, cited in Garabad Paelian, *Nicholas Roerich* (Sedona, AZ: Aquarian Educational Group, 1996), 46–51.

20. Francis Adney, in *Theosophist* 43 (April 1922): 33.

21. HRD, vol. 1 (April 13, 1921).

22. Poliakova, NR, 210. Andreyev, MotM, 158, regards this gesture as possibly one of "the artist's earliest overtures" to the Bolshevik regime. Precisely when Roerich began shifting from an anti-Soviet stance to a pro-Soviet one remains uncertain and is discussed below.

23. N. Roerich to N. Bel Geddes, June 28, 1921. Harry Ransom Center, University of Texas at Austin, Musicians Collection, folder list L–N. All errors in the original.

24. Robert C. Williams, *Russian Art and American Money: 1900–1940* (Cambridge, MA: Harvard University Press, 1980), 119.

25. Robert Tuggle, *The Golden Age of Opera* (New York: Holt, Rinehart and Winston, 1983), 49–53, notes that Garden "hired many more artists than could possibly be used and lost a million dollars in one year."

26. Poliakova, NR, 210.

27. Roerich is invariably referred to as Cor Ardens's founder, but Hoeckner, its secretary, spoke of how the group was "well along in forming our constitution" when "Professor Roerich came to this city" in April 1921: "He gave our plans the greatest encouragement, joined the organization, and made many excellent suggestions." Carl Hoeckner to Akseli Gallen-Kallela, August 1, 1921. FNA, microfilm 3508 (A. Gallen-Kallela). See also the Carl

Hoeckner Papers, American Archive of Art (AAA), reel 14048.

28. D. H. Lawrence, "New Mexico," in *Phoenix* (New York: Viking, 1936), 142–43.

29. Fechin, famed for his Southwestern scenes and Native American portraits, knew Roerich. Their paths in America never quite crossed, but they both worked with Christian Brinton and Robert Harshe, not to mention their mutual New Mexico acquaintances. Occasionally in his diaries (e.g., Rerikh, LD, 3:314, 466), Roerich wondered how Fechin was faring. See also Galina Tuluzakova, *Nicolai Fechin* (Taos, NM: Fechin Art Reproductions, 2012); and Mary Balcomb, *Nicolai Fechin* (Flagstaff, AZ: Northland Press, 1986).

30. Cited in Ruth Abrams Drayer, *Wayfarers: The Spiritual Journeys of Nicholas and Helena Roerich* (La Mesilla, NM: Jewels of Light, 2003), 59–60. See also the *Santa Fe New Mexican* (August 13, 1921); Maurice Tuchman, "Hidden Meanings in Abstract Art," in *The Spiritual in Art: Abstract Painting, 1890–1985*, ed. Maurice Tuchman (New York: Abbeville, 1999), 43–45; and Sharon Rohlfsen Udall, *Modernist Painting in New Mexico* (Albuquerque: University of New Mexico Press, 1984), 93–94, 218.

31. On the "root race" idea, widely adapted by other new age thinkers, see Maria Carlson, *"No Religion Higher Than Truth": A History of the Theosophical Movement in Russia, 1875–1922* (Princeton, NJ: Princeton University Press, 1993), 117–19; and Holly De Nio Stephens, "The Occult in Russia Today," in *The Occult in Russian and Soviet Culture*, ed. Bernice Glatzer Rosenthal (Ithaca, NY: Cornell University Press, 1997), 357–76.

32. Nicholas Roerich, *Realm of Light* (New York: Roerich Museum Press, 1931) [Derzhava sveta (Riga, 1992)], 189; also Roerich, HoA, 4; and Roerich, AH, 249.

33. Roerich, *Adamant*, 62–66.

34. Roerich, *Adamant*, 22–23.

35. Rerikh, LD, 3:334.

36. Carl Hoeckner Papers, AAA, reel 14048; and "'Predstoit Bol'shaia Rabota v Rossii': Pis'ma N.

K. Rerikha k V. A. Shibaevu (1922–1924)," *Vestnik Ariavarty* 1, no. 2 (2002): 54–55.

37. Roerich, *Adamant*, 108–24 ("Joy of Art"), 125–38 ("The Stone Age").

38. Alexander Kaun, "Nicolas [*sic*] Roerich in the Himalayas," *University of California Chronicle* (October 1926): 454.

39. A. C. Bossom, "Nicholas K. Roerich," *Architectural Record* 50 (August 1921): 82–92; "Unity of Art," *Theater Arts* (October 1921): 297–99; Leonid Andreyev, "The Realm of Roerich," *New Republic* (December 21, 1921): 97–99; and N. K. Roerich, "Joy of Art in Russia," *Art and Archaeology* 13 (February–March 1922): 50–68, 123–34.

40. E. Gollenbakh, "The Art of Roerich," *The Twentieth Century*, clipping from RGALI, f. 2408, op. 1, d. 35, ll. 40–50.

41. Mentioned as background in "Japanese Expel Explorers," *Chicago Tribune* (June 24, 1935).

42. ELD #5 (May 1, 1930) and #6 (July 31, 1930); and Williams, *Russian Art and American Money*, 118–22.

43. Note from Roerich's attorney, Henry Slobodin, November 7, 1921. ACRC, Roerich Scrapbook Xeroxes.

44. HRD, vol. 3 (October 26, 1921), vol. 4 (November 27, 1921), and vol. 3 (September 9, 1921).

45. "'Predstoit Bol'shaia Rabota v Rossii,'" 50–51; HRD, vol. 2 (August 27, 1921; September 4, 1921), vol. 4 (December 31, 1921).

46. Rerikh, *Pis'mena*, 103–7, on Tibet.

47. V. A. Rosov, "Man'chzhurskaia ekspeditsiia N. K. Rerikha: v poiskakh 'Novoi Strany,'" *Ariavarta* 3 (1999): 7–10; and Andreyev, MotM, 101–4.

48. Jonathan Smele, *The "Russian" Civil Wars 1916–1926: Ten Years That Shook the World* (Oxford: Oxford University Press, 2017), 220–25; John Stephan, *The Russian Far East: A History* (Stanford, CA: Stanford University Press, 1994); and Blaine Chiasson, *Administering the Colonizer: Manchuria's Russians under Chinese Rule* (Vancouver: University of British Columbia Press, 2010).

49. Andrei Znamenski, *Red Shambhala:*

Magic, Prophecy, and Geopolitics in the Heart of Asia (Wheaton, IL: Quest Books, 2011), 33.

50. Alexandre Andreyev, "Dreams of a Pan-Mongolian State," paper presented at the Second Conference "Buddhism and Nordland," Tallinn University, September 25–27, 2008; and James Forsyth, *A History of the Peoples of Siberia: Russia's North Asian Colony 1581–1990* (Cambridge: Cambridge University Press, 1992), 273.

51. "Instruct Chistyakov as I direct you to," Morya told the Roerichs on November 12, 1921 (HRD, vol. 3). Multiple entries from HRD, vols. 3–4, show that they did.

52. HRD, vol. 4 (December 25–28, 1921).

53. HRD, vol. 4 (December 8, 1921). See also HRD, vol. 3 (November 10–11, 1921).

54. First quote from HRD, vol. 5 (February 4, 1922); the second from Rosov, "Man'chzhurskaia ekspeditsiia," 7.

55. A. I. Andreev and Dany Savelli, eds., *Rerikhi: mify i fakty* (Saint Petersburg: Nestor-Istoriia, 2011), 73–75; and "Iz Kembridzhskikh zapisei," *Vestnik Ariavarty* 2 (2002): 45–57.

56. On Roerich's interest in Rurik as a possible ancestor, see Paelian, *Nicholas Roerich*, 33–34; Fosdik, MU, 345; and ELD #6 (several entries).

57. See "'Predstoit Bol'shaia Rabota v Rossii.'"

58. P. N. Krasnov, *Za chertopolokhom* (Moscow: Intelvak, 2000), discussed by Rosov, NRVZ, 2:267–68; Andreyev, MotM, 161–62; and Znamenski, *Red Shambhala*, 252. Korenev is not an exact replica of Roerich: he is younger, his place of exile is Berlin (not London or New York), and he has no spouse analogous to Helena.

59. Cited in Sergei Golynets, *Ivan Bilibin* (New York: Abrams, 1982), 188–89.

60. Fosdik, MU, 56. Among those who objected and left was Avrahm Yarmolinsky, whose job at the New York Public Library was a more solid posting in any event.

61. Williams, *Russian Art and American Money*, 118.

62. Both incidents related by Fosdik, MU, 80.

63. HRD, vol. 5 (February 23, 1922). Also, from February 21: "Not another word to the Russians. Consider them dead to you." Similar remarks were made on December 6, 1921; February 17, 1922; and February 22, 1922.

64. HRD, vol. 5 (February 22, 1922).

65. In an unconvincing letter from July 30, 1938, Narodny, contacting Louis Horch after a yearslong silence—and clearly hoping for some kind of handout—told this story, claiming to have heard it from a friend still in Russia. He spoke of the offer being made in or around 1922. ACRC, Roerich 1988 addl. (gray box). When Igor Grabar visited New York in December 1923, he found the Russia community there abuzz with bewilderment about the Roerichs' elusive behavior (Igor' E. Grabar', *Moia zhizn'* [Moscow: Iskusstvo, 1937], 294–96).

66. Norman E. Saul, *The Life and Times of Charles R. Crane, 1858–1939* (Lanham, MD: Lexington Books, 2013); *Alphonse Mucha* (Prague: Mucha Foundation, 2000), 17, 19, 156–57; and Rerikh, LD, 2:186–87, 279–84.

67. ELD #1 (May 24, 1929), #6 (July 31, 1930).

68. FRGP, "Frances Grant: History of Roerich Museum" (January 30, 1941), 6–9.

69. This introduction is based on published sources and my own conversations, both in person and in email, with the Horches' daughter, Oriole Farb Feshbach. A noteworthy—but almost certainly erroneous—minority view of Horch involves Oleg Shishkin's assertion (seconded by Anton Pervushin, *Okkul'tnye tainy NKVD i SS* [Leningrad: Neva, 1999] and Richard Spence, "Red Star over Shambhala," *New Dawn Magazine* 109 [July–August 2008]) that Horch was a Comintern agent, codenamed "Buddhist," who cooperated with Vladimir Shibaev to recruit Roerich to the Soviet cause (Shishkin, BzG, 51–59).

70. N. K. Rerikh to B. K. Rerikh, July 3, 1922. OR GTG, f. 44, op. 1, ed. khr. 146, l. 1. Emphasis in the original. See also PRS, 2/3:353–56; and Fosdik, MU, 129–30.

71. NARA, Record Group 59. Visa Division, Visa Case Files, 811.111 (Roerich, Boris).

72. Fosdik, MU, 74–88; and HRD, vols. 7–8 (multiple entries).

73. Fosdik, MU, 74–75.

74. ELD #2 (June 22, 1929).

75. FRGP, folder 65.

76. Fosdik, MU, 75.

77. Fosdik, MU, 76.

78. July 11 is traditionally given as the day of founding, but the Roerichs were on Monhegan then, and Sina admits that an earlier date was chosen to make Corona Mundi seem older than a rival group (Fosdik, MU, 109).

79. Roerich, *Adamant*, 32.

80. Roerich, AH, 4.

81. Nina Selivanova, *The World of Roerich* (New York: Corona Mundi, 1923), 96–104; and Mary Fanton Papers, AAA, reel D163.

82. HRD, vol. 5: 35, 69.

83. Fosdik, MU, 152, 227; and HRD, vol. 1: 89–93, V: 63. Helena's séances often promised that aid would someday be pried out of "stern Rockefeller."

84. Nicholas Roerich, *Fiery Stronghold* (Boston: Stratford, 1933), 217–24.

85. For example, in Williams, *Russian Art and American Money*, 117. Kenneth Archer, "The Theatrical Designs of Nicholas Roerich: Problems of Identification" (MA thesis, Antioch University, 1985), 28–29; and Belikov and Kniazeva, NKR, 123, refute this error. On the Prokofiev meeting, see Rerikh, Izln, 104–5.

86. E. More, *Forty Years of Opera in Chicago*, cited in John E. Bowlt, *Russian Stage Design: Scenic Innovation 1900–1930* (Jackson: Mississippi Museum of Art, 1982), 255.

87. *Chicago Daily News* review, reproduced in *Musical Courier* (December 21, 1922).

88. Fosdik, MU, 105. Roerich declared in November 1922 that, while individuals involved with the Master Institute did not need to hide their Theosophical inclinations, the school itself should not be described or seen publicly as a Theosophical institution (Fosdik, MU, 130–31).

89. Horch's first spiritual name was Odomar,

but soon changed. Sina noted in October 1924 that Sviatoslav "knows next to nothing" (Fosdik, MU, 206).

90. Fosdik, MU, 97, 125–28; and HRD, vols. 5–13 (multiple entries on group readings).

91. Markus Osterrieder, "From Synarchy to Shambhala: The Role of Political Occultism and Social Messianism in the Activities of Nicholas Roerich," in *The New Age of Russia: Occult and Esoteric Dimensions*, ed. Birgit Menzel, Bernice G. Rosenthal, and Michael Hagemeister (Munich: Kubon & Sagner, 2012), 116–17; and Fosdik, MU, 439, 483, 506, 537. Roerich was in contact with the Rosicrucians' leader, Harvey Spencer Lewis, no later than May 1922.

92. Fosdik, MU, 97, 147, 228–29 (on Steiner and Gurdjieff).

93. Cited in Fosdik, MU, 14. On occasion, the group would gaze into mirrors to divine the future.

94. HRD, vol. 1:29, 35–39, 63; vol. 7 (September 23–October 14, 1922).

95. See Fosdik, MU, 326–27; and multiple entries in HRD, vol. 7.

96. ACRC, Roerich 1988 addl. (gray box).

97. HRD, vol. 7 (September 23, 1922).

98. Both quotes from ACRC, Roerich Data and Personal Data, blue folder.

99. Fosdik, MU, 115–16 ("heavy character"), 119 (Helena's remarks). Esther's diaries contain numerous complaints about Frances, and even more about Sina, while Frances's papers at Rutgers University show what a difficult time she had dealing with both women.

100. Fosdik, MU, 154–55.

101. Fosdik, MU, 115–16, 119.

102. HRD, vol. 7 (December 2, 1922), for "talisman"; Fosdik, MU, 109–10, 186–87, on "evil energies."

103. HRD, vol. 7 (September 23, 1922).

104. Fosdik, MU, 125–26, 183.

105. Fosdik, MU, 110–11, 176, speaks of the group's perceptions of Crane, as does Esther Lichtmann (ELD #1, #6). Saul, *Life and Times*, 84,

269–70, alludes to Crane's antisemitism, but gingerly, in contrast to Robert Michael, *A Concise History of American Antisemitism* (Lanham, MD: Rowman and Littlefield, 2005), 129–30, which labels him an "arch" antisemite, and Erik Larson, *In the Garden of Beasts: Love, Terror, and an American Family in Hitler's Berlin* (New York: Broadway Books, 2011), 38–39, who features him as an example of antisemitism among American diplomatic elites. Readers can examine Crane's papers at Columbia University's Bakhmeteff Archive to judge for themselves.

106. Fosdik, MU, 31–32.

107. Fosdik, MU, 112, 120–33, 140–44.

108. Rosov, NRVZ, 2:14–22. Paul Robinson, *The White Russian Army in Exile, 1920–1941* (Oxford: Clarendon Press, 2002), 151, 214–18, notes that Golovin's Sorbonne courses attracted enough émigré Russians to constitute "a general staff academy in exile," with more than four hundred passing through it by 1940.

109. "Manziarly" is typically rendered in Russian as Mantsiarli; "Marcelle" sometimes appears as "Marcielle." The George–Marcelle drama is related by Fosdik, MU, 148, 159–62, 172, 368–69; M. Mantsiarli, "Sviaz' mezhdu dushami vremia ne v silakh unichtozhit': Pis'ma k Iuriiu Rerikhu, 1923–1925," *Vestnik Ariavarty* 2 (2002): 27–40; and Andreyev, MotM, 111–25. All quotations come from these sources.

110. George Roerich to his parents, early 1923, in Andreyev, MotM, 117, translation slightly amended by me.

111. On Jean Horch's illness and death, see Fosdik, MU, 161–66.

112. FRGP, "Frances Grant: History," 38.

113. Fosdik, MU, 155–57.

114. Fosdik, MU, 143, on Roerich's "constellation" of moles.

115. Helena Roerich, *On Eastern Crossroads* (Delhi: Prakashan Sansthan, 1995), 46.

116. HRD, vol. 6:31–35.

117. Andreyev, MotM, 101.

118. Roerich, *Adamant*, 97–107.

119. Selivanova, *World of Roerich*, 91. See also Fosdik, MU, 164.

120. Expenses detailed in ACRC, Roerich Folders, folder 139; and FRGP, "Frances Grant: History."

121. Williams, *Russian Art and American Money*, 122–23; FRGP, "Frances Grant: History," 6–11; and "Nicholas Roerich, Petitioner, v. Commissioner of Internal Revenue, Respondent," docket no. 86065, vol. 38, *United Board of Tax Appeals Reports* (1938): 569–70.

122. ACRC, Roerich 1988 addl. (gray box). Also Williams, *Russian Art and American Money*, 122–23.

123. Fosdik, MU, 194.

124. N. K. Rerikh to M. V. Rerikh, April 19, 1923. OR GTG, f. 44, op. 1, ed. khr. 465, l. 1.

Chapter 10: The Messenger, 1923–1925

1. Nicholas Roerich, *Himalayas: Abode of Light* (London: Marlowe, 1947), 13.

2. The painting's dedication to Blavatsky has led some to read it as a portrait of her (Sylvia Cranston, *HPB: The Extraordinary Life and Influence of Helena Blavatsky, Founder of the Theosophical Movement* [New York: Tarcher/Putnam, 1993], 552; and Karl E. Meyer and Shareen Blair Brysac, *Tournament of Shadows: The Great Game and the Race for Empire in Central Asia* [Washington, DC: Counterpoint, 1999], 459). But if the messenger symbolizes Blavatsky, it can only be in the most abstract sense; Russian scholars, including Rosov, NRVZ, 1:73; and Korotkina, *Nikolai Rerikh*, plate 51, tend to identify the figure as male. (If the messenger is taken to be Morya, the woman greeting him could conceivably represent Blavatsky.) Roerich wrote Besant about *The Messenger* on March 31, 1924 (NRM, ref. no. 201848).

3. Nicholas Roerich, *Himavat: Diary Leaves* (Allahabad: Kitabistan, 1947), 186.

4. HRD, vol. 17 (August 22, 1923).

5. ACRC, Roerich Folders, folder 140.

6. Rosov, NRVZ, 1:93; and Peg Weiss, *Kandinsky and Old Russia* (New Haven, CT: Yale University Press, 1995), 144–45. In Russian, *Zvenigorod*

oklikannyi, published by the Roerich-affiliated press Alatas.

7. Cited by Paul Robinson, *The White Russian Army in Exile, 1920–1941* (Oxford: Clarendon Press, 2002), 21.

8. HRD, vol. 15 (May 26, 1923).

9. On dietary restrictions, see Fosdik, MU, 287, 325, 375 (among other entries); Kordashevskii, TiS, 80, 279; and Anita Stasulane, *Theosophy and Culture: Nicholas Roerich* (Rome: Pontifica università gregoriana, 2005), 241–42.

10. HRD, vol. 17 (August 16, 1923), vol. 20 (May 3, 1924); Fosdik, MU, 196, 201–2. By fall 1924, plans to build an "experimental station" at seven thousand feet had been added (HRD, vol. 21 [September 6–7, 1924]).

11. Fosdik, MU, 202 (emphasis in the original). For a sample of Grebenshchikov's writing, see "The Call of Asia," in Nicholas Roerich, *Roerich-Himalaya* (New York: Brentano's, 1926), 43–62; on his US activities, see Andrei Harwell, "Churaevka: A Russian Village in the Connecticut Woods," *Russian Life* 50 (July–August 2007): 52–58.

12. Letter from N. K. Kordashevskii to N. K. Rerikh, cited in Kordashevskii, TiS, 320–21.

13. Helena describes such legends in volumes 17 and 18 of HRD; Helena Roerich, *On Eastern Crossroads* (Delhi: Prakashan Sansthan, 1995), 93–102; and E. I. Rerikh, *Kriptogrammy Vostoka* (Paris, 1929), 68–70. See also Roerich, *Himalayas: Abode of Light*, 173–76; Alla Shustova, *Sokrovishche mira* (Moscow: Del'fis, 2018); and Ian Heron, "The Chintamini of the Roerichs" (unpublished manuscript).

14. Fosdik, MU, 197.

15. Andreyev, MotM, 127–43, believes that Nicholas and Helena faked this event for the Horches' benefit (and perhaps even for George's), but holds open the possibility that Roerich was in contact with a Masonic group—the Astreia Lodge—organized by anti-Soviet Russian émigrés in 1922. One of Astreia's founders, the socialist Nikolai Chaikovsky, had worked with Roerich against the Bolsheviks in 1918–1920. Rosov, NRVZ, 1:77–78, identifies a secret society known as l'Ordre du Prieuré de Sion as the Stone's sender, and Markus Osterrieder ("From Synarchy to Shambhala: The Role of Political Occultism and Social Messianism in the Activities of Nicholas Roerich," in *New Age of Russia*, ed. Birgit Menzel, Bernice G. Rosenthal, and Michael Hagemeister [Munich: Kubon & Sagner, 2012]), favors a Martinist explanation. No scenario can be definitively proved, but even if the Roerichs stage-managed the Stone's delivery, it does not necessarily mean they did not believe in the Stone itself or the myth behind it.

16. P. A. Chistiakov to N. K. Rerikh, November 12, 1923, NRM archive.

17. Harwell, "Churaevka," 54.

18. The date of the Roerichs' arrival is variously given as December 2 and any one of several dates in November. British reports refer to a November 30 entry. British Library, India Office Library and Records [hereafter IOLR], L/P&S/10/1145, P. 2029 (1930). The family was still traveling with the Russian passports issued to them by the Provisional Government.

19. Roerich, AH, 3.

20. Roerich, AH, 6; and Belikov and Kniazeva, NKR, 128.

21. Pierre Teilhard de Chardin, *Letters from a Traveller* (New York: Fontana, 1973), 59–61.

22. The disappointment felt by Westerners whose spiritual fantasies of Asia fail to conform to reality is dealt with by Orville Schell, "Virtual Tibet: Where the Mountains Rise from the Sea of Our Yearning," *Harper's* (April 1998): 39–50; Donald S. Lopez Jr., *Prisoners of Shangri-La: Tibetan Buddhism and the West* (Chicago: University of Chicago Press, 1998); and Peter Bishop, *The Myth of Shangri-La: Tibet, Travel Writing, and the Western Creation of Sacred Landscape* (Berkeley: University of California Press, 1989).

23. On Roerich's meetings during these weeks, see Roerich, AH, 4; Rerikh, LD, 2:114–15; and Belikov and Kniazeva, NKR, 128.

24. Fosdik, MU, 201.

25. Fosdik, MU, 201.

26. Mahendra Pratap, *My Life Story of Fifty-Five Years* (Dehradan: World Federation, 1947), 266.

27. Rerikh, AG/PB, 528, speaks of admiring Pratap but does not make it clear if the two met.

28. On Altai beliefs, see Marjorie Mandelstam Balzer, ed., *Shamanic Worlds: Rituals and Lore of Siberia and Central Asia* (Armonk, NY: M. E. Sharpe, 1996), 91, 108, 147; Lawrence Krader, "A Nativistic Movement in Western Siberia," *American Anthropologist* 58 (April 1956): 282–92; Donald Rayfield, *The Dream of Lhasa: The Life of Nikolay Przhevalsky* (London: P. Elek, 1976), 98; and T. B. Allen, "The Silk Road's Lost World," *National Geographic* 183 (1996): 44–51. Belovodye features in Olga Kharitidi's new age bestseller, *Entering the Circle: Ancient Secrets of Siberian Wisdom Discovered by a Russian Psychiatrist* (San Francisco: Harper, 1997). See also John McCannon, "By the Shores of White Waters: The Altai and Its Place in the Spiritual Geopolitics of Nicholas Roerich," *Sibirica: Journal of Siberian Studies* 2 (October 2002): 167–90.

29. On the Chud, see Roerich, *Himalayas: Abode of Light*, 102–17; Nicholas Roerich, *Shambhala the Resplendent* (New York: Nicholas Roerich Museum, 1978 [orig. 1930]), 210–22. For examples of "hollow world" theses, see Raymond Bernard, *The Hollow Earth* (New York: Bell, 1969); Joscelyn Godwin, *Arktos: The Polar Myth in Science, Symbolism, and Nazi Survival* (Grand Rapids, MI: Phanes, 1996), 105–23; and Ferdinand Ossendowski, *Beasts, Men and Gods* (New York: E. P. Dutton, 1922), 299–316. Blavatsky's "hollow earth" ideas are thought to have been influenced by Edward Bulwer-Lytton's 1871 novel *Vril*. The Agartha myth also appears in the 1927 book *Le Roi du Monde*, by the French metaphysician René Guenon.

30. N. K. Rerikh to G. D. Grebenshchikov, January 3, 1924. Cited in Rosov, NRVZ, 1:92. The same news was relayed to Sina Lichtmann; see Fosdik, MU, 699.

31. HRD, vol. 20 (February 24, 1924).

32. Roerich, AH, 13–15, for first impressions of Darjeeling.

33. Roerich, AH, 9, 51.

34. N. K. Rerikh, *Izbrannoe* (Moscow: Sovetskaia Rossiia, 1979), 103–4.

35. Roerich, AH, 26–27.

36. Roerich, AH, 58–60.

37. Roerich, *Himalayas: Abode of Light*, 21, 32–33.

38. N. S. Sergeeva, *Rerikh i Vrubel'* (Moscow: MTsR, 2002), 50, 67, speaks of a single vision in June; Helena talks of several, the first taking place as early as March (HRD, vol. 21). Ancient India's *Tantrasara*, which contains a hymn to the "mother of the world," was available in English translation by 1913 [Joseph Campbell, *The Masks of God* (New York: Viking, 1962), 39, 521], but whether the Roerichs were aware of this text is unknown.

39. Wade Davis, *Into the Silence: The Great War, Mallory, and the Conquest of Everest* (Toronto: Vintage Canada, 2012), 115; and Wade Davis, *The Clouded Leopard: A Book of Travels* (Vancouver: Douglas and McIntyre, 1998), 73–94.

40. Roerich, AH, 26–27.

41. Roerich, AH,

42. HRD, vol. 21 (February 24, 1924). Also in Sikkim, the Roerichs claimed to have met a crowned lama who, they hinted, was Morya in the flesh (Roerich, AH, 116; and Roerich, HoA, 125). As Anita Stasulane, *Theosophy and Culture: Nicholas Roerich* (Rome: Pontifica università gregoriana, 2005), 89, points out, this suspiciously echoes the story Helena Blavatsky told in the 1800s about meeting Morya in the same place. Andreyev, MotM, 178–84, is equally skeptical.

43. Among others, see Belikov and Kniazeva, NKR, 130–31; V. M. Sidorov, "Sem' dnei v Gimalaiakh," in *Na vershinakh* (Moscow: Sovetskaia Rossiia, 1983); Andreyev, MotM, 176–77; Meyer and Brysac, *Tournament of Shadows*, 457; Osterrieder, "From Synarchy," 122; and Shishkin, BzG, 110–12. Interpretations of the ordination vary. Although the presence of noteworthy Buddhists is attested to by photographs and written evidence, what

they thought of Roerich and the honor they were bestowing upon him, or to what extent they saw the event as part of a political scheme, remains unclear at best. No concrete proof indicates that the Panchen Lama approved or even knew of Roerich's ordination, and as for the idea that Roerich was acknowledged in any meaningful way as the newly incarnated Dalai Lama, Andreyev, MotM, 176–77, suggests it "should be taken with a large pinch of salt."

44. George Roerich, *Trails to Inmost Asia: Five Years of Exploration with the Roerich Central Asian Expedition* (New Haven, CT: Yale University Press, 1931), 156–57 [hereafter TtIA]. Osterrieder, "From Synarchy," 120, asks the same question: "Was there some truth in the recurrent claim that there existed a hidden 'great Asian brotherhood' with a spiritual-political agenda of its own?"

45. See Alexandra David-Néel's *My Journey to Lhasa* (1927) and *Magic and Mystery in Tibet* (1929). Among others, Andy Lamey, "Stop the Lama Love-in," *Maclean's* (November 25, 2009), discusses various ways that contemporary celebrities have gained the status of Buddhist "clergy."

46. Andreyev, MotM, 292–93, notes that the Panchen finally addressed a boilerplate letter to Roerich, calling him an "American Buddhist abbot" and thanking him for "all the gifts, which made me feel that I am seeing you in person." (For the original, see the NRM archive.) The letter encourages Roerich to "continue . . . promot[ing] the teaching of the Buddha," but was not sent until the fall of 1928—indicating that cooperation with Roerich was not the Panchen's highest priority—and not even received by Roerich till October 1935.

47. ELD #5 (May 31, 1930).

48. Ruskin cited by Simon Schama, *Landscape and Memory* (New York: Knopf, 1995), 506. See Roerich, AH, 36 (negative opinions about climbing), 28 (the climbers' visit); and Riabinin, RT, 515. Roerich exaggerates the climbers' praise, portraying them as so amazed by the "accuracy" of his paintings that they had to be persuaded he had never been on Everest.

49. On Finch's family background, see Davis, *Into the Silence*, 141–45.

50. For Bailey's career, see Meyer and Brysac, *Tournament of Shadows*, 328–30, 430–32; and Davis, *Into the Silence*, 210–14, 563–64.

51. Alexandre I. Andreyev, *Soviet Russia and Tibet: The Debacle of Secret Diplomacy* (Leiden: Brill, 2003), 117–238; and Rosov, NRVZ, 1:8–10. In 1919, the Soviets considered, but rejected, a proposal by the Kalmyk communist Arashi Chapchaev to have agents disguised as Buddhist pilgrims smuggle weapons to pro-Russian locals in Tibet, Nepal, Bhutan, and Sikkim.

52. Cited in Andreyev, *Soviet Russia and Tibet*, 9–10.

53. Gill Bennett, *Churchill's Man of Mystery: Desmond Morton and the World of Intelligence* (London: Routledge, 2007), 72.

54. Bailey's impressions are recorded in IOLR L/P&S/10/1046 and elsewhere in the archive, and cited by Meyer and Brysac, *Tournament of Shadows*, 472.

55. Fosdik, MU, 206 (on the Lichtmanns' Jewish relatives); and HRD, vol. 20 (February 3, 1924; June 1–4, 1924; and July 7, 1924), HRD, vol. 21 (August 1–14, 1924; and September 5, 1924).

56. HRD, vol. 21 (January 5, 1925), on Akbar and Sergius; vol. 21 (September 5, 1924) on violence.

57. HRD, vol. 20 (March 12, 1924; April 4, 1924, "tormented" in the next sentence; April 7, 1924, "vulgarity").

58. Kordashevskii, TiS, 108–11, recalls one such conversation. Kordashevsky met the actual Khutuktu while fighting in the east during Russia's Civil War.

59. HRD, vol. 20 (June 26–28, 1924; and July 4, 1924).

60. HRD, vol. 20 (May 22, 1924; June 6, 1924; and July 6, 1924); HRD, vol. 21 (August 3, 1924).

61. HRD, vol. 22 (May 29, 1925); and A. I. Andreev and Dany Savelli, eds., *Rerikhi: mify i fakty* (Saint Petersburg: Nestor-Istoriia, 2011), 83. Andrei Znamenski, *Red Shambhala: Magic, Prophecy, and Geopolitics in the Heart of Asia* (Wheaton, IL: Quest

Books, 2011), 181; and Rosov, NRVZ, 1:118, give the date as May 29, 1924, though Rosov cites it correctly in his notes. Roerich spoke of being in spiritual contact with Lenin, and occasionally of having met him in real life (e.g., Rosov, NRVZ, 1:136–37). This is not impossible, but neither is it probable, and Andreyev, MotM, 213, categorically states that Roerich "never met Lenin." Either way, claims like the one Roerich made in 1925 to Chicherin to have "worked at Lenin's behest . . . to apply religious belief to communism" are implausible in the extreme (HRD, vol. 22 [July 24, 1925]).

62. HRD, vol. 22 (June 28, 1925). According to Morya, Lenin's "time of purging" would end in 1931.

63. N. K. Rerikh to E. I. Rerikh, September 24, 1924, cited in Andreyev, MotM, 187–88.

64. Rosov, NRVZ, 1:95–99; and Harwell, "Churaevka." The chapel was built in 1929 and consecrated in 1930.

65. Marie Urbow Lampad et al., eds., *The Uncommon Vision of Sergei Konenkov, 1874–1971* (Camden, NJ: Rutgers University Press, 2001), 154.

66. Fosdik, MU, 210, 216, 226, 233. As noted in chapter 9, the compilers of Sina's diary have confused Spencer Kellogg with the US diplomat Frank Kellogg.

67. On Serafima's loose lips and Remizov's "different path," see Fosdik, MU, 202–3, 224.

68. Fosdik, MU, 232.

69. Fosdik, MU, 202, 207.

70. Fosdik, MU, 232.

71. Fosdik, MU, 224–25.

72. HRD, vol. 21 (October 27, 1924, and October 29, 1924).

73. Besant and Blavatsky quotes from HRD, vol. 21 (October 6, 1924).

74. Cited in Roerich, *Roerich-Himalaya*, 24.

75. Fosdik, MU, 201, 240–41, mentions Merritt as "a dear man," but does not give his first name or describe him as a writer. The identification of him as A. Merritt, author of sci-fi classics like *The Face in the Abyss* (1923) and *The Ship of Ishtar* (1924), is my own.

76. D. D. Burliuk, "Tvorchestvo Rerikha," *Russkii golos* (November 23, 1924). See also Fosdik, MU, 229–30.

77. Expedition underwriters included the Horches ($500,000), Curt N. Rosenthal ($150,000), Edward and Harry Bloomberg ($50,000), Elias Silverstein ($50,000), Frances Grant ($25,000), F. W. Trabold ($25,000), Howard F. Clark ($25,000), John Hoyler ($25,000), and R. W. Hall ($2,500). List compiled in August 1929 and filed in NARA, Record Group 59, General Records of the Department of State, Central Decimal File, 1910–1929, 031.11 R62, 17½ [hereafter, all citations from RG 59, 1910–1929, given as NARA, followed by file number].

78. On the visa, see Meyer and Brysac, *Tournament of Shadows*, 457–58; "Bolsheviks" is from Fosdik, MU, 206. On Beluha and the GKK, see Rosov, NRVZ, 1:120–31; the NRM archive; and GARF, f. 8350, op. 1, dd. 729, 730. The company took its name from Mount Belukha in the Altai, although romanized slightly differently. This book will refer to the company by its legally registered name of "Beluha," and the mountain as "Belukha."

79. GARF, f. 8350, op. 1, d. 730, ll. 19–24.

80. Fosdik, MU, 209, 219–21, 233, 240–42; Rosov, NRVZ, 1:118–31; Znamensky, *Red Shambhala*, 183–84 (who believes Borodin may have been a Comintern or OGPU agent); and Andreyev, MotM, 192–95.

81. Fosdik, MU, 219.

82. HRD, vol. 21 (September 10, 1924).

83. On final preparations, see Fosdik, MU, 206–8, 230–35.

84. IOLR, L/P&S/10/1151, 147–52. The American report is referred to in British correspondence.

85. On the Krestinsky meeting, see Rosov, NRVZ, 1:120–24.

86. N. K. Rerikh to G. A. Astakhov, February 1925. NRM Archive, cited in Rosov, NRVZ, 1:126.

87. N. N. Krestinskii to G. V. Chicherin, January 2, 1925. AVP RF, f. 04, op. 13, p. 87, d. 50117, l. 13a, cited in Rosov, NRVZ, 1:122–23.

88. G. V. Chicherin to N. N. Krestinskii, March

31, 1925. AVP RF, f. 04, op. 13, p. 87, d. 50117, l. 14, cited in Rosov, NRVZ, 1:127; and Aleksandr I. Andreev, *Vremia Shambaly* (Saint Petersburg: Neva, 2004), 309–10.

89. Shishkin, BzG, 115–25, puts a different spin on this. In his view, Horch—Roerich's alleged spymaster—agreed to release expedition funds only if the artist visited Krestinsky and Astakhov. Astakhov directed Roerich to meet with Mahendra Pratap in Berlin, then proceed to board the *Katori Maru* in Marseilles. At sea, Roerich was to mediate between Alexander Troianovsky and Yosuke Matsuoka, Japan's future foreign minister, to smooth the way for Soviet–Japanese talks held publicly in January 1925. Shishkin offers nothing to verify this cloak-and-dagger scenario—except to claim that one of the Japanese tourists in a grainy photo of Roerich and Shibaev by the Giza pyramids looks like Matsuoka—and does not explain why Krestinsky and Astakhov would, without authorization, entrust such a delicate operation to a neophyte to whom they would not even issue a visa. Rerikh, AG/PB, 528, mentions Pratap, but only vaguely, and 513, where Roerich mentions Japanese voyagers speaking with approval about an agreement "between our two countries," is presumably the basis of Shishkin's Matsuoka theory. This exchange, however, took place in 1923, not 1924.

90. Among those linking Roerich and Chicherin are John Snelling, *Buddhism in Russia* (Rockport, MA: Element, 1993), 229; and Shishkin, BzG, 27–31, but they do so based on assumption, not documentation. Standard biographies of Chicherin, such as Timothy O'Connor, *Diplomacy and Revolution: G. V. Chicherin and Soviet Foreign Affairs, 1918–1930* (Ames: Iowa State University Press, 1988), say nothing of Roerich.

91. Nicholas Roerich, *Realm of Light* (New York: Roerich Museum Press, 1931), 310–16.

92. Meyer and Brysac, *Tournament of Shadows*, 457–58.

93. Rosov, NRVZ, 2:169–72. Nine years later, Japanese intelligence turned out to have copies of this letter and others sent during this voyage. Rosov, among others, theorizes that Japanese agents photographed Roerich's papers during his time on the *Katori Maru*. As discussed in later chapters, another, more prosaic, explanation may be that the leak took place in Harbin, where Japanese police supervised White Russians like Vladimir.

94. Rerikh, LD, 3: 64, 70; and Rerikh, AG/PB, 521. Shishkin, BzG, 115–25, maintains without proof that Roerich visited Ghose on Soviet orders.

95. Fosdik, MU, 299–300, 713.

96. Rosov, NRVZ, 1:131; HRD, vol. 21 (January 27, 1925); and IOLR, L/P&S/10/1145, P. 2029 (March 27, 1930, plus Appendix 2 to Notes). In a potentially related note, Andreyev, MotM, 244–45, notes that Dhan Gopal Mukerji, a lecturer at Roerich's Master Institute, knew Roy personally.

97. Roerich, AH, 69–79; and HRD, vol. 21 (March–April 1925).

98. Kordashevskii, TiS, 331–32, 335.

99. HRD, vol. 21 (May 29, 1925).

100. HRD, vol. 21 (May 15, 1925). This is the earliest text I have found referring to renewed contact between Roerich and Dorjiev, but they may have communicated earlier.

101. N. K. Rerikh to G. V. Chicherin, July 24, 1925. Copied in HRD, vol. 22; cited in Rosov, NRVZ, 1:136–37.

102. HRD, vol. 21 (April 30, 1925).

103. HRD, vol. 21 (multiple entries, especially April 30, 1925).

104. Rosov, NRVZ, 1:131; IOLR L/P&S/10/1145, P. 2029, Appendix 2 to Notes. Roerich's quarrel with Hinde is mentioned in *Roerich-Himalaya*, 137, but dropped from later accounts like *Altai-Himalaya*.

105. Louis Horch and Frances Grant to US Department of State, April 16, 1925; and telegram from US State Department to US Embassy in London, April 18, 1925. Both documents in NARA, 031.11 R62.

106. IOLR L/P&S/10/1145, 464.

107. George Roerich, TtIA, 6. See also Roerich, AH, 78–79.

108. On outfitting, see Meyer and Brysac, *Tournament of Shadows*, 460; and K. N. Riabinin, "Pokazaniia Doktora K. N. Riabinina 23–24 iuliia 1930 goda," *Aryavarta* 1 (1997): 173.

Chapter 11: Searching for Shambhala, 1925–1928

1. Alexandra David-Néel, cited in Rerikh, AG/PB, 637–38.

2. The expedition is typically described as having covered sixteen thousand miles, but this includes much travel through civilized territory, most notably the 1925 transfer from Darjeeling to Srinagar (a preparatory step) and, in 1926, a round-trip journey to Moscow from the Soviet border (an unpublicized interruption). It is more accurate to measure the circular route from Srinagar to Darjeeling through Central Asia, Mongolia, and Tibet.

3. Pierre Teilhard de Chardin, *The Future of Man* (New York: Fontana, 1969), 34.

4. Roerich, AH, 2.

5. Roerich, HoA, 5; see also George Roerich, TtIA, xi–xii.

6. David Grann, *The Lost City of Z: A Tale of Deadly Obsession in the Amazon* (New York: Vintage, 2010), 14. However different they were as explorers, Fawcett shared one thing with Roerich: an abiding interest in Theosophy.

7. Nicholas Roerich, *Fiery Stronghold* (Boston: Stratford, 1933), 120.

8. Roerich, *Fiery Stronghold*, 100. George Roerich, TtIA, 7, does not mention the disturbance at all.

9. Simla Political Department to British Resident in Kashmir, August 9, 1925. IOLR 1145, 532–33. Shishkin, BzG, 141–46, proposes the unlikely theory that Wood staged the Tangmarg incident to dissuade Roerich from continuing his journey.

10. IOLR 1145, 532–33. Louis Horch, in a June 25, 1926, letter to Assistant Secretary of State Leland Harrison, complained that this telegram had been faked by the British police (NARA, 031.11 R62).

11. IOLR 1145, 532–33. On September 25, 1925, the British Foreign Office sent a memo based on this report to the US Embassy in London, which forwarded it to the State Department. NARA, 031.11 R62.

12. Roerich, AH, 107.

13. Roerich, AH, 132: "... an unexpected discovery. It appears that the lama speaks Russian. He even knows many of our friends." The identity of this lama, who asked on September 17 if he could travel with the caravan, remains a mystery. Shishkin, BzG; Anton Pervushin, *Okkul'tnye tainy NKVD i SS* (Leningrad: Neva, 1999) and Richard Spence, "Red Star over Shambhala," *New Dawn Magazine* 109 (July–August 2008), argue that this was Bliumkin. Bliumkin operated in Central Asia, often in native disguise, and is known to have met Roerich in Mongolia in 1927, but no proof shows him to have been part of the expedition, either in Ladakh or later (Alexandre I. Andreyev, *Soviet Russia and Tibet: The Debacle of Secret Diplomacy* [Leiden: Brill, 2003], 308–9, and Andrei Znamenski, *Red Shambhala: Magic, Prophecy, and Geopolitics in the Heart of Asia* [Wheaton, IL: Quest Books, 2011], 254n25, do not believe he took part). Karl E. Meyer and Shareen Blair Brysac, *Tournament of Shadows: The Great Game and the Race for Empire in Central Asia* (Washington, DC: Counterpoint, 1999), 463, identify the lama as a student of Dorjiev's. Native attendants identified by name at this stage include Tsering Konchog, a Tibetan, and Ramzana, a Ladakhi.

14. Rerikh, AG/PB, 592; and Roerich, AH, 116.

15. Notovitch claimed to have read the Issa manuscripts while recovering from a broken leg at Hemis. See Müller's refutations in *Nineteenth Century* 36 (July–December 1894): 515–22, and 39 (January–June 1896): 667–77; other debunkings are too numerous to list, but as the eminent Bible scholar Bart Ehrman puts it, "not a single recognized scholar on the planet ... has any doubt about the matter. The entire story was invented by Notovich" (Bart Ehrman, *Forged: Writing in the Name of God—Why the Bible's Authors Are Not Who We Think They Are* [New York: Harper, 2011], 252–54). Although Swami Abhedananda, a colleague of Vivekananda's, spoke of having validated Notovitch's story with the monks of

Hemis, the vast majority of interview evidence casts doubt on the manuscripts' existence. More generally, tales of Christ in Asia, native and Western, are analyzed by Olav Hammer, *Claiming Knowledge: Strategies of Epistemology from Theosophy to the New Age* (Leiden: Brill, 2001), 152–54; Douglas Groothius, *Revealing the New Age Jesus: Challenges to Orthodox Views of Christ* (Downers Grove, IL: Intervarsity, 1990); Charles Allen, *The Search for Shangri-La* (London: Abacus, 2000), 160–61; Erik Hornung, *The Secret Lore of Egypt: Its Impact on the West* (Ithaca, NY: Cornell University Press, 2001), 178–79; and Peter Hopkirk, *Foreign Devils on the Silk Road: The Search for the Lost Cities and Treasures of Chinese Central Asia* (Oxford: Oxford University Press, 1984), 26–30. The US Supreme Court justice William O. Douglas traveled to Ladakh in 1951 and reported in *Beyond the High Himalayas* (Garden City, NY: Doubleday, 1952), 152: "There are those who to this day believe that Jesus visited this place," and several works of fiction allude to such legends, including Paul Park's *The Gospel of Corax* (1996), Yann Martel's Booker Prize–winning *The Life of Pi* (Toronto: Alfred A. Knopf, 2001), and Christopher Moore's *Lamb: The Gospel According to Biff, Christ's Childhood Pal* (New York: HarperCollins, 2002), which puts a comic twist on the tale. Popular occultist works asserting the "lost years" thesis as literal truth include Elizabeth Clare Prophet, *The Lost Teachings of Jesus: Missing Texts; Karma and Reincarnation* (Corwin Springs, MT: Summit University Press, 1994); Elizabeth Clare Prophet, *The Lost Years of Jesus: On the Discoveries of Abhedananda, Roerich, and Caspari* (Malibu, CA: Summit University Press, 1984); Mark L. Prophet and Elizabeth Clare Prophet, *The Path of the Universal Christ* (Corwin Springs, MT: Summit University Press, 2003); and Tricia McCannon (no relation to the present author), *Jesus: The Explosive Story of the Lost Years* (Charlottesville, VA: Hampton Roads, 2009).

16. Fosdik, MU, 202.

17. Rerikh, AG/PB, 598. This passage does not appear in the heavily edited English translation.

18. Nicholas Roerich, *Roerich-Himalaya* (New York: Brentano's, 1926), 148.

19. Grant generated two waves of coverage, one in November–December 1925, the other in May–June 1926. Articles in the *Detroit News* (November 18, 1925); *Chicago Tribune* (December 15, 1925); *Boston Globe* (May 27, 1926); and *New York Sun* (May 28, 1926) represent a sample. See Dany Savelli, "Shambhala de-ci, de-là: syncrétisme ou appropriation de la religion de l'Autre?" *Slavica Occitania* 29 (2009): 324–31. "Banners of the East" is in Roerich, *Roerich-Himalaya*, 73–181.

20. Roerich, AH, 332.

21. Roerich, *Fiery Stronghold*, 283.

22. Roerich, AH, 113–14. Anita Stasulane, *Theosophy and Culture: Nicholas Roerich* (Rome: Pontifica università gregoriana, 2005), 274; and Darya Kucherova, "Art and Spirituality in the Making of the Roerich Myth" (PhD diss., Central European University, 2006), 245, say unequivocally that Roerich discovered no manuscript, with the former adding that he "pretended for a time" to have done so. Even Elizabeth Prophet, who wants badly to believe that Roerich found an Issa text at Hemis, admits that he "does not specify" whether he did (*Lost Years of Jesus*, 62–63).

23. Ian Heron, "The Mission of Nicholas Roerich" (unpublished manuscript), 17–18.

24. Roerich, AH, 89–95, 113–20, 125–26, 242–43; Roerich, HoA, 18, 23–24; and Roerich, *Fiery Stronghold*, 283–88. Roerich claims to have encountered Ladakhi, Torgut, Kalmyk, Turfan, and other variants of the myth. On the regional impact of Nestorianism and Manicheanism, see David Morgan, *The Mongols* (Oxford: Blackwell, 2007), 24, 41, 109–10, 140.

25. Rerikh, AG/PB, 599.

26. Hopkirk, *Foreign Devils*, 13, for both Hedin's and Stein's comments.

27. Roerich, AH, 126.

28. George Roerich, TtIA, 53–54, describes the warning. Nicholas, unwilling to admit having walked into a trap, says nothing about it (AH, 152; AG/PB, 618). The "kind" description is his.

29. Roerich, HoA, 28–29.

30. Roerich, AH, 158.

31. Pierre Teilhard de Chardin, *Letters from a Traveller* (New York: Fontana, 1973), 135–39.

32. Roerich, AH, 162.

33. Belikov and Kniazeva, NKR, 133–39; and Rosov, NRVZ, 1:133–34. Shishkin, BzG, 171–80, names Dumpis an OGPU agent (and a cocaine addict to boot).

34. Nicholas Roerich to Louis Horch, received by US State Department on December 14, 1925. NARA, 031.11 R62.

35. Charles Crane to Nelson T. Johnson, December 14, 1925. NARA, 031.11 R62.

36. Louis Horch to Nelson T. Johnson, December 16, 1925. NARA, 031.11 R62.

37. IOLR 1145, 520. Message of January 25, 1926. Sent after Gillan secured permission for Roerich to leave Khotan, but before the two met in person.

38. Roerich, AH, 163.

39. This series includes *Shambhala Approaches*, *The Steed of Happiness*, *Walled Strongholds*, *Banner of the Coming One (Song of Rigden Djapo)*, *Maitreya the Conqueror*, *Power of the Caves*, and *Whispers of the Desert (Tale of the New Era)*. V. A. Rosov, "Velikii Vsadnik: O Lenine i simvolike zvezdy na kartinakh Nikolaia Rerikha," *Vestnik Ariavarty* 1, no. 2 (2002): 38–47, discusses the pro-Soviet iconography of these and similar works.

40. Rerikh, AG/PB, 610. Omitted from the English translation. Also during the family's time in Khotan, a "sending" from Morya comforted them with the thought that when they reached their next destination, "perhaps Dorjiev will have sent news" (HRD, vol. 22).

41. Roerich, AH, 97 ("mahatma"), 178 ("Vedantists").

42. Roerich, *Roerich-Himalaya*, 142 ("Buddha"), 157 ("communal welfare"). The English *Altai-Himalaya* replaces the phrase "communal welfare" with "human welfare" (AH, 97), and Buddha is described as "the great teacher" instead of "the great communist." The reference to "property" is also dropped (AH, 85).

43. Rerikh, AG/PB, 574. Here, Christ is described not as a *kommunist*, but as an *obshchinnik*, a Slavonic word more properly translated as "communalist" and generic enough to not always have Marxist connotations. Roerich's "Banner of the East" (*Roerich-Himalaya*, 148), uses the words "communist" and "capitalists," whereas the English *Altai-Himalaya* omits reference to the latter and refers to Christ as a "teacher" (AH, 90).

44. Rosov, NRVZ, 1:184.

45. Roerich, AH, 215; and Roerich, *Fiery Stronghold*, 283.

46. IOLR 1145, 502–3. Gillan attributed Roerich's Khotan troubles to confusion about his citizenship and the fact that the party's permit to carry arms was valid only in India.

47. Roerich, AH, 219–21; Gillan's comments in IOLR 1145, 503. Helena's feelings in ELD #6 (June 1930).

48. Roerich "insisted on continuing his journey through China notwithstanding present conditions," Gillan reported to the Foreign Office and State Department in May 1926 (received in Washington on June 2, 1926), by which point both governments had lost track of the expedition. NARA, 031.11 R62.

49. George Roerich, TtIA, 89, which also states that the party had originally wanted to move on through Gansu Province—the exact route they had refused when Taotai Ma suggested it to them in Khotan.

50. Russian State Military Archive (RGVA), f. 25895, op. 1, d. 831, ll. 76–78.

51. IOLR 1146, 195–96; and IOLR 1145, 171–72.

52. In English, Roerich gives this distance as 1,800 miles (AH, 218–19), but this is a mistranslation of *versty*, a Russian measurement roughly equivalent to a kilometer. See Rerikh, AG/PB, 665–66.

53. Roerich, AH, 221.

54. Roerich, HoA, 1.

55. Roerich, AH, 235.

56. Rerikh, AG/PB, 687 ("Ruskinism"; erased from the English translation); Roerich, AH, 235 ("cemetery"); and Roerich, AH, 226 ("absurd").

57. Rerikh, AG/PB, 692, 769. Riabinin, RT, 169, and other sources show how Roerich wished to choose one official language for use throughout Asia. Other pan-Asianists, including Mongolia's Khayan Khirva, whom Roerich may have known personally, felt similarly or advocated universal languages like Esperanto.

58. Roerich, AH, 264.

59. Roerich, AH, 252, 258–60; see also George Roerich, TtIA, 103.

60. Roerich, AH, 267, 269, 271.

61. Hopkirk, *Foreign Devils*, 117–18.

62. Roerich, AH, 277. In TtIA, 116, 120–21, George insists, "We were told [in Urumchi] that the only route open for us was by way of Siberia. . . . It seemed as if we should be forced once more to change our route." Compare this with Roerich's telegram to Leonid Krasin on January 22, 1926: "I have extraordinary material. Tell Chicherin I can be in Moscow by May" (Rosov, NRVZ, 1:140).

63. RGVA, f. 25895, op. 1, d. 831, l. 77.

64. Roerich, AH, 282–83. Rerikh, AG/PB, 711–34, refers openly to Bystrov's name and official status.

65. Bystrov's diary is in the Foreign Policy Archive of the Russian Federation (AVP RF), f. 0303, op. 1, port. 30, pap. 4. My references from it are taken from Rosov, NRVZ.

66. Andreyev, MotM, 240, based on HRD, vol. 22, entries from January 1926.

67. Consular diary of A. E. Bystrov, April 19, 1926, cited in Rosov, NRVZ, 1:141. Bystrov recorded another conversation on the same theme on May 6, 1926 (1:156).

68. G. Goncharenko, "Polozhenie v Sin'-tszane," RGVA, f. 25895, op. 1, d. 832, l. 454.

69. Bystrov's consular diary, cited in Andreyev, MotM, 229.

70. ELD #5 (May 5, 1930).

71. Roerich told Sina that Bystrov received two separate pieces of mail from Chicherin: a transit visa for the Roerichs and an order not to hand it over till the family took Soviet citizenship. If the story is true, Bystrov agreed to pretend the second letter arrived only after the Roerichs' departure. Fosdik, MU, 256–57.

72. Cited in Rosov, NRVZ, 1:143–46. Three other copies were made, one going to Roerich, the other two to Mikhail Trilisser, head of the OGPU's Foreign Department (INO). Shishkin, BzG, 198–200, maintains that Bliumkin, still accompanying the expedition disguised as a lama, drafted the will.

73. Andreyev, *Soviet Russia and Tibet*, 298. A date of June 13 is given by others.

74. *New York Evening Graphic* (July 19, 1926); *New York World* (July 25, 1926); *New York Sun* (September 1, 1926); *New York American* (September 5, 1926); *New York Times* (April 5, 1927); and *Peking and Tientsin Times* (April 29, 1927).

75. Fosdik, MU, 246–57. See GARF, f. 8350, op. 1, d. 729, ll. 32, 38, 57, on granting the Lichtmanns visas.

76. Cited in Belikov and Kniazeva, NKR, 139.

77. G. V. Chicherin to V. M. Molotov, June 13, 1926. AVP RF, fond Otdela Dal'nego Vostoka NKID, in Rosov, NRVZ, 1:149. Chicherin also informed Karl Radek of the Comintern and I. S. Unshlikht of the Revolutionary Military Committee about Roerich's visit. According to Andreyev, *Soviet Russia and Tibet*, 299, the casket's and letter's whereabouts remain unknown. Helena proposed the"Great Teacher" inscription, channeling it, as she claimed, from Allal-Ming (HRD, vol. 22 [April 21, 1926]).

78. GARF, f. 8350, op. 1, 729, ll. 3, 4, 6, 7, 8, 14, 17–19, 20–22.

79. G. V. Chicherin, memo of June 25, 1925, marked "secret." GARF, f. 8350, op. 1, d. 730, l. 33.

80. GARF, f. 8350, op. 1, d. 729, l. 38.

81. GARF, f. 8350, op. 1, d. 729, ll. 17–19, 20–22, 46, 50, 57.

82. GARF, f. 8350, op. 1, d. 730, ll. 3–13, 14–25.

83. In July 1926, VSNKh and the GKK noted that "to this date, the Belukha region has not been subjected to systematic study." GARF, f. 8350, op. 1, d. 729, l. 61.

84. GARF, f. 8350, op. 1, d. 729, ll. 81, 82–84, 96. Also ACRC, Roerich Data and Personal Data (gray box).

85. M. S. Iapol'skii to L. D. Trotskii, July 20, 1926. GARF, f. 8350, op. 1, d. 729, l. 85.

86. See S. Zarnitskii and L. Trofimova, "Put' k Rodine," *Mezhdunarodnaia zhizn'* 1 (1965): 96–107; and Belikov and Kniazeva, NKR, 178–79. Andreyev, MotM, 240, dismisses both letters as "agitprop" fabrications.

87. The orientalist Alexander Piatigorsky, George Roerich's student, knew the OGPU typist who transcribed the minutes of these meetings and related the identity of some of the attendees (Ian Heron, "The Chintamini of the Roerichs" [unpublished manuscript]).

88. Shishkin, BzG, 208–13. As noted in chapter 2, it is possible that Roerich had a nodding acquaintance with Menzhinsky, who studied law at Saint Petersburg University at the same time. Shishkin believes that the future secret police head Genrikh Yagoda also attended these talks.

89. The existence of the Spetsotdel and the United Brotherhood of Labor is a matter of recorded fact. Bokii and Barchenko have been written about insightfully by Aleksandr I. Andreev, *Vremia Shambaly* (Saint Petersburg: Neva, 2004); Aleksandr I. Andreev, *Okkul'tist Strany Sovetov* (Moscow: Eksmo, 2004); Rosov, NRVZ; Markus Osterrieder, "From Synarchy to Shambhala: The Role of Political Occultism and Social Messianism in the Activities of Nicholas Roerich," in *The New Age of Russia: Occult and Esoteric Dimensions*, ed. Birgit Menzel, Bernice G. Rosenthal, and Michael Hagemeister (Munich: Kubon & Sagner, 2012); and Znamenski, *Red Shambhala*.

90. HRD, vol. 24 (April 28, 1927). This entry postdates the Roerichs' time in Moscow and refers not to an actual conversation, but to Morya's suggestion that Sina and Maurice—who continued the Beluha talks in Moscow while the Roerichs proceeded to Tibet—seek Bokii out and secure his support. The entry shows the Roerichs' awareness of who Bokii was and implies (though does not prove) that they had met him earlier.

91. Lev Razgon, *True Stories* (Dana Point, CA: Ardis, 1997), 278–83, details Bokii's confession of June 1, 1937, whose substance he dismisses as "schoolboy nonsense" (he seems to be unaware of how Bokii and Roerich may have met in 1926). Barchenko was interrogated further on June 10, 1937, and Bokii in May and August 1937 (when he confessed not only to spying for Britain but also to plotting the demolition of the Kremlin and the assassination of Stalin). "Dunkhor" is Russian for *dus'khor*, the Tibetan translation of the Sanskrit *kalachakra*.

92. Fosdik, MU, 265, 284. Alternatively, this passage may refer to Trilisser, whom Sina called "Our Friend" for his patient (and pretended) willingness to hear the group out about astral projection and other such topics.

93. Heron, "Chintamini," compiles the many theories regarding this question. The parapsychologist Konstantin Ivanenko argues that Roerich gave the Stone to Barchenko, who attempted to use it as a "psi-transmitter." Heron contends that Roerich, intending to return the Stone to Asia, kept it, and Daniel Entin of the Nicholas Roerich Museum maintained that the Roerichs kept it even after the journey, and that it remains in safe but secret custody.

94. Quoted by Igor' E. Grabar', *Moia zhizn'* (Moscow: Iskusstvo, 1937), 296–97.

95. G. Goncharenko of military intelligence described competing Anglophile and Anglophobe camps in Lhasa, hoping that the latter might win over the Dalai Lama (RGVA, f. 25895, op. 1, d. 832, ll. 73–82). Rosov, NRVZ, 1:42–49, cites Narkomindel concerns that the Panchen might turn to Japan. Andreyev, MotM, 261–66, notes that a minority among Soviet officials, including Pyotr Nikiforov, the USSR's representative in Mongolia, shared Roerich's aim of returning the Panchen to Tibet (however skeptical Nikiforov was of Roerich himself).

96. Fosdik, MU, 284, 733; and Rosov, NRVZ, 1:80.

97. Fosdik, MU, 257, notes that the "question of who should have power" was "touched on" several times, but provides no details.

98. Fosdik, MU, 265, 363; Rosov, NRVZ, 1:187; and Andreyev, MotM, 246–48.

99. Grabar', *Moia zhizn'*, 296–97.

100. Poliakova, NR, 245.

101. Rerikh, AG/PB, 762, on Savonarola (edited out of the English version); Rosov, NRVZ, 1:152, on the books. Based on Lyudmila Mitusova's memoirs, Andreyev, MotM, 247, sees Lunacharsky as more sympathetic to Roerich.

102. The photo appears in Fosdik, MU, 250.

103. On Stanislavsky, see ACRC, Roerich Folders, folder 141. Shishkin, BzG, 203–8, alleges that before the revolution, Merkurov and Roerich had belonged to the same occultist circle as Barchenko, who now brought the two together once more.

104. John Snelling, *Buddhism in Russia: The Story of Agvan Dorzhiev; Lhasa's Emissary to the Tsar* (Rockport, MA: Element, 1993), 228; and Heron, "Chintamini," based on testimony from Alexander Piatigorsky.

105. Robert C. Williams, *Russian Art and American Money: 1900–1940* (Cambridge, MA: Harvard University Press, 1980), 126; and Andreyev, MotM, 246.

106. Also in Amaravella: Alexander Sardan, Pyotr Fateyev, Sergei Shigolev, and Viktor Chernovolenko.

107. Andreyev, MotM, 247.

108. Poliakova, NR, 260–63, on Maria. My understanding of Nicholas's relationship with Lydia is informed by interviews at the NRM (especially on February 8, 2000).

109. Fosdik, MU, 258. Roerich later hinted to White émigrés that he had risked arrest in Moscow, and Alexander Piatigorsky recalls George Roerich in the 1950s mentioning Lunacharsky's "personal advice" to "leave while it was still possible" (Ian

Heron, "Chintamini"). Even if Lunacharsky encouraged Roerich to depart, this was far from barely escaping the jaws of a quickly closing trap. Esther Lichtmann repeats an anecdote from Helena about how easily the family cleared customs when leaving the USSR, an indication that the exit was not as fraught as the Roerichs later made it out to be (ELD #6 [June 15, 1930]).

110. *New York Times* (April 5, 1927).

111. Maurice Lichtmann to Louis Horch, July 15, 1926. ACRC, Roerich Folders, folder 141. See also Fosdik, MU, 257. Horch was aware of the real route, having been instructed to forward mail to Biisk, in southern Siberia. Maurice Lichtmann to Louis Horch, July 23, 1926 (ACRC, Roerich Folders, folder 141).

112. Quotes from the *New York Sun* (September 1, 1926) and *New York American* (September 5, 1926).

113. On the Roerichs in the Altai, see Roerich, AH, 334–50; Rerikh, AG/PB, 753–64; Roerich, HoA, 39–42; Fosdik, MU, 257–71; Rosov, NRVZ, 1:214–17; and L. P. Tsesiulevich, "Na Altae," in NKR: zit, 169–85. Note that George omits any mention of this time in *Trails to Inmost Asia*.

114. Roerich, AH, 349–50.

115. Roerich, AH, 349–50.

116. Tsesiulevich, "Na Altae," 176.

117. Roerich, AH, 334–47.

118. Roerich, AH, 335–38.

119. Roerich, HoA, 41–42.

120. Burkhanism is described by Marjorie Mandelstam Balzer, ed., *Shamanic Worlds: Rituals and Lore of Siberia and Central Asia* (Armonk, NY: M. E. Sharpe, 1996), 91, 108, 147; and Lawrence Krader, "A Nativistic Movement in Western Siberia," *American Anthropologist* 58 (April 1956): 282–292.

121. Tsesiulevich, "Na Altae," 176, 181–85.

122. The leading proponent is Shishkin, BzG, 220–25, who, after detailing how many miles per hour an OGPU truck would have to drive to reach Peking in four days, suggests that Roerich also sat down with left-wing members of the Kuomintang, Lev Karakhan (the USSR's ambassador to China),

and Alexander Yegorov (the Soviet military attaché). Even Shishkin admits that Roerich would have had only "a few hours" for all these meetings.

123. As related by Pankratov's pupil, Iu. L. Krol', "B. I. Pankratov," *Strany i narody Vostoka* 26 (1989): 90. Pankratov, a translator at the USSR's Peking embassy, also claimed to have carried out undercover intelligence operations disguised as a Buddhist monk. Andreyev, MotM, 254–55, acknowledges Pankratov's story, but dismisses Shishkin's conclusions and believes that the meeting referred to by Pankratov took place in 1934. Znamenski, *Red Shambhala*, 195, also doubts this story, but feels "one cannot totally exclude" it.

124. G. V. B. Gillan quoted in a letter from the British Foreign Office to the US Embassy in London, November 9, 1926. NARA, 031.11 R62.

125. IOLR 1145, 171–72, 401–4, 498.

126. IOLR 1145, March 27, 1930; and IOLR 1146, 147–52. Heron, "Chintamini," 20–23, notes British suspicions about the uncorroborated Sverdlovsk detour. While it is possible Roerich stopped in Sverdlovsk en route to the Altai, he definitely did not travel to Leningrad, and it was this inconsistency that particularly vexed the British.

127. Stephen Gaselee to William H. Taylor, July 8, 1927. NARA, 031.11 R62.

128. Nelson T. Johnson to Leland Harrison, January 13, 1927, answering Harrison's letter of January 8, 1927. NARA, 031.11 R62.

129. Fosdik, MU, 265.

130. Fosdik, MU, 270–71.

131. Snelling, *Buddhism in Russia*, 230; and Heron, "Chintamini."

132. AVP RF, f. 8/08, op. 9, port. 101, pap. 19, ll. 19–20. Cited in Rosov, NRVZ, 1:47. Nikiforov belonged to the minority among Soviet officials willing to attempt returning the Panchen to Tibet, so it was on grounds of trustworthiness, not policy, that he doubted Roerich.

133. AVP RF, f. 04, op. 13, p. 87, d. 50117, l. 14, cited by Andreyev, MotM, 201.

134. On Trilisser contra Kozlov, see Aleksandr I.

Andreev, *Ot Baikala do sviashchennoi Lkhasy* (Samara: Agni, 1997), 333–34.

135. Roerich, HoA, 118. George Roerich, TtIA, 154, makes the observation about Sukhe-Bator's troops, but does not place the same significance on the song that his father did.

136. George Roerich, TtIA, 359–61.

137. Riabinin, RT, 183; and Meyer and Brysac, *Tournament of Shadows*, 468–69.

138. Roerich, HoA, 2–3; Nicholas Roerich, *Shambhala the Resplendent* (New York: Nicholas Roerich Museum, 1978 [orig. 1930]), 163–64.

139. Andreyev, MotM, 260.

140. C. R. Bawden, *The Modern History of Mongolia* (London: Kegan Paul, 1989), 286; Michael Jerryson, *Mongolian Buddhism: The Rise and Fall of the Sangha* (Chiang Mai: Silkworm Books, 2007), 43–56, 196–98; Andreyev, *Soviet Russia and Tibet*, 45–51; and Andreyev, MotM, 256–66. Andreyev notes Jamtsarano's friendly disposition toward Roerich and his receptivity to the artist's talk of Shambhala, but remains agnostic on whether the two knew each other before the revolution.

141. Roerich, AH, 353. Khirva was named as a coconspirator in Barchenko's 1937 confession, and Oleg Shishkin, among others, has argued that he, like Roerich, belonged to Barchenko's Martinist circle before 1917.

142. Rosov, "Velikii Vsadnik."

143. Quotations from *Osnovy Buddizma*, taken from Rosov, NRVZ, 1:167.

144. *Obshchina* (Moscow: MTsR, 2004), 42, reproducing the 1927 version.

145. M. L. Dubaev, *Kharbinskaia taina Rerikha* (Moscow: Sfera, 2001), 343–48.

146. Fosdik, MU, 275. The event was covered in *Izvestiia* [Ulaanbaatar] (March 18, 1927).

147. Andreyev, *Soviet Russia and Tibet*, 308–9; Znamenski, *Red Shambhala*, 254; and Fosdik, MU, 272–82. In 1925, Bliumkin tried to attach himself to Alexander Barchenko's Tibet expedition. Barchenko rejected him, and the expedition never took place in any event. In April 1927, Bliumkin left Ulaanbaatar

for a short time and asked Roerich not to leave until he got back, raising the question of whether the agent hoped to join Roerich's venture. Nikiforov, no friend of Bliumkin's, sent Roerich on his way before the spy returned.

148. Portniagin, ST, 16, 22; Rosov, 1:42–45, citing AVP RF, f. 0111, op. 10, pap. 5, port. 4, inv. 013, l. 10; and ACRC, Roerich Folders, folder 145.

149. Andreyev, MotM, 281–83. This did not constitute the granting of citizenship, although British and American authorities continued to wonder after the Roerichs' return whether this had indeed happened.

150. On this stage of the Beluha talks, see GARF, f. 8350, op. 1, d. 729. Andreyev, MotM, 278–79, describes Trilisser's attitude toward the Roerichs' occultism (he was convincing enough that Sina considered him "Our Friend"). "Ur" was short for Uriankhai, a Mongol term for the people of Tuva and the Altai, and the name used administratively for the region by the late tsarist regime. Tuva existed between 1921 and 1944 as a nominally independent republic, but was recognized as such only by Mongolia and the USSR.

151. GARF, f. 8350, op. 1, d. 729, l. 110, inventories what the Lichtmanns brought. In TtIA, George Roerich gives March 28 as the date of their arrival.

152. See Riabinin's foreword to RT, 27–36. As noted in chapter 6, those who suspect Roerich of belonging to a Martinist circle before 1917 believe as well that Riabinin was part of it.

153. George Roerich, TtIA, 172–73; see also Portniagin, ST, passim.

154. Portniagin, ST, 25; George Roerich, TtIA, 264–65; Meyer and Brysac, Tournament of Shadows, 468–69; and Andreyev, MotM, 295–96. This shipment, which Chimpa set out to deliver in 1926, consisted of a hundred Soviet rifles, purchased by the Tibetan Donyer Lobzang Cholden. When Chimpa fell ill, members of his first caravan stole most of the rifles while he recuperated.

155. Erikh Gollerbakh, "Sud'ba Rerikha,"

Krasnaia gazeta [Leningrad] (September 6, 1926), cited by Andreyev, MotM, 248–49.

156. On Lunacharsky, see Sina's Mongolian diary, cited in Rosov, 1:162. "Lenin's spirit" from HRD, vol. 24 (April 24, 1927).

157. Portniagin, ST, 15.

158. Riabinin, RT, 107–20, 207–9, 355–56; and Portniagin, ST, 103.

159. Roerich, AH, 356.

160. George Roerich, TtIA, 208.

161. Robert Rupen, "Mongolia, Tibet, and Buddhism or, A Tale of Two Roerichs," Canada-Mongolia Review 5 (April 1979): 25.

162. V. A. Rosov, "Man'chzhurskaia ekspeditsiia N. K. Rerikha: v poiskakh 'Novoi Strany,'" Ariavarta 3 (1999): 26; and Hopkirk, Foreign Devils, 32–43, 82–87.

163. HRD, vol. 20 (April 28, 1924). See also Rerikh, LD, 2:279–81.

164. GARF, f. 8350, op. 1, d. 729, ll. 68–71; d. 970, ll. 1–2.

165. GARF, f. 8350, op. 1, d. 729, ll. 68–71.

166. ELD #5 (April 14, 1930) ("insulted"); ELD # 6 (July 3, 1930) ("suspicions").

167. On Narkomindel's objections, voiced by Lev Karakhan, see GARF, f. 8350, op. 1, d. 731, l. 7. On the Academy of Sciences, see GARF, f. 8350, op. 1, d. 729, ll. 185–86.

168. "Tired" comment from Sina in June 1927, cited by Rosov, NRVZ, 1:194.

169. HRD, vol. 24 (August 4, 1927).

170. HRD, vol. 24 (August 24, 1927). Similar messages arrived throughout September (HRD, vol. 25).

171. Kordashevskii, TiS, 1–77, describes the colonel's journey from Europe to China.

172. Roerich, AH, 361–62; Riabinin, RT, 328–30; Kordashevskii, TiS, 80–81; and Portniagin, ST, 27.

173. ELD #5 (May 26, 1930).

174. GARF, f. 5446, op. 32, d. 39, l. 46, cited by Shishkin, BzG, 247–60.

175. Portniagin, ST, 27–29; and Kordashevskii, TiS, 79–89.

176. George Roerich, TtIA, 272–75; and Kordashevskii, TiS, 119–22.

177. Translated with variations by Donald S. Lopez Jr., *Prisoners of Shangri-La: Tibetan Buddhism and the West* (Chicago: University of Chicago Press, 1998), 2; and Peter Bishop, *Dreams of Power: Tibetan Buddhism and the Western Imagination* (London: Athlone, 1992), 14.

178. Roerich's comments cited in Riabinin, RT, 487, 621–22; and Portniagin, ST, 61.

179. George Roerich, TtIA, 285.

180. IOLR 1145, 356.

181. IOLR 1145, 306–7.

182. Riabinin, RT, 379–82, 424, 443.

183. Portniagin, ST, 53, referring to a November 8 conversation.

184. Kordashevskii, TiS, 168.

185. ELD #5 (April 28, 1930, and May 18, 1930).

186. Meyer and Brysac, *Tournament of Shadows*, 470.

187. Portniagin, ST, 63–64.

188. Kordashevskii, TiS, 224, alludes to this discussion, and Chapchaev, from whose report the quotation comes, described it to his superiors in Moscow (RGASPI, f. 89, op. 4, d. 162, l. 144, cited by Andreyev, *Soviet Russia and Tibet*, 315–16). Returning to Ulaanbaatar, Chapchaev heard that Roerich was stranded at Chu-nar-gen and tried to meet him there—but by that time the Roerichs had moved to Sharugön.

189. Helena described Riabinin's and Kordashevsky's behavior to Sina; see Fosdik, MU, 285–89, 297–98, 302–3, 312–13, 368–71, 387–88. On Golubin, see Kordashevskii, TiS, 176–80.

190. Roerich, AH, 367.

191. Portniagin, ST, 56.

192. Riabinin, RT, 337–38; Portniagin, ST, 44; Roerich, AH, 335–36, 373–75; and Roerich, HoA, 70–71.

193. Roerich, AH, 378–82; and Kordashevskii, TiS, 191–92.

194. Riabinin, RT, 455–58.

195. Portniagin, ST, 73. See also Kordashevskii, TiS, 250–65, 297–313; Riabinin, RT, 363–69, 451–53, 611–12; and Roerich, *Shambhala the Resplendent*, 43–64.

196. Portniagin, ST, 86; Kordashevskii, TiS, uses the English phrase "great fleet" throughout his final chapters.

197. Roerich, HoA, 70–71. See also Roerich, AH, 374; and George Roerich, TtIA, 415–16. Both remark on Do-ring's and Carnac's physical similarities, but George does not endorse his father's views about tangible cultural connections between them.

198. *Philadelphia Inquirer* (August 22, 1928); *New York Herald* (August 25, 1928); and *Los Angeles Times* (August 22, 1928).

199. Kordashevskii, TiS, 285–87.

200. Kordashevskii, TiS, 315. See also ELD #1 (multiple entries from April and May 1929) and ELD #5 (May 21, 1930).

201. George Roerich, TtIA, 441.

202. George Roerich, TtIA, 442–44; and Kordashevskii, TiS, 303–5.

203. George Roerich, TtIA, 488–89.

204. Reproduced in Roerich, AH, vii.

205. *New York Times* (May 25, 1928).

206. Report by Colonel F. M. Bailey, May 26, 1928, and related documents. IOLR 1145, 350, 356, 405–7.

207. Dated May 15, 1928, and cited in Meyer and Brysac, *Tournament of Shadows*, 472.

208. IOLR L/P&S/10/1046, cited in Meyer and Brysac, *Tournament of Shadows*, 472.

209. Riabinin, RT, 5–25, 675–86. On Portniagin, see L. V. Peshkova's afterword to ST, 107–14.

210. Rosov, NRVZ, 1:212; and Veronica Shapovalov, *Remembering the Darkness: Women in Soviet Prisons* (Lanham, MD: Rowman and Littlefield, 2001), 144n30.

Chapter 12: The Silver Valley, 1928–1930

1. IOLR 1145, 398–99.

2. Report of M. J. Clauson, June 2, 1928. IOLR 1145, 429.

3. On August 16, 1928, the GOI's intelligence

bureau admitted that "it is still impossible to decide whether the Professor is a Bolshevik." IOLR 1145, 363.

4. *London Times* (June 13, 1928). Roerich's letter to the Manhattan Buddhist Center was sent in July. See also *Time* (July 23, 1928); and Fosdik, MU, 375–76.

5. Roerich's demands, as well as Tibet's correspondence with the British as to how to address them (the British advised Lhasa to tell Roerich that he had been treated no differently than any other traveler arriving from the north), can be found in IOLR 1145, 299–340.

6. M. J. Clauson report, June 2, 1928.

7. M. J. Clauson report, June 2, 1928.

8. Frances Grant, *Pilgrimage of the Spirit* (privately published by Beata Grant, 1997), 41.

9. Topics of discussion as described by Fosdik, MU, 287, 304–75; and ELD, notebooks #2, 4, and 5.

10. Cited in ELD #6 (November 3, 1930).

11. Fosdik, MU, 405, 409, 419; and multiple entries from ELD #A and #2.

12. ELD, #A (October 20, 1928). On reactions to Stalin, see Fosdik, MU, 315, 390; and ELD, #A (multiple items).

13. ELD, #A (October 27, 1928).

14. Fosdik, MU, 404, 415.

15. Fosdik, MU, 350, 356, 368–69, 396–97, 419, for all anecdotes in this paragraph.

16. Letter signed by Roerich on August 29, 1928. ACRC, Roerich Folders, folder 128.

17. FRGP, January 30, 1941, testimonial, 15. Estimates of the expedition's cost are in ACRC, Roerich Folders, folder 128, 132; and NARA, 031.11 R62.

18. The charter application lists the Horches, the Lichtmann family (including Sophie and Esther), and Grant, along with "associates" (ACRC, Roerich Scrapbook Xeroxes [1930s]).

19. On Peel's decision, see IOLR 1145, 294. For Roerich's perspective, see Fosdik, MU, 335–43; and the memorandum Roerich sent to the US State Department in the summer of 1929, when the British

blocked the final state of his transaction with the Maharajah (NARA, 031.11 R62).

20. H. G. Haig to N. Roerich, January 15, 1929. Copy sent to US State Department (NARA, 031.11 R62).

21. Cited in Nicholas Roerich, *Shambhala the Resplendent* (New York: Nicholas Roerich Museum, 1978 [orig. 1930]), 302. Invitations to Hoover and his officials are in ACRC, Roerich Scrapbook Xeroxes (1930s). Already in November 1928, Horch had reached out to Hoover with a post-election letter of congratulations.

22. Roerich, Nicholas K., Archive of the Federal Bureau of Investigation [hereafter FBI/Roerich]. Accessed via the Freedom of Information Act. The attorney general's inquiry reached Hoover's desk in January 1929; Appel visited the Roerich Museum in early February.

23. See I. V. Nest'ev, *Zvezdy russkoi estrady* (Moscow: Sovetskii kompozitor, 1974), 94–95, 100–104, as well as Russian émigré newspapers such as *Novaia Zaria* and *Rassvet*. On Plevitskaya, who toured the United States from January 1926 to April 1927 (including her Master Institute performance) and, with her husband, the White general Nikolai Skoblin, spied on Russian émigrés for Stalin—also aiding in the 1937 kidnapping of the White commander Yevgeny Miller—see Pamela A. Jordan, *Stalin's Singing Spy: The Life and Exile of Nadezhda Plevitskaya* (Lanham, MD: Rowman and Littlefield, 2016).

24. Programs and press clippings related to such activites are in ACRC, Roerich Scrapbook (1925–1936); and FRGP, box 14. Newspapers in many cities devoted attention to them, as did P. Kempf, "America's Businessmen Are Turning to Art as Recreation," *Musician* 31 (October 1926): 13. On Sing Sing and Leavenworth, see the *Boston Evening Globe* (April 26, 1927), *Philadelphia Inquirer* (April 24, 1927), *New York Sun* (May 2, 1927), *New York Tribune* (May 2, 1927), and *Chicago Evening Post* (May 31, 1927).

25. FRGP, testimonial of January 30, 1941.

26. *New York Times* (October 29, 1994; January 29, 1995); "Roerich Museum and Master Apartment

Building," *Architectural Record* 66 (December 1929): 509–18, 527–35. At the time of construction, the magazine *Architecture* dismissed the building's corner windows as "a gimmick." All quotations in the following paragraphs found in ACRC, Roerich Folders, folder 125.

27. Correspondence with potential donors is in ACRC, Roerich Scrapbook Xeroxes (1930s).

28. ACRC, Roerich Folders, folder 139.

29. A firm answer as to whether Roerich met FDR in person, either in 1929–1930 or in 1934, remains elusive. In 1933–1934, Roerich was angered by FDR's diplomatic recognition of the USSR, and according to Helena's journals and Sina's diaries, refused to meet him during this interlude, even while seeking the president's approval for the Banner of Peace, and even though Henry Wallace offered to introduce them. This policy difference was not an issue in 1929, during FDR's New York governorship, and FDR's adviser, Samuel Rosenman, attended the Roerich Museum's opening that year. Sumner Welles, in a 1938 exchange with the British ambassador, refers to FDR as having met Roerich, and Henry Wallace attests that the two met and were "affectionate" (Graham White and John Maze, *Henry A. Wallace: His Search for a New World Order* [Chapel Hill: University of North Carolina Press, 1995], 102–3). John Culver and John Hyde, *American Dreamer: A Life of Henry A. Wallace* (New York: W. W. Norton, 2000), 136–37; and Jonathan Alter, *The Defining Moment: FDR's Hundred Days and the Triumph of Hope* (New York: Simon and Schuster, 2006), 282–83, also maintain that the two met. Roerich-related papers cannot be entirely trusted on this matter. For example, Fosdik, MU, 436, contains an entry from June 1929, "foretelling" that the Roosevelts would someday "prove to be dangerous"—a development no one could have predicted in 1929—and showing every sign of having been retroactively inserted in the late 1930s, when the Roerichs were at odds with FDR.

30. Fosdik, MU, 425–27, 437–39. Roerich worried that this faux pas "might cost us our connection with the White House!" Also, when his painting arrived at the White House, it had to be refused, because it had been insured at a value greater than the $10,000 limit on presidential gifts. By declaring it to have no monetary value, the Roerich Museum successfully re-sent it in November; Roerich also gave Hoover a copy of *Shambhala* in 1930.

31. The temptation to credit Roerich's journey as inspiring *Lost Horizon* is understandable, but probably misguided. Edwin Bernbaum, *The Way to Shambhala: A Search for the Mythical Kingdom beyond the Himalayas* (Boston: Shambhala, 2001), 21, makes the link without hesitation, and he is followed (with more caution) by Karl E. Meyer and Shareen Blair Brysac, *Tournament of Shadows: The Great Game and the Race for Empire in Central Asia* (Washington, DC: Counterpoint, 1999), 454; and Mitch Horowitz, *Occult America: White House Séances, Ouija Circles, Masons, and the Secret Mystic History of Our Nation* (New York: Bantam, 2009), 170–75. However, Roerich was by no means the sole—or best-known—traveler to Tibet during these years, and it is well established that Hilton drew on older versions of the Shambhala myth, dating to the 1600s, in creating his fictional realm of Shangri-La. Moreover, he is known to have paid special attention to the Asian wanderings of the Austrian ethnographer-botanist Joseph Rock, whose influence on Hilton likely exceeds Roerich's. See Michael Wood, *In Search of Myths and Heroes* (Berkeley: University of California Press, 2005), 12, 18–19, 76–77; and Dany Savelli, "Shambhala de-ci, de-là: syncrétisme ou appropriation de la religion de l'Autre?" *Slavica Occitania* 29 (2009): 321.

32. FRGP, MC 671, box 14, folder, 24, on the Reuters report; and *Literary Digest* 98 (September 1, 1928): 24–25.

33. Herbert Corey, "An Artist of Mystery," *Kansas City Star* (July 8, 1929). See also Fosdik, MU, 426–27, 450, regarding articles that Roerich disliked.

34. *Time* (July 1, 1929). The magazine had taken a similar tone when Roerich returned to India from Tibet; see *Time* (September 3, 1928).

35. Fosdik, MU, 460.

36. On Roerich's disappointments with Corbett and the Master Building, see ELD #1 (May 4, 1929); and Fosdik, MU, 379, 425–26, 455, 478, 483.

37. Fosdik, MU, 446–47, 491–92 ("infection"). Multiple passages from Fosdik, MU, 442–83, convey the agony Sina felt regarding Esther's growing influence; conversely, Esther rejoices in her growing closeness to Helena from May through September 1929 in ELD #1–3. On the failure to organize lecture tours, see Fosdik, MU, 430–38. The William Feakins publicity firm was to arrange talks for Nicholas and George, but Roerich canceled most of these when Feakins charged $200 up front; he then asked Robert Harshe of the Chicago Art Institute whether any possibilities existed there, but was told "no" in July.

38. Fosdik, MU, 440.

39. Fosdik, MU, 454.

40. Fosdik, MU, 456, 466. As related to me by Oriole Farb Feshbach on October 17, 2006, Roerich repeated this feat in Louis's study in the new Master Building, where the Horches felt they would be able to prevent any trickery. Even after his falling-out with Roerich, Horch remained mystified by the event.

41. ELD #2 (July 24, 1929).

42. IOLR 1145, 345 (William Peel to the British Home Secretary about Roerich as "rather cranky"); IOLR 1145, 260–61 (Howard seeking advice from the Foreign Office about Roerich's possibly "embarrassing visit").

43. Joseph Cotton to Esme Howard, August 10, 1929. NARA, 031.11 R62, 17½.

44. IOLR 1145, 321–25.

45. ACRC, Roerich Folders, folder 132.

46. Fosdik, MU, 490–92. In Russian, Roerich used the term "baroness," rather than "princess," but the connotation is the same. See also Fosdik, MU, 288, 292, 317, 333, 396, 441, 443, 446.

47. ELD #1 (April 29, 1929).

48. See Fosdik, MU, 503–8, on Oriole's death and funeral.

49. ELD #4 (November 12, 1929).

50. Fosdik, MU, 508; and interview with Oriole Farb Feshbach, October 17, 2006. Nettie also gave the younger Oriole the middle name Helena, in honor of Mmes. Roerich and Blavatsky.

51. Fosdik, MU, 761, calls Rambova one of Svetik's "flames," as does Oriole Farb Feshbach (interview of October 17, 2006). For more, see Michael Morris, *Madam Valentino: The Many Lives of Natacha Rambova* (New York: Abbeville, 1991).

52. Interviews with staff at the NRM in August 2009, and with Oriole Farb Feshbach (October 17, 2006).

53. Fosdik, MU, 439, 483, 506, 537; ACRC, Roerich Data and Personal Data (manila folder), for the unsigned certificate naming Roerich a Chevalier of the US division of the order (November 18, 1929). The Rosicrucian leader Gary Stewart confirms that Roerich never joined (Markus Osterrieder, "From Synarchy to Shambhala: The Role of Political Occultism and Social Messianism in the Activities of Nicholas Roerich," in *The New Age of Russia: Occult and Esoteric Dimensions*, ed. Birgit Menzel, Bernice G. Rosenthal, and Michael Hagemeister [Munich: Kubon & Sagner, 2012], 116).

54. Alice Bailey, like Helena Roerich, had broken with the Theosophical Society, but claimed psychic communion with Koot Hoomi. Prince Alexei hoped to publish his *The Religion of Love* with the Roerich Museum Press, but went instead with Century in 1929. On Roerich's dealings with both, see Fosdik, MU, 514, 537–38, 553–54, 566–68.

55. Fosdik, MU, 526, 568, 583. Starting in January 1930, Kettner and the Biosophists took up residence in the Master Building, where they remained for the rest of the decade.

56. *New York Times* (July 4, 1926).

57. Cited in *Oktiabr'* 10 (1960): 231. See also Esther Lichtmann, on hearing rumors that the Roerichs had not visited every place they claimed to in *Altai-Himalaya*: "One can only smile and say that they were in many more places than spoken of in *Altai-Himalaya*" (ELD #6 [July 5, 1930]).

58. Robert Norwood, *Issa* (New York: Charles Scribner's, 1931).

59. Roerich, AH, 83.

60. As Charles P. Pierce, *Idiot America: How Stupidity Became a Virtue in the Land of the Free* (New York: Anchor Books, 2010), 54, says of Ignatius Donnelly, whose 1882 bestseller *Atlantis* propagated some of our own era's more fanciful but enduring theories about antiquity, the "pseudoscience . . . so gleams with the author's erudition that you don't notice at first that none of it makes any sense." Similarly, see Michael Gordin, *The Pseudoscience Wars: Immanuel Velikovsky and the Birth of the Modern Fringe* (Chicago: University of Chicago Press, 2012).

61. ELD #1 (entries from 1929 on Crane and Platon). On October 11, 1933, the London *Times* ("Soviet 'Museum Wreckers'") reported on the trial of Fyodor Maslov, who, as director of the Leningrad Art Institute, was said to have destroyed many of Roerich's paintings in 1929–1930 as part of an extremist campaign against art deemed "ideolog[ically] harmful." After 1932, the Kremlin found Maslov's zeal excessive, and Roerich remembered him with rage for the rest of his life (Rerikh, LD, 2:370–71, 419–20, 458). Soviet perceptions of Roerich were not universally negative in 1929–1930; in an article about the Bakhrushin Museum of theater art, *Literaturnaia gazeta* (December 9, 1929) described his designs as "interesting," and a profile about Alexander Golovin in *Ogonek* (May 10, 1930) called the artist's portrait of Roerich "monumental."

62. ELD #2 (August 15, 1929); and Fosdik, MU, 477–81, 487.

63. Fosdik, MU, 474–75, 515–16, counted approximately 5,000 in attendance, with 700 present for the formal ceremonies. The museum publicly claimed 10,000 visitors; see ELD #3 (October 18, 1929) and Frances Grant's letter of October 25, 1929, to Henry Wallace (Culver and Hyde, *American Dreamer*, 133).

64. Cited in Ruth Abrams Drayer, *Wayfarers: The Spiritual Journeys of Nicholas and Helena Roerich* (La Mesilla, NM: Jewels of Light, 2003), 218.

65. Fosdik, MU, 515.

66. *Time* (October 28, 1929).

67. *New York Evening Post* (October 26, 1929); and *New Yorker* (November 9, 1929). Of similar opinion was *Art Digest* (November 1, 1929).

68. Arthur Strawn, "Edifice Rex," *Outlook* (December 11, 1929): 524.

69. Cited in Drayer, *Wayfarers*, 219–21.

70. ACRC, Roerich Scrapbook (1925–1936), folder 40. Compare this with the 8,207 visitors the older museum welcomed between October 1, 1927, and May 31, 1928 (ACRC, Roerich Scrapbook Xeroxes [1930s]). In its first two years of operation, the new museum recorded a total of 241,097 visitors. This contrasts with the inflated total of 2.4 million" in "the first year" claimed by sympathetic biographers like Drayer, *Wayfarers*, 231.

71. Undated draft, NRM archives. For Horch's assistance with this application, see ACRC, Roerich Scrapbook Xeroxes (1930s).

72. In Fosdik, MU, 506–604, Sina regularly refers to valerian intake (and Sviatoslav's lithium) between September 1929 and April 1930.

73. Fosdik, MU, 599–601; and *Art News* (April 5, 1930): 31.

74. Fosdik, MU, 601.

75. NARA, 504.418 B1, 13.

76. NARA, 504.418 B1, 17.

77. *New York Times* (March 11, 1930); also Nicholas Roerich, *Realm of Light* (New York: Roerich Museum Press, 1931)], 100–103.

78. *New York Times* (March 16, 1930); see also Rerikh, LD, 1:539–40.

79. On Blavatsky and this symbol, see Anita Stasulane, *Theosophy and Culture: Nicholas Roerich* (Rome: Pontifica università gregoriana, 2005), 220; and Sylvia Cranston, *HPB: The Extraordinary Life and Influence of Helena Blavatsky, Founder of the Theosophical Movement* (New York: Tarcher/Putnam, 1993), 138.

80. For the Dalton text, see Roerich, *Realm of Light*, 26–35.

81. Fosdik, MU, 592–93.

82. N. K. Rerikh, "Venok Diagilevu," in I. S.

Zil'bershtein and V. A. Samkov, eds., *Sergei Diagilev i russkoe iskusstvo.* 2 vols. (Moscow: Izobrazitel'noe iskusstvo, 1982), 2:325–27, 508–9. Translated ungrammatically as "A Wreath of Diaghileff," in Roerich, *Realm of Light*, 319–24; originally published in spring 1930 by the *Journal of the League of Composers.*

83. Roerich, "Sacre," *Realm of Light*, 185–91.

84. *Time* (April 28, 1930).

85. Memorandum of December 27, 1929, from Prentiss Gilbert of the Division of Western European Affairs, US Department of State. NARA, 031.11 R62, 27.

86. Memorandum of January 8, 1930, NARA, 031.11 R62, 29; Prentiss Gilbert to Ray Atherton of the US Embassy in London, January 11, 1930, NARA, 031.11 R62, 31 (mislabeled as page 30).

87. Nicholas Shoumatoff and Nina Shoumatoff, eds., *Around the Roof of the World* (Ann Arbor: University of Michigan Press, 1996), 13, 26–34, 199.

88. Ray Atherton of the US Embassy in London, in a "strictly confidential" memorandum of March 17, 1930, to the US Department of State. NARA, 031.11 R62, 36.

89. NARA, 031.11 R62, 44, 52, 54, 55, 58, 60, 61.

90. IOLR 1145, P. 2915, P. 1826.

91. Memorandum of June 21, 1930. IOLR 1145, P. 4139.

92. IOLR 1145, P. 3262.

93. NA RG 59, 031.11 R62, 115.

94. Reuters (July 21, 1930); *New York Times* (July 18, 1930); and *New York Times* (August 3, 1930).

95. Platon's letter of July 1930. IOLR 1145, P. 5978.

96. Multiple entries in ELD #6.

97. Nicholas Roerich to Herbert Hoover, July 24, 1930. NARA, 031.11 R62, 103.

98. Walter Edge to William Castle, September 8, 1930. NARA, 031.11 R62, 120.

99. NARA, 031.11 R62, 115.

100. NARA, 031.11 R62, 74.

101. R. C. Bannerman to William Castle, July 22, 1930. NARA, 031.11 R62, 87.

102. Castle's comments repeated in an India Office document from August 1, 1930 (IOLR 1145, P. 5978).

103. William Castle to J. Theodore Marriner, July 16, 1930. NARA, 031.11 R62, 86.

104. Henry Stimson to the US Embassy in London, July 28, 1930. NARA, 031.11 R62, 79.

105. Stephen Gaselee to J. C. Walton, August 9, 1930. IOLR 1145, P. 5978.

106. ELD #6 (August 15, 1930).

107. NARA, 031.11 R62, 126, containing letters by Esther Lichtmann forwarded to the State Department.

108. Andreyev, MotM, 353. Lapeyre diagnosed Helena with "cardiac neurosis," an ailment supposedly shared by spiritually sensitive sufferers like Catherine of Siena and Teresa of Avila [ELD #7 (November 29, 1930)].

109. ELD #7 (January 14, 1931) (ambassador's comment); and IOLR 1146, 62–64 ("misbehave").

110. Memo of December 6, 1930. NARA, 031.11 R62, 142½.

111. ELD #7 (December 11, 1930).

Chapter 13: The Banner of Peace, 1931–1934

1. ACRC, Roerich Scrapbook (1925–1936), folder 91.

2. ELD #6 (October 25–26, 1930).

3. On Pool, see ELD #6 (September 9, 1930). Schomberg's comments are found in IOLR 1145, P. 5978 (August 3, 1930).

4. G. F. Waugh to R. Y. Jarvis, October 30, 1930. NARA, 031.11 R62, 128½.

5. George Orwell, *Burmese Days* (New York: Time, 1962), 28.

6. Penelope Chetwode, *Kulu: The End of the Habitable World* (London: John Murray, 1972), 155.

7. Cited in Bikash Chakravarti, ed., *Poets to a Poet, 1912–1940* (Calcutta: Visva-Bharati, 1998), 271–72. The friend in question, the Quaker poet Basil Bunting, ended up instead with a job as a *London Times* correspondent.

8. See Frances Grant's correspondence with Campbell in FRGP, box 14.

9. H. P. Lovecraft to James F. Morton, March 1937, in *The New Annotated H. P. Lovecraft*, ed. Leslie Klinger (New York: W. W. Norton, 2014), 463. See also Philip Shreffler, *The H. P. Lovecraft Companion* (Westport, CT: Greenwood, 1977); Peter Cannon, *H. P. Lovecraft* (Boston: Twayne, 1989); and S. T. Joshi, *I Am Providence: The Life and Times of H. P. Lovecraft* (New York: Hippocampus, 2013).

10. H. P. Lovecraft, *At the Mountains of Madness* (New York: Modern Library, 2005), 7.

11. Isamu Noguchi, *A Sculptor's World* (New York: Harper and Row, 1968), 19. Matthew Spender, *From a High Place: A Life of Arshile Gorky* (New York: Knopf, 1999), 79, relates Noguchi's 1989 conversation with Gorky's daughter Maro about the Roerich Museum ("spooky" and "other side" quotes).

12. ELD #7 (February 17–18, 1931). Esther considered this assessment a sign of disloyalty.

13. Charles Hanson Towne, "Books and Things," *America* (April 10, 1931).

14. Financial details from Fosdik, MU, 614, 633; ACRC Roerich Folders, folders 120, 132, 139; and FRGP, "Frances Grant: History," 19–22.

15. "Roerich Museum Loses on Appeal," *New York Evening Post* (December 30, 1932); and *Time* (April 18, 1932).

16. ELD #9 (March 3, 1934).

17. Nicholas Roerich, *Realm of Light* (New York: Roerich Museum Press, 1931), 5.

18. V. A. Rosov, *Seminarium Kondakovianum: Khronika reorganizatsii v pis'makh (1929–1932)* (Saint Petersburg, 1999); L. H. Rhinelander, "Exiled Russian Scholars in Prague: The Kondakov Seminar and Institute," *Canadian Slavonic Papers* 16, no. 3 (Fall 1974): 331–52; and KI-8, KI-15, KI-27, in the Archive of the Institute of Art History of the Academy of Sciences of the Czech Republic (AUDU AV ČR).

19. *Illustrated Weekly of India* (August 23, 1931).

20. As discussed by Roerich with Baron Taube in January 1932 (BAR MsColl/Taube, M. A., box 1).

21. NARA, 031.11 R62, 92.

22. NARA, 031.11 R62, 92.

23. NARA, 031.11 R62, 34–35.

24. IOLR 1145, P. 5978.

25. As noted in E. D. Merrill, "Exhibit of Specimens of Himalayan Flora at the Roerich Museum," *Science* 74, no. 193 (December 25, 1931): 649; and E. D. Merrill, "Cooperation with the Roerich Museum," *Journal of the New York Botanical Garden* 33, no. 386 (February 1932): 21–23.

26. ELD #6 (June 21, 1930), and other entries from ELD #5 and #6.

27. NARA, 031.11 R62, 166.

28. See letters in KI-15, AUDU AV ČR, particularly A. P. Kalitinskii to N. P. Toll', November 9, 1931.

29. Cited in Rosov, *Seminarium Kondakovianum*, 49–50.

30. Fosdik, MU, 611.

31. *New York Times* (September 11, 1931).

32. FRGP, box 14, folder 2, on Buck. Roosevelt quotation from ACRC, Roerich Scrapbook Xeroxes (1930s). See also Robert C. Williams, *Russian Art and American Money: 1900–1940* (Cambridge, MA: Harvard University Press, 1980), 135; and John Culver and John Hyde, *American Dreamer: A Life of Henry A. Wallace* (New York: W. W. Norton, 2000), 132.

33. ELD #7 (February 26, 1931) on Einstein's supposed comment to Viereck.

34. Lotus Dudley to Nicholas Roerich, December 30, 1931, BAR MsColl/Taube, M. A., box 4, folder 7. Among the several errors Dudley pointed out was Grant's mistaken assertion in the *Bulletin* that the French government had awarded Roerich the coveted Legion of Honor for organizing the Bruges Conference of 1931.

35. Marie de Vaux-Phalipau to M. A. Taube, December 31, 1931, BAR MsColl/Taube, M. A., box 4, folder 7.

36. Frances Grant to Lotus Dudley, January 18, 1932, BAR MsColl/Taube, M. A., box 4, folder 7.

37. M. A. Taube to N. K. Rerikh, November 1, 1932, BAR MsColl/Taube, M. A., box 1.

38. Crane met with Chiang Kai-shek in the fall of 1931, presenting him with books and gifts

from Roerich (Rosov, NRVZ, 1:39). Further correspondence over the next few months was handled by H. H. Kung of the Chinese Ministry of Industry.

39. Roerich's letters to M. A. Taube and Elena Miller in BAR MsColl/Taube, M. A. box 1, and MsColl/E. A. Miller; and L. A. Mnukhin, ed., *Russkoe zarubezh'e: khronika nauchnoi, kul'turnoi i obshchestvennoi zhizni 1920–1940 Frantsiia* (Paris: YMCA, 1995–1997), 2:233, 238, 293, 363. Indispensable sources on ROVS include Paul Robinson, *The White Russian Army in Exile, 1920–1941* (Oxford: Clarendon Press, 2002); and Pamela A. Jordan, *Stalin's Singing Spy: The Life and Exile of Nadezhda Plevitskaya* (Lanham, MD: Rowman and Littlefield, 2016).

40. M. A. Taube to Esther Lichtmann, December 21, 1931, and Lichtmann's reply of February 5, 1932, in BAR MsColl/Taube, M. A., box 4, folder 7.

41. Cited in Charles J. Errico and J. Samuel Walker, "The New Deal and the Guru," *American Heritage* 40 (March 1989): 93.

42. Grant describes this moment in "Henry Wallace's First Visit to the Roerich Museum," FRGP, box 14, folder 82; and Rosov, NRVZ, 2:100. She dates it to "the late twenties"; Rosov calculates that it took place in April 1927, while Errico and Walker, "New Deal and the Guru," guess at 1928. On Wallace and Roerich, see also Karl E. Meyer and Shareen Blair Brysac, *Tournament of Shadows: The Great Game and the Race for Empire in Central Asia* (Washington, DC: Counterpoint, 1999); Culver and Hyde, *American Dreamer*; Graham White and John Maze, *Henry A. Wallace: His Search for a New World Order* [Chapel Hill: University of North Carolina Press, 1995]; Philip Jenkins, *Mystics and Messiahs: Cults and New Religions in American History* (New York: Oxford University Press, 2000), 162; David Kennedy, *Freedom from Fear: The American People in Depression and War, 1929–1945* (New York: Oxford University Press, 1999), 206; Torbjörn Sirevag, *The Eclipse of the New Deal and the Fall of Vice-President Wallace 1944* (New York: Garland, 1985), 510–16; and

Arthur Schlesinger Jr., *The Coming of the New Deal, 1933–1945* (New York: Mariner, 2003), 30–33, 81.

43. Williams, *Russian Art and American Money*, 136.

44. Franklin D. Roosevelt Presidential Library and Museum, Misc. Documents, box 1 (A–Mc), Guru Corresp. [hereafter FDR Library], letter 172 (March 12, 1933).

45. FDR Library, letter 149 (September 1, 1933).

46. FDR Library, letter 172 (March 12, 1933).

47. When the Fifth Dalai Lama died in 1682, his ministers, fearing instability, kept the fact secret until 1696, and only in 1697 was the Sixth enthroned. On Roerich's fixation with these events, see Alexandre I. Andreyev, *Soviet Russia and Tibet: The Debacle of Secret Diplomacy* (Leiden: Brill, 2003), 295; and Andrei Znamenski, *Red Shambhala: Magic, Prophecy, and Geopolitics in the Heart of Asia* (Wheaton, IL: Quest Books, 2011), 208.

48. A. I. Andreev and Dany Savelli, eds., *Rerikhi: mify i fakty* (Saint Petersburg: Nestor-Istoriia, 2011), 85, 88.

49. Miller cited in Robinson, *White Russian Army in Exile*, 174–78, 214–18.

50. Cable from Charles Crane to Franklin Delano Roosevelt, September 13, 1933, in BAR MsColl/Crane, Charles, box 1, misc. See also Crane's advice to Charles Dodd, FDR's first ambassador to Nazi Germany: "Let Hitler have his way" (cited in Erik Larson, *In the Garden of Beasts: Love, Terror, and an American Family in Hitler's Berlin* [New York: Broadway Books, 2011], 38–39).

51. Charles Crane to Edward M. House, October 21, 1933, in BAR MsColl/Crane, Charles, box 1, misc.

52. Charles Crane to Edward M. House, February 4, 1933, in BAR MsColl/Crane, Charles, box 1, misc. See also Crane's letters to House of December 2, 1932 ("professional Jews"), and May 30, 1933 ("I fear we have been entirely outwitted. With Felix Frankfurter—the very efficient eyes and ears of Brandeis—right in the center of everything, I think [the Jews] are not going to miss many tricks").

53. Charles Crane to D. F. Houston, January 31, 1934, in BAR MsColl/Crane, Charles, box 1, misc.

54. M. A. Taube to N. K. Rerikh, June 19, 1933 (describing the Nazi "risorgimento" as "interesting" but not helpful where the pact was concerned), and August 18, 1933 (on Mussolini), both in BAR MsColl/Taube, M. A., box 1, folder 5. ELD #9 (May 30, 1934) describes Roerich as dismayed by a Mussolini speech declaring "peace is detrimental," and also by Hitler's demand for the return of German colonies.

55. On Roerich's brief openness to working with fascists, see, among others, Andreyev, MotM, 336, 452; and Markus Osterrieder, "From Synarchy to Shambhala: The Role of Political Occultism and Social Messianism in the Activities of Nicholas Roerich," in *The New Age of Russia: Occult and Esoteric Dimensions*, ed. Birgit Menzel, Bernice G. Rosenthal, and Michael Hagemeister (Munich: Kubon & Sagner, 2012), 129. For larger context on Russian émigré cooperation with Nazism—whether reluctant or enthusiastic—see Robinson, *White Russian Army in Exile*, passim. A curious and related note: a classic work of conspiracy-theory literature—Gregory Douglas's *Gestapo Chief: The 1948 Interrogation of Heinrich Müller* (Los Angeles: Bender, 1995), purporting to record the postwar recollections of the Gestapo head Heinrich Müller (believed by most to have perished in 1945, but, in Douglas's telling, brought to America to work for the newly established CIA)—notes Roerich's interest in a German alliance. According to Douglas, "Roerich was known to the Gestapo under the code word 'Lama'" and "had contacted the Nazi regime in 1934 to ascertain whether they were interested in supporting his undertakings." That the Gestapo knew something of Roerich and his intentions may well be true, but serious historical opinion considers Douglas's World War II–surviving, CIA-debriefing "Müller" a fabrication.

56. Fosdik, MU, 609, 649–50, 653.

57. Fosdik, MU, 608–9.

58. Fosdik, MU, 618, 660.

59. *Pittsburgh Press* (February 18, 1934); and *Times Literary Supplement* (February 22, 1934).

60. *New York Times* (December 31, 1933).

61. Unidentified Denver newspaper (February 18, 1934), ACRC, Roerich Scrapbook (1925–1936).

62. Frances Grant to Nicholas Roerich, December 28, 1933, in FRGP, box 14, folder 32.

63. ELD #9 (May 7, 1934), and other entries from March–May 1934.

64. Fosdik, MU, 648.

65. Fosdik, MU, 642–43, 657.

66. Fosdik, MU, 626–27.

67. Fosdik, MU, 656, 663. Sina's diaries provide no explanation for Crane's decision. Although a lull in communications followed between Roerich and Crane for several years, they reestablished contact in mid-1937.

68. Fosdik, MU, 631–32.

69. Fosdik, MU, 631.

70. Frances Grant to Nicholas Roerich, December 28, 1933, FRGP, box 14, folder 32.

71. FRGP, "Frances Grant: History," 27.

72. Fosdik, MU, 631–32.

73. Fosdik, MU, 632–33.

74. Fosdik, MU, 610–13.

75. FDR Library, letter 103–4 (n.d., probably April 1934).

76. Culver and Hyde, *American Dreamer*, 137, citing "Reminiscences of Knowles Ryerson," Special Collections at the University of California at Davis.

77. Culver and Hyde, *American Dreamer*, 137, citing "Reminiscences."

78. Culver and Hyde, *American Dreamer*, 137, citing "Reminiscences."

79. FDR Library, letters 61–69 (n.d., April 1934).

80. Cited in Culver and Hyde, *American Dreamer*, 138.

81. Rosov, NRVZ, 2:19.

82. See, for example, Fosdik, MU, 617–24, 633–34, 646–50; ELD #9 (multiple entries); and FDR Library, letter 110 (n.d., 1934).

83. Fosdik, MU, 617–21.

84. Fosdik, MU, 663.

85. For example, Fosdik, MU, 613, 617, 620–23, 629, 643–44.

86. "Iowa Hybrid," *Time* (August 9, 1948).

87. Morgenthau cited in Meyer and Brysac, *Tournament of Shadows*, 480–81. On their official websites, the US Mint and the Bureau of Engraving and Printing do not mention Roerich's possible role in the 1935 currency redesign (or admit any connection between the Great Seal and Masonic symbology, a link that Masonic societies themselves deny). See also Osterrieder, "From Synarchy to Shambhala," 125–26; Decter, MoB, 100; Williams, *Russian Art and American Money*, 111; Schlesinger, *Coming of the New Deal*, 31–34; and Mitch Horowitz, *Occult America: White House Séances, Ouija Circles, Masons, and the Secret Mystic History of Our Nation* (New York: Bantam, 2009), 168–74.

88. Henry A. Wallace to Cordell Hull, August 31, 1933. NARA, 504.418 B1, 42.

89. Cordell Hull to Henry A. Wallace, September 15, 1933. NARA, 504.418 B1, 66.

90. Henry A. Wallace to Cordell Hull, October 2, 1933. NARA, 031.11 R62, 95.

91. Albert Einstein to Louis Horch, January 29, 1931. ACRC, Roerich Scrapbook Xeroxes (1930s).

92. Cordell Hull to Henry A. Wallace, October 17, 1933. NARA, 504.418 B1, 84.

93. Nicholas Roerich, "Prayer for Peace and Culture," in *Fiery Stronghold* (Boston: Stratford, 1933), 192; and James Brown Scott, text of November 1933 speech reprinted as "The Banner of Peace," *Scholar* (February 1934).

94. See the correspondence in NARA, 504.418 B1.

95. Samuel J. Walker, *Henry A. Wallace and American Foreign Policy* (Westport, CT: Greenwood, 1976), 56–57.

96. Culver and Hyde, *American Dreamer*, 135.

97. Frances Grant to Nicholas Roerich, December 28, 1933, in FRGP, box 14, folder 32.

98. Henry A. Wallace to William Philipps, January 11, 1934, NARA, 504.418 B1, 111–12.

99. Culver and Hyde, *American Dreamer*, 143.

100. ELD #9 (May 9, 1934).

101. NARA, 031.11 R62, 96; NARA, 504.418 B1, 122–23.

Chapter 14: The Black Years, 1934–1936

1. N. K. Rerikh to G. Spasskii, April 7, 1931, in BAR MsColl/E. A. Miller.

2. Cited in Kenneth Archer, *Nicholas Roerich: East and West* (Bournemouth: Parkstone, 1999), 161.

3. Archer, *Nicholas Roerich*, 161

4. *Time* (August 20, 1934).

5. Cited in Andreyev, MotM, 380.

6. Cordell Hull to Consul General Arthur Garrels, June 11, 1934, cited in Graham White and John Maze, *Henry A. Wallace: His Search for a New World Order* (Chapel Hill: University of North Carolina Press, 1995), 88.

7. Rosov, NRVZ, 2:28; James Boyd, "In Search of Shambhala? Nicholas Roerich's 1934–5 Inner Mongolian Expedition," *Inner Asia* 14, no. 2 (2012): 257–77.

8. NARA, Record Group 59, 1930–1939, 102.7302 MacMillan, Howard G. & Stephens, James L., 50 [hereafter NARA, M&S].

9. NARA, M&S, 21.

10. "Kak Kharbin vstretil N. K. Rerikha," *Rupor* (May 30, 1934). In order of listing, the papers' Russian titles are *Russkoe slovo, Zaria, Rupor, Nash put', Kharbinskoe vremia,* and *Vozrozhdenie Azii.* Estimates of the crowd greeting Roerich range from 60 to 150.

11. Paul Robinson, *The White Russian Army in Exile, 1920–1941* (Oxford: Clarendon Press, 2002), 108–10.

12. Cited in Rosov, NRVZ, 2:20–21.

13. Cited in Rosov, NRVZ, 2:20–21.

14. Maksim Dubaev, *Kharbinskaia taina Rerikha* (Moscow: Sfera, 2001), 343–48, describes how Helena ordered Rihards Rudzītis to hide copies of the procommunist 1927 edition of *Community* ("do not allow anyone to see them, and do not even speak of their existence"). In letters to his brother Vladimir in 1934, Roerich expressed concern that rumors from Europe about supposed Soviet sympathies would affect White opinion of him in Asia (NRM Archive).

15. NARA, M&S, 25.

16. NARA, M&S, 41.

17. Cited in Karl E. Meyer and Shareen Blair Brysac, *Tournament of Shadows: The Great Game and*

the Race for Empire in Central Asia (Washington, DC: Counterpoint, 1999), 486.

18. NARA, M&S, 37, 41, 44 (MacMillan's memos of July 13–August 8, 1934, to US Consul General in Tokyo, forwarded to State Department).

19. NARA, M&S, 90.

20. NARA, M&S, 90.

21. NARA, M&S, 41, 44.

22. Andreyev, MotM, 384–86, relying on documents from Japan's foreign ministry archive.

23. White and Maze, *Henry A. Wallace*, 82–104.

24. John C. Culver and John Hyde, *American Dreamer: A Life of Henry A. Wallace* (New York: W. W. Norton, 2000), 139.

25. Henry A. Wallace to Nicholas Roerich, FDR Library, letter 112–13 (September 27, 1934).

26. N. K. Rerikh, "Da voskresnet Bog i rastochat'sia vrazi Ego," *Russkoe slovo* (November 8, 1934).

27. Robinson, *White Russian Army in Exile*, 223.

28. For example, V. A. Rosov, "Man'chzhurskaia ekspeditsiia N. K. Rerikha: v poiskakh 'Novoi Strany," *Ariavarta* 3 (1999): 23–25.

29. A collection of *Harbin Times* and *Our Path* clippings prepared on February 13, 1936, by the US consul general Walter Adams, gives a sense of how the press campaign unfolded against Roerich. NARA, M&S, 95.

30. Darya Kucherova, "Art and Spirituality in the Making of the Roerich Myth" (PhD diss., Central European University, 2006), 125.

31. Cited by Andreyev, MotM, 389–90.

32. For a sample of such exchanges, see NARA, 504.418 B1, 128–30.

33. Undated clipping from unknown newspaper, in FRGP, box 16, folder 16.

34. Marie de Vaux-Phalipau to Helena Roerich, December 27, 1934, BAR MsColl/Taube, M. A. box 4, folder 5. See also Vaux-Phalipau's letter to Baron Taube, September 22, 1935, in the same folder.

35. Quotation from Culver and Hyde, *American Dreamer*, 136. See also Jonathan Alter, *The Defining Moment: FDR's Hundred Days and the Triumph of Hope* (New York: Simon and Schuster, 2006), 282–83;

and ACRC, Roerich Folders, folder 135 (especially Sara Roosevelt to Louis Horch, May 14, 1933).

36. Helena Roerich to Franklin Delano Roosevelt, October 10, 1934; November 15, 1934; December 27, 1934; February 4, 1935; February 4, 1935 (addendum); December 12, 1935; and January 11, 1936, all from the FDR Library, with copies at the ACRC. Letters from April 15, 1935, and December 27, 1935, are included in this collection, but do not bear Helena's signature and were probably written by Esther Lichtmann and Louis Horch.

37. All major Roerich scholars discuss Helena's letters to FDR. Among Roosevelt and Wallace biographers doing so are Culver and Hyde, *American Dreamer*, 136–37; White and Maze, *Henry A. Wallace*, 102–3; and David Kennedy, *Freedom from Fear: The American People in Depression and War, 1929–1945* (New York: Oxford University Press, 1999), 206. Most authors assume FDR communicated with Helena, but opinions vary as to how enthusiastically he did so, and not all grapple responsibly (or at all) with the broader implications of a scenario in which FDR "manifested obvious interest" in Helena's ideas, to quote Leonid Mitrokhin, "Helena Roerich's Letters to F.D.R.," *Soviet Life* (January 1982): 38–39. Among these more uncritical voices are the diplomat Wayne Peterson (himself a believer in hidden masters), in *Extraordinary Times, Extraordinary Beings: Experiences of an American Diplomat with Maitreya and the Masters of Wisdom* (Charlottesville, VA: Hampton Roads, 2003), 161–62; and Ruth Abrams Drayer, in *Wayfarers: The Spiritual Journeys of Nicholas and Helena Roerich* (La Mesilla, NM: Jewels of Light, 2003).

38. "Visit on November 7, 1934, to the Mother [Sara] and the Meeting with Her Son," ACRC, Roerich Data and Personal Data, blue folder (underlined emphasis in the original).

39. Helena Roerich to Franklin Delano Roosevelt, November 15, 1934, FDR Library.

40. Helena Roerich to Franklin Delano Roosevelt, November 15, 1934, and December 27, 1934, FDR Library.

41. Helena Roerich to Franklin Delano Roosevelt, December 27, 1934, FDR Library.

42. The first two quotations come from Horch's November 7, 1934, notes; the third is from his December 19, 1934, notes. ACRC, Roerich Data and Personal Data, blue folder.

43. Louis Horch, report on December 19, 1934, visit. ACRC, Roerich Data and Personal Data, blue folder.

44. Louis Horch to Esther Lichtmann, describing his December 19, 1934, visit. ACRC, Roerich Data and Personal Data, blue folder.

45. On Roerich at Tientsin, see Culver and Hyde, *American Dreamer*, 141; White and Maze, *Henry A. Wallace*, 93–95; and Robert C. Williams, *Russian Art and American Money: 1900–1940* (Cambridge, MA: Harvard University Press), 140–42.

46. *North China Star* (November 28, 1934, and November 30, 1934); *Peiping Chronicle* (December 4, 1934, and December 7, 1934); Charles J. Errico and J. Samuel Walker, "The New Deal and the Guru," *American Heritage* 40 (March 1989): 97, on Roerich's sore throat.

47. Williams, *Russian Art and American Money*, 142; and Errico and Walker, "New Deal and the Guru," 97.

48. See the Russian-language version, "Sad budushchego," in Rerikh, LD, 1:279–81.

49. Culver and Hyde, *American Dreamer*, 141.

50. Walter Adams, consular report of March 25, 1935. NARA, M&S, 59.

51. Franklin Delano Roosevelt, "Statement on Pan-American Day," FDR Library.

52. Remarks reproduced as "The Roerich Pact" in *Bulletin of the Pan American Union* 59 (May 1935): 362.

53. Wallace cited in White and Maze, *Henry A. Wallace*, 97–98. See also the Nobel Prize Nomination Archive (www.nobelprize.org/nomination/archive/show_people.php?id=7805).

54. Richard Southgate to and from J. Holmes, April 3, 1935, and April 4, 1935. NARA, 504.418 B1, 162–63.

55. Correspondence with Great Britain, Spain, the Netherlands, Belgium, Germany, and France, to take a few examples, in NARA, 504.418 B1, 204, 206, 211, 214, 215, 217, 218.

56. Nicholas Roerich, "The Banner," in *Invincible* (New York: Roerich Museum Press, 1974), 155–61.

57. Helena Roerich to Franklin Delano Roosevelt, February 4, 1935, FDR Library.

58. "Visit to Stephen on January 31, 1935." ACRC, Roerich Data and Personal Data, blue folder. On March 8, 1935, Horch described FDR as especially touched by Helena's gifts of a carving and a prayer banner.

59. "Visit to Stephen on January 31, 1935." ACRC, Roerich Data and Personal Data, blue folder.

60. Cited in L. V. Shaposhnikova, "Vrata v budushchee," foreword to Rerikh, LD, 1:15–16.

61. Communication of January 1935, cited in White and Maze, *Henry A. Wallace*, 93–94.

62. For a useful map, see Rosov, NRVZ, 2:150. Rosov provides the fullest general account of Roerich's journey; see also Andreyev, MotM, 357–98; and Boyd, "In Search of Shambhala?" Lingering talk that this trip somehow took Roerich back to Tibet seems to have arisen from a misinterpreted comment made by George about wanting to visit "a Tibetan monastery"—by which he would have meant one devoted to Tibetan Buddhism, not located in Tibet. Some also speculate that the Roerichs ventured far enough through the Gobi to approach Nicholas's beloved Altai, but this remains unproved and unlikely.

63. Rosov, NRVZ, 2:20–21, describing Iu. N. Rerikh, "Dnevnik Man'chzhurskoi ekspeditsii, 1934–1935," held by the P. K. Kozlov House-Museum in Saint Petersburg.

64. Lattimore's reports on Roerich's conversation with the Tiluwa Khutuktu (April 6, 1935) and his own talk with Pao Yueh-ch'ing about Roerich's April 10, 1935, meeting with Teh Wang are summarized in memos of April 10, 1935 and April 19, 1935, sent by Nelson Johnson to the Secretary of State. NARA, M&S, 61, 93–94.

65. Andreyev, MotM, 392–93, speaks of Teh Wang as becoming friendlier in the spring.

66. "Japanese Expel Explorers Sent by Sec. Wallace," *Chicago Tribune* (June 24, 1935). Errico and Walker, "New Deal and the Guru," 97, believe the *Tribune* was prompted to publish by a deliberate leak from one or more parties in the State Department, out of aggravation with Roerich.

67. "Roerich Activities 'Embarrass' U.S.," *New York Times* (June 24, 1935).

68. Cited in Andreyev, MotM, 407–8.

69. Notes from visit with FDR by Louis Horch and Esther Lichtmann, January 15, 1936. See also this note from December 15, 1935: "Mad. R. has lost the Contact, which is now in New York." ACRC, Roerich Data and Personal Data, blue folder.

70. Culver and Hyde, *American Dreamer*, 142.

71. Henry A. Wallace to Louis Horch, July 3, 1935. NARA, M&S, 86.

72. Earl Bressman to Nicholas Roerich, July 9, 1935. NARA, M&S, 86.

73. *China Weekly Review* (July 27, 1935). For a sample of similar articles, see also the *Tientsin Times* (June 26, 1935) and the *North China Star* (July 23, 1935; September 6, 1935; and September 8, 1935).

74. Nicholas Roerich to Henry A. Wallace, July 27, 1935, from Camp Temur-Khada [*sic*], forwarded by Wallace to State. NARA, M&S, 87.

75. George Roerich to Earl Bressman, July 11, 1935, from Naran Obo ("notwithstanding"), and August 16, 1935, from Timur Hada ("considerable merriment"). NARA, M&S, 86.

76. Maurice Lichtmann to Sina Lichtmann, July 10, 1935 (NRM Archive).

77. Frances Grant to Sviatoslav Roerich, September 17, 1978, FRGP, box 15, folder 19.

78. Louis Horch to Helena Roerich, July 30, 1935, cited in Andreyev, MotM, 411–14.

79. Louis Horch to Nicholas Roerich, August 7, 1935, FRGP, box 14, folder 13.

80. Frances Grant to Helena Roerich, September 27, 1935, cited in Andreyev, MotM, 414.

81. Meyer and Brysac, *Tournament of Shadows*, 488; and White and Maze, *Henry A. Wallace*, 99–100. The Soviets also believed George was a former tsarist officer, but here they were confusing him with his uncle Vladimir (who was not even part of the expedition at this point).

82. NARA, M&S, 86. This packet is also the source for the details and quotations in the following paragraph.

83. Henry A. Wallace to George Roerich, September 4, 1935, and Henry A. Wallace to Nicholas Roerich, September 21, 1935, both in NARA, M&S, 86.

84. Henry A. Wallace to William Phillips (the undersecretary who had brought Moscow's concerns about Roerich to Wallace's attention in August), September 26, 1935. Phillips asked his supervisor, M. M. Hornbeck, how to reply; Hornbeck's answer came on October 4, 1935. NARA, M&S, 86.

85. White and Maze, *Henry A. Wallace*, 100–103, citing Wallace's letter of January 8, 1936.

86. W. J. Carr to Treaty Division, January 2, 1936, summarizing Wallace's request. NARA, 504.418 B1, 230.

87. Culver and Hyde, *American Dreamer*, 144; and Errico and Walker, "New Deal and the Guru," 99.

88. NARA, 504.418 B1, 237. Hall Kinsey, reporting to A. R. Burr (Special Agent in Charge, New York).

89. See Roerich v. Horch, 254 App. Div. 663 (Nicholas Roerich, Helena Roerich, Maurice M. Lichtmann, Sina Lichtmann and Frances R. Grant, Appellants, v. Louis L. Horch, Nettie S. Horch, and Master Institute of United Arts, Inc., Respondents. April 22, 1938); and Roerich v. Horch, May 25, 1938. Appellate Division, First Department, Supreme Court, State of New York.

90. FRGP, January 30, 1941, testimonial, 3–4a, 45.

91. *New York Daily News* (January 31, 1936).

92. Visits to FDR on January 13 and January 28, 1936. ACRC, Roerich Data and Personal Data, blue folder.

93. For coverage of Roerich, see *Newsweek* (February 8, 1936); and *Washington Daily News* (January 30, 1936). See also *New York World-Telegram* (January 30, 1936); *New York Daily News* (January 31, 1936); and *New York Sun* (January 31, 1936). Explanation for Roerich's suit quoted in *New York Law Journal* (March 19, 1937).

94. *New York Sun* (January 31, 1936).

95. The Alberich theme would have occurred naturally to Roerich, a lifelong devotee of Wagner, but one wonders how far his use of it was tinged with antisemitism, especially given that he and Helena

now began referring to Horch as "Levi" (his middle name, but also an emphatic marker of his Jewish identity). How directly Wagner himself intended the Nibelungs to embody negative stereotypes of Jews remains a topic of debate, but the tendency of audiences and critics to interpret them as expressions of antisemitism is well established. Sina Lichtmann and Frances Grant, both Jewish, likewise wrote of Horch as "Alberich" and "Levi."

96. Rerikh, IzLN, 215.

97. Helena Roerich to Franklin Delano Roosevelt, December 12, 1935, and January 11, 1936 (FDR Library).

98. Nicholas Roerich, December 18, 1935. FRGP, box 14, folder 36.

99. George Roerich to Frances Grant, December 24, 1935. FRGP, box 14, folder 25.

100. Frances Grant to George Roerich, January 19, 1936 [date mistakenly given as 1935 in original]. FRGP, box 14, folder 25.

101. Frances Grant to George Roerich, July 31, 1936. FRGP, box 14, folder 80.

102. Frances Grant to George Roerich, July 31, 1936. FRGP, box 14, folder 80. Emphasis in the original.

103. Nicholas Roerich, December 18, 1935. FRGP, box 14, folder 36.

104. Frances Grant to George Roerich, January 19, 1936 [date mistakenly given as 1935 in original text]. FRGP, box 14, folder 25.

105. FRGP, "Frances Grant: History," 34.

106. FRGP, "Frances Grant: History," 34.

107. White and Maze, *Henry A. Wallace*, 142–43.

108. *New York Law Journal* (March 19, 1937). Roerich's cases were dismissed on the grounds that he was not present to testify. He was given a deadline of January 1, 1941, to appear.

109. FRGP, "Frances Grant: History," 41–44.

110. "Exit: Greatest One Man Show on Earth," *Art Digest* (July 1, 1938): 10.

111. Nicholas Roerich to "Dear Friend" in the United States, July 9, 1938, responding to a letter of May 31, 1938, in Emily Genauer Papers, Archives of American Art, reel NG 1. "Shekels" appears as "shakles" in the original.

112. ACRC, Roerich Data and Personal Data, blue folder.

113. Esther Lichtmann to Franklin Delano Roosevelt, April 29, 1942. NRM Archive.

114. Errico and Walker, "New Deal and the Guru," 98.

115. The following account, including most quotations, is principally from Samuel Rosenman's perspective—not from his famed memoir, *Working with Roosevelt* (New York: Harper and Brothers, 1952), which barely mentions the episode, but from material held by the FDR Library, Samuel I. Rosenman Papers (box 18, folder Working with Roosevelt; and "Summary of Events Relating to the 'Guru' Letters"). See also Culver and Hyde, *American Dreamer*, 231–34; White and Maze, *Henry A. Wallace*, 142–45; Meyer and Brysac, *Tournament of Shadows*, 489–90; Mitch Horowitz, *Occult America: White House Séances, Ouija Circles, Masons, and the Secret Mystic History of Our Nation* (New York: Bantam, 2009), 170–75; Kenneth Davis, *FDR: Into the Storm* (New York: Random House, 1993), 616–17; and Ted Morgan, *FDR: A Biography* (New York: Simon and Schuster, 1985), 531–34.

116. According to Culver and Hyde, *American Dreamer*, 231–34, other accounts have FDR laughing aloud upon reading the letters and even wondering whether Wallace and Grant had been romantically involved.

117. Conversation captured by the recording device kept by FDR in his desk in the summer of 1940. See Culver and Hyde, *American Dreamer*, 231–34, 240–42.

118. Rosenman, *Working with Roosevelt*, 438–43.

119. See Robert Ferrell, *Choosing Truman: The Democratic Convention of 1944* (Columbia: University of Missouri Press, 1994), 16–17; Culver and Hyde, *American Dreamer*, chap. 18; and Torbjörn Sirevag, *The Eclipse of the New Deal and the Fall of Vice-President Wallace* (New York: Garland, 1985), 510–12. Ferrell mentions Roerich only in passing.

120. Henry A. Wallace, *The Price of Vision:*

The Diary of Henry A. Wallace, 1942–1946 (Boston: Houghton Mifflin, 1973), 358–60 ("peddle"); Culver and Hyde, *American Dreamer*, 482 ("sub rosa"). White and Maze, *Henry A. Wallace*, 144–45, speak of "presidential concern" over the letters; even Rosenman, who takes pains to minimize their impact, concedes that the 1940 "hullabaloo" was still causing Wallace in 1944 to be "suspected" as "a mystic and supernaturalist" (*Working with Roosevelt*, 438).

121. Allen Weinstein and Alexander Vassiliev, *The Haunted Wood: Soviet Espionage in America* (New York: Random House, 1999), 8–21, 44–49, 156–61; and Christopher Andrew and Vasili Mitrokhin, *The Sword and the Shield: The Mitrokhin Archive and the Secret History of the KGB* (New York: Basic Books, 2005), 137–44.

122. On Pegler, see Diane McWhorter, "Dangerous Minds," *Slate* (March 4, 2004) ("leading popularizer"); Finis Farr, *Fair Enough: The Life of Westbrook Pegler* (New Rochelle, NY: Arlington, 1975); and Dorothy Herrmann, *Helen Keller: A Life* (New York: Knopf, 1998), 282–83.

123. McWhorter, "Dangerous Minds," for the "bigotry" and "geese" quotes.

124. *New York Daily News* (June 17, 1947).

125. *New York American* (June 18, 1947).

126. *New Haven Evening Register* (August 27, 1947).

127. FRGP, Daily Record, 1948.

128. *Washington Times Herald* (March 9, 1948).

129. *Newsweek* (March 22, 1948): 27–29.

130. Cited in Culver and Hyde, *American Dreamer*, 482–83.

131. Quotes and details in these paragraphs come from Meyer and Brysac, *Tournament of Shadows*, 475–77; see also White and Maze, *Henry A. Wallace*, 271–74.

132. *Chicago Daily News* (July 27, 1948).

133. All electoral details from David McCullough, *Truman* (New York: Simon and Schuster, 1992), 656–771.

134. Columbia University Oral History Project, Wallace Oral History, 5102–11.

Chapter 15: Readjustment and Resignation, 1936–1939

1. Rerikh, IzLN, 150.

2. "India's Nine Treasured Artists," *India Times* (September 29, 2013), and Krittika Kumari, "Who Are India's National Treasures?" Bengaluru Museum of Art and Photography (map-india.org/who-are-indias-national-treasures/).

3. See P. F. Belikov, "V Gimalaiakh," NKR: zit, 202, 210–13; Iraida Bogdanova-Rerikh, "O postoiannom i vechnom," *Rabotnitsa* 10 (1974): 25–26; and Decter, MoB, 137–39.

4. As translated by Decter, MoB, 137–39.

5. BAR MsColl/Taube, M. A., box 1, October 1, 1935, and November 27, 1935.

6. BAR MsColl/Taube, M. A., box 1, December 12, 1935, and January 26, 1936.

7. Cited by Andreyev, MotM, 420–21.

8. Rerikh, "Voina," LD, 2:201–2.

9. BAR MsColl/Zeeler, box 3.

10. See V. F. Bulgakov, *Vstrechi s khudozhnikami* (Leningrad: Khudozhnik RSFSR, 1969); V. F. Bulgakov and A. I. Iupatov, *Russkoe iskusstvo za rubezhom* (Prague, 1938); L. P. Muromtseva, "Muzeinye sobraniia rossiiskikh emigrantov v Chekhoslovakii," *Kul'turnoe nasledie rossiiskoi emigratsii* (Moscow, 1994), 1:63–70.

11. Barnett Conlan, *Nicholas Roerich: A Master of the Mountains* (Liberty, IN: Flamma, 1938); and Barnett Conlan, "Nicholas Roerich and Art's Legendary Future," *The Studio* 118 (July–December 1939): 66–71.

12. Anna Ostroumova-Lebedeva, *Avtobiograficheskie zapiski*, 2 vols. (Leningrad: Iskusstvo, 1935–1945), 2:129.

13. A. A. Rylov, *Vospominaniia* (Leningrad: Iskusstvo, 1940). The quoted passages and Roerich's responses to them are in Rerikh, "Rylov," LD, 3:205–6.

14. Igor' E. Grabar', *Moia zhizn'* (Moscow: Iskusstvo, 1937), esp. 170–76 and 289–97.

15. Bulgakov, *Vstrechi*, 131–32. Roerich attributes the "Herod" epithet to P. G. Shchedrov; punning on Grabar's first name and patronymic, others mocked him as Ugor' Obmanuilovich ("deceiving eel"). Viktor Baranovsky and Irina Khlebnikova,

Anton Azhbe i khudozhniki Rossii (Moscow: Moscow State University Press, 2001), 108, note that some of Grabar's colleagues disapproved of the methods by which he acquired art for the Soviet state in the 1920s and 1940s (the 1930s he spent in semiretirement). Although the "Herod" slur sounds antisemitic, both sides of Grabar's family were Rusyns (Eastern Slavs from the Carpathians).

16. Zil'bershtein and Samkov, SDiRI, 2:272, 278, 510 (last page citing N. K. Rerikh to A. N. Benua, March 14, 1939); and Rerikh, "Mir iskusstva," LD, 2:207–10.

17. Zil'bershtein and Samkov, SDiRI, 2:510.

18. Bulgakov, *Vstrechi*, 262.

19. The bulk of Benois's review is reproduced in Poliakova, NR, 276–77; and Decter, MoB, 161, whose translation I have relied on heavily.

20. Benois's review, as translated by Decter, MoB, 161.

21. N. K. Rerikh to V. F. Bulgakov, July 1, 1939, cited in Bulgakov, *Vstrechi*, 186.

22. Rerikh, LD, 3:20–21.

23. Rerikh, IzLN, 170–72.

24. Anatoli Boukreev, *Above the Clouds: The Diaries of a High-Altitude Mountaineer* (New York: St. Martin's Press, 2001), 111. Roerich's Pax Cultura symbol appears throughout the book.

25. Barry Lopez, *Horizon* (New York: Knopf, 2019), 29–31. Roerich's 1924 canvas *Remember* (see Illustration 34) serves as the endpaper for both of *Horizon*'s inside covers.

26. Charles Crane to Helena and Nicholas Roerich, September 6, 1937. BAR MsColl/Crane, Charles, box 1, microfilm reel 91–2096.

27. Nicholas Roerich to Charles Crane, July 3, 1937. BAR MsColl/Crane Family Papers, box 7, folder 10.

28. Charles Crane to Helena and Nicholas Roerich, September 6, 1937. BAR MsColl/Crane, Charles, box 1, microfilm reel 91–2096.

29. BAR MsColl/Crane, Charles, box 1, misc., includes the June statement and Crane's November 13, 1937, letter to FDR.

30. Pares's comments paraphrased by Roerich in his July 3, 1937, letter to Charles Crane. BAR MsColl/Crane Family Papers, box 7, folder 10.

31. Rerikh, LD, 2:84–85.

32. Bulgakov, *Vstrechi*, 273.

33. Bulgakov, *Vstrechi*, 277.

34. *Pravda* (September 21, 1937, and September 30, 1937); and Andreyev, MotM, 423.

35. C. Crane to N. Roerich, July 15, 1938. BAR MsColl/Crane, Charles, box 1, microfilm reel 91–2096.

36. Andreyev, MotM, 425.

37. Cited in Roman Lunkin and Sergei Filatov, "The Rerikh Movement: A Homegrown Russian 'New Religious Movement,'" *Religion, State, and Society* 28 (March 2000): 142.

38. HRD, vol. 43 (December 16, 1936), cited by Andreyev, MotM, 425, with his translation altered slightly.

39. HRD, vol. 44 (March 29, 1937), cited and translated by Andreyev, MotM, 425.

40. Robert Rupen, "Mongolia, Tibet, and Buddhism or, A Tale of Two Roerichs," *Canada-Mongolia Review* 5 (April 1979): 18.

41. Rerikh, LD, 3:96–97.

42. Author's February 8, 2000, interview with Aida Tulskaya at the NRM ("misused"); and Andreyev, MotM, 422–23 (complaint about Helena).

43. Rerikh, "Opiat' voina," IzLN, 167–69.

Chapter 16: Into the Twilight, 1939–1947

1. As translated by Douglas Penick for the 1996 Sony recording of *King Gesar*, a seven-song ensemble piece composed by Peter Lieberson in 1991–1992 and featuring Yo-Yo Ma on cello (Sony Classical 57971).

2. Rerikh, LD, 2:410–11.

3. Rerikh, LD, 2:375–76.

4. Rerikh, LD, 2: 342–43.

5. Cited in V. P. Menon, *The Transfer of Power in India* (Bombay: Orient Longman, 1957), 60.

6. Jawaharlal Nehru, ed., *A Bunch of Old Letters: Written Mostly to Jawaharlal Nehru and Some Written by Him* (Delhi: Viking Penguin, 2005), 430.

7. Rerikh, IzLN, 191–95.

8. Rerikh, LD, 2: 299–300.

9. V. F. Bulgakov, *Vstrechi s khudozhnikami* (Leningrad: Khudozhnik RSFSR, 1969), 134–35.

10. Rerikh, LD, 2:360–61.

11. Rerikh, IzLN, 187–90, 216–17.

12. By 1944, more than fifty periodicals in India had published Roerich's work (Rerikh, LD, 3:216).

13. Rerikh, LD, 2:438–39.

14. Rerikh, LD, 2:414–15.

15. Rerikh, LD, 2:420–21.

16. Rerikh, LD, 2:458–60; and 3:12–13.

17. Rerikh, LD, 2:457–58.

18. Rerikh, LD, 3:36–37.

19. Jawaharlal Nehru, *Toward Freedom* (London: The Bodley Head, 1936), 9.

20. Pupul Jayakar, *Indira Gandhi: A Biography* (New Delhi: Penguin, 1992), 119. See also Rerikh, LD, 3:39–40, 56.

21. Rerikh, LD, 3:60–61, 63–64.

22. Rerikh, LD, 3:66.

23. Rerikh, LD, 3:135.

24. Rerikh, LD, 3:105–7.

25. Rerikh, LD, 3:164–65.

26. Rerikh, LD, 3:113–14, 129–30, 135–36.

27. Rerikh, LD, 3:98–99.

28. Rerikh, LD, 3:219–20.

29. Rerikh, LD, 3:189–90.

30. Rerikh, LD, 3:189–90.

31. See Rerikh, LD, 3:126–27, 132–33, 136–37, 159–60, 165, 177, 182–83, 211–12, 214–15, 220.

32. Rerikh, LD, 3:234–35.

33. Rerikh, LD, 3:239.

34. Rerikh, IzLN, 256.

35. Rerikh, LD, 3:458.

36. Rerikh, LD, 3:271–72. For another early statement of this theme, see Rerikh, LD, 3:229–30.

37. Rerikh, LD, 3:187.

38. Rerikh, LD, 3:267–68.

39. Rerikh, LD, 3:197–98.

40. Rerikh, LD, 3:265.

41. N. K. Rerikh to T. G. Rerikh, May 17, 1945, in Rerikh, LD, 3:279–80.

42. Rerikh, LD, 3:273.

43. Rerikh, IzLN, 239 (as translated by Decter, MoB, 174).

44. Kenneth Archer, "The Theatrical Designs of Nicholas Roerich: Problems of Identification" (MA

thesis, Antioch University, 1985), 56. See also Rerikh, IzLN, 279–80; and Iakovleva, TDI, 243–48, 265–66.

45. Andrei Sakharov, *Memoirs* (New York: Knopf, 1990), 41.

46. Rerikh, LD, 3:214–15.

47. Rerikh, LD, 3:287, 440, 553.

48. Rerikh, LD, 3:287, 455, 496.

49. Rerikh, LD, 3:283, 466, and elsewhere.

50. Rerikh, LD, 3:420–21, 429, 479.

51. Heidok's paraphrase cited in Rerikh, LD, 3:380. On Gladyshev, see Rerikh, LD, 3:257, 413.

52. Rerikh, LD, 3:336–37.

53. Rerikh, LD, 3:427. See also 435 and 506.

54. Rerikh, LD, 3:420–21.

55. Shishkin, BzG, 303, proposes that Grabar, on orders from the Kremlin, was attempting to lure Roerich back to the USSR for punishment. Not only is this supposition made without proof, it fails to explain why the authorities did not allow Roerich to return when he was so eager to do so.

56. N. K. Rerikh to I. E. Grabar', August 20, 1946. IzLN, 416. Here, Roerich refers to himself in the plural, an affectation I have discarded for clarity's sake.

57. Rerikh, LD, 3:439.

58. Rerikh, LD, 3:321–25.

59. Rerikh, LD, 3:420–21.

60. Rerikh, LD, 3:417–19.

61. Kalidas Nag cited in Rerikh, LD, 3:252–53; for the invitation ("properly able"), see Rerikh, LD, 3:367.

62. Rerikh, LD, 3:364.

63. Rerikh, LD, 3:441–42.

64. Clement Attlee, "Change of Viceroy," House of Commons debate, February 10, 1947. Hansard, vol. 433, cc. 1395–1404.

65. Rerikh, LD, 3:514–19.

66. Sunil Khilnani, *The Idea of India* (London: Penguin, 1997), 165.

67. Rerikh, LD, 3:542.

68. Rerikh, LD, 3:532–34. In the original, Roerich writes "temnye massy" (dark masses), a phrase commonly used in prerevolutionary Russia to describe the supposed primitiveness of the lower classes, especially peasants. To avoid creating an

impression that Roerich is speaking racially, I have used a less literal translation.

69. Bulgakov, *Vstrechi*, 206–8, 290–92; and Andrei Znamenski, *Red Shambhala: Magic, Prophecy, and Geopolitics in the Heart of Asia* (Wheaton, IL: Quest Books, 2011), 222.

70. Rerikh, LD, 3:472.

71. Cited in James C. Davis, *The Human Story: Our History, from the Stone Age to Today* (New York: HarperCollins, 2004), 365.

72. Khilnani, *Idea of India*, 129.

73. Rerikh, LD, 3:514. For more on Russophobia, see Rerikh, LD, 3:502–7, 520–23, 528–32.

74. Rerikh, LD, 3:546, 550–53.

75. Rerikh, LD, 3:364.

76. Rerikh, LD, 3:488 (to Heidok), 513–15 (to Maurice).

77. *Bhagavad-Gita* (New York: New American Library, 1958), 38.

78. Rerikh, IzLN, 437–38.

79. Bulgakov, *Vstrechi*, 292.

80. Rerikh, LD, 3: 559–60 (to Shanghai), 560–62 (to Sina and her husband Dudley).

81. E. I. Rerikh, *Pis'ma v Ameriku (1948–1955)* (Moscow, 1996), 245–46.

82. Cited in Decter, MoB, 168, following Belikov and Kniazeva, NKR, 192–93.

83. Fosdik, MU, 39.

84. State Department report of March 22, 1950. ACRC, Roerich Folders, folder 147.

85. *New York Times* (December 16, 1947).

86. "Fabulous Roerich," *Art Magazine* 22 (January 1948): 16.

87. "Silver Valley," *Time* (December 29, 1947).

88. Reprinted by All-India Radio in *Akashvani* 39 (October 1974): 1705. See also Rerikh, IzLN, 7.

89. Rerikh, "Stroitel'," LD, 3:536.

Epilogue: Contested Legacies

1. Rosov, NRVZ, 2:274.

2. Roman Lunkin and Sergei Filatov, "The Rerikh Movement: A Homegrown Russian 'New Religious Movement,'" *Religion, State, and Society* 28 (March 2000): 140.

3. Letter to Balthazar Bolling in 1950, cited in Rosov, NRVZ, 2:273–76.

4. E. I. Rerikh to A. Ia. Vyshinskii, December 17, 1950, cited in Rosov, NRVZ, 2:273–76.

5. Sergei Khrushchev, *Khrushchev on Khrushchev* (Boston: Little, Brown, 1990), 341. In *Buddhism in Russia: The Story of Agvan Dorzhiev; Lhasa's Emissary to the Tsar* (Rockport, MA: Element Books, 1993), 259–60, John Snelling refers to George as having been "lured back" by "wily Soviet officials," but in fact George actively strove to return. On Khrushchev and Sviatoslav, see "Razbuzhennyi Vostok," *Sovetskaia kul'tura* 127 (October 25, 1960).

6. Andreyev, MotM, 439–40. Alexander Piatigorsky testified to George's interest in such matters in interviews with Ian Heron (my thanks to him for access to unpublished manuscripts containing these details).

7. N. Dmitrievna, "Vystavka proizvedenii N. K. Rerikha," *Iskusstvo* 8 (1958); and N. Sokolova, "Rerikh," *Oktiabr'* 10 (1958). On attendance figures and guest book comments, see Darya Kucherova, "Art and Spirituality in the Making of the Roerich Myth" (PhD diss., Central European University, 2006), 307–8, using materials from the Tretyakov Gallery's archives (translations are hers).

8. The convention can be found on UNESCO's website (www.unesco.org) and elsewhere. See also M. M. Boguslavsky, "Legal Aspects of the Russian Position in regard to the Return of Cultural Property," in *The Spoils of War: World War II and Its Aftermath; The Loss, Reappearance, and Recovery of Cultural Property*, ed. Elizabeth Simpson, 186–90 (New York: Abrams, 1997); Karl Meyer, "Limits of World Law," *Archaeology* 48 (July–August 1995): 51; and Petr Barenboim, "Esteticheskaia kontseptsiia pravovogo gosudarstva," *Novaia advokatskaia gazeta* 8 (2010).

9. E. P. Matochkin, "Kosmichnost' iskusstva N. K. Rerikha," in *Rerikh i Sibir'*, ed. V. E. Larichev and E. P. Matochkin (Novosibirsk, 1993), 162.

10. Zhivkova's interest in Theosophy and similar creeds is well documented, as are her friendship with Sviatoslav Roerich and her sponsorship of 1978 as

"Roerich Year" in Bulgaria. She died in June 1981 of a brain tumor, but rumors persist that she was murdered because her esoteric activities "encountered growing resistance among ruling circles in Bulgaria and the USSR" (T. Yalamov, "The Activities of Lyudmila Zhivkova," www.roerich-heritage.org/ENGL/summary2001_eng.doc).

11. I. S. Kuznetsov, *Inakomyslie v Novosibirskom Akademgorodke* (Novosibirsk, 2006), esp. 147–50. See also Paul Josephson, *New Atlantis Revisited: Akademgorodok* (Princeton, NJ: Princeton University Press, 1997).

12. Text displayed at Naggar's Roerich Gallery and Urusvati Folk and Art Museum.

13. Sarah McPhee, "One Man's Museum," *ARTNews* 85 (April 1986): 14.

14. Elizabeth Clare Prophet, *The Lost Years of Jesus: On the Discoveries of Abhedananda, Roerich, and Caspari* (Malibu, CA: Summit University Press, 1984); Elizabeth Clare Prophet, *The Lost Teachings of Jesus: Missing Texts; Karma and Reincarnation* (Corwin Springs, MT: Summit University Press, 1994), 81–98; and Mark L. Prophet and Elizabeth Clare Prophet, *The Masters and Their Retreats* (Malibu, CA: Summit University Press, 2003), 244–49. The Prophet couple frequently used Roerich's paintings to illustrate their publications.

15. Tricia McCannon (no relation to the present author), *Jesus: The Explosive Story of the Lost Years* (Charlottesville, VA: Hampton Roads, 2009); plus the website triciamccannonspeaks.com.

16. Anna Kisselgoff, "Roerich's 'Sacre' Shines in the Joffrey's Light," *New York Times* (November 22, 1987).

17. Acocella comment cited by Richard Taruskin, *Defining Russia Musically* (Princeton, NJ: Princeton University Press, 1997), 380–81.

18. Karl E. Meyer, "The Two Roerichs Are One," *New York Times* (January 22, 1988).

19. Nanette Hucknall, "Nicholas Roerich, Artist, Author, Peace Builder," *New York Times* (February 9, 1988).

20. Cited in and translated by Decter, MoB, foreword.

21. Quotation from Bernice Glatzer Rosenthal, "Introduction," in Rosenthal, ed., *The Occult in Russian and Soviet Culture* (Ithaca, NY: Cornell University Press, 1997), 29.

22. Raisa Gorbacheva, *Ia nadeius'* (Moscow: Kniga, 1991), 135–36. *Pravda* (May 15, 1987) reported on Sviatoslav's first meeting with the Gorbachevs, which took place on May 14, 1987.

23. Sviatoslav expressed his preference for "flexibility" and "the ability to operate beyond administrative barriers" in *Sovetskaia kul'tura* (July 29, 1989).

24. Sviatoslav's death in 1993 left no one alive who could speak about the Roerich family's intentions. Neither he nor George had any legitimate heirs, and no relatives of Sviatoslav's widow, Devika Rani, who died in 1994, have (as yet) established any legal claim to the Roerich inheritance. Lyudmila Bogdanova died in 1961, shortly after George's death. Her sister Iraida, who died in 2004, changed her surname to Bogdanova-Rerikh and insisted that the family had adopted her, but this claim went unrecognized.

25. Rosenthal, "Introduction," 29; Lunkin and Filatov, "Rerikh Movement," 144–47.

26. Interviews in *India Today* and *Russia Journal*, cited in Markus Osterrieder, "From Synarchy to Shambhala: The Role of Political Occultism and Social Messianism in the Activities of Nicholas Roerich," in *The New Age of Russia: Occult and Esoteric Dimensions*, ed. Birgit Menzel, Bernice G. Rosenthal, and Michael Hagemeister (Munich: Kubon & Sagner, 2012), 132–33.

27. Lunkin and Filatov, "Rerikh Movement," 147.

28. For example, Pyotr Barenboim, "Esteticheskaia kontseptsiia pravovogo gosudarstva," in the journal of the Federal Palace of Advocates, *Novaia advokatskaia gazeta* 8 (2010).

29. Andrei Tsygankov, *Whose World Order?* (South Bend, IN: Notre Dame University Press, 2004), 87–112, 163; Alexander Rahr, "'Atlanticists' vs. 'Eurasians' in Russian Foreign Policy," *RFE/RL Research Report* 1, no. 22 (1992); Vera Tolz, "The Burden of Imperial Thinking," *RFE/RL Research Report* 1, no. 49 (1992); and David Kerr, "The New Eurasianists," *Europe-Asia Studies* 47, no. 6 (1995). Roerich's paintings have been used to illustrate editions of essays by Lev Gumilev,

known for his views of Russia as a pan-Asianist "super-ethnos," and the combative neo-Eurasianist Aleksandr Dugin has encouraged loose associations between Roerichite thought and his own quasi-millenarian vision of a Russia rising to glory over the "Atlantic" West (although links with Dugin are generally disavowed by Roerich's adherents).

30. Lunkin and Filatov, "Rerikh Movement," 136.

31. Daniel Entin, interviews with the author (October 1999); and Roman Lunkin, "Rerikhovskoe dvizhenie," *Sovremennaia religioznaia zhizn' Rossii*, vol. 4 (Moscow: Logos, 2006), 24.

32. Description given in early 2018 at www.moscow. info/museums/state-museum-of-the-east.aspx.

33. See, for example, Feliks El'demurov, "Ezotericheskie chastushki" (2008), stihi. ru/2008/06/10/3679.

34. Shishkin, BzG, passim. Shishkin's book grew out of three articles from 1994: "N. K. Rerikh v ob"iatiakh 'naglogo monstra,'" *Segodnia* 208 (October 29, 1994); "N. K. Rerikh: ne schest' almazov v kamennykh peshcherakh," *Segodnia* 222 (November 19, 1994); and "N. K. Rerikh: moshch' peshcher," *Segodnia* 237 (December 10, 1994).

35. The Russian equivalent of the Anglo-American PhD is the *kandidatskaia* degree; the *doktorskaia* degree involves scholarship at a distinguished level and culminates in a public defense. For attacks on Rosov (or discussion of them), see the MTsR website, plus "Kul'tura, ne politika . . . K voprosu o neudachnoi dissertatsii o N. Rerikhe," *Literaturnaia gazeta* (September 26, 2006); "Etika lzhenauki" and "Staroe pod maski novogo," both in *Novaia gazeta* (November 23, 2006); and "Zaiavlenie Sibirskogo Rerikhovskogo obshchestva po povodu doktorskoi dissertatsii V. A. Rosova," *Voskhod* 156, no. 4 (2007): 15–18.

36. Author interviews with Aida Tulskaya of the NRM (April 15 and April 18, 2002), and numerous entries on the MTsR website. See also John McCannon, "Competing Legacies, Competing Visions of Russia," in Menzel, Rosenthal, and Hagemeister, *New Age of Russia*, 348–69. Moscow's

Yeltsin-era mayor, Yuri Luzhkov, supported the MTsR's case against the Museum of Oriental Art, but could not prevail against the federal government.

37. Rachel Polonsky, "Letter from Peryn," *Times Literary Supplement* (June 7, 2002): 5.

38. Andrei Kuraev, *Satanism dlia intelligentsii: o Rerikhakh i Pravoslavii* (Moscow: Otchii dom, 1996–1997).

39. Polonsky, "Letter from Peryn," who rightfully describes Myalo's essay as "a terrifying screed."

40. Polonsky, "Letter from Peryn."

41. "Roerich Row," *Russia and India Report* (April 26, 2012); and "Russia and India Need to Urgently Solve the Row over the Roerich Estate," *Russia and India Report* (May 4, 2012). Local officials in Naggar accused the trust's Russian members—including the museum's director, Alena Adamkova, and Russia's then ambassador to India, Alexander Kadakin—of exerting undue influence over economic development in the region.

42. For a useful profile of the NRM in recent years, see John Varoli, "Mysterious Russian Artist Nicholas Roerich's New York Headquarters," *Russia Beyond* (February 20, 2020): rbth.com.

43. See Leonid Bershidsky, "Even a Putin Couldn't Launder Russia's Seediest Bank," *Bloomberg* (November 20, 2013), referring to how Putin's cousin Igor had served on Master-Bank's board.

44. "Russia's Oriental Museum Takes Custody of Roerich Paintings Seized in Fraud Probe," TASS (March 9, 2017); Nick Holdsworth, "How an Art Museum in Russia Became the Target of Kremlin Police," *Christian Science Monitor* (May 3, 2017); and Isabel Gorst, "Mystic's Art Collection at Front Line of Russia's Culture Wars," *Irish Times* (March 8, 2017). See also Mi You and Eszter Szakács, "Secularity in the Case of Nicholas Roerich," *Parse* 6 (Autumn 2017): 156–75.

45. As of 2021, the center still maintains a "Save the Roerich Museum" site at save.icr.su.

46. BAR MsColl/Zeeler, box 3, item 3c.

Selected Bibliography

Archives and Museums

Amherst Center for Russian Culture, Amherst College, Amherst, Massachusetts.

Archive of the Institute of Art History of the Academy of Sciences of the Czech Republic, Prague.

Archives of American Art, Washington, DC.

Art Institute of Chicago.

Bakhmeteff Archive of Russian and East European Culture at Columbia University, New York.

Bakhrushin Central State Theater Museum, Moscow, Russia.

Buddhist Temple Datsan Gunzechoinei, Saint Petersburg, Russia.

Franklin D. Roosevelt Presidential Library and Museum, Hyde Park, New York.

Federal Bureau of Investigation (via Freedom of Information Act), Washington, DC.

Finnish National Archives, Helsinki, Finland.

Gallen-Kallela Museum, Tarvaspää, Finland.

Harry Ransom Humanities Research Center, University of Texas, Austin.

International Center of the Roerichs and Roerich Museum, Moscow, Russia.

Irkutsk Art Museum, Irkutsk, Russia.

Latvian State Museum of Art, Riga, Latvia.

Museum of the Russian Academy of Arts, Saint Petersburg, Russia.

National Archives, Washington, DC, and College Park, Maryland.

Nicholas Roerich Museum, New York.

Nicholas Roerich Museum-Estate (Isvara), Izvara, Russia.

Novosibirsk Picture Gallery, Novosibirsk, Russia.

Roerich Gallery and Urusvati Himalayan Folk and Art Museum, Naggar, India.

Russian State Archive of Literature and Art, Moscow, Russia.

Russian State Archive of Social and Political History, Moscow, Russia.

Russian State Military Archive, Moscow, Russia.

Rutgers University Special Collections and University Archives, New Brunswick, New Jersey.

St. Petersburg State Museum-Institute of the Roerich Family, Saint Petersburg, Russia.

State Archive of the Russian Federation, Moscow, Russia.

State Museum of Oriental Art, Moscow, Russia.

State Museum of Theatrical and Musical Art, Saint Petersburg, Russia.

State Russian Museum, Saint Petersburg, Russia.

Tretyakov Gallery, Moscow, Russia.

Zimmerli Art Museum, Rutgers University, New Brunswick, New Jersey.

Books and Articles

Alexander, Sidney. *Marc Chagall*. New York: G. P. Putnam's, 1978.

Allen, Charles. *The Search for Shangri-La*. London: Abacus, 2000.

Andreev, Aleksandr I. [Andreyev, Alexandre] *Gimalaiskoi bratstvo*. Saint Petersburg: Saint Petersburg University Press, 2008.

Andreev, Aleksandr I. *The Myth of the Masters Revived: The Occult Lives of Nikolai and Elena Roerich*. Leiden: Brill, 2014.

Andreev, Aleksandr I. *Okkul'tist Strany Sovetov*. Moscow: Eksmo, 2004.

Andreev, Aleksandr I. *Ot Baikala do sviashchennoi Lkhasy*. Samara: Agni, 1997.

Andreev, Aleksandr I. *Soviet Russia and Tibet: The Debacle of Secret Diplomacy*. Leiden: Brill, 2003.

Andreev, Aleksandr I. *Vremia Shambaly*. Saint Petersburg: Neva, 2004.

Andreev, A. I., and Dany Savelli, eds. *Rerikhi: mify i fakty*. Saint Petersburg: Nestor-Istoriia, 2011.

Archer, Kenneth. *Nicholas Roerich: East and West*. Bournemouth: Parkstone, 1999.

Archer, Kenneth. "The Theatrical Designs of Nicholas Roerich: Problems of Identification." MA thesis, Antioch University, 1985.

Baal-Teshuva, Jacob. *Marc Chagall*. Cologne: Taschen, 2000.

Baer, Nancy Van Norman, ed. *The Art of Enchantment: Diaghilev's Ballets Russes, 1909–1929*. New York: St. Martin's Press, 1988.

Baer, Nancy Van Norman. *Theatre in Revolution: Russian Avant-Garde Stage Design*. New York: Thames and Hudson, 1991.

Bailey, James, and Tatyana Ivanova, eds. *An Anthology of Russian Folk Epics*. Armonk, NY: M. E. Sharpe, 1998.

Baltrushaitis, Iu., A. N. Benua, A. I. Gidoni, A. M. Remizov, and S. P. Iaremich. *Rerikh*. Petrograd: Svobodnoe iskusstvo, 1916.

Balyoz, Harold. *Three Remarkable Women*. Flagstaff, AZ: Altai, 1986.

Balzer, Marjorie Mandelstam, ed. *Shamanic Worlds: Rituals and Lore of Siberia and Central Asia*. Armonk, NY: M. E. Sharpe, 1996.

Bartlett, Rosamund. *Wagner and Russia*. Cambridge: Cambridge University Press, 1995.

Bassin, Mark. *The Gumilev Mystique: Biopolitics, Eurasianism, and the Construction of Community in Modern Russia*. Ithaca, NY: Cornell University Press, 2016.

Belikov, P. F. *Rerikh*. Novosibirsk, 1994.

Belikov, P. F., and V. P. Kniazeva. *N. K. Rerikh*. Samara: Agni, 1996 [orig. 1972].

Benois, Alexandre. *Memoirs*. 2 vols. London: Chatto and Windus, 1960–1964.

Benois, Alexandre. *Reminiscences of the Russian Ballet*. London: Putnam, 1941.

Berberova, Nina. *The Italics Are Mine*. London: Vintage, 1993.

Bernbaum, Edwin. *The Way to Shambhala: A Search for the Mythical Kingdom beyond the Himalayas*. Boston: Shambhala, 2001.

Bishop, Peter. *The Myth of Shangri-La: Tibet, Travel Writing, and the Western Creation of Sacred Landscape*. Berkeley: University of California Press, 1989.

Blagovo, Nikita. *Sem'ia Rerikhov v gimnazii K. I. Maia*. Saint Petersburg: Nauka, 2006.

Blakesley, Rosalind P., and Susan E. Reid, eds. *Russian Art and the West*. DeKalb: Northern Illinois University Press, 2007.

Blavatsky, Helena. *From the Caves and Jungles of Hindostan*. London: Theosophical Society, 1892.

Blavatsky, Helena. *Isis Unveiled*. 2 vols. New York: J. W. Bouton, 1901.

Blavatsky, Helena. *The Secret Doctrine*. 2 vols. Pasadena, CA: Theosophical University Press, 1994.

Boguslavskii, M. M. "Pakt Rerikha i zashchita kul'turnykh tsennostei." *Sovetskoe gosudarstvi i pravo* 10 (1974): 111–15.

Bohm-Duchen, Monica. *Marc Chagall*. London: Phaidon, 1998.

Borisova, Elena A., and Grigory Sternin. *Russian Art Nouveau*. New York: Rizzoli, 1998.

Bowers, Faubion. *Scriabin: A Biography*. Mineola: Dover, 1996.

Bowlt, John E. *Moscow and St. Petersburg, 1900–1920*. New York: Vendome, 2008.

Bowlt, John E. "Nikolai Roerich at Talashkino." *Experiment* 7 (Winter 2001): 103–21.

Bowlt, John E. *Russian Stage Design: Scenic Innovation 1900–1930*. Jackson: Mississippi Museum of Art, 1982.

Bowlt, John E. *The Silver Age: Russian Art of the Early Twentieth Century and the "World of Art" Group*. Newtonville, MA: Oriental Research Partners, 1979.

Bowlt, John E. "Two Russian Maecenases: Savva Mamontov and Princess Tenisheva." *Apollo* 98 (December 1973): 444–53.

Boyd, J. G. "In Search of Shambhala? Nicholas Roerich's 1934–5 Inner Mongolian Expedition." *Inner Asia* 14, no. 2 (2012): 257–77.

Brinton, Christian. *The Nicholas Roerich Exhibition*. New York: Redfield-Kendrick-Odell, 1920.

Buckle, Richard. *Diaghilev*. New York: Atheneum, 1979.

Buckle, Richard. *Nijinsky*. New York: Simon and Schuster, 1971.

Bulgakov, Valentin F. *Vstrechi s khudozhnikami*. Leningrad: Khudozhnik RSFSR, 1969.

Bulgakov, Valentin F., and A. I. Iupatov. *Russkoe iskusstvo za rubezhom*. Prague and Riga, 1938.

Burliuk, David. *Rerikh*. New York, 1930.

Burns, Richard Dean, and Charyl L. Smith. "Nicholas Roerich, Henry A. Wallace and the 'Peace Banner': A Study in Idealism, Egocentrism, and Anguish." *Peace and Change: A Journal of Peace Research* (Spring 1973): 40–49.

Burton, Dan, and David Grandy. *Magic, Mystery, and Science: The Occult in Western Civilization*. Bloomington: Indiana University Press, 2004.

Carlson, Maria. *"No Religion Higher Than Truth": A History of the Theosophical Movement in Russia, 1875–1922*. Princeton, NJ: Princeton University Press, 1993.

Chagall, Marc. *My Life*. New York: Orion Press, 1960.

Chaliapin, Feodor. *Man and Mask: Forty Years in the Life of a Singer*. London: Victor Gollancz, 1932.

Chamberlain, Lesley. *Lenin's Private War*. New York: St. Martin's, 2006.

Chetwode, Penelope. *Kulu: The End of the Habitable World*. London: John Murray, 1972.

Chiasson, Blaine R. *Administering the Colonizer: Manchuria's Russians under Chinese Rule, 1918–29*. Vancouver: University of British Columbia Press, 2010.

Cioran, Samuel. *Vladimir Solov'ev and the Knighthood of the Divine Sophia*. Waterloo, ON: Wilfrid Laurier University Press, 1977.

Clarke, J. J. *Oriental Enlightenment: The Encounter Between Asian and Western Thought*. London: Routledge, 1997.

Cohen, Aaron J. *Imagining the Unimaginable: World War, Modern Art, and the Politics of Public Culture in Russia, 1914–1917*. Lincoln: University of Nebraska Press, 2008.

Conlan, Barnett D. "Nicholas Roerich and Art's Legendary Future." *The Studio* 118 (July–December 1939): 66–71.

Conlan, Barnett D. *Nicholas Roerich: A Master of the Mountains*. Liberty, IN: Flamma, 1938.

Conrad, Peter. *Modern Times, Modern Places*. New York: Knopf, 1999.

Corten, Irina H. *Flowers of Morya: The Theme of Spiritual Pilgrimage in the Poetry of Nicholas Roerich*. New York: Nicholas Roerich Museum, 1986.

Corten, Irina H. *Nicholas Roerich: An Annotated Bibliography*. New York: Nicholas Roerich Museum, 1986.

Craft, Robert. "100 Years On: Igor Stravinsky on *The Rite of Spring*." *Times Literary Supplement* (June 19, 2013).

Craft, Robert. *Stravinsky: Chronicle of a Friendship*. Nashville, TN: Vanderbilt University Press, 1994.

Craft, Robert. *Stravinsky: Glimpses of a Life*. New York: St. Martin's Press, 1993.

Cranston, Sylvia. *HPB: The Extraordinary Life and Influence of Helena Blavatsky, Founder of the Theosophical Movement*. New York: Tarcher/Putnam, 1993.

Cross, Jonathan, ed. *The Cambridge Companion to Stravinsky*. Cambridge: Cambridge University Press, 2003.

Culver, John C., and John Hyde. *American Dreamer: A Life of Henry A. Wallace*. New York: W. W. Norton, 2000.

Dalbotten, Diana. "Ancient Souls and Modern Art: Nicholas Roerich and the Silver Age of Russian Art." PhD diss., University of Minnesota, 2000.

Davis, Wade. *The Clouded Leopard: A Book of Travels*. Vancouver: Douglas and McIntyre, 1998.

Davis, Wade. *Into the Silence: The Great War, Mallory, and the Conquest of Everest*. Toronto: Vintage Canada, 2012.

Decter, Jacqueline. *Messenger of Beauty: The Life and Visionary Art of Nicholas Roerich*. Rochester, VT: Park Street Press, 1997. Originally published as *Nicholas Roerich: The Life and Art of a Russian Master*. Rochester, VT: Park Street Press, 1989.

Dixon, Joy. *Divine Feminine: Theosophy and Feminism in England*. Baltimore: Johns Hopkins University Press, 2001.

Dobuzhinskii, Mstislav V. *Vospominaniia*. Moscow: Nauka, 1987.

Drayer, Ruth Abrams. *Wayfarers: The Spiritual Journeys of Nicholas and Helena Roerich*. La Mesilla, NM: Jewels of Light, 2003.

Dubaev, Maksim. *Kharbinskaia taina Rerikha*. Moscow: Sfera, 2001.

Dubaev, Maksim. *Nikolai Rerikh*. Moscow: Molodaia gvardiia, 2003.

Dutta, Krisha, and Andrew Robinson. *Rabindranath Tagore: The Myriad-Minded Man*. London: Bloomsbury, 1995.

Duvernois, Jean. *Roerich: Fragments of a Biography*. New York: Roerich Museum Press, 1933.

Eksteins, Modris. *Rites of Spring: The Great War and the Birth of the Modern Age*. New York: Anchor Books, 1990.

Eliade, Mircea. *Occultism, Witchcraft, and Cultural Fashions*. Chicago: University of Chicago Press, 1976.

Elliott, David. *New Worlds: Russian Art and Society, 1900–1937*. New York: Rizzoli, 1986.

Ely, Christopher David. *This Meager Nature: Landscape and National Identity in Imperial Russia*. DeKalb: Northern Illinois University Press, 2002.

Ernst, Sergei. *N. K. Rerikh*. Petrograd: Sv. Evgenii, 1918.

Errico, Charles J., and J. Samuel Walker. "The New Deal and the Guru." *American Heritage* 40 (March 1989): 92–99.

Ferrell, Robert H. *Choosing Truman: The Democratic Convention of 1944*. Columbia: University of Missouri Press, 1994.

Figes, Orlando. *Natasha's Dance: A Cultural History of Russia*. London: Allen Lane, 2002.

Fitzpatrick, Sheila. *The Commissariat of Enlightenment: Soviet Organization of Education and the Arts under Lunacharsky*. Cambridge: Cambridge University Press, 1970.

Fokine, Michael. *Memoirs of a Ballet Master*. Boston: Little, Brown, 1961.

Forbes, Andrew. *Warlords and Muslims in Chinese Central Asia*. Cambridge: Cambridge University Press, 1986.

Fosdick, Sina Lichtmann [Fosdik, Zinaida Grigor'evna]. *Moi uchitelia: po stranitsam dnevnika, 1922–1934*. Moscow: Sfera, 1998.

Fülöp-Miller, René. *The Russian Theatre*. New York: Benjamin Blom, 1968.

Garafola, Lynn. *Diaghilev's Ballets Russes*. New York: Oxford University Press, 1989.

Gleason, Abbott, Peter Kenez, and Richard Stites, eds. *Bolshevik Culture*. Bloomington: Indiana University Press, 1985.

Goldstein, Melvyn. *A History of Modern Tibet, 1913–1951*. Berkeley: University of California Press, 1989.

Golynets, Sergei. *Ivan Bilibin*. New York: Abrams, 1982.

Gordin, A. M., and M. A. Gordin. *Aleksandr Blok i russkie khudozhniki*. Leningrad: Khudozhnik RSFSR, 1986.

Grabar', Igor' E. *Moia zhizn'*. Moscow: Iskusstvo, 1937.

Grabar', Igor' E. *Pis'ma, 1891–1917*. Moscow: Nauka, 1974.

Grann, David. *The Lost City of Z: A Tale of Deadly Obsession in the Amazon*. New York: Vintage, 2010.

Grant, Frances. *Pilgrimage of the Spirit*. Privately published by Beata Grant, 1997.

Gray, Camilla, and Marian Burleigh-Motley. *The Russian Experiment in Art, 1863–1922*. London: Thames and Hudson, 1986.

Gray [Blakesley], Rosalind P. *Russian Genre Painting in the Nineteenth Century*. Oxford: Oxford University Press, 2000.

Griffiths, Paul. *Stravinsky*. New York: Schirmer Books, 1993.

Gumilev, Lev. *Drevniaia Rus' i velikaia step'*. Moscow: ACT, 2001.

Gumilev, Lev. *Drevnii Tibet*. Moscow: DI DIK, 1996.

Gumilev, Nikolai S. *Pis'ma o russkoi poezii*. Moscow: Sovremennik, 1990.

Hahl-Koch, Jelena. *Kandinsky*. New York: Rizzoli, 1993.

Haney, Jack V. *An Introduction to the Russian Folktale*. Armonk, NY: M. E. Sharpe, 1999.

Hansen, R. C. *Scenic and Costume Designs for the Ballets Russes*. Ann Arbor: University of Michigan Press, 1985.

Harshav, Benjamin. *Marc Chagall and His Times: A Documentary Narrative*. Stanford, CA: Stanford University Press, 2004.

Harwell, Andrei. "Churaevka: A Russian Village in the Connecticut Woods." *Russian Life* 50 (July–August 2007): 52–58.

Haskell, Arnold L., with Walter Nouvel. *Diaghileff: His Artistic and Private Life*. New York: Simon and Schuster, 1935.

Heissig, W. *The Religions of Mongolia*. Berkeley: University of California Press, 1980.

Hill, Peter. *Stravinsky: The Rite of Spring*. Cambridge: Cambridge University Press, 2000.

Hilton, Alison. *Russian Folk Art*. Bloomington: Indiana University Press, 1995.

Hilton, Isabel. *In Search of the Panchen Lama*. New York: W. W. Norton, 1999.

Hodson, Millicent. "Nijinsky's Choreographic Method: Visual Sources from Roerich for *Le Sacre du Printemps*." *Dance Research Journal* 18 (Winter 1986–1987): 7–15.

Hodson, Millicent. *Nijinsky's Crimes Against Grace: Reconstruction Score of the Original Choreography for* Le Sacre du Printemps. New York: Pendragon Press, 1996.

Hodson, Millicent. "*Sacre*: Searching for Nijinsky's Chosen One." *Ballet Review* (Fall 1987): 53–66.

Hoffman, Stefani. "Scythianism: A Cultural Vision in Revolutionary Russia." PhD diss., Columbia University, 1975.

Hoogen, Marilyn Meyer. "Igor Stravinsky, Nikolai Roerich, and the Healing Power of Paganism." PhD diss., University of Washington, 1997.

Hopkirk, Peter. *Foreign Devils on the Silk Road: The Search for the Lost Cities and Treasures of Chinese Central Asia*. Oxford: Oxford University Press, 1984.

Hopkirk, Peter. *The Great Game: The Struggle for Empire in Central Asia*. New York: Kodansha, 1994.

Hopkirk, Peter. *Setting the East Ablaze: Lenin's Dream of an Empire in Asia*. London: John Murray, 1984.

Horgan, Paul. *Encounters with Stravinsky: A Personal Record*. New York: Farrar, Straus and Giroux, 1972.

Horowitz, Mitch. *Occult America: White House Séances, Ouija Circles, Masons, and the Secret Mystic History of Our Nation*. New York: Bantam, 2009.

Hutton, Ronald. *Shamans: Siberian Spirituality and the Western Imagination*. London: Hambledon and London, 2001.

Iakovleva, Elena P. *Teatral'no-dekoratsionnoe iskusstvo N. K. Rerikha*. Samara: Agni, 1996.

Iuzefovich, L. A. *Samoderzhets pustyni*. Moscow, 1993.

Ivanits, Linda J. *Russian Folk Belief*. Armonk, NY: M. E. Sharpe, 1989.

Ivanov, V. N. *Ogni v tumane: Rerikh—Khudozhnik-myslitel'*. Moscow: Sovetskii pisatel', 1991.

Ivanov, V. N., and E. Gollenbakh. *Rerikh*. Riga, 1939.

Jahn, Hubertus F. *Patriotic Culture in Russia during World War I*. Ithaca, NY: Cornell University Press, 1998.

Jerryson, Michael K. *Mongolian Buddhism: The Rise and Fall of the Sangha*. Chiang Mai: Silkworm Books, 2007.

Johnson, Paul K. *The Masters Revealed: Madame Blavatsky and the Myth of the Great White Lodge*. Albany: State University of New York Press, 1994.

Johnson, Robert. *Spying for Empire: The Great Game in Central and South-East Asia, 1757–1947*. London: Greenhill, 2006.

Kapstein, Matthew T. *The Tibetans*. Oxford: Blackwell, 2006.

Karlinsky, Simon. "Stravinsky and Russian Preliterate Theater." *Nineteenth-Century Music*. 6 (Spring 1983): 232–40.

Karsavina, Tamara. *Theatre Street*. New York: E. P. Dutton, 1931.

Kelly, Catriona, and David Shepherd, eds. *Constructing Russian Culture in the Age of Revolution, 1881–1940*. Oxford: Oxford University Press, 1998.

Kelly, Thomas Forrest. *First Nights: Five Musical Premieres*. New Haven, CT: Yale University Press, 2001.

Kennedy, Janet. *The "Mir iskusstva" Group and Russian Art*. New York: Garland, 1977.

Khilnani, Sunil. *The Idea of India*. London: Penguin, 1997.

King, David, and Cathy Porter. *Images of Revolution: Graphic Art from 1905 Russia*. New York: Pantheon, 1983.

King, Richard. *Orientalism and Religion: Postcolonial Theory, India, and 'The Mystic East.'* London: Routledge, 1999.

Kirichenko, Evgeniia. *Russian Design and the Fine Arts, 1750–1917*. New York: Abrams, 1991.

Klimoff, Eugene. "Alexandre Benois and His Role in Russian Art." *Apollo* 98 (December 1973): 460–69.

Kniazeva, V. P. *Nikolai Konstantinovich Rerikh*. Moscow: Iskusstvo, 1963.

Kochno, Boris. *Diaghilev and the Ballets Russes*. New York: Harper and Row, 1970.

Kordashevskii, N. V. *Tibetskie stranstviia polkovnika Kordashevskogo (s ekspeditsiei N. K. Rerikha po Tsentral'noi Azii)*. Saint Petersburg: Dmitrii Bulanin, 1999.

Korotkina, L. V. *Nikolai Rerikh*. Leningrad, 1976.

Korotkina, L. V. *Nikolai Rerikh*. Saint Petersburg: Khudozhnik Rossii, 1996.

Korotkina, L. V. *Rerikh v Peterburge-Petrograde*. Leningrad: Lenizdat, 1985.

Kovtun, Yevgeny. *The Russian Avant-Garde in the 1920s and 1930s*. Bournemouth: Parkstone, 1996.

Krader, Lawrence. "A Nativistic Movement in Western Siberia." *American Anthropologist* 58 (April 1956): 282–92.

Krakauer, Jon. *Under the Banner of Heaven: A Story of Violent Faith*. New York: Anchor Books, 2004.

Krasovskaya, Vera. *Nijinsky*. New York: Schirmer Books, 1979.

Kripalani, Krishna. *Tagore: A Biography*. New York: Grove, 1960.

Krzhimovskaia, E. "Skriabin i Rerikh." *Muzykal'naia zhizn'* (August 1983): 15–16.

Kucherova, Darya. "Art and Spirituality in the Making of the Roerich Myth." PhD diss., Central European University, 2006.

Kul'turnoe nasledie rossiiskoi emigratsii. 2 vols. Moscow: Nasledie, 1994.

Kuraev, Andrei. *Ob otluchenii Rerikhov ot Tserkvi*. Mstitslav': Prosvetitel', 1995.

Kuraev, Andrei. *Satanizm dlia intelligentsii: O Rerikhakh i Pravoslavii*. Moscow: Otchii dom, 1997.

Kuz'mina, M. T., ed. *N. K. Rerikh: Zhizn' i tvorchestvo*. Moscow: Izobrazitel'noe iskusstvo, 1978.

Kuznetsov, I. S. *Inakomyslie v Novosibirskom Akademgorodke: 1979 god*. Novosibirsk, 2006.

Larichev, V. E., and E. P. Matochkin. *Rerikh i Sibir'.* Novosibirsk, 1993.

Larichev, V. E., and N. Velizhanina, eds. *Rerikhovskie chteniia*. Novosibirsk, 1976–1980.

Laruelle, Marlène. *Mythe aryen et rêve impérial dans la Russie du XIXe siècle*. Paris: CNRS, 2005.

Laruelle, Marlène. *Russian Eurasianism: An Ideology of Empire*. Baltimore: Johns Hopkins University Press, 2008.

Le Symbolisme Russe. Bordeaux: Musée des Beaux-Arts de Bordeaux, 2000.

Levitskii, V. N., ed. *Rerikh*. Prague, 1916.

Lichtmann, Esther J. *Au Royaume des Dieux: Moeurs et Coutumes de la vallée de Kulu*. Alençon: Laverdure, 1931.

Lifar, Serge. *Serge Diaghilev*. New York: G. P. Putnam's, 1940.

Lim, Susanna Soojung. "Between Spiritual Self and Other: Vladimir Solov'ev and the Question of East Asia." *Slavic Review* 67 (Summer 2008): 321–41.

Lincoln, W. Bruce. *Between Heaven and Hell: The Story of a Thousand Years of Artistic Life in Russia*. New York: Viking, 1998.

Lincoln, W. Bruce. *Red Victory: A History of the Russian Civil War*. New York: Simon and Schuster, 1989.

Lopez, Barry. *Horizon*. New York: Knopf, 2019.

Lopez, Donald S. Jr. *Prisoners of Shangri-La: Tibetan Buddhism and the West*. Chicago: University of Chicago Press, 1998.

Lunkin, Roman, and Sergei Filatov. "The Rerikh Movement: A Homegrown Russian 'New Religious Movement.'" *Religion, State, and Society* 28 (March 2000): 135–46.

Maes, Francis. *A History of Russian Music: From Kamarinskaya to Babi Yar*. Berkeley: University of California Press, 2002.

Mandelstam, Nadezhda. *Hope Against Hope*. New York: Modern Library, 1999.

Manin, V. S. *Arkhip Ivanovich Kuindzhi*. Leningrad: Khudozhnik RSFSR, 1990.

Manin, V. S. *Arkhip Ivanovich Kuindzhi i ego shkola*. Leningrad: Khudozhnik RSFSR, 1987.

Manin, V. S. *Konstantin Bogaevskii*. Moscow: Belyi gorod, 2000.

Manin, V. S. *Kuindzhi*. Saint Petersburg: Khudozhnik Rossii, 1997.

Mansbach, S. A. *Modern Art in Eastern Europe*. Cambridge: Cambridge University Press, 1999.

Mantel', A. *N. Rerikh*. Kazan: N. N. Andreev, 1912.

Martin, Timo, and Douglas Sivén. *Akseli Gallen-Kallela*. Helsinki: Watti-Kustannus, 1985.

Masing-Delic, Irene. *Abolishing Death: A Salvation Myth of Russian Twentieth-Century Literature*. Stanford, CA: Stanford University Press, 1992.

McCannon, John. "Apocalypse and Tranquility: The World War I Paintings of Nicholas Roerich." *Russian History* 30 (Fall 2003): 301–21.

McCannon, John. "By the Shores of White Waters: The Altai and Its Place in the Spiritual Geopolitics of Nicholas Roerich." *Sibirica: Journal of Siberian Studies* 2 (October 2002): 167–90.

McCannon, John. "Competing Legacies, Competing Visions of Russia: The Roerich Movement(s) in Post-Soviet Russia." In Menzel, Rosenthal, and Hagemeister, *New Age of Russia*, 348–69.

McCannon, John. "In Search of Primeval Russia: Stylistic Evolution in the Landscapes of Nicholas Roerich, 1897–1914." *Ecumene* [now *Cultural Geographies*] 7 (July 2000): 271–97.

McCannon, John. "Mother of the World: Eurasian Imagery and Conceptions of Feminine Divinity in the Works of Nikolai Roerich." In *Russian Art and the West*, edited by Rosalind Blakesley and Susan Reid. DeKalb: Northern Illinois University Press, 2006.

McCannon, John. "Passageways to Wisdom: Nicholas Roerich, Maurice Maeterlinck, and Symbols of Spiritual Enlightenment." *Russian Review* 63 (July 2004): 449–78.

McCannon, John. "Searching for Shambhala: The Mystical Art and Epic Journeys of Nikolai Roerich." *Russian Life* 44 (January–February 2001): 48–56.

Menzel, Birgit, Bernice G. Rosenthal, and Michael Hagemeister, eds. *The New Age of Russia: Occult and Esoteric Dimensions.* Munich: Kubon & Sagner, 2012.

Messena, Colleen. *Warrior of Light: The Life of Nicholas Roerich.* Malibu, CA: Summit University Press, 2002.

Meyer, Karl E. "Who Owns the Spoils of War?" *Archaeology* 48 (July–August 1995): 46–52.

Meyer, Karl E., and Shareen Blair Brysac. *Tournament of Shadows: The Great Game and the Race for Empire in Central Asia.* Washington, DC: Counterpoint, 1999.

Miliukov, Paul. *Outlines of Russian Culture, Volume 3: Architecture, Painting, and Music in Russia.* Philadelphia: University of Pennsylvania Press, 1942.

Mitrokhin, Leonid. "Helena Roerich's Letters to F.D.R." *Soviet Life* (January 1982): 38–39.

Mnukhin, L. A., ed. *Russkoe zarubezh'e: khronika nauchnoi, kul'turnoi i obshchestvennoi zhizni 1920–1940 Frantsiia.* Paris: YMCA-Press, 1995–1997.

Morrison, Simon. *Russian Opera and the Symbolist Movement.* Berkeley: University of California Press, 2003.

Murphy, George. *Soviet Mongolia.* Berkeley: University of California Press, 1966.

Narodny, Ivan. *American Artists.* Freeport, NY: Books for Libraries, 1969.

Neff, Severine et al., eds. The Rite of Spring *at 100.* Bloomington: Indiana University Press, 2017.

Nemirovich-Danchenko, Vladimir. *My Life in the Russian Theatre.* New York: Theatre Arts Books, 1968.

Nesterov, M. V. *Davnie dni.* Moscow: Iskusstvo, 1959.

Nicholas Roerich: Decors and Costumes for Diaghilev's Ballets Russes and Russian Operas. New York: Cordier and Ekstrom, 1974.

Nicholas Roerich: The Mystical Journey. Atlanta, GA: Oglethorpe University Museum of Art, 2004.

Nijinska, Bronislava. *Early Memoirs.* New York: Holt, Rinehart and Winston, 1981.

Nikolai Rerikh. Novosibirsk: Novosibirskaia kartinnaia galereia, 1990.

Nilsson, Nils Åke, ed. *Art, Society, Revolution: 1917–1921.* Stockholm: Almqvist & Wiksell, 1979.

Noguchi, Isamu. *A Sculptor's World.* New York: Harper and Row, 1968.

O'Connor, Timothy Edward. *Diplomacy and Revolution: G. V. Chicherin and Soviet Foreign Affairs, 1918–1930.* Ames: Iowa State University Press, 1988.

O'Connor, Timothy Edward. *The Engineer of Revolution: L. B. Krasin and the Bolsheviks, 1870–1926.* Boulder, CO: Westview Press, 1992.

O'Connor, Timothy Edward. *The Politics of Soviet Culture: Anatolii Lunacharskii.* Ann Arbor, MI: UMI Research Press, 1983.

Odom, Anne, Abbott Gleason, William C. Brumfield, and Alison Hilton. *The Art of the Russian North.* Washington, DC: Hillwood Museum and Gardens, 2001.

Ossendowski, Ferdinand. *Beasts, Men and Gods.* New York: E. P. Dutton, 1922.

Osterrieder, Markus. "From Synarchy to Shambala: The Role of Political Occultism and Social Messianism in the Activities of Nicholas Roerich." In Menzel, Rosenthal, and Hagemeister, *New Age of Russia*, 101–34.

Ostroumova-Lebedeva, Anna. *Avtobiograficheskie zapiski.* 2 vols. Leningrad: Iskusstvo, 1935–1945.

Owen, Alex. *The Place of Enchantment: British Occultism and the Culture of the Modern.* Chicago: University of Chicago Press, 2004.

Paelian, Garabad. *Nicholas Roerich.* Sedona, AZ: Aquarian Educational Group, 1996.

Paine, S. C. M. *Imperial Rivals: China, Russia, and Their Disputed Frontier, 1858–1924.* Armonk, NY: M. E. Sharpe, 1996.

Paris-Moscou, 1900–1930. Paris: Centre Pompidou/Gallimard, 1991.

Paston, Eleonora. *Abramtsevo: iskusstvo i zhizn'.* Moscow: Iskusstvo, 2003.

Penick, Douglas J. *The Warrior Song of King Gesar.* Boston: Wisdom, 1996.

Pereira, N. G. O. *White Siberia: The Politics of Civil War.* Montreal: McGill-Queen's University Press, 1996.

Pervushin, Anton. *Okkul'tnye tainy NKVD i SS.* Leningrad: Neva, 1999.

Peterburgskii Rerikhovskii sbornik. 5 vols. Saint Petersburg: Bukovskoe, 1998–2002.

Petrov, Vsevolod. *Russian Art Nouveau.* Bournemouth: Parkstone, 1997.

Pierce, Charles P. *Idiot America: How Stupidity Became a Virtue in the Land of the Free.* New York: Anchor Books, 2010.

Poliakova, E. I. *Nikolai Rerikh*. Moscow: Iskusstvo, 1983.

Polonsky, Rachel. "Letter from Peryn." *Times Literary Supplement* (June 7, 2002): 5.

Portniagin, Pavel K. "Sovremennyi Tibet. Missiia Nikolaia Rerikha. Ekspeditsionnyi dnevnik, 1927–28." *Aryavarta* 2 (1998): 11–106.

Proffer, Carl, and Ellendra Proffer. *The Silver Age of Russian Culture*. Ann Arbor: Ardis, 1975.

Prophet, Elizabeth Clare. *The Lost Teachings of Jesus: Missing Texts. Karma and Reincarnation*. Corwin Springs, MT: Summit University Press, 1994.

Prophet, Elizabeth Clare. *The Lost Years of Jesus: On the Discoveries of Abhedananda, Roerich, and Caspari*. Malibu, CA: Summit University Press, 1984.

Prophet, Mark L., and Elizabeth Clare Prophet. *The Masters and Their Retreats*. Corwin Springs, MT: Summit University Press, 2003.

Prophet, Mark L., and Elizabeth Clare Prophet. *The Path of the Universal Christ*. Corwin Springs, MT: Summit University Press, 2003.

Prothero, Stephen. *The White Buddhist: The Asian Odyssey of Henry Steel Olcott*. Bloomington: Indiana University Press, 1996.

Pyman, Avril. *A History of Russian Symbolism*. Cambridge: Cambridge University Press, 1994.

Pyman, Avril. *The Life of Alexander Blok*. 2 vols. Oxford: Oxford University Press, 1980.

Rambert, Marie. *Quicksilver*. London: St. Martin's Press, 1972.

Razgon, Lev. *True Stories*. Dana Point, CA: Ardis, 1997.

Rhinelander, L. H. "Exiled Russian Scholars in Prague: The Kondakov Seminar and Institute." *Canadian Slavonic Papers* 16 (Fall 1974): 331–52.

Riabinin, Konstantin N. "Pokazaniia Doktora K. N. Riabinina 23–24 iuliia 1930 goda." *Aryavarta* 1 (1997): 172–79.

Riabinin, Konstantin N. *Razvenchannyi Tibet*. Magnitogorsk: Amrita-Ural, 1996 [orig. 1928].

Rice, Tamara Talbot. *A Concise History of Russian Art*. New York: Praeger, 1965.

Rice, Tamara Talbot. *The Scythians*. London: Thames and Hudson, 1957.

Richardson, William. *Zolotoe runo and Russian Modernism: 1905–1910*. Ann Arbor, MI: Ardis, 1986.

Rimsky-Korsakov, Nikolai A. *My Musical Life*. New York: Knopf, 1947.

Robb, Peter. *A History of India*. New York: Palgrave, 2002.

Robinson, Paul. *The White Russian Army in Exile, 1920–1941*. Oxford: Clarendon Press, 2002.

Roerich. New York: Corona Mundi, 1924.

Roerich, George [Rerikh, Iu. N.]. *Izbrannye trudy*. Moscow: Nauka, 1967.

Roerich, George. *Pisma v 2-kh tomakh*. Moscow: MTsR, 2002.

Roerich, George. *Tibetan Paintings*. Paris: Geuthner, 1925.

Roerich, George. *Trails to Inmost Asia: Five Years of Exploration with the Roerich Central Asian Expedition*. New Haven, CT: Yale University Press, 1931.

Roerich, Helena [Rerikh, E. I.]. *Foundations of Buddhism*. New York, 1930.

Roerich, Helena. *Kriptogrammy Vostoka*. Paris, 1929.

Roerich, Helena. *Okkul'tizm i ioga*. Belgrade, 1936.

Roerich, Helena. *On Eastern Crossroads*. Delhi: Prakashan Sansthan, 1995.

Roerich, Helena, and Nicholas Roerich. "Agni Yoga" series, 13 vols. *Leaves of Morya's Garden* [Vols. 1–2 ("The Call" and "Illumination"), 1923–1926]; *Community* [Vol. 3, 1926]; *Agni Yoga* [Vol. 4, 1929]; *Infinity*, parts 1–2 [Vols. 5–6, 1930]; *Hierarchy* [Vol. 7, 1931]; *Heart* [Vol. 8, 1932]; *Fiery World*, parts 1–3 [Vols. 9–11, 1933–1935]; *Aum* [Vol. 12, 1936]; *Brotherhood* [Vol. 13, 1937]. New York: Agni Yoga Society.

The Roerich Museum: A Decade of Activity, 1921–1931. New York: Roerich Museum Press, 1931.

Roerich, Nicholas [Rerikh, N. K.]. *Adamant*. New York: Corona Mundi, 1922.

Roerich, Nicholas. *Altai-Gimalai*. In Roerich, Nicholas, *Puti blagosloveniia*.

Roerich, Nicholas. *Altai-Himalaya*. Brookfield: Arun Press, 1983 [New York: F. A. Stokes, 1929].

Roerich, Nicholas. *Fiery Stronghold*. Boston: Stratford, 1933 [*Tverdynia plamennaia*. Paris, 1933].

Roerich, Nicholas. *Flame in Chalice*. Translated by Mary Siegrist and Esther Lichtmann. New York: Roerich Museum Press, 1929.

Roerich, Nicholas. *Heart of Asia*. Rochester, VT: Inner Traditions, 1990. [New York: Roerich Museum Press, 1929, 1930].

Roerich, Nicholas. *Himalayas: Abode of Light*. London: Marlowe, 1947.

Roerich, Nicholas. *Himavat: Diary Leaves*. Allahabad: Kitabistan, 1947.

Roerich, Nicholas. *Invincible*. New York: Roerich Museum Press, 1974 [*Nerushimoe*. Riga, 1936].

Roerich, Nicholas. *Izbrannoe*. Moscow: Sovetskaia Rossiia, 1979.

Roerich, Nicholas. *Iz literaturnogo nasledii*. Moscow: Izobrazitel'noe iskusstvo, 1974.

Roerich, Nicholas. *Listy dnevnika (1931–1935)*. Vol. 1. Moscow: MTsR, 1999.

Roerich, Nicholas. *Listy dnevnika (1936–1941)*. Vol. 2. Moscow: MTsR, 2000.

Roerich, Nicholas. *Listy dnevnika (1942–1947)*. Vol. 3. Moscow: MTsR, 2002.

Roerich, Nicholas. *Puti blagosloveniia*. Moscow: Eksmo, 2007 [Riga, 1924].

Roerich, Nicholas. *Realm of Light*. New York: Roerich Museum Press, 1931 [*Derzhava sveta*. Riga, 1992].

Roerich, Nicholas. *Roerich*. New York: International Art Center, 1924.

Roerich, Nicholas. *Roerich-Himalaya*. New York: Brentano's, 1926.

Roerich, Nicholas. *Shambhala the Resplendent*. New York: Nicholas Roerich Museum, 1978 [orig. 1930].

Roerich, Nicholas. *Sobranie sochinenii*. Moscow: Sytin, 1914.

Roerich, Nicholas. *Sviashchennyi Dozor*. Harbin, 1934.

Roerich, Nicholas. *Tsvety Morii*. Berlin: Slovo, 1921.

Roerich, Nicholas. *Violators of Art*. London, 1919.

Roerich, Nicholas. *Vrata v budushchee*. Riga, 1936.

Roerich, Nicholas. *Zazhigaite serdtsa*. Moscow: Molodaia gvardiia, 1990.

Rosenfeld, Alla, ed. *Defining Russian Graphic Arts: From Diaghilev to Stalin, 1898–1934*. New Brunswick, NJ: Rutgers University Press, 1999.

Rosenthal, Bernice Glatzer. *New Myth, New World: From Nietzsche to Stalinism*. University Park: Pennsylvania State University Press, 2002.

Rosenthal, Bernice Glatzer, ed. *The Occult in Russian and Soviet Culture*. Ithaca, NY: Cornell University Press, 1997.

Rosenthal, Bernice Glatzer, and Martha Bohachevsky-Chomiak, eds. *A Revolution of the Spirit: Crisis of Value in Russia, 1890–1918*. Newtonville, MA: Oriental Research Partners, 1982.

Rosov, Vladimir A. "Man'chzhurskaia ekspeditsiia N. K. Rerikha: v poiskakh 'Novoi Strany.'" *Aryavarta* 3 (1999): 1–36.

Rosov, Vladimir A. *Nikolai Rerikh: Vestnik Zvenigoroda. Kniga I: Velikii Plan*. Saint Petersburg: Aleteia, 2002.

Rosov, Vladimir A. *Nikolai Rerikh: Vestnik Zvenigoroda. Kniga II: Novaia Strana*. Moscow: Ariavarta Press, 2004.

Rosov, Vladimir A. *Seminarium Kondakovianum: Khronika reorganizatsii v pis'makh (1929–1932)*. Saint Petersburg, 1999.

Rudnitsky, Konstantin. *Russian and Soviet Theatre, 1905–1932*. New York: Abrams, 1988.

Rueschemeyer, Marilyn, Igor Golomshtok, and Janet Kennedy. *Soviet Emigré Artists: Life and Work in the USSR and the United States*. Armonk, NY: M. E. Sharpe, 1985.

Rupen, Robert A. "Mongolia, Tibet, and Buddhism or, A Tale of Two Roerichs." *Canada-Mongolia Review* 5 (April 1979): 1–36.

Rylov, Arkadii A. *Vospominaniia*. Leningrad and Moscow: Iskusstvo, 1940.

Sagan, Carl. *The Demon-Haunted World: Science as a Candle in the Dark*. New York: Random House, 1996.

Salmond, Wendy R. *Arts and Crafts in Late Imperial Russia: Reviving the Kustar Art Industries, 1870–1917*. Cambridge: Cambridge University Press, 1996.

Sarab'ianov, Dmitrii V. *Russian Art: From Neoclassicism to the Avant-Garde*. New York: Abrams, 1990.

Sarkisyanz, Emanuel. "Communism and Lamaist Utopianism in Central Asia." *Review of Politics* 20, no. 4 (1958): 623–33.

Saul, Norman E. *The Life and Times of Charles R. Crane, 1858–1939*. Lanham, MD: Lexington Books, 2013.

Savelli, Dany. "L'Asiatisme dans la Littérature et la Pensée Russes de la fin du XIXème siècle au début du XXème siècle." PhD diss., Université de Lille III, 1992.

Savelli, Dany. "Shambhala de-ci, de-là: syncrétisme ou appropriation de la religion de l'Autre?" *Slavica Occitania* 29 (2009): 311–51.

Sayler, Oliver. *The Russian Theatre*. New York: Brentano's, 1920.

Schama, Simon. *Landscape and Memory*. New York: Knopf, 1995.

Schell, Orville. "Virtual Tibet: Where the Mountains Rise from the Sea of Our Yearning." *Harper's Magazine* (April 1998): 39–50.

Schimmelpenninck van der Oye, David. *Russian Orientalism: Asia in the Russian Mind from Peter the Great to the Emigration*. New Haven, CT: Yale University Press, 2010.

Schimmelpenninck van der Oye, David. *Toward the Rising Sun: Russian Ideologies of Empire and the Path to War with Japan*. DeKalb: Northern Illinois University Press, 2006.

Schlesinger, Arthur M., Jr. *The Coming of the New Deal*. New York: Mariner, 2003.

Schloezer, Boris de. *Scriabin: Artist and Mystic*. Berkeley: University of California Press, 1987.

Schouvaloff, Alexander. *The Art of the Ballets Russes*. New Haven: Yale University Press, 1997.

Schouvaloff, Alexander, and Victor Borovsky. *Stravinsky on Stage*. London: Steiner and Bell, 1982.

Selivanova, Nina. *The World of Roerich*. New York: Corona Mundi, 1923.

Sergeeva, N. S. *Rerikh i Vrubel'*. Moscow: MTsR, 2002.

Shaposhnikova, L. V. *Uchenyi, myslitel', khudozhnik*. Moscow: MTsR, 2006.

Shaposhnikova, L. V. *Velikoe puteshestvie po marshrutu Mastera*. Moscow: Master-Bank, 1999.

Shaumian, Tatiana. "Agvan Dorzhiev: les missions tibétaines auprès du tsar." *Slavica Occitania* 21 (2008): 135–52.

Shaumian, Tatiana. *Tibet: The Great Game and Tsarist Russia*. New York: Oxford University Press, 2000.

Shishkin, Oleg P. *Bitva za Gimalai. NKVD: magiia i shpionazh.* Moscow: OLMA-Press, 1999.

Shoumatoff, Nicholas, and Nina Shoumatoff, eds. *Around the Roof of the World.* Ann Arbor: University of Michigan Press, 1996.

Shustova, Alla. *Sokrovishche mira.* Moscow: Del'fis, 2018.

Sidorov, Valentin M. *Na vershinakh.* Moscow: Sovetskaia Rossiia, 1983.

Sirevag, Torbjörn. *The Eclipse of the New Deal and the Fall of Vice-President Wallace, 1944.* New York: Garland, 1985.

Slobin, Greta. *Remizov's Fictions.* DeKalb: Northern Illinois University Press, 1991.

Slonim, Marc. *Russian Theater: From the Empire to the Soviets.* Cleveland, OH: World, 1961.

Smith, John Boulton. *The Golden Age of Finnish Art.* Helsinki: Otava, 1976.

Snelling, John. *Buddhism in Russia: The Story of Agvan Dorzhiev; Lhasa's Emissary to the Tsar.* Rockport, MA: Element Books, 1993.

Soini, E. G. *Severnyi lik Nikolaia Rerikha.* Samara: Agni, 2001.

Sovremennaia religioznaia zhizn' Rossii. Vol. 4. Moscow: Logos, 2006.

Spender, Matthew. *From a High Place: A Life of Arshile Gorky.* New York: Knopf, 1999.

Stasulane, Anita. *Theosophy and Culture: Nicholas Roerich.* Rome: Pontifica università gregoriana, 2005.

Stephan, John. *The Russian Far East: A History.* Stanford, CA: Stanford University Press, 1994.

Stephan, John. *The Russian Fascists.* New York: Harper and Row, 1978.

Stites, Richard. *Revolutionary Dreams.* New York: Oxford University Press, 1989.

Storr, Anthony. *Feet of Clay: Saints, Sinners, and Madmen.* New York: Free Press, 1996.

Stravinsky, Igor. *Memories and Commentaries.* Garden City, NY: Doubleday, 1960.

Stravinsky, Igor. *The Rite of Spring: Sketches, 1911–1913.* London: Boosey and Hawkes, 1969.

Stravinsky, Igor. *Stravinsky: Selected Correspondence.* Edited by Robert Craft. 3 vols. New York: Knopf, 1983–1985.

Stravinsky, Igor, and Robert Craft. *Conversations with Igor Stravinsky.* London: Faber and Faber, 1959.

Stravinsky, Vera, and Robert Craft. *Stravinsky in Pictures and Documents.* New York: Simon and Schuster, 1978.

Stupples, Peter. *Pavel Kuznetsov.* Cambridge: Cambridge University Press, 1989.

Suleski, Ronald. *Civil Government in Warlord China.* New York: Peter Lang, 2002.

Sunderland, Willard. *The Baron's Cloak: A History of the Russian Empire in War.* Ithaca, NY: Cornell University Press, 2014.

Tagore, Rabindranath. *Song Offerings (Gitanjali).* London: Anvil, 2000.

Tagore, Rabindranath. *A Tagore Reader.* New York: Macmillan, 1961.

Tampy, K. P. *Nicholas Roerich.* Trivandrum: THCS, 1935.

Taruskin, Richard. *Musorgsky.* Princeton, NJ: Princeton University Press, 1993.

Taruskin, Richard. *Stravinsky and the Russian Traditions: A Biography of the Works through Mavra.* 2 vols. Berkeley: University of California Press, 1996.

Tatarinova, Irina. "'The Pedagogic Power of the Master': The Studio System at the Imperial Academy of Fine Arts in St. Petersburg." *Slavonic and East European Review* 83 (July 2005): 470–89.

Teilhard de Chardin, Pierre. *The Future of Man.* New York: Fontana, 1969.

Teilhard de Chardin, Pierre. *Letters from a Traveller.* New York: Fontana, 1972.

Tenisheva, M. K. *Khram Sviatogo Dukha v Talashkine.* Paris, 1938.

Tenisheva, M. K. *Vpechatleniia moei zhizni.* Leningrad: Iskusstvo, 1991.

Thompson, Edward. *Rabindranath Tagore.* Oxford: Oxford University Press, 1926.

Tierney, Neil. *The Unknown Country: A Life of Igor Stravinsky.* London: Robert Hale, 1977.

The Times Atlas of World Exploration. New York: HarperCollins, 1991.

Topsfield, Andrew. *In the Realm of Gods and Kings: Arts of India.* London: Philip Wilson, 2004.

Torgovnick, Marianna. *Gone Primitive: Savage Intellects, Modern Lives.* Chicago: University of Chicago Press, 1990.

Treitel, Corinna. *Science for the Soul: Occultism and the Genesis of the German Modern.* Baltimore: Johns Hopkins University Press, 2004.

Tschudi Madsen, Stephan. *Art Nouveau.* New York: McGraw-Hill, 1970.

Tuchman, Maurice, ed. *The Spiritual in Art: Abstract Painting, 1890–1985.* New York: Abbeville, 1999.

Tulskaya, Aida. "A Brief History of the Buddhist Temple in St. Petersburg." Unpublished manuscript, 2009.

Turner, Frank M. *Between Science and Religion: The Reaction to Scientific Naturalism in Late Victorian England.* New Haven, CT: Yale University Press, 1974.

Valkenier, Elizabeth Kridl. *Ilya Repin and the World of Russian Art.* New York: Columbia University Press, 1990.

Valkenier, Elizabeth Kridl. *Russian Realist Art: The Peredvizhniki and Their Tradition.* Ann Arbor, MI: Ardis, 1977.

van den Toorn, Pieter. *The Music of Igor Stravinsky.* New Haven, CT: Yale University Press, 1983.

van den Toorn, Pieter. *Stravinsky and* The Rite of Spring: *The Beginnings of a Musical Language*. Berkeley: University of California Press, 1987.

Volodarskii, Vsevolod. *Rerikh*. Moscow: Belyi gorod, 2003.

von Waldenfels, Ernst. *Nikolai Roerich: Kunst, Macht und Okkultismus*. Berlin: Osburg, 2011.

Voronova, O. P. *Kuindzhi v Peterburge*. Leningrad: Lenizdat, 1986.

Walker, Samuel J. *Henry A. Wallace and American Foreign Policy*. Westport, CT: Greenwood, 1976.

Wallace, Henry A. *The Price of Vision: The Diary of Henry A. Wallace, 1942–1946*. Boston: Houghton Mifflin, 1973.

Waller, John H. "At the Roof of the World." *Military History* 10 (April 1993): 18–24.

Walsh, Stephen. *Stravinsky: A Creative Spring*. New York: Knopf, 1999.

Washington, Peter. *Madame Blavatsky's Baboon*. New York: Schocken Books, 1995.

Webb, James. *The Occult Establishment*. La Salle, IL: Open Court, 1976.

Webb, James. *The Occult Underground*. La Salle, IL: Open Court, 1974.

Weiss, Peg. *Kandinsky and Old Russia*. New Haven, CT: Yale University Press, 1995.

West, James. *Russian Symbolism*. London: Methuen, 1970.

White, Eric Walter. *Stravinsky: The Composer and His Works*. Berkeley: University of California Press, 1984.

White, Frederick R. *Memoirs and Madness: Leonid Andreev through the Prism of the Literary Portrait*. Montreal: McGill-Queen's University Press, 2006.

White, Graham, and John Maze. *Henry A. Wallace: His Search for a New World Order*. Chapel Hill: University of North Carolina Press, 1995.

Williams, Robert C. *Artists in Revolution: Portraits of the Russian Avant-Garde, 1905–1925*. Bloomington: Indiana University Press, 1977.

Williams, Robert C. *Russia Imagined*. New York: Peter Lang, 1997.

Williams, Robert C. *Russian Art and American Money: 1900–1940*. Cambridge, MA: Harvard University Press, 1980.

Wood, Michael. *In Search of Myths and Heroes*. Berkeley: University of California Press, 2005.

Wright, Lawrence. *Going Clear: Scientology, Hollywood, and the Prison of Belief*. New York: Vintage, 2013.

Young, George. *The Russian Cosmists*. New York: Oxford University Press, 2012.

Zelinskii, A. N. "Ekspeditsiia N. K. Rerikha v Tsentral'nuiu Aziiu." *Priroda* 10 (1974): 3–13.

Zenkovsky, Serge A., ed. *Medieval Russia's Epics, Chronicles, and Tales*. New York: E. P. Dutton, 1974.

Zhuravleva, L. S. *Kniaginia Mariia Tenisheva*. Smolensk, 1992.

Zhuravleva, L. S. *Talashkino*. Moscow: Izobrazitel'noe iskusstvo, 1989.

Zil'bershtein, I. S., and V. A. Samkov, eds. *Sergei Diagilev i russkoe iskusstvo*. 2 vols. Moscow: Izobrazitel'noe iskusstvo, 1982.

Zil'bershtein, I. S., and A. N. Savinov, eds. *Aleksandr Benua razmyshliaet*. Moscow: Sovetskii khudozhnik, 1968.

Zlochevskii, G. D. *Nasledie Serebrianogo veka*. Moscow: Institut naslediia, 2006.

Znamenski, Andrei. *The Beauty of the Primitive: Shamanism and Western Imagination*. New York: Oxford University Press, 2007.

Znamenski, Andrei. *Red Shambhala: Magic, Prophecy, and Geopolitics in the Heart of Asia*. Wheaton: Quest Books, 2011.

Index

Menzhinsky, Vyacheslav, 28, 307, 565n88

Merezhkovsky, Dmitri, 46, 71, 75

Merkurov, Sergei, 138, 311, 566n103

Merritt, Abraham, 271, 367, 559n75

Meštrović, Ivan, 237, 391

Metalnikov, Sergei, 28, 370

Michelson, Albert, 370, 437

Mikeshin, Mikhail, 16, 21–22, 24

Miliukov, Paul, 72, 184, 187, 209, 213, 266, 546n72

Miller, Yevgeny, 379, 570n23

Minaev, Ivan, 59, 135

Mir iskusstva. See World of Art

Mitusov, Stepan (Helena's cousin), 59, 76, 102, 125, 169–71, 192–94, 311–12, 455, 466, 477; on edge of "inner circle," 231, 239

Moiseyev, Alexander, 413–14

Molotov, Vyacheslav, 304, 480

Monteux, Pierre, 159–61, 163

Morgenthau, Henry, 366; and redesign of dollar bill, 5, 389, 578n87

Morris, William, 34, 39, 41, 69, 103, 207, 222

Morya, 89, 91, 245, 258, 303, 364, 385, 408, 426, 458, 509, 529n105; Helena Roerich's early visions of, 44; Helena Roerich's physical meeting with, claims of, 214, 557n42; on Lenin and Marx, 267–68, 301, 320, 322, 559n61–62; the Roerichs' psychic communications with, claims of, 89, 214–15, 221, 225, 227, 229–30, 232, 234–36, 239–40, 242, 244–47, 250, 262, 271, 273, 279, 312, 317, 324, 326, 339–40, 347, 379, 381, 416–17, 422, 563n40, 565n90. *See also* Allal-Ming; Koot Hoomi

Moscow Art Theatre (MKhT), 143, 185, 311, 344, 349

Mucha, Alphonse, 233, 237, 391, 451

Müller, Max, 31, 89, 292, 561n15

Mundy, Talbot, 358, 360

Muraviev, Mikhail, 126–27, 129

Muromtsev family (Helena Roerich's relatives), 219, 239, 472, 478

Museum of Alexander III. *See* State Russian Museum

Museum of Oriental Art (Moscow), 8, 503–5, 508, 510–12, 588n36

Muslim League. *See* All-India Muslim League

Nabokov, Vladimir D. (*père*), 209, 223, 447

Nag, Kalidas, 210, 431

Narbut, Georgii, 175

Narkomindel. See People's Commissariat of Foreign Affairs

Narodny, Ivan, 219, 232, 553n65

Nationalist Party (Chinese). *See* Kuomintang

Naumov, Pavel, 145, 159

Nehru, Jawaharlal, 357, 462–63, 467–68, 475, 482–84; friendship with Roerich, 5, 211, 467–68, 487, 501

Nemirovich-Danchenko, Vladimir, 104, 143–44, 185, 344, 538n96

Nesterov, Mikhail, 45, 49, 63, 77, 79, 85, 102, 238

Nestor, Archbishop (Harbin), 399, 405

Nevsky Pickwickians. *See* Benois, Alexandre; May Gymnasium

Newberger, Sidney, 237, 247

Nicholas II, Emperor of Russia, 15, 29, 63, 67, 70–74, 104, 136–37, 173, 180, 184–85, 350; patronage of Roerich, 46, 58, 64–65, 133

Nicholas Roerich Museum (New York), 67, 432, 453, 502–3, 505, 510–11, 517n13, 529n107, 565n93, 589n42

Nietzsche, Friedrich, 42, 52, 60, 88, 92, 183, 545n71

Nijinska, Bronislava, 108, 154, 158–59

Nijinsky, Vaslav, 108, 212, 163, 503; choreography for *The Rite of Spring*, 148, 154–63, 542n176; friendship with Roerich, 108, 124, 139, 157–59

Nikiforov, Pyotr, 318, 320, 322–23, 565n95, 567n132, 568n147

1905 Revolution, 61, 71–74, 103. *See also* Russo-Japanese War

Nobel Peace Prize. *See* Roerich, Nicholas: Nobel Peace Prize, nominated for

Noguchi, Isamu, 344, 355, 366–67, 575n11

Norwood, Robert, 237, 351

Notovitch, Nicolas. *See* Jesus, "lost years" myth

Nourok, Alfred ("Silenus"), 45, 50–51, 58, 62

Nouvel, Walter, 19, 45, 154, 546n81

Novgorod Society of Antiquarian Enthusiasts (NOLD), 126–27, 129. *See also* Muraviev, Mikhail; Roerich, Nicholas: archaeology and

occultism, influence on Russian culture, 6, 33, 44, 87–92, 135–39, 181. *See also* Spiritualism; Theosophy

October Revolution (1917), 190–94. *See also* Roerich, Nicholas: revolutions of 1917, reactions to

OGPU (Soviet secret police), 274–76, 305–8, 314, 321, 335, 510, 559n80, 563n33, 564n72, 565n87, 566n122. *See also* Astakhov, Georgii; Barchenko, Alexander, Bliumkin, Yakov; Bokii, Gleb; Spetsotdel; Trilisser, Mikhail

Okakura Kazuko, 255

Olcott, Henry, 89–90. *See also* Blavatsky, Helena; Theosophy

Oldenburg, Sergei, 136, 138, 307

orientalism, 16, 32, 44, 56, 59, 101, 168, 293–94, 457, 477; academic study of Asia and Buddhism, 134–36, 205, 229, 267, 319, 370, 499; ideologies of, 40, 93, 109, 112, 125, 135–38, 532n78, 588n29. *See also* Roerich Nicholas: Asiatic themes in work of

competition over, 136–38, 200, 228–29, 253, 265, 268, 274–76, 301–2, 305–9, 397; legends and prophecies from, 86, 137–38, 147, 252, 269, 291–93, 318–19, 332, 364, 380, 443, 460, 474; Roerich's interest in and travels to, 3–4, 7, 20, 109, 138–39, 227–30, 234, 240, 252–56, 260–63, 274–79, 292, 301–2, 305, 317–18, 321–22, 326–34, 338, 375, 378–81, 397, 413; Western idealization of, 5, 88, 254–55, 346–47, 411, 441; Western visits to, 302, 318, 329, 473–74. *See also* Dalai Lama; Dorjiev, Agvan; Panchen Lama; Shambhala

Tiluwa Khutuktu, 419–20, 581n64

Toïn Lama, 299–300

Tolstoy, Ilya Lvovich (Leo Tolstoy's son), 80, 104, 269

Tolstoy, Leo, 14, 31, 41–42, 59, 139, 207, 447, 466; Roerich's visit to, 36–37, 521n55–56

Trails to Inmost Asia. See Roerich, George

Trepsa, Gvido, 502

Tretyakov Gallery (Moscow), 58, 62, 94, 500, 506

Tretyakov, Pavel, 36, 45

Trilisser, Mikhail, 305–7, 318, 321, 335, 564n72, 565n92, 568n150

Trotsky, Leon, 72, 187, 190, 193, 276, 326, 336; and Main Concessions Committee, 272, 305–6, 310

Truman, Harry S., 435–36, 439–40, 475

Tsarong Shape, 262–63, 265, 329, 331

Tsiolkovsky, Konstantin, 529n101

Tulpinck, Camille, 374, 407

Ukhtomsky, Esper, 136

UNESCO, 362, 505, 516n4, 587n8

Ungern-Sternberg, Roman von, 199–201, 216, 229, 257, 318, 547–48n16. *See also* Roerich, Vladimir

Union of Practitioners of Art (SDI, or Arts Union), 186–88. *See also* Gorky Commission

Union of Russian Artists (SRKh), 3–64; exhibitions, 64, 77, 101, 107, 125; temporary merger with World of Art, 64, 74–75, 123

United Brotherhood of Labor. *See* Spetsotdel

United States Department of State, 234, 351, 371, 379, 389, 420; interventions on Roerich's behalf, 279–80, 296, 298, 315–16, 348, 357, 359–61; investigation of Roerich enterprises, 274, 316, 359, 372, 427–28; Roerich Pact, opposition to and handling of, 7, 354–55, 375, 381, 385, 390–93, 406–7, 415; Roerich's 1934–1935, frustrations with, 386, 396, 401–4, 426–27. *See also* Hull, Cordell

Ur Cooperative (Tuva), 321, 326, 528n150. *See also* Beluha Corporation; Main Concessions Committee (GKK)

Urusvati Himalayan Research Institute (Naggar), 341–42, 347, 357–60, 369–73

Vasnetsov, Viktor, 26–27, 34, 45–46, 49–50, 77, 177, 199; Roerich's admiration of, 27, 59, 79, 175

Vaux-Phalipau, Marie de, 359, 370, 374, 407, 445

Vavilov, Nikolai, 273, 311, 370

Vedanta, 61, 88, 218, 226, 432, 528n100. *See also* Ramakrishna; Vivekananda

Vereshchagin, Vasily, 20, 36, 49

Vernadsky, George, 356, 372

Verzhbitsky, Grigori, 228, 400, 404–5

Veselovsky, Nikolai, 24, 34, 41

Viereck, George Sylvester, 367, 374

Vivekananda, 11, 88, 138, 210, 239–40, 255, 260, 278, 332, 528n100. *See also* Ramakrishna; Vedanta

VOKS. *See* All-Union Society for Cultural Relations with Foreign Countries

Voloshin, Maximilian, 91, 98, 147, 192

Vorontsov, Yulii, 505

Vroblevsky, Konstantin, 30, 102

Vrubel, Mikhail 45, 49–50, 68–69, 76, 77, 80, 126, 165, 178

Wadia, Bahman Pestonji, 210, 216, 242

Wagner, Richard, 14, 34, 46, 61, 429; concept of united art work, 34, 46, 107, 231; Roerich compared to, 213; Roerich's admiration for, 19, 59, 74, 291, 324, 444, 521n56; Roerich's designs for, 106, 145, 223.

Walker, Jimmy, 345–46, 353

Wallace, Henry A. (Galahad), 5, 379–80, 384, 410–11, 416, 441, 486, 503–4, 571n29, 583n116, 583n120; as member of Roerich's "inner circle," 7, 349, 378, 381, 408; "Dear Guru" letters and political impact of, 7, 378, 409, 432–41, 484; expedition of 1934–1935, handling of, 382–89, 39–98, 402–4, 412–13, 418, 422–26; Roerich Pact, support of, 385, 389–94, 406, 414; rupture with Roerich group, 8, 417, 422–23, 426–27; spiritual beliefs of, 377; U.S. presidential election of 1948, participation in, 436–41

Wanderers (*peredvizhniki*), 26–31, 36, 40, 77, 99–100; clash with World of Art, 45–57

Watts, Alan, 207

Wells, H. G., 4, 207, 213, 391

White Army officers. *See* expedition of 1934–1935; Russian All-Military Union

White Brotherhood. *See* "ascended masters" concept; Theosophy

Willkie, Wendell, 434–35

Witte, Sergei, 72–73, 136

World of Art (*Mir iskusstva*), 19, 39, 45–51, 54, 58, 61, 68, 75, 99–100, 108, 250, 388, 448, 450, 456–57, 503; as art journal, 46, 50–51, 58, 71; as exhibition society, 46, 62–64, 77, 123–25, 133, 167, 173–75, 177–79, 184, 192, 194; break from

Wanderers, 46–47; merger with SRKh, 63–64, 74–75, 77, 123; style seen as outmoded by World War I, 174, 177–78, 184. *See also* Ballets Russes; Benois, Alexandre; Diaghilev, Sergei; Roerich, Nicholas, World of Art, relations with and as chair of

World Service, 251–53, 269, 272

World War I, 85, 172, 196–97, 201–2; effect on Roerich's worldview, 92, 165, 181; fundraising and relief work by Roerich, 172–73; impact on Roerich's art and career, 145, 168, 173, 178–80; "prophetic" paintings and, 134, 178, 184, 459, 464, 536n58. *See also* Roerich, Nicholas: warfare, reactions to

World War II, 459, 460–62, 465–67, 469–71, 474–75, 477; as apocalypse in Roerich's eyes, 467, 470, 474; family and friends, the Roerichs' fear for, 466–67, 470, 473, 475, 477; fundraising and relief work by Roerich, 463, 465–66, 468–69, 474; impact on the Roerichs' living conditions, 461–62, 472–73; Leningrad, Roerich family's concern for, 465–66, 469–71; Soviet patriotism in Roerich's art and writings, 464–65, 470–72. *See also* Roerich, Nicholas: warfare, reactions to

Wrangel, Nikolai, 75, 80, 175

Yakovlev, Alexander, 124, 127, 358

Yalovenko, Anton, 297, 443, 459, 522n26

Yapolsky, Mikhail, 304–6

Yaremich, Stepan, 27, 75, 125, 144, 175, 546n81

Yarmolinsky, Avrahm, 219, 239, 553n60

Yeats, William Butler, 87, 93, 96

Yevgenia Maximilianovna, Grand Duchess, 80–81, 98

Younghusband, Francis, 136–37, 264

Yudenich, Nikolai, 199, 203

Yuon, Konstantin, 177

Zamirailo, Viktor 78, 144

Zaporozhets, Kapiton 111

Zarubin, Viktor 30, 102, 107, 125–28, 138, 188

Zavadsky, Vasily 251, 270, 388

Zeeler, Vladimir 447, 513

Zhdanov, Andrei 470, 479

Zhivkova, Lyudmila 501, 587n10

Ziloti (Siloti), Alexander 199, 219, 232, 239

Zimin, Sergei 145, 174

Zoroastrianism 95, 140

Zuloaga, Ignacio 224, 271, 391

Zvenigorod motif, 251, 258, 313, 507. *See also* Altai Mountains; Great Plan

Index of Roerich's Artistic Works (illustrations in bold)

Alexander Nevsky (1940), 464, 466

the "Architectural Studies" (1903–1904), 64–68, 71, **117 (Ill. 7)**, 503

Armageddon (1935–1936), 445–46, 465, **495 (Ill. 36)**

Arrows of Heaven, Spears of the Earth (1915), 179

The Atlantean (1921), 225

Banner of the Coming One (Song of Rigden Djapo) (1925–1926, "Maitreya" series), 563n39

"Banners of the East" series (1924–1925), 260–61, **286 (Ill. 22–23), 288 (Ill. 25)**

The Battle (1906), 87, 94

Battle with the Serpent (1902), 57

Beda the Preacher (1945), 46

The Benevolent Nest (1911), 134, 535n55

The Benevolent Tre Bearing the Gift of Solace to the Eyes (1912), 134

Boats (1901), 524n84

"Bogatyr" frieze (1908–1910), 94, 530n7

The Book of Doves (2 versions, 1911, 1922), 238

The Book of Life (1939), 452

Boris and Gleb (2 versions, 1919, 1942), 211, 466

Boundaries of the Kingdom (1916), 179

Brahmaputra (2 versions, 1940, 1945), 464, 476

Bridge of Glory (1923), 238

Burning of Darkness (1924, "His Country" series), 260, 264

Call of the Skies (1935–1936), 453

Call of the Sun (1919), 159, 211

The Campaign (1899), 40, 48–49

Chalice of Christ (1925), 292

The Chapel (1935–1947?), 459

Charaka (1935–1936), 452

Chintamini (1935–1936), 446

The Chud Departed Beneath the Earth (1913), 134

Church of the Holy Spirit, interior décor for (1910–1914), 69, 85–86, 101, 129, 140–41, 145–47, 168, 171–72, 261, **287 (Ill. 24)**

Church of the Savior at Nereditsk (1898–1899), 40

City on a Hill (1907), 84, 125–26

The Command (1917), 180

The Commands of Heaven (1915), 180, 184

The Command of Rigden Djapo (1927), 320

Conflagration (1914), 178

The Conjuration by Water (1905), 87, 96

Crossroads of the Paths of Christ and Buddha (1925), 292

Crowns (1914), 178

Cry of the Serpent (1912), 135